Adobe Photoshop Elements 11 Photographers

Philip Andrews

First published 2013 by Focal Press 70 Blanchard Road, Suite 402, Burlington, MA 01803

Simultaneously published in the UK by Focal Press 2 Park Square, Milton Park, Abingdon, Oxon OX14 4RN

Focal Press is an imprint of the Taylor & Francis Group, an informa business

© 2013 Philip Andrews

The right of Philip Andrews to be identified as author of this work has been asserted by him in accordance with sections 77 and 78 of the Copyright, Designs and Patents Act 1988.

All rights reserved. No part of this book may be reprinted or reproduced or utilised in any form or by any electronic, mechanical, or other means, now known or hereafter invented, including photocopying and recording, or in any information storage or retrieval system, without permission in writing from the publishers.

Notices

Knowledge and best practice in this field are constantly changing. As new research and experience broaden our understanding, changes in research methods, professional practices, or medical treatment may become necessary.

Practitioners and researchers must always rely on their own experience and knowledge in evaluating and using any information, methods, compounds, or experiments described herein. In using such information or methods they should be mindful of their own safety and the safety of others, including parties for whom they have a professional responsibility.

Product or corporate names may be trademarks or registered trademarks, and are used only for identification and explanation without intent to infringe.

Library of Congress Cataloging in Publication Data A catalog record for this book has been requested

ISBN: 978-0-415-82445-3 (pbk)

ISBN: 978-0-203-50114-6 (ebk)

Printed in the United States of America by Courier, Kendallville, Indiana.

Contents

Introduction	V
Acknowledgements	VII

Section One: Introducing Photoshop Elements

DIGITAL BASICS Photography is everywhere The beginning – the digital photograph Creating digital photos Quality factors in a digital image The steps in the digital process Where does Photoshop Elements fit into the process?

PHOTOSHOP ELEMENTS	g
Top tools for the photographer	1(
The Photoshop Elements workflow	10
The Organizer workspace	12
The Editor workspace	14
Moving between Organizer and Editor spaces	17
The Create and Share panes	19
New and improved features for	
Photoshop Elements 11	20
Photoshop Elements for the Apple Macintosh	22
Photoshop Elements and Premiere Elements	22
First steps	22
The Welcome screen	23
Step 1: Getting your pictures into Elements	24
Step 2: Viewing your pictures	39
Step 3: Image rotating	41
Step 4: Cropping and straightening	42
Step 5: Automatic corrections	46
Step 6: Printing	50
Step 7: Saving	52
Step 8: Organizing your pictures	53
Step 9: Backing up your files	57

Section Two: The Photographer's Toolkit

ORGANIZE 5	59
The Organizer workspace	60
The Welcome Screen	62
The Organizer Menu Bar	64
The Organizer Shortcuts Bar	66
Introducing the Actions Bar	67
Managing your photos with the Organizer	69
Organizing and searching features	74
Albums – the Elements way to group alike photos	80
Locating files	86
Attaching a Map Reference (Windows only)	89
Protecting your assets	93

FIX	99
The Fix Task Pane	100
Automatic editing options	101
Automating editing of several pictures at once	105

CREATE	107
Photo projects	108
Photo Book and Photo Collages	110
Photo Calendar	111
Greeting Cards	112
Photo Prints	113
Slide Shows (Win only)	114
CD and DVD Jackets	115
DVD with Menu	116
CD/DVD Labels	117
Instant Movie	118

Action SHARE 119 ADVANCED TECHNIQUES Share, share and share alike! The importance of Bit Depth 120 Online Album 121 Manual tonal control E-mail Attachments Specialized color control 122 Share Video with YouTube High quality sharpening techniques 122 Photo Mail (Win) 123 Retouching techniques Burn Video DVD/BluRay 124 Adding texture to an image Online Video Sharing 124 Changing the size of your images Adobe Revel 125 Phone Photos 126 Share to Flickr 127 SELECTIONS Share to Facebook 128 Send to SmugMug Gallery 129 Selection basics PDF Slide Show 130 **Beyond One Step Selections** Sending videos to Photoshopshowcase.com 131 Vimeo 132 **AYERS** RAW SHOOTING 133 Layers and their origins Layer Masking techniques Better digital capture 134 Enabling your Raw camera 136 Modifying your capture workflow for Raw 137 **Auto Raw Conversions** 138 TEXT The Adobe Camera Raw utility 140 Output options 155 Creating simple type The manual raw conversion process via ACR 157 Creating paragraph text Keeping ACR up to date 160 Basic text changes Other Raw plug-ins 161 Align that type! Raw file queue 162 Creating and using type masks Reducing the 'jaggies' Warping type 165 EDITOR GUIDED Applying styles to type layers Debunking some common type terms Other ways to add text The Guided editor mode – 'help when you need it' 166 Guided edit options 167 PAINTING AND DRAWING

179

180

183

184

194

197

203

205

Painting tools

Drawing tools

Custom brush creation

Painting tools in action

EDITOR QUICK

EDITOR EXPERT

Dodge and Burn tools

Color corrections

The Expert editor interface

Setting up your screen for Elements

Brightness and contrast changes

The Quick editor mode – 'quick change central'

Setting Color Management in Photoshop Elements 196

Section Three: Elements in

215

216

220

225

232

237

243

248

253

254

270

281

282

296

305

308

308

308

310

312

313

314

314

316

318

321

322

333

335

337

FILTERS	343	WEB AND SERVICES	421
Using filters	344	Photoshop Elements and the Web	423
New filters for Elements 11	348	Account creation workflow	424
		Images and the Net	424
		Getting the balance right	426
	THE EAST	Web compression formats side by side	429
PHOTOMERGE	361	Making your own web gallery	431
自然其是他的心理构创拓州。1863年2017年2016年		Other ways to share Albums	438
Taking images with Photomerge in mind	362	Other options for sharing your images online	441
Getting images into Photomerge	366	Sending your Elements photos to Flickr	441
Photomerge Group Shot	368	Other Photo Site Sharing options	443
Photomerge Faces	370	Sending images as email attachments	445
Photomerge Scene Cleaner	372	Photoshop.com is your online partner	448
Photomerge Exposure	376	Creating your own slideshows	460
Photomerge Panorama	380		
Fixing Photomerge problems	385		
Photomerge Style Match	386	PRINTING	465
		AUSTRALIA CHEZIONE CHEZIONE	
DUOTO BOOKE COLLACEE		Pathways to printing in Elements	466
PHOTO BOOKS, COLLAGES,		Making your first print	476
CALENDARS AND CARDS	391	Making multiple prints	477
		Color Management in the Print Dialog	481
Elements' advanced layout options	392	Typical printing problems and their solutions	484
Creating Photo Books with Elements	396	Web-based Printing	485
Creating Photo Collages with Elements	398		
Creating Greeting Cards with Elements	401		
Creating Photo Calendars with Elements	402	INDEX	487
Creating an Elements Photo Book in detail	403		40/
Edit an existing design	408		
Adding, replacing and removing photos	410		
Adding, moving and deleting pages	412		

Introduction

"If you, unknowingly, are able to create masterpiece in color, then unknowledge is your way. But if you are unable to create masterpieces in color out of your unknowledge then you ought to look for knowledge."

This fact which Johannes Itten, the great Bauhaus teacher in Germany, told his students, applies very well to the art of image editing as well. With all your images and a powerful tool like Photoshop Elements at your disposal, the only thing that you need to create great images and photo creations, share them with friends and store them in a perfectly organized manner, is the knowledge of how to put the product to good use. That is exactly where this book comes into the picture. It provides you with not only the knowledge about how the various features and tools work but also helps you to understand that what to do with your images and make sound decisions regarding which editing feature to use and by how much.

Discussing the whole range of tools and features and their optimum use in an easy-going manner requires a three dimensional understanding – of the product itself, of the digital imaging environment and, most importantly, of the user. Philip has vast experience in this area, being a professional photographer, international author of over 55 photographic titles, editor of Better Photoshop Techniques and DI (for the iPad) magazines and proud Adobe

Ambassador for the company's digital imaging products. This experience means that he underpins the illustrations and explanations he provides with thorough knowledge resulting from his own personal experience.

In this book, Philip uses a very simple and easy-to-understand style to illustrate the basic functionalities and then moves onto the more advanced techniques. He winds it up with wonderful illustrations and pictures which are perfectly complemented by the video tutorials and resources download section of the associated website. Further, there are many general digital imaging concepts and expert's tips which make the package extremely contextual with respect to current imaging technology.

As you go through the book you will develop an ease with the product as one feature after another gets added to your editing quiver.

Chhaya Pandey

Photoshop Elements Quality Engineering Team, Adobe Systems Incorporated

Get direct control over Photoshop Elements 10/11 from your iPad with the fantastic collection of tips, tricks and techniques available in the companion iPad applications for this book. Search for 'Photoshop Elements for Photographers' at the iTunes App Store.

Acknowledgements

Always for Kassy-Lee, but with special thanks to Adrian and Ellena for putting up with a 'would-be author' for a father for the last few months. Yes it is over...until next time at least!

Thanks also to the enthusiastic and very supportive staff at Focal Press whose belief in quality book production has given life to my humble ideas – yet again! Special thanks to Emily McCloskey, Valerie Geary, Melissa Read and Karen Andrews for as everyone knows, but doesn't acknowledge nearly enough, 'good book production is definitely a team effort'.

My appreciation goes to Bob Gager and Tom Paderna of the Photoshop Elements team for their encouragement and their belief in crazy dreams of linking the iPad and Elements.

And thanks once more to Adobe for bringing image enhancement and editing to us all through their innovative and industry-leading products, and the other hardware and software manufacturers whose help is an essential part of writing any book of this nature. In particular I wish to thank technical and marketing staff at Adobe, Microsoft, Sony, Canon, Nikon and Epson.

And finally my thanks to all the readers who continue to inspire and encourage me with their generous praise and great images. Keep emailing me to let me know how your imaging is going.

Philip Andrews www.photoshopelements.net

Digital Basics

There is no way to get around the fact that the quality of your final digital pictures is dependent upon how well they were captured initially. Poorly photographed or badly scanned images take their problems with them throughout the whole production process and end up as poor quality prints. One of the best ways to increase the level of your work is to ensure that you have the skills and knowledge necessary to create the best digital file possible at the time of capture. This is true for the majority of you who now shoot with a digital camera as well as those who are converting existing photographic images to digital with a scanner.

To help gain this level of control let's go back to the basics and see how factors like resolution and numbers of colors affect the quality of image capture.

1/250

so

PHOTOS IN ACTION

Photoshop Elements can be used to manipulate and enhance photos so that they can be easily presented in a variety of ways: from the traditional print, to the photo frame and slideshow and onto the web, or smart phone. It is even possible to create DVD presentations ready for viewing on wide screen TVs.

Print

The print was, and still is, the way that most people first engaged with a photographic image. Although this fact is clearly changing, the increase in the quality of desktop printing output, coupled with easier to use printers has made the task of making your own photos simpler than ever before. The print options in Elements too provide a faster and more accurate route from screen to print than in earlier years of digital photography.

Photo Frame

The ever-increasing popularity of the digital photo frame has led to a huge range of products being available on the market. Although most frames have similar features, each make and model are likely to have their own specific requirements when it comes to the images they display. This can mean that each photo added to the frame needs to be optimized in terms of size, compression and file type. Rather than perform these tasks manually, Elements provides an automated process to tweak sets of images in a single step.

Slideshow

No I'm not talking the click-clack of uncle Jimmy's dusty, faded, travel slides! I am referring to the allsinging, all-dancing, multi-media extravaganzas much favoured by wedding photographers. Although at first glance creating such presentations complete with sound track, narration, pan and zoom effects, snazzy transitions and associated titles seems daunting. the Elements' Slide Show editor contains all these features and more. See Chapter 19 for instructions on how to use the Slideshow editor.

Photography is everywhere

Apart from the initial years of the invention of photography, I can't think of a more exciting time to be involved in making pictures. In fact, I believe that Fox Talbot, as one of the fathers of the medium, would have little difficulty in agreeing that over the last few years the world of imaging has changed forever. Digital photography has become the two buzz-words on everyone's lips. Increasing levels of technology coupled with comparatively affordable equipment have meant that sophisticated imaging jobs that were once the closely guarded domain of industry professionals are now being handled daily by home users and enthusiasts.

This book introduces you to the techniques of the professionals and, more importantly, shows you how to use these skills to produce high quality images for yourself, your friends and your business.

The text centers on Adobe's popular Photoshop Elements program and covers all the features in version 11 as well as the tools common to the previous versions of the program.

You will learn the basics of good digital production from the point of capturing the picture, through simple manipulation techniques, to outputting your images for print and web. To help reinforce your understanding, you can practise with many of the same images that I have used in the step-by-step demonstrations by downloading them from the supporting website (www.photoshopelements.net).

Animated Gallery

The internet has transformed the way that photographers display their photos. Now a photographer without a website is like a musician who never plays to an audience. As the net has matured, so too have our expectations about what constitutes a good web gallery. The simple set of thumbnails followed by a larger gallery image design simply doesn't cut it anymore. In its place are animated galleries ranging from page-turning books to flying postcards. Thankfully Elements provides a simple workflow for creating such dynamic sites.

Phone Folio

With high resolution screens, stereo output and processors powerful enough to display full screen video, smart phones are fast becoming the portable folio of choice for professional photographers, But posting your folios to your phone is not as simple as copying from desktop to portable. There are a range of settings that need to be considered if folios are to be displayed smoothly and in high quality. Rather than spending time testing different settings, Premiere Elements provides single click workflow for porting your pictures to your phone.

DVD Presentation

Big screen TVs provide big opportunities for photographers to have their images proudly displayed in lounge rooms throughout the country. A CD/DVD based slideshow is the 21st century equivalent of the photo album. If you have a computer with a writer attached, then Photoshop Elements has several ways to get your photos to disk quickly and easily. See Chapter 5 for a step-by-step guide about how to create your own DVD presentations.

This book's associated website contains practise images as well as video tutorials and galleries that are designed to build your skills and knowledge. Look for the 'on the web' icon throughout the text. This indicates that there are associated images, or video tutorials available on **www.photoshopelements.net**, for the technique. And the unique Photoshop Elements for Photographers and Digital Darkroom Almanac applications for iPad provide additional must-have interactive content for all Elements users.

A good selection of video tutorials can also be found on this site, giving me the chance to guide you personally through your skills-building tasks. You will find a web icon (like this one) placed throughout the book to identify when such web content is available.

And we have produced special iPad and Android tablet applications to be used alongside the book. These interactive applications can be downloaded from the iTunes App Store for iPad users or from the Android Market Place if you have an Android tablet (search for *Photoshop Elements for Photographers*). The applications include a roundup of the top new features in Photoshop Elements 11 as well as a real-life project showing you how to use your new-found skills to enhance your own images and create a professional-looking photo book. Source files and comprehensive video tutorials are included in the application giving you the opportunity to practise your skills on a real-world task.

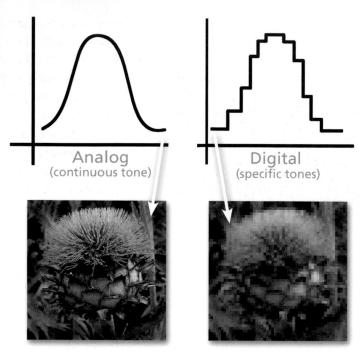

Continuous tone images have to be converted to digital form before they can be manipulated by computers.

The beginning – the digital photograph

Computers are amazing machines. Their strength is in being able to perform millions of mathematical calculations per second. To apply this ability to working with images, we must start with a description of pictures that the computer can understand.

This means that the images must be in a digital form. This is quite different from the way our eye, or any film-based camera, sees the world. With film, for example, we record pictures as a series of 'continuous tones' that blend seamlessly with each other. To make a version of the image that the computer can use, these tones need to be converted to a digital form.

The process involves sampling the image at regular intervals and assigning a specific color and brightness to each sample. In this way, a grid of colors and tones is created which, when viewed from a distance, will appear like the original image or scene. Each individual grid section is called a picture element, or pixel.

Creating digital photos

Digital files can be created by taking pictures with a digital camera or by using a scanner to convert existing prints or negatives into pixel form. Most digital cameras have a grid of sensors, called charge-coupled devices (CCDs), in the place where traditional cameras would have film. Each sensor measures the brightness and color of the light that hits it. When the values from all sensors are collected and collated, a digital picture results.

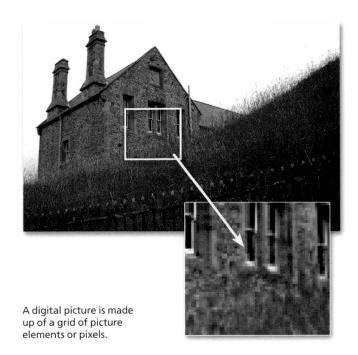

Scanners work in a similar way, except that these devices use rows of CCD sensors that move slowly over the original, sampling the picture as they go. Generally, different scanners are needed for converting film and print originals; however, some companies are now making products that can be used for both.

Video cameras use the same principle but rapidly capture a sequence of images. Any movement in the subject is recorded on successive photos. When these images, or frames,

are quickly redisplayed one after another, the motion of the subject is replicated on screen. Until recently, capturing digital video required a separate camera, now, many still cameras also contain a very usable video mode.

Photographs and negatives, or slides, are converted to digital pictures using either film or flatbed scanners.

Quality factors in a digital image

The quality of the digital file is largely determined by two factors – the number of pixels and the number and accuracy of the colors that make up the image. The number of pixels in a picture is represented in two ways – the dimensions, i.e. 'the image is 900×1200 pixels', or the total pixels contained in the image, i.e. 'it is a 3.4 megapixel picture'.

Generally, a file with a large number of pixels will produce a better quality image overall and provide the basis for making larger prints than a picture that contains few pixels. The second quality consideration is the total number of colors that can be recorded in the file. This value is usually referred to as the 'color or bit depth' of the image.

The size of a digital image is measured in pixels. Images with large pixel dimensions are capable of producing big prints and are generally better qual-790 pixels 430 pixels 1050 pixels

The current standard is known as 24-bit color or 8 bits per Red, Green and Blue channel. A picture with this depth is made up of a selection of a possible 16.7 million colors. In practice this is the minimum number of colors needed for an image to appear photographic. In the early years of digital imaging, 256 colors (8 bits of color per channel) were considered the standard.

Although good for the time, the color quality of this type of image is generally unacceptable nowadays. In fact, new camera and scanner models are now capable of 12 bits per channel (36-bit color altogether) or even 16 bits per channel (48-bit color altogether). This larger bit with most files being made depth helps to ensure greater color and tonal accuracy.

The steps in the digital process

The digital imaging process contains three separate steps - capture, manipulate and output.

Capturing the image is the first step. It is at this point that the color, quality and detail of your image will be determined. Careful adjustment of either the camera or scanner settings will help ensure that your images contain as much of the original's information as possible. In particular, you should ensure that delicate highlight and shadow details are evident in the final image.

Color or bit depth determines the number of colors possible in a digital file. Confusingly the number of colors is often referred to as 'bits per color channel' up of three channels - Red. Green and Blue. This gives a total of three times the bits per channel.

Images below:

- 1. 8 bits per color channel or 24-bit total color (16.7 million colors).
- 2. 8-bit total color (256 colors).
- 3. 4-bit total color (16 colors).
- 4. 1-bit total color (two colors).

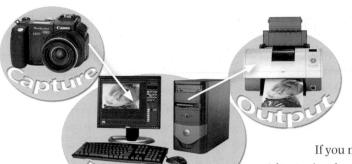

The digital imaging process contains three steps – capture, manipulate and output.

If you notice that some
'clipping', or loss of detail, is occurring
in your scans, try reducing the contrast
settings. If your camera pictures are too
dark, or light, adjust the exposure manually to

compensate. It is easier to capture the information accurately at this point in the process than try to recreate it later.

Manipulation is where the true power of the digital process becomes evident. It is here that you can enhance and change your images in ways that are far easier than ever before. Altering the color, contrast or brightness of an image is as simple as a couple of button clicks. Changing the size or shape of a picture can be achieved in a few seconds, and complex manipulations like combining two or more images together can be completed in minutes rather than the hours, or even days, needed with traditional techniques. Manipulation gives digital illustrators the power to take a base image and alter it many times so that it can be used in a variety of situations and settings. Once changed, it is possible to output this same image in many ways. It can be printed, used as an illustration in a business report, become part of a website, be sent to friends on the other side of the world as an email attachment, or projected onto a large screen as a segment in a professional presentation.

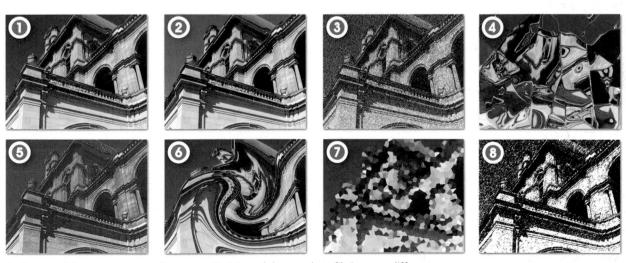

An image-editing program can enhance, manipulate and change a base file in many different ways.

(1) Original picture. (2) Black and white. (3) Add noise. (4) Reflected. (5) Change color saturation. (6) Twirled. (7) Crystallized. (8) Convert to ink pen.

Where does Photoshop Elements fit into the process?

Photoshop Elements is a program that can be used for enhancing, manipulating, printing. presenting and organizing your digital photographs. Put simply, this means that it is the pivot point for the whole digital imaging process. Its main job is to provide the tools, filters and functions that you need to manage, change and alter your pictures.

Elements is well suited for this role as it is built upon the same core structure as Adobe's famous professional-level program Photoshop. Many of the functions found in this industry-leading package are also present in Elements but, unlike Photoshop, Adobe has made Elements easier to learn and, more importantly, easier to use, than its professional cousin. In this way, Adobe has thankfully taken into account that, although a lot of users need to produce professional images as part of their daily jobs, not all of these users are, or want to be, imaging professionals.

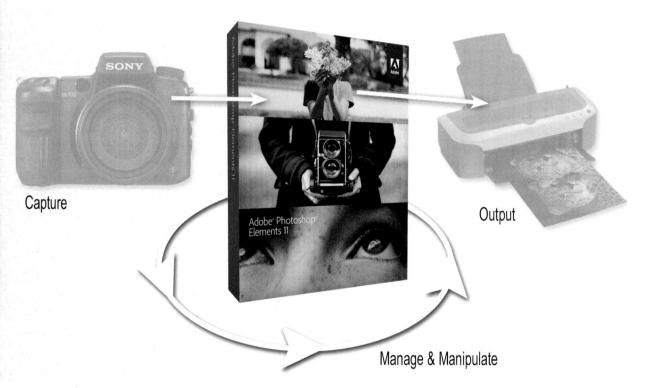

the imaging process, providing the ability to import, manipulate and output digital pictures.

Elements is the center of In addition, Elements contains features designed to download digital pictures from your camera, or scanner, directly into the program, as well as functions that allow you to easily output your finished images to web or print. When used in conjunction with other programs, like Premiere Elements, it is also possible to edit and enhance video sequences and then combine the images from Photoshop Elements with the movies from Premiere Elements in a combined presentation.

Photoshop Elements

Photoshop Elements is the type of software tool that photographers, designers and illustrators use daily to manage, enhance and present their photos. There are many companies who make programs designed for this purpose but Adobe has a substantial advantage over most of its competitors because it also produces the flagship for the industry – Photoshop. Elements draws a lot of strength from its association with Photoshop, but don't think that is the whole Elements story. The program contains a host of its own features and tools and has workflow that is quite unique.

In this chapter, as a way of orientating you to the program, we will look at the various tools, functions and interface components that make up Photoshop Elements,

Organize button

Photo Editor button

The Welcome Screen provides a starting point for all Photoshop Elements activities. Here the user chooses between organizing or editing their pictures.

Both Macintosh and Windows versions now contain the Welcome Screen.

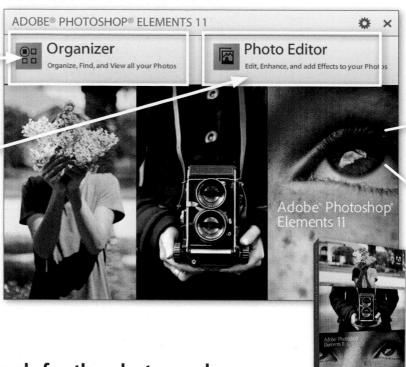

Top tools for the photographer

With Photoshop Elements, Adobe recognized that not all digital imaging consumers are the same. Professionals do require a vast array of tools and functions to facilitate almost any type of image manipulation, but there is a significant and growing number of users that want the robustness of Photoshop but don't require all the 'professional bells and whistles'. Savvy Elements users will see a lot of similarity between the programs, especially in the Editor workspace. This is because both programs are based on the same core technologies, but feature different front ends. This makes Elements sound like a cut-down version of Photoshop, but there is a lot more to this package than a subset of Photoshop's features. Adobe has taken the time to listen to its customers, and has designed and included in Elements a host of extra tools and features that are not available in Photoshop.

It's this combination of proven strength and new functions that makes Elements the perfect imaging tool for digital camera owners who need to produce professional-level images and at the same time be able to manage and present their photos, easily and economically.

The Photoshop Elements workflow

Photoshop Elements provides a workflow solution from the moment you download your files from camera, scanner or the net, through organization and manipulation phases and then onto printing (photos, books) or sharing the pictures electronically (online album, slide shows, e-mail attachments). Understanding how the various components in the system fit together will help you make the most of the software and its powerful new features.

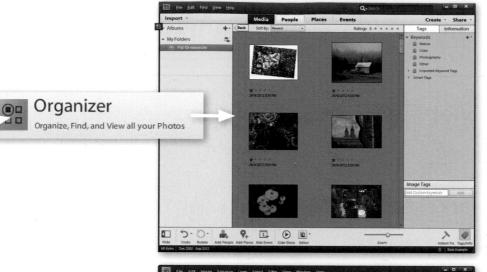

The Organizer workspace works like a 'super' file browser, allowing you to manage, search, tag and back up all the photos in your picture catalog. You can view the photographs in Media, People, Places or Event views. Pictures can be grouped into Albums and you can find specific images via the unique 'keyword tags' that you attach to the files or the star ratings you give them.

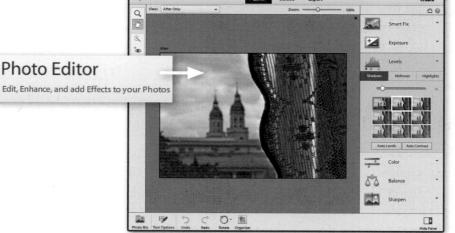

The Editor workspace is the pivot point for all your editing and enhancement activities. Here you can do everything from making small adjustments in color or brightness to major changes such as swapping a dull sky with one that contains a colorful sunset.

Two workspaces - Organizer/Bridge and Editor

Tasks within Photoshop Elements are broken into two different varieties – those activities that are concerned with organizing or managing your photos and those tasks that involve editing or enhancing your pictures. Adobe has created two different workspaces to accommodate these tasks – **Organizer** and **Editor**. All your activities in Elements will be conducted in one or the other of these spaces. Macintosh users now have the same Organizer workspace as Windows users. This wasn't the case in previous versions of the program.

Welcome Screen

The Welcome screen is the first dialog box that the user sees when opening Photoshop Elements. From this screen you can choose to Organize or Edit your pictures. In previous versions of the program, users could also sign into a special Elements online comunity account at this welcome screen. But there have been big changes in this area for version 11. You will find that many community and online activities have been eliminated. The Elements team assures us that these changes are in preparation for even better features in the future.

MAC = WINDOWS

In earlier versions of Elements the Mac version didn't contain the Organizer workspace. Apple users had a utility called Bridge which provided similar image browsing and management features. But that situation changed in version 9. Now Elements functions in the same way irrespective of the platform you are working on.

PHOTOSHOP ELEMENTS

These are not the only feature changes in this release of the program. As well as adding a bunch of new tools and features and revamping some of the old favorites, the Elements' team has been pretty ruthless in removing functions that are no longer needed or are superseded. For a full list of those features and tools no longer present in Elements go to the Appendices at the end of this book.

The Organizer workspace

One of the core strengths of Photoshop Elements is its image management tools. The Organizer is the center for these tools. Not only will you find a sophisticated file browsing workspace but you will also have access to a huge range of search, tag, sort and display options and powerful backup and album features.

Once the picture files have been imported (Organizer: File > Get Photos and Videos) into Elements they can be viewed as groups of photos in different ways such as by date taken, their associated tags and even their folder location. Keyword tags can be added to any image. You can even create your own tags (keywords). You can also form subsets of pictures based around an Album categories and headings. Both these features make finding your favorite pictures much easier.

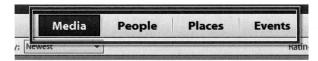

Organizer files can be displayed in different ways via four View modes selectable at the top of the workspace.

In Photoshop Elements 11 we now have four distinct ways of displaying groups of our images. These are called Views and the options are Media, People, Places and Events.

Media displays the files you have in your Organizer. You can sort or filter these files according to their type (photos, videos, projects etc.), albums, import folders or using settings like star ratings.

Events replaces Date View and it is here that images are grouped and displayed based on the date they were taken.

Places is like Map view from previous versions and takes a different approach, displaying photos based on *where* they were taken rather than *when*.

People builds on the face recognition technology found in last few revisions of the program to create groups of images that feature the same people.

Different views can be selected by clicking the View buttons at the top of the workspace.

Ratings, Albums, and Tags as well as the People, Places and Events view modes are used to filter or narrow down the number of files being displayed to redisplay the your whole collection you need to select the Media view button and then click the All Media button at the top left of the workspace.

Instant slide shows of whole albums, or just those pictures selected within the browser, can be created and displayed using the Organizer: View > Full Screen feature or by clicking the Slideshow button in the Taskbar at the bottom of the workspace.

Simple editing tasks, such as the automatic adjustment of levels, contrast and/or sharpness along with simple orientation and crop changes can be performed directly from inside the browser with the auto enhance features in the Photo Fix Options pane. Finding your favorite pictures has never been easier as you can search by date, caption, filename, history, media type, tag and color similarity (to already selected photos).

More information on the inner workings of the Organizer can be found in Chapter 3.

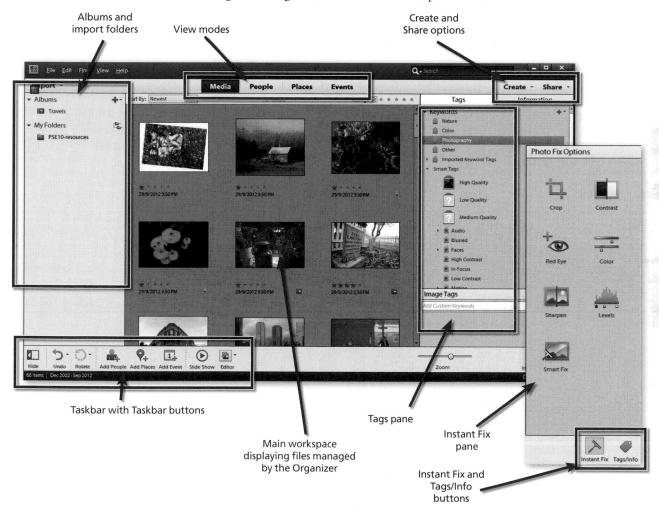

The Organizer workspace excels at search, management and viewing tasks for your collection of images. Simple auto enhancement options can be found in the Instant Fix Options pane on the right. By default the Tags pane is displayed. Switch to the Fix pane by clicking the button at the bottom.

Create and Share photo projects can be started here by selecting the images first and then choosing the project type from the drop down menus.

A new taskbar has been added under the main workspace. It contains a variety of button shortcuts to often used features such as Add People, Slideshow and Undo.

The Editor workspace

The other key workspace in Photoshop Elements is designed for making adjustments to your

photos. In earlier releases of Elements this workspace looked and felt like Photoshop and, to a certain extent, this is still true, but the guys at Adobe recognized that such a workspace could be a little daunting for the new user. So they have created a tiered approach to editing in Elements.

Photo Fix Options Crop Contrast Red Eye Color Sharpen Levels

Four levels of editing - Yep! Count 'em.

The editing options can be grouped around four different approaches to the task. Including four levels of editing features is Adobe's way of providing digital photographers with exactly the tools they need irrespective of their experience level and understanding. It also means that users can progress to more sophisticated tools as their confidence and knowledge grow. This said, it can be a little confusing for those of you who are new to the program to know 'what tool to use when'. For this reason I have broken down the features into the four categories detailed below and have separated their introduction into different chapters in the book.

The enhancement options listed in the Instant Fix pane in the Organizer workspace provide single click changes to your photos.

Automatic - The Instant Fix pane in the Organizer

The simplest tools are almost always fully automatic with the user having little control over the final results. These are the types of color, contrast and brightness controls that are available in the Organizer grouped in the Instant Fix panel. I know that these tools are not found in the Editor workspace but I thought that they were worth mentioning here as part of Adobe's tiered approach to editing.

Seven options (Crop, Contrast, Red Eye, Color, Sharpen, Levels, and Smart Fix) are available for use on the images displayed as thumbnails in the Organizer workspace.

This is the place to start if you are new to digital photography and want good results quickly and easily. See Chapter 4 for more details.

MAC = WINDOWS

The Mac version of Photoshop Elements now contains the Organizer workspace and so Apple users also have access to the options in the Fix panel to apply to their images.

Semi-Automatic - The Quick mode in the Editor

The second level of features sits in the middle ground between total user control and total program control over the Editing results. The tools in this group are primarily available in the Quick mode of the Editor workspace (previously called Quick Fix) but also encompass some of the more automatic or easy-to-use controls available in the Full edit mode.

This mode cleverly combines a variety of commonly used enhancement and correction tools into a single image control center. With this feature the user no longer needs to access each individual tool or menu item in turn – rather all the options are available in one place. The mode is accessed via the Quick button at the top of the workspace.

The mode's workspace has a before and after type layout and contains a reduced tool and feature set designed to facilitate the fast application of the most frequent of all enhancement activities undertaken by the digital photographer.

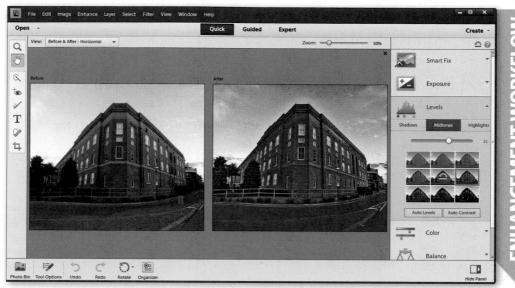

The Quick editor mode brings together all your most commonly used tools and adjustment features into one easy- and quick-to-use workspace.

The Zoom, Hand, Crop, and Quick Selection tool (and the nested Selection Brush), located in a small tool bar to the left of the screen, are available for standard image-editing changes. The other tools listed here provide paint-on adjustments to remove red-eye, whiten teeth, remove spots, add text, and crop the photo. The fixed Panel, to the right, contains the necessary features to alter and correct the lighting, color and the sharpness of your pictures. At the top of the workspace is the Zoom slider and the Rotate, Redo and Undo buttons are located on the taskbar at the bottom.

One of the best aspects of the Quick editing option is the fact that the user can choose to apply each image change automatically, via the Auto button, or manually using the supplied sliders and thumbnails. This approach provides both convenience and speed when needed, with the option of a manual override for those difficult editing tasks.

The adjustment features are arranged in a fashion that provides a model enhancement workflow to follow – simply move from the top to the bottom of the tools starting with Smart Fix, working through lighting and color alterations and, lastly, applying sharpening. Alongside the tools found in the panel on the right of the workspace you can still make use of many of the features available via the menu options located at the top of the screen.

Move to this editing mode from the tools you will find in the Instant Fix pane once you feel more confident with the digital photography process as a whole (downloading, making some changes, saving and then printing) and find yourself wanting to do more with your pictures.

More details on this approach to editing are available in Chapter 9.

Guided - The Edit Guided mode in the Editor

This approach to editing was introduced a couple of editions ago and provided a much-needed synthesis of having the program perform enhancements automatically, with no user control,

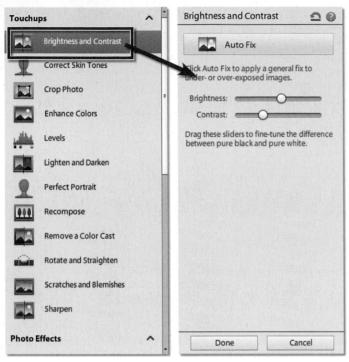

and the completely manual editing approach of the Expert and Quick edit workspaces. Using a unique step-by-step approach, the Guided edit feature leads the new user through the processes involved in performing a specific technique. The techniques are grouped in the Edit Guided option found under the Edit panel.

For some tasks, duplicate controls are included in the Guided panel that directly manipulate their counterparts in the wider editing workspace. Guided is a great place to start learning more about how to use the powerful tools in the Edit workspaces. Selecting the Guided entry from the edit options at the top of the workspace displays a list of the tutorials that ship with Elements. Clicking a tutorial heading will reveal subheadings for specific topics. Selecting a heading topic will then display a set of instructions together with associated buttons and controls.

The Edit Guided edit workspace combines stepby-step instruction with embedded enhancement or edit controls.

For instance, in the example here, two slider

controls for brightness and contrast are displayed in the panel. Moving either of slider will perform the same action as adjusting the same controls in the Brightness/Contrast dialog located on the Enhance > Adjust Lighting menu.

Guided edit is best used for learning how to use new tools and techniques or, as is the case with the Photomerge Faces, Photomerge Scene Cleaner, Group Shot and Exposure options, as a way to step through complex techniques. There are three headings in the Guided panel - Touchups, Photo Effects, and Photo Play. Each entry contain a collection of guided edits that are useful when correcting images, applying multi-step changes, or wanting to create a stylized effect.

For extra information on using the Edit Guided mode go to Chapter 8.

Manual – The Expert mode in the Editor

The final editing approach is designed to give the user professional control over their editing and enhancement tasks. Looking a lot like a funky version of Photoshop, the Expert mode (previously called Edit Full) provides access to the complete range of editing tools available in Photoshop Elements. Many of the features detailed here are very similar to, and in some cases exactly the same as, those found in the Photoshop program itself.

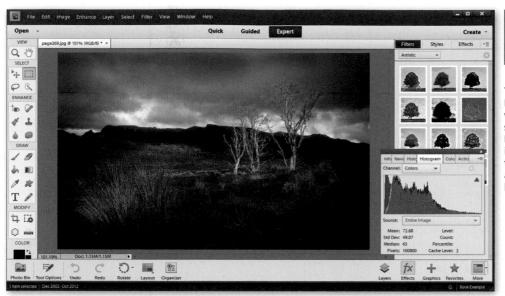

The interface for the Edit Full mode of the Editor workspace has many similarities with Photoshop including a familiar toolbar, menu structure and pane (palette) layout.

These tools provide the best quality changes available with Elements, but they do require a greater level of understanding and knowledge to use effectively. The extra editing and enhancement power of these tools comes at a cost of the user bearing all responsibility for the end results. Whereas the automatic nature of many of the features found in the other three groups means that bad results are rare, misusing or overapplying the tools found here can actually make your picture worse. This shouldn't stop you from venturing into these waters, but it does mean that it is a good idea to apply these tools cautiously rather than with a heavy hand. You can find more details about the Edit Full mode in Chapter 10.

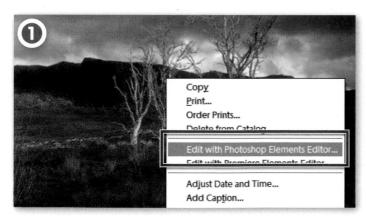

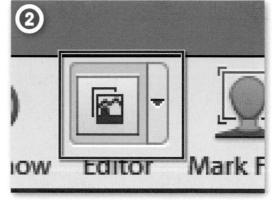

Moving between Organizer and Editor spaces

With the Organizer providing the image management environment and the Editor the tools and features needed for enhancing the photos, it is critical that moving files between both workspaces is a simple and efficient as possible. Thankfully there are several different ways to move from one space to the other.

The two fastest ways to get your photos from Organizer into Editor is to select the Edit with option from the right-click menu (1) or to click the Editor button in the Taskbar at the bottom of the Organizer workspace (2).

PHOTOSHOP ELEMENTS

Organizer to Editor

There are two different ways to move files from the Organizer space to the Editor.

- 1. Choose the Edit with Photoshop Elements Editor entry from the menu that pops up when you right click a thumbnail in Organizer.
- 2. After selecting the photo in the Organizer work space, pick Photo Editor from the pop-up menu that is displayed when clicking the Editor button on the taskbar at the bottom of the workspace.

Editor to Organizer

Working in the reverse direction it is important that any files that you create or enhance in the Editor space are added to, or updated in, the Organizer catalog. Thankfully this scenario is well handled in Elements with the following options being available:

Choosing the Include in the Elements Organizer option in the Save dialog will ensure that your adjusted images are added to the Organizer catalog.

Save Option Organize:	Include in the Elements Organizer	Save in Version Set with Original
Save:	1	As a Copy
Color:	▼ ICC Profile: sRGB IEC61966-2.1	
▼ Thumbna	ail	e Extension

- For newly-created images, photos opened directly into the Editor (File > Open) or
 pictures selected in the Organizer, simply make sure that the Include in Organizer
 setting in the Save Options of the Save dialog is checked when saving your adjustment changes.
- 2. Any auto-enhancements applied via the Fix pane features in the Organizer space will automatically add the altered photo as an extra entry in a version set in the Organizer.

A small version of the Organizer inside the Editor – Introducing the Photo Bin

The Photo Bin (previously called the Project Bin), which sits at the bottom of the Editor workspace, not only serves as a place to store images when they are being enhanced, but the feature can also act as a window to the files stored in the Organizer. Albums in the Organiz-

The Photo Bin provides two-way interaction between the Organizer workspace and the Editor. Here you can see the contents of an Album created in the Organizer displayed in the Editor.

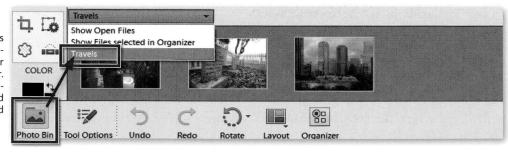

er will appear as entries in the Project Bin menu. Selecting an Album will display the images it contains in the Bin. Conversely, using the Save Bin as an Album option located on the Bin Actions menu, creates a new Album entry and adds photos displayed in the bin to the entry.

Photo Bin behaviors:

- To display a photo in the bin, in the editor workspace, double-click its thumbnail.
- Ctrl-click or Shift-click on thumbs to select multiple thumbs, then use context menu to Open, Close, etc.
- Photos in albums or in Show Files from Organizer are not open in the Editor until vou double-click them.
- · Bin Actions works on all photos in the bin, whether they are selected or not.
- You don't have to open the photos in an album to use them in a project or in Group Shot/Faces.
- For Group Shot/Faces, you should select at least two thumbnails in the bin that you want to use, otherwise all will be used.

Options in the Bin Actions menu:

- Show Open Files: Shows files currently open in the Editor.
- Show Files selected in Organizer: Shows any files currently selected in the Organizer. If the selection changes (e.g. files are added to or removed from selection), the bin updates dynamically.
- · Albums: Shows the files in a given album.
- Album Group: Shows all the files of all albums in the group.

Options in the Bin Settings menu:

- Save Bin as Album: Creates a new Album using the bin photos.
- Print Bin Photos: If a single photo or PSE document in the bin, opens the Editor's Print dialog. If several photos in the bin, opens the Organizer's Print dialog.
- Show Grid: Displays grid lines between thumbnails in the bin.

The Create and Share panes

Photoshop Elements not only provides the user with strong image management and editing features, but the program also includes a host of photo projects aimed at providing you with many options for distributing and presenting your photos. These photo projects are broken into two separate groups and listed in the Create and Share panes. Most options use a step-by-step approach with instructions and controls located in the panel on the right of

The Create and Share panes in the Organizer and Editor workspaces provide button-based access to a range of organizing, editing and sharing options for selected thumbnail images.

the workspace. You can commence the creation process from the Organizer or Edit workspaces by selecting the desired project from the appropriate Task pane. The Share options are only available in the Organizer workspace.

The Create and Share panes are the starting point for the production of slide shows, greeting and postcards, online galleries, photo books and collages and Video CD (VCD) presentations. Whole albums, Project Bin photos, several individually selected files from the Organizer or images open in the Editor, can be used as a basis for the projects.

The steps involved in creating the project are clear and precise, with sophisticated and professional results being available in minutes rather than hours, which would be the case if manually produced. For more details on creating photo projects go to Chapter 5 for Create options and Chapter 6 for Share projects.

New and improved features for Photoshop Elements 11

Version 11 sees a complete revamp of the interface for both the Organizer and Editor workspaces. Even with these visual changes the development team has been able to extend the power of existing features and add a few new ones. For instance, folder view in the Organizer has been reworked so that we can now more easily use folders as an alternative to albums as a way to group images. Here we look at the key changes in brief but in later chapters we'll delve much deeper into these features.

Online content – Adobe provides extra photo project templates available for downloading any time.

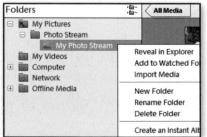

Supercharged folder view -

Folder view get more features and becomes a pivot point for organising your images.

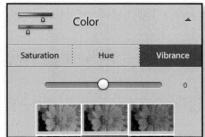

Exposure and Vibrance sliders – Two new slider controls are now available in the Quick edit workspace.

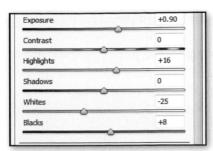

Changes for Adobe Camera Raw -

With new tonal controls and a new raw engine you now have better Raw file conversions at your finger tips.

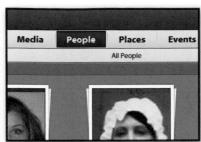

Places, People and Events view modes

- Four new modes for viewing the images in your catalog are now always present at the top of the Organizer screen.

Low Key Guided edit -

Add mood and atmosphere to your pictures with the Low Light Guided edit entry.

Vignette Guided Edit-

Introduce creative vignettes to any photo with this new Guided edit entry.

Tilt-Shift Guided Edit -

Create model toy town effects with the Tilt-Shift feature.

High Key Guided Edit -

Produce dreamy pastel colored portraits or delicate monochromes with the High Key Guide edit.

Graphic Novel filter –

Recreate dramatic monochrome effects using this new filter.

Comic filter -

Flatten colors and outline details with the Comic filter.

Pen and Ink filter -

Go beyond the abilities of the Graphic Pen filter with this new addition to the filter line up.

Changes to the Actions palette -

Get better access and more control of automated enhancement with the new Actions palette.

New tools in the Quick Editor workspace—

The Spot Healing Brush and the Healing Brush have been added to the Quick edit workspace.

Revel integration in Organizer -

Quickly upload your best Elements images to your Revel account for syncing across multiple devices.

Photoshop Elements for the Apple Macintosh

Apple users have been rejoicing since the version 9 release of Photoshop Elements because from this date the Macintosh and Windows editions of the program are released at the same time. But more importantly, from version 9 Mac and Windows editions of Photoshop Elements are almost exactly the same in terms of layout, design, and feature set. For all practical purposes there are no real differences between the two versions, except for the areas of DVD and slideshow creation, where Windows still contains more functionality.

With the feature set being pretty much the same between the two versions of Elements, the main differences noticed by the user are either cosmetic, or the result of the differences in the computer's own operating system.

Photoshop Elements and Premiere Elements

With the increasing popularity of still cameras that can shoot great video material and video cameras that can capture high quality stills, more and more users don't just want manage and edit just one type of imagery. With this in mind the folks at Adobe have been gradually increasing the links between their stills and video editing packages. For Photoshop Elements users this means an ever-growing list of links between their favorite imaging package and its sister program, Premiere Elements.

In this release, not only do the two packages share a similar looking interface but they also share the management abilities of the Organizer. This is true of both Windows and Macintosh versions of the program as now Premiere Elements is available on the Mac platform. Now you can import your video (and audio files) directly into the Organizer. You can tag, manage and sort them just like you would any other of your photos, and when it comes time to edit your movie sequences, just right-click on the thumbnail and choose the Edit in Premiere Elements option from the menu to transfer your file to the video editing workspace.

Not only does this close linking of the two programs mean a more seamless workflow when editing and enhancing different image assets, but it also provides extra options for the Photoshop Elements user. This includes such things as the ability to output the slide shows you make in Photoshop Elements to range of different devices such as iPhone, Play Station Portable or even upload them directly to your YouTube account. Cool!

First steps

As a simple introduction to the program, this section will take you through the first basic steps involved in digital photography from downloading your pictures from your camera to the computer to holding an enhanced print in your hand. We won't get involved in any manual or complex editing or enhancement techniques – there will be plenty of time for

these in the next few chapters – instead, we will look at the various ways that you can get your images from your camera or scanner into the program, and see how you can manage the pictures once they are there. Then we will select an individual photograph, rotate and crop the image, save the changed file and finally print the picture. So let's get started.

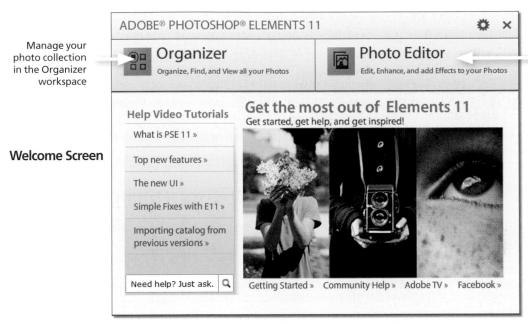

Edit and enhance photos within the Full, Quick or Guided edit workspaces

The Elements
Welcome screen
appears as the user
opens the program.
The screen can also
be displayed by
selecting the
Welcome Screen
option from the Help
menus or both the
Editor and Organizer
workspaces.

The Welcome screen

When Elements is first opened, the user is presented with a Welcome screen containing several options. The selections are broken into different types of imaging activities and, depending on where you are in the workflow, will determine your entry point into the program. Mac and Windows users the same options. So to start let's overview the options in the Welcome screen.

Organizer – Designed as the first port of call for downloading your pictures from cameras, scanners and mobile phones, this selection takes you to the Organizer component of the Elements system. Start here when first introducing your pictures into Elements and when managing your photos.

Photo Editor – This selection takes you directly to the Edit workspace where you can choose between the three different editing modes – Expert (previously call Full), Quick and Guided. *Expert* provides you with the most powerful enhancement and editing tools and features available in Elements. *Quick* provides more manual control than is available with the Auto Fix features in the Organizer space, but less than that found in the more sophisticated Expert edit area. The *Guided Edit* workspace provides the user with step-by-step instructions on how to enhance their images.

Step 1: Getting your pictures into Elements

The first step is to add images to Elements. For the most part this will mean transferring images from a camera or memory card to your computer. Both Windows and Macintosh users will make use of the Adobe Photo Downloader for this purpose.

Transferring photos from your camera to Elements

Select the From Camera or Card Reader option from the File > Get Photos and Videos menu in Organizer or from the Import drop-down menu locate in the top left of the workspace. Next you will see the Adobe Photo Downloader (APD) dialog. This feature is designed to quickly and easily transfer images from camera to computer. APD contains the option of using either a Standard or Advanced dialog. The Advanced option not only provides thumbnail previews of the images stored on the camera or card but the dialog also contains several features for sorting and managing files as they are downloaded. But let's start simply, with the options in the Standard dialog.

Standard Dialog Workflow

After finding and selecting the source of the pictures (the card reader or camera) you will then see a thumbnail of the first file stored on the camera or memory card. By default all pictures on the card will be selected ready for downloading and cataloging.

Next, set the Import Settings. Browse for the folder where you want the photographs to be stored and if you want to use a subfolder select the way that this folder will be named from the Create Subfolder drop-down menu. To assist with finding your pictures later it may be helpful to add a meaningful name, not the labels that are attached by the camera, to the beginning of each of the images. You can do this by selecting an option from the Rename File drop-down menu and adding any custom text if needed. It is at this point that you can choose what action Elements will take after downloading the files via the Delete Options menu.

It is a good idea to choose the Verify and Delete option as this makes sure that your valuable pictures have been downloaded successfully before they are removed from the card. Clicking the Get Photos button will transfer your pictures to your hard drive – you can then catalog the pictures in the Organizer workspace. For more choices during the download process you will need to switch to the Advanced mode.

Advanced Mode Workflow

Selecting the Advanced dialog button at the bottom left of the Standard mode window will display a larger Photo Downloader dialog with more options and a preview area showing a complete set of preview thumbnails of the photos stored on the camera or memory card. If for some reason you do not want to download all the images, then you will need to deselect the files to remain by unchecking the tick box at the bottom right-hand of the thumbnail.

PRO'S TIP

Only files that are selected in Adobe Photo Downloader can be deleted from the camera. This means they have to be downloaded and added to the catalog (even if they're already there from a previous download) before they are deleted.

.

.

.

.

Elements Organizer - Photo Downloader

Location:

Create Subfolder(s):

Rename Files:

Delete Options:

Get Photos from: F:\<Camera or Card Reader>

130 Files Selected - 2.3GB

C:\...\Pictures\[Shot Date]

Shot Date (vvvv mm dd)

Example: _DSC2581.ARW
Preserve Current Filename in XMP

Automatic Download

After Copying, Do Not Delete Originals

Do not rename files

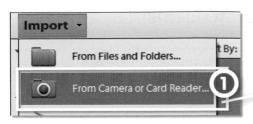

To download the pictures from your camera's memory card:

- (1) Select File > Get Photos and Videos > From Camera or Card Reader or pick the From Camera or Card Reader option on the Import menu.
- (2) Locate the card reader in the drop-down menu
- (3) Browse for the folder to store the pictures
- (4) Choose a renaming option
- (5) Elect to Rename or Auto Fix Red Eye
- (6) Tag or import photos into an album, and then
- (7) Click the Get Photos button.

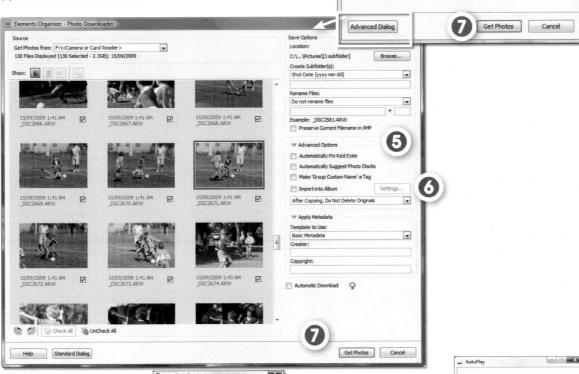

The Adobe Photo Downloader software also provides an autostart option (right) that allows the user to select the feature from a pop-up window when a memory card (in reader) or camera is attached to the computer.

The User note if an one devisible on your system. Procee celect a groupe to use in development or your system. Procee celect a groupe to use in development of the development of the

Windows 7 and Vista users may also see the operating system's AutoPlay dialog when inserting a card or connecting a camera. To use APD simply select the Organize and Edit option from the list of available choices.

NEW VOLUME (H:)

Always do this for pictures:

Pictures options

Import pictures

Import pi

PHOTOSHOP ELEMENTS

If you are upgrading from a previous version of Elements Windows and have retained that version of the program alongside the new version, then selecting the Get Photos and Videos > From Camera or Card Reader option will display the warning seen here. Use this dialog to select the downloader version that you wish to use.

This version of the Photo Downloader contains the same 'Location for saving transferred files', Rename and 'Delete after importing' options that are in the Standard dialog. In addition, this mode contains the following options:

Automatically Fix Red Eyes – This feature searches for and corrects any red eye effects in photos taken with flash.

Automatically Suggest Photo Stacks (Win) – Select this option to get the downloader utility to display groups of photos that are similar in either content or time taken. The user can then opt to convert these groups into image stacks or keep them as individual thumbnails in the Organizer.

Make 'Group Custom Name' as a Tag – To aid with finding your pictures once they become part of the larger collection of images in your Elements catalog, you can group tag the photos as you download them. Adding tags is the Elements equivalent of including searchable keywords with your pictures. This task is normally handled once the photos are in the Organizer workspace but the Windows version of the downloader contains an automated

way to add the same tag to all the photos downloaded in a single session was introduced. The tag name used is the same as the title added in the Rename section of the Photo Downloader utility.

Import into Album – Also included is the ability to create albums for the photos you are transferring inside the Adobe Photo Downloader. After selecting the Import to Album option you can click the Settings button. This will display a new pop-up window where you can either select an existing album or create a new one. Being able to download directly into albums will greatly speed up the time taken to locate images to be used in Elements projects.

Using the Import to Album option allows you to create a new album for the images you are downloading.

Apply Metadata – With this option you can add both

author name and copyright details to the metadata that is stored with the photo. Metadata,

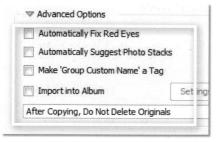

The Photo Downloader utility's Advanced mode contains several other options including auto red eye fix, auto stacking, auto tagging and adding metadata on the fly. The Mac version of APD contains a slightly different set of options including the ability to convert to DNG as the files are downloaded.

or EXIF data as it is sometimes called, is saved as part of the file and can be displayed at any time with the File Info (Editor), Properties (Organizer), or Metadata (Bridge) options in Elements or with a similar feature in other imaging programs.

Automatic Downloads

Both the Standard and Advanced dialogs contain the option to use automatic downloading the next time a camera or card reader is attached to the computer. The settings used for the auto download, as well as default values for features in the Advanced mode of the Photo Downloader, can be adjusted in the Organizer: Edit > Preferences > Camera or Card Reader dialog.

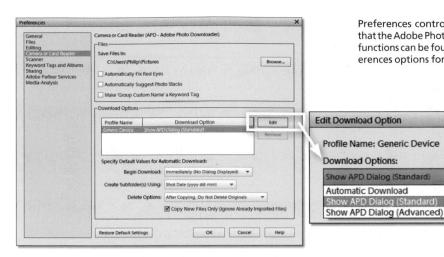

Preferences controlling the way that the Adobe Photo Downloader functions can be found in the Preferences options for Organizer.

By editing the download option you can control the mode that the downloader uses when first starting.

Starting with a Scanner

The Organizer: Get Photos and Videos > From Scanner option enables users to obtain images directly from the scanners they have connected to their computers. A similar entry is located on the Import drop-down menu. A dialog asking the user to 'Select an input source' and choose a download folder and image quality may appear if your scanner is not automatically detected. To continue, select the device from the list and click OK. Next, the scanner driver window will be displayed. In this dialog you can preview the picture and adjust the settings that will govern the scanning process. The default settings for importing files from an attached scanner for Windows users can be adjusted in the Scanner area in the Organizer: Edit > Preferences > Scanner dialog.

Start by performing a Preview scan (some scanners handle this step automatically). This will produce a quick low-resolution picture of the print or negative. Using this image as a guide, select the area to be scanned with the Marquee or Cropping tool. Next, adjust the brightness, contrast and color of the image to ensure that you are capturing the greatest amount of detail possible. Now input your scan sizes, concentrating on ensuring that the final dimensions and resolution are equal to your needs. As a rough guide, remember that if your original print or film frame is small you will need to scan at a high resolution in order to produce a reasonable file size. Large print originals, on the other hand, can be scanned at lower resolutions to achieve the same file size. Sound a little confusing? It can be, but most scanner software is designed to help you through the maze.

Ensuring enough pixels for the job

When you capture an image using a print or film scanner, you are creating a digital file. Unlike the situation with most digital cameras, where the largest pixel dimensions of the file are fixed by the size of the sensor, images made via a scanner can vary in size depending on the settings used to create them. To make sure that you have enough pixels for your requirements, it is important to remember that the quality of the image, and the size that it can be printed, are determined, in part, by its pixel dimensions. It is therefore good practice to choose the

The Import drop-down menu contains the five most common sources used for bring photos into the Organizer space of Photoshop Elements.

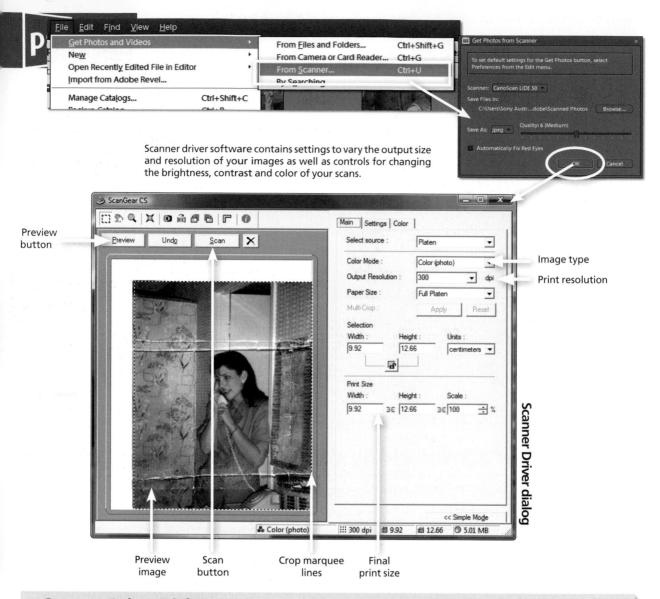

Scanner Driver Dialogs

The Scanner Driver dialog is designed and supplied by the same company that manufactures the scanner itself. When the Organizer: File > Get Photos and Videos > From Scanner option is selected, the Elements program goes in search of this driver software and displays it in a separate window on screen. When you alter settings you are controlling the scanning process only. All of this process happens outside of Elements and, once completed, the scanned file is then passed to the Elements program. This is the reason why after scanning you sometimes need to close the Control dialog to see the finished image waiting in the Elements workspace behind. The Driver dialog detailed here is supplied with Canon scanners. Your own scanner control may appear different from this one but all but the most basic machines will have options for changing size, resolution, contrast, brightness and color. Look to your manual or the online Help option for your model to locate the controls.

pixel dimensions for your image based on what that picture will be used for. An image that is destined to become a poster will need to have substantially more pixels than one needed for a postage stamp. 'Just how many more pixels are needed?' is a good question. The answer can be found in the numbers that you input into the scanner dialog.

Downsizing - retains quality

Upsizing – loses quality

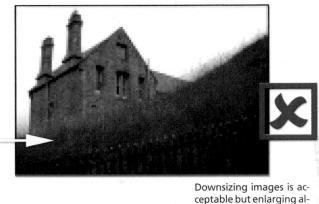

ways produces a final picture that is poor in quality. It is better to rescan the original if you need to print it bigger. Only enlarge a small picture as a

last resort.

The final dimensions of your digital picture should be input directly into the Width and Height boxes of the control. Next, the output resolution that you will use when printing your picture is placed in the Resolution box. The scanner driver will usually handle the rest, working out the exact file size needed to suit your requirements.

If you are unsure what resolution to input, use the settings in the following table as a starting point. If your picture is to be printed at a variety of sizes, scan your image for the largest size first and then use the tools in Elements (Editor: Image > Resize > Image Size) to downsize the digital file when necessary. Making large images smaller preserves much of the quality of the original but the reverse is not true. Enlarging small files to create the correct resolution needed for a big print job will always produce a poor quality file, especially when it is compared to one that was scanned at the right size in the first place.

How the image will be used	The final print resolution to select
Screen or web use only	72 dots per inch (dpi)
Draft quality inkjet prints	150 dpi
Large posters (that will be viewed from a distance)	180-220 dpi
Photographic quality inkjet printing	240–360 dpi
Magazine printing	300 dpi

Different image outcomes require different levels of output resolution. Use the values in this table as a guide when sizing your photo.

Importing photos from your computer

The Organize: File > Get Photos and Videos > From Files and Folders provides you with the familiar window that allows you to browse for and open pictures that you have already saved to your computer. You have the option to view your files in a variety of ways. You can choose between Thumbnails, Tiles, Icons, List and Detail Views using the drop-down menu from the top of the window. The Thumbnail option provides a simplified File Browser View of the pictures on your disk and it is this way of working that will prove to be most useful for digital photographers. After selecting the image, or images, you wish to import into the Photo Browser or Organizer, select the Get Photos button.

When importing images located on an external hard drive or archived to a CD/DVD you can deselect the Copy Files On Import option to choose to reference the photos in their original location rather than transfer a copy to your computer. If you are working this way then it is a good idea to select the Generate Previews option as this will ensure that the thumbnails of these 'Offline' photos which are displayed in the browser workspace of the Organizer are always good quality.

Editor: Image > Divide Scanned Photos

For those readers with many pictures to scan, the Divide Scanned Photos feature will prove a godsend. With this feature you can scan several prints at once on a flatbed scanner and then allow Elements to separate each of the individual pictures and place them in a new document.

To ensure accurate division of photos, place a colored backing sheet on top of the prints to be scanned. This helps the program distinguish where one picture starts and the other ends.

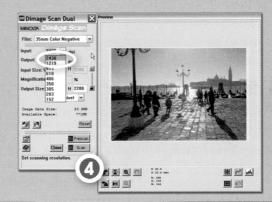

Scanning summary

Making a scan is a four-step process that starts with previewing the image (1). Next, the area to be scanned is selected (2), the brightness, contrast and color changed (if needed) (3), and finally the output dimensions and resolution set (4).

Step-by-step to better scanning

ing down the Shift key,

click on the last file in

the group.

Using Watched Folders (Win)

You can set up an alternative way to automatically add photos to your Organizer workspace with the Watched Folders option found in the File Menu. This is a particularly useful option when you have devices such as mobile phones that download images to specific directories on your computer when they are connected. Using the Watch Folder system you can point Photoshop Elements at the same folder that the phone uses and the program is smart enough to know when new pictures are saved to the folder and Elements will automatically add them to your Organizer library. The option does not link your computer directly to your mobile phone (you will need the software that came with the unit for that), but rather watches the default folder where your phone pictures are downloaded. When new pictures are added to the folder, Elements either adds them to your catalog automatically or notifies you of the new files and asks permission to add them.

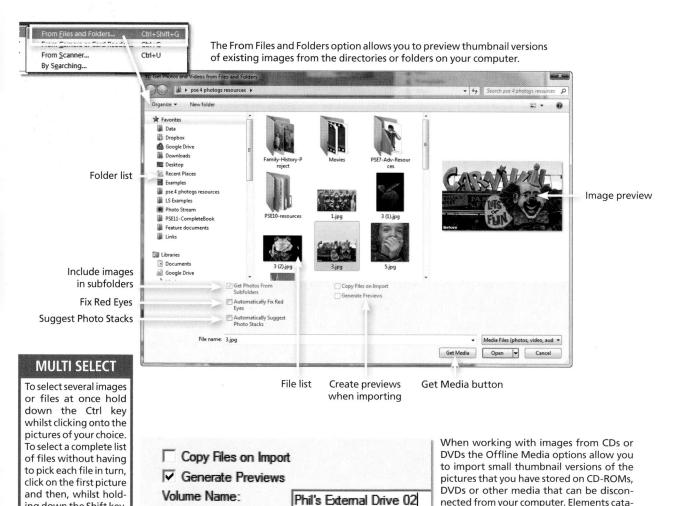

nected from your computer. Elements cata-

logs these pictures and allows you to search

and organize the thumbnails just like any

other picture.

To make sure that you can import your mobile phone pictures directly into Elements, select the default download folder using the options in the Watch Folders dialog. This window will be displayed when selecting the File > Watch Folders menu option. In the dialog displayed, browse for the folder that you use to store your mobile phone pictures. Click OK to set the folder as the default and choose whether to be notified when new photos are found or have them automatically added to the Organizer.

This feature can also be used by photographers who like to remotely control their cameras from an attached laptop. Called tethered shooting, the images are downloaded directly from the camera to the laptop hard drive and then automatically imported into Photoshop Elements.

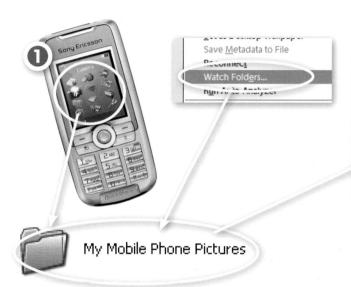

Getting pictures from your mobile phone is a two-part process. Firstly the pictures are downloaded from the phone to your computer (1) and then Elements imports them from this folder into the Photo Browser (2).

Organizer: File > Get Photos and Videos > By Searching

The Get Photos and Videos > By Searching option provides a speedy way to locate all the folders connected to your computer that contain pictures that you may want to add to your Organizer catalogs. After you set the search options and click the Search button, Elements will weave its way through your computer hunting down folders that contain candidate picture files. By default the program will not locate files in the GIF or PNG formats (both of which are almost exclusively used for web pages). If you are looking for these file types then you will need to use the Get Photos > From Files and Folders option. You can also choose to exclude small pictures and those images contained in system or program folders. Both these options should be selected to speed up the search process. Once the folder list has been compiled, which usually only takes a few seconds, you can select (or multi-select) the folders with images you wish to import. Clicking the Import Folders button will then add the pictures contained into the catalog of the Photo Browser.

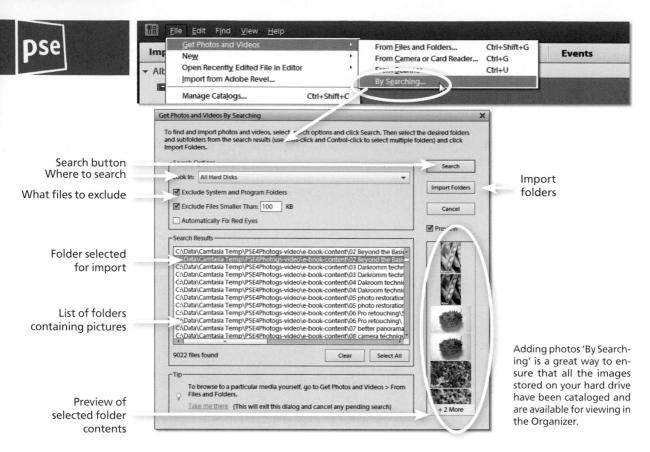

Organizer: File > Get Photos and Videos > From iPhoto (Mac)

Macintosh users also have the option of importing photos from their iPhoto library directly into Photoshop Elements. This makes the transition from using iPhoto as the primary place to manage your photos to employing the Organizer for the task, as simple as selecting the new option in the Get Photos and Videos menu. After selecting the From iPhone option a new dialog will be displayed listing your iPhoto items that you can select and then import into Photoshop Elements as new Albums.

The first step in switching from iPhoto to the Organizer is to import your pictures from the iPhoto library. Do this with the dedicated option in the Get Photos And Videos menu.

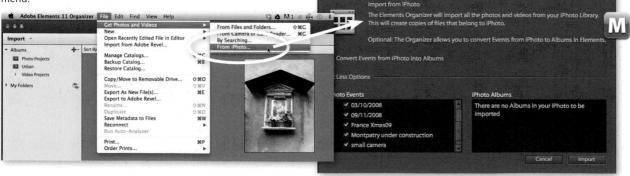

Other options for getting your photos into Elements

Although my recommendation is that you always import and organize your pictures via the Organizer and Get Photos features, there will be times when you need to access existing files, or even newly photographed images, whilst in one of the Elements editor modes – Quick Fix or Full Edit. The follow options give you just this type of access.

Selecting File > Open displays the standard Windows Open dialog. (1) You can alter the range of files displayed by selecting the specific file format to show.

Editor: File > Open

Selecting File > Open presents you with the standard Windows file browser or Mac Finder window. From here you can navigate from drive to drive on your machine before locating and opening the folder that contains your pictures. You can refine the display options by selecting the specific file type (file ending) to be displayed and as we have already noted you can also choose the way to view the files. In the example here the thumbnail view was selected so that it is possible to quickly flick through a folder full of pictures to locate the specific image that you are after.

Editor: Flle > Open As (Win)

On the odd occasion that a specific file won't open using the File > Open command you can try to open the file in a different format. Do this by selecting the File > Open As option and then choosing the file you want to open. After making this selection pick the desired format from the Open As pop-up menu, and click the Open button. This action forces the program to ignore the file format it has assumed the picture is saved in and treat the image as if it is saved as the new file type. If the picture still refuses to open, then you may have selected a format that does not

match the file's true format, or the file itself may have been damaged when being saved.

This feature is also used for open files where the extension is unknown. This is particularly useful if a picture is saved on a Macintosh machine without a file extension and then transferred to a computer running the Windows operating system which requires a file extension to open it.

With the File > Open As command you can force the Elements program to open image files in specific file formats. After choosing File > Open As select the image to be opened (1) and then pick the file format to be used for the action (2).

Editor: File > Open Recently Edited File

As you browse, open and edit various pictures from your folders, Elements keeps track of the last few files and lists them under the File > Open Recently Edited Files menu item. This is a very handy feature as it means that you can return quickly to pictures that you are working on without having to navigate back to the specific folder where they are stored. By default Photoshop Elements lists the last 10 files edited. You can change the number of files kept on this menu via the Recent File List setting in the Editor: Edit > Preferences > Saving Files window. Don't be tempted to list too many files as each additional listing uses more memory.

Photos that you have been working on can be located and opened quickly by selecting them from the Recently Edited Files option in the Editor's File menu.

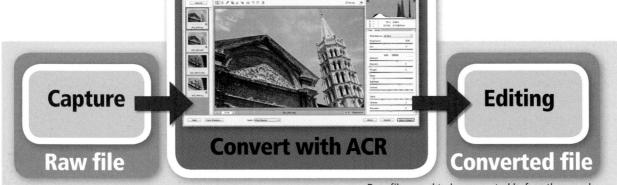

Opening raw files

Raw files need to be converted before they can be edited or enhanced in Photoshop Elements.

Raw files are a special capture file format and are unlike other imaging files that you deal with in Photoshop Elements. Rather than being able to be opened directly into the Editor workspace, they must first be converted from the capture format (.CR2 for Canon, .NEF for Nikon, .ARW for Sony, etc.) to a standard imaging format (.TIFF, JPEG, PSD). This is not to say that raw files can't be managed in the Organizer, on the contrary, raw files downloaded with the Adobe Photo Downloader and added to the Elements' library behave like other file formats for the majority of the time. With a couple of exceptions:

- 1. When applying any of the auto features (plus cropping) listed in the Fix panel, the enhancement is applied to a converted copy of the file and then this new picture is stacked with the raw original.
- 2. When opening raw files into any mode of the editing space, the picture is first opened in Adobe's conversion utility, Adobe Camera Raw (ACR), where special raw-based enhancements are applied and then a converted version of the file is opened into the editing space. Any changes made in ACR are remembered with the file and reflected in the thumbnail in the Organizer.

What does this mean in reality? Yes it means that there is an extra step in the editing process, but the increased level of control offered by raw shooting and careful conversion is worth it. For a more comprehensive look at raw formats and how to use them with Photoshop Elements go to Chapter 7.

Editor: File > Place

Although not strictly an opening action, the File > Place command is very important as it provides the Elements user with the ability to insert pictures with transparent backgrounds into Photo Book or Photo Collage projects. Normally photos are added to these projects by dragging the images from the Project Bin but this action doesn't suit photos where the backgrounds have been removed. Instead open the project file and then use File > Place to insert your image.

pse

Editor: File > Organize Open Files

This option adds files that are currently open in the Editor workspace to the Organizer catalog, if they're not already there and they don't need resaving.

Creating new documents

Editor: File > New > Blank File

The Editor: File > New > Blank File option create an Elements picture from the settings selected in the New dialog box. The dialog has sections for the image's name, width, height, resolution and mode. The background content of the image can be chosen from the list at the bottom of the box and you can also choose an existing template from a range of document types from the drop-down Preset menu.

The File > New > Blank File dialog box is used for setting the dimensions, resolution and mode of new image documents. There are a variety of preset sizes available in the File > New dialog. To choose a new preset select the Preset group first from the upper menu (1) and then choose a specific document template from the second menu immediately below it (2).

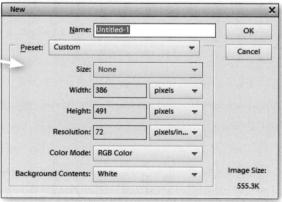

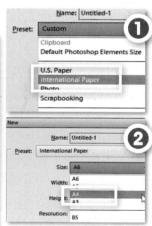

At this stage it is important to remember that the quality of the image, and the size that it can be printed, are determined, in part, by its pixel dimensions. As we saw in the scanner section earlier in the chapter, you should choose your image's pixel dimensions based on what you intend to use the picture for. Small prints need fewer total pixels than those images intended for large posters. To ensure that your document will suit your end purpose, input the final dimensions of your product directly into the Width and Height boxes. Next, add the resolution that you will use when outputting your image in the Resolution box. Be

The New > Image from Clipboard dialog box is used for pasting already copied pictures as a layer in a new Elements document.

sure to check that the resolution unit is set to 'pixels/inch' not 'pixels/cm'; inadvertently picking the wrong option here will have you creating huge images needlessly.

Editor: File > New > Image from Clipboard

Many programs contain the options to copy (Edit > Copy) and paste (Edit > Paste) information. For the most part, these functions occur within a single piece of software, but occasionally the process can also be used to copy an image, or some text, from one program and place it in another. Once a picture has been copied to memory, selecting the New > Image from Clipboard option automatically creates a new document of the correct size to accommodate the copied content and pastes the picture in as a new layer. There is no need to guess the size of the copied picture as Elements automatically determines this when it creates the new document. It is worth noting that if there is no image stored in memory then this option will be 'grayed out' (unavailable) in the menu list.

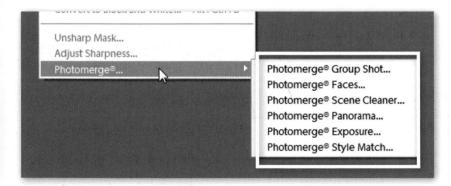

Photomerge has six different features that use sophisticated tools to combine several photos.

Photomerge options

One of the most popular features of all those included in Elements is the special stitching tool called Photomerge. There are now six different options for this feature which are now listed in the Enahnce > Photomerge menu in the Editor and Organizer workspace. The menu entries are

grayed out (can't be selected) until two or more thumbnails are selected from the Organizer. Once the photos are multi-selected, choosing a Photomerge option will transfer the images to the Editor workspace and proceed with the stitching task.

Editor: File > Import > Frame From Video (Win)

Almost hidden from view in a new position on the File > Import menu is the Frame From Video option. The option gives the users the opportunity to capture still frames from a variety of stored video formats.

The Frame From Video dialog employs familiar video player buttons to play, rewind and fast-forward the selected footage. The Grab button snatches still frames from the playing

The Frame from Video option allows you to capture a single frame from a video clip or movie.

video and places them into Elements ready for editing. Although images captured in this fashion are rarely of equal quality to those sourced from a dedicated stills camera or scanner. there are occasions when a feature such as this fits the bill.

pictures

After importing your pictures into the Organizer, you can then choose to display them in Photo Browser or Date mode.

Step 2: Viewing your

Organizer: Display > View Photos in Full Screen

The View Photos in Full Screen option provides an instant slide show of the files that you have currently displayed in the Organizer. Seeing the photos full size on your machine is a good way to edit the shots you want to keep from those that should be placed in the 'I will

Organizer's Full Screen mode includes Quick Fix (1) and Quick Organize (2) floating panels.

PHOTOSHOP ELEMENTS

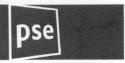

remember not to do that next time' bin. The feature includes floating Quick Fix and Quick Organize panes. The VCR-like controls allow you to play, pause or advance to next or last photos. As well as showing all the photos currently in the browser you can also multi-select the images to include in the review session before starting the feature, or even limit those pictures displayed to a particular album.

More details on both viewing modes can be found in Chapter 3.

Zoom		
⊕ Q	Zoom: O 196	1:1
7	Resize Windows To Fit	1:1 Fit Screen Fill Screen Print Size
	Zoom All Windows	
	· and a second and a second second second	

The buttons and controls on the Zoom Tool's options bar provide quick access to set sizes such as 1:1, Fit Screen, Fill Screen and Print Size.

Editor: View > Zoom In and Zoom Out

Images displayed in the Editor workspace can be viewed at a variety of different magnifications. To alter the size of the picture on screen, use either the menu option View > Zoom In or Zoom Out, or the Zoom tool. Clicking on a photo with the tool selected will enlarge the picture and clicking with the Alt/Opt key held down will reduce the size. Clicking and dragging will draw a marquee, which will then enlarge the selected part to fill your window. Double-clicking the Zoom tool automatically displays the image at 100%. Double-clicking the Hand tool fits to screen. Holding down the Shift key while zooming (with the Zoom tool) or panning (with the Hand tool) applies the changes to all open photos in the Edit workspace. To quickly zoom in or out of a photo use the Ctrl/Cmd + and Ctr/Cmd - keys.

The Navigator palette provides both zoom and movement control in one feature. If you have a large screen, this is a good palette to have visible all the time.

Editor: Window > Navigator

When the picture is enlarged beyond the boundaries of the window, you will only be able to see a small section of the image at one time. To navigate around the picture, use the Hand tool to click and drag the picture within the box. Alternatively, Elements contains a special Navigator window, where you can interactively enlarge and reduce image size, as well as move anywhere around the image boundaries.

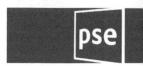

Step 3: Image rotating

One of the first tasks to undertake on pictures that you have downloaded from your camera or scanner is to correct their orientation. This, of course, is only true for those images that were taken with the camera on the side, or prints that were inadvertently scanned the wrong way up. You can rotate your pictures back to their rightful orientation in a variety of different ways. Use the steps below to reorientate your photos depending on the workspace you have open.

Organizer: Select the thumbnail of the picture that needs rotating and then select Rotate 90° Left or Right from either the Edit menu, Shortcut bar or the right-click menu.

View Photos in Full Screen: Either wait until the image you need to rotate is displayed on the main screen, or select it from the Thumbnail well on the right of the window, and then click one of the Rotate buttons located at the top of the Organizer window.

Full Editor: To rotate the whole picture using the Image > Rotate > 90° Left or Right options. Rotating the photo 180° will turn the picture upside down. Flipping the canvas provides a mirror image of the original.

Edit Quick: As well as using the same menu commands detailed for the Full Edit above, you can also click on the Rotate buttons displayed at the bottom of the preview area.

Edit Guided: Select the Rotate and/or Straighten options from the Basic Photo Edits section of the Guided menu. Select either the Rotate Left or Rotate Right buttons to pivot the picture.

Adobe Photo Downloader: You can also rotate photos in the Advanced section of the Photo Downloader utility. Just click on the thumbnail and then select the appropriate Rotate button.

Step 4: Cropping and straightening

Cropping

Cropping a picture can help add drama to an image by eliminating unneeded or unwanted detail. It can also be a good method for altering the orientation of a crooked scan. Again there are several different ways of cropping your pictures depending on which Elements workspace you are using, but all are dependent on selecting the portion of the image you wish to retain, using either the Marquee or Crop tools.

Full editor: With the first approach you need to select the Marquee tool and then click and drag the tool over the image to define a selection (of the area you wish to keep). Then, to apply the crop, choose Image > Crop from the menu bar.

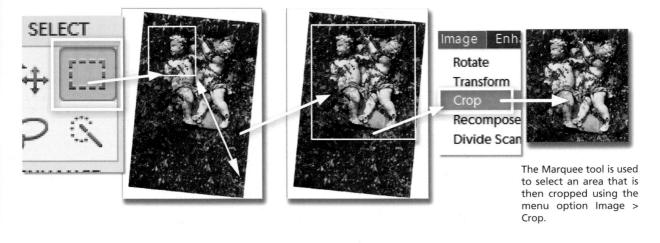

Guided editor: After selecting the Crop Photo option from the Basic Photo Edits menu, you will notice that a cropping marquee is automatically added to the photo. Use the corner or side handles to adjust the shape and size of the crop before clicking Done to apply the settings. Alternatively you can select a specific crop size from the Crop Box Size menu.

Cropping in the Organizer: First introduced in Photoshop Elements 6 was the ability to crop photos from inside the Organizer workspace. After selecting the thumbnail choose the Crop option from the Fix panel. The Crop Photo Dialog is displayed. Here you can use the Crop tool to reshape or resize the marquee that is previewed on the photograph. It is also possible to select from a variety of preset sizes or add in your own custom ratio for the crop using the Aspect Ratio menu. Clicking the Apply button performs the crop and displays the results on

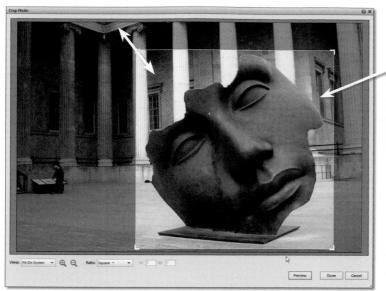

The Crop Photo section of the Guided editor panel automatically applies a crop marquee to the image. The user then adjusts the size and shape via the side and corner handles or with the options in the Crop Box Size menu.

screen. The Undo button can be used to reverse cropping changes and the OK button crops a duplicate of the original photo before saving them both in a Version Set in the Organizer. When cropping a raw file the feature creates a copy of the picture in a different format and applies the crop to this photo.

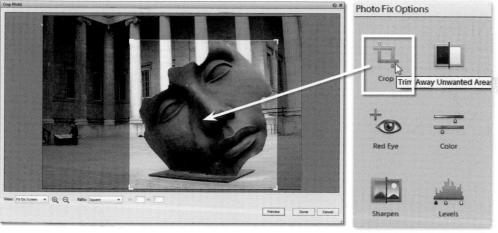

The Crop feature, located in Organizer's Instant Fix panel, provides the ability to crop photos without first opening them into an Editing space.

Cropping in the Editor: If you want a little more control then try using the specialist Crop tool. Looking like a set of darkroom easel arms, it is present in both editors' tool bars. Once the tool is selected click and drag on the image surface. You will see a marquee-like box appear. The box can be resized at any time by dragging the handles positioned at the corners or sides. When you are satisfied with the changes, crop the image by either clicking the green tick button at the bottom of the crop marquee or by double-clicking inside the crop marquee.

PHOTOSHOP ELEMENTS

The Overlay menu on the Crop tool's Options Bar cropping guides to help you add focus, create balpictures.

Cropping overlays: Starting with Photoshop Elements 10, the crop tool contains a set of cropping guides on your image when using the Crop tool. There are three overlays to choose from - Rule Of Thirds, Grid, and Golden Ratio - which can be selected from the tool's options bar. The Grid overlay is useful for aligning key picture parts, such as horizons, to grid lines when straightening crooked photos. contains three different Rule Of Thirds and Golden Ratio provide an

easy way to position key focus points in a photo so the cropped results have a natural balance. ance and straighten your The Flip The Overlay button (), also located on the Options Bar, is used with the Golden Ratio overlay to help position the focus point of the overlay. For more flexibility, use the Swap Height And Width button () to change the orientation of the crop.

ABOVE: The Crop tool allows adjustment of the selection via the handles positioned at the corners and sides of the Bounding box.

Auto Straightening

The crop marquee, in the Editor workspaces, can also be rotated to suit an image that is slightly askew. You can rotate the selection box by clicking and dragging the mouse pointer outside the edges. Now when you click the OK button the image will be cropped and straightened. If this all seems a little too complex, Elements also supplies automatic Straighten Image and Straighten and Crop Image functions. Designed especially for people like me, who always seem to get their

print scans slightly crooked, these features can be found at the bottom of the Image > Rotate menu.

The Straighten tool

The Editor contains a specialized tool designed to help you straighten the horizon lines in your photos. Called the Straighten tool, you can automatically rotate your pictures so that any line is aligned horizontally. Start by selecting the tool from the tool bar and then click-drag the cursor to draw a line parallel to the picture part that should be horizontal. Once you release the mouse button Elements automatically rotates the photo to ensure that the drawn line (and the associated picture part) is horizontal in the photo.

But don't stop there. The tool also has the ability to straighten vertically which can be very usefully for making the edges of buildings vertical. Hold down the Ctrl/Cmd key while you drag the Straighten tool along a vertical line and then release the mouse button.

When rotating the image, Elements can handle the resulting crooked edges of the photo in three different ways. The three approaches are listed in the drop-down menu in the options bar. They are:

Grow Canvas to Fit – The canvas size is increased to accommodate the rotated picture. With this option you will need to manually remove the crooked edges of the photo with the Crop tool. **Crop to Remove Background** – After rotating Elements automatically removes the picture's crooked edges. This results in a photo with smaller dimensions than the original.

Crop to Original Size – The photo is rotated within a canvas that is the size of the original picture. This option creates a photo which contains some edges that are cropped and others that are filled with the canvas color.

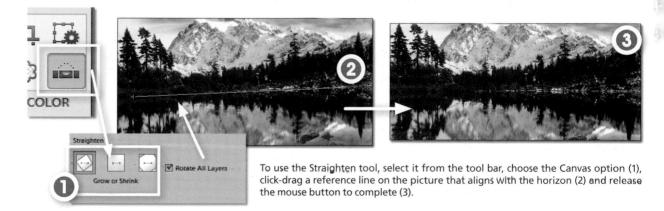

Other rotation controls

When Adobe first introduced Frame layers they also created a new way to rotate layer content in Elements. Like the corner handles that appear on the edges of the layers when using the Free Transform feature, the new rotate handle provides a click and drag pivoting option. In addition to their use with frame, the rotate handles are also available with the Image >

PHOTOSHOP ELEMENTS

In addition to the resizing handles that are normally found on the edges of layer content, there is also a rotate handle in the middle of the bottom edge. Click and drag to pivot the image around a central reference point. To pivot around an edge or corner click on a new reference in the feature's options bar to establish a new pivot point (1).

Transform > Free Transform and Image > Rotate > Free Rotate Layer commands. By default the layer content pivots around the center but you can also pivot from the corner or edges of the layer. Just select another Reference Point location in the feature's options bar.

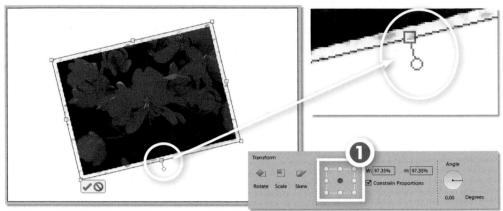

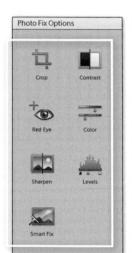

Photoshop Elements contains a range of editing and enhancement features grouped according to complexity and degree of user control. These editing options are available in the Instant Fix panel in the Organizer.

Step 5: Automatic corrections

First some background

As we have seen one of the real strengths of the Elements program is that the editing and enhancement capabilities of the software are built upon the industry standard Photoshop platform. But as most people who have had a play with Photoshop will tell you, this 'killer' application is not an easy beast to tame, let alone master. This is where Elements steps in. It combines the majority of the editing abilities of Photoshop with an easier interface and therefore a much simpler learning curve. This version continues the tradition by providing a variety of levels of enhancement and editing tools for the digital photographer. They are skilfully arranged from the automatic 'press this button now' type tools that provide quick and accurate results for the majority of pictures, through to the more sophisticated and user-controlled features required for completion of more complex, professional-level, correction tasks. The differences that existed between the Mac and Windows versions in this area have now disappeared with the creation of the Organizer workspace for Apple users. Now users of both versions can make use of the simple editing features in the Organizer's Fix panel.

The editing and enhancement options presented in the later chapters are capable of results that rival the professionals. But that's coming up; for the moment let's look at the quick and efficient changes we can make using simpler tools.

Organizer: Fix panel > Auto options

There are six auto enhancement features listed in the Fix panel in the Organizer. As well as Smart Fix and Red Eye Fix features, there is Color, Levels, Contrast, and Sharpen. All of these features can be applied to individually selected, or multi-selected, pictures in the Organizer workspace.

The **Smart Fix** option analyzes the colors and tones in the picture before automatically adjusting the brightness, contrast and color cast in the photo. For general images this auto-only solution produces good results but if you are unhappy with the changes simply select the Edit > Undo option to return the picture to its original state.

The **Color** option concentrates its enhancement on the colors in a photo. This feature works well with neutralizing color casts resulting from taking pictures under mixed or colored lighting.

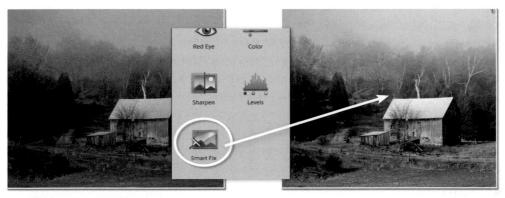

Smart Fix adjusts the color, brightness and contrast of the picture in a single step. This option can be found in the Fix pane in the Organizer as well as the Enhance menu in the Editor.

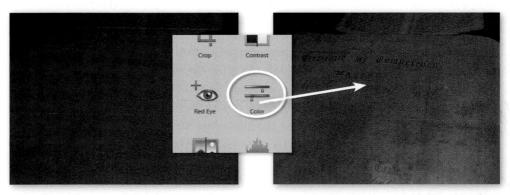

The Color feature neutralizes the wayward colors that sometimes appear when a photo has been taken under mixed lighting. This feature is called Auto Color Correction in the Editor workspace.

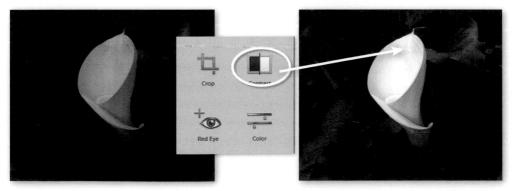

The Contrast feature automatically adjusts the spread of tones between black and white in the photo.

PHOTOSHOP ELEMENTS

Levels provides similar color balancing abilities to Auto Color but with the added benefit of also tweaking the contrast of the photo.

The Contrast feature ignores the color in a photo and just works with balancing the spread of the tones. This option works particularly well when trying to brighten and add some zap to photos taken under cloudy conditions.

The **Sharpen** control applies a set amount of sharpening to the photo to make the edges in the photo appear more crisp.

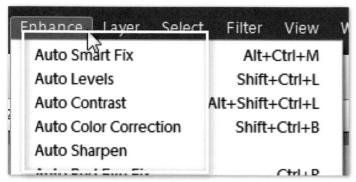

The **Red Eye Fix** feature is part of the new red eye correction technology that has been added into all levels of the Elements program. You can now automatically remove the dreaded red eye effect at the time of downloading your pictures from a memory card or camera, when importing files from a folder or from inside the Photo Browser. For the last option simply right-click the offending photo and select the Auto Red Eye Fix option from the displayed menu. If the automatic function

The Enhance menu in the Mac and Windows versions of Elements contain ment options located in the Fix pane of the Organizer.

Editor workspaces of both doesn't eliminate the problem you can manually remove red eye in the Full Edit or Quick Fix editor workspace using the Red Eye Removal tool. Adobe offers two options for red eye many of the simple adjust- correction as sometimes the auto algorithm produces unexpected results.

Auto options also available in the Editor

Many of these auto enhancement options grouped in the Fix panel of the Organizer can also be accessed inside both the Full and Quick modes of the Editor workspace. This gives Mac users the chance to access these one click enhancement options.

Click the button here to expand/collapse the Version Set

The Organizer keeps separate versions of your edited files and groups them in Version Sets. Options for the display (expand/collapse) of Versions Sets can be accessed either from the right-click menu or via the Edit > Version Set menu in the Organizer workspace.

Version Sets

When working in Windows the changed file that results from these auto adjustments is not saved over the top of the original; instead a new version of the image is saved with a file name that is appended with the suffix '_edited' attached to the original name. This way you will

always be able to identify the original and edited files. The two files are 'stacked' together in the Organizer with the latest file displayed on top. The stack of photos representing different editing stages in the picture's history is called a Version Set and is identified with an icon in the top right of the picture showing a pile of photos. To see the other images in the version stack simply click the Expand button to see the images in the Version Set. Alternatively you can right-click the thumbnail image and select Organizer: Version Set > Reveal Photos in Version Set.

Using the other options available in this pop-up menu the sets can be expanded or collapsed, the current version reverted to its original form or all versions flattened into one picture. Version Set options are also available via the Organizer's Edit menu.

Image changes can be reversed by using either the Undo (Edit > Undo) feature or Revert options (File > Revert).

Undo, Revert and Undo History

With so many options available for changing images, it's almost inevitable that occasionally you will want to reverse a change that you have made. One way to step back through your changes is to select an earlier permutation of your picture via the Version Sets feature as detailed above, but Elements also provides several other methods to achieve this.

The Undo control, Edit > Undo, will successfully take your image back to the way it was before the last change. The Undo command is available in all Elements' workspaces. If you are unhappy with all the alterations you have made since opening the file, you can use the Revert feature, Use the Edit > Revert to exchange the last saved version of your file with the one currently on screen. Revert options are available in all the editing workspaces in Elements.

The Undo History palette (Window > Undo History) provides complete control over the alterations made to your image. Each action is recorded as a separate step in the palette. Reversing any change is a simple matter of selecting the previous step in the list.

Step 6: Printing

The falling price of quality inkjet printers means that more and more people are now able to output photographic quality prints right at their desktop. To get you started quickly we will look at the print options available from the Organizer but keep in mind that these features are also available from the Editing workspaces as well. For more details on printing see Chapter 20.

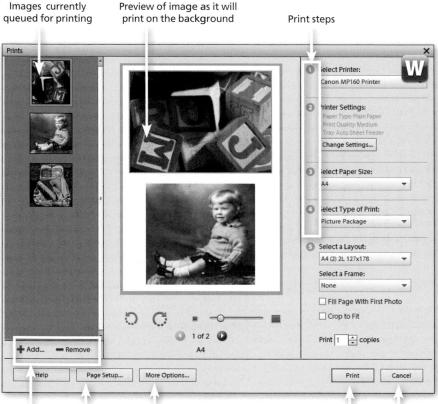

1 Select Printer:
Adobe PDF 8.0

2 Select Paper Size:
Letter

3 Select Print Size:
10.2cm x 15.2cm

Crop to Fit

Print 1 copies of each page

The Print Selected Photos dialog is the pivot point for all your printing activities. From this one spot you can output individual photos, contact sheets, picture packages and label sets.

The settings options are slightly different for Mac and Windows users, with the latter having two extra sections on the right of the Print Dialog.

See Chapter 20 for more details on advanced printing tasks.

Add extra images or delete images for printing

Set up page options for your printer

Access advanced options such as color management

Hit this button after setting dialog all the options

Organizer: File > Print or Editor: File > Print

The File > Print feature provides users with a common place to start the print process. The Print dialog was totally revamped for version 8 and now the same window is common to both Windows and Mac users. Before selecting print, choose the image or images that you want to output. Don't worry if you need to add more pictures when you are in the dialog as the great guys at Adobe have kindly added an Add Photos button at the bottom left of the screen. The process for creating a print project is as easy as setting the options in sections listed on the

right side of the dialog. When printing from the Organizer on a Macintosh system the selected image or images are transferred to the Editor space first before the Print dialog opens.

Select Printer: Start by selecting the printer that will output the image from those listed for your computer.

Printer Settings: At this stage you should also check that the actual settings for the printer match the type of image you are printing and the media (paper) you are using. Windows users can do this by adjusting the settings in the Printer Settings section. Mac users will need to click the Page Setup button to display a new window where these settings can be altered.

Select Paper Size: This setting determines the size of the paper that you are printing on.

Type of Print: Next, Windows users can choose the type of print you wish to create. There are three options to select from:

- Individual Prints designed for printing a single photograph per page,
- Contact Sheets used for creating a sheet of small thumbnails of a group of selected pictures, and
- Picture Packages ideal for putting several larger photos on a single page using templates.

Mac users printing from the Editor workspace will automatically be set up for producing Individual Prints. To create a Contact Sheet or a Picture Package, select the required option from the File menu and then work your way through the settings in the displayed dialog.

Print Size: This setting determines the size of the photo on the background. If the picture is not the same format as the print size then the picture will be resized to fit. Selecting the Crop to Fit option fills the print size frame, sometimes called the Print Well, with the photo, even if this means that some of the picture is cropped.

After adjusting the settings in each of the sections of the Print dialog click the Print button to output your photograph. Now sit back and enjoy your first digital photograph.

More printing options

See Chapter 20 for further details on the array of print options available to Photoshop Elements users.

You can select a range of different print types from the Print Selected Photos dialog. The options include (1) Individual Prints, (2) Contact Sheets and (3) Picture Packages with a variety of images per page templates.

MAC ≠ WINDOWS

Mac users have three setting sections in the Print dialog whereas Windows users have five. The main differences are that the Windows version contains extra options for adjusting Printer Settings as well as the ability to choice from different print types.

Step 7: Saving

Whilst you are making changes to your photos, the picture is stored in the memory (RAM) of the computer. With the alterations complete, the file should then be saved to a hard drive or disk. In previous versions of Elements the user needed to perform this saving step habitually after completing editing, and this still remains the case for images edited in the Full, Quick and Guided Edit workspaces. But as we have already seen, for Windows users making changes in the Organizer, Elements automatically saves the edited file and the original together in a Version Set. These auto save actions are terrific for the new user as they reduce the chance of overwriting the original file or losing changes that have taken valuable time to complete. For non-Organizer-based changes here is a summary of the other save options.

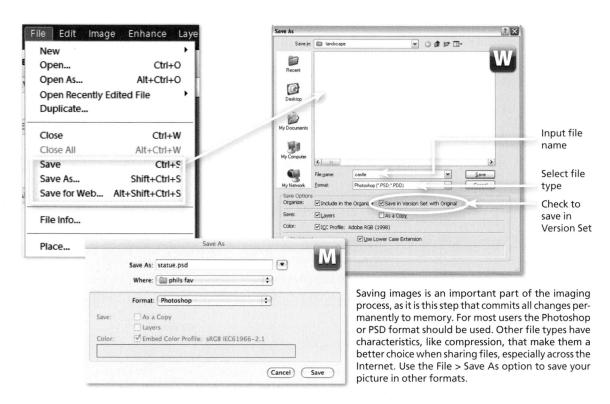

MAC ≠ WINDOWS

Mac users don't have the option in the Save dialog to include the edited image in a Version Set. This is an Organizer-only feature.

Editor: File > Save

Saving images edited in either the Quick or Full Edit workspace is a three-step process that starts by choosing File > Save from the menu bar. With the Save dialog open, navigate through your hard drive to find the directory or folder you wish to save your images in. Next, type in the name for the file and select the file format you wish to use. Windows users also have the ability to include the edited file in a Version Set with the original. They just need to click-check the Save in Version Set with Original box at the bottom of the dialog.

Editor: File > Save As

When saving editing changes, for most images, you should use the Photoshop or PSD format. This option gives you a file that maintains all of the specialized features available in Elements. This means that when you next open your image you will be able to continue to use items like layers and editable text. If, on the other hand, you want to share your images with others, either via the web or over a network, then you can choose to save your files in other formats, like JPEG or TIFF. Each of these options can provide more compact files than PSD, but doesn't support all of Elements' advanced features.

To coincide with the introduction of the new multi-page creations in Photoshop Elements 5.0, Adobe released a new file format that was capable of storing the individual pages, their content and settings. Called the Photoshop Project Format, or .PSE, it contains all of the characteristics of the PSD file type but with the added ability of being able to save multiple pages (documents) in the one file.

Step 8: Organizing your pictures

Over the last couple of releases Adobe has packed Photoshop Elements with a range of management and organizational features that help bring order to the vast number of picture files that we are all accumulating on our hard drives. The majority of these features are contained in Organize panel in the Organizer. Here images are not just previewed as thumbnails but can be split into different Catalogs, located as members of different Albums or searched for based on the keywords associated with each photo.

The Organizer creates a catalog version of the pictures and uses these as the basis for searches and management. This makes the process fast and efficient. With this approach it is possible for one picture to be a member of many different Albums and to contain a variety of different keywords. So with this in mind let's look at how to use **Keywords** and **Albums** to help manage our photos.

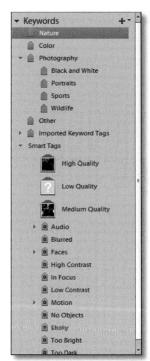

The Keyword Tags panel in the Organize Task Pane area at the right of the Organizer workspace houses current keyword tags and allows you to create new tags, categories and subcategories.

Keywords

The keywording feature is located in the Tags/Info panel on the right of the Organizer workspace. The features here allow you to create, manage and add and remove tags from pictures. Multiple tags can be applied to the one picture and then all the photographs in the browser can be searched for the individual images that feature a specific tag.

PHOTOSHOP ELEMENTS

By default several different categories of keywords are included in the Elements Keywords pane. New categories and sub-categories can be created via the New button (green +) in the top right of the pane.

Tags are applied to a picture by selecting and dragging them from the pane onto the thumbnail or alternatively the thumbnail can be dragged directly onto the Tags pane. Multiple tags can be attached to a single picture by multi-selecting the tags first and then dragging them to the appropriate thumbnail.

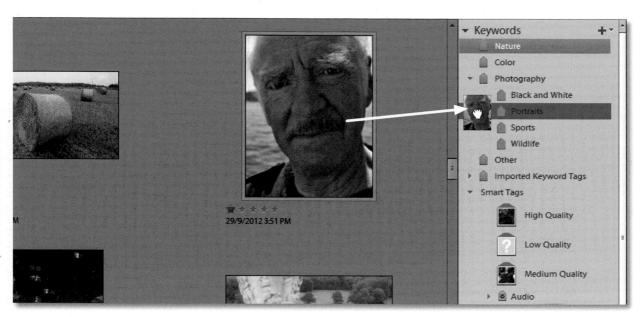

Organizer's Keywords pane both displays the current Keywords tags list Albums and includes buttons for categories. A tag can be videos by selecting the files and then dragging pane.

adding new keywords and A Photoshop Elements' Album is another associated with photos or way that you can order and sort your photos. After creating an album you drag them to the entry in the selected images from the Photo Browser to the Album panel, or vice versa, where they can be used to make a new photo project or displayed using the Full Screen slide show feature. Unlike when working with tags, pictures grouped in an album are numbered and can be sequenced and backed up or synchronized online to your Photoshop. com account. To quickly add photos to an album, drag the collection onto the multiple selected photos.

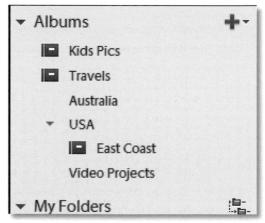

Albums are the Organizer's way to group your photos into different subject or project groups. Use the options in the Albums panel in the Task pane to create new albums. Click and drag the Album icon to any photo in the workspace to add it to the group.

File Type	Compression	Color Modes	Layers	Metadata	Uses
Photoshop (.PSD)	×	RGB, CMYK*, Indexed color, Grayscale	√	✓	Desktop publishing (DTP), Internet, publishing, photographic work
Photoshop Elements (.PSE)	×	RGB, Indexed color, Grayscale	✓	√	The new Elements multi-page document for- mat used for saving creation projects and their contents
GIF (.GIF)	✓	Indexed color	×	×	Internet
JPEG (.JPG)	✓	RGB, CMYK*, Grayscale	×	√	DTP, Internet, publishing, photographic work
TIFF (.TIF)	√	RGB, CMYK*, Indexed color, Grayscale	√	✓	DTP, Internet, publishing, photographic work
PNG (.PNG)	✓	RGB, Indexed color, Grayscale	×	×	Internet
Digital Negative (.DNG)	✓	Raw color data	×	✓	A format used for saving the raw file data from your digital camera

This table lists the characteristics of different file types and their suitability for use with different tasks. *Photoshop Elements doesn't support the CMYK color mode.

'The file formats I use'

Elements, like its industry-leading brother Photoshop, can open and save files in a multitude of different file formats. It's great to have such a choice, but the big question that most new digital photographers ask is 'What format should I use?'

And like most of the big questions in life there is no single answer to this query. The best way to decide is to be clear about what you intend to use the image for. Knowing the 'end use' will help determine what file format is best for your purposes. Until we look more closely at format characteristics like compression, use the way I work as a starting point. My approach is outlined below.

At the *scanning* or *image capture* stage, I tend to favour keeping my files in a TIFF or raw format. The save options in most scanning software will usually give you the option to save as a TIFF straight after capture and many digital cameras offer the option to store pictures as either raw or TIFF files. If I need to use JPEG with my camera to increase the number of shots I can fit on my compact flash cards, I change the format to TIFF or PSD after downloading. This way, I don't have to be concerned about any further loss of image quality derived from opening and saving JPEG files, but I still get the advantages of

good compression. As an added bonus, I can also use the files on both Mac and IBM platforms.

When *manipulating* or *adjusting*, I always use the PSD or the Photoshop and Photoshop Elements format, as this allows me the most flexibility. I can use, and maintain, a number of different layers which can be edited and saved separately. Even when I share my work, I regularly supply the original PSD file so that last-minute editing or fine-tuning can continue right up to going to press. If, on the other hand, I don't want my work to be easily edited, I supply the final image in a TIFF format that can be opened by both Mac and Windows machines.

With the introduction of *multi-page* documents from version 5.0, any projects produced with the new creations options are saved in the new Photoshop Elements file format or PSE.

If the final image is to be used for *web*, then I use GIF, PNG or JPEG depending on the number of colors in the original and whether any parts of the image contain transparency. There is no firm rule here. A balance between size and image quality is what is important, so I will try each format and see which provides the best mix. Only GIF and PNG have transparency options.

PHOTOSHOP ELEMENTS

The same photo can be a part of several different albums. When adding your photos to an album you are not duplicating these photos but rather adding the pictures to a visual list of the group's contents. In this way, only one copy of the original photo is stored on the computer but it can be viewed and used in many ways. To display all photos in your library after showing the contents of an album, select the Grid button at the top left of the workspace.

Saved Searches (previously Smart Albums)

Elements contains an extensive search feature which you can use to quickly locate specific photos or groups of photos. The criteria you use for a particular search can be saved so you can easily use it again later. Saved Searches replace Smart Albums found in previous versions of Elements.

Create a Saved Search by performing a search using any of the options listed under the Find menu. Then select the option to 'Save this Search Criteria as a Saved Search', at the bottom of any of the Find dialogs. After the search is performed the results are automatically displayed in the browser area of the Organizer. Alternatively, you can

provided.

To perform the search again simple choose the Saved Searches option from

create Saved Searches directly from the Saved Searches dialog using the button

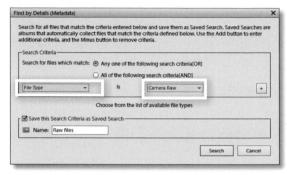

Saved Searches display the results of a specific search. Here a new Saved Search is created to show all Raw files.

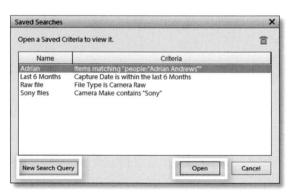

The Saved Searches dialog lists previously saved searches, allows you to select and open them as well as create new ones.

the Search drop down menu, select the entry from those listed and click the Open button. Select a saved search entry performs the search process across all your files again (based on the criteria you initially used), and any new candidate photos added to your catalog are also searched providing you with the most up to date results.

Stacks and Auto Stacks

The idea of grouping together like photos in a single stack is also possible in the Organizer. With the ever-growing number of photos in photographer's libraries, using a stack system to group together similar images, or pictures on a single topic, and then displaying the set layered under a single thumbnail, is a great space saver. Stacking options are located in the Stack section of the right-click menu in the Organizer.

Access the Saved Search dialog by selecting its entry from the drop-down search menu at the topright of the workspace.

To create a stack, select a group of thumbnails and choose the Stack Selected Photos entry from the right-click Stack menu in Organizer. The stack is expanded by either clicking the arrow on the right side edge of the Organizer thumbnail. Options in the Stacks menu can be used to expand or contract the stack, replace the top image or unstack the photos.

The Organizer has stacking options that can be accessed from the right-click menu of any thumbnail. Stacks can be displayed in Collapsed, grouped under a single thumbnail, or Expanded.

Auto stacking in Organizer: The ability to auto stack images as they are downloaded from camera, imported into Elements from folders or even when displayed in the Organizer workspace became a reality in the last few releases. There are several ways you can do this:

- To auto stack pictures already in your catalog select a group of thumbnails and then choose Automatically Suggest Photo Stacks from either the Edit > Stack or the right-click pop-up menus.
- To stack when importing choose the Automatically Suggest Photo Stacks option in the Get Photos and Videos dialog.
- Choose the Duplicate Photo Search option in the Search drop-down menu at the top right of the workspace.

Any of these options will then display a new window with alike pictures pre-grouped. Choosing the Stack All Groups button converts the groups to stacks. The Remove Group button prevents the group of pictures being made into a stack.

The Duplicate Photo Search entry provides another way to get Elements to suggest the photos in your collection that can be arranged in Stacks.

Elements contains its own backup options making protecting your precious photos a simple task of using the feature regularly.

Step 9: Backing up your files

There is no doubt that for most of us the many digital photographs that are saved on our computers are irreplaceable both in terms of their content and also the countless hours spent in capturing and enhancing. Given this scenario it is always puzzling to me that most people do not make duplicates or backups of such a valuable asset. Thankfully for Elements users

PHOTOSHOP ELEMENTS

Adobe includes an easy-to-use Backup feature. The last step in your photographic workflow should be to regularly back up your photos.

Organizer: File > Backup Catalog

The feature is designed for copying your pictures (and catalog files) onto a hard drive, DVD or CD for archiving purposes. Follow the steps in the wizard to make a copy or backup of all the photos you have currently listed in your Photo Browser. Simply activate the feature and follow the wizard's step-by-step prompts to create your own backup. For big catalogs the feature estimates the space required for creating the backup copy of the catalog and, after selecting the drive that will be used for archiving, the feature also determines the number of disks required to complete the action. To restore a catalog from a set of backup disks use the File > Restore Catalog option in the Organizer workspace.

Organize

One of the very exciting parts of being a digital photographer is that it is possible to take thousands of images without having to worry about the costs of having each image processed and printed. I believe that this freedom has led to more and more people enjoying and improving their own photography. The downside of all this shutter clicking is that our computers are often filled with thousands of images and the task of locating specific photos becomes harder by the day. This is the reason why Adobe includes the Organizer for both Macintosh and Windows users. It is not just a place to view your photos and videos, it should become a pivotal part of your digital photography workflow as it provides many ways for you to sort, manage and locate your files.

The smart digital photographer will reap the rewards of time spent working with their image collection in Organizer as they will be able to find the images they need faster and easier than ever before.

Menu bar

View modes

Search box

Create menu Share menu

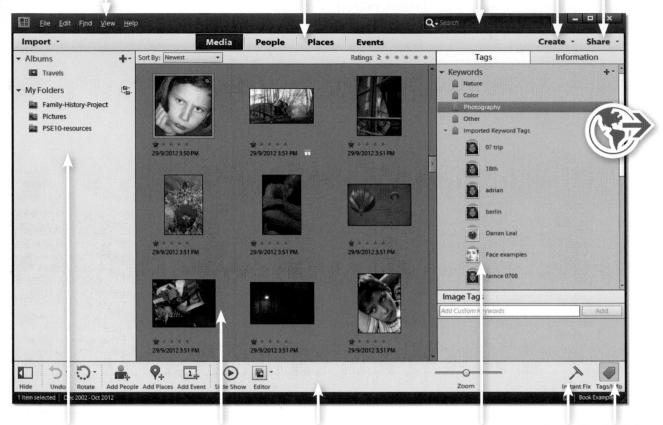

Albums and import folders pane

Organizer workspace

Action bar

Tags (Keywords)
pane

Instant Fix pane button

Tags Info pane button

The Organizer workspace is the starting point for all your image management and organization activities. That said, the workspace also includes simple enhancement options located in the Instant Fix pane, plus loads of ways to incorporate your photos into projects via the options in the Create and Share drop-down menus.

The Organizer workspace

The Organizer is a sophisticated file browsing and management workspace. From version 9 of Elements both Mac and Windows users have had access to this workspace. In earlier releases, Mac users had to make use of an Elements' version of Photoshop's Bridge browser which provided a quick way to visually locate your images but didn't contain the range of search, tag, create, fix, display and share options that the Organizer workspace boasts.

- (1) Multi-page .PSE.
- (2) Online gallery.
- (3) Slide Show.
- (4) Video.

The Mac version of Photoshop Elements contains the Organizer workspace. So apart from some slight differences in the look of the workspace, Apple-based image makers get an copy of all the features and functionality Windows users enjoy.

You can open the workspace by either selecting the Organize option from the Welcome Screen or by clicking the Organizer button in the Actions bar of the Editor workspace. Once your pictures have been imported into the Organizer (Organizer: File > Get Photos and Videos) they can be viewed in a range of different ways including by date taken, their associated tags, albums and even their folder location. Pairs of pictures can be viewed side by side with the Organizer: View > feature to help choose the best shot from a series of images taken of the same subject. Instant slide shows of whole albums, or just those pictures selected from the browser, can be created and displayed using the Organizer: View > Full Screen feature.

Simple editing tasks such as the automatic adjustment of levels, contrast and/or sharpness, along with simple orientation and crop changes can be performed directly from inside the browser with the auto enhance features in the Instant Fix pane. Finding your favorite pictures has never been easier as you can search by date, caption, filename, history, media type, tag and visual similarity (to already selected photos).

Pictures can be used as part of a wide variety of photo projects listed in the Create menu or presented to friends or clients via Share menu options. This chapter will concentrate on introducing you to the key tools and features in the Organizer workspace. Specific details about the options found in the Instant Fix, Create and Share menus will follow in separate chapters.

You can access the Organize workspace via the Organize button in the Welcome Screen (1) or by clicking the Organizer entry in the Editor Actions Bar (2).

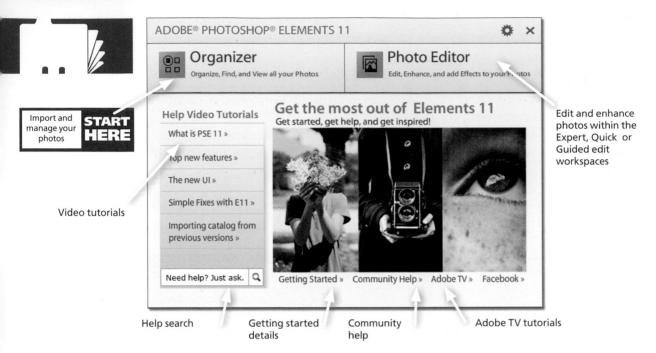

MAC = WINDOWS

Remember one of the biggest difference between Mac and Windows in previous versions of Elements was the part of the program that is used to manage and browse your photos

With Windows this is called the Organizer, and previously in the Mac environment, there was Bridge. Both platforms now have access to the Organizer.

The Welcome Screen

When Elements is first opened, the user is presented with a Welcome screen containing two key options concerning the type of imaging activity that you want to carry out, Organize or Edit, as well as help videos and Elements' community information and notices. I love the simplicity of this choice as it sums up the photography process really well – you organize or you edit your photos. The option you select will depend on where you are in the workflow. Let's look at each of these options in turn.

Organizer

Designed as the first port of call for downloading your pictures from cameras, scanners and mobile phones, this selection takes you to the Organizer component of the Elements system.

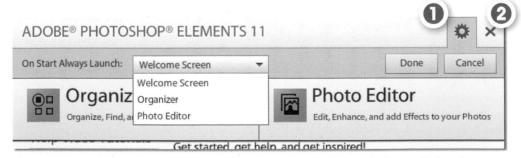

There is a Settings button in the top right of the Welcome screen (1). Clicking the button displays three start options for Elements. Next to the settings button is a Close button (2) for shutting down the Welcome Screen.

Start here when first introducing your pictures into Elements, when managing your photos or as the starting point for locating images or integrating items into projects.

Photo Editor

This selection takes you directly to the Edit workspace where you can choose between three different editing modes – Expert, Quick and Guided. Expert (previously called Full) provides you with the most powerful enhancement and editing tools and features available in Elements. Quick provides more manual control than is available with the Auto Fix features in the Organizer space, but less than that found in the more sophisticated Expert edit area. The Guided workspace provides the user with step-by-step instructions on how to enhance their images.

The Elements Welcome screen appears as the user opens the program. The screen can also be displayed by selecting the Welcome Screen entry in either the Organizer or Editor workspaces.

Photoshop.com membership details and Elements' community information

In previous versions users could sign up for a Photoshop.com membership to take advantage of the integrated features between the site and Elements. In Photoshop Elements 11 this is no longer the case. Adobe has announced that the linked functionality lost as a result of these changes will be replaced with better and more exciting functionality in a few months. I guess we'll have to wait until then to see what they have in store for us.

So just to clarify, Photoshop.com still functions as a pivotal site for Elements users but the linked functionality features are no longer available.

NOTE: Photoshop.com users no longer have direct access to your account via the Welcome Screen. In fact all links between Elements and the site have been removed from this release.

Startup settings

In the top right of the Welcome screen is a Settings button that displays a dialog with three different start options for Elements. You can choose to display the Welcome Screen by itself or with either the Editor or Organizer starting behind the screen as well.

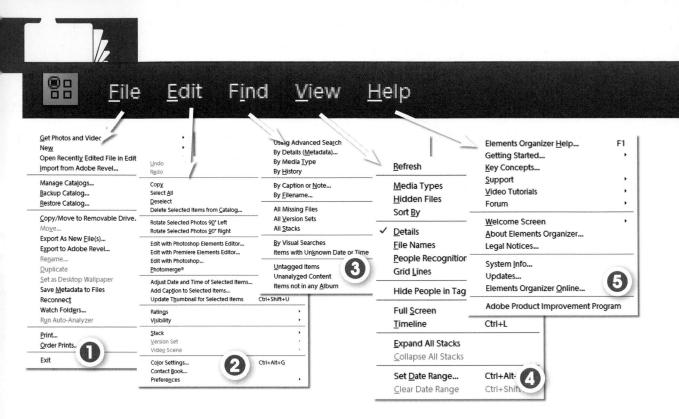

MAC ≠ WINDOWS

Most features contained in the Windows version of Photoshop Elements 11 are replicated on the Macintosh but occasionally there are slight differences. For example Windows contains burn to DVD options as well as a Watch Folder feature in the File menu.

The Organizer Menu Bar

The Menu Bar runs along the top edge of the Organizer window and, as the name suggests, is the place where you will find the headings for all the workspace's menus. Many of the menu items can also be accessed by keyboard shortcuts for quick application. If a keystroke combinations is available then it is listed on the right of the menu entry.

File: The File menu contains options for importing files from camera, card reader, scanner or folders. There is also several entries for managing the Elements library or catalog and file specific features such as renaming, reconnecting and exporting. The Print and Order Print options provide ways to output your photos directly from the Organizer and the Exit entry closes the program.

Edit: Along with the copy and paste options usually found on the Edit menu, the Organizer also includes buttons for rotating photos, adjusting stacks and version sets and links for editing images either automatically via Smart Fix or in the Editor space. Many of the features listed here are also available on the right-click menu of any thumbnail. Key program settings are located in the Color Settings and Preferences entries.

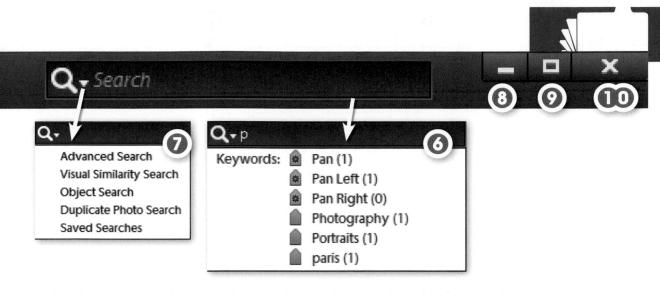

The Organizer menu bar contains a range of menu headings containing the majority of the features and functions of the program. These options are grouped around the following headings:

- (1) File menu.
- (2) Edit menu.
- (3) Find menu.
- (4) View menu.
- (5) Help menu.
- (6) Search input.
- (7) Search type menu.
- (8) Minimize window.
- (9) Maximize window.
- (10) Close window.

Find: The extensive options listed in the Find menu helps you locate specific images in your growing Elements catalog. You can search for pictures based on date, caption, filename, media type and details or metadata. From version 10 Adobe has added new Object-based and duplicate photo searches that can be accessed from the menu or search field.

View: The View menu options control what type of content is displayed in the Organizer and how this content is displayed. Under the View > Media Types menu you can choose to display photos, videos, audio, projects and/or PDF file types. Other entries in the menu provide options for displaying details and filenames with the thumbnails and settings to show grid lines or thumbnail borders.

Help: All the Help options available to the Elements user are listed here. This includes traditional program help pages as well as new support videos tutorials and user forums. There is also a link here to the Inspirational Browser where you will find tips, tricks and techniques from Elements authors and experts.

Search: The search feature provides a quick way to locate items within your catalog. These may be individual images, groups of photos identified by their keywords or other metadata associated with the photos. Elements displays results as you start to enter your criteria within the box. The small down facing arrow on the left of the search box displays a drop-down menu with different search type options. Change the way Elements searches by selecting a different entry here.

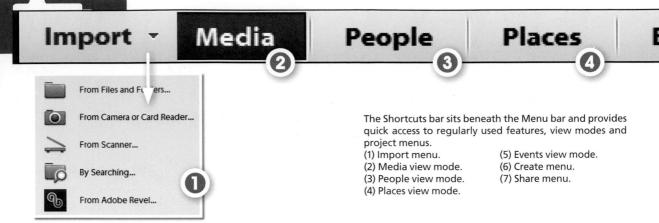

The Organizer Shortcuts Bar

Sitting just beneath the Organizer's menus is the Shortcuts bar. Here you will find a series of buttons and features designed to make your task of working with images in the workspace easier. Features include:

Import Menu: The Import menu lists the key ways to bring your photos into Elements. The options listed here largely duplicate those found in the File > Get Photos and Videos menu but with faster access to those that you will use the most.

Catalog View Modes

New for Photoshop Elements 11 is the inclusion of four different view modes for your catalog images. This is not a radical departure from the way Adobe has been heading over the last few revisions, but rather it more a simplification of the viewing options. The four modes are:

Media View Mode: Use this mode to view all the images and resources you have within your catalog. Of course you are able to show picture sub-sets using keyword tags, album entries or search criteria, but generally this is the mode you will use to see your collection as a whole.

People View Mode: Once you start to use the Add People feature in Elements to identify the individuals in your photos you are then able to display these groups of photos according to the people they contain. It is important to note that by default no images will be displayed in this mode until you add People Tags to your photos.

Places View Mode: This option replaces Map View and allows you to associate photos with specific locations and then display these groups of pictures on a map.

Events View Mode: Replacing the Time Line view of previous versions, the Events mode groups your photos according to events and the dates they occurred. Use the Add Event feature to manually group pictures around a date or select the Smart Event setting to get Elements to do it for you.

aces Events Create Share

Task Menus: There are two task menus in the Organizer workspace. They are located on the right of the shortcuts bar. To display the contents of a menu click on the associated heading. The menus group together similar activities you can undertake with your image. under different headings.

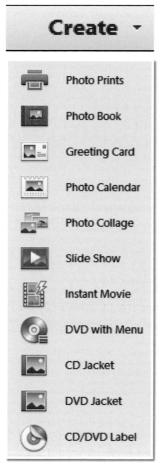

Create – This menu includes a variety of photo projects including photo books, calendars, greeting cards, slide shows and prints.

Share – Lists more photo projects based around the idea of sharing your photos. Here you will find options such as web galleries (Online Album), emailing photos, upload to photo sharing sites and burning DVDs.

Introducing the Actions Bar

Located at the bottom of the screen is the new Actions Bar. Here you will find the buttons and controls that used to sit on the shortcuts bar, such as rotate, undo, and the thumbnail zoom, plus additional features like Add People, Add Places, Add Event, and Slide Show, thrown in for good measure. The Actions Bar is common to both the Organizer and Editor workspaces and both contain quick button links to transfer the files between the two.

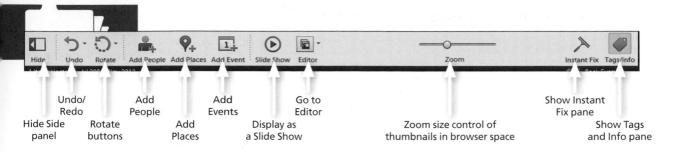

The Actions Bar is new for Photoshop Elements 11 and can be found in both the Organizer and Editor workspaces. **Hide side panel:** Displays or hides the left side panel.

Undo/Redo Buttons: Reapplies or removes the last action.

Image rotate buttons: Change the orientation of a selected picture by clicking one of these buttons. You can also perform the same action to several images at once by multi-selecting the files first.

Add People, Places, and Events buttons: Manually tag photos with people, places and/or event details so they can be categorized according to these settings.

Slide Show buttons: Show selected images in full-screen slideshow mode.

Go to Editor button: Display the Editor workspace and open any currently selected images into the workspace.

Thumbnail size slider: Slide the control to the left to reduce the size of the thumbnails, and to the right to increase their dimensions.

Instant Fix button: Display the Instant Fix pane on the right of the workspace.

Tags/Info button: Switch the right side panel display to show the Tags and Info panes.

The Organizer Bottom Bar

At the bottom of the Organizer window is yet another bar containing settings and information. Termed the bottom bar, here you will find the name of the catalog, the number of items selected, the number of items being displayed and total number of items in the catalog.

The Bottom Bar in the Organizer contains information about selected images and your catalog.

Managing your photos with the Organizer

Now that we have had a look at the various parts of the Organizer workspace let's see how the program works in practice as part of holistic approach to managing our pictures.

With no film or processing costs to think about each time we take a picture, it seems that many of us are pressing the shutter more frequently than we did when film was king. The results of such collective shooting frenzies are hard drives all over the country full of photos. This is great for photography, but what happens when you want to track down that once-in-a-lifetime shot that just happens to be one of thousands stored on your machine? Well, believe it or not, being able to locate your files quickly and easily is more a task in Organizer management, naming and camera setup than browsing through loads of thumbnails.

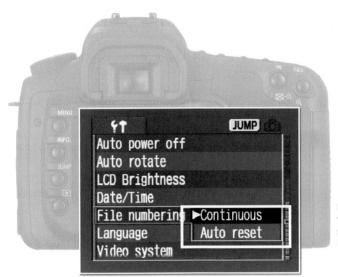

Most cameras provide options for selecting the way in which files are numbered. The Continuous option ensures that a new number is used for each picture even if memory cards are changed in the middle of a shoot.

It starts in-camera

Getting those pesky picture files in order starts with your camera setup. Most models and makes have options for adjusting the numbering sequence that is used for the pictures you take. Generally you will have a choice between an ongoing sequence, where no two photos will have the same number, and one that resets each time you change memory cards or download all the pictures. In addition, many models provide an option for adding the current date to the file name, with some including customized comments (such as shoot location or photographer's name) in the naming sequence or as part of the metadata stored with the file.

To adjust the settings on your camera search through the Set Up section of the camera's menu system for headings such as File Numbering and Custom Comments to locate and change the options. Ensure that number sequencing and date inclusion options are switched on and, where available, add these comments along with the photographer's name and copyright statement to the metadata stored within the picture file.

Adobe Photoshop Elements 7.0 - Photo D

Standard dialog

Uncheck All

options

And continues when downloading

As we have already seen Photoshop Elements includes the popular transfer utility that is designed to move pictures from your camera or memory card to the computer. Called the Adobe Photo Downloader, the feature is designed to detect when a camera or card reader is attached to the computer and then automatically transfer your pictures to your hard drive. As part of the download process, the user gets to select the location of the files, apply metadata, auto tag and stack, and selects the way that the files are to be named and numbered. For more details on the Adobe Photo Downloader go back to Chapter 2.

Source of download

Display image, video and audio file buttons

Location for saving Save Optio downloaded files C-1. Wich wee Wirle B Create subfolder Create Subfolder(s): options and names Kids Birthda File rename options ws 2008 02 24 0001, IPG Auto Red Eye Fix Automatically Fix Red Ever Auto stacking Make group tag 1 Import to Album After Copying, Do Not Delete Original Add author and . Creator: Philip Andrew copyright details Automatic download option UnCheck All Get Photos Cancel Switch to Check All/ Check box for Get Photos button

Image Rotate buttons

The Adobe Photo Downloader that comes bundled with Photoshop Elements allows the user to automatically apply naming changes and to determine the location where transferred files will be Advanced mode images can be auto stacked and name.

It is at this point in the process that you need to be careful about the type of folder or direcsaved. In addition, in the tory structure that you use. Most photographers group their images by date, subject, location or client, but the approach that you employ is up to you. Once you have selected a folder tagged with a group structure though, try to stick with it. Consistency is the byword of photo organization.

download

If your camera doesn't provide enough automatic Naming and Metadata options to satisfy your needs then use the Elements Photo Downloader feature to enhance your ability to distinguish the current images from those that already exist on your hard drive by setting the location, group tag, and filename of the picture files as you transfer them. It may also be useful to select the Auto Stack feature as a way of suggesting alike images which can be grouped into Albums or tagged together in the Organizer workspace. Also keep in mind that there is the ability to add downloaded images directly to an album inside the Photoshop Elements Organizer.

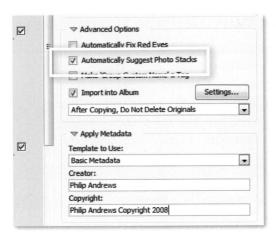

Use the options in the Photo Downloader to thoughtfully name, tag, stack and locate your digital photos.

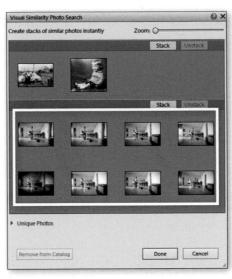

Group alike images when transferring your photos by selecting the Automatically Suggest Photo Stacks option in the Adobe Photo Downloader.

Transferring files with the Photo Downloader workflow:

- 1 Start by connecting the memory card reader or camera/ phone to your computer.
- 2 The Photo Downloader should auto launch when a camera or card reader is attached. If this doesn't occur then select File > Get Photos > From Camera or Card Reader. Switch to the Advanced mode.
- 3 Choose the device where your photos are stored (camera or card reader) from the drop-down list in the Source section of the dialog (top left).
- 4 Scroll through the thumbnails that are displayed and select images to be transferred and deselect those to be left on the card using the check box on the bottom right of the thumbnail.
- 5 Choose the location and set the subfolder options in the Save Files section of the dialog.
- 6 Input a new title into the renaming options.
- 7 For photographs taken with a flash, select the Automatically Fix Red Eyes option to remove the crimson pupils in your portraits.
- 8 Click the Get Photos button to transfer the photos and automatically categorize them in the Organizer workspace.
- 9 Once the files have transferred successfully you will be offered the opportunity to delete the files from the card or camera, freeing up the device for taking more photos.

Once you have sorted the photos into groups, just press the Stack All Groups button to create Photo Stacks in the Organizer.

Advanced organization options with the Photo Downloader

Gradually over the last few releases of Photoshop Elements, Adobe has been adding extra functionality to the Adobe Photo Downloader (APD) utility. The extra features added have been good news for photographers as they help organize your photos by automatically suggesting photo stacks, adding tags and now, we can even import images into an Elements Album while downloading. Let's look a little closer at each of these features that are located in the Advanced dialog of the downloader.

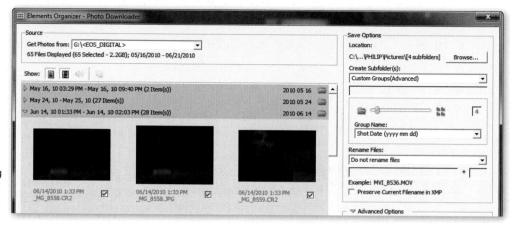

To use the group tagging feature start by selecting the Custom Groups (Advanced) item.

Automatically Suggest Photo Stacks

Choosing the Automatically Suggest Photo Stacks in the Advanced options of the APD instructs Elements to sort through the images as they are downloaded to your computer. What the program is looking for is similarities in picture content and proximity of capture. These photos are then presented back to the user in groups that can be stacked together by simply clicking a single button. So if you have a bunch of images of the same subject shot in quick succession, they will be grouped together and displayed as a possible Photo Stack in the Automatically Suggest Photo Stacks dialog.

Images can be added to or subtracted from groups by click-dragging the photos around the dialog. Alternatively, photos that you don't want stacked can be selected and removed from the process by clicking the Remove Group button. Once you are satisfied with the groupings, pressing the Stack All Groups option will create a Photo Stack in the Organizer workspace. See later in the chapter for more information on creating and using Photo Stacks.

This option is also available when selecting the Get Photos and Videos > From Files and Folders option.

Make Group Custom Name a Tag

Another image management option available at the time of download is the ability to add a tag to groups of photos. Tags, which are also referred to as Keyword Tags in Photoshop Elements, are a set of descriptive words attached to pictures that can used to help locate specific photos in large catalogs. Generally Tags are added to photos in the Organizer workspace (see

the next section in this chapter for more details) but the Make 'Group Custom Name' a Tag option in APD allows you to add a tag when downloading. Using this feature is a four step process.

Tag using a Custom Name workflow:

- Select the Custom Groups (Advanced) option in the Create Subfolders area. Use the slider control to adjust the number of photos included in each group.
- 2 Choose the Custom Name option from the Group Name dropdown menu.
- 3 Ensure that the 'Make Group Custom Name a Tag' option is selected in the APD dialog.
- 4 Click on the tag name entry (called Custom Name by default) on the title bar of each group and type in a new Tag name. Click Get Photos to download the files and add the new Tag names to groups.

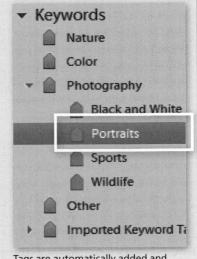

Tags are automatically added and applied using this feature.

Individual photos can be excluded from the download and tagging process by unchecking the tickbox at the bottom right of the thumbnail. After setting up and selecting the Get Photos button, APD downloads the photos, creates new tag entries and then attaches these tags to the selected photos.

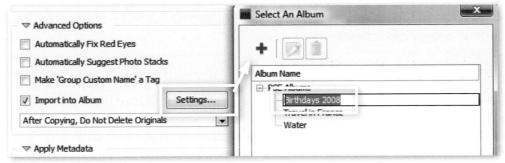

Automatically add photos to Albums using the new Import into Album option.

Import into an Album

Photoshop Elements has the ability to add photos to Albums as they are transferred from camera card to computer. After selecting the Import Into Album option in the Advanced dialog of the Adobe Photo Downloader, pressing the Settings button displays the Select an Album window where you can choose the Album to which the photos will be added. The window also contains buttons to add new tags, edit the name of tags and delete tags. The edit and delete options are only available when selecting empty Albums that have been

added in the window. After setting up a new Album for the download, clicking OK will close the Settings window and Get Photos will download the pictures and add them to the new Album.

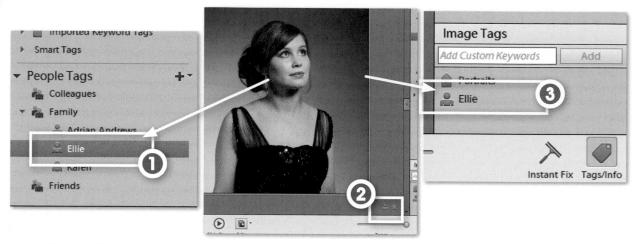

Keyword Tags and Albums are used to organize the pictures in the Organizer workspace. One photo can belong to many different Albums and contain multiple tags but it is only stored once in the catalog. (1) Keywords Tags panel with Keyword Tags (3) Keywords Tags listed in the Properties dialog.

Organizing and searching features

The Organizer workspace not only provides thumbnail previews of your photos but images can be categorized with different tags (keywords), notes and caption entries, split in different Albums (Collections) and then searched for based on the tags and metadata associated with (2) Organizer thumbnail each photo. Also, photos that are alike in appearance or subject matter can be stacked or grouped together. Unlike a traditional browser system, which is folder based (i.e. it displays thumbnails of the images that are physically stored in the folder), the Elements Organizer creates a catalog version of the pictures and uses these as the basis for searches and organization. With this approach it is possible for one picture to be a member of many different albums and to contain a variety of different keywords.

Tagging your photos

Keyword Tags are simple descriptors which can be added to your photos and used to help organize your images. The Keyword Tags panel stores the tags, provides an easy drag-anddrop approach to adding tags to selected photos, and sits to the right of the main thumbnail area in the Organizer workspace. The pane is no longer grouped together with the Albums panel. Instead it is positioned on the right of the workspace with the Info and Instant Fix panels. Tags are applied to a picture by selecting and dragging them from the panel onto the thumbnail or, alternatively, the thumbnail can be dragged directly onto the Tags pane. Multiple tags can be attached to a single picture by multi-selecting the tags first and then dragging them to the appropriate thumbnail.

Tagging workflow:

- 1 To add a tag to a single image, click and drag the tag from the Keyword Tags panel to the thumbnail image in the Organizer workspace.
- 2 To add a single tag to multiple thumbnails, multi-select the thumbnails in the images and then drag the tag from the Keyword Tags panel onto one of the selected thumbnails.

Creating new keyword tags

New keyword tags are created and added to the panel by selecting the New Tag option from the menu displayed after pressing the '+' button at the top left of the panel. Next, fill out the details of the new entry in the Create Keyword Tag dialog, select a suitable icon for the tag label and click OK.

You can add to the existing set of tags using the New Tag option. There is even an option to add your own pictures as the tag icon.

Creating new Keywords Tags workflow:

- 1 To create a new keyword tag, select the New Keyword Tag option from the '+' button menu at the top of the Tags panel.
- 2 In the Create Keyword Tag dialog select a category for the new tag, add in a name and include any explanatory notes.
- 3 Next, press the Edit Icon button and select a picture to include with the tag label before sizing and cropping the photo in the Edit Tag Icon dialog.
- 4 Click OK to close both dialogs and add the new keyword tag to the tag list.

Keyword Tags Categories and Sub-Categories

As you start to build a list of Keyword Tags to be used with your Elements it can become more and more difficult to manage the list of entries. For this reason Adobe has included the option to create Keyword Tag categories and sub categories. This provides a great structure for organizing your tags. Categories are the upper most level, with sub-categories sitting beneath. These can be created by selecting the entry from the green '+' menu in the top left of the panel. Individual Keyword Tags can be added at any level.

Keyword Tags (3) can be organized into a structure containing Categories (1) and Sub-Categories (2).

Creating Keyword Tags Category and Subcategories workflow:

- 1 To add a new Category select the option from the green '+' menu, add a name in the Create Category dialog and select an icon before clicking OK.
- 2 To create a new Sub-Category select the option from the green '+' menu, add a name and choose the parent category that the new entry will sit beneath. Click OK.

The People Recognition option quickly scans a group of selected photos and identifies those pictures that contain faces and displays these in a separate dialog ready for tagging. Just add in the name of the person (1) in the photo to automatically add an entry to the new People Tags panel and associate the new tag with the photo.

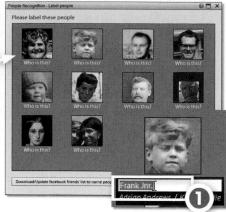

People Recognition technology (Face Tagging)

The ability to search through a group of photos and automatically select those that contain faces was first introduced in Elements 4.0. Using this feature makes it much easier to locate and tag photos of family and friends in the batches of pictures that you import. From version 8 this feature has been updated and renamed to People Recognition and is now part of the technology powering the new People view mode. Start by selecting a group of photos from inside the Organizer workspace. Next, click the Add People button in the Actions Bar at the bottom of the screen. A new dialog will be displayed showing the photos where Elements has located a person. The utility displays a thumbnail of just the face in the image. If a tag has already been associated with the person then Elements will show this entry beneath the thumbnail, if not, then a small text box featuring a 'Who is this?' entry will be displayed. To add a tag just click on the text box and add the name of the individual. This will automatically create a new keyword tag and add the tag to the photo.

When the People Recognition feature locates a face that hasn't been assigned a tag it displays a 'Who is this?' text box (1). You can add the name of the person by typing directly into the text box (2). This in turn will add a new Peoples Tag to the feature's panel (3).

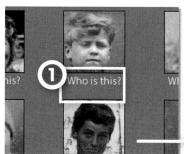

Face Tagging workflow:

- 1 Multi-select a group of images from inside the Organizer workspace.
- 2 Press the Add People button on the Actions panel.
- 3 Elements will display any people photos it finds in the selected photos in a new dialog. Faces are displayed with a white frame around them and a text box below.
- 4 If the face is recognized then Elements will display the appropriate tag in the text

box, if not, then replace the 'Who is this?' message with the name of the person. Now you can click the right or left arrows along the edges of the dialog to move to the next picture.

5 If Elements has not located the people in the photo, Click the Add Missing Person button and drag the white rectangle over the face in the photo and add in their name to the text box. Click the Done button to add the new tags to the new People Tags panel and to associate these tags with the photos.

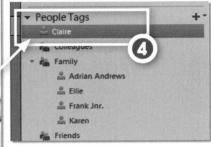

Recognizing People Automatically

Also new from version 8 is the option to have Elements check for faces in your Organizer catalog while you are working on other tasks. You can start the process by selecting the Recognize People Automatically setting in the Auto-Analyzer Options section of Edit > Preferences. Instead of displaying the people photos the program finds in its own window, a 'Who is this?' text box is displayed on the thumbnail of the photo in the full Organizer space.

Unrecognized people can be tagged manually by clicking the Mark Face button (1) in the Actions Bar and then dragging the rectangle over their face (2). Next add their name to the text box (3) and click Done. The new tag is associated with the photo and added as a new entry to the People Tags panel (4).

Organizer-based face recognition workflow:

- Start by selecting the Recognize People Automatically option in the Edit > Preferences > Auto-Analyzer Options dialog.
- 2 Now when there is a period of inactivity in Elements, the People Recognition technology will search through your catalog and display 'Who is this?' text boxes on photos where it locates people.
- 3 Click on the text box and add the name of the person highlighted in the white rectangle.

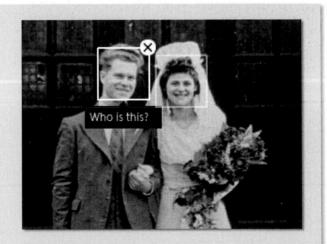

The Media-Analysis feature (previously called the Auto-Analyzer) filters the images in your catalog according to a set of criteria established in the feature's preferences (1) and automatically adds them to a set of Smart Tags in the Keyword Tags panel (2). The feature also includes settings for the new search features along with people recognition options (3).

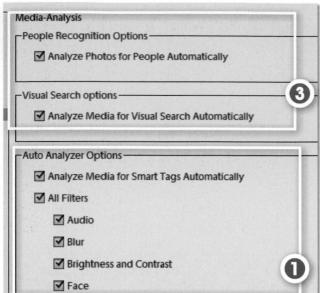

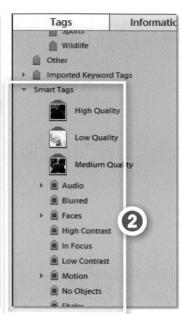

The Media-Analysis feature and Smart Tags

The auto option for the People Recognition software along with the new visual search options is part of a mechanism for background categorizing called the Media-Analysis (previously Auto-Analyzer). Once activated, the feature searches through your Organizer catalog tagging and analyzing media (photos, audio, video) with a set of characteristics. When a piece of media meets the search criteria, then it is automatically added to a related Smart Tag entry and visual searches are performed quickly. In this way, Elements does the heavy lifting by automatically helping to organize your photos, videos and audio.

Media-Analysis workflow:

- 1 Go to Edit > Preferences > Media-Analysis to set the options for the feature.

 Here you can set the feature to analyze the contents of the catalog automatically, run the analyzer at start up, select the filters to use and opt to recognize people automatically.
- 2 Now the feature will search through your catalog looking for images that meet the filter criteria that you have selected. When candidate images are found, a Smart Tag is automatically added to the photo.
- 3 The feature can be paused, or set to resume its activity, using the dedicated button in the Organizer's bottom bar.
- 4 It is possible to analyze individual photos, or sets of pictures, by choosing the images in the Organizer space first and then selecting the Run Media-Analyzer option from the right-click menu.

Keywords can be added to images when in Full View mode by typing the word in the text box at the bottom of the tag area (1) and clicking the Add button (2) or by clicking on existing keywords displayed in the panel (3).

Full View tagging

In the last chapter we saw how it was possible to view the contents of your catalog in a special Full View display mode by selecting the Full Screen entry from the View menu. Alternatively, you can also hit F11 to jump to the Full View mode.

Your photos will be displayed as thumbnails in a queue on the right side of the screen, the selected picture will be displayed in the center of the screen and two palettes, Quick Fix and Quick Organize, are located on the left. The palettes can be set to auto reveal, that is, popout from the side of the screen when you move your mouse cursor over them, or you can set them to be permanently displayed by clicking the small pin icon on the right hand edge of the window.

The Quick Organize palette provides a fast way to add existing or new Keyword Tags to the photo that is currently being displayed full screen.

Tagging in Full Screen mode workflow:

- 1 Start by selecting the images that you want to display from the Organizer in Full Screen mode and then hit the F11 key.
- 2 Now select a photo to display full screen from those queued on the right of the screen.
- 3 Move the mouse over the Quick Organize palette on the left of the window and click on the pin icon to fix the palette in view. Just click onto one of the keywords displayed in the palette to add it to the picture.
- 4 To add a new Keyword Tag, type it into the text box and then click the green Add button to the right.

Sort your pictures into groups of the same subject or theme using the Elements Albums feature.

After setting up, clicking the Saved Search (previously Smart Album) entry will automatically search for, and include, any new images to the Album.

Albums – the Elements way to group alike photos

Apart from tagging, Photoshop Elements also uses Albums (previously called Collections) as a way to organize your photos. Albums allows you to group images of a similar theme together in the one place, making it easier to locate these images at a later date. Another benefit is that the images contained in an album can also be ordered manually. After creating an album in the Albums pane, photos are simply dragged from the Photo Browser workspace to the Album heading to be added to the group. In the latest versions of Elements you can also share albums online, use them as a basis for creating photo books, burn them onto CD/DVD discs, email them to friends, and sync them online to Photoshop.com.

The Albums feature allows you to allocate the same image to several different groups. Unlike in the old days with simple folders-based systems, this doesn't mean that the same file is duplicated and stored multiple times in different folders; instead, the picture is only stored or saved once and a series of Album associations is used to indicate its membership in different groups. When you want to display a group of images based on a specific subject, taken at a particular time or shot as part of a certain job, the program searches through its database of Album entries and only shows those images that meet your search criteria. The Albums panel is the pivot point for all your Album activities. Here you can view, create, rename and delete Album entries.

Adding photos to an Album workflow:

To start using Albums make a new album first and then add it to your photos.

- 1 Start by making a new album by clicking on the '+' button in the Albums panel and selecting the New Album menu item.
- 2 In the Album Details dialog choose the group that the new album will belong to, add the name and include any explanation details for the group. Click OK.

- 3 Select the photos to be included in the album in the Organizer and drag them to the Items area in the Albums panel. Then click Done.
- 4 To view all the pictures contained in an album, click on the Album heading in the Albums panel.
- 5 Single photos or even groups of pictures can be added to more than one album at a time by multi-selecting the album names first before dragging the images to the pane.

Saved Searches (previously Smart Albums)

Elements contains a second collection type, the Saved Search which was previously called Smart Albums. Because of this heritage we include the feature here. Images that are included in a Saved Search are based on one or more search criteria established at the time that the collection is created. Each time the Saved Search entry is selected, Elements automatically adds any new photos that meet the criteria to the group. Saved Searches are a great way to keep important collections of images up to date without the need to manually find and add images to the group. You can create Saved Searches either via the New Saved Search entry in the Saved Search dialog (click the magnify icon on the left of the search field at the top of the screen and choose the Saved Searches entry), or by executing a search using the Find > By Details (Metadata) feature. Both avenues provide the user with the chance to choose the search criteria used for the basis of the Saved Search. With the Find option, it is necessary to select the Save this Search Criteria as Saved Search setting from the options menu at the top of the results display.

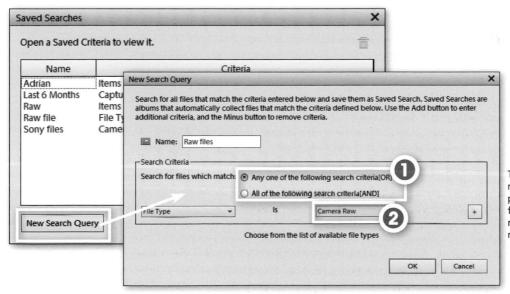

To set up the search criteria used for a Saved Search pick the matching option first (1) and then the criteria from the drop-down menus (2).

Establishing search criteria

The idea of setting up specific search criteria as the basis of creating a Saved Search may seem a little daunting, but the range of possibilities included in the search dialog, either

New Saved Search, or the Find by Details, makes the process as simple as selecting options from several drop-down menus. With the dialog open, start by choosing whether the photos need to contain any, or all, of the search criteria to be included in the album. Obviously for single criteria searches this isn't an issue, but the dialog allows the user to add several criteria (click the '+' button at the right end of the criteria entry) for searching. Next, create the basis for the search by selecting the criteria. There are no less than 30 different criteria that can be used for the search. These include most camera settings (sometimes called EXIF data) such as lens, ISO, F-stop and Shutter Speed, individual photo details including file size, pixel dimensions and filename as well as Elements-specific criteria like keyword tags, project name, version set, project type or even map location. Once you are comfortable with creating search criteria, the whole Saved Search system provides a very powerful and efficient way to locate groups of images in your catalog.

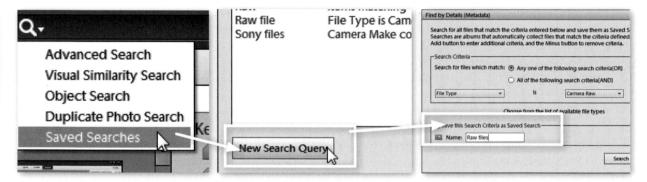

To create a Saved Search choose the Saved Search option from the Search drop-down menu and use the New Saved Search option.

Creating a new Saved Search

There are four ways to create Saved Searches in Elements. The first is via the options in the Album panel.

Saved Search creation:

- 1 Start by selecting the Saved Searches option from the Search drop-down menu and then the New Saved Search button at the bottom of the dialog.
- 2 Next, add in a name for the album in the text box at the top of the New Saved Search dialog.
- 3 Choose how the files will match the criteria. You can select between matching **any** of the criteria or **all** of the criteria.
- 4 Now start with the drop-down menu on the left of the dialog and select the criteria group to use for the search, i.e. Filename, Project Name, Keyword Tags, Camera Model, etc.
- 5 Depending which entry you choose in the first menu the number of menus (and their content) on the right will change accordingly. The entries in these menus

are designed to refine the search. For instance, if you choose the Project Type as your main search criteria then you will have a second menu containing Gallery, Photo book and Slideshow.

6 With one criteria established you can add other criteria by clicking the '+' button on the right of the Search entry. This displays a new search criteria menu set.

You can also create a new Saved Search using specific search criteria detailed in the Find > By Details or Find > By Visual Searches features.

Use the criteria input into the search features as the basis of a new Saved Search.

Using Find to make Saved Searches:

The second way to create Saved Searches in Elements is to use the search abilities in the Find > By Details (Metadata) or Find > By Visual Searches.

- 1 Select the By Details (metadata) entry from the Find menu to display the Find by Details dialog. Input the match option and search criteria in the same way as outlined in steps 3–6 above.
- 2 Next, select the Save this Search Criteria as Saved Search option at the bottom of the dialog. This makes the Name text box active. Add a title for the New Saved Search here.

Saved Searches via the Search feature:

The Adobe staff decided to include a Search feature in the shortcuts bar at the top of the Organizer workspace. Like other such features typically found in computer operating systems, this dedicated search box provides a speedy way to locate images based on text entries associated with an image. This information may be stored in the filename, as a keyword or as part of the EXIF data for the photo.

Elements refines the results of the search as you type. Locating pictures in this way has the added bonus that the search term that you employed can be used to create a new Saved Search.

- 1 Start by typing the search term into the new text box located on the left of the Shortcuts bar. You may need to try a range of different search terms.
- 2 Once the correct photos are displayed in the Organizer workspace choose the Save Search Criteria as Saved Search entry from the Options menu.

Click onto the Keyword Tag entry to display the pictures with the associated keyword then choose the Save Search Criteria As Saved Search entry from the Options menu.

Converting Keyword Tags to Saved Searches:

The last way to create Saved Searches is to use existing Keyword Tags as the basis for creating a new Saved Search.

1 After clicking the Keyword Tag entry to display the images containing the tag, choose the Save Search Criteria As Saved Search entry from the Options menu at the top right of the workspace.

Albums in Full Screen mode

We have already seen how it is possible to tag your photos while reviewing them in Full Screen mode, but it is also possible to add images to Albums with other options found in the Quick Organize palette. Once your pictures are displayed in the Full Screen, add them to an existing album is a simple matter of clicking onto the Album entry in the palette to add the picture.

It is important to note that this feature relies on the albums already being created before entering the Full View mode. In this way, it is different to the tagging options found here as Keyword Tags can be both created, and applied, in the Full View mode.

Quickly add pictures being viewed in Full View mode by clicking onto one of the Albums listed in the palette.

Adding photos to Albums in Full View:

- 1 Select the photos to be displayed in the main Organizer space and then hit the F11 key or choose the View, Edit, Organize in Full View option from the Display menu.
- 2 Add the displayed photo to an Album by clicking on the Album entry in the Quick Organize palette.
- 3 Use the left and right arrows to move between queued photos, adding images to Albums as you go.

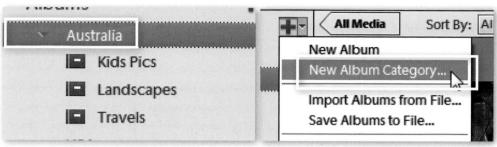

Album Categories are used to help organize Albums with common themes under one heading.

Add new Albums to existing Categories by selecting the Album Category entry in the Album Details pane.

Using Album Categories (Groups)

Different albums (and the photos they contain) can also be organized into groups that have a common interest or theme. For instance, albums that contain pictures of the kids, family vacations, birthday parties and mother and father's days events can all be collated under a single 'Family' Album Category heading.

Create an Album Category by selecting the New Album Category entry from '+' menu in the Albums panel. Next, click and drag existing album entries listed in the pane to the category heading. After creating an Album Category you can add any new Albums to the group by selecting the Category entry from the Album Category drop-down menu in the Album details pane.

Album and Keyword Tagging strategies

The approach you choose when making use of the Keyword Tagging and Album features in Elements will depend a great deal on the way that you work, the pictures you take and the type of content that they include, but here are a few different proven methods that you can use as a starting point.

Subject:

Photos are broken down into subject groups using headings such as family, friends, holidays, work, summer, night shots, trip to Paris, etc. This is the most popular and most applicable approach for most readers and should be the method to try first.

Timeline:

Images are sorted and stored based on their capture date (when the picture was photographed), the day they were downloaded or the date that they were imported into the organizational package. This way of working links well with the auto file naming functions available with most digital cameras but can be problematic if you can't remember the approximate dates that important events occurred. Try using the date approach as a subcategory for subject headings, e.g. Bill's Birthday > 2005.

File type:

Image groups are divided into different file type groups. Although this approach may not seem that applicable at first glance it is a good way to work if you are in the habit of shooting raw files which are then processed into PSD files before use.

Project:

This organizational method works well for the photographer who likes to shoot to a theme over an extended period of time. All the project images, despite their age and file type, are collated in the one spot, making for ease of access.

Client or Job:

Many working pros prefer to base their filing system around the way that their business works, keeping separate groups for each client and each job undertaken for each client.

Locating files

One of the great benefits of managing your pictures in the Organizer workspace is the huge range of search options that are available. In fact there are so many search options that Adobe created a new menu heading 'Find' specifically to hold all the choices. Here you will be able to search for your photos based on a selected date range, filename, caption, media type (video, photo, audio or creation), history (when an item was emailed, printed, received, imported, used in a creation project or even shared online) and even visually with the 'By Visual Searches' options.

After selecting one of the Find menu options, Elements either displays files that meet the search criteria in Photo Browser workspace or opens a new dialog where the user must enter specific details (dates, filenames, details, captions) which will be used to search.

F <u>i</u> r	d <u>V</u> iew <u>H</u> elp	
	Using Advanced Search	
	By Details (Metadata)	
	By Media <u>T</u> ype	
	By <u>H</u> istory	
	By Caption or Note	
50	By <u>F</u> ilename	
4	All Missing Files	
784	All <u>V</u> ersion Sets	
	All Stacks	
.]	By Visual Searches	
Į€	Items with Unknown Date or Time	
	<u>U</u> ntagged Items	
5	Unanalyzed Content	
1	Items not in any Album	
100000		

The Find menu in the Organizer workspace lists the many different ways to locate images within Elements.

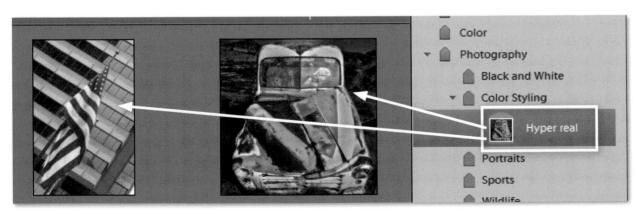

To display all images tagged with a specific entry click the Keyword Tag or Album name in the Keyword Tags or Albums panel.

When choosing the Date Range, Caption or Note, Filename, History and Details find options Elements displays a dialog into which your search criteria can be entered.

Finding photos with Keyword Tags or those in an Album

As well as the search options located in the Organizer: Find menu, you can make use of the Tags and Albums features to quickly locate and display sets of photos from your catalog.

To find tagged photos: Click the Keyword Tag entry in the Keyword Tags panel.

To display all the images in an album: Click on the Album entry in the Albums panel.

To return the browser back to the original catalog of thumbnails: Click on the Back button (previously Back to All Photos) at the top of the thumbnail group.

Press the Back button (previously Back to All Photos) to return to displaying the images in the full catalog after conducting a search.

Locating file with the Organizer Search box

Photoshop Elements also contains a special search box that can be used to quickly locate photos with different tags. It is located in the main Organizer space at the top of the window in the Shortcuts bar. Typing a search term here will create a live list of all the keywords that match in a popup menu. Selecting one of the list entries will display just those images associated with the keyword.

Find by details (metadata)

As we have already seen in passing, the Find option is designed to allow users to search the details or metadata that are attached to their picture files. Most digital cameras automatically store shooting details from the time of capture within the photo document itself. Called metadata, you can view this information by clicking the Metadata button inside the Properties palette.

The Find by Details feature allows you to customize the search options used via settings within the dialog. Start by selecting how the criteria will be matched (1). Choosing the type of detail to look for from the drop-down list (2) determines the contents of the rest of the dialog. In this instance selecting 'Filename' displays a second list (3) describing how to match the text that you input (4). Extra search criteria can be added or removed by pressing the Plus or Minus buttons to the right of the dialog (5). Also included is the ability to save the search criteria as a Saved Search (6).

The Find > By Details (Metadata) option displays a sophisticated search dialog that allows you to nominate specific criteria to use when looking within the metadata portion of the picture file. The dialog provides a section to input the text to search for, as well as two dropdown menus where you can set where to look (Filename, Camera Make, Camera Model, Capture Date, etc.) and how to match the search text (Starts with, Ends with, Contains, etc.).

Beyond camera-based metadata you can also use this dialog to search for any captions, notes, tags or albums that you have applied to your pictures.

Finding photos by their details workflow:

- 1 Select Find > By Details (Metadata) from the Organizer workspace.
- 2 Select the match option any or all.
- 3 Choose the type of details that you are looking for Filename, Camera Make, Camera Model, etc. from the drop-down list in the Find by Details dialog.
- 4 Enter the text you want to search for (if needed).
- 5 Enter how the search text should appear in the located files (contained, not contained, etc.)
- 6 Also included is the ability to save the Find settings that you input here as the search criteria for a Saved Search.

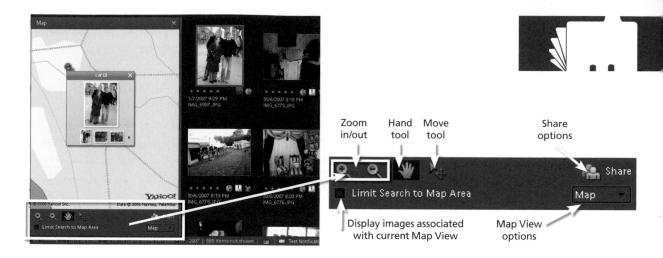

Elements includes a Map feature which provides the ability to associate photos in the Organizer with points on an interactive map. After making the link, clicking the map pin with the Hand tool will display a pop-up window of the associated photos.

Attaching a Map Reference (Windows only)

Elements also contains the ability to link map references with the photos in the Organizer catalog. This feature provides a great way to reference and locate your photos. The mapping technology is provided in association with Yahoo! and one of the ways that you can share your map-referenced picture is via the company's popular photo sharing site, Flickr, at www.flickr.com.

To create a map reference for a photo, drag and drop the thumbnail from the main Organizer workspace onto the Map pane. If the Map pane is not shown then select the Show Map option from the Display menu on the right of the shortcuts bar. Or use the Place on Map command from the Context menu or Edit menu to type in a location. This approach can be more accurate than dragging the photo to a map. To reference a group of photos, tag these images first and then drag the tag to the map. Both these actions will place a pin on the map to indicate that there are photos linked with this area. To view photos associated with a map reference click on a pin using the Hand tool. Alternatively, to display all the photos associated with the current map, select the Limit Search to Map Area option in the tool bar below the map display.

The referenced maps you create, and their linked photos, can be shared online by uploading either to your own website using the Online Albums feature or to **www.flickr.com**.

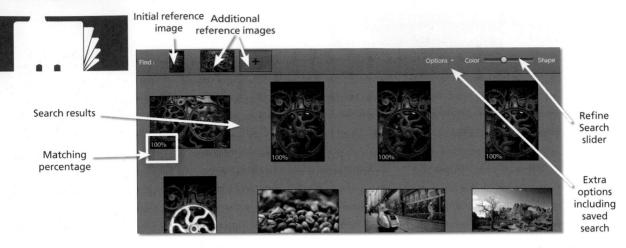

After refining the results you can save the search as a Saved Search for later

Find > By Visual Searches > Search For Visually Similar Photos

Building upon the technology used for the Face Recognition and Media Analysis technologies in Elements, the Search For Visually Similar Photos feature uses a reference image to locate images in your catalog that contain similar characteristics. In particular, the feature hunts down common colors, textures and shapes and then displays all the matching photos along with a percentage score indicating the degree of similarity.

The feature is great for searching for photos with the same color, texture or tonal range and also works well with well-defined shapes. It is possible to improve the accuracy of the results by refining the search in two different ways:

- By dragging photos with similar characteristics to + icon on the options bar, and
- By adjusting the Refine Search slider to favor Color or Shape characteristics.

The refined search can be saved as a Smart Album, allowing you to find similar images at a later date without the need to use the workflow employed by the Search For Visually Similar Photos feature.

Search For Visually Similar Photos workflow:

- 1 Start by displaying the set of images you want to search in the workspace. You can search albums, a group of images that you have multi-selected or even your whole catalog.
- 2 Now select an image to act as the reference image and then choose the Search For Visually Similar Photos entry from the Find > By Visual menu.
- 3 After the candidate photos are displayed, refine the search by dragging photos with similar characteristics to the + sign on the options bar.
- 4 Refine the search further by using the Refine Search button in the Options bar and dragging the slider control between the Shape or Color options.
- 5 Save the search as a Saved Search to reuse later by choosing the Save.. entry from the Options menu on the Options bar.

Find > By Visual Searches > Search for Objects Within Photos

The second visual search option included from Photoshop Elements 10 refines the search for similar pictures idea further by allowing the user to highlight a part of a picture, or object, as a reference for the search. Armed with this information, Elements searches your catalog, or open album, for other images containing the same reference object.

The results can be refined in the same way as the Visually Similar search feature with the Shape/Color slider, giving preference to one characteristic more than the other, as well as the ability to drag extra reference images to the Options bar.

Once you are happy with the results, the search can be saved as a Saved Search via the Options menu in the Options bar.

Search For Objects Within Photos workflow:

- 1 Start by displaying the set of images you want to search in the workspace. You can search albums or even your whole catalog.
- 2 Now select an image containing the object you wish to use as the basis of the search. If no picture is selected then the first image in the workspace will be used.
- 3 Choose the Search For Objects Within Photos entry from the Find > By Visual menu.
- 4 After the display is switched to single image view, resize the displayed marquee so that it sits around the search object in the photo. Click the Search Object icon to start the search or Cancel to quit the feature.
- 5 After the candidate photos are displayed refine the search by dragging photos with similar characteristics to the + sign on the options bar.
- 6 Fine-tune the search further by using the Refine Search button in the Options bar and dragging the slider control between the Shape or Color options.
- 7 Save the search as a Saved Search to reuse later by choosing the Save.. entry from the Options menu on the Options bar.

- (1) The first step in creating an Object Search is to use the feature's marquee to isolate the object to be used as a reference.
- (2) After clicking the Search Object button you are presented with the same display and refinement window as is used with the Visual Similarity search feature.

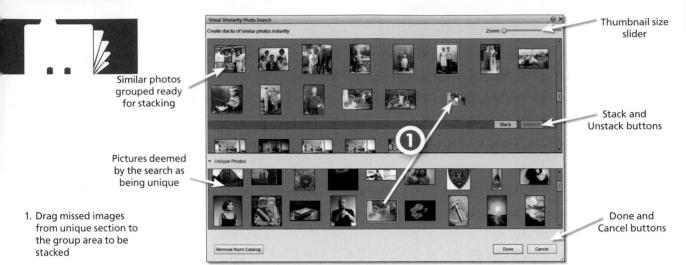

Stack Selected Photos Unstack Photos Expand Photos in Stack Collapse Photos in Stack Remove Selected Photos from Stack Set as Top Photo

Right-click any of the images to be stacked to display a pop-up menu with several stack options. Choose the last entry to set the photo as the top image in the stack.

Find > By Visual Searches > Search For Duplicate Photos

As your catalog of images gets bigger you may find that you end up with multiple copies of the same image where only small changes are present in each individual photo. You can use the new Search for Duplicate photos feature to isolate not just those images that are derived from the same base photo, but also pictures with similar characteristics (taken at the same time, featuring the same subject, etc).

The search feature groups these similar photos and displays them in a new window where you can create a new stack and add the pictures with a single button click. There are also options for removing true duplicate images from the catalog (be very careful using this features) and for displaying Unique Photos, those not marked as duplicates during the search. Image thumbnails can be dragged between duplicate and unique sections of the window allowing you to add images missed by, or mistakenly added by, the search process. You can set any image as the top of the stack by selecting the option from the right-click menu.

Access the Duplicate Photo Search feature from the drop-down menu alongside the Search Box in the Organizer's Options Bar (above) or via the entry in the Find > By Visual Searches menu.

Search For Duplicate Photos workflow:

- 1 Start by displaying the set of images you want to search in the workspace. You can search albums, a group of images that you have multi-selected or even your whole catalog but if you have many images this may take a little while.
- 2 Choose the Search For Duplicate Photos entry from the Find > By Visual Searches menu.
- 3 Click the Stack button on the right of each group of photos to stack the images. Click the Unstack button to reverse the action.
- 4 To remove a true duplicate image from the Organizer, select the image first and then click the Remove From Catalog button.
- 5 Drag incorrectly grouped images from the upper part of the window to the Unique Photos section at the bottom or drag missed pictures from this section to their correct group. Click the Done button to complete the process.

space or to permanently move files to another destina-

Protecting your assets

Ensuring that you keep up-to-date duplicates of all your important pictures is one of the smartest work habits that the digital photographer can learn. Ask yourself 'What images can't I afford to lose – either emotionally or financially?' The photos that you include in your answer are those that are in the most need of backing up. If you are like most image makers then every picture you have ever taken (good and bad) has special meaning and therefore is worthy of inclusion. So let's assume that you want to secure all the photos you have accumulated.

Unlike in previous versions of Elements the backup files and Copy/Move Files functions have been separated into two different

To backup files select the File > Backup Catalog to CD, DVD, or Hard Drive option. To copy or move files choose the File > Copy/Move to Removable Disk entry.

Offline Media

-Stacks and Version Sets

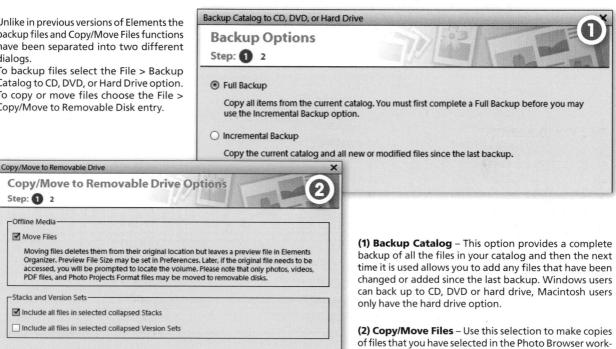

tion.

Making your first backup

Gone are the days when creating a backup of your work involved costly tape hardware and complex server software. Now you can archive your pictures from inside the very software that you use to enhance them – Photoshop Elements.

The Backup feature (Organizer: File > Backup Catalog to CD, DVD or Hard Drive) is designed for copying your pictures (and catalog files) onto DVD, CD or an external hard drive for archiving purposes. To secure your work simply follow the steps in the wizard. The feature includes the option to backup all the photos you currently have cataloged in the Photo Browser along with the ability to move selected files from your hard disk to CD or DVD to help free up valuable hard disk space.

Backup workflow:

- 1 To start the backup process Select File > Backup Catalog to CD, DVD, or Hard Drive from the Organizer workspace.
- 2 Next, select Full Backup for first time archiving or Incremental Backup for all backups after the first one. Click Next.
- 3 And, finally, select the place where you want the backup to be stored. This may be on a series of CDs or DVDs or on an internal drive, and then click Done to backup your files.

Multi-disk Backup

With the Backup Catalog feature it is also possible to archive your catalog over a series of CD or DVD disks. Multiple disk options like this are sometimes referred to as 'disk spanning'.

In earlier versions, the Backup feature only allowed writing to a single disk and, even with the growing use of DVD-ROMs for archive scenarios, many digital photographers have a catalog of photos that far exceeds the space available on a single disk.

The Backup feature estimates the space required for creating the backup copy of the catalog and, after selecting the drive that will be used for archiving, the feature also determines the number of disks required to complete the action. During the writing process the feature displays instruction windows at the end of writing each disk and when you need to insert a new disk. All disks need to be written for the backup to be complete. To restore a catalog from a set of backup disks use the File > Restore Catalog option in the Organizer workspace.

Elements includes the ability to backup the Organizer catalog across multiple disks.

Multi-session Backup

As well as providing the ability to backup large catalogs over multiple disks, the revised Backup feature also allows multi-session recording of archives. Multi-session DVD or CD-ROM recording means that you can add extra backup files to disks that you have already recorded to. This means that if you only fill a quarter of the storage space of a DVD disk when you first create a backup, you will be able to write to the non-used area in a later backup session. Most Elements users will find this useful when performing incremental backups.

Back up regularly

There is no point having duplicate versions of your data if they are out of date. Base the interval between performing manual backups on the amount of work you do. In heavy periods when you are downloading, editing and enhancing many images at a time, backup more often; in the quieter moments you won't need to duplicate files as frequently. Most professionals back up on a daily basis or at the conclusion of a work session. Alternatively add the pictures used in your current projects to an Album with the Backup/Synchronization feature switched on. It should be noted that synchronization is not instantaneous, especially for large files.

Backup glossary

Multi-disk archive – A process, often called spanning, by which chunks of data that are larger than one disk can be split up and saved to multiple CD-ROMs or DVDs using spanning software. The files can be recompiled later using utility software supplied by the same company that wrote the disks.

Full backup – Duplicates all files even if they haven't changed since the last time an archive was produced.

Incremental – Backs up only those files that have changed since the last archive was produced. This makes for faster backups but means that it takes longer to restore files as the program must look for the latest version of files before restoring them.

Restore – Reinstates files from a backup archive to their original state on your hard drive.

Backup hardware

CD-ROM or DVD writer – This option is very economical when coupled with software that is capable of writing large numbers of files over multiple disks. The sets of archive disks can easily be stored off-site, insuring you against theft and fire problems, but the backup and restore process of this approach can be long and tedious.

Internal hard drive – Adding an extra hard drive inside your computer that can be used for backing up provides a fast and efficient way to archive your files but won't secure them against theft, fire or even some electrical breakdowns such as power surges.

External hard drive – Connected via USB or Firewire these external self-contained units are both fast and efficient and can also be stored off-site, providing good all-round protection.

Store the duplicates securely

In ensuring the security of your images you will not only need to protect your photos from the possibility of a hard drive crash but also from such dramatic events as burglary and fire. Do this by storing one copy of your files securely at home and an extra copy of your archive disks or external backup drives somewhere other than your home or office. Synchronized Albums account for such events by storing their contents both in Elements and also online.

The bundled photos icon at the top right of the thumbnail indicates that the photo is part of a Version Set.

To create a Version Set when saving an edited file from inside the Quick or Standard editor workspace, make sure that the Save in Version Set with Original option is selected.

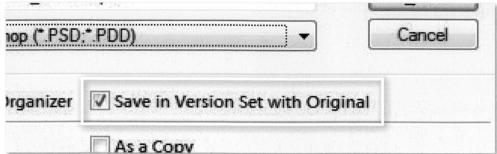

Versioning your edits

Creating a good archival system goes a long way to making sure that the images you create are well protected, but what about the situation where the original photo is accidentally overwritten as part of the editing process? Embarrassing as it is, even I have to admit that sometimes I can get so involved in a series of complex edits that I inadvertently save the edited version of my picture over the top of the original. For most tasks this is not a drama as the edits I make are generally non-destructive (applied with adjustment layers and the like) and so I can extract the original file from inside the enhanced document but sometimes, because of the changes I have made, there is no way of going back. The end result of saving over the original untouched digital photo is equivalent to destroying the negative back in the days when film was king. Yep, photographic sacrilege!

So you can imagine my relief to find that in the last few versions of Photoshop Elements, Adobe featured a technology that protects the original file and tracks the changes made to the picture in a series of successively saved photos. The feature is called Versioning as the software allows you to store different versions of the picture as your editing progresses. What's more, the feature provides options for viewing and using any of the versions that you have previously saved. Let's see how this file protection technology works in practice.

Selecting the Version Set > Expand Items in Version Set option from the right-click menu displays the various pictures that have been bundled together in the set.

Versions and Photoshop Elements

Versioning in Elements extends the idea of image stacks by storing the edited version of pictures together with the original photo in a special group or Version Set.

All photos enhanced in the Organizer space using tools like Auto Smart Fix are automatically included in a Version Set. Those images saved in the Quick and Expert editor spaces with the Save As command can also be added to a Version Set by making sure that the Save with Original option is ticked before pressing the Save button in the dialog.

Saving in this way means that edited files are not saved over the top of the original; instead, a new version of the image is saved in a Version Set with the original. It is appended with a file name that has the suffix '_edited' attached to the original name. This way you will always be able to identify the original and edited files. The two files are 'stacked' together in the Organizer with the most recent file displayed on top.

The Expand and Collapse buttons are positioned to the right of the thumbnail of standard image stacks as well as Version Sets.

When a photo is part of a Version Set, there is a small icon displayed in the top right of the Photo Browser thumbnail. The icon shows a pile of photos.

To see the other images in the version stack simply click the sideways arrow on the right of the thumbnail or right-click the thumbnail image and select Version Set > Expand Items in Version Set. Using the other options available in this pop-up menu the sets can be expanded or collapsed, the current version reverted to its original form or all versions flattened into one picture. Version Set options are also available via the Photo Browser Edit menu. Only the top-most photo in a version set is synchronized, but all photos in a stack are synchronized online.

Elements' photo stacks

A photo stack is slightly different from a Version Set as it is a set of pictures that have been grouped together into a single place in the Organizer workspace. Most often, stacks are used to group pictures that have a common subject or theme and the feature is one way that Elements users can sort and manage their pictures. To create a version stack, multi-select a series of thumbnails in the workspace then right-click on one of the selected images to show the menu and from here select the Stack > Stack Selected Photos option. The photo you right-click on will be the top photo in the new stack. You can identify stacked image groups by the small icon in the top right of the thumbnail.

Photo stacks use a layered photos icon in the top right of the thumbnail to indicate that the picture is one of several images that have been grouped together. All photos In a stack are synchronized.

To manually group alike photos into a photo stack, multi-select the pictures in the Photo Browser workspace before choosing Stack > Stack Selected Photos from the right-click menu.

Auto stacking

The idea of grouping together alike photos in a single stack was introduced in version 3.0 of the program. Elements also contains the ability to auto stack images as they are downloaded from camera, imported into Elements from folders or even when displayed in the Organizer workspace. The feature looks for images that are visually similar, or were captured within a short time interval, when suggesting groups of images that are suitable for stacking. You can employ the Elements Auto Stacking feature in a couple of different ways:

Photos in the Organizer – To auto stack pictures already in your catalog select a group of thumbnails and then choose Automatically Suggest Photo Stacks from either the Edit > Stack or the right-click pop-up menus.

Photos being imported – To stack when importing choose the Automatically Suggest Photo Stacks option in the Get Photos and Videos dialog.

Either of these two options will then display a new window with alike pictures pre-grouped. Choosing the Stack All Groups button converts the groups to stacks.

The Remove Group button prevents the group of pictures being made into a stack.

- 1 To automatically stack alike photos that have already been imported into the Organizer, start by multi-selecting pictures from the Media Browser.
- 2 Next right-click one of the thumbnails and choose Stack > Automatically Suggest Photo Stacks from the menu that is displayed.
- 3 Elements will then show you a new screen containing the groups of images that it suggests should be stacked. Click the Stack All Groups option to convert the groups to stacks.
- 4 To stop a set of pictures becoming a photo stack press the Remove Group button before conversion.

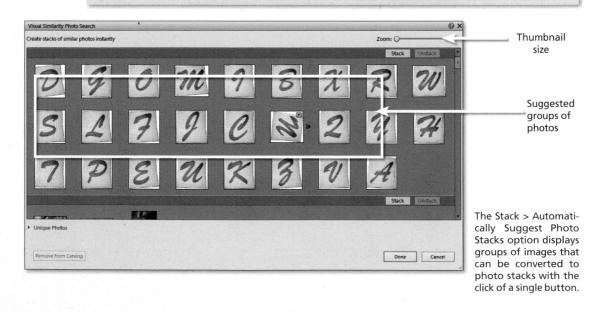

Fix

Auto Sharpen

In earlier editions of Photoshop Elements all editing and enhancement actions were centered around the tools and features in the Full Edit workspace. More recently Elements has provided the photographer with several different levels of editing to choose from.

And in the last couple of versions the staff at Adobe have also introduced a dedicated Fix uto Red Eye Fix pane into the program. In version 11 this has been renamed Instant Fix. Here you will find a bunch of single-click enhancement options that can be applied to images from inside the Organizer workspace. As we have already seen, Elements has a range of different ways to edit your photos. All have their own strengths and challenges, but in this rop... chapter we will concentrate on those features available in the Instant Fix pane within the Organizer.

And remember, with the Organizer now available for Mac users as well, they too will have access to all the great features in the Instant Fix pane.

Mor

Edit with Photoshop...

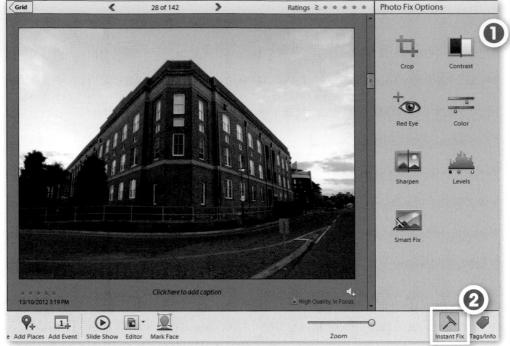

Automatic editing options, which are sometimes called are Photo Fix Options, are grouped in the Instant Fix pane on the right of the Organizer workspace (1). If the Tags and Information panel is displayed instead, just click on the Instant Fix button at the bottom right of the pane area (2) to show the Instant Fix options.

The Fix Task Pane

In the last couple of revisions of Photoshop Elements, some of the auto editing options that were previously only available in the Enhance menu of the Edit workspace, have been added to the Instant Fix pane in the Organizer. From version 9, Mac users can also take advantage of these fast enhance options.

Quick guide to the Fix panel's auto enhance features		
Correction needed	Feature to use	
Low contrast problem	Contrast or Smart Fix	
High contrast problem	Contrast or Smart Fix	
Color cast problem	Color, Levels or Smart Fix	
Color cast and contrast problem	Levels or Smart Fix	
Sharpness or clarity problem	Sharpen	
Red Eye	Red Eye (yep, you guessed it!)	

If the Instant Fix pane is not being displayed on the right side of the Organizer workspace then click the Instant Fix button on the Actions Bar at the bottom of the workspace.

The Smart Fix option enhances several different image characteristics in the one action, whereas features like Levels, Contrast, Sharpen, and Color concentrate on adjusting just one aspect of the photo, providing more specific and controllable changes to your photo.

When working with single-click adjustments such as these, keep in mind that sometimes such automatic fixes do not produce the results that you expect. In these scenarios use the Undo (Edit > Undo or Ctrl+Z) command to reverse the changes and try one of the manual correction tools detailed in the Editor workspace.

Automatic editing options

The simplest tools are almost always fully automatic with the user having little control over the final results. These are the types of color, contrast, brightness and sharpness controls that are available in the Photo Browser in the Instant Fix panel on the right of the Organizer workspace. These options provide a great place to start if you are new to digital photography and want good results quickly and easily, but experienced users will find the lack of control frustrating.

The Smart Fix feature applies a variety of color, tone and sharpness changes to correct problems in an image.

Smart Fix

The Smart Fix feature enhances both the lighting and color in your picture automatically. The command is used to balance the picture hues and improve the overall shadow and highlight detail. Most images are changed drastically using this tool. In some cases the changes can be too extreme. If this occurs, the effect should be reversed using the Edit > Undo command and the more controllable version of the tool – Adjust Smart Fix – used instead. Adjust Smart Fix is located in the Editor workspace.

The Color feature tries to remove color casts from your photos.

Color

Color concentrates on correcting the color in the midtones of the picture and adjusting the contrast by reassigning the brightest and darkest pixels to white and black. The feature works in a similar way to tools like Enhance > Auto Levels and Enhance > Auto Contrast in the Editor workspace, providing a one-click fix for most color problems.

Levels can be used for correcting both brightness and color problems.

Levels

The Levels command is similar to Contrast in that it maps the brightest and darkest parts of the image to white and black. It differs from the previous technique because each individual color channel is treated separately.

In the process of mapping the tones (adjusting the contrast) in the Red, Green and Blue channels, dominant color casts can be neutralized. This is not always the case; it depends entirely on the make-up of the image. In some cases the reverse is true; when Auto Levels is put to work on a neutral image, a strong cast results. If this occurs, undo (Edit > Undo) the command and apply the Contrast Instant Fix feature instead.

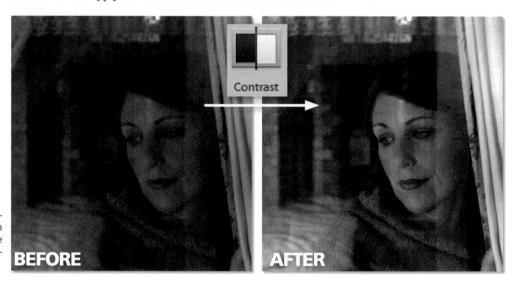

Contrast tends to concentrate on just the tones in the photo and to a large degree ignores any problem color casts.

Contrast

Contrast is designed to correct images that are either too contrasty (black and white) or too flat (dull and lifeless). Unlike the Levels feature, Contrast ensures that the brightest and darkest pixels in the picture (irrespective of their colors) are converted to pure white and black. In doing so all the tones in between are expanded or contracted to fit. Apply Contrast to grayscale photos like the example above or pictures where the contrast needs improving but there is a strong color tint that you wish to retain. This feature is a good correction option if Levels creates more color cast problems than it corrects.

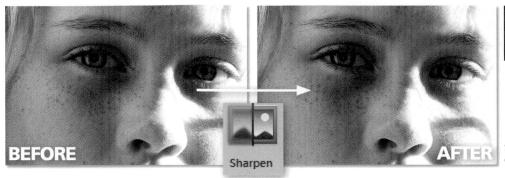

Sharpen adds a sense of clarity to photos.

Sharpen

Sharpen applies a set amount of sharpening to the photo. Most photographers prefer to be able to adjust the degree of sharpening that is applied to their images and so would avoid using this auto feature in favour of a more manual approach involving the Editor: Enhance > Adjust Sharpness filter.

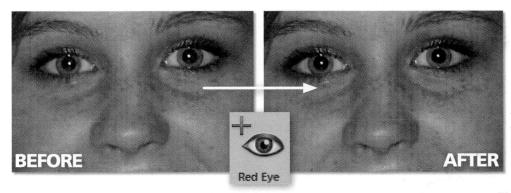

The Red Eye Instant Fix option searches fro and removes the red area in the eyes of portraits photographed with flash.

Red Eye Fix

One of the possible side effects of using the in-built flash on your compact digital camera is the appearance of red eyes in the subject. Elements has always had great options for correcting this problem and the current release is no different, containing a specific Red Eye Removal tool.

As well as the Red Eye Removal Tool in the Editor workspace, Elements also contains the ability to automatically detect the presence of red eye in a photo and then correct the problem. The feature cleverly checks out the metadata attached to the photo to see if a flash was used to record the image before searching for the problem eyes and automatically correcting the red hue. This feature can also be applied when transferring images from camera to computer by selecting the Automatically Fix Red Eyes option in the Photo Downloader.

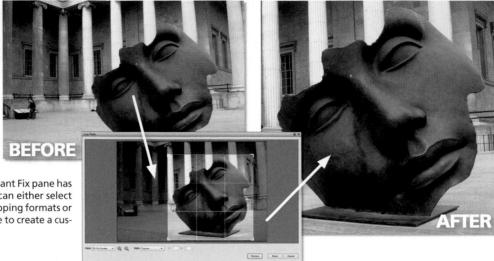

The Crop option in the Instant Fix pane has its own dialog where you can either select from one of a range of cropping formats or use the on-image marquee to create a custom crop.

Crop

The Crop option is the only feature in the Instant Fix pane that has its own dialog plus a set of controls and settings to adjust its output. You have a choice of creating a customized crop or selecting a preset crop that is designed to suit the format (and size) of a range of specific printing papers. For more details on using the Instant Fix Crop option, go to Chapter 2.

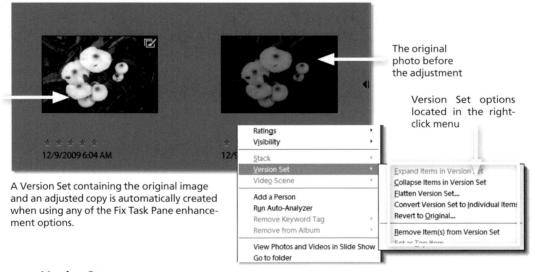

After the auto adjustment has been applied

Version Sets

Any changes made to images using Instant Fix pane options results in a new version of the photo being created and the original and the new copy being stacked together in Organizer as a Version Set. This means that you can always revert to your original photo at a later date if you decide that you don't like the adjustment changes that were made.

More details about Version Sets and how they fit into your editing workflow can be found in Chapters 2 and 3.

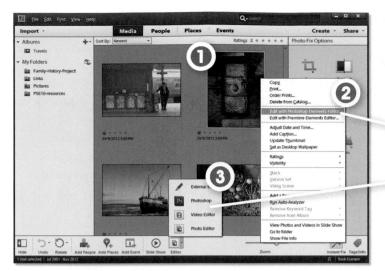

After selecting a photo in the Organizer (1) transfer it to the Editor workspace (4) by choosing the Edit with Photoshop Elements Editor option on the right click menu (2) or by clicking the Editor (or Photo Editor entry on the pop-up menu) (3) button at the bottom of the screen.

Other editing options

To complement the auto editing options listed in the Instant Fix pane, the Editor button popup menu provides a variety of other editing options:

Editor button or the **Photo Editor** menu entry – Choose either of these entries to open any photos selected in the Organizer in the Photoshop Elements Editor space. This action is the same as selecting the Edit with Photoshop Elements option from the right-click menu.

Video Editor – The Video Editor option performs a similar function except that the selected images, or videos, are opened in the Premiere Elements program. It provides an easy-to-use video editing environment designed to work side-by-side with Photoshop Elements. If Premiere Elements is not installed then an information window with options to install, download a trial or cancel the action will be displayed. Options to edit media in Premiere Elements can also be found in the Right-click menu.

Photoshop and/or **External Editor** — Other entries in the Editor pop-up menu are for passing the photos managed in the Organizer to enhancement applications other than the Photoshop Elements Editor. If a version of Photoshop is installed on the computer then an Photoshop entry will automatically appear here. Other applications can be added via the settings in the Edit > Preferences > Editing dialog. There are also settings in this dialog to remove links to the Edit in Photoshop Elements or Premiere Elements menu entries.

Automating editing of several pictures at once

It's true that shooting digital has meant that many photographers have saved the time that they used to spend in the darkroom processing their images. The flip side to this coin is that now we while away the hours in on-screen production instead. Surely with all the power of the modern computer and flexibility of Elements there must be quicker ways to process files. Well yes there is!

Processing multiple files

Photoshop Elements users are able to automate a variety of editing functions in two different ways depending on which workspace you are using.

Elements displays a progress window when applying Fix Pane enhancements to multiple photos in the Organizer space.

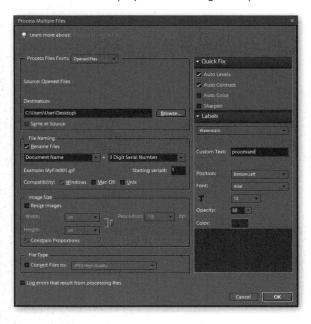

Elements users can automate the application of basic enhancement and editing features to a group of files using the Process Multiple Files feature located in the Filemenu of the Editor workspace.

File naming – naming styles.

Image Size – Swith from the company of the Editor workspace.

File type – Sel

Organizer

Multi-selected photos in the Organizer space can be adjusted together by selecting the enhancement type from those listed in the Instant Fix pane. Each of the selected photos will be adjusted in turn and then the processed picture will be added to a newly created version set with the original. Elements will display a progress window as it enhances the photos.

Editor

When working in the Editor space similar multi-image processing can be achieved with the Process Multiple Files feature located in the File menu. The feature is like a dedicated batch processing tool that can name, size, enhance, label and save in a specific file format a group of photos stored in a folder or selected via the file browser or Open Files.

The dialog's options include:

Source – Files to be processed can be stored in a single folder, the files currently open in the workspace, pictures in the Project Bin or images multi-selected in the file browser.

Destination – Sets the location where processed files will be saved.

File naming – Options for naming or renaming of selected files including a range of preset naming styles.

group of files using the Process Multiple Files feature located in the File with from the drop-down menu. Proportions can be constrained.

File type – Select the file format that processed files will be saved or converted to.

Quick Fix enhancement – Use the options here to apply automatic enhancement of the files being processed.

Add Labels – Add caption or file name labels to each of the processed files. Also contains an option for watermarking the pictures.

After setting the options for each of the sections in the dialog press the OK button to process the pictures.

Create

As we have already seen in previous chapters, Photoshop Elements includes a variety of ways to use the photos that you enhance with the program. The various output options 5 how. can be broken into two broad groups that are reflected in two different task pane -Create and Share.

The Create options are sophisticated imaging projects that enable users to quickly and easily include their pictures in a range of project forms. The Share entries on the other tant Movie... hand provide a variety ways that you can distribute your photos.

In this chapter we will concentrate on those projects listed in the Create pane.

DVD with Menu...

DVD Jacket..

CD/DVD Lab

A few years ago it would have been sufficient for a good image-editing package to include a print command and maybe a way to export pictures in a variety of different file formats, but these days photos are compiled, shared, distributed and displayed in a much broader range of ways. With the inclusion of the Create and Share photo projects in Elements you too can start to use your pictures in forms that you may never have thought possible.

The Create option is one of the action panes available in both Organizer (1) and Editor (2) workspaces.

Photo projects

Elements users can access the various photo projects from both the Organizer and Editing spaces by selecting an option from the Share or Create task panes on the right of either workspaces. In earlier Mac versions users had to commence their photo project creation from the panes in the Editor space. Now both versions work in a similar way.

A list of key project types are grouped in each pane. All of the projects will already be familiar to Elements users as they have appeared in various forms in previous versions of the program.

Each project requires you to have some basic resources prepared before starting out. For the most part this means that you should have selected, enhanced and edited any pictures you wish to include before commencing the creation process.

In the case of the DVD with Menu option you will need to create the slide shows that you want to feature before selecting these options. For this reason it is a good idea to follow the workflow detailed below when making your Photo Creations.

As you need to have all your pictures edited and enhanced before adding them to your Photo Creation projects, start by enhancing your pictures then save the finished file back to the browser. Now select the pictures to include and then select the Photo Creations project. The selected images will now appear in the Project dialog.

Editor workspace

Organizer workspace

Create Task Pane options:

- 1. Photo Prints Automatically add selected images to an online printing order supplied by companies such as ShutterFly.com or Kodak.
- 2. Photo Book Take your page layout activities further by creating a whole book of pages that you can then print or have published online.
- 3. Greeting Card Create your own personalized greeting cards from a range of preset designs but featuring your pictures and words.
- 4. Photo Calendar For the first time the same approach used for Books and Collages is now available for creating Photo Calendars. You can print at the desktop or have your calendar produced online
- 5. Photo Collage A free form layout option that includes the ability to add frames, graphics, text and backgrounds in a multi-page format.
- 6. Slide Show Used for creating multimedia extravaganzas complete with title slides, narration and accompanying music.
- 7. Instant Movie Combine video clips quickly and easily with this Premiere Elements only feature.

- 8. **DVD with Menu** This DVD option creates a disc of your slide shows with an accompanying menu but is only available if you have Premiere Elements installed.
- 9. CD Jacket Produce a jacket for either a CD case based on a variety of template designs featuring your own photos.
- **10.DVD Jacket** Produce a jacket for a DVD case based on a variety of template designs featuring your own photos.
- 11. CD/DVD Label Generate a photo-based design that is pre-sized ready for printing on CD or DVD labels.

Photo Book and Photo Collages

The Photo Book and Photo Collage options use a similar interface for projects that make use of the special frames, backgrounds, themes (matched back-

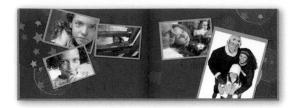

grounds and frame sets), graphics and text to create multi-page documents from a group of selected photos. The big difference between the two options is that with Photo Books, the creation is optimized for multi-page documents, whereas the Photo Collage option creates a series of single page layouts which can be printed using your desktop machine.

The Theme and Layout options allow the user to automatically design their pages and insert pictures using one of a range of templates and styles, and then edit or add to the layouts after creation. For more details on creating Photo Books and Collages see Chapter 18.

Start by selecting the photos that you wish to include from the thumbnails displayed in the Organizer workspace. Next choose the Photo Book option in the Create Task Pane.

The first step is to pick the type of book (printing online or with a desktop printer) you want to create. Next, select the page size from those listed under each book type. NOTE: All book types can be printed to a desktop printer.

In the next step select a theme (matched background and frame set) to use for the Photo Book. Also choose if you want Elements to 'Auto-fill' the frames with the images you selected and insert a figure for the number of pages if you want to include. Click OK to produce the book.

Adjust the size and positioning of frames by clicking onto each in turn and dragging the corner handles. Alter the size and position of the photos inside the frames by double-clicking on the photo and either using the corner handles, the tools in the edit bar at the top of the frame or the options in the right-click pop-up menu.

With the adjustments complete, save the project by clicking Done at the bottom of the right panel. To print the book to a desktop printer open the saved project in the Edit space and then choose File > Print. Alternatively with the Photo Book file open in the Editor space, click the Print button at the bottom of the workspace.

To have the multi-page document professionally printed and bound using the Shutterfly service, select this option at the first screen when starting the book creation process. After completing the book click the Order button at the bottom of the Create panel to place an online request for publishing.

Photo Calendar

Photoshop Elements provides a mechanism for the easy creation of professional-looking calendar which you can print with your desktop printer. Photos are selected in the Organizer space before being uploaded to the web where a step-by-step wizard takes over the production process.

See Chapter 18 for more information about editing your photo calendar styles.

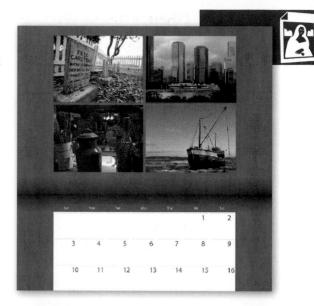

Start by selecting the photos that you wish to include from the thumbnails displayed in the Organizer workspace. Choose the Photo Calendar option in the Create Task Pane. Now pick the Starting Month and Year and choose if the calendar will be printed online or locally. The options available here will depend on your geographic location.

Now select the style of the Calendar from the Themes area. Select the Auto Fill option to instruct Elements to place all selected images into the calendar. Click OK to produce the calendar. You can now adjust the images, frames and backgrounds just like photo books.

Calendar at any time by selecting the Replace Photo option in the right-click menu. Or alternatively images displayed in the Photo Bin can be dragged to one of the picture frames in the design for automatic

replacement.

Once completed you can click the Save button to store the project. Saved projects can be edited at a later date. Click the Print button at the bottom of the workspace to output the calendar to a desktop printer.

Greeting Cards

Creating greeting or birthday cards customized with your own pictures and heartfelt message is a good way to make the cardgiving experience a little more personal. Like Photo Books and Photo Calendar projects, the Greeting Cards workflow includes a range of sizes and styles of card that can be produced online or printed at the desktop. See Chapter 18 for more information about editing your Greeting Card project.

Start by multi-selecting photos from the Organizer workspace before choosing Greeting Card from the Create task pane. You will now be presented with a choice of sizes and online providers. Remember now all Greeting Cards designs can also be printed locally so there is no need to select a specific print option if you want to output to your own printer.

Next choose the theme and then the Layout for the card. You can pick between a range of designs based on the occasion or event the card is celebrating. Don't panic if the position of the photos is not exactly what you want as this can be changed later. Click OK to create the card.

Adjust the position, size, shape and orientation of the photos placed on the greeting card using the corner and side handles. See Chapter 18 for more details. When finished click the Commit button (green tick) at the bottom of the frame to apply the changes.

Add text to the card by firstly clicking on the TEXT heading in the Create task pane and then selecting the Add Text Block entry. This will add a text block to the card. Type your text into the block. The font, style, size, alignment, color and warp text values can be adjusted with the options in the Settings part of the Create panel. Text can be styled by selecting the text block (not the type itself) and double-clicking a STYLES entry.

Click the Switch to Advanced Mode button (top left of workspace) and then Window > Effects to display the Effects panel. Select an object in the design such as a block of text and then double click an entry in either the Effects, Filters, or Styles lists to add the effect to the object. Alter the look of characteristics or shadows, strokes and bevels using the controls in the Style Settings dialog accessed by selecting the Edit Layer Style option from the right-click menu.

Once the card design is completed you can print the card with a desktop machine connected to your computer by clicking the Print button at the bottom of the workspace. Selecting the Save button stores the photo project and clicking the Order button uploads the design to an online publisher for printing.

Photo Prints

The Photo Print option is available for both Mac and Windows users. It provides a quick way to output your photos to your desktop printer. For Windows users there are the additional options of creating and printing a Picture Package, or transferring the photos to an online print provider such as **Shutter-Fly.com**. As with many of the other partner service offerings in Elements, the number of online print companies will depend on the geographic region in which you reside.

Start by selecting the photos that you wish to print from those listed in the Organizer space. Next select the Photo Prints option from the Create Task Pane.

Next you will see a second screen in the task pane which lists the options available. In this example this includes options to:

- print locally,
- create a print package made up of multiple photos on individual pages,
- produce a contact sheet of thumbnail size photos on a individual pages and
- send to online print provider.

For Online printing options the selected images will be uploaded to the web server where you will need to log into the service to place the print order.

The other print options transfer the selected photos to the Print dialog box.

Slide Shows (Win only)

The Slide Show utility in Elements is capable of producing very sophisticated multimedia presentations. Gone is the simple menu-based wizard that Elements featured in earlier versions of the product. Now, using a single Slide Show editor, you create and arrange slide shows, add music, text, graphics and narration then finally produce the show in one of a range of formats.

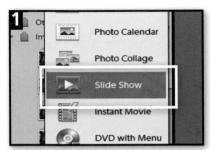

Start creating your slide show by selecting the photos that you wish to include from the thumbnails displayed in the Organizer workspace. To select a group of pictures click on the first thumbnail and then hold down the Shift key whilst selecting the last photo. To pick individual images Ctrl-click on the thumbnails.

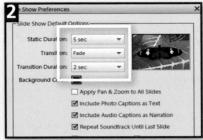

With the pictures selected, choose the Slide Show option from the Create task pane. This action will display the Slide Show Preferences dialog. Using the controls here set the general slide duration, transition, transition duration, background color, cropping and caption options that will be used for the whole show. There are also options for adding a sound track and the quality of the video preview in the Editor space.

The Slide Show editor is displayed after clicking OK at the Preferences dialog. Adjust the sequence of the photos in the presentation by switching to the Quick Reorder screen (View > Quick Reorder). Click and drag photos to a new position to change their place in the show's sequence. When finished choose View > Quick Reorder to change back to the Slide Show editor view.

To make basic (automatic) editing changes to the slides in the presentation, click on the preview picture (large) and then adjust the settings in the Properties pane. Here you can rotate, adjust picture size, alter cropping and apply Auto Smart Fix and Auto Red Eye Fixes. There are also three quick Photo Effect buttons that convert the slide to black and white, sepia and back to color.

Along with the basic transition effects there is also the ability to animate the pictures in the presentation. This effect is created with the Pan and Zoom controls, which are displayed in the Properties pane when the slide thumbnail is selected in the time line. Click the check box to enable the feature and then set the Start (Green) and End (Red) marquees on the slide preview.

In addition the Editor allows you to add graphics, text and narration to your show. Simply select the heading in the Extras pane and then drag and drop the text or graphics onto the slide and adjust size and color or effects using the options in the Properties pane. Select the Narration option to record any comments to be added to the slide.

To add a music track to the show, click the music bar below the time line and browse for the file to include. The transitions added to all slides can be changed or customized by clicking on the 'A-B box' between slides in the time line and altering the settings in the Properties pane. Once you are happy with the presentation design save the show (File > Save Slide Show Project) before outputting (File > Output Slide Show) the presentation in one of the formats listed in the Output dialog.

CD and DVD Jackets

CD and DVD jackets are the sheets of paper or thin card that wrap around the inside of the CD/DVD case. The inclusion of a photo project option for the creation of these jackets first appeared in Elements 5.0. There is no real difference between the two choices except for the size of the finished document. For this reason I have presented only one step-by-step technique here. After creating

a jacket with a combination of your images and one of the themes provided in the Creation dialog, the final design is printed, the edges trimmed and the paper inserted into the cover space of the case.

NOTE: CD/DVD cases normally open like a book so remember to position the front cover details on the right-hand side of the design.

Start by multi-selecting photos from the Organizer workspace before choosing CD or DVD Jacket from either the main Create pane or the extra options in the More Options section.

Choose the theme for the jacket from the thumbnails listed in the centre of the dialog. Next, select the Auto Fill option to have Elements place images automatically into the design.

A new project document is produced with the selected images inserted into the frames and placed onto the background. If more images were selected than the places available in the document then Elements uses only those images it needs to fill the frames in the layout.

Right-click on each image in turn and choose Fit Frame To Photo. Next adjust the size and orientation of the photo and the frame using the side and corner handles. For more details on how to manipulate frames and the pictures they contain, go to Chapter 18.

With the images in place we can now turn our attention to adding other details to the design. Here an extra film Frame is added from the Graphics pane (to display the pane click the Graphics button at the bottom right of the workspace). Double-click the frame entry to apply the new frame.

The size, shape, rotation and position of the added images, text and graphics are adjusted in the same way as the frame photos.

After saving the completed composition the CD/DVD jacket is then printed using the Actual Size setting to ensure that the jacket fits the case.

ataign

DVD with Menu

Well, the days when most photographers recorded the family history on slide film have long gone but the slide show events that accompanied these images are starting to make a comeback, thanks in part to the ease with which we can now organize and present our treasured digital photos on new media like DVD. Gone too are the dusty projectors, being replaced instead by DVD players hooked to widescreen 'tellies'. This photo project converts your Elements slide shows (Win) or video files to DVD format ready for viewing on most DVD players or computers with a DVD drive. Windows users can add their slideshows directly to the DVD projects whereas in previous versions this was only possible by outputting directly to DVD in the revised Slide Show editor.

NOTE: Any DVD burning does require Premiere Elements to be installed alongside Photoshop Elements.

Before you can create a DVD with a menu you must have at least one slide show video (Win) or a movie file saved into the Organizer. If you don't have a candidate slide show then Windows users can start the process by selecting the Slide Show option and creating a multimedia presentation complete with sound. Save the project to the Organizer and then export the project as a video file.

Select the slide shows or videos that you want to include in the DVD from the Photo Browser and then pick DVD with Menu from the Create task pane. Add or Remove slide shows or videos from the thumbnail list if you are unhappy with your selection. Click and drag slide shows or movies to new positions in the list to adjust where they will be placed in the menu of the DVD. The small number in the top left of each thumbnail indicates the sequence.

Click Next when you are happy with the arrangement. Premiere Elements will open and a new project created. You will be prompted to pick a Theme for your menu. NOTE: Themes marked with a blue ribbon across the top right corner need to be downloaded before being used.

Add menu markers to key points in your movie(s) and then click the Done button in the top left of the Premiere Elements workspace.

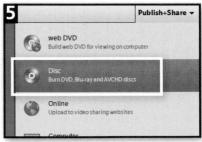

Now choose the way you want to produce the video by selecting one of the options from the Publish+Share menu.

CD/DVD Labels

Another inclusion for image makers saving their files to disk is the CD/DVD Label project. This photo project produces a circular design that is suitable for printing onto the surface of printable CDs or on perforated label paper. Like the other projects in Elements, an image or images are selected from the Organizer workspace or Project Bin, before selecting the CD/DVD Label option from the More Options menu in the Create task pane. Once selected the panel options will not provide a choice for the document's size as all the templates are designed with dimensions to suit a standard DVD or CD disk. The choice of layouts is largely based on the number of images to include on the CD label, but the selection you make here doesn't restrict you from adding (or taking away) images later in the design process. Some of the same themes that are available in the CD/DVD Jacket creation are also contained here and so it is possible to create matching label and jacket sets for your projects.

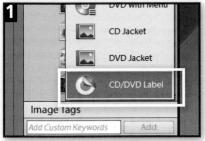

Start by multi-selecting photos from the Organizer workspace before choosing CD or DVD Label from the menu in the Create task pane. Choose the theme and the Auto-Fill option from the dialog displayed. Click OK to create the label and insert the images.

Right-click on the photo and choose Fit Frame To Photo. Next adjust the size and orientation of the photo and the frame using the side and corner handles. Keep in mind that the edges will be cut to suit the disk shape.

After positioning the pictures we can now add some text to the composition. As we are matching the design used in the CD/DVD Jacket creation, the text is inserted in an appropriate section in the theme's background. The color and style of the text are matched with the design.

Once the design is completed save the creation project and then insert the CD/DVD or label sheet into the printer ready for printing. Select File > Print and ensure that the print size is set to Actual size (scale = 100%). This will guarantee that the final label is an exact match to the CD/DVD disk.

If you want to add more images to the design then locate a frame to include from the Graphics section of pane on the right of the workspace. Click the Graphics button to display the pane. Drag the frame thumbnail onto the document. A new frame will appear. To add a photo either drag one from the Project Bin to the frame or click in the center and browse for a picture file in the dialog that opens.

Basic Black 10px

Instant Movie

Photoshop Elements continues to build upon the level of integration available with its sister program, Premiere Elements. With the Organizer common to both programs and still and

video content being managed equally, many Photoshop Elements users will find themselves starting to enhance their own movie footage. To make this prospect a little easier, Adobe has included simple-to-use features such as Instant Movie on the Create pane so that they are close to hand when you are managing your video files. Designed as fast way to compile several raw video clips into a themed movie complete with titles, introduction, edited clips, transitions and sound track, Instant Movie is a great way for stills shooters to move into the unfamiliar territory of video editing with Premiere Elements.

NOTE: This option is only available to Photoshop Elements users if Premiere Elements is also installed.

As with most photo projects, the beginning of the process involves selecting several clips from those listed in the Organizer space. Remember you can display only the video files in your catalog by deselecting the other media types in the View > Media Types menu. Now select the clips to include and choose Instant Movie from the Create pane.

Premiere Elements will open and a new project will be created. Next you will be prompted to choose a video theme for your movie. After selecting click Next to continue. Some themes need to be downloaded from the internet before use. If this is the case with the theme you selected the downloading process will start now.

Next the Instant Movie settings dialog will appear. This displays a list of controls and settings available for the theme. Work your way through these options adjusting, changing or substituting settings for those listed. Once you are happy click the Apply button.

Premiere Elements will apply the Instant Movie settings to the clips and display the results in the preview section of the workspace. You can review the movie with the VCR type buttons just under the preview area.

Next Save the completed project before clicking onto the Publish+Share pane to display the various ways that you can output your movie. There are options for saving to disk, mobile phones, or computer as well as single click online uploads to YouTube or Photoshop.com.

Share

The Share menu contains a series of photo projects that can be used to showcase and distribute your images. The pane can be found in both Macintosh and Windows versions of the software and unlike in previous versions, it is only to be found in the Organizer workspace.

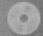

Burn data CD / DVD...

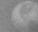

Online Video Sharine

Mobile Phones and Pl

Mo.

snare with Kodak Easysnare

Send to SmugMug Gallery...

Send to CEIVA Digital Photo

Share menu options:

- Share to Facebook Upload directly to your Facebook account.
- E-mail Attachments Optimize your images for email and then automatically attach them to a newly-created message ready for sending.
- Photo Mail (Win only) Create a special Photo Mail email message featuring your photos, fancy frames and a background.
- Vimeo Upload videos and movie clips to this webbased sharing platform.
- 5. YouTube Upload the videos you produce in Premiere Elements to your YouTube account.
- **6. Photoshop Showcase** Add videos you create to your Photoshopshowcase.com account.
- 7. Share to Flickr Upload directly to your Flickr account.
- Send to SmugMug Gallery Direct link for placing images on the SmugMug Gallery site.
- 9. Online Album Automatically produce a gallery website from a selection of your photographs and save it to disk or hard drive or upload it to your Photoshopshowcase.com account.
- 10.Burn Video DVD/BluRay Write images and video to DVD/BluRay disks using the options available in Premiere Elements.
- 11. Online Video Sharing Upload videos to sharing websites such as YouTube, Photoshopshowcase.com, or Podbean using the settings and features in Premiere Elements.
- **12.Mobile Phones and Players** Images are passed to Premiere Elements first before being output in a format suited for mobile devices.
- **13.PDF Slide Show** Create high quality slide shows in a special Acrobat or PDF format. Windows users can access this option in the Share Task Pane.
- 14.Adobe Revel Link your Elements images with your Revel account so you can view your pictures easily on phones and tablets.

	Create - Share -	
f	Facebook	0
0	Email Attachments	0
	Photo Mail	3
V	Vimeo	4
You	YouTube	6
O	Video to Photoshop Showcase	3
••	Flickr	0
ö	SmugMug Gallery	3
8	Online Album	0
0	Burn Video DVD / BluRay	00
	Online Video Sharing	00
	Mobile Phones	02
1	PDF Slide Show	03
9	Adobe Revel	00

Share, share and share alike!

Gone are the days when photographers passed around a few prints or walked their relatives past the 'hallway gallery' in order to show off their image making exploits. Instead the age of digital has opened a whole new range of distribution opportunities for the switched-on photographer. In fact, there are now so many choices available that keeping track of how best to optimize your photos to suit each presentation type can become a bit of a nightmare.

Thankfully Adobe has brought together a range of sharing options and made the process of image preparation as simple as implementing a few basic steps. These options are listed in the Share Task Pane that is available in the Organizer workspaces of both the Macintosh and Windows versions of the program.

In Photoshop Elements there is a default set of options available to all users and then there are a couple of extra share features if you have Premiere Elements installed as well. New for this release is a dedicated export function for Adobe Revel and Vimeo as well as Photoshop Showcase. Let's look at them each in turn here, and for more detail about web-based sharing projects, go to chapter 19.

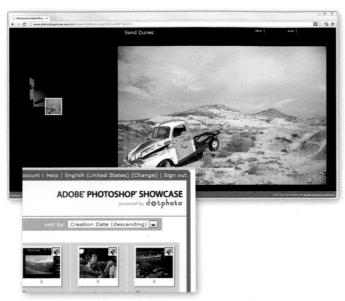

Online Album

Using the Photoshop Elements Online Album feature is one of the fastest ways I know of creating a professional-looking website that features your own photos. Albums are built with the aid of a special design template into which Elements places any images that you have selected at the start of the project. A good variety of templates are included in Elements and the final results can be distributed via CD/DVD, saved to a hard drive or uploaded to Photoshopshowcase.com.

Start by selecting the pictures you want to include in the site from those thumbnails displayed in the Organizer workspace. Hold down the Ctrl/Cmd key to multi-select individual files and the Shift key to select all the files in a list. Alternatively, you can also drag a selection marquee around thumbnails in the Photo Browser.

Choose the Create a new Album option to add the selected images to and then make a selection for how you want to share the album (Photoshopshowcase.com, CD/DVD, Hard Drive). Click Next to move to the following pane.

Next, add a title in the Album Name section of the pane.

Add or remove photos from the list of those to be included in the album by clicking the '+' button to add more images or the '-' button to remove ones already listed. Adjust the position of the images in the presentation sequence by click-dragging the thumbnail within the group. Click the Sharing tab to move to the next step.

Select a template from the thumbnails across the top of the screen. If you want to alter the look of your online gallery at anytime then double-click an alternative design thumbnail from those listed horizontally above the preview space.

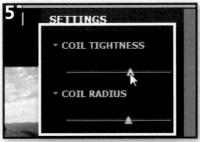

If the template can be customized, a floating palette containing a summary of any changeable settings and details will be displayed on the left of the workspace. Its display can be toggled on and off using the button on the right hand end of the Templates menu bar.

There is no formal Save step in the wizard as clicking the Done button in the final pane automatically adds the new Album to list in the Organizer workspace as well as publishing it online.

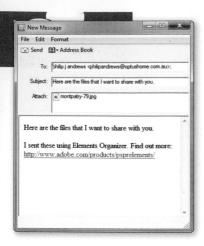

E-mail Attachments

Both the Windows and Macintosh versions of Photoshop Elements contain the E-mail Attachments option in the Share panel in the Organizer workspace. The feature takes much of the guess work out of optimizing your photos for speedy email transmission. There is nothing worse than accidentally sending an email with a series of high resolution (big files) photos to your friends or relatives. On the one hand it will take ages to process the email and then when it gets to the other end the recipient won't thank you for clogging up their Inbox.

Use this feature to avoid these hassles by always ensuring that the pictures you email are designed for the job.

You can select to use a photo that is currently open in the Editor workspace or multi-select images from inside the Organizer workspace. Select the E-mail Attachments option in the Share task pane to start the feature.

Add or delete photos from the thumbnail list of those to include with the buttons at the top right of the dialog. Adjust size and compression of the photos and click Next.

Choose an existing recipient from the contacts list or add a new contact; add in a message and click Next to open your email program and create the new message.

Share Video with YouTube

There has been a YouTube sharing option in previous releases of Photoshop Elements for those users who also have Premiere Elements installed, but in this version the option gets its own entry. Now video files that are being managed in the Organizer space can be selected and uploaded directly to your YouTube account

Start by choosing the video you want to upload from those displayed in the Organizer workspace and then select the Share Video with YouTube option in the Share task pane to start the feature.

Next, you will need to supply your YouTube login details. If you don't have these then sign up for a YouTube account first and restart the sharing process. With the details entered click the Authorize button.

In the next screen you will see a thumbnail for the selected video and a form for you to enter details about the video. As well as adding in the title, description and category information, be sure to choose if the video is to be Public or Private. Click the Upload button to complete the process.

Photo Mail (Win)

Whereas the E-mail Attachments feature is designed for sending photos to recipients whose mail reader only handles text messages, the Windows-only Photo Mail entry in the Share panel creates a HTML-based email. The different format provides the opportunity to create a message more designed to showcase your photos.

You can select to use a photo that is currently open in the Editor workspace or multi-select images from inside the Organizer workspace. Select the E-mail Attachments option in the Share task pane to start the feature.

Add or delete photos from the thumbnail list of those to include with the buttons at the top right of the dialog. Adjust size and compression of the photos and click Next.

Choose an existing recipient from the contacts list or add a new contact; add in a message and click Next to open your email program and create the new message.

In the new dialog that is displayed, select the stationery (frames and background) style for the Photo Mail. Click the Next Step button.

Customize the look of the stationery by adjusting the background color, layout, photo size, font, borders and the inclusion of drop shadows.

Click Next to open your email program and create the new Photo Mail message.

Burn Video DVD/ BluRay

The extra space afforded by DVD and BluRay disks when compared to the humble CD makes these media the best choice when storing large numbers of photos or video files. Photoshop Elements passes the tricky task of burning these formats to its sister program Premiere Elements. It has all the disk writing tools you need to complete the task. Clicking the Burn Video DVD/BluRay option in the Share panel transfers your files to Premiere Elements to finish the process.

Start by selecting the videos to be burnt to disk in the Organizer workspace. To only display video files in the Organizer select just this media type from those listed in the View > Media Types menu. Next pick the Burn Video DVD/BluRay from the Share panel.

Choose from the other settings in the next screen. In the Quality area choose between allowing Elements to pick the best quality for the disk space available (Fit Contents To Available Space) and manually setting the bit rate with the slider control.

Premiere Elements now opens with the selected video files added to the timeline and the Publish + Share menu displayed on the right of the workspace. Select the output option (e.g. Disk) from those listed in the panel.

Clicking the Burn button at the bottom of the panel will start the writing process. This can take some time depending on the number of videos and their length. A confirmation message is displayed in the panel when completed and the disk drive door opens.

Online Video Sharing

Photoshop Elements also borrows features from its sister program
Premiere Elements when it comes to sharing videos online. With the Organizer workspace now common to both Elements programs many photographers are managing their video and still files together in the workspace. It makes sense then to have an online sharing option dedicated to the moving image available in Organizer's Share pane.

Select the video files within the Organizer workspace and then click the Online Video Sharing option located in the Share panel. The file(s) will be transferred to the Premiere Elements workspace where a new project will be created. Add the project details and click Okay to proceed.

Add in the necessary naming and description details required by the sharing service and click Next.

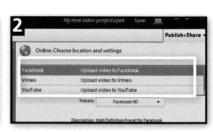

The Online section of the Publish + Share menu is then displayed in the Premiere Elements workspace. Choose the sharing site that you want to use (Facebook, Vimeo, You-Tube) and then pick a preset option from the drop-down menu. The presets provide a great way to ensure the video is optimized properly for the sharing service. Click Next to continue.

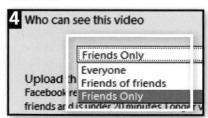

Determine the sharing characteristics between private and public. Click Share to start the optimization and upload process.

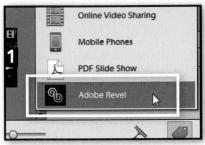

After selecting your files in the Organizer space, choose the Adobe Revel option from the Share menu.

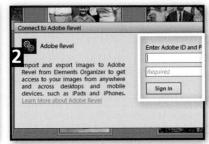

Add your login details and password to the screen that is displayed. If you are not yet registered for Adobe Revel then you can sign up for the free 30 day account to try the system.

After logging in Elements will display a new screen. Here you can review thumbnails of the images to be added to your Revel account. Click the upload button to start the transfer process.

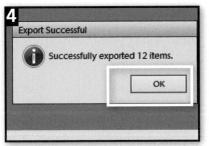

Once the transfer is complete your will see a small dialog noting the number of files that have been successfully uploaded. These files can be view immediately in your Revel application on your phone or tablet. In fact you can watch them as they progressively sync onto your devices.

Adobe Revel

The new way to view your favourite photos on a variety of devices including Macintosh desktop, iPad tablets and iPhones is to use Adobe's own syncing software - Revel. Photoshop Elements 11 now includes a simple way to add your best photos to your Revel collection directly from the Organizer workspace.

Phone Photos

It seems as though it was only yesterday that the mainstay of professional photo presentations was the ubiquitous black folio case. Pitching for work from clients, or agencies, involved dragging the stuffed A3 (20×16 inches in old money) case to the interview and then proceeding to spread the large prints over the biggest surface that was available. Now there is a distinct digital feel to most pitches. Either the photographer's

work is viewed on the net in a web gallery format or, in the case of a face-to-face meeting, the images are often presented with the aid of a mobile storage device. With the increasing quality and size of mobile phone screens it is not an unusual event to see photographers sharing their latest image successes via these devices.

One of the tricky tasks associated with porting your images to a Smart Phone is ensuring that the images are delivered in a file type, size and compression that suits the playback device. Selecting the Mobile Phones and Players option from the Share Task Pane fast-tracks the process by taking advantage of one of the many already-tested output presets available in Premiere Elements.

By selecting the photos or videos first in the Organizer the images are transferred into Premiere Elements and added to a new project entry. When this file opens in Premiere Elements, the pictures/videos are automatically laid out. To output proceed to the Publish + Share Pane.

There are a range of phone models and makes that you can select from. Here we select the iPod and iPhone - High Quality option. Click the Save button to create the optimized video file. The next step is to transfer the files to the portable device. In the case of the iPhone or iPod this process is handled via the Apple iTunes software.

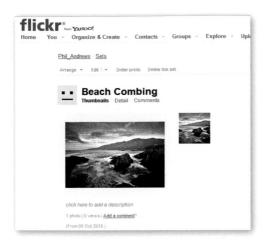

Share to Flickr

The Share To Fickr option in the Share panel of Photoshop Elements provides a very simple way for Elements users to add the photos they manage in the Organizer to their Flickr site.

Obviously to take advantage of this feature you must already have a Flickr account. A new account can be created for free by visiting www.Flickr.com and clicking the Sign Up option in the site's menu bar.

Before you start make sure that you have a current Flickr account and that you have the login name and password handy. Next select a single image from the Organizer workspace and choose the Share To Flickr entry from the Share Task panel.

A new dialog will be displayed asking if you want to commence the linking process. Click the Authorize button to continue. Next a new web browser window will open displaying a Flickr login screen. Add your login name or ID and your password before clicking the Sign In button.

The next screen will summarize the types of activities that Photoshop Elements will be able to undertake within your Flickr account. Click the OK, I'll Authorize It button to establish the link. Now switch back to the Organizer workspace and you will notice that the open dialog is now displaying a message that the linking process is almost finished. Click the Complete button to finalize the process.

With the link to Flickr now authorized, uploading your photos to your account is a very simple matter. Start by selecting your photos from the Organizer workspace. Now click the Share To Flickr option in the Share panel.

The image or images you selected will then be listed as thumbnails on the left of a new dialog which appears. You can add to or remove images from the list using the + and - buttons. Choose who can view the photos from the options on the right of the dialog.

Add Tags or search words to help viewers find your work. Separate individual tag words with a space and group multiple words as a single tag by encasing them in double quotes. Click Upload to optimize and then transfer your selected image(s) to your Flickr Photostream.

Share to Facebook

Facebook has fast become the primary way that many people keep in contact with friends and relatives. One key aspect of this communication is the sharing of photos. Photoshop Elements provides a simple way to add the pictures you work with in the program to your Facebook page with the Share To Facebook feature. Once the connection between Elements and Facebook has been authorized, photos can be sent to your page with a few simple clicks.

The share to Facebook process has been revamped in Photoshop Elements 11 to allow easier and quicker uploading to your account.

After selecting an image in the Organizer workspace, click onto the Share To Facebook option in the create panel. If you haven't already authorized a connection between Elements and your Facebook account you will need to do this first.

Now your selected photos will be prepared and then displayed in the Share To Facebook dialog where you choose the destination of the photos (existing album or newly-created one) and who will be able to see the photos (Friends, Friends of Friends or Everybody).

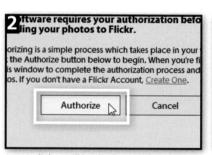

A new dialog will be displayed informing you that authorization is needed to continue. Click the Authorize button to start the process. From version 10, the authorization process will remain active for 24 hours after you first sign in, making it easier to upload several images in a session.

With the settings selected, clicking the Upload button will transfer the photos to your account at the Facebook site. A confirmation dialog will be displayed in Elements along with a button to take you directly to your Facebook page.

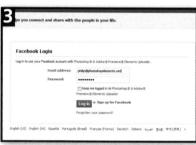

Next, the login page for Facebook will appear in your default browser. Type in your email address and password and Click the Log In button. Follow the authorization steps before returning to Elements to complete the process.

Send to SmugMug Gallery

SmugMug.com is a resource site that photographers can use to store, display and sell their photos. There are different levels of paid service with Photoshop Elements users getting a discount on their first year. The Send to SmugMug Gallery share option provides an easy way to transfer the images which are ready for display and sale to your SmugMug account.

Start by selecting an image or images from the Organizer workspace. Now pick the Send to SmugMug Gallery option from the Share pane.

A dedicated SmugMug dialog will then be displayed. First time users will have the option to click the Try It button to sign up for a free trial. Returning members can sign into their account.

If you already have a gallery created in your SmugMug account you will be offered the chance to upload the selected image(s) to this gallery. If you don't have a current gallery or if you want to upload the photos to a different gallery then you can create a new entry. Click the Create Gallery button after adding in the details.

The file or files with then be transferred to SmugMug. When the process is finished you will see a confirmation screen that includes a button to take you straight to the gallery.

One of the real strengths of the SmugMug system is the way that you generate an income from your photos by selling them as prints or downloads or even as the feature photo in different types of merchandising products.

PDF Slide Show

Elements can produce simple presentations of your images in the PDF (Adobe Acrobat) format that are suitable for emailing or passing to a client on a CD or DVD disk.

NOTE: Windows users can produce PDF slide shows in two different ways: one from within the Slide Show editor and one via the options in the Share task pane.

Multi-select your images in the Organizer and then choose the PDF Slide Show entry from the Share menu pane. This option creates the presentation and then automatically adds it to an email message.

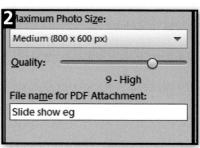

Adjust the sequence of pictures, the photo size and quality and input the name for the presentation then click the Next button.

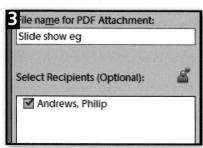

Add in Recipient details and a message before clicking Next to build the show and create a new email message.

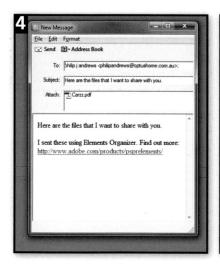

The final PDF presentation file will be created and added to a new email message that, in turn, will be displayed in your default email software. All you need to do then is click the Send button to mail the message.

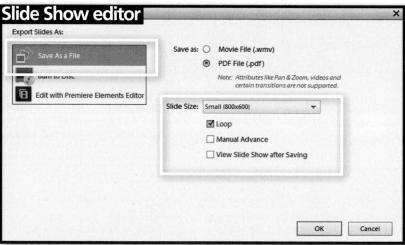

WINDOWS ONLY: Alternatively, after creating your presentation in the Slide Show editor, save the production and then select File > Output Slide Show. Choose the Save as a File option and then the PDF File entry to set the dialog for Adobe Acrobat output. Next select the slide size from the drop-down menu and choose Loop, Manual Advance and View Slide Show after Saving options as appropriate.

Sending videos to Photoshopshowcase.com

As well as being able to send your favourite photos to Photoshopshowcase.com you can upload videos and movies directly to the site as well. Of course you will need an account to do this but the same login and password can be used to send pictures and videos to the site.

As part of the upload process you can invite people from your address book to view your latest creation with a special email containing a direct link to the video.

Start by selecting the videos within the Organizer that you want to send to the sharing site - Photoshopshowcase.com. Then select the Video to Photoshop Showcase option from the Share menu.

The login screen for Photoshopshowcase. com will be displayed. If you don't yet have a free account then sign up for one, otherwise sign in with your email address and password.

Add a name for the gallery in the next screen and check both your details (in the summary area) and the video you are about to upload (in the thumbnail area). Click Next to Continue.

Select the people you want to share your video with from the list in the Address Book section of the next screen. You can also add new contacts here. Then add a subject and message for the email invitation to view the video. Click Next to start the upload process.

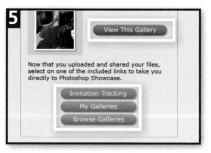

After the upload is complete you will see a Finish dialog listing those people you sent a sharing invitation email to, as well as quick link buttons to this new gallery and your other galleries.

Vimeo

Like YouTube, Vimeo provides users the chance to show off their video files online. You can choose to have the clips available for everyone to see or restrict the viewing to only those you nominate.

Start by selecting the video file(s) you want to upload from all of your assets in the Organizer workspace. Remember the you can use the options in the View > Media Types menu to filter the files being displayed. For instance, selecting Video from this menu and nothing else will only show thumbnails of the video files in your catalog.

Like all sharing sites you will need to have an account with Vimeo in order to upload your files. You can create an account on the Vimeo.com website or from the Authorize screen in Photoshop Elements. Once this is done then click Authorize to allow Elements and Vimeo to talk with each other.

In the next screen that is displayed you can add in a title and description and check the video being uploaded. There is also a drop down menu with options for the privacy settings for the video. Finally, choose if you want others to be able to download the video from the site and then press the Upload button.

After the upload process is completed, a new screen shows that your video file is being processed by Vimeo. After a few minutes the video will be available on the site.

Raw Shooting

Photoshop Elements has always been a software program that could produce professional results that go way beyond what you would expect, given its modest price. So it should come as no surprise when we come across tools and features that are very similar to, and in some cases exactly the same as, those found in Photoshop. It is these very features, when coupled with a professional approach to their use, that will get you producing high quality digital photographs just like the pros (but at a fraction of the price!).

Elements 11 carries on this tradition by including plenty of great 'high-end' tools for us to play with. One of the most dramatic of these is the built-in Raw conversion utility (yes, just like Photoshop). This feature might not mean much to you now, but this chapter will introduce how switching to the Raw file format when shooting can provide you with the highest detail photos ever. We'll also look at how the Raw editing utility in Elements helps ensure that you produce the absolute best quality pictures possible.

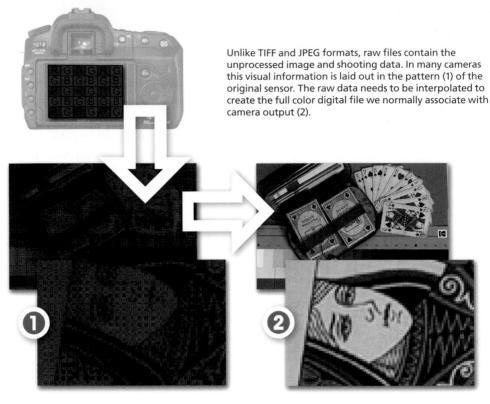

RAW SWITCHING

Most cameras set Jpeg as the default file format for capture. To shoot in Raw you will need to change this setting. This can usually be achieved by altering the settings in the Setup menu on the back of the camera.

Better digital capture

More and more medium- to high-end cameras are being released with the added feature of being able to capture and save your pictures in the raw format. Selecting Raw, instead of the usual JPEG, stops the camera from processing the color information from the sensor and reducing the image's bit depth, and saves the picture in this unprocessed file type. This means that the full description of what the camera 'saw' is saved in the image file and is available to you for use in the production of quality pictures. Many photographers call this type of file a 'digital negative' as it has a broader dynamic range, extra colors and the ability to correct slightly inaccurate exposures.

Sounds great, doesn't it? All the quality of an information-rich image file to play with, but what is the catch? Well, raw files have to be processed before they can be used in Photoshop Elements. When you are applying automatic changes using the options in the Instant Fix pane of the Organizer space, this conversion happens automatically. All you need to do is select the conversion format from the pop-up dialog and Elements does the rest.

But to access the full power of these digital negatives you will need to employ a special dedicated Raw editor. Photoshop Elements includes just such an editor. Called Adobe Camera Raw (ACR), this feature is designed specifically to allow you to take the unprocessed raw data directly from your camera and convert it into a usable image file format. The Elements Raw editor also provides access to several image characteristics that would otherwise be

locked into the file format. Variables such as color depth, White Balance mode, image sharpness and tonal compensation (contrast and brightness) can all be accessed, edited and enhanced as part of the conversion process. Performing this type of editing on the raw data provides a better and higher quality result than attempting these changes after the file has been processed and saved in a non-raw format such as TIFF or JPEG.

The raw file is composed of three separate sections: Camera Data, Image Data and the Image itself. By keeping these components separate it is possible to edit variables like white balance and color depth, which are usually a fixed part of the file format, in the Raw file editor.

So what is in a raw file?

To help consolidate these ideas in your mind try thinking of a raw file as having three distinct parts:

Camera Data, usually called the EXIF or metadata, including things such as camera model, shutter speed and aperture details, most of which cannot be changed.

Image Data that, although recorded by the camera, can be changed in the Elements Raw editor and the settings chosen here directly affect how the picture will be processed. Changeable options include color depth, white balance, saturation, distribution of image tones and application of sharpness.

The Image itself. This is the data drawn directly from the sensor in your camera in a non-interpolated form. For most raw-enabled cameras, this data is supplied with a 16 bits per channel color depth, providing substantially more colors and tones to play with when editing and enhancing than found in a standard 8 bits per channel camera file.

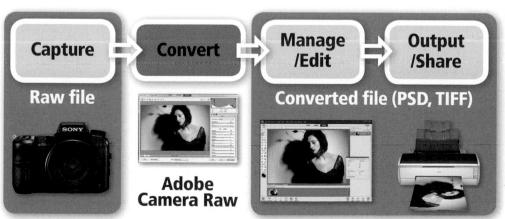

Photoshop Elements employs a Convert then Edit approach to working with raw files. The photo needs to be converted before it can be worked on in the Editor. The conversion can occur automatically in the background or via the Adobe Camera Raw utility. It is this second approach that provides more control over the final results.

Enabling your Raw camera

With most Raw-enabled cameras, switching from one capture format to another is a simple matter of entering the camera Setup menu and selecting the Raw entry from the Image Quality or File Format options. With some models you can also make this change via a Quality toggle or switch elsewhere on the camera.

Occasionally there is also a choice between

saving compressed and non-compressed versions of the Raw file. Unlike the algorithms used for compressing JPEG files, the method used when compressing Raw files is 'lossless', meaning that all the detail that was captured is retained in the compressed file. Compressing will mean that pictures will take up less space on the memory card, but the process of compression does result in longer saving times. For most shooters this isn't an issue but if you like to photograph sports or action, then the extra time taken to compress the file will reduce the frames per second rate of your camera. In practice most Raw shooters opt for non-compressed files and just buy more memory cards to accommodate the larger file sizes that need to be saved.

There are several cameras on the market that also have the ability to save both Raw and JPEG versions of the same file at the time of capture. This option can be a real time saver if you need to access your pictures quickly, but the feature is less of an advantage if you regularly perform many enhancement steps to your files, as in the end the captured JPEG will not resemble the processed Raw file.

At the big end of town most of the high-resolution camera backs, which are destined for use with medium format camera bodies, only capture in Raw formats. Many make use of dedicated software to control the camera, capture the photo and then process the Raw file. Other manufacturers, such as Hasselblad, Samsung, Ricoh and Leica even use Adobe's DNG format as the capture format, making the transition to Elements a simple one.

CAPTURE FILE SIZE COMPARISONS	JPEG file size (Fine setting)	JPEG file size (Normal setting)	JPEG file size (Basic setting)	TIFF file size	Raw file size	Raw file size (compressed)
Example file 1	2997 Kb	1555 Kb	782 Kb	17708 Kb	9777 Kb	5093 Kb
Example file 2	2466 Kb	1575 Kb	748 Kb	17712 Kb	9776 Kb	4275 Kb

Capture format versus file size: The capture format you select directly affects not only the way the file is saved and its visual quality but also the size of the final file. JPEG produces the smallest files but uses a 'lossy' compression system to do so. In the JPEG format you can adjust the level of compression used when saving the photo. In this table the Fine setting uses the least compression and the Basic option the most. Both TIFF and Raw formats preserve all the image detail and any compression used with these formats is 'lossless'.

Modifying your capture workflow for Raw

Switching capture formats to Raw impacts directly on the role that controls such as saturation, sharpness, white balance and contrast play in your digital capture. These factors are not fixed in Raw files and are only applied at the time of conversion or after the image exits the Adobe Camera Raw utility and is opened in the Editor workspace. So rather than these factors being applied in-camera, as is the case with JPEG and TIFF capture, they are applied via the ACR utility. In fact, any of the adjustments you make to these settings on the camera can be reversed or tweaked in ACR.

So if these factors are controllable at conversion then should the Raw shooting photographer bother with them at time of capture? This is a good question to which you will receive many answers. Unfortunately many shooters believe that capturing in Raw is a 'fix all' for poor camera technique. Haven't selected the right white balance? No problem, fix it in Raw. Haven't judged the light quite right? Again, not a big deal just fix it in Raw. Nor adjusted your lighting for good contrast? Again, not an issue, there is contrast control in Raw. But to my mind, although many factors can be altered in Raw, this approach has four main drawbacks:

- Correctly captured pictures need less correction when converting, saving valuable time.
- The white balance settings determined at time of capture provide a good starting point for further fine-tuning during the conversion process.
- If a Raw + JPEG capture mode is being used then the color in the accompanying JPEG photo will better match the processed Raw file as it was more accurate at the time of capture.
- Correct exposure provides better quality edited images as ideally no shadow or highlight details are clipped when the picture is taken.

Raw capture implications on workflow

So what changes to standard capture workflow should the Raw shooter make? Let's examine the impact of Raw capture on some of the standard camera controls.

Resolution – The largest photo possible (one sensor site to one pixel) is generally recorded in the Raw file.

Color Depth – Raw photographers automatically get access to the full bit depth the sensor is capable of. At time of conversion in ACR you can select the bit depth of the converted file.

Saturation – As the vibrance or saturation of the converted image can be controlled on a picture-by-picture basis in ACR it is a good idea to leave this camera setting on the default or normal value.

White Balance – Despite the fact that white balance can be losslessly adjusted in ACR, it is good practice to match white balance settings with the dominant light source in your scene. This helps to maintain the photographer's own capture skill as well as ensuring speedier color cast removal in ACR, as the camera settings are loaded as default.

Contrast – Raw shooters have the luxury of being able to make contrast adjustments much more accurately and on an image-by-image basis back at the desktop.

Sharpening – Professionals now employ a workflow that applies sharpening at three different times during the enhancement process – at time of capture, during enhancement and then when preparing for output. For Raw shooters adopting this approach means adding a little global sharpening incamera or at the time of conversion.

Noise Reduction – Reducing noise on the desktop, either during Raw conversion or afterwards inside Photoshop Elements, provides better control over the process and therefore better results than the auto approach adopted by in-camera systems. **ISO** – Shooting in Raw doesn't directly affect the selection of ISO setting used for capture. These settings will be based on the available light in the scene or the shutter speed required to freeze or blur motion.

Camera Exposure - Shooting in Raw doesn't change the fact that exposure is key to the creation of high quality images. It is true that the slider controls in ACR provide a great deal of flexibility when it comes to processing the tones in a photo and that this means that slight problems with exposure (under- or overexposure) can be corrected more easily than with other capture formats. What is important to remember, however, is that this doesn't provide photographers with a license for poor exposure control. The best conversions are made with images that are well exposed.

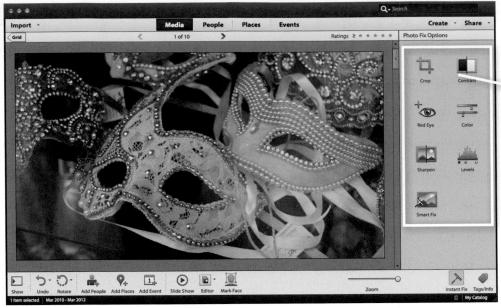

PRO'S TIP

When choosing which file format to use for the converted file, stick to PSD, or the Photoshop format. This file type conserves the most image information and at the same time ensures that all the advanced features such as adjustment layers can be used with your photo. You can always save a copy of the photograph as a JPEG later.

Auto Raw Conversions

One of the real strengths of Elements is that it provides a variety of levels of sophistication for many of its functions. This allows the new user to start with automatic editing features and then move onto more manual versions as their skill and understanding grows. This is true in the area of Raw conversion as well.

If you are new to Elements, but have been capturing your images in the Raw format, then you can convert your files automatically by selecting one of the adjustments in the Fix pane of the Organizer workspace. To apply the changes to your image, Elements has to first convert the photo from Raw to a standard file format. You get to pick between JPEG, PNG, TIFF or PSD formats. Both JPEG and PNG file types are generally used for images that are destined for the web, whereas TIFF and PSD are designed for editing, for producing high quality prints and for archiving. After selecting the file type the auto edit change is applied to the converted photo and the image is saved in a Version Set with the original raw file.

The auto conversion downsides

The downside of working this way, is that you need to apply an enhancement to access this auto convert option. If you are shooting Raw then you are probably interested in making the best images that you can. This in turn probably means that you are wanting to oversee any enhancement steps applied to the image. The options in the Fix pane don't allow this level of control. This is true of the Raw conversion process itself. As we'll see over the next few pages there is much to be gained in spending the time and effort to manually set the controls used for converting your raw files. It is these controls that provide much of the real power of shooting with raw in the first place.

When enhancing your Raw files with Fix panel options in the Organizer workspace the file conversion process is handled automatically for you. Here Auto Smart Fix is applied to a Sony Raw file (.ARW). The user is then asked to choose which conversion format to work with (1) and then the enhanced and converted picture is saved as a new file (2) in a Version Set with the original Raw photo (3). Selecting the 'Always use this format...' option (4) will instruct Elements to convert all files to this format and will remove the Select Output Format dialog from the process.

Step-by-step

Start by selecting a Raw file in the Organizer workspace. Next, click the Instant Fix button located on the bottom right of the screen. You will now see a range of enhancement entries. For more details on these options go to Chapter 4. Here I selected the Smart Fix entry.

Elements will now display a Fixing photo window complete with a progress bar indicating how much of the conversion and auto enhancement tasks have been completed. If you applied the Fix option to more than one photo in the Organizer then this window will also display a tally of the completed images.

Next, Elements will display a new window – Select Output Format for Edited file. Here you can choose the file type that will be used to save the converted Raw file. In this example I have chosen the Photoshop File as it offers the best balance between image quality and enhancement features. Click OK to continue.

Depending on the size and resolution and number of the Raw files that you are working with, the fixing process can take a little while. Once completed the converted, and now enhanced, file is saved with the original Raw file in an Elements' Version Set. For more details about using Version Sets go to Chapter 3.

VERSION SETS

This feature stores the edited version of pictures together with the original photo in a special photo stack called a Version Set.

All photos enhanced in the Organizer space are automatically included in a Version Set. Those images saved in the Quick Edit and Full Edit spaces with the Save As command can also be added to a Version Set by making sure that the Save with Original option is ticked.

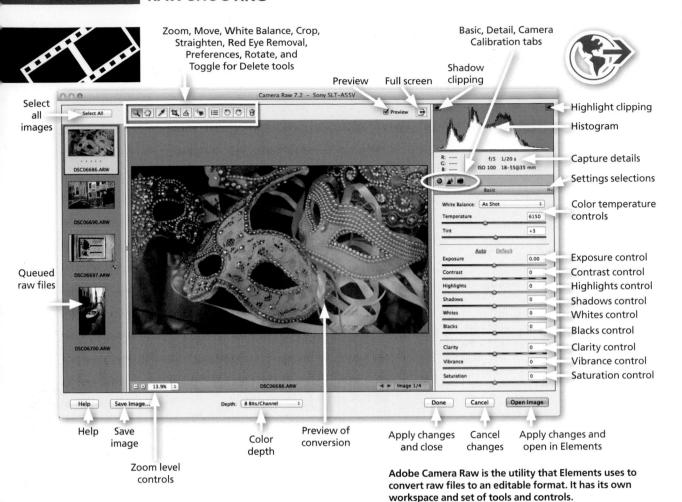

MAC = WINDOWS

The Adobe Camera Raw utility looks and works the same on both platforms.

The Adobe Camera Raw utility

When you open a raw file into the Editor workspace of Elements you are presented with the Adobe Camera Raw editing dialog (above). This window contains a full color preview together with a variety of menu options, dialogs and image tools that you can use to interactively adjust image data factors such as exposure, contrast and color saturation. Many of these changes can be made with familiar slider-controlled editing tools normally found in features like Levels and the Shadows/Highlights control. The results of your editing can be reviewed immediately via the live preview image and the associated histogram graph.

After these general image-editing steps have taken place you can apply some enhancement changes such as filtering for red-eye removal, straightening, cropping, sharpness, removing color noise and applying some smoothing. The final phase of the process involves selecting the color depth and image orientation. Clicking the Open Image button sets the conversion utility into action applying your changes to the raw file, whilst at the same time interpolating the Bayer data to create a full color image, and then opening the enhanced and converted file into the full Elements workspace.

Key tools in the Adobe Camera Raw utility

Zoom tool (Z): The Zoom tool is used to enlarge or reduce the magnification of the image. Click on the preview to zoom in, Alt/Opt click to zoom out and click-drag to zoom to an area.

Hand Tool (H): This tool is used to click-drag the preview image around when it is zoomed in. You can switch to the Hand tool when using another tool by pressing the Space bar.

White Balance Tool (I): Used to neutralize color casts. Click onto an area in the preview that is meant to be neutral (light, mid or dark gray) to balance the photo's colors.

Straighten Tool (A): Use this tool to

straighten horizons or verticals. Click-

drag a line along the edge to

straighten. Press the Esc to remove

the effect and another tool to apply.

Crop Tool (C): The ACR Crop tool works in the same way as it does in Elements. It is used to reshape the format of the photo by removing unwanted sections.

Red Eye Removal (E): Click-drag the marquee around an eye to remove the redness from the pupil. Use the sliders to refine the effect. Alt/Opt click on the entry to delete it.

Crop Tool Menu: By holding down the Crop Tool

button you will display a

list of crop format options.

These can be used to crop

the image to a set ratio.

There is also a Custom option so that you can add

> 6% 12%

25%

33%

50% 66%

100%

200% 300%

400%

Preferences Dialog (Ctrl/Cmd K): This button displays the Camera Raw preferences dialog. More details on these settings can be found later in this chapter.

Rotate 90° Counter Clockwise (L): This button rotates the preview image by 90° in a counter clockwise direction (to the left).

Rotate 90° Clockwise (R): This button rotates the preview image by 90° in a clockwise direction (to the right).

Toggle Full Screen (F): Click this

displaying ACR in full screen or

button to toggle between

windows modes.

Mark for Deletion: Use this icon to mark the current image, or those multi-selected in the queue, for moving to the Trash. To remove this deletion mark click the button again.

Shadow Clipping Warning (U): Use this feature to display shadow pixels that are being clipped or converted to pure black. See the Histogram section later in the chapter.

Highlight Clipping Warning (O): Use this feature to display highlight pixels that are being clipped or converted to pure white. See the Histogram section later in the chapter.

ACR Crop applied: This icon will be

displayed on the thumbnails of raw

images in the ACR queue when they

have been cropped in the utility.

be displayed on the thumbnails of raw images in the ACR queue when adjustment settings have been applied to the picture.

Basic pane: Click on this tab icon to display the slider controls in the Basic pane.

Detail pane: Click on this tab icon to display the slider controls in the Detail pane.

Camera Calibration pane: Click on this tab icon to display the Camera Profile drop-down menu in the Camera Calibration pane.

Zoom Level buttons: Click the plus button to magnify by one zoom level. Click the minus button to zoom out by one level. This is the same as Ctrl/ Cmd + and Ctrl/Cmd - keystrokes.

Preview setting: Be sure to have this setting checked so that the preview image updates after each adjustment change.

Fit	in View	9
6.3%	-	
Zoom Le	vel Mer	nu: On the
right of	the Zo	om Level
buttons	is a do	wnwards-
facing a	rrow th	at, when
clicked, w	vill displ	ay a menu
of zoom	level er	ntries.

ACR conversion settings: This button displays a list of conversion options including the ability to Clear, Save, Reset or use Previous conversion settings for a particular image.

to navigate between the photos.

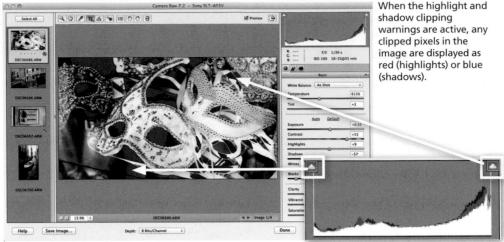

The Preview displays the raw image and updates it after you make any enhancement changes.

The preview space

The preview displays the changes you make to your image via the develop or enhancement settings in the Basic and Detail panes. Any adjustment of these controls are reflected immediately in the preview image, providing a visual reference to the effectiveness of the alterations. The preview can be enlarged or reduced in size to suit the screen area available. When making some changes, such as Sharpening or Noise Reduction, the preview should be magnified to at least 100%. At zoom settings lower than 100%, you will not be able to preview the results of the adjustments of these controls.

There are three ways for you to change the magnification level of the preview to 100%:

- 1. Double-click the Zoom tool,
- 2. Select the 100% entry from the zoom menu at the bottom left of the dialog, or
- 3. Use the Ctrl/Cmd + to magnify or Ctrl/Cmd to reduce the size of the preview to the zoom value in the window at the bottom left of the dialog.

The preview image also plays another significant role when used in conjunction with the Clipping Warnings in the Histogram. When these features are turned on, any highlight or shadow pixels which are being converted to pure black or white are highlighted in the preview. Clipped shadow detail is shown as blue and clipped highlights as red. For this reason, it is good idea to always leave the clipping warnings active when making color or tonal changes to your image.

Histogram

A full color histogram is located on the right of the workspace. The feature graphs the distribution of the pixels within your photo. The graph updates after changes are made to the color, contrast and brightness of the picture. By paying close attention to the shape of the graph you can pre-empt many image problems. The aim with most enhancement activities is to obtain a good spread of pixels from shadow through midtones to highlights without clipping (converting delicate details to pure black or white) either end of the tonal range.

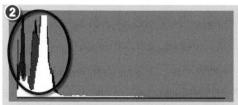

Image tones and histogram shapes:

The histogram in ACR shows the distribution of pixels across the image. Areas with the most pixels are the tallest areas of the graph. The shape of the histogram indicates the look of the picture.

- 1. An overexposed image has a histogram with the pixels bunched to the right end of the graph.
- Conversely, underexposed photos have pixels pushed to the left.
- 3. Flat or low-contrast pictures typically have all their pixels grouped in the middle.
- High-contrast photos or those that have 'clipped' highlights and shadow areas usually have many pixels at the extreme ends of the graph.
- 5. For the best results, with most images, you should always aim to spread the pixels between the maximum black and white points without clipping any of the image pixels.

 This is not the case for all photos. Take, for instance, the case of a black cat in a darkened room. The correct histogram for this photo will show a bunching of the pixels towards the left side of central. Whereas a shot of the ski slopes, however, also correctly exposed, will display most pixels to the right of the histogram graph.

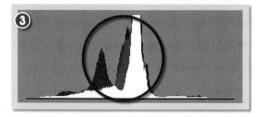

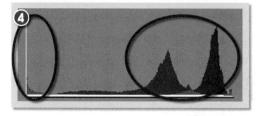

Active Not-Active

To activate the highlight and shadow clipping warnings you click onto the upward-facing arrows in the top left or right corners of the histogram. The feature is active when the box surround is white. The warning is off when the box is outlined in dark gray.

RGB readout and camera settings summary

There is a two-part information panel beneath the histogram. The left hand side contains a RGB (Red, Green, Blue) R: 165 G: 175 B: 184 ISO 400 70 mm

readout for the pixels beneath the mouse cursor. An 8 bits per channel scale with values between 0 (black) and 255 (white) is displayed (1).

On the right hand side is a summary of the camera settings used to capture the image. The values displayed include aperture (f-stop), shutter speed, ISO and focal length (2).

HISTOGRAMS

Histograms display a graph of all the pixels in your image. The lefthand side represents the black values, the right the white end of the spectrum and the center section the midtone values.

In a 24-bit image (8 bits per channel) there are a total of 256 levels of tone possible from black to white - each of these values is represented on the graph. The number of pixels in the image with a particular brightness or tonal value is displayed on the graph by height. The higher the spike at any point the more pixels of this value are present in the picture.

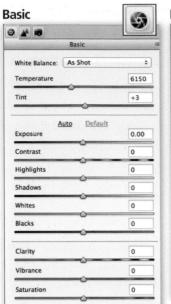

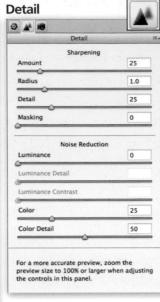

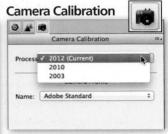

The main adjustment controls are located on the right side of the Adobe Camera Raw workspace. They are split into three groups that are accessible by clicking the icon tab at the top of the pane.

Basic contains controls for adjusting color and tone in the image.

Detail houses sliders for sharpness and noise enhancement.

Camera Calibration allows the selection of Camera Profiles.

Key Adobe Camera Raw Controls

Color and Tonal adjustments via the Basic tab

Below the histogram is a tab area containing three options – Basic, Detail and Camera Calibration. The Basic tab contains all the tone and color controls that you can use to enhance the raw file, sharpening and noise reduction features are grouped under the Detail tab and camera profile selections are listed under the Camera Calibration heading. We will look at each tab in turn, concentrating first on the controls under the Basic tab.

PRO'S TIP

As ACR recognizes the raw file created by different cameras, the new Camera Raw Default will be applied to only those photos captured with the specific camera that the settings have been saved for.

ACR Conversion Settings menu

The Settings drop-down menu is displayed by clicking the Settings button on the right side of the Tabs. The menu contains the Image Settings, Camera Raw Defaults, Previous Conversion, Custom, Clear Imported Settings, Save New Camera Raw Defaults, and Reset Camera Raw Defaults entries. Here are some more details on each entry:

Image Settings: The Image Settings option restores the original settings of the current photo. Use this selection when you want to reverse changes that you have made and wish to restore the photo to its virgin state.

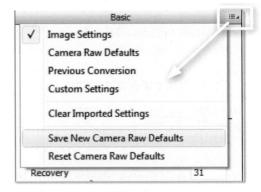

ACR Conversion Settings menu:

The Settings menu contains options for saving or recalling image settings associated with specific cameras.

Camera Raw Defaults: This option applies a group of slider settings that are default values associated with a specific camera and photograph. When a photo is opened for the first time, the settings and white balance will be altered to Camera Raw Defaults (based on the camera model) and As Shot (based on the camera settings used for the photograph), respectively.

Previous Conversion: Another option in the Settings drop-down menu is Previous Conversion. This setting stores the 'last used' values for all controls and is an efficient way to apply the enhancements used with the previous image to one currently open in the dialog. Using this option will help speed up the conversions of a series of photos taken at the same time under the same lighting conditions. Simply make the adjustments for the first image and then use the Previous Conversion option to apply the same settings to each of the successive photos from the series in turn.

Custom: Moving any of the slider controls such as Temperature or Tint sliders under the White Balance menu automatically changes the settings entry to Custom. Once the settings have been customized for a particular photograph the values can be saved as a new Camera Raw Default entry using the save option in the pop-up menu accessed via the sideways arrow next to the Settings menu.

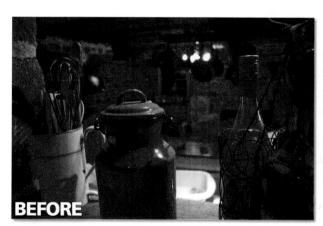

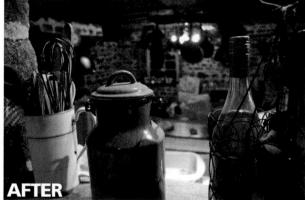

White balance correction

White balance is used to correctly balance the color of the scene to the lighting conditions at the time the shot was taken. Leaving white balance set at As Shot means you elect to keep the white balance values that were used when taking the picture.

As you know, one of the advantages shooting raw is that this setting is not a fixed part of the picture file. Altering the specific white balance setting at the time of raw conversion is a 'lossless' action. This is not the case if you have used an incorrect setting and have shot in JPEG or TIFF. Use either of these two formats and the white balance setting will be fixed in the file and can only be changed with destructive adjustments using features like Color Variations or Remove Color Cast. In this regard raw shooters have much more flexibility.

The overall color of an image is often determined by the color of the light it was photographed under. Here the photo was taken using domestic light bulbs as the only light source. The result is an overly orange photo. The White Balance features in ACR can be used to easily neutralize this color cast.

White Balance - Step-by-step

There are three different ways to remove color casts in Adobe Camera Raw. The method you use will be determined by the type of photo you are correcting, or the method you find easiest. With tricky white balance problems you may have to try a couple of approaches before finding a method that works.

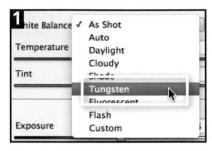

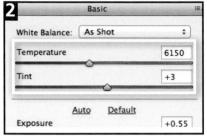

White Balance drop-down menu: If you selected a Daylight setting in-camera and think that Shade or another white balance preset may be closer to the actual lighting conditions you may select one of the options from the list of presets under the White Balance drop-down menu.

In this example the Daylight setting was used to capture the photograph. Simply switching the setting to Tungsten or Auto will remove the majority of the color cast in the picture. Moving either the Temperature or Tint sliders switches the setting to Custom. These controls are used for matching the image color temperature with that of the scene.

Temperature slider: The Temperature slider is a fine-tuning device that allows you to select a precise color temperature in units of degrees Kelvin. When an image is too yellow, meaning it has a lower color temperature than you prefer, move the Temperature slider to the left to make the colors bluer and compensate for the lower color temperature. When an image is too blue, or higher in temperature than you prefer, move the slider to the right to make the image warmer, adding more yellow compensation. So, left is to make image colors cooler and right is to make image colors warmer.

Tint slider: The Tint slider fine-tunes the white balance to compensate for a green or magenta tint.

Moving the Tint slider to the left adds green and to the right adds magenta. This control is often used to neutralize a color cast caused by lighting from fluorescent tube or strip sources.

White Balance tool: The quickest and perhaps easiest way to adjust white balance is to select the White Balance tool and then click in an area that should be neutral gray or even amounts of red, green and blue. For best results, use a dark to midtone area as the reference and be careful not to click on an area with pure white or specular highlights. These will produce unreliable results so keep away from the bright highlight areas of highly reflective or chrome surfaces. One suggestion for working with neutral gray is to:

- 1. Click on the White Balance tool.
- Move the White Balance tool cursor over a midtone area which should be neutral gray (e.g. textured white area) but contains a color cast in the preview.
- Click on the image location to neutralize the cast not just in the selected area but in the whole photo.

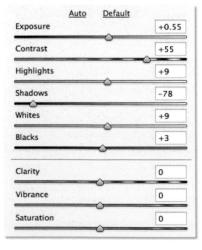

Making tonal and color adjustments

Below the white balance controls are the Exposure, Contrast, Highlights, Shadows, Whites, Blacks, Clarity, Vibrance and Saturation sliders which are also available for making adjustments to raw files. Adobe has positioned these controls in the dialog so that when working from top to bottom you follow a specific enhancement workflow.

For this reason you should make enhancement changes in the following order.

Raw Enhancement Workflow

- 1. Set the overall brightness using the **Exposure** slider.
- 2. Set the overall contrast using the **Contrast** slider.
- 3. Use **Highlights** to alter the brightest tones.
- 4. Brighten shadow areas using the **Shadows** control.
- 5. Set the white clipping point using the **Whites** slider.
- 6. Set the black clipping point using the **Blacks** slider.
- 7. Use the **Clarity** slider to adjust local contrast.
- 8. Boost pastel or desaturated colors with the **Vibrance** slider.
- 9. Adjust the strength of all colors, if needed, using the **Saturation** slider.

Exposure

Concentrating on the midtone or middle values in an image, the Exposure slider adjusts the brightness or darkness of an image using value increments equivalent to f-stops or EV (exposure values) on a camera. An image is underexposed when it is not light enough or too dark and it is overexposed when it is too light. Simply move the slider to the left to darken the image and to the right to lighten (brighten) the image.

What do the f-stop or EV equivalents indicate? An adjustment of -1.50 is just like narrowing the aperture by 1.5 (one and a half) f-stops. Moving the slider 1.33 places to the left will dramatically darken an image and to the right the same amount will result in a bright image. If you have to move more than two full stops in either direction this probably indicates your settings at capture were inaccurate. Making adjustments beyond two stops starts to deteriorate image quality as invariably shadow or highlight detail is lost (clipped) in the process.

When the Shadows and Highlights Clipping Warning features are selected at the top of the Histogram graph, areas of highlight clipping are displayed in the preview as red and shadows as blue.

Holding down the Alt/Opt key whilst moving either the any tonal slider, except Contrast, will convert the preview to black (for Exposure) or white (for Shadows). Any pixels being clipped will then be shown as a contrasting color against these backgrounds.

Highlight and Shadow clipping warnings options: To ensure that you don't accidently convert shadow or highlight detail to pure black or white pixels ACR contains two different types of 'Clipping' warnings.

RAW SHOOTING

If you have used ACR before you will see that altering midtones is a different role for the Exposure slider. In previous versions of the program the Exposure slider set the white clipping points in the image. This task is now handled by the Whites slider.

NOTE: The Brightness slider has been removed from ACR so the next setting is Contrast.

Contrast

Contrast adjusts the spread of the midtones in the image. A move of the Contrast slider to the right spreads the pixels across the histogram, actually increasing the midtone contrast. Conversely movements to the left bunch the pixels in the middle of the graph. It is important to adjust the contrast of midtones after working on exposure, shadows and brightness.

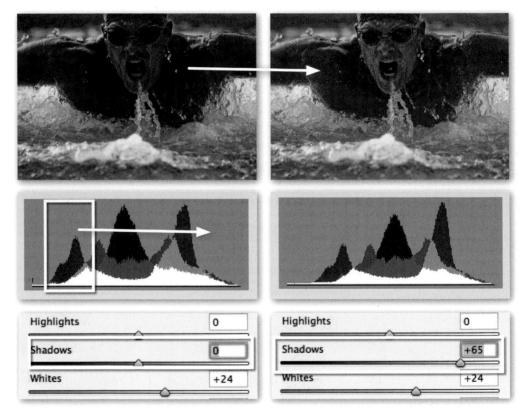

Boosting shadows: The Shadows slider manipulates the mid to dark tones in the photo. Moving the slider to the right pushes these tones towards the highlight end of the histogram, lightening them. Moving in the opposite direction darkens these tones.

Highlights

The Highlights slider works with the lighter tones in the image. The control doesn't alter the white clip point but rather concentrates its efforts on allowing you to darken or lighten the brightest 25% of values in the picture. This equates to the delicate tones in a white dress, the texture in fluffy white clouds and the tiny bubbles in sea spray.

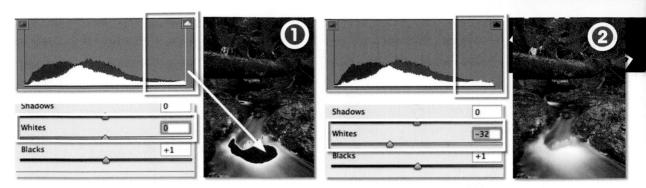

Shadows

Shadows replaces the Fill Light slider of previous versions and is used to lighten the darker tones in a picture without affecting the middle to highlight values. It works at the opposite end of the spectrum to Highlights slider as the changes it makes are concentrated on the darkest 25% of tones in the image. Use this control to brighten backlit subjects or boost shadow details. The beauty of this control is that the changes it makes do not generally impact on mid to highlight values.

Recovering highlight details: The Whites slider is used for correcting clipped highlights. With the clipping warning activated it is easy to see problem highlights (1). When moving the slider to the left, ACR will attempt to reconstruct clipped details from the information stored in the non-clipped channels (2).

Whites

The Whites slider sets the brightest part of the photo. This is generally called the white point. When adjusting the white point in your images you need to be aware of clipping. Clipped areas are completely black or white and contain no detail. As you want to maintain as much detail in the shadows and highlights as possible, your aim should always be to spread the picture tones but not to clip delicate highlight or shadow areas so if you start to see clipping occurring reduce the degree of the change you are applying. Movements left darken whites and movements to the right brighten the same pixels.

Blacks

Moving the Blacks slider adjusts the position of the black point within the image. Just as with the Whites control, you should only make shadows adjustments when the clipping warning is active. This will ensure that you don't unintentionally convert shadow detail to black pixels. Remember movements of the slider to the right decrease shadow clipping. Moving it to the left increases or produces clipping.

Clarity

Located along with Vibrance and Saturation controls at the bottom of the Basic panel, this new slider produces localized contrast changes to otherwise flat images.

Rather than adding contrast to the whole image by stretching the tones between black and white points, Clarity works on changing contrast on the detail in your photos. There are many sophisticated, multi-step, sharpening techniques that produce similar effects but

Adding contrast using the Clarity slider:

The Clarity slider gradually increases the contrast of details in the photo.
(1) Original.

- (2) Clarity + 50.
- (3) Clarity + 100.

thankfully Adobe has managed to squeeze much of their contrast-increasing abilities into a single control. Moving the slider to the right increases the effect.

Vibrance

Like the Saturation control, Vibrance controls the strength of the color in the photo. Movements to the right boost the color and movements to the left make the vividness of the hue more subtle. But unlike the Saturation slider, Vibrance manages these changes selectively, targeting the least saturated colors and protecting (to some extent) skin tones.

Targeting dull colors:

The Vibrance control is different to the Saturation slider in that it concentrates on altering desaturated or pastel colors in the image. Moving the slider to the right gradually increases the strength of pastel colors, whereas movements to the left decrease their saturation. (1) Original.

- (2) Vibrance + 50.
- (3) Vibrance + 100.
- (4) Vibrance 100.

This makes the control the first tool to reach for when you want to boost, or reduce, the color in your photos. The results are easier to control and less likely to display posterization or color clipping from over-application than the traditional Saturation control.

Saturation

If desired, the Saturation slider may be used to adjust the strength of the color within the photo. A setting of -100 is a completely desaturated monochrome image and a value of +100 doubles the saturation. Watch changes in the histogram when you move the Saturation slider in either direction, so that you don't introduce clipping into the photo. Some photographers

use this - 100 saturation setting as a quick way to convert their photos to black and white but most prefer to make this change in Photoshop Elements proper, where more control can be gained over the conversion process with features such as the Convert to Black & White.

Auto tonal control

When first opening a picture ACR will adjust the tonal controls to an average setting for the picture type and camera make/model. When the Auto setting is selected, ACR examines the picture and adjusts the controls according to the images' content. When these settings are in place, moving the associated slider will remove the selection but these values can be reinstated by selecting the check box again.

SATURATION

The saturation of a color photo is usually described as the color's strength or vibrancy.

Decreasing the saturation in a picture gradually removes the color from the image, creating more subtle or pastel shades.

Continuing to lessen the saturation will eventually reach a point where no color remains and the photo is effectively a grayscale image.

Increasing the saturation makes the colors more vibrant.

ACR auto options: A single Auto button is provided at the top of the slider controls in the Basic pane.

Sharpening, Luminance Smoothing and Color Noise Reduction

Sharpening (Amount, Radius, Detail, Masking), Luminance Smoothing and Color Noise Reduction are all controls that can be accessed under the Detail tab.

These controls are used to improve the clarity of the photo. The sharpening sliders make the edges of the image parts clearer and the noise reduction controls reduce the appearance of digital grain in the photo.

Sharper	
Amount	25
Radius	1.0
Detail	25
Masking	0
Luminance	0
Luminance Detail	
Luminance Contrast	
Color	25
^	

Sharpening

Sharpening is an enhancement technique that is easily overdone and this is true even when applying the changes at the time of raw conversion. The best approach is to remember that sharpening should be applied to photos as the very last step in the editing/enhancement process and that the settings used need to match the type of output the photo is destined for. In practice this means images that are not going to be edited after raw conversion should be sharpened within ACR, but those pictures that are going to be enhanced further should have a small amount of subtle sharpening applied in ACR and specific output sharpening applied later using the specialist filters in Photoshop Elements.

When a picture is first opened into the ACR the program sets the sharpening and noise values based on the camera type and model used to capture the image. For many photographers making further adjustments here is an exception rather than a rule as they prefer to address sharpening in the Editor after cropping, straightening, enhancing, resizing and going to print.

Sharpening control – Two new controls have been added to the Detail section of the Camera Raw dialog in recent versions of ACR. These new controls contribute substantially to the user's ability to fine-tune the sharpening in their images. Added to the existing Amount (strength of the effect) and Radius (number of pixels from an edge that will be changed in the sharpening process) sliders is the Detail and Masking controls. Both sliders are designed to control what parts of the image the sharpening effect is applied to. As with all sharpening techniques ensure that the preview is set to 100% before playing with the new controls. In fact, this magnification level is essential if you are to see the masking previews mentioned below.

Detail – Moving the Detail slider to the right increases the local contrast surrounding edge areas and therefore enhances the appearance of details. Moving the slider to the left decreases the effect and also reduces the appearance of halos.

Sharpening examples:

The sharpening slider controls affect the strength and type of sharpening applied to the image.

- (1) Detail of original.
- (2) No sharpening.
- (3) Amount + 90.
- (4) Amount + 150.
- (5) Radius + 3.0.
- (6) Detail + 150.

Masking - The Masking control interactively applies an edge locating mask to the sharpening process. Sharpening through an edge mask is nothing new but encapsulating the process in a single slider control is. A setting of O applies no mask and therefore all detail in the photo is sharpened.

Moving the slider to the right gradually isolates the edges within the photo until, at a setting of 100, sharpening is only being applied to the most contrasty or dominant edges in the picture. Holding down the Alt key (at 100% magnification) as you move the slider previews the masked areas, allows you to fine-tune exactly where the sharpening is being applied. Remember no sharpening is occurring in the black parts of the mask, in the areas masked by gray tones only partial sharpening is being applied, and in white mask sections the full effect is revealed.

RAW SHOOTING

Previewing Masking – As well as including a mask display option, in the latest version of ACR you can also preview the settings for the other sharpening sliders. Holding down the Alt keys while moving the Amount slider displays a 'luminosity only' version of the image so that you can gauge the sharpening effect without the distraction of color. This preview also reminds us that in the latest version of ACR sharpening is applied to detail only and not the color information in the photo. With the preview at 100% or more the Alt/Opt keys are used with the Radius slider the preview highlights the 'edges' in the image that will be sharpened and the width of the sharpening effect.

Sharpening preview options: After magnifying the preview to 100% there are four different preview options available when holding down the Alt keys and sliding one of the Sharpening sliders.

- (1) Amount slider.
- (2) Detail slider.
- (3) Radius slider.
- (4) Masking slider.
- (5) Detail of original.

Noise Reduction

ACR contains two different noise reduction controls: the Luminance slider and the Color control. The Luminance slider is designed to reduce the appearance of grayscale noise in a photo. This is particularly useful for improving the look of images that appear grainy. The second type of noise is the random colored pixels that typically appear in photos taken with a high ISO setting or a long shutter speed. This is generally referred to as chroma noise and the effect is reduced using the Color slider in ACR. The noise reduction effect of both features is increased as the sliders are moved to the right.

Noise Reduction: The Luminance and Color sliders can be used in combination to reduce the appearance of noise resulting from high ISO capture.

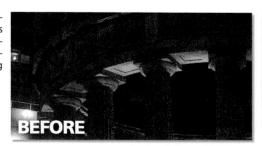

Output options

Now to the business end of the conversion task – outputting the file. At this stage in the process ACR provides several options that will govern how the file is handled from this point onwards. In previous versions of the dialog the lower right-hand corner housed all the output options, now they are spread along the bottom of the window. The options include Save Image, Cancel, Open Image, Done and Help, and a further three: Save Image (without the options dialog), Reset and Open Copy, when the Alt button is pushed.

Help: Opens the Photoshop Elements help system with raw processing topics already displayed.

Cancel: This option closes the ACR dialog not saving any of the settings to the file that was open.

Save Image...: The normal Save Image button, which includes several dots (...) after the label, displays the Save Options dialog. Here you can save the raw file, with your settings applied, in Adobe's own DNG format. The dialog includes options for inputting the location where the file will be saved, the ability to add in a new name as well as DNG file-specific settings such as compression, conversion to linear image and/or embed the original raw file in the new DNG document. It is a good idea to select Save in Different Location in the Destination drop-down at the top to separate processed files from archive originals. Clearly the benefits of a compressed DNG file are going to help out in the storage issue arena and compression is a big advantage with DNG. Embedding the original raw file in the saved DNG file begs the questions of how much room you have in the designated storage device and whether you really want to have the original raw file here.

Save Image (without save options): Holding down the Alt key when clicking the Save button skips the Save Options dialog and saves the file in DNG format using the default save settings.

Open Image: If you click on the Open button Elements applies the conversion options that you set in ACR and opens the file inside the Editor workspace. At this point, the file is no longer in a raw format so when it comes to saving the photo from the Editor workspace, Elements automatically selects the Photoshop PSD format for saving.

Open Copy: The Open Copy option (Alt/Opt key plus Open Image button) differs from Open Image in that it applies the development settings to a duplicate of the file which is then opened into the Elements Editor workspace.

Reset: The Reset option resets the ACR dialog's settings back to their defaults. This feature is useful if you want to ensure that all settings and enhancement changes made in the current session have been removed. To access the Reset button click the Cancel button while holding down the Alt key.

Done or Update: The Done button applies the current settings to the photo and the dialog is then closed. The thumbnail preview in the PhotoBrowser workspace will also be updated

THUMBNAILS

If the thumbnail doesn't update automatically, select the picture and then choose Edit > Update Thumbnail in the PhotoBrowser workspace.

to reflect the changes. In previous versions of the dialog clicking the Open button in conjunction with the Alt/Option key (the Update button) will update the raw conversion settings for the open image in the same way.

Skip: In previous versions of Adobe Camera Raw holding down the Shift key whilst clicking the Open button will not apply the currently selected changes and just close the dialog. In this way it is similar to the Cancel button.

□ 5·0

P. I

The manual raw conversion process via ACR

Okay, now that we have a good understanding of the features and controls within the Adobe Camera Raw dialog let's move on and look at a typical conversion workflow.

Opening the raw file in the Editor workspace: Once you have downloaded your raw files from camera to computer you can start the task of processing. Keep in mind that in its present state the raw file is not in the full color RGB format that we are used to, so the first part of all processing is to open the picture into Adobe Camera Raw. Selecting File > Open from inside Elements will automatically display the photo in this.

Starting with the Organizer: Starting in the PhotoBrowser or Organizer workspace simply rightclick on the thumbnail of the raw file and select Edit with Photoshop Elements from the pop-up menu to transfer the file to the Elements version of ACR in the Editor workspace.

Rotate right or left: Once the raw photo is open in ACR you can rotate the image using either of the two Rotate buttons at the top of the dialog. If you are the lucky owner of a recent camera model then chances are the picture will automatically rotate to its correct orientation. This is thanks to a small piece of metadata supplied by the camera and stored in the picture file that indicates which way is up.

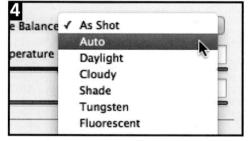

Preset changes: As we have seen you can opt to stay with the settings used at the time of shooting ('As Shot') or select from a range of light-source-specific settings in the White Balance drop-down menu of ACR. For best results, try to match the setting used with the type of lighting that was present in the scene at the time of capture. Or choose the Auto option from the drop-down White Balance menu to get ACR to determine a setting based on the individual image currently displayed.

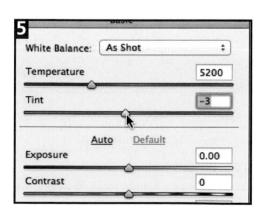

Manual adjustments: If none of the preset white balance options perfectly matches the lighting in your photo then you will need to fine-tune your results with the Temperature and Tint sliders (located just below the Presets drop-down menu). The Temperature slider settings equate to the color of light in degrees Kelvin – so daylight will be 5500 and tungsten light 2800. It is a blue to yellow scale, so moving the slider to the left will make the image cooler (more blue) and to the right warmer (more yellow). In contrast the Tint slider is a green to magenta scale. Moving the slider left will add more green to the image and to the right more magenta.

The White Balance tool: Another quick way to balance the light in your picture is to choose the White Balance tool and then click on a part of the picture that is meant to be neutral gray.

ACR will automatically set the Temperature and Tint sliders so that this picture part becomes a neutral gray and in the process the rest of the image will be balanced. For best results when selecting lighter tones with the tool ensure that the area contains detail and is not a blown or specular highlight.

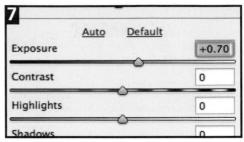

Overall brightness changes: The next control is the Exposure slider. Use this setting to adjust the overall brightness of the image. When making changes concentrate on how the setting is affecting the middle vales of the picture. We'll alter the highlights and shadows later. Moving the slider to the right lightens the whole image and movements to the right darkens the picture.

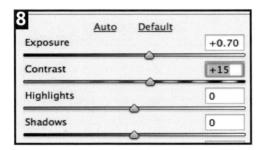

Increasing/decreasing contrast: The second tonal control in the dialog is the Contrast slider. The feature concentrates on the midtones in the photo with movements of the slider to the right increasing the midtone contrast and to the left producing a lower contrast image. Like the Exposure slider, overall contrast changes are best applied first with highlight and shadow tones finely adjusted afterwards.

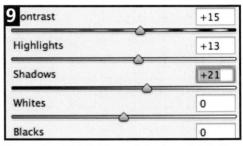

Recovering highlights and shadow detail: Now lets move to altering the brightest 25% of image tones in the highlights, and the darkest 25% tones in the shadows. Darken the lightest tones by moving the Highlight slider to the left. Brighten darker tones by moving the Shadows slider to the right.

Setting the white clip point: Establish the white clip point with the Whites slider. Use this slider to peg or set the white tones. Your aim is to lighten the highlights in the photo without clipping (converting the pixels to pure white) them. To do this, hold down Alt/ Option whilst moving the slider. This action previews the photo with the pixels being clipped against a black background. Move the slider back and forth until no clipped pixels appear.

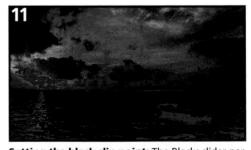

Setting the black clip point: The Blacks slider performs a similar function with the shadow areas of the image. Again, the aim is to darken these tones but not to convert (or clip) delicate details to pure black. Just as with the Exposure slider, the Alt/Option key can be pressed whilst making Shadows adjustments to preview the pixels being clipped. Shadow pixels that are being clipped are displayed in blue and clipped highlight tones in red.

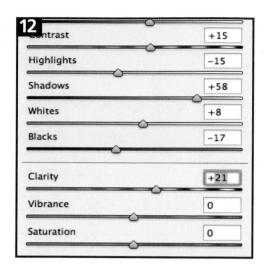

Local contrast control: The Clarity slider is used to alter the local contrast or the contrast of details within the photo. It works well with photos that have been photographed with diffused light or on a cloudy day. Use Clarity and Contrast sliders together. You can now also apply negative Clarity values to soften details or provide a diffused look to your images.

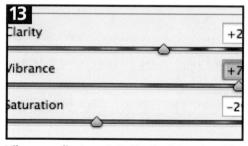

Vibrance adjustment: Unlike the Saturation slider, which increases the strength of all colors in the photo irrespective of their strength in the first place, Vibrance targets its changes to just those colors that are desaturated. Use this control to boost the strength of colors in the photo with less risk of posterized results.

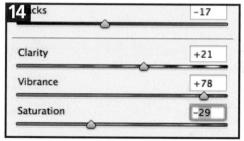

Saturation control: The strength or vibrancy of the colors in the photo can be adjusted using the Saturation slider. Moving the slider to the right increases saturation, with a value of +100 being a doubling of the color strength found at a setting of 0. Saturation can be reduced by moving the slider to the left, with a value of -100 producing a monochrome image.

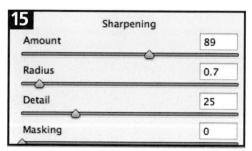

To sharpen or not to sharpen: ACR contains four sharpening controls. Use the Amount slider to determine overall sharpening strength. The Radius is used to control the number of pixels from an edge that will be changed in the sharpening process. The Detail and Masking sliders are both designed to help target the sharpening at the parts of the image that most need it (edges) and restrict the sharpening effects from being applied to areas that don't (skin tone and smooth graded areas). The Masking control interactively applies an edge locating mask to the sharpening process.

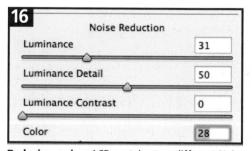

Reducing noise: ACR contains two different Noise Reduction controls. The Luminance Smoothing slider is designed to reduce the appearance of grayscale noise in a photo. This is particularly useful for improving the look of images that appear grainy.

The second type of noise is the random colored pixels that typically appear in photos taken with a high ISO setting or a long shutter speed. This is generally referred to as chroma noise and is reduced using the Color Noise Reduction slider in ACR.

The noise reduction effect of both features is increased as the sliders are moved to the right.

Color depth: The section below the main preview window in ACR contains the output options settings. Here you can adjust the color depth (8 or 16 bits per channel) of the processed file. Earlier versions of Photoshop Elements were unable to handle 16 bits per channel images but the last two releases have contained the ability to read, open, save and make a few changes to these high color files.

Opening the processed file in Photoshop Elements: The most basic option is to process the raw file according to the settings selected in the ACR dialog and then open the picture into the Editor workspace of Photoshop Elements. To do this simply select the Open Image button. Select this route if you intend to edit or enhance the image beyond the changes made during the conversion.

Holding down the Alt key whilst clicking the Save button allows you to store the file (with the raw processing settings applied) without actually going through the Save Options dialog.

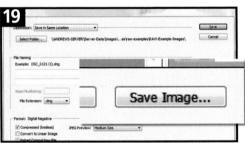

Saving the processed raw file: Users also have the ability to save converted raw files from inside the ACR dialog via the Save Image button. This action opens the Save Options dialog which contains settings for inputting the file name as well as file type-specific characteristics such as compression. Use the Save option over the Open command if you want to process photos quickly without bringing them into the editing space.

Applying the raw conversion settings: There is also an option for applying the current settings to the raw photo without opening the picture. By Clicking the Done button (or Alt-clicking the OK button – holding down Alt key changes the button to the Update button in previous versions of the dialog), you can apply the changes to the original file and close the ACR dialog in one step.

The great thing about working this way is that the settings are applied to the file losslessly. No changes are made to the underlying pixels, only to the instructions that are used to process the raw file.

When next the file is opened, the applied settings will show up in the ACR dialog ready for fine-tuning, or even changing completely.

Keeping ACR up to date

The Adobe Camera Raw feature is installed as a plugin inside Photoshop Elements when you first install the program. Periodically Adobe updates the feature releasing a new version that can be freely downloaded and installed. Typically the updates contain support for the latest digital camera models and occasionally new features and tools are included as well.

Automatic updating of the Camera Raw plug-in

The easiest way ensure that you have the very latest Adobe Camera Raw installed is to select the Update entry from the Help menu in either the Organizer or Editor workspaces. This action instructs Elements to search for any new updates for the program, this includes any changes for the Adobe Camera Raw update. If an update is located Elements automatically notifies you and displays a new dialog for downloading and installing.

Manual updating of the Adobe Camera Raw Plug-in

To download the latest ACR update point your browser to **www.adobe.com** (specifically http://www.adobe.com/products/photoshop/cameraraw.html) and then look for the Adobe Camera Raw update page. Next download the latest version of the utility and install using these steps:

- 1. If Photoshop Elements is open exit the program.
- 2. Open the system drive (usually C:).
- Locate the following directory: Program Files\Adobe\Photoshop Elements 11\Plug-Ins\ File Formats
- 4. Find the Adobe Camera Raw. 8bi file in this folder.
- 5. Move the plug-in to another folder and note down its new location just in case you want to restore the original settings.
- 6. Drag the new version of the Adobe Camera Raw plug-in, the Adobe Camera Raw.8bi file (that you downloaded), to the same directory as in Step 3.
- 7. Restart Photoshop Elements.

Other Raw plug-ins

Often when installing the support software that was supplied with your digital camera an extra Raw utility is installed on your computer. This can mean that after installing the camera drivers you find that you no longer have access to Adobe Camera Raw and that instead the camera-based plug-in keeps appearing when you are attempting to open Raw files. If this occurs and you want to restore ACR as the default Raw utility then you will need to remove the camera-based plug-in from the plug-ins\Adobe Photoshop Elements 11\File Formats folder in Elements and add in the Adobe Camera Raw.8bi instead.

This is a problem that is often seen with Nikon users as the NEF.8bi plug-in designed to display and adjust Nikon Raw or NEF files takes precedence over the ACR utility.

Raw file queue

The thumbnail section of the Photoshop Elements ACR dialog appears when you select multiple raw files inside the Organizer workspace and then choose the Edit in Photoshop Elements option from the right-click menu. The selected files are opened into the ACR dialog and listed as thumbnails on the left-hand side of the main workspace.

In general, only one image can be selected from the grouping, and displayed in the preview area, at a time. All changes made to the image settings are applied to the selected photo only. Users then move from image to image, making the necessary enhancements before clicking the Done key to apply the changes without transferring the files, or the Open key to display the converted pictures in the Full edit workspace.

But this is not the only way to work with the files. The Select All button at the top of the queued files can be employed for a more efficient workflow. Queued images can also be multi-selected by Shift-clicking or Ctrl-clicking the thumbnails. With this feature, enhancement changes made to a single photo can be applied across the whole range of images queued in the dialog.

The Select All button at the top of the queue area allows the user to apply settings used for a single image across a range of the photos grouped here.

Applying changes across multiple raw files

- 1 For best results, start by multi-selecting files from the Organizer space that have similar characteristics or were shot under the same lighting conditions.
- 2 Next, open the pictures in ACR by selecting one of the editing options from the right-click menu.
- 3 Now select a single photo from the queue that is indicative in tone and color of the whole group. With this photo displayed in the preview area, choose the Select All option from the top of the dialog.
- 4 Proceed to make enhancement changes to the previewed files as you would normally. Notice that these changes are also applied to the other photos in the queue.

- 5 The changes made to all the photos can then be fine-tuned to suit the characteristics of individual images (if needed) by selecting each picture in turn and adjusting the controls.
- 6 If no changes for individual files are necessary, then the selected photos can be saved, using the Save Images button, transferred to the Edit workspace with the Open Images option, or the enhancement settings applied by clicking the Done button.

Applying changes across rated raw files

DSC_0124.NEF

②★・・ ★

DSC_0125 (1).NEF

- In addition to being able to apply image changes across all the queued files by choosing the Select All button, it is also possible to adjust just a subset of the files listed. Start by reviewing each of the queued files in turn by clicking onto the thumbnail on the left of the dialog.
- 2 During the review process rate those files that you want to adjust as a group. Do this by clicking the star rating section located under each thumbnail.
- 3 Once the review process is completed and all files to be enhanced as a group are rated, hold down the Alt key and choose the Select Rated button at the top of the queued list. Notice that this action selects only those files with a star rating attached.
- 4 Now you can set about applying the changes to those selected as before.
- 5 If you want to remove an image from the Rated grouping simply click on the No Rating option under the thumbnail.

If you want the best quality pictures always make sure that your scanner or camera captures in 16 bit per channel or 48-bit mode. On most cameras this is referred to as the 'TIFF' or 'Raw' setting.

The Raw advantage

The real advantages of editing and enhancing at the raw stage are that these changes are made to the file at the same time as the primary image data is being converted (interpolated) to the full color picture. Editing after the file is processed (saved by the camera in 8 bits per channel versions of the JPEG and TIFF format) means that you will be applying the changes to a picture with fewer tones and colors.

A second bonus for the dedicated raw shooter is that actions like switching from the White Balance option selected when shooting, to another choice when processing, are performed without any image loss. This is not the case once the file has been processed with the incorrect White Balance setting, as anyone who has inadvertently left the tungsten setting switched on whilst shooting in daylight can tell you.

Editor Guided

The Guided Edit workspace is designed as an interactive help environment as it combines both the tools and the step-by-step instructions needed to complete a range of Photoshop Elements tasks. A variety of activity types and levels are included in the pane ranging from the simple, cropping and resizing photos, to the more sophisticated: combining differently exposed photos to produce a single, more detailed result using the Photomerge Exposure feature.

This is a good place to start when wanting to move from the simple 'single button to make a change' approach of the Organizer's Fix pane to the fuller enhancement environment of the Edit workspace.

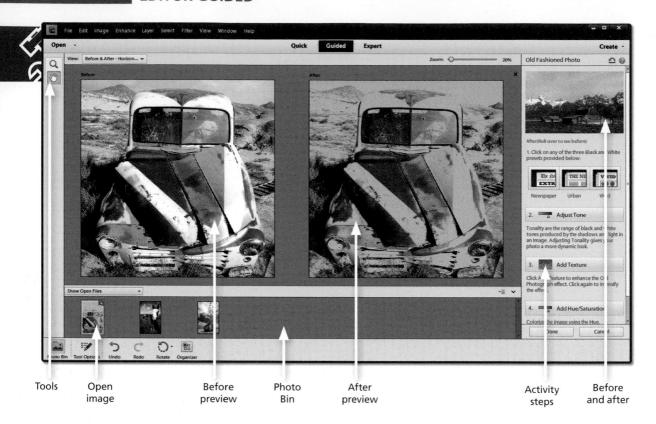

The Guided Edit mode has its own workspace complete with preview area, small toolbar on the left and dedicated step-bystep pane on the right.

The Guided editor mode – 'help when you need it'

The Guided editor mode can be found in the Edit Task Pane of both the Macintosh and Windows versions of Photoshop Elements. The mode has its own workspace with a very simple tool bar containing several tools depending on the activity you are undertaking, a preview area displayed in the middle of the screen and a series of step-by-step instructions in the dedicated Guided edit task pane on the right. The pane includes a list of activity groupings such as 'Touch Ups' and 'Photo Play' with a series of activity entries listed under each heading.

Unlike other edit spaces in Elements, the Guided Edit mode groups together the tools needed to perform the chosen activity with clear and detailed instructions about the best way to use these tools. It is a bit like having your own tutor right in the program.

For instance, if you wanted to know how to create an old-world-looking version of your photo, like the example above, then just select the Old Fashion Photo entry listed under the Photo Effects heading in the Guided edit task pane. The pane's display changes to show a series of steps, instructions, a Before and After example and several buttons to produce the effect.

With many Guided Edit entries the various tools and controls needed to complete the technique are also included in the pane and are positioned within the tutorial steps where and when you need them. This set up makes using features like the Recompose Tool a cinch as

all you need to do is follow the steps using the various brushes, controls and menu options as you go. Once you get the hang of the featured tool's operation it is then an easy step to move over to using the feature in the Full edit workspace.

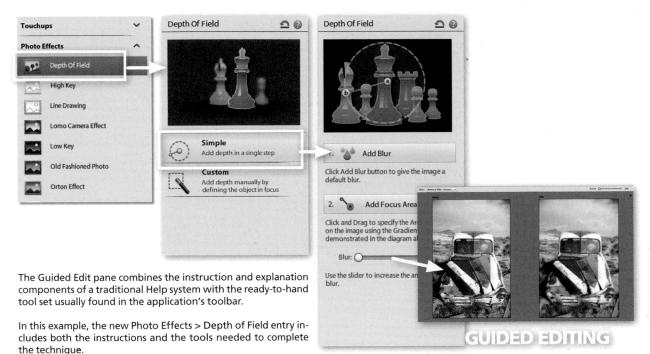

New Guided Edit entries for Photoshop Elements 11

Because of the tutorial nature of the entries in the Guided Edit pane, it pays to look here first when wanting to learn new skills or extend the ones you already have.

Photoshop Elements 11 contains four new entries in the panel – Vignette, Tilt-Shift, High Key, and Low Key – providing you with extra creative options when it comes to processing your images.

Guided Edit Options

The entries in the Guided edit panel are arranged under three different headings. Each heading contains several different techniques or step-by-step effects.

Touch Ups: This heading contains options for cropping, rotating and straightening, as well as sharpening of images. Using a step-by-step approach these entries walk you through a series of changes designed to enhance your photo.

You can fast-track your learning of new Elements techniques, such as adding a Tilt-Shift effect to a photo, by working your way through the Guided Edit entries first before attempting the technique by yourself.

Photo Effects: Go beyond simply applying a filter to your photos with these multi-step effects. This is where the four new entries are listed.

Photo Play: The Fun Edits heading in the Guided Edit panel and the entries it contains was introduced in the last version of the program. Options include the Picture Stack effect, Reflection, Pop Art and Out of Bounds effects.

Photo Play > Photo Stack

The Photo Stack Guided Edit option takes a single photo and converts it into a montage of several smaller pictures. The steps in the Guided Edit panel include options for the number of photos used in the composition, the size of the frame that borders each picture and the type of background included. And as the effect is created with a set of linked layers, the composition as well as the size and position of each frame can be adjusted after creation.

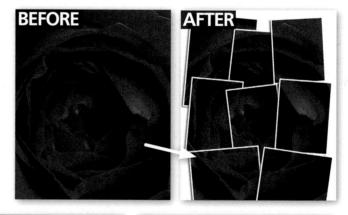

Choose the Picture Stack entry from those listed under the Photo Play heading. Pick the Before and After option from the View section (top left) of the Guided Edit workspace.

Click onto the number of pictures thumbnail to break the image into several smaller photos. In this example I selected the 8 Pictures option. Now choose the thickness of the border used to surround each photo.

Click the Done button to apply the effect or select a different background style with the options in the 3rd step of the Guided Edit instructions. Here I added a white background using the Solid Color option.

Adding darkened or lightened edges to a photo has been a long tradition with photographers and dates back to the days when pictures were made in darkroom. This process is called adding a Vignette and in this version of Elements it is introduced as a new entry in the Photo Effects section of the Guided Edit panel.

Choose the Vignette entry from those listed under the Photo Effects heading. Pick the Before and After option from the View section (top left) of the Guided Edit workspace.

A High Key portrait retains all of the key details of the subject but presents them with predominantly light tones. Traditionally careful exposure and image-processing is needed to create such a stylized portrait, but in Elements 11 you can produce similar results with the High Key Guided Edit entry. There is even the ability to soften the final result by filtering with Diffuse Glow.

Choose the High Key entry from those listed under the Photo Effects heading. Pick the Before and After option from the View section (top left) of the Guided Edit workspace.

Photo Effects > Vignette Effect

Choose to apply a dark or light vignette and then use the Intensity slider to change the strength of the effect.

Click Refine Shape button to display a dialog with Feather and Roundness sliders. Move the Feather control to change the softness of the vignette edge and the Roundness slider to alter its shape.

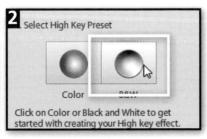

Start by picking the style of effect by clicking the Color or B&W button. As there is no way to alter the strength of High Key effect during the process, you may need to darken your starting image a little first.

If your aim is a soft and dreamy result then as a finishing touch you can add a diffuse glow to the High Key conversion.

Opacity Opacity Custom Simple Background Lock: ■ □

Both DOF approaches store the changed image in a separate layer stacked above the original background.

Photo Effects > Depth of Field

Depth of Field (DOF) or, the area of sharpness in a photo, is one of the key creative controls photographers use to change the way their images look. I am sure that you have all seen landscape images where the detail appears sharp from the foreground right through to the background ('deep DOF'). And then, in contrast, there are the photos where just one part of the image is sharp with the rest left blurry ('shallow DOF'). Traditionally, the control over which parts of your scene are sharp and which are blurry is determined by a combination of focal length, distance-to-subject and aperture, but with some cameras, or shooting situations, there is not the opportunity of selecting the necessary combination of these factors to ensure a shallow depth of field picture. So what are you to do if you want a photo where only the main subject is sharp but you end up with a picture with sharpness throughout? The short answer is to use the Depth of Field Guided Edit option in Photoshop Elements to create the look of shallow DOF on your desktop.

There are two types of DOF control possible with this Elements feature – Simple and Custom. Essentially the difference between the two is how the blur is applied to the photo. With the Simple approach the blur is added using a standard Radial Gradient. This produces an even change from sharpness to blur radiating from a central point. The result is an artistic interpretation of depth of field and works well with images that you would normally apply a vignette to. Think moody, wispy and soft. The Custom option uses a more selective approach

Simple DOF

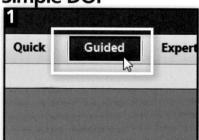

Start by selecting a photo in the browser space of the Organizer. Next Click on the Editor button in the action bar at the bottom of the workspace.

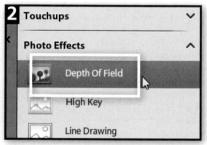

The photo will be opened in the Editor workspace and the Guided Edit panel will be displayed on the right. Choose the Depth of Field option from the Photo Effects section of the panel.

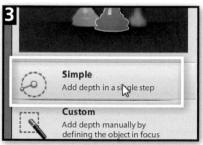

Now click onto the Simple option in the Choose a Method section of the panel.

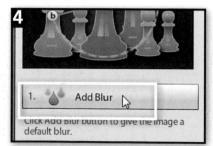

Click the Add Blur button in the first step of the Guided Edit instructions to blur the whole of the photo. Don't worry at this point as we'll add the sharpness back with the next step.

Now click onto the Add Focus Area button (this selects the tool to the Radial gradient mode). Click and drag the tool from the area you want to remain sharp to the part of the photo that you want to be blurred.

In the last step you can adjust the degree of blur in the image with the Blur slider. Once you are happy with the effect, click the Done button. You can also select the Reset button to start the process again or the Cancel button to quit the Guided Edit panel.

AFTER SIMPLE DOF

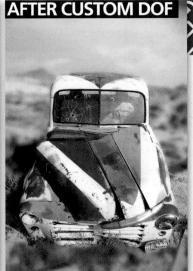

as the user is able to choose precisely which parts of the picture are sharp and which are blurred. And because this approach employs a layer mask for the effect, you also have the opportunity to edit the mask at a later date to change the areas left sharp and the characteristic of the transition between sharp and blurred areas. Cool!

Open a photo into the Guided Edit workspace using the first two steps of the previous technique. Choose the Custom option in the Method section of the Depth of Field panel.

Click onto the Quick Selection Tool button in the first step of the instructions. Drag the tool over the areas you want to remain sharp. If need be, hold down the Alt/Opt key to remove unwanted areas from the selection.

Next, click the Add Blur button in the second step of the instructions to apply the DOF effect to the image.

Use the Blur slider in the final step to adjust the degree of blur in the photo before clicking Done to apply the changes. For further editing, select the Full option from the Create task panel (at the top) to switch to the Full Edit workspace.

Display the Layers panel (Window > Layers) and click onto the layer mask thumbnail of the upper layer. Choose the brush tool and to make blurry areas sharp simply paint over these parts with a white brush.

Alternatively, if you want sharp areas to become blurry, paint these sections with a black brush. You can also soften the transition between sharp and blurry picture parts by painting over the edge with a soft-edged brush set to a low opacity.

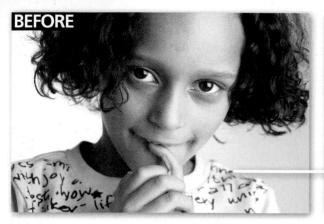

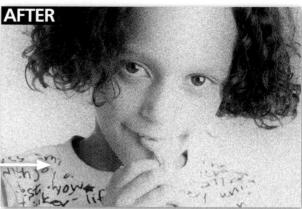

Photo Effects > Orton Effect

In recent years the Orton Effect has become very popular among photographers who want to bring a mystical, other-world, quality to their photos. You may have seen examples of the technique in wedding or portrait photographer's windows and wondered how they were created.

Images processed with this technique typically contain some blur and grain and often the tones they contain are processed brighter than normal. Well now you can process your image using this technique courtesy of the new Orton Effect entry in the Guided Edit section of Elements.

Start by selecting a photo in the browser space of the Organizer. Next Click on the Editor button in the action bar at the bottom of the workspace.

The photo will be opened in the Editor workspace. Select the Guided mode button at the top of the screen. The Guided edit panel will be displayed on the right. Choose the Orton Effect entry from the Photo Effects section of the panel.

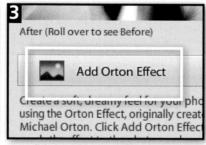

Now click the Add Orton Effect button. You may not see much change to your photo at this point especially if the Increase Blur and Increase Noise sliders are set all the way to the left.

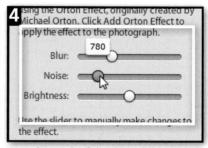

Next alter each of the three slider controls – Increase Blur, Increase Noise, and Apply Brightness – to control the effect. When you are happy with the results, click the Done button to apply the effect.

Low Key is a traditional photography term that describes photos with predominantly dark and contrasty tones. When shooting photographers careful control their lighting to produce this moody effect. Here we replicate the look and feel with the new Low Key entry in the Photo Effects section of the Guided edit pane.

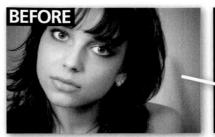

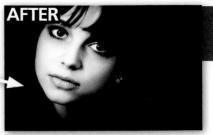

Photo Effects > Low Key

Choose the Low Key entry from those listed under the Photo Effects heading. Pick the Before and After option from the View section (top left) of the Guided Edit workspace.

Click on the Color or the B&W button to determine the style of the effect. In this example I selected the B&W option which removed all color from the portrait.

The two other controls in the pane, Background Brush and Reduce Effect are provided so you can fine tune the results. Both tools use a brush to paint on the alterations.

Photo Effects > Tilt Shift

The Tilt Shift option adds to the lens effects possibilities created with the Depth Of Field entry. Use this feature as another way of adding creative blur to your photos and for producing the 'model toy town' effect popular today.

Choose the Tilt Shift entry from those listed under the Photo Effects heading. Pick the Before and After option from the View section (top left) of the Guided Edit workspace.

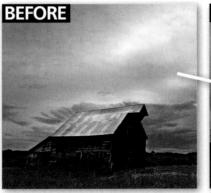

Click the Add Tilt-Shift button to apply the effect across the whole of the image. Next click the Modify Focus Area button and clickdrag a focus line across the photo.

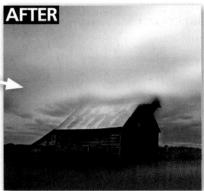

If the effect is not exactly as you would like, then click-drag and additional line on the image. The second line will replace the first. Now use the Refine Effect control to alter the style of the blurred areas.

Photography Effects > Lomo Camera Effect

With the increase in popularity of images photographed with toy cameras or specialized lenses such as the Lens Baby, Adobe decided to include a Lomo Camera Effect entry in the Guided Edit pane. Using two different effects, Cross Processing and Vignetting, you can simulate the effects of photos taken with these cameras or lenses with your own photos.

Start by selecting a photo in the browser space of the Organizer. Next Click on the Editor button in the action bar at the bottom of the workspace.

The photo will be opened in the Editor workspace. Select the Guided mode button at the top of the screen. The Guided Edit panel will be displayed on the right. Select the Lomo Camera Effect entry from the photography Effects heading.

Roll your mouse over the photo at the top of the Lomo Camera Effects pane to see an example of the before and after effect. Click the Lomo Effect button to adjust the colors in the photo. Click-again to emphasize the changes.

Next click the Apply Vignette button to darken the edges of the photo. Again you can increase the strength of the effect by reclicking the button.

If you are unhappy with the results, click the Reset button at the top of the pane and then start the enhancement process again. Click Done to complete the effect and then File > Save to store the enhanced photo.

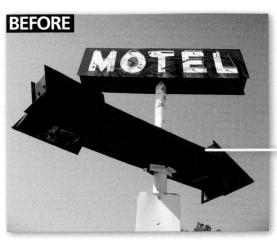

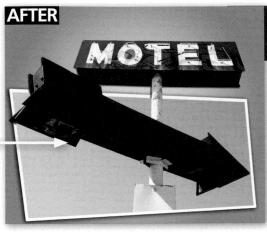

Photo Play > Out Of Bounds

The Out of Bounds entry in the Photo Play section of the Guided Edit panel creates a very interesting effect where the main subject in the photo looks like it is breaking out of the boundaries of the photo. This is a sophisticated effect and one which most users would not attempt but with the step-by-step nature of the guided edit workspace such complex editing tasks become much easier for even the newest Elements users.

As with most Guided Edit techniques, start by selecting a photo from the Organizer workspace and click the Editor button at the bottom of the screen. The photo will open into the Editor workspace, choose Guided from the top and then choose the Out Of Bounds entry from the pane on the right.

Now click on the Quick Selection tool (in the right panel) and paint onto the subject areas outside the photo frame to be displayed in the final illustration. Use the Alt/Opt key to remove sections from the selection if any other areas are inadvertently included.

Start by clicking the Add Frame button and using the side and corner handles to draw a marquee that will become the photo frame. Hold down the Ctrl/Cmd key and drag the corner handles to add perspective to the frame. Click the Green tick to apply the marquee.

Click the Create Out Of Bounds buttons to process the image and create the photo and 'break out' subject. Click the Add a Background Gradient button to place a gradient in the background of the design.

Next, move the side and corner handles a second time so that they are sitting just outside of the selected region. The area between the photo and the marquee edges will become the white photo frame. Click the green tick to apply the photo edge selection.

Next, add a shadow to the design by clicking either the Small, Medium or Large buttons. Finally, click the Done button to finish the process.

Photo Play > Pop Art

In a three step process the Pop Art entry takes a standard photo and creates a pop art style artwork.

After opening the photo into the Editor workspace, select the Pop Art entry in the Guided Edit pane. Next click the Convert Image Mode button.

Now click the Add Color button to mix a color with the now black and white image.

Finally click the Duplicate Image button to make and arrange three extra color copies of the photo. Press the Done button to complete the process.

Photo Play > Reflection

Creating a reflection is a popular visual effect used to highlight graphic photo subjects. The Reflection Guided Edit entry is capable of creating three different styles of reflections: Floor Reflection, Glass Reflection or Water Reflection.

Start by opening the photo into the Editor workspace and then select the Reflection entry in the Guided Edit pane. Click the Add Reflection button to create the base reflection.

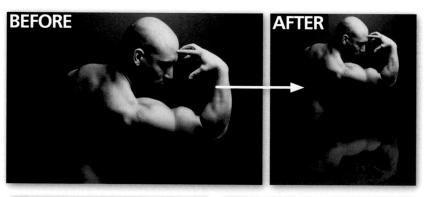

Pick the eyedropper tool and use it to sample the color in the photo to be used as the background for the reflection. Next press the Fill Background button and then choose the reflection type – Floor, Glass, or Water.

Change the strength of the reflection with the slider and reduce the height of the reflection with the Add Distortion button. Finally click the Gradient Tool button and drag the cursor from bottom to top of the reflection.

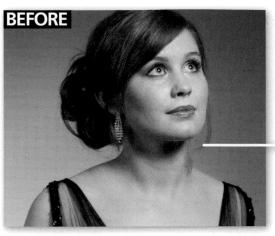

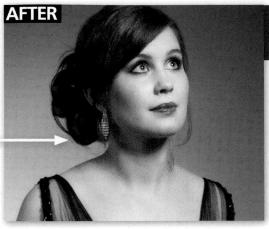

Advanced Edits > Perfect Portrait

The Perfect Portrait entry steps you through key enhancement changes needed to create a polished photo from a regular people shot. Users can select just the steps they need from the range available in the right pane of the workspace.

Start by selecting a photo in the browser space of the Organizer. Next Click on the Editor button in the action bar at the bottom of the workspace. The picture will be transferred to the Editor. Select the Perfect Portrait entry from the Fun Edits heading.

Work your way through the rest of the Facial Feature tools removing red eye, brightening the eyes, burning in eyelashes and whitening teeth. Note that not all portraits need to be adjusted using all tools.

Click the Apply Smart Blur button to display the filter's dialog. Adjust the Radius and Threshold sliders to control the blur effect so the skin areas are softened. Click the Reveal Original button and then select the Blur Brush from the pane, drop the brush opacity to 50% and paint over the skin areas.

At this point you can click the Done button to finish the process or continue enhancing by clicking the Add Glow button. This opens the Add Glow filter dialog where you can adjust the Graininess, Glow Amount and Clear Amount sliders until the skin tones are lightened but not lost.

The next step in the process allows you to tweak the tones in your photo by clicking the Add Contrast button. Images photographed under soft lighting will benefit from this change. Now move to the next section of pane. Select the Spot Healing brush button and click onto small blemishes to remove.

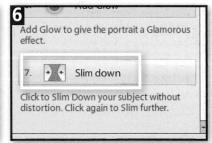

The last option allows you to slim the subject by slightly reducing the width of the photo by pressing the Slim button. Note that clicking the button again will increase the strength of the effect, but be careful not to be tempted to overuse the feature. Click the Done button to finish the process.

Restricted access to other options

It is important to note that when working in the Guided Edit mode that you will not be able to access the complete range of Elements' tools and features. Part of the guided nature of the workspace is that it will limit the tasks that you do to just those indicated in the task pane. For this reason most menu options will be grayed out and not selectable in the Guided Edit mode.

Automated processing

A feature that used to live in the Guided Edit pane is the Action Player. It is a separate panel and can be

When working in the Guided Edit mode you will not be able to access any Elements' features and tools not being used in the guided activity.

displayed by selecting the entry in the Windows menu. Actions make it possible to automate the application of a series of editing or enhancement steps with a single button click. Based on the Actions technology found in Photoshop, the player ships with a variety of action sets. Each set contains a series of different actions that can be applied to your photo by simply selecting them in the Action Player pane.

Keep in mind that it is always possible to undo the effects of the action by choosing the Undo option from the Edit menu or by clicking Ctrl/Cmd Z.

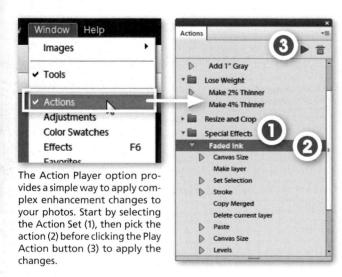

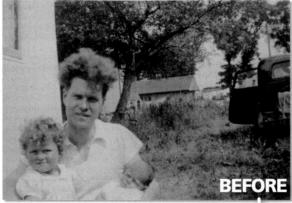

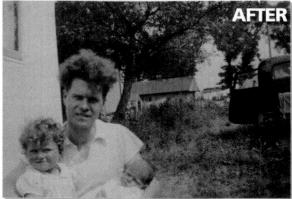

Before

Editor Quick

In the last chapter we looked at the Guided Editing workspace, here we will move to the second level of editing which sits in the middle ground between total user control and total program control over the editing results. The tools in this group are located in a dedicated workspace call the Quick Editor which is available in both the Macintosh and Windows versions of the programme. Move to this workspace once you feel more confident with the digital photography process as a whole (downloading, making some auto-editing changes, saving and then printing) and find yourself wanting to do more with your pictures.

Again, for the advanced user, the tools listed here will provide a degree of frustration as the amount of control over the results is still fairly limited, but for those users building their skills this is a great place to start to take a little more control.

PROJECT BIN

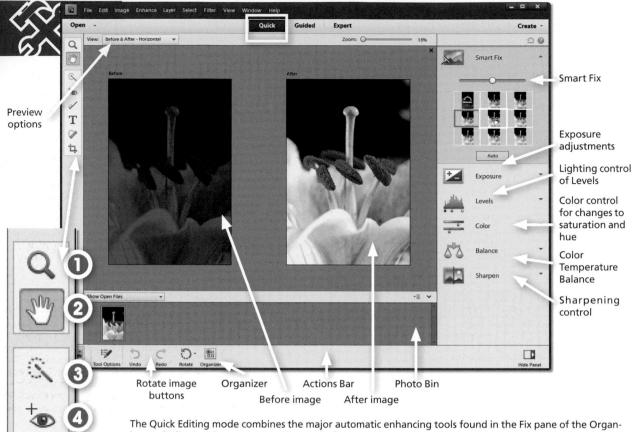

The Quick Editing mode combines the major automatic enhancing tools found in the Fix pane of the Organizer and Editor's Enhance menu with great before and after preview pictures. The Quick Fix editor also includes some paint on enhancement options which include Whiten Teeth and Remove Red Eyes.

The Quick editor mode – 'quick change central'

The Quick editing mode is home for many of the automatic or 'quick and easy' enhancement tools that we have already seen featured in Organizer's Fix pane or the Enhance menu in the Editor workspace. You can access and apply the features via the menu system or take advantage of the controls displayed in the pane on the right of the workspace. Here you will find features that will enable you to quickly and easily adjust lighting, color, color balance, sharpening and, with the Smart Fix option included, highlight and shadow detail as well.

You can let the program apply the changes for you by pressing the Auto button, clicking one of the thumbnail icons, or you can take control of the changes that you apply by using the slider controls. Best of all, you can see the before and after results of your changes onscreen via the zoomable previews.

The workspace includes a simplified toolbar containing key tools such as Zoom, Hand, Quick Selection tool, Selection Brush and Crop. Also there are special paint-on adjustment tools including Red Eye Removal and Whiten Teeth tools. Simply click on the entry that you want to use and then paint the effect onto your photo. The tools automatically anticipate the area that you want changed and apply the alteration before your eyes. Similar results can be

The Quick Edit toolbar includes (shortcut key):

- includes (shortcut key (1) Zoom Tool (Z)
- (2) Hand Tool H)
- (3) Quick Selection Tool and Selection Brush (A)
- (4) Red Eye Removal (Y)
- (5) Whiten Teeth (F)
- (6) Type tool (T)
- (7) Spot Healing Brush (J)
- (8) Crop tool (C)

obtained using the Smart Brush Tool in the Full Edit workspace. And new for the Quick edit workspace is the Type tool providing extra design options for all users.

Previewing and fine-tuning changes

In this version Adobe re-introduces the ability to preview the effect each control has on the image by clicking one of a series of preview thumbnails located under the manual slider control. Each preview thumbnail displays a different degree of change. Moving your mouse over a thumbnail will preview the effect in the After image in the main workspace. Clicking the thumbnail will apply the adjustment. Click-dragging the mouse cursor left or right will fine-tune the setting from its current values by small increments allowing you to customize the adjustment. Clicking the central thumbnail that features an orange circular arrow returns the image to its original settings.

Adjustments are automatically applied to an image but can be removed by clicking the Reset Panel icon at the top of the panel.

Quick Fix panel controls

Smart Fix - This is the same control that is found in the right-click menu and Fix pane in the Organizer and the Enhance menu in the Editor. The Auto button applies color, tone and sharpness changes automatically whereas the slider allows the user to gradually change the degree of adjustment. This is an all-in-one adjustment. The effects of the control can be undone by selecting the Edit > Undo Smart Fix entry.

Exposure – The Exposure control provides the fastest way to change the overall brightness of the photo. Use this control as your first adjustment when images are too dark or too light. Be careful to check that highlight and shadow detail has not been inadvertently lost when using this adjustment.

Levels — A second lighting control comes in the form of the Levels control. Here we have auto buttons for both Levels and Contrast as well as slider adjustments for lightening shadows, darkening highlights and altering midtone contrast. The auto options are the same as those found in the Enhance menu. Both controls enhance contrast with the levels option also changing the color.

You can see the effects of different levels of change being applied to the After image by clicking the adjustment entry heading (1) and then moving the mouse cursor over each of the thumbnails (2). The change will be shown on the After image. Click-dragging the mouse over a thumbnail allows you to fine-tune the settings (3) and clicking the thumbnail in the center will return the picture to its original settings (4).

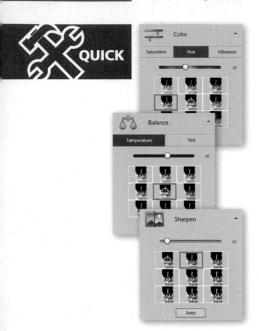

Color – The Saturation and Hue sliders owe their heritage to the Hue/Saturation feature found in the Expert editor workspace. Together with a new Vibrance adjustment they form the Color control. Saturation affects the strength of the color and Hue changes the color itself. Vibrance is similar to the Saturation control because it changes color strength but instead of applying the changes across all hues, Vibrance only affects pastel colors.

Balance – Based on the color temperature controls found in the Adobe Camera Raw utility, the Temperature slider neutralizes color casts by adding blue or yellow to the photo. The Tint slider is used to remove green/red casts.

Sharpen – Previously call the Detail section, the sharpen slider is used to make images clearer. Be careful with this control as overapplication is very noticeable. Using the Auto button is a good place to start the sharpening process.

Menus and other features

Despite the fact that the Quick Edit mode has its own dedicated workspace complete with simplified control pane on the right of the screen and small tool bar on the left, many of the menu entries and their associated functions can also be applied to your photos in this space. In this example the Convert to Black and White feature is applied to the image currently open in the Quick Edit mode.

Editor Expert

In Chapter 2 we looked at how to download, crop, rotate, auto enhance, print and save images directly from the Photo Browser or Organizer workspace. We have also overviewed how to make use of the automatic, guided and quick editing options in Elements. Now you can try your hand at some simple changes courtesy of the Full Edit mode of Photoshop Elements.

It is here that you will start to see the power of the digital process. With a few clicks of the mouse you can perform basic picture adjustments and enhancements easier than ever before. This chapter will take you step-by-step through these changes and also show you how to use these techniques.

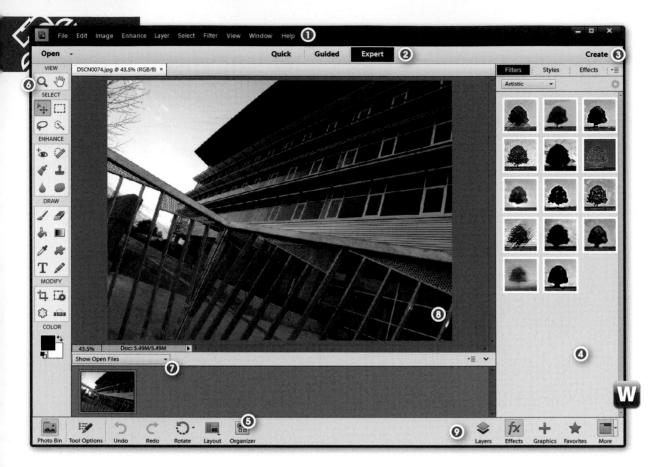

- Menu bar contains features grouped in menu and sub-menus
- 2. Editor Modes the three different editor modes
- 3. Create Menu button display the various creation projects available in the Editor workspace
- 4. Panes for storing panels, palettes, similar to the Palette Well/Bin in previous versions
- 5. Organizer button go to Organizer
- Tool bar displays icons of the tools available; can also be displayed in two-column view
- Photo Bin for easily switching to the active document from those open in the Editor workspace and displaying files selected in the Organizer or Albums
- Image window displays the open picture in Elements; can be maximized, minimized and cancelled using the corner buttons
- Actions Bar provides links to most used actions for a given workspace
 - **Options bar (not shown)** displays the options for the currently selected tool

The interface for the Expert edit workspace in the Windows version of Photoshop Elements 11.

The Expert editor interface

The program interface is the link between the user and the software. Most graphics packages work with a system that includes a series of menus, tools, palettes and dialog boxes. These devices give the user access to the features of the program. The images themselves are contained in windows that can be sized and zoomed. In this regard the Expert Edit space of Elements for both Macintosh and Windows is no different. Version 11 carries on the same feel that we have seen in the last couple of versions of the programme, but the dark gray interface and colored Task Pane section has given way to a lighter and more modern look to the whole program. Now there is only a single task heading - Create. Clicking this button will display a list of options in a drop-down menu rather than a pane, as was the case in the previous version.

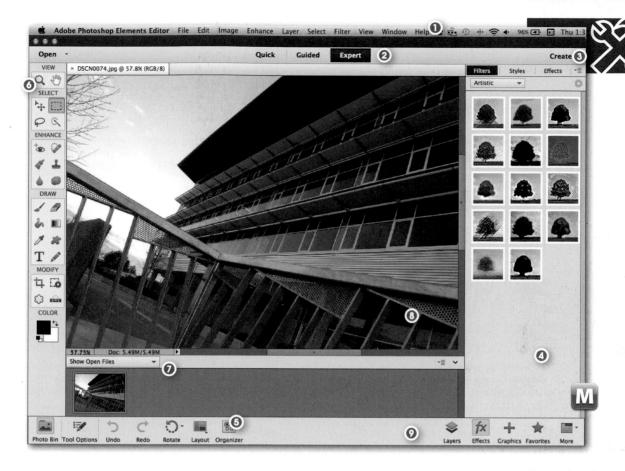

The interface for the Expert edit workspace in the Macintosh version of Photoshop Elements 11.

As we have already seen in the last two chapters, the Editor in Photoshop Elements contains three different editing workspaces — Expert (previously called Full), Quick and Guided. These are accessed via the edit mode buttons at the top of the workspace.

For many editing and enhancement tasks you will be using the Expert editor, so over the next few pages we will look at the various parts of this screen and how they allow you to interact with, and change, your pictures. Version 9 of Photoshop Elements marked the first time that both Macintosh and Windows versions of the product were released at the same time and with the same image management features – the Organizer. If you have been using Elements for a while you will know that it has always been the case that the main Editor spaces are very similar on both platforms but in more recent versions, this now applies to image management as well. Once your images are open in the Editor, the range of features and tools available to you is virtually identical. For this reason the majority of techniques in this chapter and the ones that follow are equally applicable to Mac and Windows users.

EDITOR EXPERT

Menus

Most image-editing programs contain a menu bar with a range of choices for program activities. In addition to the standard File, Edit, View, Window and Help menus, Elements contains five other specialist headings designed specifically for working with digital pictures.

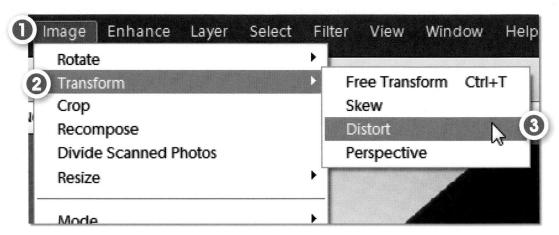

The menu bar provides access to the major features and commands in the program.

- (1) Main menu bar.
- (2) Menu.
- (3) Sub-menu.

The Image menu contains features that change the shape, size, mode and orientation of the picture. Grouped under the Enhance heading is a range of options for altering the color, contrast and brightness of images, as well as the Auto Sharpen, Adjust Sharpness and Convert to Black and White features. All functions concerning image layers and selections are contained under the Layer and Select menus. The special effects that can be applied to images and layers are listed under the Filter menu, but the sharpen filters can be found in the Enhance menu.

Selecting a menu item is as simple as moving your mouse over the menu, clicking to show the list of items, and then moving the mouse pointer over the heading you wish to use. With some selections a second menu (sub-menu) appears, from which you can make further selections.

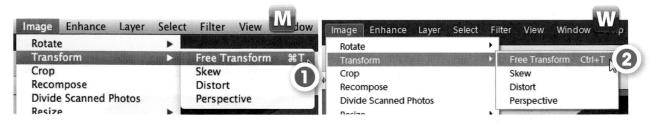

Shortcut keys provide easy access to regularly-used features and tools. (1) Macintosh shortcut keys for Free Transform. (2) Windows shortcut keys for Free Transform.

Some menu items can also be selected using a combination of keyboard strokes called shortcuts. The key combinations for these features are also listed next to the item in the menu list. For example, the Free Transform can be selected using the menu selections Image > Transform > Free Transform or with the key combination of Ctrl + T (the Control key and the letter 'T') for Windows users or Cmd + T for Macintosh users.

Arrange document windows

Photoshop Elements 8 introduced a new way to arrange the photos you have open in the Editor space. Photos can be arranged in a tabbed setup, as individual windows or automatically sized and arranged to all be displayed at the same time.

The Layout button sits on the Actions bar. It was previously called Arrange Documents and was located on the Menu Bar. When pressed, the pop-up menu displays a range of choices that determine the way that the open documents in Elements are displayed. There are a series of arrangement icons in the menu. Selecting one of these will automatically rearrange any open documents in the manner indicated by the icon.

The entries in the View menu provide extra display options that govern how individual images are shown.

Layout

The Menu bar in both the Mac and Windows versions of Elements contains main headings for different feature groups.

The Layout menu (above) contains a comprehensive list of options for the display of open documents in the Editor workspace. Other display choices for individual images are available on the View menu (below).

The Arrange menu provides multiple ways to display open documents in the Editor workspace. Here the same three photos are shown in four different arrangements.

Tools

Unlike menu items, tools interact directly with the image and require the user to manipulate the mouse to define the area or extent of the tool's effect. Over the years the number and types of tools found in digital photography packages have been distilled to a common few that find their way into the toolbox of most programs. Amongst these familiar items are the Magnifying Glass or Zoom tool, the Brush, the Magic Wand, the Lasso and the Cropping tool. In addition to these few, each company produces a specialized set of customized tools that are designed to make particular jobs easier. Of these, Elements users will find the Red Eye Removal tool, Custom Shape, the Selection Brush, Cookie Cutter, Straighten, Healing Brush and the Quick Selection tools particularly useful.

With each version of the program the Elements' engineers work hard to bring new tools and features to users. In version 7 it was the Smart Brush Tool, in Photoshop Elements 8 it was

Selecting a tool in the toolbox displays the tool's other modes, its options or related tool choices in the Options pane at the bottom of the workspace.

the Recompose Tool and in version 10 there was a set of tools labeled with Text on a ... and extras like the Crop Overlay grid option in the Crop tool. More details on these tools can be found later in the chapter.

Some tools contain extra tool modes or hidden options. Clicking the tool in the toolbox displays the options bar at the bottom of the screen. Here you will find not just the options for the tools, but also the different tool modes. These used to exist on sub-menus in previous versions of the software. Selecting a new tool mode from those listed will replace the current icon in the toolbox with your new choice. To switch back simply reselect the original tool or repeatedly press the tool's hot key.

The tool box or tool bar in the Elements Expert editor contains a set of tools that are used directly on the picture surface. Keystrokes for selecting tools are indicated in brackets.

Tool types

The many tools available in Photoshop Elements can be broken into several different groups based on their function or the task that they perform and their groupings and position in the toolbar.

Move and view tools

The Hand tool helps users navigate their way around images. This is especially helpful when the image has been 'zoomed' beyond the confines of the screen. When a picture is enlarged to this extent it is not possible to view the whole image at one time; using the Hand tool the user can drag the photograph around within the window frame. The Zoom tool allows you to get closer to, or further away from, the picture you are working on.

Selection tools

Selection tools are designed to highlight or isolate parts of an image for editing. This can be achieved by drawing around a section of the picture using either the Marquee or Lasso tools or by using the Magic Wand tool to define an area by its color. The Selection Brush tool allows the user to select an area by painting the selection with a special brush tool. Careful selection is one of the key skills of the digital imaging worker. Often, the difference between good quality enhancement and a job that is coarse and obvious is based on the skill taken at the selection stage. Also included in this group is the Quick Selection tool that selects picture parts interactively as you drag the brush over the image surface. The Move tool is used to select, and move, individual picture parts within the picture itself.

Enhancement tools

These tools are designed specifically for use on existing pictures. Areas of the image can be sharpened or blurred, darkened or lightened and smudged using features like the Burn or Dodge tool. The Red Eye Brush is great for removing the 'devil'-like eyes from flash photographs and the Clone Stamp tool is essential for removing dust marks, as well as any other unwanted picture details. The Spot Healing tool works like an advanced version of the Clone Stamp.

Adobe also includes the Smart Brush Tool in this grouping. Its 'paint on' workflow for making adjustments makes it a great inclusion. In recent versions we have seen a range of new pattern and effect presets included in the tool's options bar ensuring the tool is a must-use addition to any enhancement workflows.

Painting/drawing tools

Although many photographers and designers will employ Elements to enhance images captured using a digital camera or scanner, some users make pictures from scratch using the program's drawing tools. Illustrators, in particular, generate their

images with the aid of tools such as the Paint Bucket, Airbrush and Pencil. However, it is possible to use drawing or painting tools on digital photographs. In fact, the judicious use of tools like the Brush can enhance detail and provide a sense of drama in your images.

Also included in this grouping are the Eraser tool, which comes in handy for cleaning up drawn illustrations and photographs alike, the Gradient tool used for filling areas with a blend from one color to another, and the Custom Shape tool. Unlike the other tools in this group, the Custom Shape tool creates vector-based or sharp-edged graphics. This tool is especially good for producing regularly shaped areas of color that can be used as backgrounds for text.

Combining text with images is an activity that is used a lot in business applications. Elements provides the option to apply text horizontally across the page, or vertically down the page. It is also possible to drag the cursor on the image to create Paragraph text. In addition, there are two special text masking options have been included that can be used in conjunction with images to produce spectacular effects. In version 10 Adobe added the Text On Selection, Text On Custom Path, and Text On Shape tools.

Cropping and straightening tools

The final group of tools is designed for removing unwanted sections of the image, altering the format of photos and straightening crooked pictures. Using the standard and familiar Crop tool we can drag a marquee around the part of the picture that we wish to keep and then double-click inside the frame to remove the image areas outside the selection. The Cookie Cutter tool takes the idea further by providing the ability to crop your picture to a specific shape on the rectangular canvas.

The Recompose tool was introduced in Elements 8. It provides the ability to intelligently change the format of a photo. You get to choose which parts of the picture remain unchanged and which sections are stretched or squashed to create the new shape. There will be more details on this later in the chapter.

The Straighten tool is used to correct pictures that are slightly crooked by click-dragging a line along the edge of objects that are meant to be horizontal. After letting the mouse go, Elements rotates the photo so that the marked line becomes horizontal. Using the Ctrl or Cmd keys while drawing also allows you to straighten vertically.

Color options

The color section at the bottom of the toolbar contains two swatches for current foreground and background hues. There is also a button for quickly switching fore- and background colors and a second one for setting the swatches to the defaults - black on white.

The options pane contains all the settings for the currently selected tool. The way that a tool behaves is based on the values found here.

Options pane

Each tool and its use can be customized by changing the values in the options pane (previously the Options Bar). The pane is located at the bottom of the editor workspace and also contains different modes for each tool. The default settings are displayed automatically when you select the tool. Changing these values will alter the way that the tool interacts with your image. For complex tools, like the Brush, more settings can be found by selecting the More button located to the extreme right of the bar.

Panes

Panes are small windows that help users enhance their pictures by providing extra information about images or by listing a variety of modification options. The most regularly used panes are docked on the right hand side of the workspace in the Panel Bin and are displayed by clicking the associated button at the bottom of the area (Actions Bar).

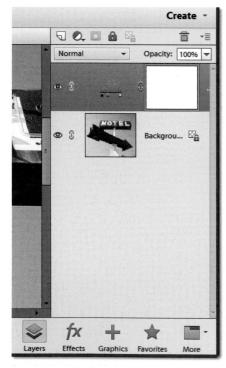

Key Panes are displayed in the Panel Bin by clicking their button in the Actions bar. Use the More button drop-down menu to show extra panes not listed.

The Layers, Effects, and Graphics panes are grouped here and are accessed quickly via their buttons. The Favorites pane provides a place for users to collect the effects, filters, styles, and artwork they use regularly. Entries from other panes can be added here by selecting the Add To Favorites option from the right-click menu when selecting the entry.

Panes not listed in the panel with their own dedicated button are displayed by clicking the More button. The extra panes are grouped together in their own floating window. This group includes the info, Histogram and Color Swatches panes which are displayed by default and Actions, Adjustments, History, and Navigator, which are displayed when selected from the More button's drop-down menu.

Each pane can be moved from the group by click-dragging the title tab. The panes can be regrouped by dragging each pane, by their tab, onto a single palette window.

Selecting the Custom Workspace entry from the More drop-down menu switches the mode of the Panel Bin to a version where any pane can be added to, or removed from, the bin. Return the Panel Bin to the default mode by selecting the Basic Workspace option from the More drop-down menu.

To save space, you should only have open those panes that you need for the editing or enhancing job at hand. Close the remaining panes by

clicking the Close button in the top of the pane window. It is important to note that, unlike in previous versions of the program, these extra panes cannot be dragged to the pane area on the right of the workspace.

The contents of the Panel Bin can be hidden from view by deselecting the Panel Bin option in the Window menu. Alternatively, deselect any button selected at the bottom of the Panel Bin. Unlike previous versions, the panes in the Panel Bin cannot be displayed in different ways: full width, icon view with title or icon-only view. Instead the left edge of the pane can be dragged to the left to enlarge or to the right to make smaller. To restore panels to their default view, click the Reset Panels button in the menu bar or select the same option from the Window menu.

Quick and Guided Editor Panes

In addition to editing panes detailed above, Photoshop Elements also contains fixed panes containing settings, instructional steps, or controls in the Guided and Quick editor modes. These panes cannot be dragged onto the main workspace.

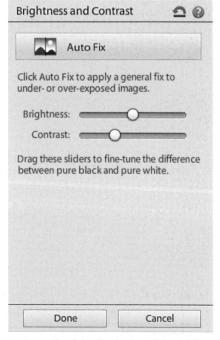

An example of the fixed panes featured in the Guided editor workspace.

Even with exactly the same file and editing program, images can appear very different on several machines

Setting up your screen for Elements

One of the truly amazing features of digital imaging is the diversity of people using the technology. Many individuals in a range of occupations, using various brands of equipment, in different countries across the world, use computer-based picture making as part of their daily work or personal life. The popularity of the system is both its strength and, potentially, one of its weaknesses.

On the positive side it means that an image I make in Australia can be viewed in the United Kingdom, enhanced in the United States and printed in Japan. Each activity would involve importing my picture into a different computer, with a different screen, running an image-editing package like Elements. This is where problems can occur. Even though the program and image are exactly the same, the way that the computer is set up can mean that the picture will appear completely different on each machine. On my computer the image exhibits good contrast and has no apparent color casts. In the UK, however, it might look a little dark, in the USA slightly blue and in Japan too light and far too green.

Before you start

To help alleviate this problem Adobe has built a color management system into its imaging programs that will help you set up your machine so that what you see will be as close as possible to what others see. For this reason it is important that you set up your computer using the system before starting to make changes to your images. The critical part of the process is

ensuring that your monitor is set up correctly. Most default profiles for screens are correctly set up at the time that the installation CD/DVD is run, but if this is not the case then use these following steps to manually install the monitor profile:

1. Windows XP users should select the Control Panel option from the Start menu.

2. Click on the Display icon from those listed.

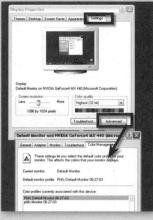

3. Select the Settings tab and then the Advanced settings. Click Add to install a new profile.

1. In Windows Vista or Win7 select the Control Panel option from the Start Orb menu. Switch to Classic View.

2. Click on the Color Management icon in the Control Panel. Choose your monitor from the Device menu.

3. Click the Use My Settings For This Device option and then click the Add button to locate the ICC profile from the driver disk.

- 1. To add a new monitor profile to a Macintosh computer copy the profile to either one of these directories /Library/Colorsync/Profiles (System wide) or ~/Library/Colorsync/Profiles (User folder).
- 2. To check what profile is currently being used navigate to the ColorSync panel (OSX) and then selecting the Devices or Profiles tabs from the list at the top. Now click on the Displays entry and you will see the profile currently being used by the system.

Mac OSX

Hardware-based monitor calibration

The profile that is included with your screen driver is based on the average characteristics of all the screens produced by the manufacturer. Individual screens will display slightly different

characteristics even if they are from the same manufacturer and are the same model number. Add to this the fact that screens' display characteristics change as they age and you will start to see why some photographers who are interested in ensuring that their photos are displayed accurately on screen resort to using a hardware calibration solution such as the ones provided by X-RITE or ColorVision.

The ColorVision option uses a seven-filter colorimeter attached to the screen during the calibration process. This piece of hardware samples a range of known color and tone values that the software displays on screen. The sampled results are then compared to the known color values, the difference calculated and this information is then used to generate an accurate ICC profile for the screen. Unlike when using the supplied profile, this method does require the purchase of extra software and hardware, but it does provides an objective way for the digital photographer to calibrate his or her screen.

For more accurate displays of your photos, calibrate your monitor with a hardware device such as the Spyder.

Calibrate all screens and use color management wherever possible

ware device such as the Keep in mind that for the color management to truly work, all your friends or colleagues Spyder. Who will be using your images must calibrate their systems as well.

PRO'S TIPS

Before you start...

- 1. Set the screen to 24-bit color and a resolution of at least 640 x 480 pixels or greater and ensure that the screen has warmed up for at least 30 minutes.
- 2. Make sure that you know how to change the color, contrast and brightness settings of your monitor. This may be via dials or on-screen menus.
- 3. Ensure that no light source is shining on the screen during the calibration process.
- 4. Once the calibration process has started, don't move the onscreen calibration window.

Setting Color Management in Photoshop Elements

From version 4.0 of Photoshop Elements, Adobe revamped the color management system to make it easier to understand and more logical to use. There are now four options to choose from in the Edit > Color Settings dialog. To ensure that Elements is operating with a color-managed workflow think about how you would normally view your work and then choose between Screen Optimized and Print Optimized options. If you need image-by-image control over what profile is used then select the Allow Me to Choose setting.

Color Management options:

No Color Management – This option leaves your image untagged, deletes attached profiles when opening images and doesn't add a profile when saving.

Always Optimize Colors for Computer Screens – Attaches sRGB to photos without a profile and uses sRGB as the working space but maintains any attached profiles when opening images.

Always Optimize for Printing – Attaches AdobeRGB to photos without a profile and uses AdobeRGB as the working space but maintains any attached profiles when opening images.

Allow Me to Choose – Maintains all attached profiles but allows the user to choose between sRGB and AdobeRGB when opening untagged files (Editor workspace only).

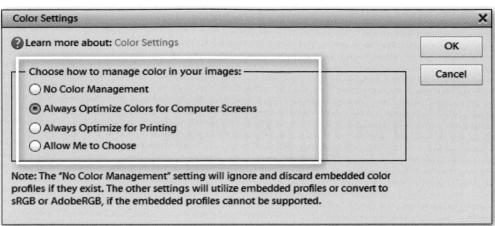

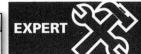

The Color Setting dialog in Photoshop Elements is the control center for the program's color management system. There are four different options found here.

Brightness and contrast changes

As we have already seen in previous chapters, a digital picture is made up of a grid of pixels, each with a specific color and brightness. The brightness of each pixel is determined by a numerical value between 0 and 255. The higher the number, the brighter the pixel will appear; the lower the value, the darker it will be. The extremes of the scale, 0 and 255, represent pure black and white, and values around 128 are considered midtones.

In a correctly exposed image with good brightness and contrast, the tones will be spread between these two extremes. If an image is underexposed, then the picture will appear dark on screen and most of its pixels will have values between 128 and 0. In contrast, images that have been overexposed appear light on screen and the majority of their pixels lie in the region between 128 and 255.

A well-exposed photograph (2) will have good brightness and contrast, and will display a good spread of tones between black and white or shadow and highlight. An underexposed image (3) appears dark on screen whereas an overexposed image (1) appears light on screen.

Highlight areas with no details

Shadow details much too light

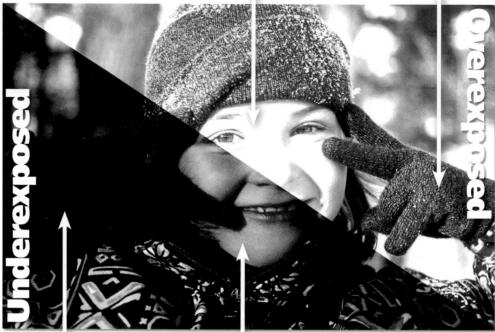

Image details are lost when an image is either under- or overexposed.

Shadow details converted to pure black

Highlight areas more like midtones

The best method for correcting these situations is for you to recapture the picture, changing the settings on your scanner or camera to compensate for the exposure problem. Good exposure not only ensures a good spread of tones, but also gives you the chance to capture the best detail and quality in your photographs. It is a misunderstanding of the digital process to excuse poor exposure control by saying 'it's okay, I'll fix it in Elements later'. You will not get the best quality pictures possible if you use Elements to correct shooting or scanning mistakes as vital detail has been lost forever in images that are either too dark or too light. Sometimes, though, a reshoot is not possible or a rescan is not practical. In these circumstances, or in a situation where only slight changes are necessary, Elements has a range of ways to change the brightness and contrast in your photos.

Editor: Enhance > Adjust Lighting > Brightness/Contrast

The Brightness/Contrast command helps you make basic adjustments to the spread of tones within the image. The feature was revamped for version 6 so that the changes it makes are less harsh. When opened you are presented with a dialog containing two slider controls. Click and drag the slider to the left to decrease brightness or contrast, or to the right to increase the value. Keep in mind that you are trying to adjust the image so that the tones are

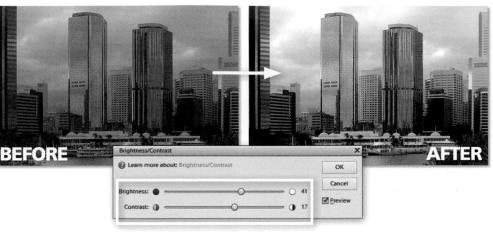

The Brightness/Contrast feature is located under the Adjust Lighting section of the Enhance menu. After adjusting the brightness and contrast of an image, the picture will appear clearer and its tones will be spread more evenly.

more evenly distributed between the extremes of pure white and black. Too much correction using either control can result in pictures where highlight and/or shadow details are lost. As you are making your changes, watch these two areas in particular to ensure that details are retained.

Adjusting Brightness and Contrast:

- 1 Select Enhance > Adjust Lighting > Brightness/Contrast.
- 2 Move sliders to change image tones.
- 3 Left to decrease brightness/contrast, right to increase.
- 4 Click OK to finish.

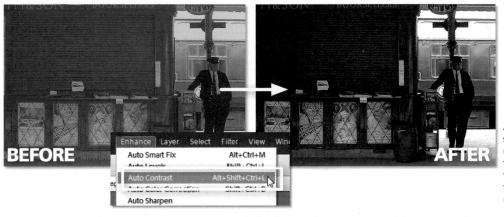

Auto Contrast adjusts and spreads image tones automatically and is available from the Enhance menu in the Editor workspace or the Fix panel in the Organizer.

Editor: Enhance > Auto Contrast

The Auto Contrast command can be used as an alternative to the Brightness/Contrast sliders. In this feature Elements assesses all the values in an image and identifies the brightest and darkest tones. These pixels are then converted to white and black, and those values in between are spread along the full tonal range. Auto Contrast works particularly well with

photographic images but can produce unpredictable results with graphic illustrations. This option is also available in the Fix panel in the Organizer workspace.

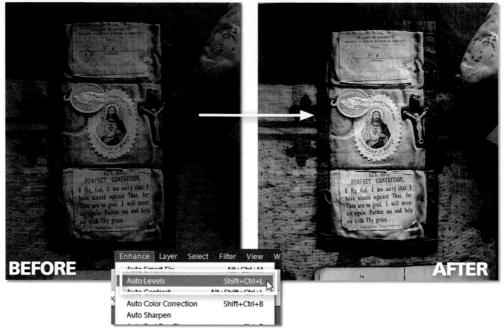

Auto Levels adjusts and spreads the tones of each individual color channel. In some pictures this feature can help to reduce color casts. The feature can be found under the Editor's Enhance menu or in the Organizer's Fix panel.

Editor: Enhance > Auto Levels

The Auto Levels command is similar to Auto Contrast in that it maps the brightest and darkest parts of the image to white and black. It differs from the previous technique because each individual color channel is treated separately. In the process of mapping the tones in the Red, Green and Blue channels, dominant color casts can be neutralized.

This is not always the case; it depends entirely on the make-up of the image. In some cases the reverse is true; when Auto Levels is put to work on a neutral image, a strong cast results. If this occurs, undo (Edit > Undo) the command and apply the Auto Contrast feature instead. This option is also one of the Organizer's Fix panel enhancement options.

Editor: Enhance > Auto Smart Fix

The Auto Smart Fix feature enhances both the lighting and color in your picture automatically. The command is used to balance the color and improve the overall shadow and highlight detail. Most images are changed drastically using this tool. In some cases the changes can be too extreme, in which case the effect should be reversed using the Edit > Undo command and the more controllable version of the tool – Adjust Smart Fix – used instead. Auto Smart Fix can also be applied from inside the Organizer workspace.

Editor: Enhance > Adjust Smart Fix

The Adjust Smart Fix version of the feature provides the same control over color, shadow and highlight detail but with the addition of a slider control that determines the strength of

the enhancement changes. Moving the slider from left to right will gradually increase the amount of correction applied to your picture. This approach provides much more control over the enhancement process and is a preferable way to work with all but the most general photos. The Auto button, also located in the dialog, automatically applies a fix amount of 100% and provides a similar result to selecting Enhance > Auto Smart Fix.

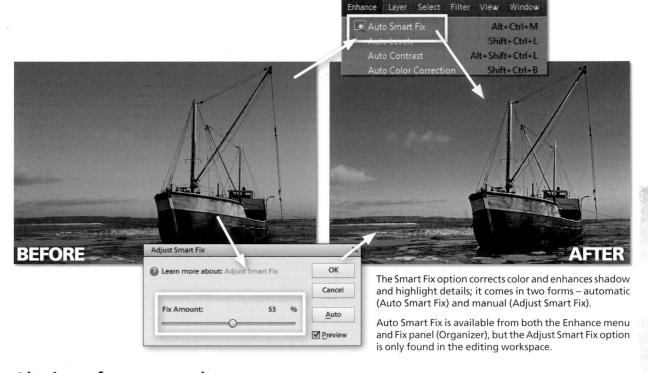

Altering a few tones only

Now that we have changed the brightness and contrast of the image so that the tones are more evenly spread between black and white, we can start to look at individual areas or groups of tones that need special attention.

For instance, when you are taking pictures on a bright sunny day, or where the contrast of the scene is quite high, the shadows in the image can become so dense that important details are too dark to see. A traditional method used by photographers to lighten the shadows is to capture the scene using a combination of existing light and a small amount of extra light from a flash. The flash illuminates the shadows, in effect 'filling' them with light, hence the name 'Fill Flash'. This is a great solution for a difficult problem.

Similarly, if the foreground or center section of a scene is dark, then the exposure system in a digital camera can overcompensate and cause the surrounding area to become too light. 'No problem', you say, as you adjust the brightness so that the whole picture is darker, but this action also affects the shadow and midtone areas of the picture, causing them to lose detail.

So how can we alter the brightness of just the shadow or only the highlight areas? Well, Adobe provided quite a clever solution to these problems in the earlier versions of the program, employing two features – Fill Flash and Adjust Backlighting. Version 3.0 replaced these with yet another feature called the Shadow/Highlight control. The tool combines two different controls that performed similar functions in previous versions of the product into the one dialog.

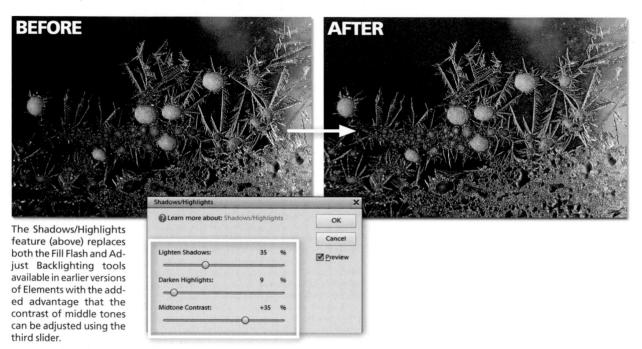

Editor: Enhance > Adjust Lighting > Shadows/Highlights

Designed as a replacement for both the Fill Flash and Adjust Backlighting controls, this one little dialog contains the same power as the previous two features in an easy-to-use format. The tool contains three sliders – the upper one is for Lightening Shadows, which replaces the Fill Flash tool, the control in the middle Darkens Highlights and is a substitute for the Adjust Backlighting tool, and the final slider adjusts Midtone Contrast.

Moving the Shadows control to the right lightens all the tones that are spread between the middle values and black. Sliding the Highlights control to the right darkens those tones between middle values and white. The beauty of this feature is that unlike the Brightness/Contrast tool, these changes are made without altering other parts of the picture. To fine-tune the tonal changes a third slider is also included in the dialog. Moving this Midtone control to the right increases the contrast of the middle values, and movements to the left decrease the contrast, making the image 'flatter'. You can also use the Midtone Contrast slider in the Advanced options of the Adjust Color Curves dialog box to produce similar results.

Shadow and Highlight adjustment workflow:

- 1 Select Enhance > Adjust Lighting > Shadows/Highlights.
- 2 Move all sliders so that their values are set to 0%.
- 3 Move the Lighten Shadows slider to the right to lighten the dark tones.
- 4 Move the Darken Highlights slider to the right to darken light areas.
- 5 Adjust the Midtone Contrast slider to restore any lost contrast to the picture.

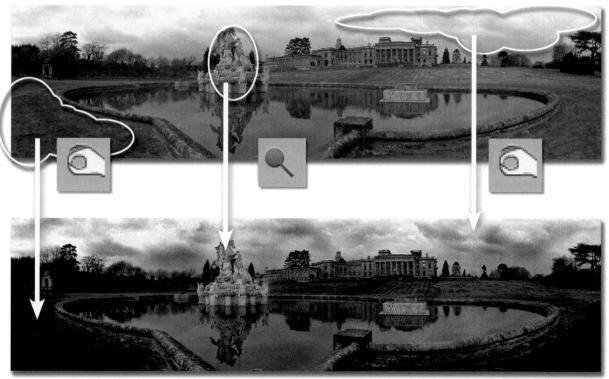

Dodge and Burn tools

It is no surprise, given Adobe's close relationship with customers who are professional photographers, that some of the features contained in both Photoshop and Elements have a heritage in traditional photographic practice. The Dodge and Burn tools are good examples of this. Almost since the inception of the medium, photographers have manipulated the way their images have printed. In most cases this amounts to giving a little more light to one part of the picture and taking a little away from another. This technique, called dodging and burning, effectively lightens and darkens specific parts of the final print.

Adobe's version of these techniques involves two separate tools. The Dodge tool's icon represents its photographic equivalent – a cardboard disk on a piece of wire. This device was used to shade part of the photographic paper during exposure. Having received less exposure,

Skillful dodging and burning can help improve the appearance of specific dark and light picture areas.

Highlights, shadows and midtones can be dodged and burnt separately.

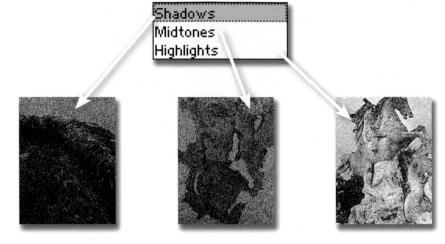

the area is lighter in the final print. When you select the digital version from the Elements toolbox, you will notice the cursor change to a circle which you can click and drag over your image to lighten the selected areas.

The size and shape of the circle is based on the current brush size and shape. This can be changed via the palette in the options bar. Also displayed here are other options that allow you to lighten groups of tones like shadows, midtones and highlights independently. There are also controls to change the strength of the lightening process by adjusting the exposure.

Dodging workflow:

- 1 Select the Dodge tool from the toolbox.
- 2 Choose the brush size from the palette in the options bar.
- 3 Select the group of tones to adjust highlights, midtones or shadows.
- 4 Set the strength of the effect via the exposure value.
- 5 Click and drag the cursor over the image to lighten.

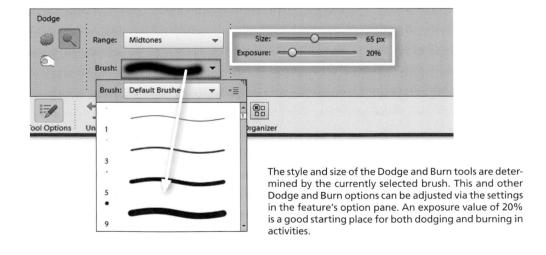

The Burn tool's attributes are also based on the settings in the options bar and the current brush size, but rather than lightening areas, this feature darkens selected parts of the image. Again, you can adjust the precise grouping of tones, highlights, midtones or shadows that you are working on at any one time.

Burning workflow:

- 1 Select the Burn tool from the toolbox.
- 2 Choose the brush size from the palette in the options bar.
- 3 Select the group of tones to adjust highlights, midtones or shadows.
- 4 Set the strength of the effect via the exposure value.
- 5 Click and drag the cursor over the image to darken.

As with many digital adjustment and enhancement techniques, it is important to apply dodging and burning effects subtly. Overuse is not only noticeable, but you can also lose the valuable highlight and shadow details that you have worked so hard to preserve.

Color corrections

Our eyes are extremely complex and sophisticated imaging devices. Without us even being aware of it, they adjust to changes in light color and level, For instance, when we view a piece of white paper outside on a cloudy day, indoors under a household bulb or at work with fluorescent lights, the paper appears white. Our eyes adapt to each different environment.

Unfortunately, digital sensors, including those in our cameras, are not as clever. If I photographed the piece of paper under the same lighting conditions, the pictures would all display a different color cast. Under fluorescent lights the paper would appear green, lit by the household bulb it would look yellow, and when photographed outside it would be a little blue.

The dominant color cast in an image changes when it is shot under different light sources.

- (1) Fluorescent.
- (2) Household bulb.
- (3) Candlelight.
- (4) Daylight.

This situation occurs because camera sensors are generally designed to record images without casts in daylight. As the color balance of the light for our three examples is different from daylight - that is, some parts of the spectrum are stronger and more dominant than others – the pictures record with a cast. Camera manufacturers are addressing the problem by including Auto White Balance functions in their designs. These features attempt to adjust the captured image to suit the lighting conditions it was photographed under, but even so some digital pictures will arrive at your desktop with strange color casts.

Some cameras include an Auto White Balance feature designed to compensate for different light sources.

Auto Color Correction, known as just Auto Color in the Organizer's Fix panel, provides a one-click correction for most cast problems.

Editor: Enhance > Auto Color Correction

The Auto Color Correction feature, first seen in version 2.0 of the program, works in a similar way to tools like Auto Levels and Auto Contrast, providing a one-click fix for most color problems. As with all 'I'll let the computer decide' features, sometimes such automatic fixes do not produce the results that you expect. In these scenarios use the Undo (Edit > Undo) command to reverse the changes and try one of the manual tools detailed below.

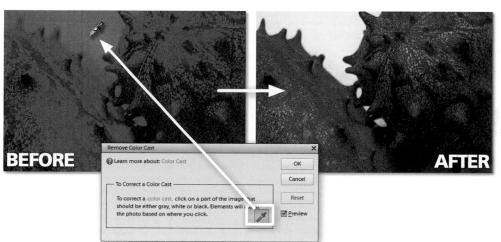

The Remove Color Cast feature works when you select a portion of the picture that should be neutral (white, gray or black) but exhibits a cast. Elements then rebalances the rest of the hues in the image to ensure that this part of the picture is cast-free.

Editor: Enhance > Adjust Color > Remove Color Cast

To help provide a more selective solution to the color cast problem, Adobe included the Color Cast command in Elements. This function is designed to be used with images that have areas that are meant to be white, gray or black. By selecting the feature you can then click onto the neutral area and all the colors of the image will be changed by the amount needed to make the area free from color casts. This command works particularly well if you happen to have a gray or black area in your scene. Some image makers include a gray card in the corner of scenes that they know are going to produce casts in anticipation of using Color Cast to neutralize the hues later.

Remove Color Cast workflow:

- 1 Select Enhance > Adjust Color > Remove Color Cast.
- 2 Use the Eyedropper tool to click on a part of the image that is meant to be either a neutral white, gray or black.
- 3 If you are unhappy with the results, click the Reset button to start again or keep clicking until you get a suitable result.
- 4 Click OK when the cast has been removed.

Keep in mind that this command produces changes based on the assumption that what you are clicking with the Eyedropper is meant to be neutral – that is, the color should contain even amounts of red, green and blue. In practice, it is not often that images have areas like this. For this reason Elements contains another method to help rid your images of color casts.

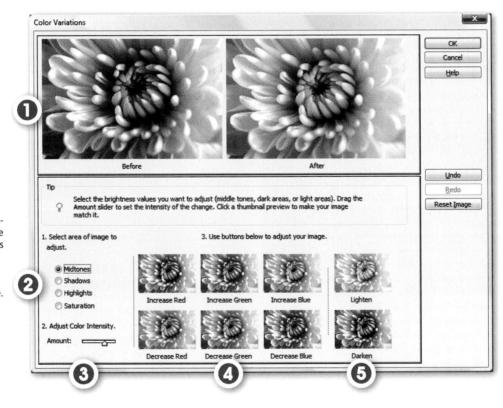

The Color Variations feature gives the user more control over color changes in the image.

- (1) Before and after thumbnails.
- (2) Image area to change.(3) Color strength or
- intensity.
 (4) Color variation thumbnails.
- (5) Brightness thumbnails.

Editor: Enhance > Adjust Color > Color Variations

An alternative to using the Remove Color Cast feature is the Color Variations command. From version 2.0 Elements has included a revised and simplified Color Variations dialog. Over the last few versions the color changing thumbnails have been rationalized so that users only have to make simple decisions about increasing or decreasing the red, green or blue components of their images. The Color Variations feature is now divided into four parts.

The top of the dialog contains two thumbnails that represent how your image looked before changes and its appearance after. The radio buttons in section 2 (middle left) allow the user to select the parts of the image they wish to alter. In this way, highlights, midtones and shadows can all be adjusted independently. The Amount slider in section 3 (bottom left) controls the strength of the color changes. The final parts, sections 4 and 5 (bottom), are taken up with six color and two brightness preview images. These represent how your picture will look with specific colors added or when the picture is brightened or darkened. Clicking on any of these thumbnails will change the 'after' picture by adding the color chosen. To add a color to your image, click on a suitably colored thumbnail. To remove a color, click on its opposite.

Color Variations workflow:

- 1 Select Enhance > Adjust Color > Color Variations.
- 2 Choose the tones you want to change (shadows, midtones or highlights) or alternatively select saturation.
- 3 Adjust the Amount slider to set the strength of each change.
- 4 Click on the appropriate thumbnails to make changes to your image.
- 5 Click OK to finish.

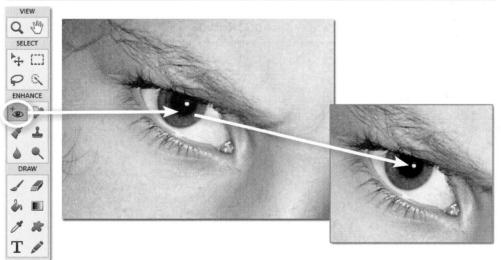

The Red Eye Removal tool is designed to eliminate the 'devil-like' eyes that result from using the inbuilt flash of some digital cameras.

The Red Eye Removal tool

Using the built-in flash in your camera is a great way to make sure that you can keep photographing in any light conditions. One of the problems with flashes that are situated very close to the lens is that portrait pictures, especially when taken at night, tend to suffer from 'red eye'. The image might be well exposed and composed, but the sitter has glowing red eyes. This occurs because the light from the flash is being reflected off the back of the eye.

EDITOR EXPERT

Adobe recognized that a lot of small modern digital cameras have flashguns close to their lens — the major cause of this problem — and developed a specialist tool to help retouch these images. Called the Red Eye Removal tool since version 3.0 and the Red Eye Brush in previous releases, it changes the crimson color in the center of the eye to a more natural-looking black.

To correct the problem is a simple process that involves selecting the tool and then clicking on the red section of the eye. Elements locates the red color and quickly converts it to a more natural dark gray. The tool's options bar provides settings to adjust the pupil's size and the amount that it is darkened. Try the default settings first and if the results are not quite perfect, undo the changes and adjust the option's settings before reapplying the tool.

Red Eye Removal workflow:

- 1 Select the Red Eye Removal tool from the toolbox.
- 2 Click on the red area of the eye or drag a marquee around the eye to apply the color change.
- 3 If the results are not perfect, Edit > Undo the changes and adjust the Pupil Size and Darken Amount settings in the options bar. Click on the red area to reapply the color change.

The Red Eye Removal tool is available in both the Quick Fix and Full editing workspaces.

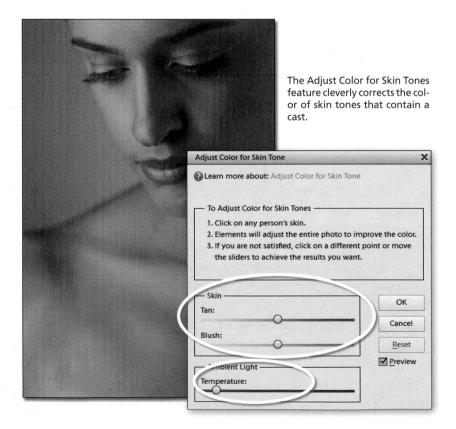

Editor: Enhance > Adjust Color > Adjust Color for Skin Tone

The Adjust Color for Skin Tones feature is designed to allow you to adjust the hue of the skin tones within your picture.

Making changes is a two-step process. When the feature first opens you need to use the Eyedropper tool to select a typical section of skin within the photo. Next, you can adjust the color of the skin using the Tan and Blush sliders and the overall color of the picture with the Temperature control.

The picture can be reverted to its original hues by selecting the Reset button or the changes applied by pressing the OK button.

Skin Color Enhancement workflow:

- 1 Select Enhance > Adjust Color > Adjust Skin Tone.
- 2 Use the Eyedropper tool to click on an area of typical skin in the picture.
- 3 Adjust the Skin and Blush sliders to alter skin color.
- 4 Change the Temperature slider to alter the color of the whole image.
- 5 Click Reset to remove changes or OK to finish.

As the Skin Tone tool averages tones as it works, multiple clicks around different parts of a person's face will often refine the results. Holding down the Ctrl key while clicking turns off the averaging and will resample with each click.

Transforming the shape of photos

In previous chapters we have looked at how it is possible to change the shape of your photo by cropping away parts of the image that you don't want. Typically the crop tool is used for this purpose, but what if you wanted to preserve the all of the content in the photo and still change its shape from say, landscape to something that was a squarer format.

This is when most people would reach for the Free Transform tool (Editor: Image > Transform > Free Transform). After selecting the feature from the menu you will notice small handles at the corners and edges of your photo. These can be dragged with the mouse to alter the format of the picture. The only problem with this approach is that if we drag in the edges of the landscape photo to create a picture that is square, all the details in the photo are squashed in the process. For some imagery, such as landscapes, this might not be too notice- The Recompose tool is able but in photos containing people the subjects do take on a very tall and thin look.

grouped with the Crop tool in the Elements' toolbar.

Introducing the Recompose tool

So what is the solution? Well in version 8 of Photoshop Elements the Adobe folks introduced a new feature called the Recompose Tool. Designed specifically for this situation, the tool can be used to isolate the parts of the image that you do and

don't want to change shape during the transformation process. So in the case of the example you see here, the people in the center of the photo are Marked for Protection using a special green-colored brush. The rest of the scene is left untouched signifying to Elements that this detail can be adjusted. The Recompose Tool uses the same edge and corner handles as the Free Transform tool, so after areas are marked for protection, the format of the picture can be adjusted by dragging on of the handles.

After selecting the Mark for Protection brush from the Recompose options bar, you can paint over the important parts of the image to ensure that these key details are not altered in the transformation process.

The Recompose Tool in Action

In this example, the panorama format image needs to be changed so that it is more of a square shape. The key details are the people in the center, so the Mark for Protection brush is used to paint over these parts of the photo. The tool's options bar also includes a Mark for Deletion brush which can be used to paint over areas that you want removed during the transformation process. This brush paints in red. Both brushes have Eraser equivalents that can be used to fine-tune the areas marked for deletion or protection.

Once all areas have been marked, the edge handles are used to drag in the left and right sides of the photo to create a square-shaped picture. The end result sees the people left untouched and the background and surrounds squashed to accommodate the new format. Cool!

Recomposing to a specific shape

As well as the free form transformations like the example above, the tool can be used to reformat an image to a specific ratio. This is pretty handy if you are trying to get a photo to fit a specific piece of printing paper. To recompose to size just select the format from the drop-down list in the Preset section of Options bar.

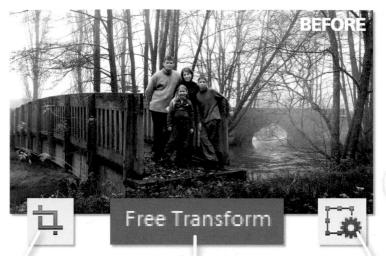

Until the release of the Recompose Tool in Photoshop Elements 8 the only way to change the format of a photo was to use the Crop Tool (1) or the Free Transform tool (2).

Both approaches had their own problems. The Crop tool removed important parts of the photo and the Transform tool squashed and stretched all the details in a photo, even if they were important.

The new Recompose Tool (3) provides a better solution by allowing the user to mark important parts of the picture and therefore protect them from alteration in the transformation process.

The example above displays the results of all three approaches as the landscape photo is reformatted to a square shape.

The Recompose tool's options bar contains 'Protect' (1) and 'Delete' (2) brushes and erasers, brush tip size slider (3), a highlight skin tones button (4), crop preset menu (5), crop width and height input boxes (6) and threshold control (7).

EDITOR EXPERT

If the actual paper size is not listed in the preset menu, you can add a custom size by typing in the page dimensions in the width (W) and height (H) text boxes which are also located on the tool's options bar. The two arrows button between the dimension text boxes is used to swap height and width values which allows for quick changes between portrait and land-scape formats.

Automatic protection of skin tones

For most photographers it will be the people in their photos that they will want to protect from scaling changes made with the Recompose tool. For this reason Adobe has also included a button on the options bar that marks for protection any skin tones within a photo. Clicking this button provides a fast way to paint over all skin colored areas in the photo. In practise the results tend to include areas beyond just skin tones, but these can be quickly removed with the Mark for Protection Eraser tool. Any areas missed can be added by painting over them with the Mark for Protection Brush tool.

The Recompose tool workflow:

- 1 With an image open in the Editor workspace, select the Recompose tool from the toolbar. As the feature is grouped with the Crop tool it maybe necessary to click on the small arrow at the bottom right of the tool icon to reveal the Recompose tool first before you can select it.
- 2 Use the Mark for Protection brush (green) to paint over areas of the photo that you don't want to change during the transformation process.
- 3 Use the Mark for Deletion brush (red) to paint over areas of the photo that you want removed from the picture during the transformation process.
- 4 Alternatively you can click the Highlight Skin Tones button to automatically paint green on the skin colored areas of the photo.
- 5 User the Eraser tools to fine-tune the protection and deletion areas.
- 6 Choose a crop size from the Preset menu on the options bar to reshape the picture to a specific format. Type in actual dimensions in the Height and Width text boxes for a custom size or dimensions not listed on the Presets menu.
- 7 For custom scaling drag one of the edge or corner handles to alter the shape of the photo.
- 8 Click the green tick icon at the bottom of the window to commit to the transformation.

Advanced Techniques

There is no denying that Photoshop Elements has many features that make it easy to use. In fact, I know from first-hand experience that the development team at Adobe HQ spend a lot of time and effort ensuring that you, the user, can edit and enhance your photos quickly and easily.

But this is not where the Elements story ends. Behind the glossy interface of the program lies all the power and sophistication of Photoshop itself. That's right, the core coding that drives Photoshop also gives life to Photoshop Elements. This means that for those users who want to delve a little deeper into the editing process, Elements has the power to support their quest.

In the next few chapters we will look a little closer at the tools and features inside the Elements' Editor workspace.

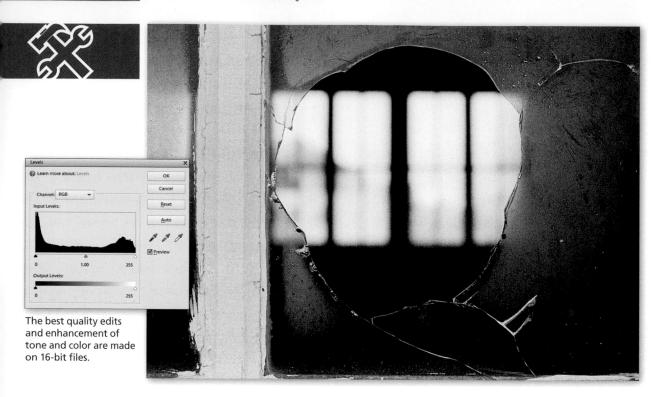

Pictures that have been imported into the Organizer space or opened in the Editor as 16-bit files can be converted to 8 bits per channel via the Image > Mode menu.

The importance of Bit Depth

Each digital file you create (capture or scan) is capable of representing a specific number of colors. This capability, usually referred to as the 'mode' or 'color depth' of the picture, is expressed in terms of the number of 'bits'. Most photos these days are created in 24-bit mode. This means that each of the three color channels (Red, Green and Blue) is capable of displaying 256 levels of color (or 8 bits per channel). When the three channels are combined, a 24-bit image can contain a staggering 16.7 million separate tones/hues.

This is a vast amount of colors and would be seemingly more than we could ever need, see or print, but many modern cameras and scanners are now capable of capturing up to 16 bits per channel or 'high-bit' capture in either Raw or TIFF file formats. This means that each of the three colors can have as many as 65,536 different levels and the image itself, with all three channels combined, a whopping 281,474,976 million colors (last time I counted!). But why would we need to capture so many colors?

More colors equals better quality

Most readers would already have a vague feeling that a high-bit file (16 bits per channel) is 'better' than a low-bit (8 bits per channel) alternative, but understanding why is critical for ensuring the best quality in your own work.

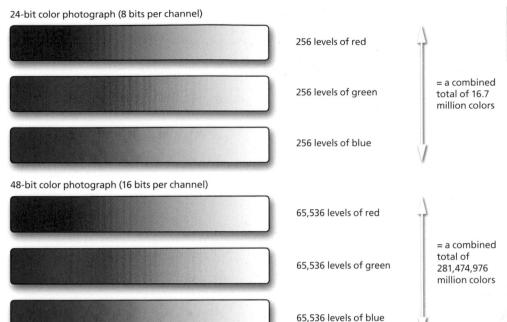

Comparing Bit Depth: The higher the bit depth of an image the more levels of tone and number of colors it can display.

Here are the main advantages in a nutshell:

- 1 Capturing images in high-bit mode provides a larger number of colors for your camera or scanner to construct your image. This in turn leads to better color and tone in the digital version of the continuous tone original.
- 2 Global editing and enhancement changes made to a high-bit file will always yield a better quality result than when the same changes are applied to a low-bit image.
- 3 Major enhancement of the shadow and highlight areas in a high-bit image is less likely to produce posterized tones than if the same actions were applied to a low-bit version.
- 4 More gradual changes and subtle variations are possible when adjusting the tones of a high-bit photograph, using tools like Levels, than is possible with low-bit images.

Redistributing the tones on an 8 bits per channel file (2) can lead to loss of levels of gray (white spikes) and noticeable 'banding' in the image. 16 bits per channel files (1), by contrast, maintain their appearance of continuous tone even after guite drastic editing and enhancement actions.

ADVANCED TECHNIQUES

Photoshop Elements is 16-bit enabled

But why all this talk about 16 bits per channel files (48-bit color in total)? Well, since the version 3.0 release of Elements, the program has been 16-bit enabled. This means that if you have a camera or scanner that is capable of capturing in this mode you can now take advantage of the extra color and tone it provides. 'Fantastic!' you say. 'No more 8 bits per channel (24-bit image) tweaking for me, I'm a 16 bits per channel fanatic from here on in.' But there is a catch (you knew there had to be).

Despite the power and sophistication of Elements, only a subset of its features is available for working on 16-bit files. Of the tools, the Rectangular and Elliptical Marquee and Lasso, Eyedropper, Move, Crop and Zoom tools all function in this mode. In addition, you can rotate, resize, apply auto levels, auto contrast or auto color correct or use more manual controls such as Levels, Shadows/Highlights and Brightness/Contrast features. The Sharpen, Noise, Blur and Adjustment filter groups also work here. Does this mean that making enhancement changes in 16-bit mode is unworkable? No, you just need to use a different approach. Read on.

Global versus local enhancement

Because of the limitations when working with a 16 bits per channel file in Elements, some digital photographers break their enhancement tasks into two different sections – global and local.

Global, or those changes that are applied at the beginning of the process to the whole picture. These include general brightness and contrast changes, some color correction and the application of a little sharpening.

Local changes are those that are more specific and are sometimes applied to just sections of the picture. They may include dodging and burning in, removal of unwanted dust and scratches, the addition of some text and the application of special effects filters.

This separation of enhancement tasks fits neatly with the way that the 16-bit support works in Photoshop Elements. Global changes can be applied to the photograph whilst it is still in 16-bit mode; the file can then be converted to 8 bits per channel (Image > Mode > 8 Bits/channel) and the local alterations applied. This is the process that the professionals have been using for years and now Elements gives you the power to follow suit.

Common high-bit misconceptions

Elements can't handle high-bit images. Not true. Previous versions of the program couldn't handle high-bit pictures but since Elements 3.0, the program has contained a reduced feature set that can be used with 16 bits per channel images. And even with this limitation there are enough features available to ensure quality enhancement of your images.

High-bit images are too big for me to handle and store. Yes, high-bit images are twice the file size of 8-bit pictures and this does slow down machines with limited resources but, if this is a concern, put up with the inconvenience of a slow machine whilst you make tonal and color changes then convert to a speedier 8-bit file for local changes.

I can't use my favorite tools and features in high-bit mode so I don't use high-bit images at all. You are losing quality in your images needlessly. Perform your global edits in 16-bit mode and then convert to 8-bit mode for the application of your favorite low-bit techniques.

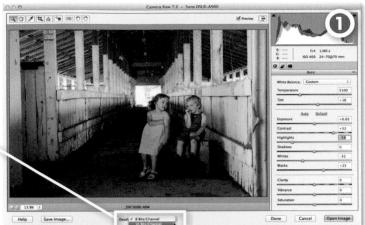

Depth √ 8 Bits/Channel 16 Bits/Channel

The Bit Depth that is used for outputting processed images can be selected from the Depth menu at the bottom of the work screen.

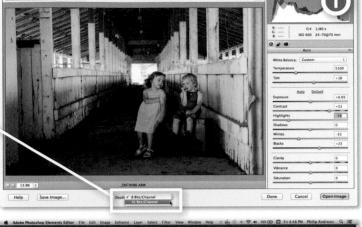

16-bit files are changed to 8-bit images by selecting the 8 bits/channel option in the Image > Mode menu.

Select

VAXV

Filter View

Grayscale

✓ RGB Color

8 Bits/Chai

Guided

mage Enhance Layer

Divide Scanned Photos

Convert Color Profile

Magic Extractor

Rotate

Crop

Resize

Transform

Recompose

DSC9086.ARW @ 13.9% (RGB/16)

Q I

to 0

4 0

D- 📠 😤

The title bar shows the bit depth of the open file.

Notice the grayed out features in the Enhance menu that can't be used with a 16-bit file.

_DSC9086.ARW @ 13.9% (RGB/8)

The title bar shows the bit depth of the open file.

8-bits per channel files can be enhanced with the full set of features in Elements.

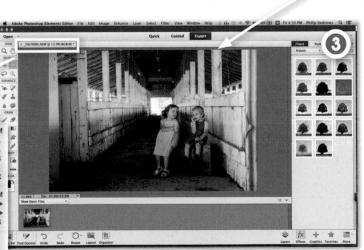

16-bit Workflow:

The aim is to perform as many of your standard editing tasks on the Raw and 16-bit file as possible as this will give you the best overall editing results. Once these changes have been made it is then time to convert the file to 8 bits per channel to finish your enhancement techniques.

- (1) Create 16-bit files from raw format pictures.
- (2) Perform all possible enhancement steps whilst the image is in 16-bit mode.
- (3) Convert to 8-bit mode and complete editing and enhancing the photo with tools and techniques that are only possible with 8-bit files.

Manual tonal control

The Brightness/Contrast feature that we looked at in the last chapter is a great way to start to change the tones in your images, but as your skill and confidence increase you might find that you want a little more control. Adobe included the Histogram feature and the Levels function from Photoshop in Elements for precisely this reason.

Editor: Window > Histogram

The first step in taking charge of your pixels is to become aware of where they are situated in your image and how they are distributed between black and white points. As we have seen in the Raw Shooting chapter, a Histogram is a graph of all the pixels in your image. The left-hand side represents the black values, the right the white end of the spectrum. As we already know, in a 24-bit image there are a total of 256 levels of tone possible from black to white – each of these values is represented on the graph. The number of pixels in the image with a particular brightness or tone value is displayed on the graph by height.

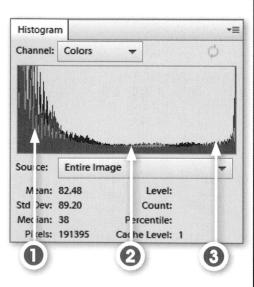

The Histogram provides graph-based information about the spread of pixel tones within your image so that you can see the number of pixels grouped in the shadows (1), midtones (2) and highlights (3) areas.

Knowing your images

After a little time viewing the histograms of your images, you will begin to see a pattern in the way that certain styles of photographs are represented. Overexposed pictures will display a large grouping of pixels to the right end of the graph, whereas underexposure will be represented by most pixels bunched to the left. Flat images or those taken on an overcast day will show all pixels grouped around the middle tones and contrasty pictures will display many pixels at the pure white and black ends of the spectrum.

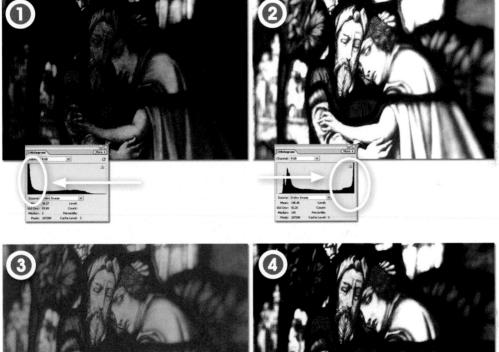

You can diagnose the problems with your photos and predict the way that your picture looks by the shape of the graph in the Histogram palette and the Levels feature.

(1) The pixels are bunched to the left end of the graph for underexposed images and (2) to the right end for overexposed ones.

(3) Pixels are bunched together in the middle of the graph for flat images. (4) The pixels are spread right out to the left and right edges for contrasty pictures.

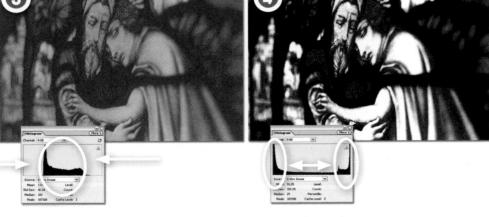

Previously in this book we have fixed these tonal problems by applying one of the automatic correction features, such as Auto Contrast or Auto Levels, or by using a simple slider control such as Brightness/Contrast. All of these tools remap the pixels so that they sit more evenly across the whole of the tonal range of the picture. Viewing the Histogram of a corrected picture will show you how the pixels have been redistributed.

Editor: Enhance > Adjust Lighting > Levels

If you want to take more control of the process than is possible with the auto solutions, open the Levels dialog. Looking very similar to the Histogram, this feature allows you to interact directly with the pixels in your image. As well as a graph, the dialog contains two slider bars. The one directly beneath the graph has three triangular controls for black, midtones and white, and represents the input values of the picture. The slider at the bottom of the box shows output settings, and contains black and white controls only.

To adjust the pixels, drag the Input Shadow (left end) and Highlight (right end) controls until they meet the first set of pixels at either end of the graph. When you click OK, the pixels in the original image are redistributed using the new white and black points. Altering the Midtone control will change the brightness of the middle values of the image, and moving the output black and white points will flatten, or decrease, the contrast. Clicking the Auto button is like selecting Enhance > Auto Levels from the menu bar.

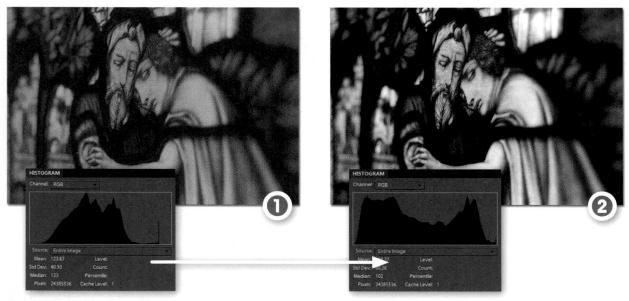

Auto Levels:

The Auto Levels or Auto Contrast feature redistributes pixels in the graph between the black and white points.
(1) Before Auto Levels.

(2) After Auto Levels.

Pegging black and white points

On the right-hand side of the Levels dialog is a set of three Eyedropper buttons used for sampling the black, gray and white pixels in your image. Designed to give you ultimate control over the tones in your image, these tools are best used in conjunction with the Info palette (Window > Info).

To use this technique, start by making sure that the Info palette is visible (Window > Info) and then select the black point eyedropper from the Levels dialog. Locate the darkest point in the picture by moving the dropper cursor over your image and watching the values in the Info palette. Your aim is to find the pixels with RGB values as close to 0 as possible. By clicking on the darkest area you will automatically set this point as black in your graph (and your picture). Next, select the white point eyedropper, locate the highest value and again

click to set. With Highlight and Shadow values both pegged, all the values in the picture will be adjusted to suit. Note that the Info palette will show before and after values when making changes, for example 42/48 (before/after). When sampling white areas, you should avoid specular highlights such as the shine from the surface of a metallic object as these parts of the picture contain no printable details.

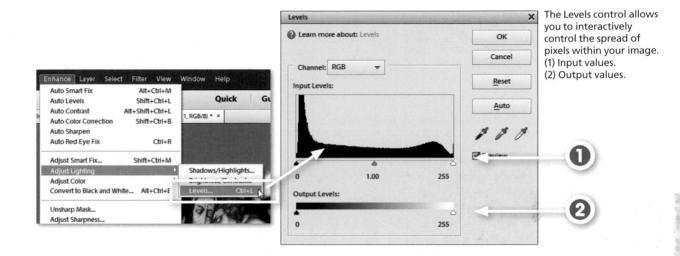

Color correction with the gray point eyedropper

The gray point eyedropper performs in a similar manner to the Color Cast command. With the tool selected, the user clicks on an area in the picture that should be a neutral gray. The color of the area is changed to neutral gray or equal amounts of red, green and blue, changing with it all the other pixels in the image. This tool is particularly useful for neutralizing color casts.

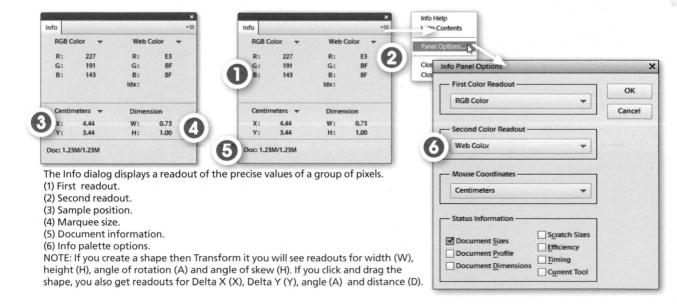

Info Palette + Levels: With the aid of the details in the Info palette locate the darkest and lightest points in your picture and peg these with the black and white point eyedroppers from the Levels feature.

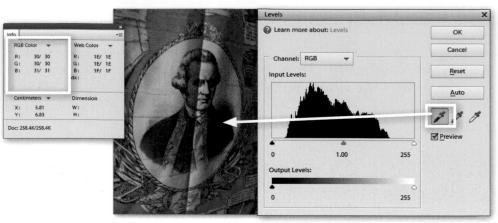

Make Levels changes in 16-bit mode

Levels changes can be performed and indeed should be performed when your photographs are in 16-bit mode. Adjusting your contrast and brightness here will give you much smoother gradation of tones and preserve more detail in your final picture.

Levels summary

Use this guide to help you make tonal adjustments for your images using Levels.

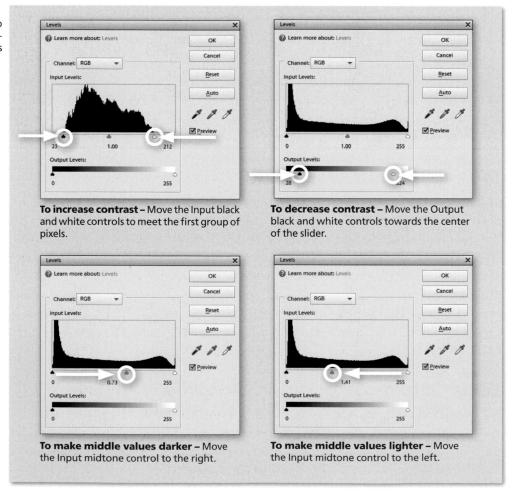

Specialized color control

In traditional imaging it is very difficult to manipulate the hues in an image. Thankfully, this is not the case in digital picture making. Fine control over color intensity and location is an integral part of the new technology. Apart from the Variations and Color Cast features that we looked at in the last chapter, Elements also contains the Hue/Saturation command and the Auto Color feature.

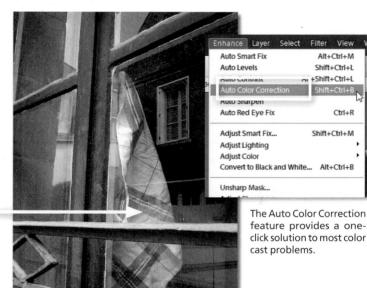

Editor: Enhance > Auto Color Correction

This feature works in a similar way to Auto Levels and Auto Contrast in that it identifies the shadows, midtones and highlights in an image and uses these as a basis for image changes. The feature adjusts the contrast of the image by remapping the shadows and highlights to black and white, and neutralizes any color casts by balancing the red, green and blue values in the picture's midtones. As with most Auto functions, this tool works well for the majority of images. For most users this is a good place to start to enhance and correct images, but for those occasions where Auto Color Correction produces poor results then my suggestion is to undo the automatic changes and rework the picture using either the Variations or Color Cast features. This option is also available in the Organizer's Fix panel.

Editor: Enhance > Adjust Color > Adjust Hue/Saturation

To understand how this feature works you will need to think of the colors in your image in a slightly different way. Rather than using the three-color model (Red, Green, Blue) that we are familiar with, the Hue/Saturation control breaks the image into different components – Hue or color, Saturation or color strength, and Lightness (HSL).

The Hue/Saturation control provides control over the color within your image. (1) Target tones selected for adjustment. (2) Color slider. (3) Strength slider. (4) Lightness slider. (5) Colorize option.

The dialog itself displays slider controls for each component, allowing the user to change each factor independently of the others. Moving the Hue control along the slider changes the dominant color of the image. From left to right, the hue's changes are represented in much the same way as colors in a rainbow. Alterations here will provide a variety of dramatic results, most of which are not realistic and should be used carefully. Moving the Saturation slider to the left gradually decreases the strength of the color until the image is reduced to just gray tones. In contrast, adjusting the control to the right increases the purity of the hue and produces images that are vibrant and dramatic. The Lightness slider changes the density of the image and works the same way as the Brightness slider in the Brightness/Contrast feature. You can use this feature to make slight adjustments when a color change darkens or lightens the midtones of the image, but more critical brightness changes should be made with the Levels feature.

By selecting the Colorize option and then moving the Hue control, it is possible to simulate sepia- or blue-toned prints. The option converts a colored image to a monochrome made up of a single dominant color and black and white.

Hue/Saturation workflow:

- 1 Select Enhance > Adjust Color > Hue/Saturation.
- 2 Select the Colorize option to make toned prints.
- 3 Change Hue, Saturation and Lightness by adjusting sliders.
- 4 Select OK to finish.

Typical Hue/Saturation changes: (1) Original picture. (2) Moving the Hue slider changes the dominant colors in the image. (3) The Saturation slider controls the strength or purity of colors in the picture. (4) Movements of the Lightness slider control the brightness of the picture. (5) Selecting the Colorize option changes the image to a tinted monochrome, containing one main color and tones between white and black.

Editor: Enhance > Adjust Color > Color Variations

The Variations command that we looked at in the last chapter can also be used to convert full color images to tinted monochromes. First, change your color image to grayscale using the Enhance > Convert to Black and White feature. Your image will now appear to be a grayscale but the file is still in RGB mode so color can be added at any time. Open the Variations command (Enhance > Adjust Color > Color Variations) and tone your picture by clicking on the appropriate thumbnails. For some users this method might be a little easier to use than the Hue/Saturation command, as the results and color alternatives are previewed and laid out clearly.

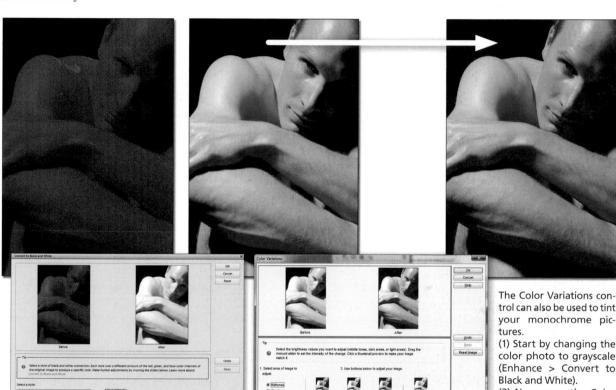

Color Variations workflow:

- 1 Open color image.
- 2 Select Enhance > Convert to Black and White using any of the Preset options.
- 3 Select Enhance > Adjust Color > Color Variations.
- 4 Adjust strength of the color changes using the Adjust Color Intensity slider.
- 5 Pick the thumbnails to change image color and check progress by viewing the Before and After images. Click OK to finish.

trol can also be used to tint your monochrome pic-

- (1) Start by changing the color photo to grayscale (Enhance > Convert to
- (2) Now open the Color Variations control (Enhance > Adjust Color > Color Variations) and click on the thumbnails to tint your picture.

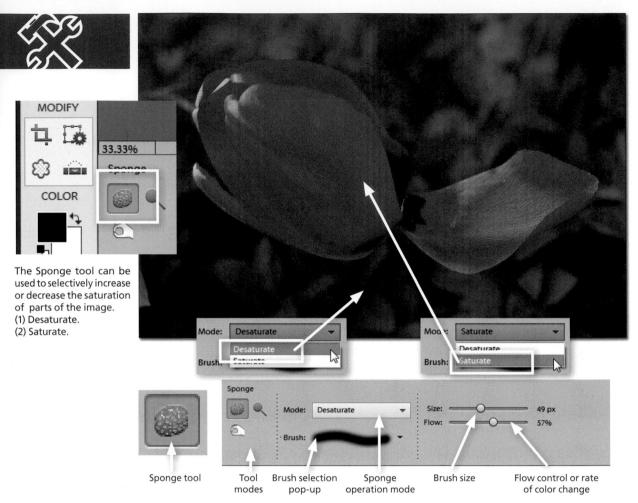

Sponge

It is possible to draw a viewer's attention to a particular part of an image by increasing its saturation. The difference in color (contrast) makes the saturated part of the picture a new focal point. The effect can be increased greatly by desaturating (reducing the color strength) the areas around the focal point. The Sponge tool is designed to make such saturation changes to the color within your photos. It can be used to saturate or desaturate and, in grayscale mode, it will even decrease or increase contrast. As with most other tools, size and mode can be changed in the options bar. Changing the Flow settings in the bar alters the rate at which the image saturates or desaturates.

Sponge workflow:

- 1 Pick the Sponge tool from the toolbox.
- 2 Select brush size, type and flow rate from the options bar.
- 3 Select the mode to use Saturate or Desaturate.
- 4 Drag over the part of the image you want to change.

The Adjust Color Curves feature provides the Elements user with another way to fine-tune the tones in their pictures.

Editor: Enhance > Adjust Color > Adjust Color Curves

The Adjust Color Curves option provides another way that you can alter the brightness and contrast in your photo. Unlike the very basic Brightness/Contrast control, Adjust Color Curves provides separate controls for altering the brightness of highlights, shadows and midtones as well as a separate slider for changing midtone contrast. The feature has been revamped since its introduction in version 6.0 and now contains two separate sections – Style and Adjust Sliders. The features dialog contains both Before and After previews so that the effect of curve changes can be seen as you make them.

The **Style** area contains a series of preset curves settings for the most widely used enhancements, which include Backlight, Darken Highlights, Default, Increase Contrast, Increase Midtone, Lighten Shadows and Solarize.

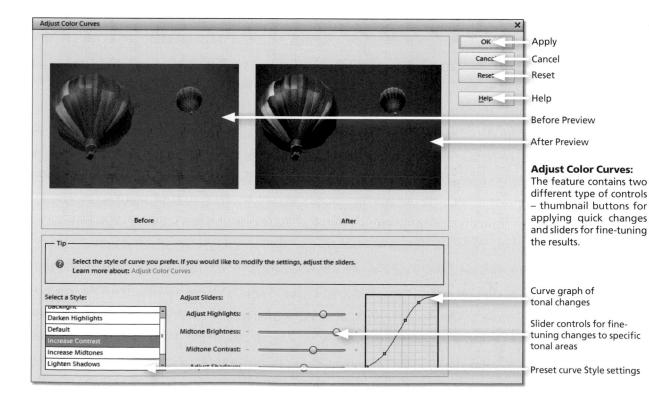

ADVANCED TECHNIQUES

The **Adjust Sliders** section contains four slider controls plus a curves graph that plots the tonal relationships in the picture. Whereas the Samples thumbnails provided a one-click adjustment, the controls here allow multiple, additive, fine-tuning changes.

The best approach is to select a style of curve adjustment first, e.g. Lighten Shadows, and then fine-tune the results with the sliders. To reset the Curves feature back to its original position click the Default style entry or the Reset button in the top right of the dialog.

Adjust Color Curves workflow:

- 1 Open color image and Select Enhance > Adjust Color > Adjust Color Curves.
- 2 Select the base curves adjustment style from the options on the left of the dialog.
- 3 Use the slider controls to fine-tune the results and then click OK to apply the changes or Reset to start again.
- 4 To reset the feature and remove any current adjustments click the Reset button.

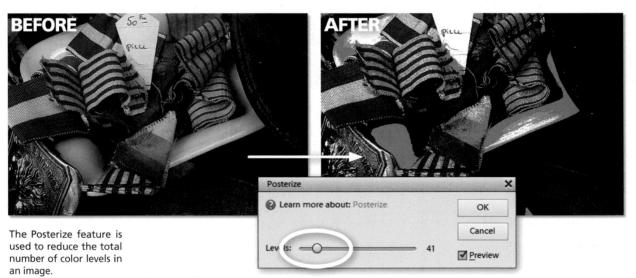

Editor: Filter > Adjustments > Posterize

The Posterize feature reduces the number of color levels within an image. This produces a graphic design-type illustration with areas of flat color from photographic originals. This type of image has very little graduation of tone; instead, it relies on the strength of the colors and shapes that make up the image for effect. The user inputs the number of tones for the images and Elements proceeds to reduce the total palette to the selected few.

Posterize workflow:

- 1 Select Filter > Adjustments > Posterize.
- 2 Input the number of levels required.
- 3 Select OK to finish.

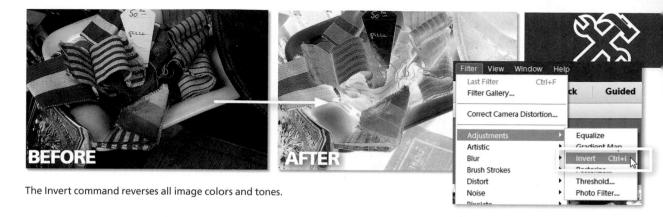

Editor: Filter > Adjustments > Invert

The Invert command produces a negative version of your image. The feature literally swaps the values of each of the image tones. When used on a grayscale image the results are similar to a black and white negative. However, this is not true for a color picture as the inverted picture will not contain the typical orange 'mask' found in color negatives.

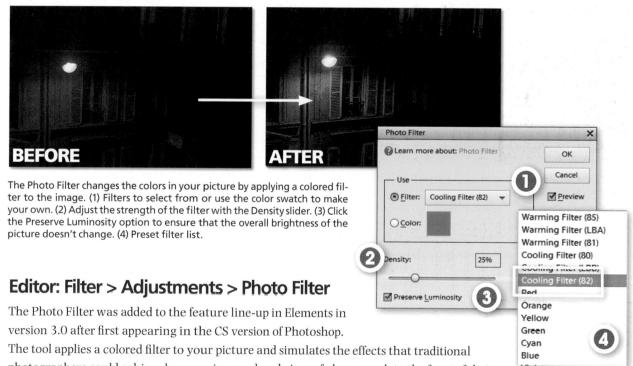

photographers could achieve by screwing a colored piece of glass, or gel, to the front of their camera lenses. The change in color that this technique produces can be used for visual effect, such as making a cloudy day appear more sunny (by applying a warm-up filter) or to help correct color cast problems like those displayed in the example. Here a Cooling Filter (82) is applied to the warm image to help eliminate the yellow cast.

Also included in the feature's dialog are areas for you to select the exact color of the filter applied, a Density slider that controls the strength of the filter, and the Preserve Luminosity check box that ensures that the overall tone of your picture doesn't darken or lighten with your filter changes.

Photo Filter workflow:

- 1 Select the Filter > Adjustments > Photo Filter.
- 2 Ensure that the Preview and Preserve Luminosity options are selected.
- 3 Pick the filter from the drop-down list or double-click the color swatch to pick the color more precisely.
- 4 Adjust the density of the filter to suit the image. Click OK to apply.

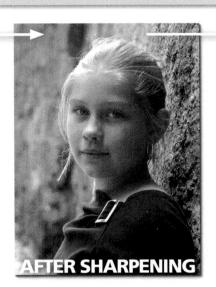

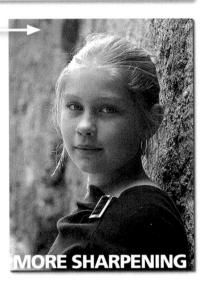

All digital photos need some sharpening to improve the overall clarity of the image. But sharpening needs to be applied carefully as it can easily be over-done.

High quality sharpening techniques

Sometimes, during the image capture process, the picture loses some of the subject's original clarity. This can be especially true if you are scanning small prints or negatives at high resolutions. To help restore some of this lost clarity, it is a good idea to get into the habit of applying sharpening to images straight after capture (although ensure that your digital camera has not already done this as an automatic feature). I should say from the outset that although the specialist features in Elements will improve the appearance of sharpness in an image, it is not possible to use these tools to 'focus' a picture that is blurry. In short, sharpening won't fix problems that arise from poor camera technique; the only solution for this is ensuring that images are focused to start with. That said, let's get sharpening.

There are three sharpening options are grouped under the Enhance menu. The Unsharp Mask filter from previous releases is now joined with the Auto Sharpen and Adjust Sharpness features. These together with the specialized Sharpening tool provide a variety of methods for adding extra clarity to your pictures.

The **Amount** slider controls the strength of the sharpening effect.

- (1) Amount = 50%.
- (2) Amount = 150%.
- (3) Amount = 500%.

The Radius slider determines the number of edge pixels that are sharpened.

- (1) Radius = 1.0 pixels.(2) Radius = 20 pixels.(3) Radius = 250 pixels.

The **Threshold** slider controls the point at which the effect is applied.

- (1) Threshold = 0 levels.
- (2) Threshold = 8 levels.
- (3) Threshold = 100 levels.

Editor: Enhance > Auto Sharpen

Most digital sharpening techniques are based on increasing the contrast between adjacent pixels in the image. When viewed from a distance, this change makes the picture appear sharper. The Auto Sharpen feature applies basic sharpening to the whole of the image.

Editor: Enhance > Unsharp Mask

This feature is based on an old photographic technique for sharpening images that used a slightly blurry mask to increase edge clarity. The digital version offers the user control over the sharpening process via three sliders — Amount, Radius and Threshold. By careful manipulation of the settings of each control the sharpness of images destined for print or screen can be improved. Beware though — too much sharpening is very noticeable and produces problems in the image, such as edge haloes, that are very difficult to correct later.

Overuse of the Unsharp Mask filter can lead to irreversible problems.

- (1) Too much contrast.
- (2) Coarse skin tones.
- (3) Haloes.

Before using the Unsharp Mask filter, make sure that you are viewing your image at 100%. If you intend to print the sharpened image, make test prints at different settings before deciding on the final values for each control. Repeat this exercise for any pictures where you want the best quality, as the settings for one file might not give the optimum results for another picture that has a slightly higher or lower resolution.

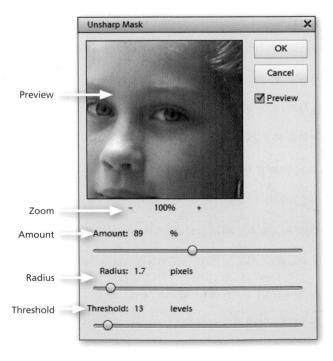

The Unsharp Mask controls

The **Amount** slider controls the strength of the sharpening effect. Values of 50–100% are suitable for low-resolution pictures, whereas settings between 150% and 200% can be used on images with a higher resolution.

The **Radius** slider value determines the number of pixels around the edge that is affected by the sharpening. A low value only sharpens edge pixels. Typically, values between 1 and 2 are used for high-resolution images, and settings of 1 or less for screen images.

The **Threshold** slider is used to determine how different the pixels must be before they are considered an edge and therefore sharpened. A value of 0 will sharpen all the pixels in an image, whereas a setting of 10 will only apply the effect to those areas that are different by at least 10 levels or more from their surrounding pixels. To ensure that no sharpening occurs in sky or skin tone areas, set this value to 8 or more.

Unsharp Mask filter workflow:

- 1 Select Filter > Sharpen > Unsharp Mask.
- 2 Adjust Amount slider to control strength of filter.
- 3 Adjust Radius slider to control the number of pixels surrounding an edge that is included in the effect.
- 4 Adjust Threshold slider to control what pixels are considered edge and therefore sharpened.

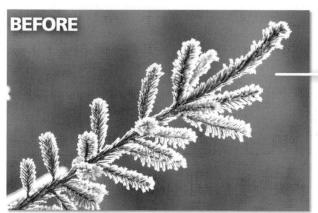

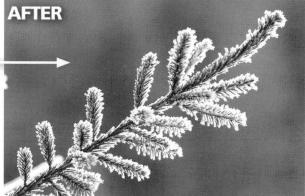

Editor: Enhance > Adjust Sharpness

The Adjust Sharpen feature provides all the control that we are familiar with in the Unsharp Mask dialog plus better edge detection abilities, which leads to better results and in particular less apparent sharpening haloes. The feature's dialog contains a zoomable preview, two slider controls, a drop-down menu to choose the sharpening approach used and a More Refined option.

The user can control the sharpening effect with the following settings:

Amount – Strength of sharpening effect.

Radius – Determines the extent of sharpening. Higher values equal more obvious edge effects.

Remove – Determines sharpening algorithm used. Gaussian Blur uses the same approach as the Unsharp Mask filter. Lens Blur concentrates on sharpening details and produces results with fewer haloes. Motion Blur reduces the effects of blur caused by camera shake or subject movement.

The Adjust Sharpness feature contains Amount and Radius sliders as well as a variety of sharpening approaches in the Remove menu.

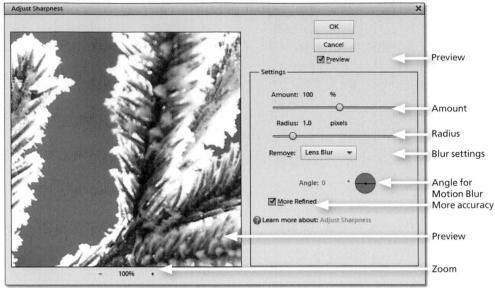

Angle – Sets Motion Blur direction.

More Refined – Longer processing for better results.

PRO'S TIP

Applying sharpening makes permanent and irreversible changes to your photos so it is always a good idea to keep an unsharpened copy of your image as an original. Alternatively you can apply sharpening changes to a duplicate layer that is positioned above the background in the Layers Palette.

Unsharp Mask filter workflow:

- 1 For best results, choose the Remove setting first. The Lens Blur option provides a good balance between sharpening effects and minimal sharpening artifacts.
- 2 Enlarge the preview to at least 100%. Next, select a low Radius value 1 or 2 for high-resolution images and 1 or less for low-resolution photos.
- 3 Now gradually move the Amount slider from left to right, stopping occasionally to check the results of the sharpening.
- 4 When you reach a setting that provides good sharpening, but doesn't create halo artifacts, click OK to apply.
- 5 To see the results of your sharpening being reflected in the Elements document itself, make sure that the Preview option is selected.

Elements' sharpening tools

In addition to using a filter to sharpen your image, it is also possible to make changes to specific areas of the picture using one of the two sharpening tools available. The Blur and Sharpen tools are located in the Elements toolbox.

The size of the area they change is based on the current brush size. The intensity of the effect is controlled by the Strength value found in the options bar.

As with the Airbrush tool, the longer you keep the mouse button down the more pronounced the effect will be. These features are particularly useful when you want to change only small parts of an image rather than the whole picture.

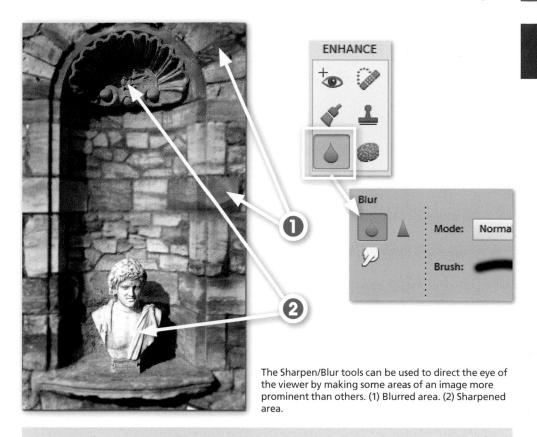

Sharpening Tools workflow:

- 1 Select the Blur or Sharpen tool from the toolbox.
- 2 Adjust the size and style of the tool with the Brush palette in the options bar.
- 3 Change the intensity of the effect by altering the Strength setting.
- 4 Blur or sharpen areas of the image by clicking and dragging the tool over the picture surface.
- 5 Increase the change in any one area by holding the mouse button down.

Retouching techniques

Used for more than just enhancing existing details, these techniques are designed to rid images of visual information, like dust, scratches and sensor marks, that can distract from the main picture.

Editor: Filter > Noise > Dust & Scratches

It seems that no matter how careful I am, my scanned images always contain a few dust marks. The Dust & Scratches filter in Elements helps to eliminate these annoying spots by blending or blurring the surrounding pixels to cover the defect. The settings you choose for

Too much Dust & Scratches filtering can destroy image detail and make the picture fuzzy.

- (1) Original picture.
- (2) Photo after too much Dust & Scratches filtration.

this filter are critical if you are to maintain image sharpness whilst removing small marks. Too much filtering and your image will appear blurred, too little and the marks will remain.

To find settings that provide a good balance, first try adjusting the Threshold setting to zero. Next, use the Preview box in the Filter dialog to highlight a mark that you want to remove. Use the zoom controls to enlarge the view of the defect. Now drag the Radius slider to the right. Find, and set, the lowest Radius value where the mark is removed. Next, increase the Threshold value gradually until the texture of the image is restored and the defect is still removed.

Dust & Scratches workflow:

- 1 Select Filter > Noise > Dust & Scratches.
- 2 Move preview area to highlight a mark to be removed.
- 3 Zoom the preview to enlarge the view of the mark.
- 4 Ensure that the Threshold value is set to zero.
- 5 Adjust the Radius slider until the mark disappears.
- 6 Adjust Threshold until texture returns and the mark is still not visible.
- 7 Click OK to finish.

Step-by-step Dust & Scratches application:

Follow the three-step process to ensure that you choose the optimal settings for the Dust & Scratches filter.

Set both sliders to minimum (all the way to the left). Preview the Dust Mark area.

Adjust the Radius slider until the mark disappears.

Raise the Threshold slider to regain texture in the non-marked area of the image.

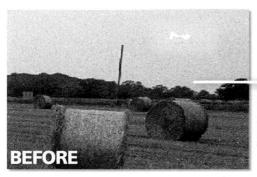

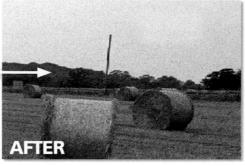

The Clone Stamp tool is perfect for retouching the marks that the Dust & Scratches filter cannot erase.

Clone Stamp

In some instances the values needed for the Dust & Scratches filter to erase or disguise picture faults are so high that it makes the whole image too blurry for use. In these cases it is better to use a tool that works with the problem area specifically rather than the whole picture surface.

The Clone Stamp tool samples an area of the image and then paints with the texture, color and tone of this copy onto another part of the picture. This process makes it a great tool to use for removing scratches or repairing tears or creases in a photograph. Backgrounds can be sampled and then painted over dust or scratch marks, and whole areas of a picture can be rebuilt or reconstructed using the information contained in other parts of the image.

Using the Clone Stamp tool is a two-part process. The first step is to select the area that you are going to use as a sample by Alt/Opt-clicking the area. Now move the cursor to where you want to paint, and click and drag to start the process.

The size and style of the sampled area are based on the current brush and the Opacity setting controls the transparency of the painted section.

Clone Stamp workflow:

- 1 Pick the Clone Stamp tool from the toolbox.
- 2 Adjust the brush size via the Brush palette in the options bar.
- 3 Set the opacity for the painted area.
- 4 Position the mouse cursor on a part of the image you want to sample and Alt/Opt-click.
- 5 Move the tool to the area of the image you want to use the sample to cover and click and drag to paint.

Alt/Opt-click to mark the area to be sampled. Move the cursor over the mark and click to paint over with the sampled texture. (1) Sample point. (2) Retouching area.

The Spot Healing Brush tool is designed for quick, accurate repair of dust and hair marks. To use simply select the tool, adjust the size of the brush tip to suit the dust mark and then paint it out.

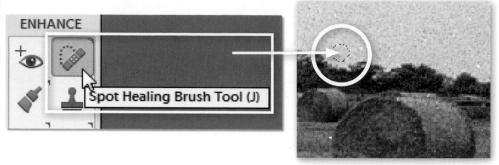

Spot Healing Brush

In recognition of just how tricky it can be to get seamless dust removal with the Clone Stamp tool, Adobe decided to include the Spot Healing Brush in Elements. After selecting the tool you adjust the size of the brush tip using the options in the tool's option bar and then click on the dust spots and small marks in your pictures.

The Spot Healing Brush uses the texture that surrounds the mark as a guide to how the program should 'paint over' the area. In this way, Elements tries to match color, texture and tone whilst eliminating the dust mark. The results are terrific and this tool should be the one that you reach for first when there is a piece of dust or a hair mark to remove from your photographs.

Spot Healing Brush workflow:

- 1 Locate the areas to be repaired.
- 2 Adjust the brush size to suit the size of the mark.
- 3 Click on the spot to repair.

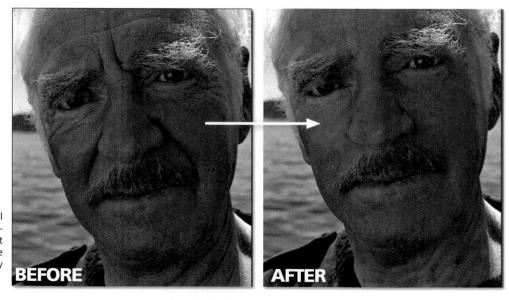

The Healing Brush tool works wonders for removing unwanted details. It can even provide a little digital plastic surgery when required.

Healing Brush tool

The Clone Stamp tool is good, but the best way to remove unwanted detail from your pictures is with the amazing Healing Brush tool. Designed to work in a similar way to the Clone Stamp tool, the user selects the area (Alt/Opt-click) to be sampled before painting and then proceeds to drag the brush tip over the area to be repaired. The tool achieves such great results by merging background and source area details as you paint. Just as with the Clone Stamp tool, the size and edge hardness of the current brush determine the characteristics of the Healing Brush tool tip.

Step-by-step Healing Brush application:

picture beneath.

Locate the areas to be healed.

Alt/Opt-click the source that you will use in the repairs.

Drag the brush tip over the area to be repaired.

Healing Brush workflow:

- 1 The first step is to locate the areas of the image that need to be retouched.
- 2 Hold down the Alt key and click on the area that will be used as a sample for the brush. Notice that the cursor changes to cross hairs to indicate the sample area.
- 3 Move the cursor to the area to heal and click and drag the mouse to 'paint' over the problem picture part. After you release the mouse button Elements merges the newly painted section with the image beneath.

PRO'S TIP

You can remove wrinkles on a duplicate layer and then fade the opacity of this layer to create a more natural appearance, where wrinkles are softened and not completely removed.

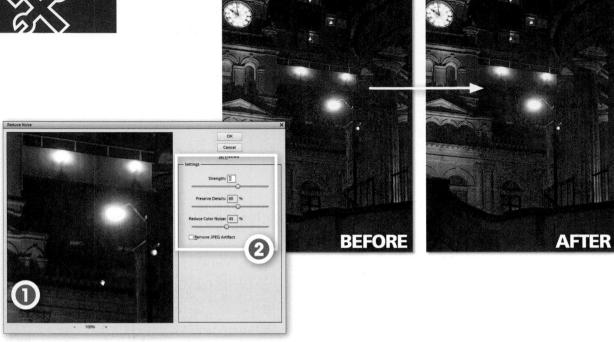

The Reduce Noise filter is great for making pictures taken when your camera less noisy. (1) Preview.

trols.

Editor: Filter > Noise > Reduce Noise

is set on a high ISO value Many new digital cameras have a variety of ISO settings to choose from. When shooting in sunny or bright conditions you generally use values of 100 or 200, giving sharp and noise-(2) Noise Reduction confree results, but when you select a higher value such as 1600 for use at night, or in low light, the resultant pictures can become very notsy. Camera manufacturers often include Noise Reduction features as part of the camera functions but sometimes the length of time the camera takes to process the file means that it is almost impossible to take a series of nighttime pictures rapidly. If this is your requirement then you are stuck with grainy photographs because you have had to shoot with the Noise Reduction feature turned off.

> With just this sort of problem in mind, the Adobe engineers included the Noise Reduction filter (Filter > Noise > Reduce Noise). The feature includes a preview window, a Strength slider, a Preserve Details control and a Reduce Color Noise slider. As with the Dust & Scratches filter you need to be careful when using this filter to ensure that you balance removing noise whilst also retaining detail.

> The best way to guarantee this is to set your Strength setting first, ensuring that you check the results in highlights, midtone and shadow areas. Next, gradually increase the Preserve Details value until you reach the point where the level of noise that is being reintroduced into the picture is noticeable and then back off the control slightly (make the setting a lower number). For photographs with a high level of color noise (random speckles of color in an area that should be a smooth flat tone) you will need to adjust this slider at the same time as you are playing with the Strength control.

Reduce Noise filter workflow:

- 1 Open the noisy image and select the Filter > Noise > Reduce Noise filter.
- 2 Drag the Preserve Details slider to the left and then gradually move the Strength slider to the right until the noise is at an acceptable level.
- 3 Now slowly move the Preserve Details slider to the right until there is an acceptable balance between detail and noise in your picture.
- 4 To reduce the appearance of JPEG compression select the Remove JPEG Artifact check box in the feature's dialog.

Adding texture to an image

At first, the idea of making a smooth, evenly graduated image more textured seems to be at odds with the general direction that digital technology has been heading over the last few years. Research scientists and technicians have spent much time and money ensuring that the current crop of cameras, scanners and printers is able to capture and produce images so that they are in effect textureless or grainless. The aim has been to disguise the origins of the final print so that the pixels cannot be seen.

For me to introduce to you at this stage a few techniques that intentionally add noticeable texture to your image may seem a little strange but, despite the intentions of the manufacturers, many digital image makers do like the atmosphere and mood that a 'grainy' picture conveys. All the techniques use filters to alter the look of the image. Filter changes are permanent, so it is always a good idea to keep a copy of the unaltered original file on your hard drive, just in case.

Editor: Filter > Noise > Add Noise

The Add Noise filter is one of four options contained under the Noise heading in the Filter menu. Using this feature adds extra contrasting pixels to your image to simulate the effect of high-speed film. When the filter is selected, you are presented with a dialog that contains several choices. A small zoomable thumbnail window is provided so that you can check the appearance of the filter settings on your image. There is also the option to preview the results on the greater image by ticking the Preview box. The strength of the effect is controlled by the Amount slider and the type of noise can be switched from Uniform, a more even effect, to Gaussian, for a speckled appearance. The Monochromatic option adds pixels that contrast in tone only and not color to the image.

Despite all the techniques in the previous section, which were designed to reduce the marks in our pictures, there are many photographers who like texture and who regularly use other techniques to intentionally put back desirable textures into their photographs.

Use the Add Noise filter for basic texture additions.

- (1) Preview thumbnail.
- (2) Filter strength.
- (3) Noise type.
- (4) Monochromatic check box.

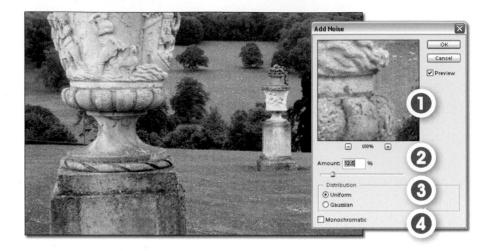

Add Noise filter workflow:

- 1 Select the Add Noise filter from the Noise section of the Filter menu.
- 2 Adjust thumbnail preview to a view of 100% and tick the Preview option.
- 3 Select Uniform for an even distribution of new pixels across the image, or pick Gaussian for a more speckled effect.
- 4 Tick the Monochromatic option to restrict the effect to changes in the tone of pixels rather than color.
- 5 Adjust the Amount slider to control the strength of the filter, checking the results in both the thumbnail and full image previews. Click OK to finish.

The Add Noise filter settings control the look of the final texture.

- (1) Original non-filtered picture.
- (2) Uniform Distribution selected.
- (3) Gaussian Distribution selected.
- (4) Uniform Distribution and Monochrome setting selected.

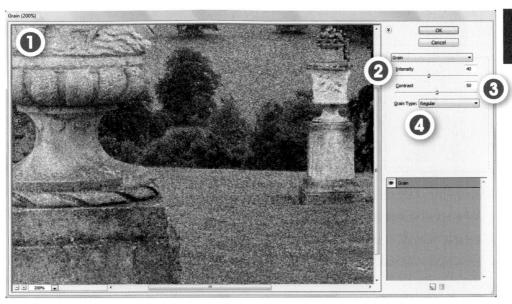

Editor: Filter > Texture > Grain

Found under the Texture option in the Filter menu, the Grain filter, at first glance, appears to offer the same style of texture changes as the Add Noise feature, but the extra controls in the dialog give users the chance to add a range of different texture types to their images. The dialog provides a thumbnail preview of filter changes. The Intensity slider controls the strength of the effect and the Contrast control alters the overall appearance of the filtered image. The Grain Type menu provides 10 different choices of the style of texture that will be added to the image. By manipulating these three settings, it is possible to create some quite different and stunning texture effects.

Grain filter workflow:

- 1 Select the Grain filter from the Texture section of the Filter menu.
- 2 Adjust thumbnail preview to a view of 100%.
- 3 Select Grain Type from the menu.
- 4 Adjust the Intensity slider to control the strength of the filter, checking the results in the thumbnail preview.
- 5 Alter the Contrast slider to change the overall appearance of the image.
- 6 Click OK to finish.

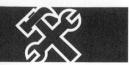

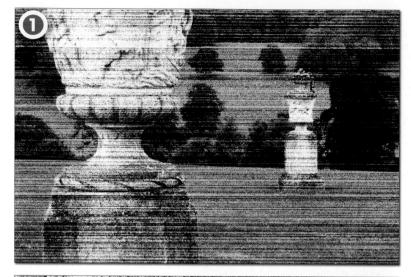

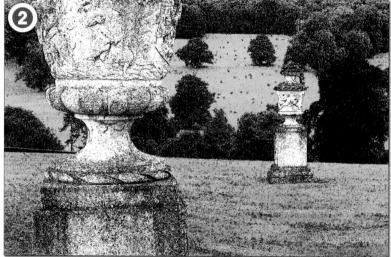

The Grain filter with a range of options selected.

- (1) Horizontal option set.(2) Speckle option set.(3) Stippled option set.

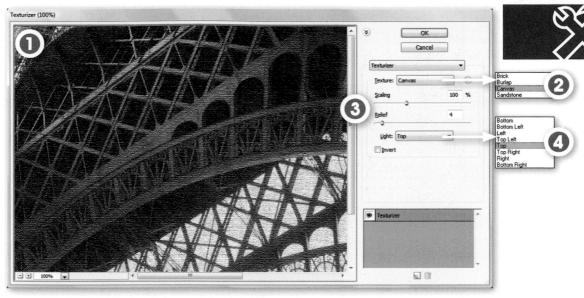

The Texturizer filter changes the image so that it appears to have been printed onto a textured surface. (1) Preview thumbnail. (2) Texture type. (3) Texture settings. (4) Light direction.

Editor: Filter > Texture > Texturizer

The Texturizer filter provides a slightly different approach to the process of adding textures to images. With this feature much more of the original image detail is maintained. The picture is changed to give the appearance that the photo has been printed onto the surface of the texture.

The Scaling and Relief sliders control the strength and visual dominance of the texture, whilst the Light direction menu alters the highlight and shadow areas. Different surface types are available from the Texture drop-down menu. The feature also contains the option to add your own files and have these used as the texture that is applied by the filter to the image.

Texturizer filter workflow:

- 1 Select the Texturizer filter from the Texture section of the Filter menu.
- 2 Adjust thumbnail preview to a view of 100%.
- 3 Select texture type from the drop-down menu.
- 4 Move the Scaling slider to change the size of the texture.
- 5 Adjust the Relief slider to control the dominance of the filter.
- 6 Select a Light direction to adjust the highlights and shadow areas of the texture.
- 7 Tick the Invert box to switch the texture position from 'hills' to 'valleys' or reverse the texture's light and dark tones.
- 8 Click OK to finish.

Changing the size of your images

As we have seen in earlier chapters, the size of a digital image is measured in pixel dimensions. These dimensions are determined at the time of capture or creation. Occasionally, it is necessary to alter the size of your digital photograph to suit different output requirements. For instance, if you want to display an image on a website that was captured in high resolution, you will need to reduce the pixel dimensions of the file to suit.

Grouped under the Resize option of the Image menu, Elements provides a couple of sizing features which can be used to alter the dimensions of your picture. PROCEED WITH CAUTION. Increasing or decreasing the dimensions of your images directly affects the quality of your files, so my suggestion is that until you are completely at home with these controls always make a backup file of your original picture before starting to resize.

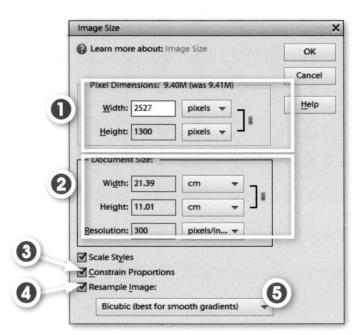

The Image Size dialog controls the dimensions and resolution of your pictures.

- (1) Pixel Dimensions section.
- (2) Document Size section.
- (3) Constrain Proportions check box.
- (4) Resample Image check box and drop-down menu.
- (5) Re-sampling method

Editor: Image > Resize > Image Size

The Image Size dialog provides several options for manipulating the pixels in your photograph. At first glance the settings displayed here may seem a little confusing, but if you can make the distinction between the Pixel Dimensions of the image (shown in the topmost section of the dialog) and the Document Size (shown in the middle), it will be easier to understand.

Pixel Dimensions represent the true digital size of the file.

Document Size is the physical dimensions of the file represented in inches (or centimeters) based on using a specific number of pixels per inch (resolution or ppi).

The example image contains 1800×1200 pixels and can be output to a print that is 6 inches \times 4 inches or 1.8 inches \times 1.2 inches, depending on how the pixels are spread (resolution). (1) 6×4 inches @ 300 dpi = 1800×1200 pixels. (2) 1.8×1.2 inches @ 1000 dpi = 1800×1200 pixels.

Non-detrimental size changes

A file with the same pixel dimensions can have several different document sizes based on altering the spread of the pixels when the picture is printed (or displayed on screen). In this way you can adjust a high-resolution file to print the size of a postage stamp, postcard or a poster by only changing the dpi or resolution. This type of resizing has no detrimental quality effects on your pictures as the original pixel dimensions remain unchanged.

To change resolution, open the Image Size dialog and uncheck the Resample Image option. Next, change either the resolution, width or height settings to suit your output.

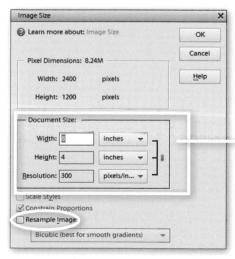

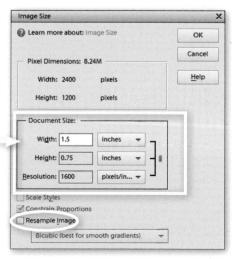

Non-detrimental size changes, or the changes that don't lose picture quality, can be made to your image if the Resample Image option is always left unchecked.

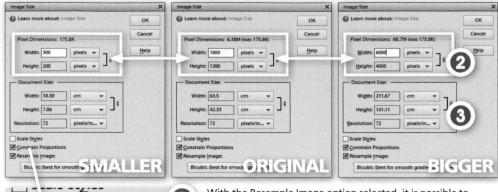

With the Resample Image option selected, it is possible to increase and decrease the total number of pixels in your image. (1) Resample Image option ticked. (2) New pixel dimensions. (3) New document size.

Upsizing and downsizing

This said, in some circumstances it is necessary to increase or decrease the number of pixels in an image. Both these actions will produce results that have less quality than if the pictures were scanned or photographed at precisely the desired size at the time of capture. If you are confronted with a situation where you are unable to recapture your pictures, then Elements can increase or decrease the image's pixel dimensions. Each of these steps requires the program to interpolate, or 'make up', the pixels that form the resized image. To increase the pixels or upsize the image, tick the Resample Image check box and then increase the value of any of the dimension settings in the dialog. To decrease the pixels or downsize the image, decrease the value of the dimension settings.

Image Size dialog settings

To keep the ratio of width and height of the new image the same as the original, tick the Constrain Proportions check box.

Interpolation quality and speed are determined by the options in the drop-down menu next to the Resample Image check box. Bicubic is the generally best setting for photographic images, but Bicubic Smoother should be used when increasing the number of pixels in a photo and Bicubic Sharper when reducing a photo's size.

Resizing workflow:

- 1 Select Image Size from the Resize option under the Image menu.
- 2 Tick the Resample Image check box for changes to the pixel dimensions of your image.
- 3 Uncheck the Resample Image option for changing image resolution.
- 4 Adjust the dimension settings to suit your output requirements.

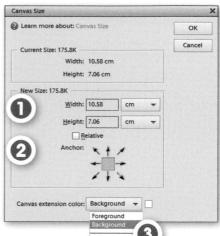

Altering the settings in the Canvas Size dialog changes the dimensions of the background the image is sitting upon. Larger dimensions than the picture result in more space around the image. Smaller dimensions crop the image.

- (1) New Size settings.
- (2) Anchor settings that determine where the new canvas area is placed.
- (3) Drop-down menu for selecting the color for the new canvas area surrounding the picture.

Editor: Image > Resize > Canvas Size

Just to add a little more complexity to the picture size discussion, Elements also provides the ability to change the size of the canvas that your photograph is sitting upon. Alterations here result in no change to the size of the image itself, but the overall canvas size does change, which means that the total dimensions of the document change as well.

This feature is particularly useful if you want to add several images together. Increasing the canvas size will mean that each of the extra pictures can be added to the newly created space around the original image.

To change the canvas size, select Canvas Size from the Resize option of the Image menu and alter the settings in the New Size section of the dialog. You can control the location of the new space in relation to the original image by clicking one of the sections in the Anchor diagram. Leaving the default setting here will mean that the canvas change will be spread evenly around the image.

Canvas Size workflow:

- 1 Select Canvas Size from the Resize option under the Image menu.
- 2 Alter the values in the New Size section of the dialog.
- 3 Set the anchor point in the Anchor diagram.
- 4 Click OK to complete.

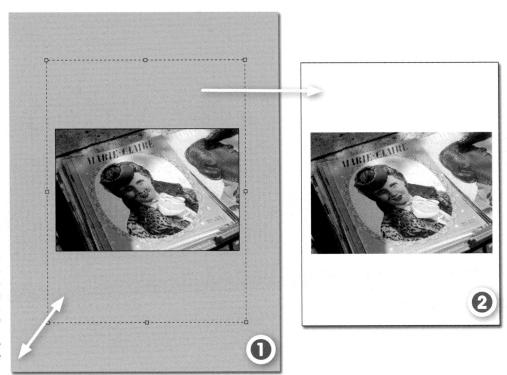

The Crop tool can be used to increase the size of the canvas by dragging the crop marquee outside the dimensions of the picture. (1) Make the crop marquee larger than the picture. (2) Double-click inside the crop marquee to increase the canvas size.

Increasing the canvas size with the Crop tool

Pros use the Crop tool to quickly increase the size of the canvas that the picture sits in. First, zoom out from the picture so that it sits smaller in the workspace, then select the Crop tool and drag a marquee around the whole image. After releasing the mouse button, click on one of the side or corner handles and drag the crop marquee outwards until it is the size and shape of the new canvas. Double-click to complete the canvas resize. The new canvas will be the color of the current background color.

Selections

When photographers first start to enhance their photos, they tend to apply changes to the whole of the photo. Very quickly though, we all find that there are times when you will want to restrict the alterations to just one part of the photograph. Thankfully the mechanics of isolating changes in a digital photograph is easier than when photographers worked in the darkroom with pieces of cardboard on short lengths of wire. That said, the basis of this approach is much the same as in darkroom days. Shield the parts of the photo where you don't want changes while enhancing the sections where you do want changes.

Photoshop Elements provides several different tools that allow the user to isolate areas to be changed. These features are called 'Selection' tools. Global enhancements are important, but the ability to fine-tune image areas with selected adjustments has the potential to transform the 'acceptable' to the 'exceptional'. In this chapter we will look at the mechanics of creating and using selections.

Selections are used in Photoshop Elements to isolate parts of the photo before making any changes. Here three pieces of clothing are selected first before changes are made to the color of the garments. If a selection wasn't created first the alterations would be applied to the whole of the photo.

Selection basics

There are many imaging scenarios that benefit from being able to restrict alterations to a specific part of a picture. For this reason, most image-editing packages contain features that allow the user to isolate small sections of the photo, and then apply changes to just this picture part.

The idea is simple. When a selection is created in Photoshop Elements, the edges of the isolated area are indicated by a flashing dotted line, which is sometimes referred to as the 'marching ants'. When a selection is active, any changes made to the image will be restricted to the isolated area. To resume full image-editing mode, the area has to be deselected by choosing Select > Deselect or pressing the Esc key.

VIEW

VIEW

SELECT

ENMANCE

DRAW

MODIFY

COLOR

The edges of an active selection are indicated using a flashing dotted line or 'marching ants'.

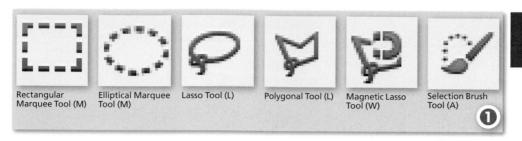

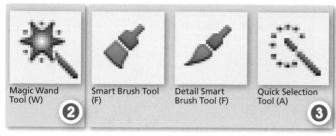

Elements' Selection Tools:

It is possible to group the selection tools in Photoshop Elements based on how they isolate picture parts. (1) Tools that create selections by drawing. (2) Selections based on locating similar colors and tones. (3) New combination tools that use both approaches. Shortcut keys in brackets.

The selection features contained in Elements can be divided into three groups:

- **Drawing selection tools**, or those that are based on selecting pixels by drawing a line around the part of the image to be isolated.
- **Color selection tools**, or those features that distinguish between image parts based on the color or tone of the pixels, and
- the Quick Selection tool, Smart Brush Tool, Detail Smart Brush Tool and Magic Extractor, which combine both drawing and color selection by using an approach that automatically creates selections based on the areas that the user has painted.

Drawing selection tools

Marquee tools

By clicking and dragging the Rectangular or Elliptical Marquees, it is possible to draw rectangle- and oval-shaped selections. Holding down the Shift key whilst using these tools will restrict the selection to square or circular shapes, whilst using the Alt/Opt key will draw the selections from their

centers. The Marquee tools are great for isolating objects in your images that are regular in shape, but for less conventional shapes you will need to use one of the Lasso tools.

Lasso tools

The normal Lasso tool works like a pencil, allowing the user to draw freehand shapes for selections. In contrast, the Polygonal Lasso tool draws straight edge lines between mouse-click points. Either of these features can be used to outline and select irregular-shaped image parts.

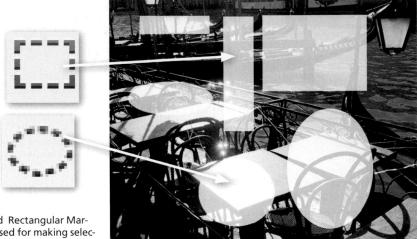

The Elliptical and Rectangular Marquee tools are used for making selections in these shapes.

Holding down the Shift key when using the Marquee tools will constrain the selection to either a square or a circle.

- (1) Constrained.
- (2) Unconstrained.

A third tool, the Magnetic Lasso, helps with the drawing process by aligning the outline with the edge of objects automatically. It uses contrast in color and tone as a basis for determining the edge of an object.

£3

The accuracy of the 'magnetic' features of this tool is determined by three settings in the tool's options bar. Edge Contrast is the value that a pixel has to differ from its neighbour to be considered an edge. Width is the number of pixels either side of the pointer that are sampled in the edge determination process and Frequency is how often fastening points are added to the outline.

The settings in the Magnetic Lasso's options bar alter how the tool snaps to the outline of particular image parts.

How far from the pointer the tool looks for contrasting edges

How often anchor points are added to an outline

For most tasks, the Magnetic Lasso is a quick way to obtain accurate selections, so it is good practice to try this tool first when you want to isolate specific image parts.

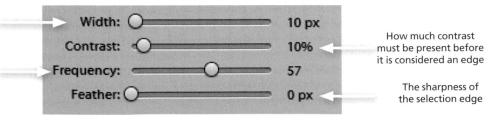

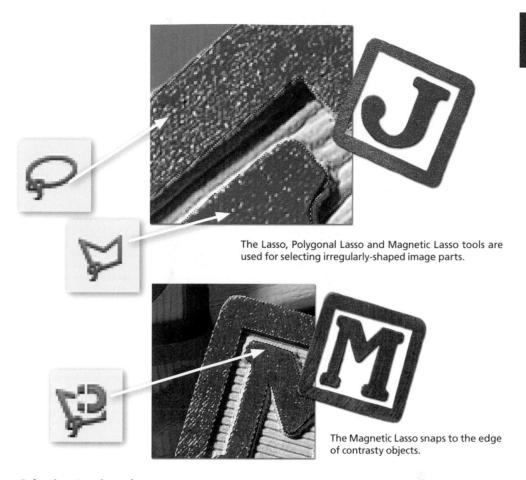

Selection Brush tool

Responding to photographers' demands for even more options for making selections, Adobe created the Selection Brush. The tool lets you paint a selection onto your image. The size, shape and edge softness of the selection are based on the brush properties you currently have set. These can be altered in the Brush Presets pop-up palette located in the options bar. The Selection Brush tool is nested in the tool bar with the Quick Selection tool.

The Selection Brush can work in either Selection or Mask modes.

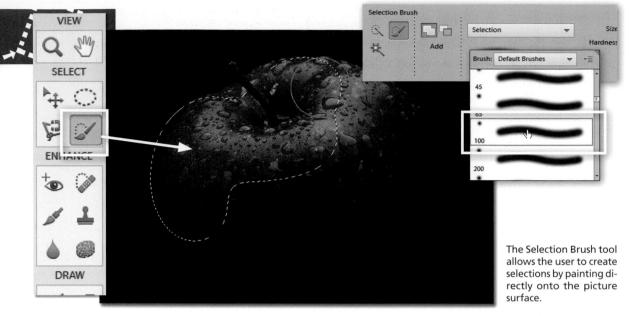

The tool can be used in two modes - Selection and Mask.

- The **Selection** mode is used to paint over the area you wish to select.
- The Mask mode works by reverse painting in the areas you want to 'mask from the selection'. It is particularly well suited for showing the soft or feathered edge selections made when painting with a soft-edged brush.

Holding down the Alt/Opt keys whilst dragging the brush switches the tool from adding to the selection to taking away from the area. Alternatively you can also switch between Add and Subtract modes using the settings in the options bar.

Drawing selection tool workflows:

Rectangular and Elliptical Marquee tools

- 1 After selecting the tool, click and drag to draw a marquee on the image surface.
- 2 Hold down the Shift key whilst drawing to restrict the shape to either a square or a circle.
- 3 Hold down the Alt (Windows) key to draw the shape from its center.
- 4 Hold down the Spacebar to reposition the marquee.

Lasso tool

- 1 After selecting the tool, click and drag to draw the selection area by freehand.
- 2 Release the mouse button to join the beginning and end points and close the outline.

Polygonal Lasso tool

1 After selecting the tool, click and release the mouse button to mark the first fastening point.

- 2 To draw a straight line, move the mouse and click again to mark the second point.
- 3 To draw a freehand line, hold down the Alt (Windows) key and click and drag the mouse.
- 4 To close the outline, either move the cursor over the first point and click or double-click.

Magnetic Lasso tool

- 1 After selecting the tool, click and release the mouse button to mark the first fastening point.
- 2 Trace the outline of the object with the mouse pointer. Extra fastening points will be added to the edge of the object automatically.
- 3 If the tool doesn't snap to the edge automatically, click the mouse button to add a fastening point manually.
- 4 Adjust settings in the options bar to vary the tool's magnetic function.
- 5 To close the outline, either double-click or drag the pointer over the first fastening point.

Selection Brush tool

- 1 After selecting the tool, adjust the settings in the options bar to vary the brush size, shape and hardness (edge softness).
- 2 To make a selection, change the mode to Selection and paint over the object with the mouse pointer.
- 3 To make a mask, change the mode to Mask and paint over the area outside the object with the mouse pointer.
- 4 Holding down the Alt (Windows) whilst painting will change the action from adding to the Selection/Mask to taking away from the Selection/Mask.

Color and tone selection tools

Magic Wand tool

Unlike the Lasso and Marquee tools, the Magic Wand makes selections based on color and tone. When the user clicks on an image with the Magic Wand tool, Elements searches the picture for pixels that have a similar color and tone. With large images this process can take a little time, but the end result is a selection of all similar pixels across the whole picture.

How identical a pixel has to be to the original to be included in the Magic Wand selection is determined by the Tolerance value in the options bar. The higher the value here, the less alike the two pixels need to be, whereas a lower setting will require a more exact match before a pixel is added to the selection. Turning on the Contiguous option will only include the pixels that are similar and are adjacent to the original pixel in the selection.

The Magic Wand selects pixels of similar color and tone.

Magic Wand workflow:

- 1 With the Magic Wand tool active, click onto the part of the image that you want to select.
- 2 Modify the Tolerance of the selection by altering this setting in the options bar, then deselect, then click the tool again to reselect with the new Tolerance settings.
- 3 Constrain the selection to adjacent pixels only by checking the Contiguous option.
- 4 Include the content of other layers in the selection with the All Layers option.

The **Tolerance** setting determines how alike pixels need to be before they are included in the selection.

- (1) Tolerance setting 10.
- (2) Tolerance setting 50.
- (3) Tolerance setting 130.

The **Contiguous** option restricts the selection to those pixels adjacent to where the tool was first clicked on the image surface. (1) A selection made with the Contiguous option turned on. (2) A selection with the option turned off.

olerance: 32

With the **Sample All Layers** option unchecked the Magic Wand only looks for pixels with similar tone and color in the current layer. Checking this option will force the tool to look at the content of all the layers in the document when creating the selection.

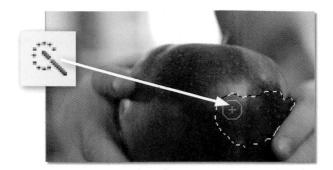

As you are drawing with the Quick Selection tool Elements automatically generates a selection of all the adjacent areas in the picture that have similar color, texture or tone.

Combination selection tools

The Quick Selection tool

Along with the Smart Brush tools, the Quick Selection tool (previously the Magic Selection Brush) provides Elements users with a unique approach to creating and modifying selections. As we have seen, when using the Selection Brush the user must paint over the area to be encompassed by the selection. The accuracy of this painting step determines the accuracy of the final selection. For example, painting over an edge accidentally will result in the creation of a selection that goes beyond this picture part.

The Quick Selection tool provides a quicker, easier and, in most cases, more accurate way to make selections by combining both the drawing and color selection approaches of the other tools we have covered. To make a selection choose the tool from the tool bar. If it is hidden from view click the small arrow at the bottom right of the Selection Brush button to reveal the tool. With this tool Elements creates the selection as you paint over specific picture areas. You don't have to be too careful with your initial painting as the program registers the color, tone and texture of the picture parts and then intelligently searches for other similar pixels to include in the selection.

Fine-tuning the areas selected with Quick Selection tool

Although this tool does a pretty good job of selecting alike areas, there will always be occasions when either too much or too little of the picture has been included. Just like the other tools we have looked at, the Quick Selection tool allows you to easily modify the selections it makes.

To include other areas in the selection, click the Add to Selection button in the tool's options bar (the cursor will change to include a small +) and paint over a new picture part. This step will cause Elements to regenerate the selection to include your changes. To remove an area from the selection, click on the Subtract from Selection button (cursor changes to the brush tip and a small - sign), and paint over the part to eliminate. Again, Elements will regenerate the selection to account for the changes. The Shift and Alt keys can be used whilst drawing to change modes on the fly and add to or subtract from the selection.

The Quick Selection tool is available in both the Full and Quick Fix editor workspaces.

Add to Selection

Subtract from Selection

The options bar of the Quick Selection tool contains several modes that can be used for altering or refining the selection created by the tool.

You can add other picture parts to a selection by clicking on the Add to Selection button and then painting over the new area.

Parts already selected can be removed by changing to the Subtract from Selection mode and painting on these areas.

Quick Selection workflow:

- 1 With the Quick Selection tool active, paint over the areas to select.
- 2 After the first selection area is drawn, the tool's mode automatically changes to Add to Selection so that you can include extra areas in the selection.
- 3 Subtract from the selection by painting over new areas after switching to the Subtract from Selection mode.

The Smart Brush tool sits aside the Brush tool in the Photoshop Elements toolbar (1). The tool's options bar contains three brush mode buttons in the middle – new selection, add to selection and subtract from selection (2), the familiar brush presets to adjust brush tip qualities (3), an Inverse check box to flip the enhancement to the non-selected part of the photos (4), a Refine Edge button to open the feature (5) and the Preset Chooser (6) that displays a preview of the different adjustment presets available with the tool.

The Smart Brush tool

One of the major changes introduced in Photoshop Elements 7.0 was the ability to select and make changes with the one tool. The Smart Brush tool brings a whole new level of ease to the process of changing specific areas of your photo. By

combining the selecting abilities of the Quick Selection tool and the enhancement options available via adjustment layers, the Adobe engineers have created a new way to change the look of your photos. And in version 10 Adobe included a bunch of presets you can use with both the Smart Brush and Detail Smart Brush tools

Unlike the traditional way of applying adjustments where the user must first make a selection and then apply the adjustment, the Smart Brush Tool creates the selection and applies the adjustment as the user paints over the image. You can select the type of adjustment that will be applied with the tool from a list of over 65 that ships with Elements.

These presets are grouped under general headings in the Preset Chooser located in the options bar. Here you will find options for altering image characteristics such as color, tone and saturation as well as subject-based enhancements such as brightening teeth or making a dull sky bluer and, of course, a bunch of special effects changes.

Preset entries can be displayed in a list or thumbnail form by selecting one of the options displayed when pressing the double sideways arrows in the top left of the Presets window.

The Smart Brush Tool is only available in Full editor workspace.

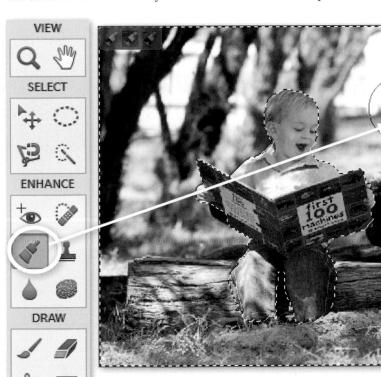

After selecting the enhancement type, (here I used one of the convert to black and white options), all you need to do is paint over the parts of the photo that you want to change. If the tool selects too much of the photo, switch to the Subtract from Selection mode (hold down the Alt/Opt key) and paint over the unwanted change to remove it.

Smart Brush workflow:

- 1 With the Smart Brush tool active, go to the Options Bar and select the type of enhancement from the Preset Chooser pop-up menu.
- 2 Now paint over the areas that you wish to select and enhance.
- 3 After the first selection area is drawn, the tool's mode automatically changes to Add to Selection so that you can include extra areas in the selection.
- 4 Subtract from the selection by painting over new areas after switching to the Subtract from Selection mode using the buttons in the Options Bar or the floating palette at the top right of the photo.

Fine-tuning Smart Brush selections

Just like the other selection tools, it is possible to add to, or take away from, an existing selection. This gives you the chance to fine-tune the areas of the photo that the Smart Brush Tool has changed. You can switch between selection modes in three different ways:

- 1. By choosing an entry from the mode buttons on the left of the options bar.
- 2. By using one of the shortcut keys Shift to add, Alt/Opt to subtract.
- 3. By choosing one of the mode entries from the buttons displayed in the new floating palette located at the top left of the open photo.

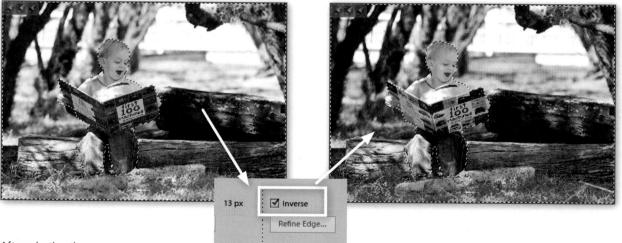

After selecting the enhancement type, all you need to do is click the Inverse option to switch the adjustment from the selected area to the non-selected area.

Choosing what not to change

We have already seen that sometimes it is easier to select what you don't want to change, rather than what you do. Imagine trying to select every small branch and twig of a bare winter-time tree against a blue sky. It would be easier to use the Magic Wand tool to select all of the blue sky and then Invert the selection to isolate the tree. With this in mind the Options Bar of the new Smart Brush Tool contains an Inverse check box. Selecting this option after painting on a change to your photo will remove the adjustment from the selected area and paste it onto the non-selected area. Some presets have the Inverse option built in so painting on an object will apply the effect to all picture parts except the object.

Adjusting Smart Brush Tool effects

When you paint on a photo with the Smart Brush Tool, Elements creates a new Adjustment Layer and adds it to the layer stack with a mask based on the painted selection. Now without going into too much detail about adjustment layers or their masks (this will be handled later

in this chapter), it is important to realize that making an change to your photo in this way has two important benefits over applying changes directly:

- Firstly, the adjustments are made non-destructively. Which means that the original photo's pixels are left untouched as the changes are made in a separate layer that sits above the background (picture) layer. You can easily hide the effect applied with the Smart Brush Tool by simply clicking on the 'eye' icon situated to the left of the layer entry. Clicking the 'eye' a second time will reapply the changes.
- Secondly, the way that the Smart Brush Tool effect alters your
 photo can be modified by adjusting how the adjustment layer
 interacts with the picture layer, and, in some cases, by changing the settings for the effect itself.

So Smart Brush Tool adjustments can be modified. Great, but how? Well again some of these concepts will be better explained later in the chapter but let's look at a simplified version here while the whole idea of this new way of altering our photos is fresh in our mind.

To alter the strength of a Smart Brush Effect: Changing the strength of the effect is a simple matter of selecting the Smart Brush Tool entry in the layers palette and then adjusting the Opacity slider at the top right of the palette. The lower the opacity number the more subtle the effect.

To change how the effect combines with the picture:

Photoshop Elements has many different ways to control how the contents of two layers are mixed together. This interaction is called layer blending and is controlled by a setting called the layer Blend Mode. By default the content of upper layers obscure the content of layers beneath. This is the Normal Blend Mode, but Elements offers many more choices about how the Smart Brush Tool layer can interact with the background or image layer. To change Blend Modes just select a new entry from the drop-down list at the top left of the layers palette. See the Blend Modes section later in the chapter for more details on Blend Modes and their effects. It is also worth noting that many Smart Brush presets use blend modes other than Normal by default.

Smart Brush Tool changes are applied via a masked adjustment layer. In the example on the previous page you can see the entry for the Convert to Black and White changes.

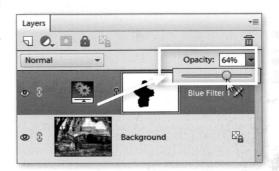

The Opacity slider at the top right of the Layers palette controls how transparent the layer content is. In the case of a Smart Brush Tool entry you can use the Opacity slider to control the strength of the effect. Here a setting of 50% will display a mixture of the original (background image) and the Smart Brush Tool effect.

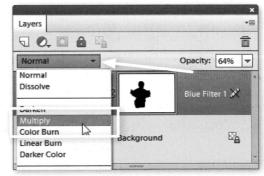

Changing the Blend Mode option of the Smart Brush Tool layer will alter the way that the effects interact with the image or background layer.

To change the settings of the effect itself: One of the great things about Adjustment layers is that you can alter the settings used at any time by double-clicking on the Layer Thumbnail (on the left) to display a dialog box complete with all the controls that you used originally to make the change. Now as all Smart Brush Tool effects are based on masked adjustment layers, to change the style of the effects, it should be possible to double-click on the layer thumbnail and simply change the settings in the dialog that appears. For most Smart Brush Tool adjustments this is true (check out the Lighting options) as they are built upon Elements Adjustment Layers, but this is not always the case as some effects are based on features that are only available in Photoshop itself. If you try to adjust these you will get a warning notice saying that it is not possible to tweak the settings.

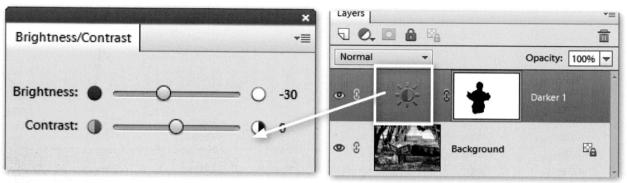

With some Smart Brush Tool entries the actual settings used for making the image adjustments can be edited. In this example, the 'Darker' preset was applied to parts of the photo with the Smart Brush Tool. A new Smart Brush Tool layer was added to the Layers palette as a result. By double-clicking on the thumbnail on the left of the entry, the Brightness/ Contrast dialog is displayed. This is the feature used to make the changes you applied with the brush. In the dialog you can change the settings used for the adjustment. Clicking OK will apply the changes to your photo.

That said, for those entries based on Elements features, double-clicking the layer thumbnail will display the feature's dialog allowing the user to fine-tune the effects applied. You can also display the adjustment dialog, when you have the Smart Brush Tool selected by double-clicking on the Smart Brush Tool icon on the photo. Single-clicking the icon reselects the area originally isolated by the brush and makes the Smart Brush Tool layer active (in the Layers palette).

Adding multiple Smart Brush Tool adjustments

The 'paint on' nature of Smart Brush Tool adjustments will mean that this feature will be one that you reach for often when wanting to tweak specific parts of your photo. This scenario will, undoubtedly, lead to you wanting to apply more than one adjustment to a single image. Thankfully, this is not a problem as each time you apply a Smart Brush Tool adjustment a new layer is added to the layer stack. This means that each change is independent and can be hidden from view (turn off the 'eye' icon) or tweaked (Opacity and Blend Mode). Along with the new layer entries, Elements also places new icons on the photo for each additional Smart Brush Tool adjustment. These are colored different hues so that you can distinguish them from each other.

To reselect the adjustment area marked out by the Smart Brush Tool, when you have the tool selected, single-click the icon on the photo. Double-clicking will open the associated adjustment dialog as long as it is an Elements feature.

Smart Brush Tool workflow:

- 1 After making a initial Smart Brush Tool, click onto the New Select mode button in the Options Bar or the floating palette to tell Elements that you want to create a new adjustment selection.
- 2 Go to the Options Bar and select the type of enhancement from the Preset Chooser pop-up menu.
- 3 Now paint over the areas that you wish to select and enhance.
- 4 After the first selection area is drawn, the tool's mode automatically changes to Add to Selection, so to add another adjustment you must click the New Selection button once again.
- 5 To reselect an existing adjustment area, make sure that the Smart Brush Tool is selected and then click onto the colored icon associated with the selected area. Now you can add to the existing selection by painting over new areas or change to the Subtract from Section mode and remove selection parts.

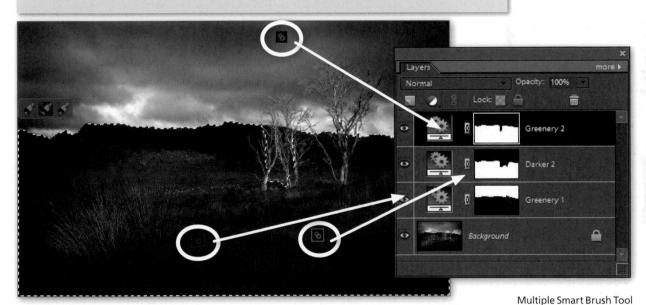

The Detail Smart Brush Tool

Grouped with the Smart Brush Tool on the Elements' toolbar is another version of the feature called the Detail Smart Brush Tool. The icon used for the tool is almost identical, but it features a fine-tipped brush rather than a wider brush design. The Detail Smart Brush Tool, as its name suggests, is used for finer work which contrasts with the Smart Brush Tool that has been designed for more broad sweep application. Importantly, selecting the Detail Smart Brush Tool version switches the way that the feature works. When painting with the tool, the brush draws the selection area in the same way as the Selection Brush.

effects can be applied to a photo. Each effect will have a separate entry in the Layers palette as well as an icon that is displayed on the surface of the photo when the tool is selected.

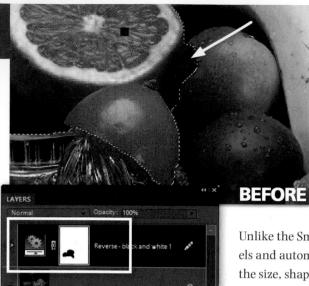

In this example the initial adjustment was added to the image using the Smart Brush Tool. Next the areas that had been included in the changes by error are removed by switching to the Detail Smart Brush tool and painting over these parts while holding down the Alt/ Opt keys.

Unlike the Smart Brush Tool, Elements doesn't try to locate similar pixels and automatically snap the selection to the border of subject. Instead the size, shape and softness of the brush tip all contribute to the quality of the selection area. This provides a far more controlled and direct mechanism for the creation of accurate selections.

The best approach for creating fast accurate adjustments is to use the Smart Brush Tool first to quickly apply big changes to the photo. Next, the Detail Smart Brush Tool is used to fine-tune the selection. Areas are removed by holding down the Alt/Opt key while painting or added by using the Shift key with additional brush strokes.

With the help of the Style Painter and Style Eraser tools you can control the areas where the 'look and feel' of the style image is transferred to the after photo.

The Style Painter approach to selecting areas

Photomerge Style Match was one of the new features first introduced in Photoshop Elements 9. It transfers the 'look and feel' of one image to another. By default this action is applied to the whole of the photo, but with the aid of the Style Eraser and Style Painter tools, you can also use the feature to paint changes onto specific areas.

Once the style is applied to the after photo, you select the Style Eraser, and paint over the picture to remove the effects of the styling. The Style Painter tool can then be used to reapply the styling to areas where the effects have been erased.

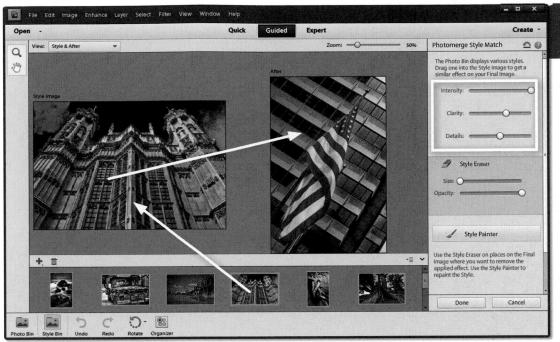

Although not specifically a selection tool, the Style Painter and Style Eraser tools can be used to mask the effects of the Photomerge Style Match feature.

Style Painter at work:

- 1 Select the image to be stylized in the Organizer workspace and then choose Enhance > Photomerge > Style Match. The image will be opened into the Editor.
- 2 Drag an example photo from the Style Bin to the Style Image area of the workspace.
- 3 Check the Transfer Tones setting and then select the Style Eraser tool from the right panel of the workspace.
- 4 Brush over the area to remove the effects of the styling.
- 5 Select the Style Painter tool to brush the styling effects over areas of the image where they have been erased.
- 6 Once the tools have been used to isolate areas of the photo, dragging a new style photo to the Style Image section of the workspace will transfer the style to the after picture but not to the sections that have been erased.

The **Style Eraser** tool is used to paint out the effects of the style match process. When applied the 'before' image is revealed.

The **Style Painter** tool is used to paint in the effects of the style match process. The tool only works in areas of the photo where the eraser tool has already removed the styling.

Beyond One Step Selections

It is not often that you can complete a specific technique in a single step. In most cases you will find that the selection creation process contains many steps and employs a variety of tools and features. In this section we'll look at the ways that you can modify and manage the selections you create.

Different selection modes are available as buttons on the options bars of the various Selection tools in Photoshop Elements. You can change the selection mode by clicking onto one of these buttons or by using associated shortcut keys.

These choices in the selection tools options bar determine how any newly-created selection interacts with any existing ones.

- (1) New selection.
- (2) Add to selection (Shift).
- (3) Subtract from selection (Alt/Opt).
- (4) Intersect with selection (Shift Alt/Opt).

Adding to a selection

By default most tools are set to create a new selection when first picked from the toolbar. To add to an existing selection, you will need to hold down the Shift key whilst selecting a new area. Notice that when the Shift key is pressed the selection tool's cursor changes to include a '+' to indicate that you are in the 'Add to Selection' mode.

As well as using the Shift key you can also pick the 'Add to Mode' from the tool's options bar in Photoshop Elements. This switches the actual mode of the tool.

Step-by-step adding to a selection:

Follow these steps to include other picture parts in your selection.

Create a Selection First:

Start by creating an initial selection. Use any of the Selection tools for this step.

Use Shift to Add to a Selection:

With the selection tool still selected, hold down the Shift key and continue to define picture areas to include in the now extended selection. It is also possible to change selection tools at this point and use a different tool to add to an existing selection.

Subtracting from a selection

Another way to modify existing selections or masks is to remove parts of the selection or erase sections of the mask. To remove sections from an existing selection hold down the Alt key (Option - Macintosh) whilst selecting the part of the picture you do not wish to include in the selection. When in the subtract mode the cursor will change to include a '-'.

Step-by-step subtracting from a selection:

Follow these steps to remove picture parts from your selection.

Create a Selection First:

Again this is a feature for modifying existing masks or selections. So the first step is to create a selection or mask on the image.

Use Alt/Opt key to Subtract from a Selection:

Once the Selection or Mask has been created, holding down the Alt/Opt keys will switch the Selection or Adjustment Brush tool to the Subtract From or Erase mode. Using the tool in this mode will remove sections of the mask or selection.

Intersecting selections

When you are trying to isolate picture parts with complex edges it is sometimes quicker and easier to make two separate selections and then form the final selection based on their intersection. Often the quickest route to selection perfection is not the most direct route. Alongside New, Add To and Subtract From, the fourth Selection mode available as a button on the option bar is the Intersect mode. Although not used often, this mode provides you with the ability to define a selection based on the area in common between two different selections.

Step-by-step creating a selection from intersecting selections:

Follow these steps to create a new selection from the intersection of two different selections.

Create the first Selection:

Start by using on of the Selection tools from Photoshop Elements to create an initial selection. Now choose the selection tool that you will use to create a second selection.

Switch to Intersect Mode:

Next, switch to the Intersect With mode by holding down the Shift and Alt/Opt keys. Notice that the tool's cursor has the addition of a small X indicating that it is now in the Intersect mode.

Create the Second Selection:

Now create the second selection, keeping in mind that it will only be the overlapping parts of both first and second selections that will remain when you release the mouse button.

Saving a selection

The Select > Save Selection option in Photoshop Elements allows the user to store complex, multi-step selections with the file for which they were created. To save a selection choose the option after creating a selection and whilst it is still active. The selection is saved as part of the Photoshop file (PSD) and can be restored, using the Load Selection feature, next time the picture is opened. The Reselect option provides a similar function but only restores the last selection made during the current editing session.

Step-by-step for saving a selection:

Follow these steps to save a selection that you have created with your photo.

Save an Existing Selection:

Photoshop Elements gives you the option to save complex selections so that they can be used again later. To save a selection start with your selection active, then choose the Save Selection option from the Select menu. Your selection will now be saved as part of the file and can be retrieved using the Load Selection option at a later date.

Save Selection Options:

The Save Selection dialog also provides you with another way to modify your selections. Here you will find the options to save a newly created selection in any of the four selection modes. This provides you with an alternative method for building complex selections based on making a selection and then saving it as an addition. In this way you can create a sophisticated selection one step at a time.

Loading saved selections

Saving a selection in Photoshop or Photoshop Elements stores the selection with the image. When you close your file and then open it again later you can retrieve the selection by choosing the saved entry from the Select > Load Selection. This feature is particularly useful when making sophisticated multi-step selections, as you can make sequential saves, marking your progress and ensuring that you never lose your work.

Step-by-step for loading a selection:

Follow these steps to reload a saved selection.

Loading a Saved Selection:

After opening an image containing a saved selection, choose Select > Load Selection to display the Load Selection dialog. To restore a specific selection, choose the entry from the drop-down Selection menu and make sure that the New Selection option is selected in the Operation section.

Other Load Options:

Extra load options become available when you choose the Load Selection feature with a selection already active. In this situation you can choose to add, subtract or intersect the selection you are loading with the one already displayed.

Transforming selections

Most readers will be familiar with the Free Transform feature that we use to manipulate the size and shape of picture and layer content. A similar feature is available for changing the size and shape of active selections.

Step-by-step selection transformation:

Follow this three-step process to transform your selections.

Create the Selection:

Start by creating the selection using any of the tools available in Photoshop Elements.

Transform the Selection:

With the selection still active, the Transform Selection option will be available on the Select Menu. Selecting this option will place handles in the corners and sides of the selection allowing the user to manipulate the size and shape of the selection without altering the image beneath.

Make Changes:

Dragging any of the handles will alter the shape and size of the selection. Holding down the Shift key will maintain the aspect ratio of the selection. Using the Alt/Opt key will adjust the selection from the center rather than the edges and using the Ctrl/Cmd key will allow the user to distort the selection. Click Enter or press the green tick button to apply the transformation.

Inverting selections

The Select > Inverse command makes a new selection by choosing all the pixels in the picture that are currently not selected. When trying to select a subject that has a complex edge but a plain background, it can be quicker to select the background first with a tool such as the Magic Wand and then swap the selection from the background to the foreground using the Select > Inverse option.

Step-by-step inverting a selection:

Follow these steps to swap selected and non-select parts of the photo.

Create Initial Selection:

Sometimes it is faster to select the part of the photo that you don't want first and then use this as the basis for creating a selection of the subject. A classic example is when you are wanting to create a vignette around a subject. It is quicker to select the subject with the Elliptical Marquee first.

Invert the Selection:

The next step is to flip the selection so that instead of isolating the subject the selection is around the outside of the photo. We do this by choosing Select > Inverse.

Apply Adjustment via Selection:

To complete the vignette effect, we will soften the edges of the selection via the Feather slider control in the Refine Edge dialog. With the selection still active apply the vignette with a new Levels Adjustment layer. Just push the mid tone and white point sliders to the left to lighten the selected area.

Growing Selections

As well as the options listed under the Select > Modify menu, an active selection can also be altered and adjusted using the Grow command. The Select > Grow feature increases the size of an existing selection by incorporating pixels of similar color and tone to those already in the selection. For a pixel to be included in the 'grown' selection it must be adjacent to the existing selection and fall within the current Tolerance settings located in the options bar.

Step-by-step selection growing:

Use these steps to increase the size of the selection to include adjacent pixels of the same color and tone.

Create a Selection First:

Like the Similar command below, the Grow feature works on an existing selection, so the first step is to create a new selection.

Apply Grow Command:

With the selection established you can now choose Select > Grow. This instruct the program to increase the selection's edges to include adjacent pixels that have similar tones and colors.

Adjust Tolerance Setting:

Elements uses the current Tolerance setting of the Magic Wand to determine how similar pixels have to be to be included in the new selection. Use a lower value to be more selective and a higher setting to include pixels with more variation.

Selecting Similar Picture Parts

Listed under the Select menu is a range of options for adjusting selections after they have been created. Select > Similar is one of these options available to Photoshop Elements users. The feature looks for, and selects, pixels throughout the whole picture with similar color and tonal characteristics to those already included in an existing selection.

Step-by-step selection of similar pixels:

Follow this three step process to locate and include pixels from the rest of the image that are similar to those already selected.

Make First Selection:

step process and is really meant to be used the program looks for other pixels in the as a refinement tool rather than a primary selection strategy. So the first step in the creates a new selection that encompasses process is to make a selection. You can use the ones it finds that are a match. any of the selection tools to do this.

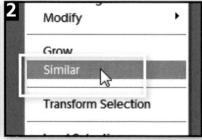

Use Select > Similar:

Using the Select > Similar feature is a two Now choose Select > Similar. Automatically image with similar characteristics and

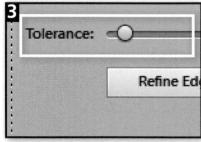

Re-select with Different Settings:

The Tolerance settings of the selection tool used to make the initial selection are used when creating the new 'similar' selection. If the tool you used doesn't have a tolerance setting, and you need to fine-tune the selection process then switch to the Magic Wand before re-selecting and applying the Similar function again.

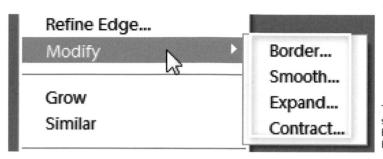

The Modify menu contains several options which can be used to alter existing selections.

Modifying Selections

The Select > Modify menu contains four options that can be used for changing the qualities of an existing selection.

Border – Choosing the Border option from the Modify menu displays a dialog where you can enter the width of the border in pixels (between 1 and 200). Clicking OK creates a border selection that frames the original selection. This feature can be used to quickly outline a selection.

Smooth – This option cleans up stray pixels that are not selected after using the Magic Wand tool. After choosing Modify enter a Radius value to use for searching for stray unselected pixels and then click OK. This feature works well when selecting skies.

Expand – You can use this feature for increasing the size of a selection by a set amount. After selecting Expand enter the number of pixels that you want to increase the selection by and click OK. The original selection is increased in size. You can enter a Pixel value between 1 and 100.

Contract – Selecting this option will reduce the size of the selection by the number of pixels entered into the dialog. You can enter a Pixel value between 1 and 100.

Three of the four options, Smooth, Expand and Contract, are also available in the Refine Edge dialog. As the Refine Edge feature provides a variety of preview options that you can use to assess the changes you make to your selection, most proficient users apply these features here rather than as simple menu selections. See the next page for details.

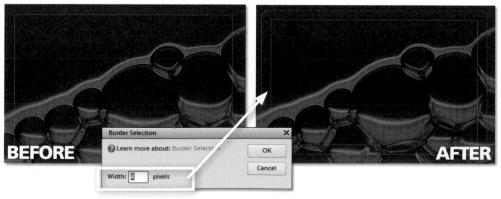

The Select > Modify > Border feature creates a feathered border around the edge of an existing selection. The size of the border is entered into the feature's dialog.

Select > Refine Edge

A new way to modify the edges of the selections you create was introduced in Photoshop Elements 6. Called the Refine Edge feature it is accessed either via the button now present in all the selection tools' options bars, or via the Select > Refine Edge menu entry. The feature brings together three different controls for adjusting the edges of the selection with two selection edge preview options. The edge controls also exist as separate entries in either the Select or Select > Modify menu. Bringing them together in the one dialog, and then providing live preview options as well, means that the refining activity will be a lot more accurate, as you will be able to see the results of the changes made to any of the controls reflected in the image itself.

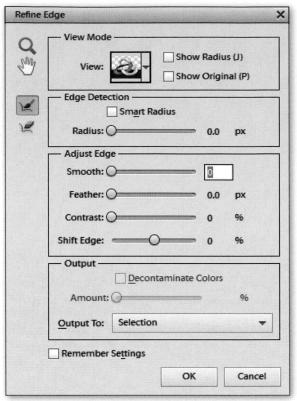

The Refine Edge dialog brings together all the controls used for altering the characteristics of the selection's edge into a single dialog. The feature also includes two edge preview options.

The feature's dialog contains a Pre-

view toggle, and Zoom and Move tools which can be used for navigating around enlarged images to check the properties of the selection edge. The edge controls themselves come in the form of the following three sliders:

Smooth – This option removes stepped or jagged selection edges.

Feather – Softens the edge of the selection by a given pixel value. You can use this setting to provide a gradual transition between selected and non-selected areas.

Contrast - Increase contrast of the selection edge.

Shift Edge – Increase or decrease the size of the area outlined by the selection by the percentage value selected.

The Preview modes buttons at the bottom of the dialog provide a range of different ways to view the selection on your picture. The left button displays a standard selection edge superimposed on the photo. The edge is outlined using the familiar 'marching ants' line.

The other button previews the selection as a mask, with the selected area displayed clear of color and the non-selected area shown with a specific color overlay. The color and transparency of the mask overlay can be altered by double-clicking the preview button.

Switching between the standard and Mask views of an enlarged image allows you to see more accurately where the selection is being applied.

Standard preview

Mask preview

Mask preview showing feathered edge

Selecting the Mask option provides a much better way of viewing the quality of the selection edge as it is possible to preview the sharpness of the edge as well as how transparent the overlap is between selected and non-selected areas (feathering). For best results, use the Mask option in conjunction with the Zoom and Move tools to inspect an enlarged preview of the selection edge, as you make changes to the dialog's slider controls.

Press the 'P' key to turn off the preview of the current Refine Edge settings and the 'X' key to temporarily display the Full Image view.

Refine Edge workflow:

- 1 When a selection is active, you can display the dialog by choosing Select > Refine Edge.
- 2 By default a selection's edge is displayed as flashing series of dotted lines. These 'marching ants' ably show where the selection starts and end but are not able to display the quality of the edge itself. Start by selecting the Preview option. Then, to better see the effect of changes made in the dialog to selection edge, choose a different preview option.
- 3 With the Preview sorted, you can now use the slider controls to alter the selection's edge qualities. Clicking the OK button will apply the changes.

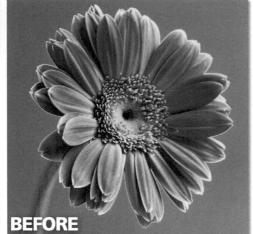

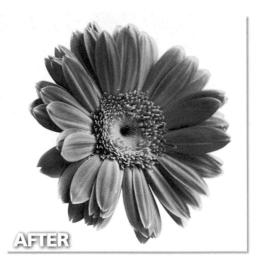

The Magic Extraction feature contains the ability to quickly remove unwanted background details leaving just the foreground.

The Magic Extractor feature

Although not strictly a selection tool the Magic Extractor feature (Image > Magic Extractor) does quickly remove the background of a picture whilst retaining the subject in the foreground. It does this by marking, with a scribbled line or a series of dots, the foreground (to be kept) and the background (to be removed) parts of the picture. Elements then automati-

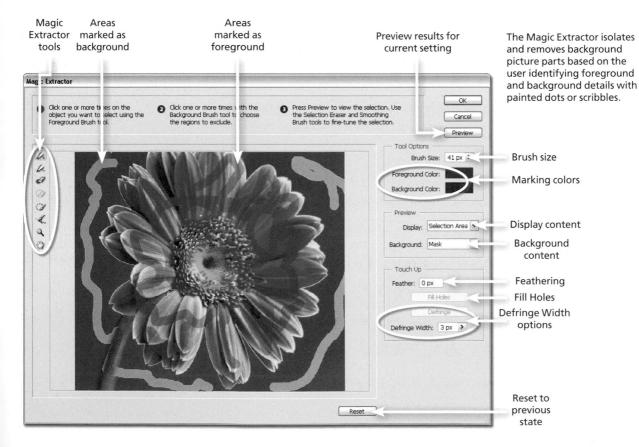

The Defringe option in the Magic Extractor feature removes any stray background colored pixels (1) from the edge of extracted foreground detail (2), whereas the Feather option softens the edge of the detail (3).

cally finds all the background parts in the picture and removes them from the document, replacing it with transparency and previewing it with your choice of black, gray, white or transparency. So in this way, the feature does contain a selection type approach, hence why I have included its use in this section of the book.

The Magic Extractor works within its own window, which includes a zoomable preview area, a set of tools for marking the foreground and background parts of a photo, touch-up options to refine extraction results as well as settings to select the background area once it is removed. Using the Magic Extractor tool is a three-step process. You start by selecting the Foreground Brush tool and scribbling or placing dots over the areas that you want to retain. Next, you switch to the Background Brush tool and scribble over the areas to be removed.

Magic Extractor workflow:

- 1 Display the Magic Extractor option by choosing the Magic Extractor option from the Image menu.
- 2 Next, select the Foreground Brush and paint, scribble or place dots on the areas to be kept.
- 3 Now select the Background Brush tool and paint over the picture parts that will be deleted as part of the extraction process.
- $4\,$ To check the accuracy of the extraction press the Preview button.
- 5 To add extra sections to the extracted area reselect the Foreground Brush, switch the Preview Display option to Original Photo and paint over the extra parts.
- 6 To remove unwanted parts from the selection do the same thing but using the Background Brush instead.
- 7 Finally, to clean up the edges of the extraction select the Smoothing Brush tool and drag it over the edges of the extraction.
- 8 Click OK to process the extraction and return the completed results to the main editing workspace.

When adding or removing parts from your extraction click the 'X' key toggle between the Preview and Extracted views.

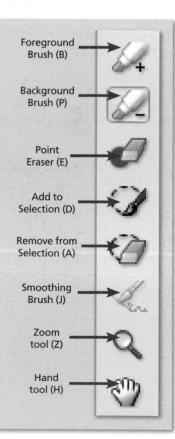

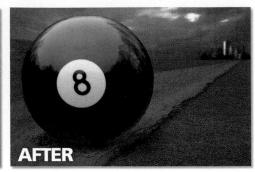

Paint on selective changes

As we have already seen Photoshop Elements contains a unique way to select and apply adjustments in one step using the Smart Brush Tool. The feature ships with over 65 preset adjustments that can be used to alter the look of your photos. There is also the ability to add extra presets, so don't be too surprised if these become available to download and install, either

The Smart Brush Tool can be used to quickly and easily apply changes to a selected part of a photo. from Photoshop.com or other Elements websites. Of those that ship with Elements, I have selected two here to demonstrate the different effects that can be achieved using the tool. The workflow for each example is very similar but the results are dramatically different.

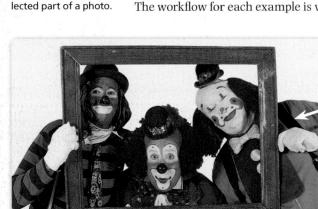

Black and white and color all in the one photo using the Blue filter painted onto the area surrounding the

With the Inverse option selected in the Smart Brush Tool's options bar, the school bag was selected using the Sepia Duotone effect.

281

Layers

Breaking an image into different component parts may not seem like something that would be all that necessary, but as you start to develop more and more sophisticated enhancement skills, you will start to see the advantages of such an approach.

Elements users are able to use a special Layers feature to help them separate different picture parts and adjustment controls. This separation helps provide better fine-tuning of enhancement and editing changes while at the same time is a key way that the quality of the original photo is maintained.

Here I will introduce the concepts behind using Layers in Elements and demonstrate the fundamental techniques that you will use on a daily basis to enhance your photos.

Image

A flat file contains all the image information in a single plane.

Layers and their origins

The first image-editing programs used a flat file format. All the information for the file was contained in a single plane and all changes made to the image were permanently and irreversibly stored in this file. It did not take users and software manufacturers long to realize that a more efficient and less frustrating way to work was to build an image from a series of picture parts each contained on its own layer.

The concept was not entirely new; the cell animation industry has used the idea for years. Each character and prop was painted onto a transparent plastic sheet, which was then layered together over a solid background. When seen from above, the components and the background appeared to be a single image.

In Photoshop and Photoshop Elements, Adobe has based its layers system on this idea. When an image is first created and opened in the editing package, it becomes the background by default. Any other images that are copied and pasted onto the image, or text that is added to the picture, become a layer that sits on top of this background. Just as with the animation version, the uppermost layer is viewed first and the other layers and background then show picture components through the transparent areas of each other layer.

Multi-layered image files are used by most editing programs as a way to separate different whilst keeping them available for editing and enhancement purposes.

The Layers palette

Undoubtedly this whole idea might seem a little confusing to the new user, but the benefits of a system that allows picture parts to be moved and adjusted independently far outweigh the time it will take to understand the concept. To help visualize the setup, Elements contains a specialized Layers palette (Editor: Window > Layers) that shows each of the individual layers, their position in the layer stack and a small thumbnail of their contents.

A transparent area is represented by a checkerboard gray and white pattern that surrounds any image parts that are smaller than the background. The eye, sitting to the left of the thumbnail, shows that the layer is visible. Clicking on this icon will make the eye disappear and visually remove the image part from the whole picture. Only one layer in the stack can be edited at a time and for this reason it is called the working layer. This layer will be colored differently to the others in the stack. Clicking on a different layer in the area to the right of the thumbnail will make this layer the new working layer.

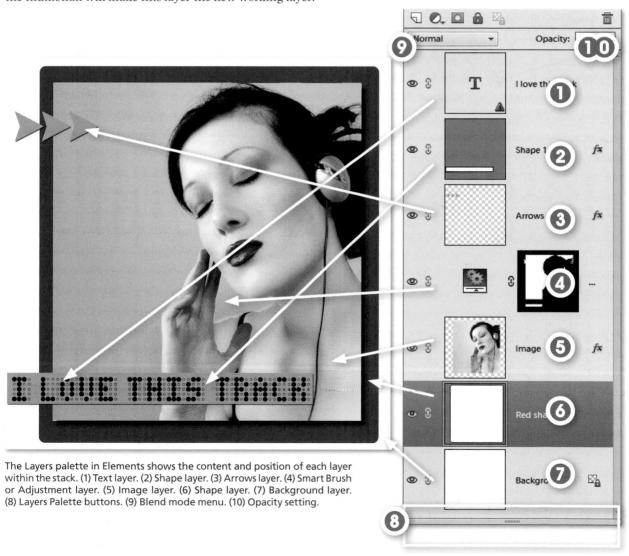

The buttons at the top of the Layers Palette can be used to quickly add, link, lock or delete layers. These same options are repeated in the entries of the Layer menu. (1) New layer. (2) New Adjustment or Fill layer. (3) Link layers. (4) Lock Transparency. (5) Lock All. (6) Delete.

When the full image is saved as an Elements file in PSD format, all the individual layers are maintained and can be manipulated individually when the picture is opened next. This is not true if the image is saved in other formats like standard JPEG. Here, the information contained in each layer is merged together at the time of saving to form one flat file.

Clicking the eye icon removes that layer from view in the image.

Layer types

Image layers

Several different types of layers can be added to an Elements image; of these the most simple, and probably the most obvious, is the image layer. When an image part is copied and pasted it automatically makes a new

layer. This is true whether the picture part came from the original image or from another picture that is already opened.

When this new layer is selected as the working layer it can be moved around the image surface using the Move tool. The contents can also be changed in size and shape using one of the four options found in the Transform menu (Image > Transform > Free Transform or Skew or Distort or Perspective). These features allow you to manipulate the layer to fit the other components of the image.

Background layers

The background layer is a special image layer. Its dimensions define the image size. It is also locked by default, meaning that it cannot be moved.

The active or working layer is a different color to the others in the stack.

You can restrict the movement of other key layers by clicking the lock icon in the top part of the Layers palette. Ticking the Transparency option located next to the lock icon will not allow any changes made to the layer to impinge on the transparent area.

Type layers

Type layers do not show a thumbnail of their contents in the Layers palette. A large 'T' is positioned in its place and the first few words of the text are used as the layer's name. Unlike other packages, Elements'

type layers remain editable even after they have been saved, provided that the file has been saved in the PSD, TIFF or PDF formats.

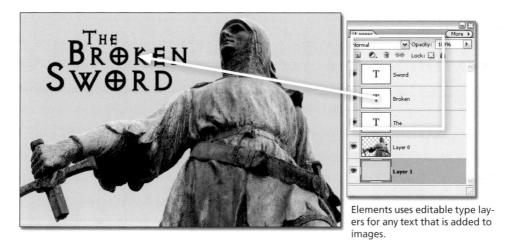

Shape layers

Drawing with any of the shape tools creates a new vector-based shape layer. The layer contains a thumbnail for the shape as well as the color of the layer. Shape layers need to be simplified or changed to a standard image layer before they can be enhanced or filtered.

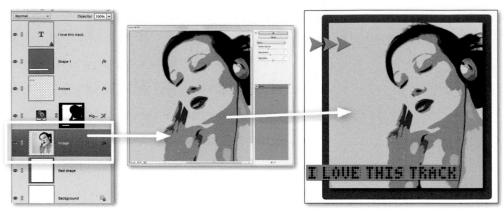

Individual image layers can be manipulated independently of other layers in the stack.

Adjustment layers

Adobe added adjustment layers to Elements as a way for users to change the look of images whilst retaining the integrity of the image file.

Familiar image-change features,

such as Levels and Hue/Saturation, are available as adjustment layers and, depending on where they are placed in the layer stack, will alter either part, or all, of the image.

Adjusting your images using these types of layers is a good way of ensuring that the basic picture is not changed in any way. The other advantage is that the settings in the adjustment layers can be edited and changed at a later date, even after the file has been saved. Users can access the original settings used to make the alteration by double-clicking the dialog icon on the left-hand side of the adjustment layer.

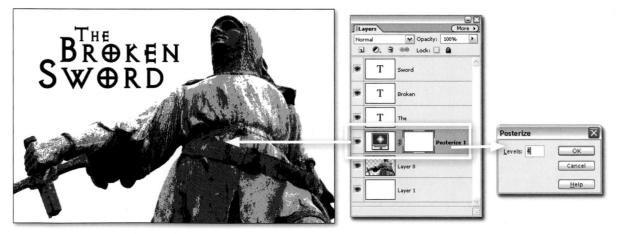

Adjustment layers alter the look of all layers that are positioned beneath them in the stack, unless they are grouped with the layer beneath by holding the Alt key down and clicking the dividing line between each layer in the Layers palette.

Smart Brush Tool layers

As we saw in the last chapter Elements contains an exciting feature called the Smart Brush Tool, which automatically enters a new adjustment layer in the layers palette

when used. This extends the functionality of Adjustment Layers and makes their use much easier than ever before. Keep in mind that you can change the whole of the image by adding an adjustment layer without using the Smart Brush Tool. However if you want the adjustment layer effects to be restricted to just one portion of the photo then either make a selection first before adding the layer or use the Smart Brush Tool to paint on the changes.

If you create an Adjustment layer manually, that is select an entry from the Layer > Adjustment Layer menu, then it will be treated like a Smart Brush layer when that tool is selected.

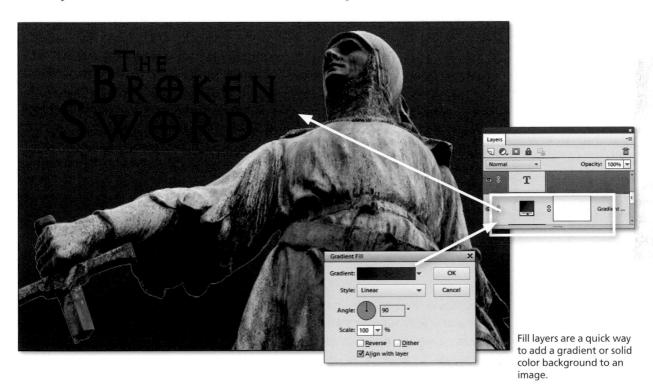

Fill layers

Users can also apply a solid color, gradient or pattern to an image as a separate layer. These three selections are available as a separate item (Layer > New Fill Layer) under the

Layer menu or grouped with the adjustment layer options via the Quick button at the top of the Layers palette.

Frame layers

Another unique layer type for Photoshop Elements is the Frame layer. It was introduced to coincide with the release of the Photo Books and Collages (see Chapter 18 for more

details). Its role is to store both the frame and the picture that sits within it. This would not be a difficult task if, once the frame and picture were combined, both parts became one entity, but this approach would not provide much room for fine-tuning later. So, instead, the development team created the Frame layer, borrowing some of the technology from the Smart Object Layer feature in Photoshop.

The Frame layer cleverly stores both the frame and photo together in the one layer. The new feature allows you to manipulate the frame and photo together, or just the photo within the frame, but you cannot manipulate just the frame alone.

Frame lavers can only be added to a Photo Collage or Photo Book project in Elements. Once you have created either of these project types you can add a frame to the document Content pane on the right side of the screen

In Frame layers both the component parts remain as separate individual images despite being stored as one layer. What does this mean in day-to-day editing? Well, it means that you can do things like change the size, shape and orientation of either the frame, or the picture, independently of each other. This level of flexibility is a godsend for those photographers who regularly compose album or scrapbook pages. Individual photos and their frames can be pushed, pulled, twisted and sized until the composition is just right.

Frame layers are also used in the production of photo projects options including Photo Collages, Photo Books, Greeting Cards, CD or DVD Jackets and CD/DVD Labels.

Frame layers appear like a standard image layer except they have a small plus sign in the bottom right-hand corner of the layer thumbnail to distinguish them from other layer types. Like text and shape layers, Frame layers are also resolution independent.

Non destructive sizing for all

The upside of this characteristic is that the frame and photo content can be up- or downsized many times with minimal or no damage to picture components. This is not the case for a by dragging it from the standard image layer where such changes over time cause the photo to become less clear. The downside, you knew there had to be one, is that because of this basic structure you cannot edit or enhance the pixels in a Frame layer directly. Any attempt to adjust brightness,

Like shape and text layers, Frame layers are resolution independent and so need to be simplified before you can edit them directly.

color, contrast or even filter the photo or the frame meets with a warning dialog that states that you must Simplify the Frame layer first. Simplifying the layer means converting it from its resolution-independent 'frame plus photo' state to a standard pixel-based image layer. For more details on Frame layers and how to use them go to Chapter 18.

Non-destructive resizing with Frame layers: To give you an example of how destructive seemingly small changes to our image layers are, I resized a standard image layer up and down three times. It is easy to see how blurry the photo has become (1). Next I added the same picture to a frame layer and performed exactly the same resizing activity. The result is an image as sharp as the original (2).

Altering the opacity of a layer allows the color, texture and tone of the image beneath to show through.

Layer transparency

Until this point we have assumed that the contents of each layer were solid. When a layer is placed on top, and in front, of the contents of another layer, it obscures the objects underneath completely. And for most imaging scenarios this is exactly the way that we would expect the layers to perform, but occasionally it is desirable to allow some of the detail, color and texture of what is beneath to show through. To achieve this effect, the Transparency of each layer can be interactively adjusted via the Opacity slider control in the top right-hand corner of the palette. Keep in mind that making the selected layer less opaque will result in it being more transparent.

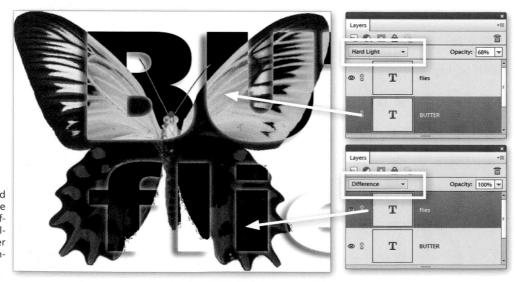

The Difference and Hard Mix blending modes are just a couple of the 23 different blend modes available in Elements that alter the way that two layers interact.

Layer blend modes

The layer blending modes extend the possibilities of how two layers interact. Twenty-three different mode options are available in the drop-down menu to the left of the Opacity slider in the Layers palette. For ordinary use the mode is kept on the Normal selection, but a host of special effects can be achieved if a different method of interaction, or mode, is selected. The mode options are the same ones available for use with tools like the Paintbrush and Pencil, and some advanced editing or enhancement techniques are based on their use. Experimenting with different modes will help you understand how they affect the combining of layers and will also help you to determine the best occasions to use this feature.

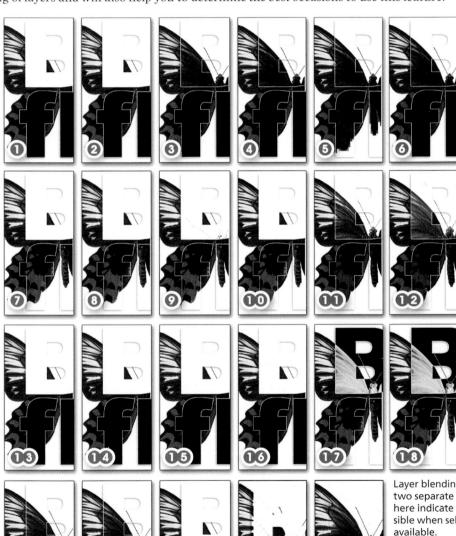

Layer blending modes control the way that two separate layers interact. The examples here indicate the different effects that are possible when selecting one of the 23 that are

- (1) Normal. (2) Dissolve. (3) Darken. (4) Multiply. (5) Color Burn. (6) Linear Burn. (7) Lighten.
- (8) Screen. (9) Color Dodge. (10) Linear Dodge. (11) Overlay. (12) Soft Light. (13) Hard Light.
- (14) Vivid Light. (15) Linear Light. (16) Pin Light.
- (17) Difference. (18) Exclusion. (19) Hue.
- (20) Saturation. (21) Luminosity. (22) Hard Mix. (23) Color.

You can add a variety of effects to the contents of your layers with the Layer Styles feature.

Layer Styles

Early on in the digital imaging revolution, users started to place visual effects like drop shadows or glowing edges on parts of their pictures. A large section of any class teaching earlier versions of Photoshop was designated to learning the many steps needed to create these effects. With the release of packages like Elements, these types of effects have become built-in features of the program. Now, it is possible to apply an effect like a 'drop shadow' to the contents of a layer with the click of a single button.

Adobe has grouped all these layer effects in a single panel called Effects. As with many features in the program, a thumbnail version of each style provides a quick reference to the results of applying the effect. You can change the size of the thumbnail or display the style names with the thumbnail by selecting a different option from the display settings menu at the top right of the palette. To add the style to a selected layer, simply double-click on the thumbnail.

Customize the look of the layer styles in your documents by changing the values in the Style Settings dialog.

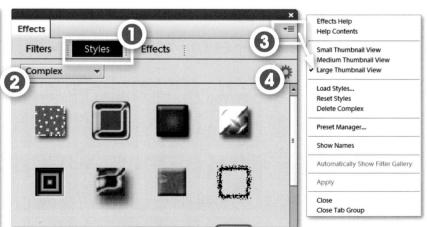

The Effect palette brings together a range of picture adjustments including Layer Styles. Click on the Styles (1) heading. Choose the group of styles from the drop-down menu (2). Change the palette's display settings (3) and functionality via the settings menu in the top right of the palette. Show the style settings for a given style (4).

Multiple styles can be applied to the one layer and the settings used to create the effect can be edited by double-clicking the fx icon on the selected layer in the palette. Remove a layer style by selecting Layer > Layer Style > Clear Layer Style whilst selecting the layer with the style applied.

Customizing of layer styles

Over the last few revisions of Elements it has became easier to customize the layer styles in your Elements documents with the controls in the Style Settings dialog. There are three ways to fine-tune your styles. Start by selecting a layer in the Layers palette and then choose Layer > Layer Style > Style Settings, or double click the fx icon on the right side of the layer entry or choose the Edit Layer Style option from the right-click menu.

The Style Settings dialog groups together a variety of sliders and settings that control the look of the style. Here you can not only adjust the settings of the applied style but you can also apply other styles. The settings and controls listed depends on the style applied to the layer.

PRO'S TIP

Double-clicking on the effects icon on the layer entry in the layers palette is a quicker way to access the Layer Styles dialog.

Alternatively, you can choose the Edit Layer Style option from the right-click menu when the image is opened in the Create tab.

Extending the library of styles you have available to you is as simple as downloading new examples from the internet and installing them in the Elements Styles folder.

Adding Elements' Layer Styles

If you spread your styles wings a little further there are many sites on the web that offer free downloadable styles that can be added to your library. Usually, the files are downloaded in a compressed form such as a zip. The file needs to be extracted and then saved to the Adobe\ Photoshop Elements 11\Presets\Styles folder before use. The next time you start Elements you will have a smorgasbord of new styles to apply to your images.

Creating Layers

When an image is first opened into the Editor space of Photoshop Elements it will contain a single Background Layer. As you edit and enhance the photo your actions will start to introduce more layers to the image. It is not unusual to end up with several layers in a document for a finished photo or composition. Here are the typical key ways that layers are created. Most of these options are available from the Layer menu.

New blank layers

The New Layer button located at the top of the Layers palette creates a new blank layer above the currently selected layer when pressed. The new layer is transparent by default. The results are the same as if the Layer > New > Layer menu item were selected.

Layer via Copy

The Layer via Copy command creates a new layer and copies the contents of the current selection onto it.

Layer Via Cut

The Layer via Cut command cuts the contents of a selection, creates a new layer and pastes it into the layer. If the detail is cut from a background layer then the empty space is filled

> with the current background color. When the detail is cut from a layer, the space that is left is filled with transparency.

You can also select the Layer From Background option located in the right-click menu to conlayer.

Layer from Background

As we have already seen the bottom-most layer of any layer stack is called the background layer. By default this layer is locked, which means that you cannot change its position in the layer stack, its opacity or the blend mode. In order to make these type of changes to the background layer it must be first converted to a standard image layer.

This can be achieved by making the background layer active (right-click on the layer) and then choosing the Layer From Background option from the Layer > New menu. Alternatively, double-clicking the background layer in vert a background layer into a normal image the Layers palette will perform the same function.

Copy and Paste

The process of copying (Edit > Copy) and pasting (Edit > Paste) content will automatically create a new layer for the pasted content. Remember that you will only be able to choose the Copy option if you have a selection active.

New Fill Layer

Choosing one of the options from the Layer > New Fill Layer will add a new layer on top of the active layer. There are three different types of Fill layers:

Solid Color – Creates a new layer filled with a color selected from the pop-up Color Picker.

Gradient – Creates a new layer filled with a gradient that gradually changes from one color to another or to transparency. Pick from preset gradient types or create your own.

Pattern – Creates a layer filled with a pattern that you choose from the palette.

New Adjustment layer

A new layer will also be added to the Layers Palette when selecting one of the entries from the Layer > New Adjustment Layer menu. These options are also found under the Enhance or Filter > Adjustments menu. There are eight different options to choose from:

Levels – Adjusts the tones in the picture.

Brightness/Contrast - This feature lightens, darkens and controls contrast.

Hue/Saturation – Changes the color and strength of color in photos.

Gradient Map – Changes the photo so that all the tones are mapped to the values of a selected gradient.

Photo Filter – Reproduces the color changes of traditional photo filters.

Invert – Reverses all the tones in a picture, producing a negative effect.

Threshold – Converts the picture to pure black and white with no grays present at all.

Posterize – Reduces the total number of colors in a picture and creates a flat paint (or poster)-like effect.

New Adjustment and Fill layers can also be created by clicking the button at the top of the Layers Palette.

MASKING TIPS

When first staring to use masks it can be a little confusing trying to figure out which parts of the image will be hidden and which parts displayed. Just remember that when it comes to masks 'Black conceals and white reveals' layer content.

Layer Masking techniques

Masking in traditional photography is used to physically protect part of the picture from development or exposure. In black and white darkrooms this process often involved the positioning of specially cut 'ruby' red sheets over the photographic paper, which shielded this part of the picture from being exposed during the enlargement process.

The digital version of masking is also designed to restrict effects to only certain portions of an image. Photoshop Elements provides a variety of ways to employ a masking system when editing your pictures. All masks in Elements are associated with a layer. The layer's mask determines which parts of the layer's content will be seen and which part will be hidden from view.

Normal Opacity: 100% V

Using the Selection Brush first is a great way to makes sure that any changes you apply via an adjustment layer are restricted to just the areas that you want altered.

Painting masks with the Selection Brush

We saw in the last chapter how the primary purpose of the Selection Brush is to aid in the creation of complex selections. But let's not forget that it can also be used in a 'Rubylith' Mask mode. Activate the mode by selecting the Mask option from the mode drop-down menu in the Tools options bar. Now when the brush is dragged across the surface of a picture it will leave a red, semi-transparent mask behind it. The mask will protect these parts of the picture from the effects of filters, color changes and tonal correction.

The size and edge softness of the Selection Brush as well as the mask opacity (overlay opacity) and mask color can be altered in the options bar. Switching back to the Selection mode

will turn off the mask preview and make a selection of the parts of the picture that weren't masked.

Whilst in Mask mode, painting with the brush will add to the mask. Applying the brush in the Selection mode will add to the selection, which effectively is removing masked areas. You can also save carefully painted masks using the Save Selection option in the Select menu and pre-saved selections can be converted into a mask by loading the selection and then switching back to Mask mode. A quick tip for power users – Alt/Opt-clicking the Layer Mask thumbnail displays the rubylith mask, which is handy when making lots of adjustments to the selected area.

Masking using the Selection Brush workflow:

- 1 Choose the Selection Brush (under the Quick Selection Brush) from the tool box and switch the brush to Mask mode.
- 2 Paint on the parts of the picture that you want to shield from the editing process.
- 3 Apply the editing changes to the non-masked (selected) areas. In this example I added a Hue/Saturation Adjustment Layer while the mask was still displayed. Elements automatically applied the restricted the changes to the non-masked areas.

Fill and Adjustment layer masks

Another form of masking is available to Elements users via the Fill and Adjustment Layers features. Each time you add one of these layers to an image, two thumbnails are created in the Layers palette. The one on the left controls the settings for the adjustment layer. Double-clicking this thumbnail brings up the dialog box and the settings used for the fill or adjustment layer. The thumbnail on the right represents the layer's mask which governs how and where the settings are applied to the image.

The mask is a grayscale image. In its default state it is colored white, meaning that no part of the layer's effects are being masked or held back from the picture below. Conversely, if the thumbnail is totally black then none of the layer's effects is applied to the picture. In

It is also possible to edit the mask associated with a Fill or Adjustment layer after it has been added to an image. Simply select the Mask Thumbnail and paint with black to hide the effect, or white to reveal it.

100%

There are two parts to the entries that are added to the layer stack when creating new Adjustment, Fill and Smart Brush Tool layers.

The **Layer Thumbnail** controls the effect of the later. In this case a Pattern Fill

The **Mask Thumbnail** controls where and how the effect is applied.

this monochrome world shades of gray equate to various levels of transparency. With this in mind we can control which parts of the picture are altered by the fill or adjustment layer and which parts remain unchanged by painting (in black and white and gray) and erasing directly on the layer mask.

To start editing a layer mask, firstly apply a Fill layer such as Pattern to the image. Check to see that the default colors (white and black) are selected for the Elements foreground and background colors. Next select the Eraser tool, and with the fill layer selected in the Layers palette, proceed to remove part of the layer. The pattern is removed and the picture beneath shows through and a black mark now appears in the layer thumbnail corresponding to your erasing actions. Switch to the Paint Brush tool and select black as your foreground color and paint onto the patterned surface. Again this action masks the picture beneath from the effects of the fill layer and adds more black areas to the thumbnail.

Painting with white as your foreground color restores the mask and paints back the pattern. You can experiment with transparent effects by painting on the mask with gray. The lighter the gray the more the pattern will dominate, the darker the gray the less the pattern will be seen. A similar semi-transparent effect can be achieved if the opacity of the eraser or brush is reduced.

Editing Adjustment and Fill Layer masks workflow:

- 1 After selecting the Brush tool ensure that the foreground and background colors are black and white.
- 2 Select the Layer Mask of the Fill or Adjustment layer.
- 3 Painting the mask with black paint has the same effect as erasing.
- 4 Painting with white paint restores the mask, which in this example is the pattern.

Using selections with layer masks

In addition to employing painting tools to work directly on the layer mask you can also use a selection in conjunction with an adjustment or fill layer to restrict the area of your image that is altered. Make a selection in the normal way and then, with the selection still active, create a new adjustment or fill layer. The selection confines the changes made by the new adjustment/fill layer. You will notice the selected area is colored white in the Layer Mask thumbnail. A layer mask made in this way can still be edited using the same painting techniques as discussed above.

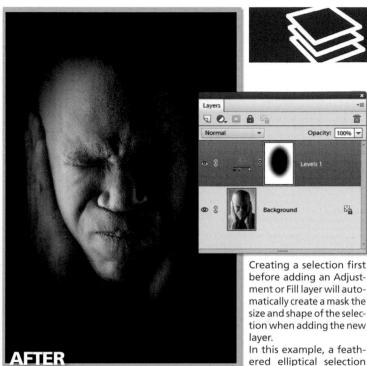

Creating masks from Selections workflow:

- 1 Use any of the Selection tools to create a selection first.
- 2 Adjust the edge qualities of the selection using the Refine Edge feature.
- 3 Now add an Adjustment or Fill layer by selecting the entry type from the Layer menu or the New Fill or Adjustment Layer button at the top of the Layers Palette.

Creating Clipping masks

Another Photoshop Elements masking technique uses the special Create Clipping Mask command (previously called Group with Previous) found in the Layer menu. This command uses the transparency surrounding objects on a layer as a mask for the content of any layers that are above it in the stack.

In the example the balloon image was placed above the test text layer. With the balloon layer active the Create Clipping Mask command (Layer > Create Clipping Mask) was selected. The result is that the example image now fills the text shape but is masked from showing through the rest of the layer by the transparency surrounding the type. This technique also works with shapes and filled selections drawn on a separate layer surrounded by transparency.

was created and inverted before adding a Levels Ad-

justment layer to darken the picture surrounds.

Creating masks from Selections workflow:

- 1 Create some bold text in a new document with a white background layer.
- 2 Copy and paste a color image in a layer above the text.
- 3 Select the color layer and choose the Create Clipping Mask command from the Layers menu.

From version 9 of Elements it is possible to add a layer mask to any image layer. This allows for the creation of sophisticated composite photos where the details of the masked layer are hidden from view so that the details of the layer beneath can been seen.

Advanced Masking Options

In Photoshop Elements before version 9, layer masks couldn't be created by themselves. They could only be created as part of an adjustment or fill

layer. But from the version 9 release, Elements users have the ability to create layer masks with any image layer.

If you look closely at the top of the Layers panel you will see an extra button between the existing New Layer and New Adjustment Layer buttons. Clicking this Add Layer Mask button will insert a new mask next to the thumbnail of the currently selected layer. By default, the new mask is filled with white.

As we have already seen, white areas in a mask reveal the details of the layer it is associated with, whereas black areas conceal the details of this layer (revealing the layer beneath). Gray mask areas display a mix of both layers depending the density of the gray. A light gray tone will show more of the upper layer, darker gray will reveal more details from the layer beneath.

Layer masks can be created and edited in the same way as the other masks we have looked to date. The mask can be produced from selections, added as a blank mask and then edited with the painting tools.

With the extra functionality provided with dedicated layer masking comes a range of new mask options available from either the Layer menu or from the pop-up menu that appears when right-clicking the mask in the layers panel.

Add Layer Mask button

Layer Masks cannot be added directly to background layers. Instead, the background needs to be converted to a standard image layer first. One of the easiest ways to achieve this is to double-click the background layer, add a name to the New Layer dialog and then click the OK button.

Layer mask shortcuts

Disable/enable layer mask -

Shift + click layer mask thumbnail

Preview contents of layer mask -

Opt/Alt + click layer mask thumbnail

Preview layer mask and image -

Opt/Alt + Shift + click layer mask thumbnail

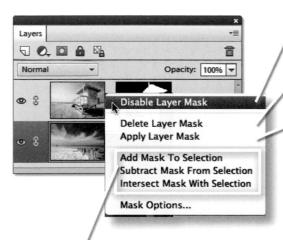

To use any of these options, create a selection first and then right-click onto the layer mask thumbnail and choose the way that you want the mask and selection to interact. A new selection will be created based on your selection.

Disable Layer Mask: Temporarily hide the effects of the layer mask.

Delete Layer Mask: Remove the layer mask permanently from the layer.

Apply Layer Mask: Apply the effects of the layer mask to the image and then remove the mask.

Add Mask To Selection: The selection and the masked areas are combined to form a new selection.

Subtract Mask From Selection.

Intersect Mask With Selection.

You can preview the mask on the main image by holding down Alt/Opt and Shift keys and then clicking on the mask's thumbnail in the Layers panel. The color and opacity of the mask preview can be adjusted in the Layer Mask Display Options dialog which is also available from the right-click menu.

Organizing layers

Moving

Layers can be moved up and down the layer stack by click-dragging them to a new position. Moving a layer upwards will mean that its picture content may obscure more of the details in the layers below. Moving downwards progressively positions the layer's details further behind the picture parts of the layers above. You can reposition the content of any layers (except background layers) using the Move tool.

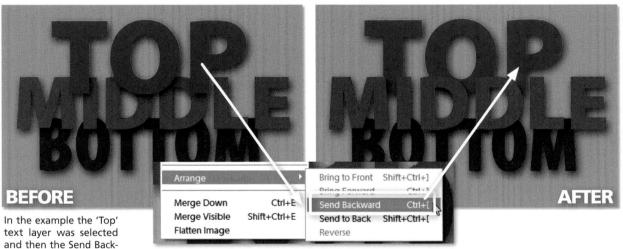

In the example the 'Top' text layer was selected and then the Send Backward option was chosen from the Layer > Arrange menu. This results in the 'Top' layer moving below the 'Middle' layer in the stack, with the consequence that the 'Middle' layer text now partially obscures the contents of the 'Top' layer.

The Layers > Arrange menu

menu. This results in the Top' layer moving below the 'Middle' layer in the Layers and their contents can also be moved up and down the stack using the options in the Layer > Arrange menu. Start by selecting the layer to move and then chose the entry from stack, with the consequence that the 'Middle' layer in the menu. There are five options in the menu:

Bring to Front – Moves the selected layer to the upper most spot in the layer stack.

Bring Forward – Moves the selected layer one place upwards in the layer stack.

Send Backward – Moves the selected layer one position downwards in the stack.

Send to Back – Moves the layer to the very bottom of the stack. If the document has a background layer then the selected layer is moved to the first position above the Background layer.

Reverse – Reverses the order of multi-selected layers.

Linking layers

Two or more layers can be joined together so that when the content of one layer is moved, the other details follow precisely. This process is called linking and preserves the content of each layer but allows them to be moved as if they were just one entity.

Layers are linked by multi-selecting the layers first, using Shift-click to select layers that are consecutive, or Ctrl-click to choose random layers to link. The selected layers will change to the active layer color – gray in this example. After selecting, the layers are linked by clicking the chain icon on the left of the thumbnail in the Layers palette. To unlink, reverse these steps or click the Unlink Layers option in the Layers Palette settings menu.

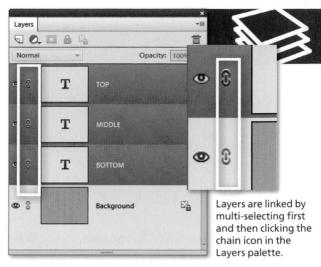

Merging the content of different layers

The contents of individual layers can be combined using the various merge options available from the Layer menu, from the menu that is displayed when right-clicking an entry in the Layers Palette or from the palette's setting menu.

The content of multi-selected layers can be combined into a single layer using the **Merge Layers** option in the Layer menu. In a similar way, a layered document can be flattened into a picture that only contains a background via the **Layer > Flatten Image** command. The **Merge Visible** option combines the content of all visible layers within the document into a single layer. The **Merge Down** command combines the contents of the selected layer with the one directly beneath it in the layer stack.

Just like the copy command, the **Copy Merged** option (Edit > Copy Merged) copies the contents of a selection, but the difference is that this command also copies and merges the contents of all the visible layers in the document at the same time.

Many options that can be used for organizing layers can be found in the Layers Palette Settings menu. Display the menu by clicking the settings icon at the top right of the palette.

Duplicating a Layer

Any layer can be copied and inserted into the current document with the Layer > Duplicate Layer command. Simply select the layer to be copied, choose Duplicate Layer from the Layer menu, insert a new name and choose the destination of the new layer in the Duplicate Layer dialog. This command can also be used to create a new document with the contents of the selected layer.

PRO'S TIP

Merging or flattening layers are not steps that are recommended as both actions remove the ability of editing the content or position of each layer individually.

Deleting layers

There are four ways to delete a single layer from the layer stack in Photoshop Eements.

- 1. Select the layer in the Layers palette and then drag it to the dustbin icon (Delete Layer button) at the top of the palette.
- 2. Select the layer in the palette, click on the Dustbin icon and then select Yes in the confirmation dialog box. To avoid this dialog box hold down the Alt/Option key when clicking the dustbin.
- 3. After selecting the layer to be discarded, choose Layer > Delete Layer.
- 4. Make sure that the layer to remove is selected in the palette then choose Delete Layer from the pop-up menu displayed via the Layers Palette Settings button (top right of the palette).

Renaming a Layer

The name of a layer can be changed by double-clicking the title in the Layers Palette and then entering a new name. Alternatively, after selecting the layer, the Rename Layer option can be selected from the Layer, or right-click menu.

Locking Layers

There are two different locking options for layer content in Photoshop Elements. The **Lock All** button (lock icon) at the top of the Layers Palette will stop the content, position or transparency in a layer from being changed. When this option is applied to a layer a locked padlock icon is added to the layer entry. Background layers have this option applied automatically.

Lock All icon

The **Lock Transparency** button is used to ensure that editing changes do not alter or impinge on upon the transparent part of a layer.

Quick guide to Layer shortcuts

- 1 To display Layers palette Choose Windows > Layers
- 2 To access layer options Click the More button in the upper right of the Layers palette
- 3 To change the size of layer thumbnails Choose Palette options from the Layers palette menu and select a thumbnail size
- 4 To make a new layer Choose Layer > New > Layer

- 5 To create a new adjustment layer Choose Layer > New Adjustment Layer and then select the layer type
- 6 To create a new fill layer Choose Layer > New > New Fill Layer and select the layer type
- 7 To add a style or effect to a layer Select the layer and click on a thumbnail in the Styles and Effects palette

198

Text

Digital imaging has blurred the boundaries between many traditional industries. No longer does the image maker's job stop the moment the illustration or photograph hits the art director's desk. With the increased abilities of software like Photoshop Elements has come the expectation that not only are you able to create the pictures needed for the job, but you are also able to perform other functions like adding text.

In this chapter we will look at some of the ways that Elements users can add type to their compositions and then check out the many ways that you can style the text.

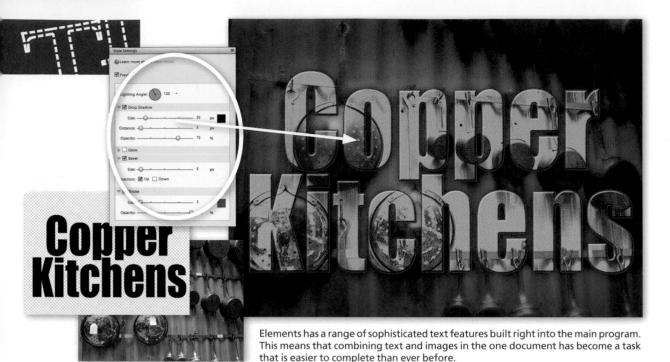

For a long time combining text and images was usually the job of a graphic designer or printer, but the simple text functions that are now included in most desktop imaging programs mean that more and more people are trying their hand at adding type to pictures. Elements incorporates many of these text features including the ability to input type directly onto the canvas rather than via a Type dialog. This means that you can see and adjust your text to fit and suit the image beneath.

Changes of size, shape and style can be made at any stage by selecting the existing text and applying the changes via the options bar. As the type is saved as a special type layer, it remains editable even when the file is closed, as long as it is saved and reopened in the Elements PSD format.

Text on a Selection, Shape, or Custom Path

The last edition saw three great new text options added to the program that allow you to align text with shapes, selections or along a custom path. Such features are normally only found in advanced layout or illustration programs. Adding this ability to Elements will greatly expand the range of designs that you can create quickly and easily and is sure to be a favorite with those of you who create photobooks and scrapbooks.

WYSIWYG font previews

One of the key features of the Elements' Type tools is the is the WYSIWYG (What You See Is What You Get) preview that is displayed on the Text tool font menu. With this feature it is possible to see an example of how the letter shapes for each font family appear right in the menu itself.

The paragraph text feature in Photoshop Elements automatically wraps text lines when they reach the boundaries of a text box

Paragraph text automatically wraps from one line to the next.

0 Kokila

The font family menu (Text tool options bar) displays a WYSIWYG example of the font.

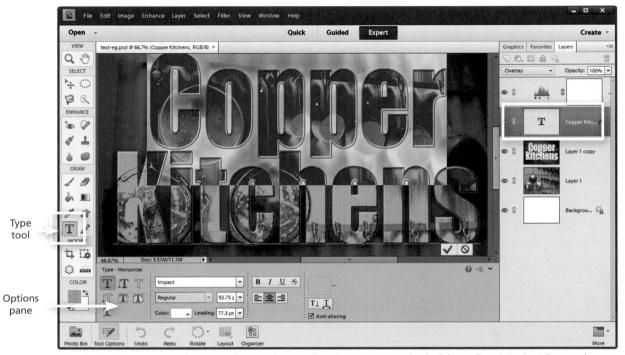

The advanced Type tools in Elements' Editor workspace allow the user to enter (and edit) text directly in the Editor workspace.

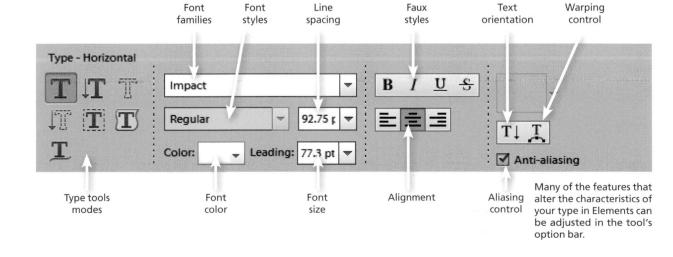

Creating simple type

There are now seven different type tools in Elements: the Horizontal and Vertical Type tool options, as well as Horizontal and Vertical Type Mask tools. And in the last version of Elements three new options were added in the form of a set of alignment tools for placing text on selections, paths and shapes. Of the standard Type tools (non-mask and non-alignment varieties), one is used for entering text that runs horizontally across the canvas and the other is for entering vertical type. Type tools are not available in the Ouick Edit and Guided Edit workspaces.

There are now seven type tools available in the Full Edit workspace of Elements.

Any text entered must be 'committed' to a type layer before other tools or menu choices can be used. As well as pressing the Commit button (green tick), pressing the Ctrl/Cmd and Return/Enter keys you can click another tool, or apply a Layer Style or menu command. The type will then auto-commit.

To place text onto your picture, select the Type tool from the toolbox. Next, click onto the canvas in the area where you want the text to appear. Do not be too concerned if the letters are not positioned exactly, as the layer and text can be moved later. Once you have finished entering text you need to commit the type to a layer. Until this is done you will be unable to access most other Elements functions. To exit the Text editor, either click the tick button in the options bar or press the Ctrl/Cmd and Enter/Return keys.

Creating paragraph text

Extending the text ability of the program, Adobe introduced the Paragraph Text options to the Simple Type ones detailed above. To create a paragraph, select the Type tool and then click and drag a text box on the surface of the picture. Automatically Elements positions a cursor inside the box and creates a new layer to hold the contents. Typing inside the box will add text that automatically wraps when it reaches the box edge. When you have completed entering text, either click the tick button in the options bar, or press the Ctrl/Cmd and Enter/Return keys.

You can resize or even change the shape of the box at any time by selecting a Type tool and then clicking onto the area where the paragraph text has been entered. This action will cause the original text box to display. The box can then be resized by moving the cursor over one of the handles (small boxes at the corners/edges) and click-dragging the text box marquee to a new position. The text inside the box will automatically rewrap to suit the new dimensions.

Basic text changes

All the usual text changes available to word processor users are contained in Elements. It is possible to alter the size, style, color and font of your type using the settings in the options bar. You can either make the selections before you input your text or later by highlighting (clicking and dragging the mouse across the text) the portion of type that you want to change. In addition to these adjustments, you can also alter the justification or alignment of a line or paragraph of type. After selecting the type to be aligned, click one of the Justi-

fication buttons on the options bar. Your text will realign automatically on screen. After making a few changes, you may wish to alter the position of the text; simply click and drag outside of the type area to move it around. If you have already committed the changes to a text layer then select the Move tool from the toolbox, making sure that the text layer is selected (just roll the mouse over text until you see the blue outline and click), then click and drag to move the whole layer.

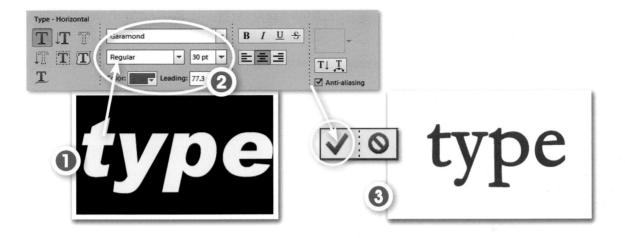

Text changes workflow:

- 1 The text options bar contains a number of settings for altering the style, font, color, aliasing, alignment and size of the type entered. To change the settings of your type start by selecting the text with the type tool.
- 2 Make the changes to the settings in the Type tool options bar.
- 3 Commit the changes by clicking the green tick icon.

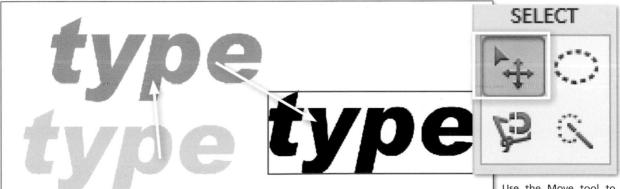

Use the Move tool to move type whose layer has been selected.

TEXT ON SELECTION TOOL: To achieve this effect you create a selection first before adding the text along the its edge.

TEXT ON SHAPE TOOL: After drawing the shape the text can be added so that it flows around the whole edge of the design.

TEXT ON CUSTOM PATH TOOL: This tool allows the user to draw a freehand path along which the text will flow. Don't worry if your hand isn't too steady there is also an option to refine the path once it is drawn.

Align that type!

Photoshop Elements 10 saw the inclusion of three new text tools in the line up for the program. With this release it became possible to align text to selections, shapes or custom paths. This ability makes it much easier for you to add non-straight text to your designs and photos. You can make text follow the hills in a landscape photo, stick to the edge of a logo or outline the shape of an apple.

Move the test along the selection edged by clicking the cursor on the text to change it to the insertion icon (used for entering and selecting text). Now hold down the Ctrl/Cmd key and click-drag the text along the edge.

Text On Selection workflow:

- 1 Choose the Text On Selection Tool by right-clicking on the Text tool in the tool bar and picking the entry from the tool's options bar.
- 2 Momentarily the text tool will turn into the Quick Selection tool. Drag the tool over the subject you want to align the text to. Move the Offset slider in the Options bar to change the position of the selection edge. Click the green tick Commit button to confirm the selection.
- 3 Now move the text cursor over the selection edge until it changes to the text insertion icon (). Click the mouse button to set the start point for the text.
- 4 Type to add text along the selection. Use the settings in the tool's options bar to change font, color, size and style.
- 5 Click the green tick commit button when you have finished typing.

Pro's Tip: When selecting the object you will align the text to, you can use the Alt/ Opt key to switch the Quick Selection tool from the 'add to' mode to the 'subtract from' selection mode, allowing you to refine the area you select.

Align and add text with the one tool

The tools essentially provide three different ways to define the line that the text will follow. Each combines both the text tools used to insert the text and the specific tool used to create the line. When aligning text to a selection, the text tool is combined with the Quick Selection tool which is used to create the selection whose edge the text will run along. When adding text to a shape the Text tool works alongside the Shape tool. In this way these tools use a different workflow to others in Elements which have you define the selection first with one tool, then switch to a second tool to add the text.

Text On Shape workflow:

- 1 Choose the Text On Shape Tool by right-clicking on the Text tool in the tool bar and picking the entry from the tool's options bar.
- 2 Next, choose a shape from those listed in the drop-down menu on the tool's options bar. Click-drag the cursor on the canvas to draw the shape. You can adjust the shape by dragging the handles of the Free Transform feature (Ctrl/Cmd T).
- 3 Now move the text cursor over the shape's edge until it changes to the text insertion icon (\mathbb{X}). Click the mouse button to set the start point for the text.
- 4 Type to add text along the selection. Use the settings in the tool's options bar to change font, color, size and style.
- 5 Click the green tick commit button when you have finished typing.

Text On Custom Path workflow:

- 1 Choose the Text On Custom Path tool by right-clicking on the Text tool in the tool bar and picking the entry from the tool's options bar.
- 2 Draw a path with the tool on the canvas of the picture. Click on the Refine Path tool () in the options bar and adjust the path shape by click-dragging the path and its control points.

- 3 Now move the text cursor over the selection edge until it changes to the text insertion icon. Click the mouse button to set the start point for the text.
- 4 Type to add text along the selection. Use the settings in the tool's options bar to change font, color, size and style.
- 5 Click the green tick commit button when you have finished typing.

Pro's Tip: Don't forget to use other text styles and effects with these new tools. For instance, a drop shadow Layer Style was added to the example image so the white text would stand out from the bright spot on the background.

Move the text to the opposite side of the line (inside to outside in this example) by clicking on the selection or shape edge or the path line to display the text insertion icon.

Now hold down the Ctrl/ Cmd key and drag the cursor to the other side of the path or edge.

NOTE: You may need to move the text along the line/edge as well to reposition the newly positioned text.

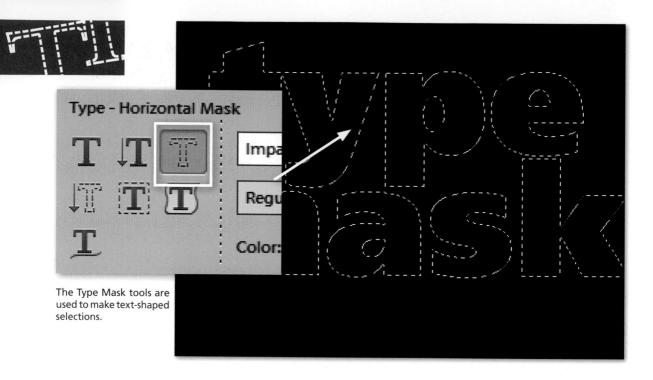

Creating and using type masks

The Type Mask tools are used to provide precise masks or selections in the shape and size of the text you input. Rather than creating a new text layer containing solid colored text, the mask tools produce a selection outline. From this point on the text mask can be used as you would use any other selection.

Adding text to images workflow:

- 1 Choose the Type tool from the toolbox. To change between Type tools, click theo other modes in the tool's options bar.
- 2 Click on the picture surface to position the start of the text or click-drag to create a text box.
- 3 Make changes to font type, size, style, justification and color by altering the settings in the options bar.
- 4 Enter your text using the keyboard or by pasting sections (Edit > Paste) from a copied word processing document.
- 5 For non-masked text, click and drag to move the text over the image background.
- 6 Commit entered text or changes to a type layer by clicking 'tick' in the options bar or by pressing Control + Enter.

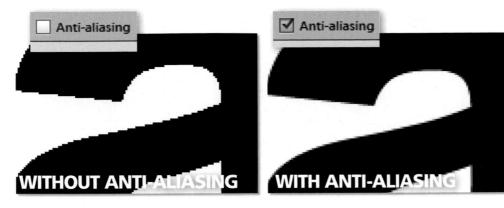

The Anti-aliasing setting helps smooth out the edges of 'jagged' text.

Reducing the 'jaggies'

One of the drawbacks of using a system that is based on pixels to draw sharp-edged letter shapes is that circles and curves are made up of a series of pixel steps. Anti-aliasing is a system where the effects of these 'jaggies' are made less noticeable by partially filling in the edge pixels. This technique produces smoother looking type overall and should be used in all print circumstances and web applications. The only exception is where file size is critical, as anti-aliased web text creates larger files than the standard text equivalent. Anti-aliasing can be turned on and off by clicking the Anti-aliased button in the options bar.

Smoothing letter edges workflow:

- 1 Turn anti-aliasing on by clicking the Anti-aliased button in the options bar, or by selecting Layer > Type > Anti-Alias On.
- 2 Turn anti-aliasing off by reclicking the button in the options bar or by selecting Layer > Type > Anti-Alias Off.

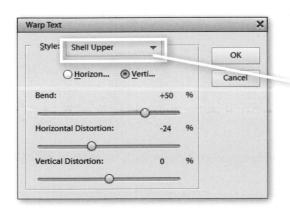

The Warp feature is used to twist and squeeze text into a range of shapes. The style of the warping can be selected from the drop-down menu in the feature's dialog.

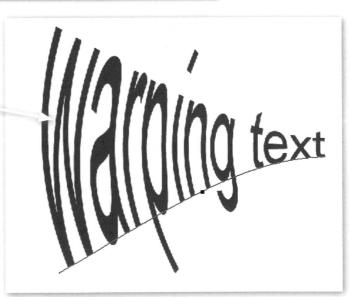

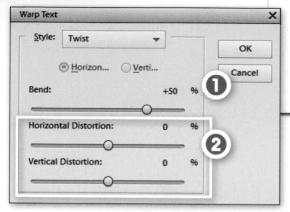

The degree of bend (1) and distortion (2) of the text can be altered using the settings in the Warp Text dialog.

Warping type

One of the special features of the Elements type system is the Warping feature. This tool forces text to distort to one of a range of shapes. An individual word, or even whole sentences, can be made to curve, bulge or even simulate the effect of a fish-eye lens. The strength and style of the effect can be controlled by manipulating the Bend and Horizontal and Vertical Distortion sliders.

This feature is particularly useful when creating graphic headings for posters or web pages.

Adding text to images workflow:

- 1 Choose a completed type layer.
- 2 Select Layer > Type > Warp Text or pick the Type tool from the toolbox and click the Warp button in the options bar.
- 3 Choose the warp style from the drop-down menu.
- 4 Adjust the Bend, Horizontal Distortion and Vertical Distortion sliders.
- 5 Click OK to finish.

Applying styles to type layers

Elements' Layer Styles can be applied very effectively to type layers and provide a quick and easy way to enhance the look of your text. Everything from a simple drop shadow to complex surface and color treatments can be applied using this single-click feature. A collection of included styles can be found under the Layer Styles heading in the Effects panel. A variety of different Style groups are available from the drop-down list and small example images of each style are provided as a preview of the effect.

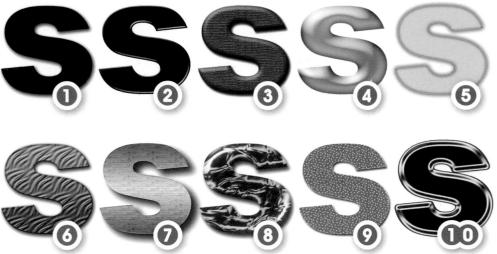

The look of text can be changed with a single click using Layer Styles.

- (1) Drop shadow.
- (2) Inner Ridge Bevel.
- (3) Wood Grain.
- (4) Pink Glass.
- (5) Purple Neon.
- (6) Waves.
- (7) Brushed Metal.
- (8) Molten Gold.
- (9) Cactus.
- (10) Chrome Fat.

Additional styles can be downloaded from websites specializing in resources for Elements users. These should be installed into the %appdata%\Adobe\Photoshop Elements\11.0\Presets\Styles folder. The next time you start Elements, the new styles will appear in the Styles and Effects panel. Extra type effects are also located in the Effects group of the Effects panel.

To apply a style to a section of type, make sure that the text layer is currently active. Do this by checking that the layer is highlighted in the Layers panel. Next, open and view the Layer Styles section in the Content panel. Click on the thumbnail of the style you want to apply to the text and then click the Apply button at the bottom of the panel.

The changes will be immediately reflected in your image. Multiple styles can be applied to a single layer and unwanted effects can be removed by using the Step Backward button (Undo) in the shortcuts bar or the Undo command (Edit > Undo Apply Style).

ELEMENTS

BEFORE

Layer styles are grouped in menus around a common theme such as Drop Shadows, Bevels and Glass Buttons and are located in the Effects Panel. In this example the Toy Layer Style was added to the 'Elements' text.

VEI EV

The settings of individual styles can be edited by double-clicking on the 'fx' icon in the text layer and adjusting one or more of the Style settings.

Changing text style settings workflow:

- 1 Ensure that the text layer is selected.
- 2 View the Text Styles by displaying the Graphics panel (Window > Graphics) and then selecting the By Type option and Text entry.
- 3 Choose the style to apply to your text from the drop-down list and thumbnails. Apply the style by double-clicking the thumbnail.
- 4 Edit Style Settings by double-clicking the 'fx' symbol in the text layer.
- 5 Remove effects by selecting Edit > Undo Layer Styles or by clearing Layer Styles.

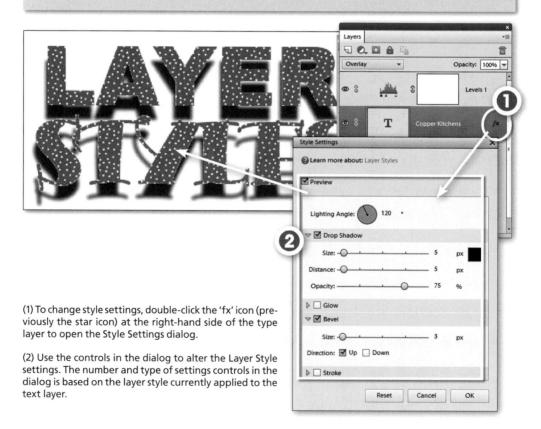

Debunking some common type terms

Font size

The size of the text you place in your image files is measured as pixels, millimeters or points. I find the pixel setting most useful when working with digital files, as it indicates to me the precise size of my text in relationship to the whole image. Millimeter and points values, on

the other hand, vary depending on the resolution of the picture and the resolution of the output device. Some of you might be aware that 72 points approximately equals 1 inch, but this is only true if the picture's resolution is 72 dpi. At higher resolutions the pixels are packed more closely together and therefore the same 72 point type is smaller in size.

Changing font size units workflow:

- 1 Windows users, select Edit > Preferences > Units & Rulers. Macintosh users will find the same setting under the Photoshop Elements > Preferences menu.
- 2 Then alter the unit of measurement for Type.

Font family and style

The font family is a term used to describe the way that the letter shapes look. Most readers would be familiar with the difference in appearance between Arial and Times Roman. These are two different families each containing different characteristics that determine the way that the letter shapes appear. The font style refers to the different versions of the same font family. Most fonts are available in regular, italic, bold and bold italic styles.

You can download new fonts from specialist websites to add to your system. Some families are available free of charge, others can be purchased online. After downloading, the fonts should be installed into the Fonts section of your system directory. Windows and Macintosh users will need to consult their operating system manuals to find the preferred method for installing new fonts on their computer.

Different font families

Same font family different style.

The family and style of a font determine its look.

The left align, or justification, fe arrange all text to the left of picture. When d to a group of sentences the left edge of the paragraph is organized into a straight vertical line whilst the right-hand edge remains uneven or ragged. Right align works in the opposite fashion, straightening the right hand edge of the paragraph and leaving the left ragged. Selecting the center text option will align the paragraph around a central line and leave both left and right edges ragged.

The left align, or justification, featual and text to the left of picture. When to a group of sentences the left edge of the paragraph is organized into a straight vertical line whilst the right-hand edge remains uneven or ragged. Right align works in the opposite fashion, straightening the right hand edge of the paragraph and leaving the left ragged. Selecting the center text option will align the paragraph around a central line and leave both left and right edges ragged.

The left align, or justification, feature all text to the left of picture. When a, ______ a group of sentences the left edge of the paragraph is organized into a straight vertical line whilst the right-hand edge remains uneven or ragged. Right align works in the opposite fashion, straightening the right hand edge of the paragraph and leaving the left ragged. Selecting the center text option will align the paragraph around a central line and leave both left and right edges ragged.

Type alignment controls how the text is arranged in the image. (1) Left Align Text. (2) Center Text. (3) Right Align Text.

Alignment and justification

These terms are often used interchangeably and refer to the way that a line or paragraph of text is positioned on the image. The Left Align Text, or Left Justify, feature will arrange all text to the left of the picture. When applied to a group of sentences, the left edge of the paragraph is organized into a straight vertical line whilst the right-hand edge remains uneven or ragged. Right Align Text works in the opposite fashion, straightening the right-hand edge of the paragraph and leaving the left ragged. Selecting the Center Text option will align the paragraph around a central line and leave both left and right edges ragged.

Leading

Originally referring to the small pieces of lead that were placed in between lines of metal type used in old printing processes, nowadays it is easier to think of the term referring to the space between lines of text. Unlike earlier versions of the program, Elements now includes the ability to alter the leading of the type input in your documents. Start with a value equal to the font size you are using and increase or decrease from here according to your requirements.

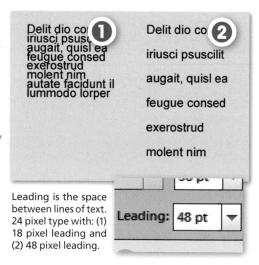

Other ways to add text

In the last couple of versions of Photoshop Elements Adobe created a new way to add and manage the text in your photos. To access this option you need to click the Create menu on the right of the Edit workspace and then select one of the projects listed. Photo Collage or

Photo Books are good examples. Once the new project document is created, you will be able to add text to the pages using one of two different methods.

Adding text to a photo project workflow:

- 1 Click onto the Type tool in the toolbar (left of the workspace). Now click onto the photo project page to start a line of text or click-drag a marquee to the size and shape that you want to hold several lines of text.
- 2 If place holder text is already on the page then click onto this text to change it to your own entry.

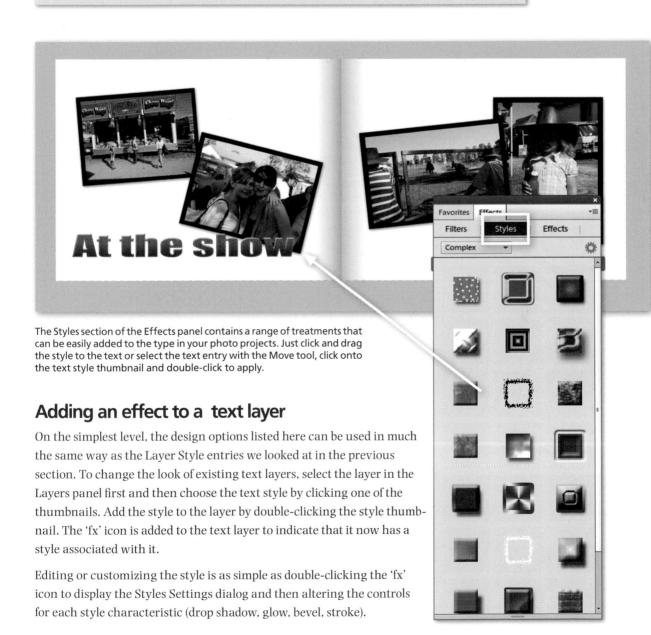

Applying a text style with no type layer selected will automatically create a new type layer and input some placeholder text in the style of your choosing.

If you have not yet created the text layer then there is no need to add it first before selecting the style. Just double-click on the thumbnail style or drag the thumbnail to your document. Either of these actions will automatically create a new text layer in your document and input some placeholder text, 'Your Text Here', with the style applied.

From this point on it is a simple matter to replace this generic text with your own. Just double-click on the text with the Move tool; Elements will then switch tools to the Type tool and select all of the placeholder text. Now type in the new text to complete the replacement. Alternatively, you can click on the text and then choose Edit Text from the Move tool's right-click menu.

Painting and Drawing

At some point during your imaging life you will need, or want, to create an image from scratch. Until now, we have concentrated on editing, adjusting and enhancing images that have been generated using either a camera or scanner; now we will look at how to use Elements' painting and drawing tools to create something entirely new.

Drawing and painting tools are used to add non-photographed information to your images.
(1) Drawing tools.
(2) Painting tools.

Although the names are the same, the tools used by the traditional artists to paint and draw are quite different from their digital namesakes. The *painting* tools (the Paint Brush, Pencil, Eraser, Paint Bucket and Airbrush) in Elements are pixel-based. That is, when they are dragged across the image they change the pixels to the color and texture selected for the tool. These tools are highly customizable and, in particular, the painting qualities of the Brush tool can be radically changed via the brush More Options panel.

The *drawing* tools (the Shape tool), in contrast, are vector- or line-based. The objects drawn with these tools are defined mathematically as a specific shape, color and size. They exist independently of the pixel grid that makes up your image. They produce sharp-edged graphics and are particularly good for creating logos and other flat colored artwork.

NOTE: Despite the differences I have just noted above, in Photoshop Elements 11 all these tools are grouped under the new Draw collection of tools.

Painting tools

The four main painting tools all apply color to an image in slightly different ways. But before we start to look at each of the tools, we should really revisit the swatch system that Elements uses for foreground and background colors.

Choosing my paint colors

The currently selected foreground and background colors are shown towards the bottom of the toolbar as two colored swatches. The topmost swatch represents the foreground color, the one beneath the hue for the background. The default values for these colors is black and white but it is possible to customize the selections at any time. Just double-click the swatch and then select a new color from the Color Picker window.

To switch foreground and background colors click the double-headed curved arrow at the top right and to restore the default (black and white) click the mini swatches bottom left. The color of the paint for all tools is based on the foreground color selected in the toolbox. To change this hue you can double-click the swatch and select another color from the panel or you can use the Eyedropper tool to sample a color that already exists in your image.

Painting tools summary

- 1 Pick foreground color (painting color).
- 2 Select the Painting tool from the toolbox.
- 3 Click the down arrow next to the sample brush in the options bar to select brush type.
- 4 Adjust brush opacity.
- 5 Adjust other options for a particular tool.
- 6 Drag brush over image surface to paint.

Brush tool

The Brush tools lays down color in a similar fashion to a traditional brush. The size and shape of the brush can be selected from the list in the Brush Presets list in the tool's options bar. Changes to the brush characteristics can be made by altering the settings in the options bar.

In addition to changes to the size, painting mode and opacity of the brush, which are made via the options bar, you can also alter how the Paint Brush behaves. The Brush Settings panel (displayed by pressing the Brush Settings button on the right end of the options bar) is used to creatively control your brush's characteristics, or brush dynamics, as it is sometimes called.

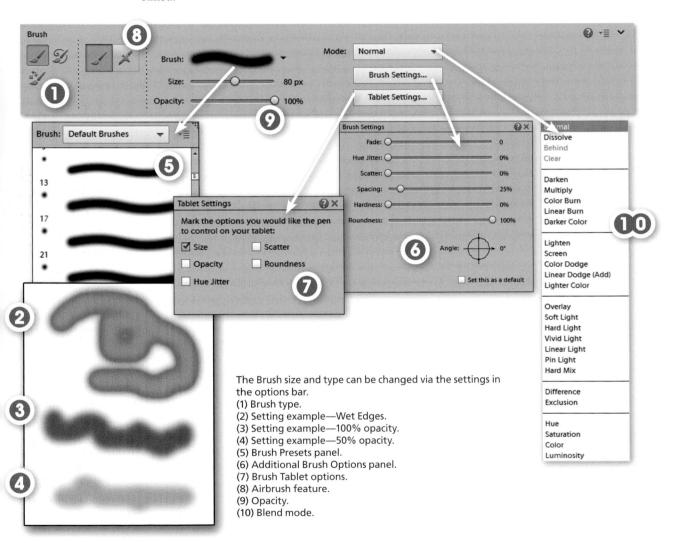

The Brush Settings panel

• **Spacing** determines the distance between paint dabs measured in brush diameters, with high values producing dotty effects.

- The *Fade* setting controls how quickly the paint color will fade to nothing. Low values fade more quickly than high ones.
- *Hue Jitter* controls the rate at which the brush color switches between foreground and background hues. High values cause quicker switches between the two colors.
- *Hardness* sets the size of the hard-edged center of the brush. Lower values produce soft brushes.
- The *Scatter* setting is used to control the way that strokes are bunched around the drawn line. A high value will cause the brush strokes to be more distant and less closely packed.
- *Angle* controls the inclination of an elliptical brush.
- The *Roundness* setting is used to determine the shape of the brush tip. A value of 100% will produce a circular brush, whereas a 0% setting results in a linear brush tip.

Photoshop Elements has a wide range of brush options and new brushes can be added to the panel by selecting the side-arrow in the Brush panel and choosing the New Brush option. For the truly creative among us, extra custom-built brush sets are available for download and installation from websites specializing in Photoshop Elements resources.

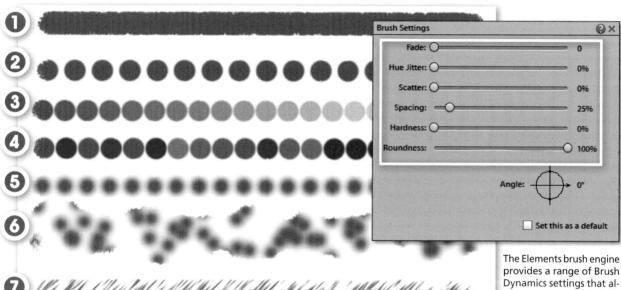

Airbrush

The Airbrush tool, located in the options bar of the Brush tool, sprays the paint color over the surface of the image. Although the size and style of the spray are determined by the selected brush (in the options bar), the edge of the area painted with this tool is a lot softer than the equivalent paint brush. Holding the mouse button down in one spot will build up the color in much the same way as paint from a spray can.

provides a range of Brush Dynamics settings that allow users to completely control the behavlour and characteristics of their brushes. (1) Normal. (2) Spacing increased. (3) Fade introduced. (4) Hue Jitter increased. (5) Hardness decreased. (6) Scatter increased. (7) Angle = 45°, Roundness = 0%.

The Airbrush sprays the color onto the canvas. The paint continues to build up as long as you keep the mouse button pressed.

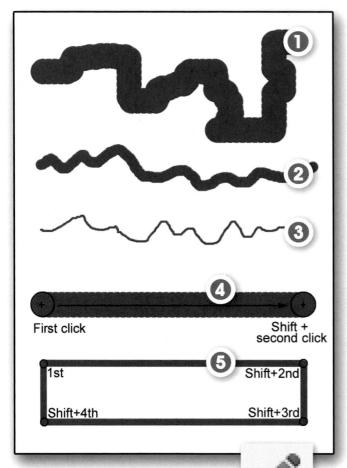

The Pencil tool draws hard-edged lines.

- (1) 70 pixel pencil.
- (2) 30 pixel pencil.
- (3) 8 pixel pencil.
- (4) To draw a straight line click to start the line and hold down the Shift key and click the mouse button a second time to mark the end of the line.
- (5) The shift + click technique is used to draw a rectangle.

Pencil

The Pencil differs from the other tools we have looked at so far in that it paints freehand lines. The thickness of these lines is dependent on the selected brush size and the lines drawn with the pencil have hard edges with no anti-aliasing. By clicking and dragging the mouse, the user can create free form lines just as if you were using a pencil and a piece of paper. Using the tool in conjunction with the Shift key means that you can draw straight lines by clicking at the beginning and end points.

The thickness or size, mode and opacity of the line can be altered via the tool's options bar. Also any brush that has a hard edge can be selected for use from the Brushes panel section also located in the options bar.

Don't confuse the Pencil with the line version of the Shape tool. The Pencil draws with pixels; the Line tool defines a beginning and end point to a mathematical pixel-free line that is drawn only at the time that it is printed.

Paint Bucket

The Paint Bucket, although not usually considered a painting tool, is included here because its main role is to apply color to areas of the image. The best way to describe how it functions is to imagine a Magic Wand tool that selects areas based on their color and then fills these selections with the foreground tint. In this way, the Paint Bucket selects and fills in a one-step action.

Just like the Magic Wand, the Paint Bucket makes its selection based on the Tolerance value in the options bar. Higher Tolerance values mean pixels with greater difference in tone and color will be marked for color changes by the tool. The Anti-aliased, Contiguous and Use All Layers settings also work in the same was as they do for the Magic Wand.

In addition to applying color to selected areas, the Paint Bucket can also fill the area with a pattern. After selecting the Pattern option you can choose from the patterns displayed in the drop-down menu. Alternatively you can create your own using the following steps.

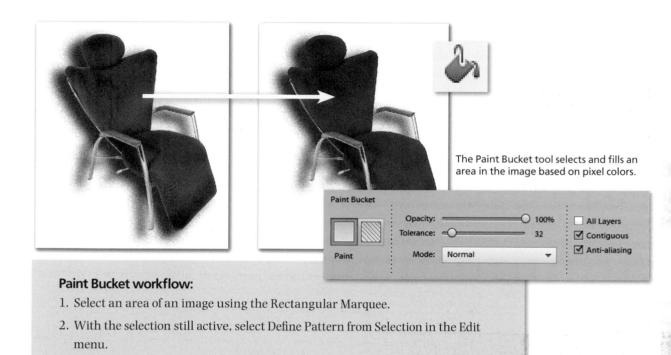

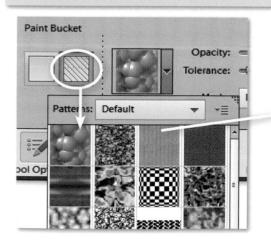

3. Enter a name in the New Pattern dialog.

Bucket tool.

4. The new pattern is now available for use from the Pattern panel of the Paint

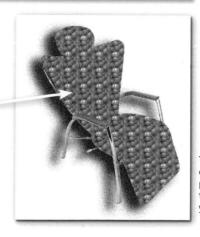

The Paint Bucket feature can also fill areas using a predefined pattern or one that you have defined yourself.

The Impressionist Brush applies a painterly effect to the picture as you brush over the surface.

The Impressionist Brush tool

In addition to these standard painting options, Elements has a specialist Impressionist Brush tool that allows you to repaint existing images with a series of stylized strokes. By adjusting the special paint Style, Area, Size and Tolerance options, you can create a variety of painterly effects on your images.

Impressionist Brush Tool workflow:

- 1 Pick Impressionist Brush from the toolbox. You may have to select the tool from the Options bar. To reveal, click and hold the cursor over the Brush tool to reveal the sub tool menu. Select the tool from these entries.
- 2 Select brush size, mode and opacity from the options bar.
- 3 Set the style, area and Tolerance values from the More Options panel.
- 4 Drag the brush over the image surface to paint.

The Color Replacement tool is used to substitute one color for another in your pictures.

Color Replacement tool

The Color Replacement tool locates and replaces a specific color in an image with one of your choosing. In this way it works a little like a more sophisticated version of the Red Eye Removal tool as you can choose both the color to be replaced as well as its substitute hue. This feature replaces the color in the photograph with the current foreground color and acts like a paintbrush that changes the color.

A more advanced technique involves setting the foreground color to black and the tool's mode to Hue. With these settings, the tool acts like a desaturation brush.

Color Replacement Tool workflow:

- 1 Pick the Color Replacement tool from the toolbox (selectable in the options bar).
- 2 Select brush size and set mode to Hue, sampling to Background Swatch and limits to Discontiguous in the options bar.
- 3 Using the Eyedropper tool select the color from the picture that you want to replace as the foreground color swatch.
- 4 Switch foreground and background swatches.
- $5\,$ Double-click on the foreground swatch and select a replacement color.
- 6 Click and drag the Color Replacement brush over the image surface to substitute the colors.

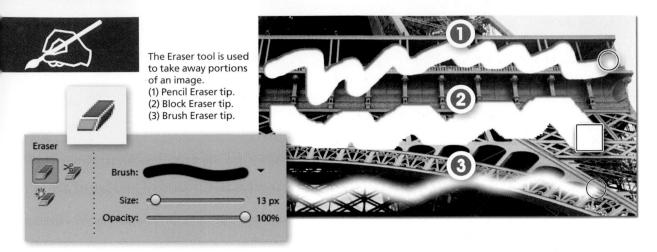

Erasing

The Eraser tool changes image pixels as it is dragged over them. If you are working on a background layer then the pixels are erased or changed to the background color. In contrast, erasing a normal layer will convert the pixels to transparent, which will let the image show through from beneath.

Brush, Pencil or Block Erasers

As with the other painting tools, the size and style of the eraser is based on the selected brush. But unlike the others the eraser can take the form of a brush, pencil or block. Pencil and Block tips are used for erasing with a hard edge, whereas altering the hardness of the edge of the brush tip will create soft edged effects. Setting the opacity in the tools options bar will govern the strength of the erasing action.

Apart from the straight Eraser tool, two other versions of this tool are available – the Background Eraser and the Magic Eraser. These extra options are found in the tool's options bar.

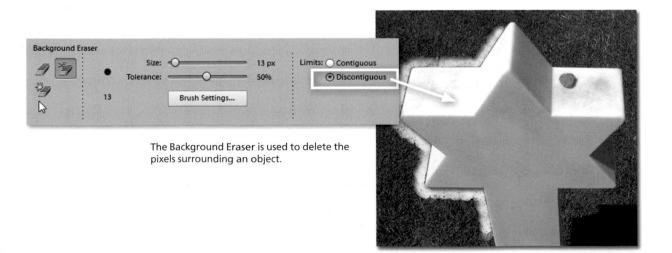

Background Eraser

The Background Eraser is used to delete pixels around the edge of an object. This tool is very useful for extracting objects from their backgrounds. The tool pointer is made of two parts – a circle and a cross hair. The circle size is based on the brush diameter. To use the tool, the cross hair is positioned and dragged across the area to be erased, whilst at the same time the circle's edge overlaps the edge of the object to be kept.

The success of this tool is largely based on the contrast between the edge of the object and the background. The greater the contrast, the more effective the tool. Again, a Tolerance slider is used to control how different pixels need to be in order to be erased.

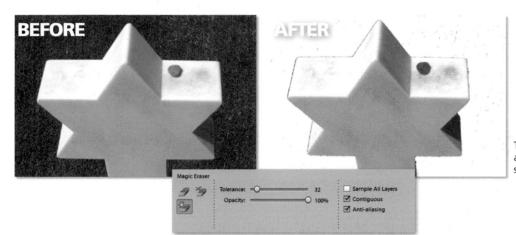

The Magic Eraser selects and erases pixels of similar color and tone.

Magic Eraser

The Magic Eraser selects and then erases pixels of similar tone and color. The tool is great for removing unwanted backgrounds when making composite or montage pictures or if the area of the image you want to erase is all the same color and contrasts in tone or color with the rest of the image.

The Tolerance setting in the tool's options bar determines how alike the pixels need to be before they are erased. High settings will include more pixels of varying shades and colors. Select the Contiguous option to force the tool to select pixels that are adjacent to each other and choose Use All Layers if you want to sample the color to be erased from a mixture of all visible layers.

PRO'S TIP

Both the Background Eraser and Magic Eraser tools replace the background color with transparency and in the process create a new image layer if the tool was applied to a background layer.

Erasing workflow:

- 1 Pick the Eraser tool type from the toolbox.
- 2 For the Eraser tool select a brush size and style and choose the form that the tool will take.
- 3 For Magic Eraser and Background Eraser set Tolerance and Contiguous values.
- 4 Drag over or click on the image to erase.

The Magic Extractor feature acts as an intelligent Eraser tool by allowing the user to mark (scribble or dot) picture parts to be retained (foreground) and areas to be erased (background).

Smart erasing

As we have seen in Chapter 12, one of the great technologies included in more recent versions of Elements is the Magic Extractor feature (Image > Magic Extractor). In this release the feature's selecting powers have been boosted so that your results will be more accurate than ever. The tool automatically erases some picture parts whilst retaining others. The user marks the areas in the photo that are to be retained or erased by painting over these sections with dots or scribbles of different colors. Elements then goes to work intelligently erasing and retaining parts throughout the photo. It is this intelligent erasing power that warrants the feature's inclusion in this part of the text.

Used carefully, the Magic Extractor has both the power and fine-tuning abilities to make it a regular part of your erasing toolset. For more details on how to use the feature turn to the selection section in Chapter 12.

Better with a tablet

Many professionals prefer to work with a stylus and tablet when working with complex drawing tasks. The extra options provided by the pressure sensitivity of the stylus, along with the familiar 'pencil and paper' feeling, make using this approach more intuitive and often faster than using a mouse. When a stylus and tablet are installed on your machine you will be able to access the extra pen or stylus options available through the program.

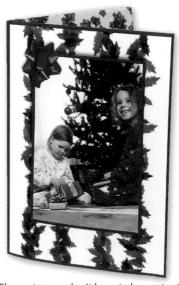

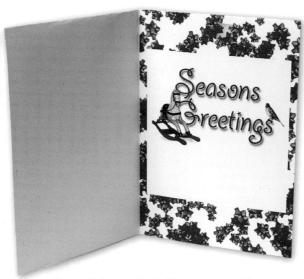

Elements users don't have to be content with using the brush tips supplied with the program. They can create their own brush tip designs by either changing the characteristics of an existing brush or using an image as the basis of a new one. In this example both the holly and bow patterns have been created using custom brushes.

Custom brush creation

In the more recent releases of Photoshop Elements, Adobe has included a sophisticated Brush engine that, when combined with the program's ability to make a brush tip from almost any image, allows the user unlimited drawing options to play with.

There are two basic approaches to creating a new brush. The first involves selecting an existing preset and then modifying the brush's characteristics before saving the altered brush as a new brush entry. The second approach uses an image as the basis for the shape, texture and design of the brush tip. In creating the card example you see here, custom Holly and Ribbon Bow brushes were used to decorate the front and inside faces of the card.

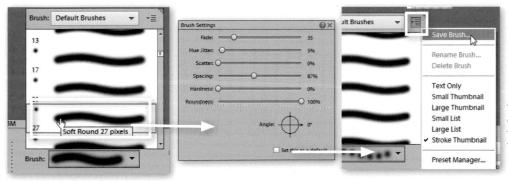

The Brush Settings pane contains a range of options that can be used to alter the characteristics of existing brush tips.

New brush from presets workflow:

1 Display the brush presets pane by clicking the down arrow next to the brush stroke preview in the options bar (on the right).

- 2 Modify the selected brush by adjusting the various settings in the options bar. For more creative changes alter the slider controls for the brush dynamics in the Brush Settings pane (display these options by clicking the button on the right in the options bar).
- 3 Display the brush presets again and select the side arrow in the top right of the pane. Choose Save Brush from the menu items. Type a name into the Brush Name dialog and click OK. The newly created brush is added to the bottom of the brush presets list.

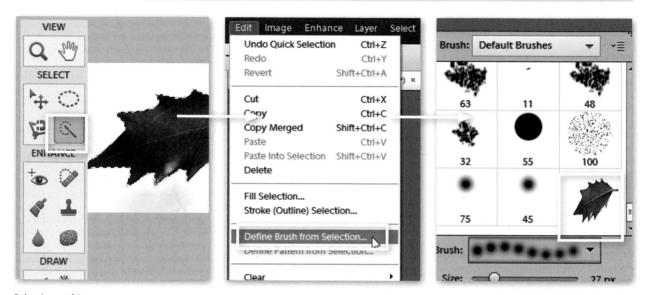

Selections of images can be used to create custom brush tips using the Define Brush from Selection entry.

Defining a new brush from an image workflow:

- 1 Open the source picture containing the image part that you want to use as a base for the new brush tip. Using one of the selection tools outline the image part. In the Christmas card example, I selected a single holly leaf.
- 2 With the selection still active pick Edit > Define Brush from Selection and enter a new name for the Holly Brush. Click OK to add the brush to the current set of brush tips.
- 3 Select the new brush tip from the bottom of the brush list thumbnails. Set the foreground color to black and click-drag to draw with the brush.
- 4 To further refine the look and characteristics of the new brush click on the More Options button in the options bar. Apply new settings for the Spacing, Fade, Hue Jitter and Scatter options and also change the fore- and background colors. Click-drag to test the new brush tip.
- 5 When completed select the Save Brush option from the pop-out menu in the brush list brush presets pane.

Painting tools in action

Hand coloring black and white photos

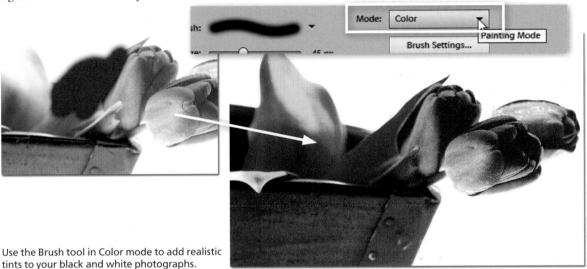

Hand Coloring workflow:

- 1 With your image open in Elements check to see what Color mode the picture is stored in. Do this by selecting Image > Mode and then locate which setting the tick is next to. For most black and white photographs the picture will be in Grayscale mode. If this is the case change it to RGB Color (Image > Mode > RGB Color).
- 2 You will not notice any difference in the picture as a result of its mode change but now the image is capable of holding colors (not just grays). Now doubleclick on the foreground swatch in the toolbox and select a color appropriate for your picture. Here I chose a dark green for the leaves.
- 3 Now select the Paint Brush tool from the toolbox and adjust its size and edge softness using the settings in the options bar. Start to paint onto the surface of the picture. You will notice straight away that the paint is covering the detail of the picture beneath. This is because the brush is still in Normal mode. Use Ctrl/Cmd + Z to undo your painting.

- 4 In order for the brush to just color the picture (keeping the details from beneath) the tool must be in the Color mode. To make the change click on the Mode drop-down menu in the options bar and select the Color option towards the bottom of the list.
- 5 With the Color mode now selected start to apply the color again. Immediately you will notice the difference. The brush is now substituting the color for the gray tones in the picture and it is doing so proportionately: dark gray = dark green, light gray = light green.
- 6 Once the leaves and stems have been colored, select new colors for the flowers and finally the bucket. The amount and areas of the picture that you choose to color is up to you. Some photographs look great with only one colored section and the rest black and white.

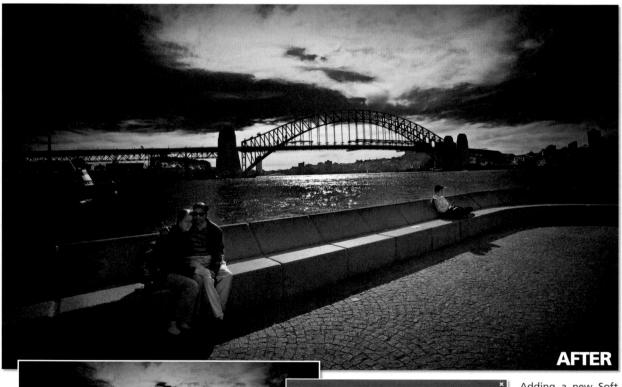

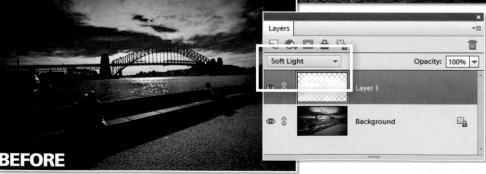

Adding a new Soft Light layer on top of the background provides the ability to paint dodge and burn effects onto the photo.

Brush on dodging and burning

One of the problems with applying dodge and burn tools directly to the photo is that these actions change the original pixels irreversibly. For this reason some photographers only ever make dodging and burning changes on copies of the their photos, not the originals, but there is another way to achieve the same ends non-destructively and without the need for creating multiple copies. The technique uses the Brush tool, a special dodge and burn layer that sits above the picture and relies on the power of Layer Blend modes to darken and lighten the image. In fact, the traditional dodge and burn tools are not used at all to achieve the outcome.

Dodge and burn workflow:

- 1 Start by creating a new blank layer above the image or background layer. Next rename the layer Dodge and Burn and change the Blend Mode of the layer to Soft Light. The lightening and darkening changes will be applied to this layer and the original pixels beneath will not be touched.
- 2 To burn in make sure that the new layer is active and then select the default colors for foreground (black) and background (white). Select a soft-edged brush and reduce the opacity to between 20-30%. Start to paint in the bright areas of the image. The black paint combined with the Soft Light blend mode acts like a non-destructive burn in tool.
- 3 To lighten or dodge areas switch paint colors so that now the foreground color is white and paint away as before. In this scenario the white paint and the Soft Light blend mode works like a non-destructive version of the dodge tool.

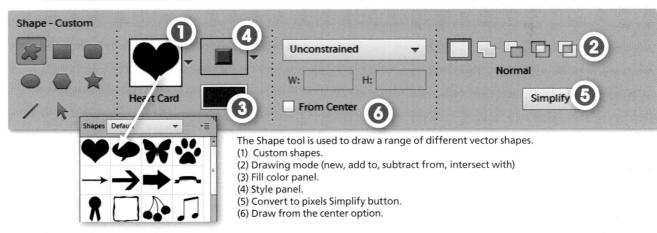

Drawing tools

The Shape Tool

With the Shape tool it is possible to draw lines, rectangles, polygons and ellipses, as well as creating your own custom shapes. After selecting the tool and picking the fill color, you can draw the shape by clicking and dragging the mouse. Although only one Shape tool is

PAINTING AND DRAWING

visible in the toolbox at any time, you can select a different option by clicking and holding the mouse button down over the tool icon and then selecting the new tool from the list as it appears.

A new shape layer is opened automatically when you select a tool and draw a new shape. Double-clicking the shape thumbnail in the Layers panel allows you to change the color.

When you create multiple shapes on a single layer you have the opportunity to decide how overlapping areas interact. Two or more different shapes can be added to form a third and the intersection of shapes can be added or subtracted from the image. At first the Shape tool can seem a little confusing, but with practise you will be able to build up complex images by gradually adding and subtracting shapes.

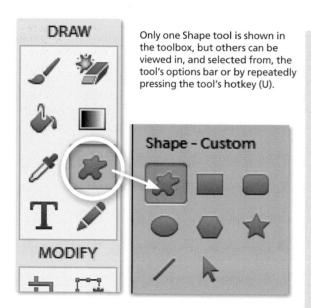

Shape Tool workflow:

- 1 Pick the Shape tool you require from the toolbox. Select other shapes from the tool's options bar.
- 2 For a new shape pick the Create New Shape Layer option. For adding to an existing shape layer, select the layer and select the Shape Area option that suits your needs. You can pick from Add, Subtract, Intersect and Exclude.
- 3 Click on the color swatch to specify the fill color for the shape.
- 4 Click and drag on the image surface to draw the shape.

The fill color of a shape can be changed by double-clicking the shape in the shape's layer or the color icon (earlier versions of Elements).

The way that successively drawn custom shapes interact can be customized via buttons on the options bar.

- (1) Single new shape.
- (2) Add shape to existing shape.
- (3) Subtract shape from existing shapes.
- (4) Subtract overlapping areas of existing shapes.
- (5) Use the intersection of the areas as a new shape.

Even more shapes

Elements comes supplied with a vast range of shapes. New shape sets can be added to those already visible as thumbnails by clicking the side-arrow button in the Custom Shape Picker panel. If you can't find a favorite here then why not try some of the extra shape sets that can be downloaded from specialist Elements resources websites?

Cookie Cutter tool

Also included in this vector type (hard-edged) Drawing tools group is the Cookie Cutter tool. Although not strictly a drawing tool, the feature works in a very similar way to the Custom Shape tool as it also allows users to select and draw a range of predesigned shapes in the workspace. It is after the drawing step that the two tools differ. The shape drawn with the Cookie Cutter is used to define the edges of the current image. In this way the feature functions as a fancy Crop tool, providing a range of graphic designs that can be used to stamp out the edges of your pictures.

PAINTING AND DRAWING

The Cookie Cutter tool is a two-step feature that crops your pictures in the shape of one of many 'cookie' designs that Elements is shipped with. The feature is a great way to add interesting edge effects to your pictures.

Cookie Cutter workflow:

- 1 Open an image to crop and select the Cookie Cutter tool from the toolbox.
- 2 Click the Shape button in the options bar to reveal the pop-up menu of cookie shapes. Select the shape to use.
- 3 To soften the edge of the cookie cutter crop, add a Feather value in the options bar before you drag the shape.
- 4 Optional Select the Crop option if you want the image cropped to the edge of the shape.
- 5 Click and drag the tool over the surface of the picture. Let the mouse button go and click and drag the edge handles to adjust the size of the cookie shape to suit the picture.
- 6 Double-click inside the cookie shape or click the tick icon in the options bar to crop.

You can also draw shapes and add graphics to your Photo Layouts by dragging them from the Shapes section of the Graphics pane.

Shapes and graphics in the Graphics pane

Recent versions of Elements include a panel that groups together a range of different graphics and shapes content. The content is available in the Graphics panel accessible through the Window menu (Window>Graphics) and also in the Create tab. This is a central location for storing frames, backgrounds, styled text, shapes and themes options and is a key place to look for small picture elements to add to compositions when you are creating photo creations such as Photo Books and Photo Collages.

You will find a large variety of shapes and graphics stored in the panel and it is for this reason that I have included details of the feature here. Both groups of picture elements are vector-based (resolution independent) and so can be scaled, rotated, twisted and distorted to fit your compositions with no loss in quality.

Unlike the Custom Shape tool though, you do not need to draw the shape onto the canvas surface: simply double-click on the thumbnail of your choice. Elements automatically creates a new layer and places the picture element on the canvas. From this point you can rotate, size and distort the shape/graphic using the handles situated on its edges. Apply the changes by clicking the green tick or Commit button that appears at the bottom edge.

To scale proportionately – Click and drag a corner handle.

To squish or stretch non-proportionately – Click and drag a side handle.

To scale or squish from the center – Hold down the Alt key whilst dragging a handle.

To rotate – Click and drag the rotate handle located in the middle of the bottom edge of the graphic/shape. Alternatively, move the mouse cursor outside the edges of the graphic and then click-drag to rotate.

To distort or twist – Ctrl-click side or corner handles to distort or change perspective.

Click-drag graphics and shapes from the Effects panel to an open document before repositioning, sizing and adding layer styles.

Shapes added to the document from the Content panel (Window > Content) are stored in a standard shape layer whereas graphics are stored in a new Smart Object layer. The Smart Object layer is similar to a Frame layer in that it is resolution independent and must be simplified before you can edit it directly. Simplifying the layer loses its ability to be scaled and distorted non-destructively.

Adding shapes or graphics from the new Effects panel is an easy task. Follow the steps on the next page to place, size and position one of these picture elements.

Adding new graphics workflow:

- 1 Display the Graphics panel by selecting Window > Graphics.
- 2 Select the By Type entry from the drop-down menu on the left and then the Graphics or Shapes option menu on the right.
- 3 With the thumbnails displayed, either click and drag the shape/graphic from the panel onto the open document or double-click the thumbnail.
- 4 To move the shape/graphic around the canvas, move the mouse cursor onto the picture element and click and drag to a new position.
- 5 To resize, click and drag a corner or side handle. To pivot, click and drag the rotate handle.

Filters

The filters contained within image-editing programs are capable of producing truly stunning effects. Digital filters are based on the traditional photographic versions, which are placed in front of the lens of the camera to change the way the image is captured. Now, with the click of a button, it is possible to make extremely complex changes to our images almost instantaneously — changes that a few years ago we couldn't even imagine.

Photoshop Elements ships with a comprehensive range of filters built right into the program. If you find that you require filtering options not available in the program, it is also possible to add to Elements' power by installing extra filters or plug-ins. These small utility programs are produced by third-party companies and generally target a particular task such as grayscale conversion or simulating film stock appearance.

This chapter covers the basics of filtering, provides examples and details of different filtering effects.

Will the transmitted to the same of the sa

Most filters are supplied with a preview and settings dialog that allows the user to view changes before committing them to the full image.

- (1) Filter preview thumbnail.
- (2) Filter controls.

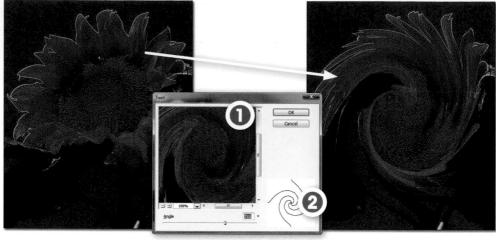

Using filters

The filters in Adobe Photoshop Elements can be found grouped under a series of subheadings based on their main effect or feature in the Filter menu for the Full Edit workspace. Selecting a filter will apply the effect to the current layer or selection. Some filters display a dialog that allows the user to change specific settings and preview the filtered image before applying the effect to the whole of the picture. This can be a great time saver, as filtering a large file with a complex filter can take a little while.

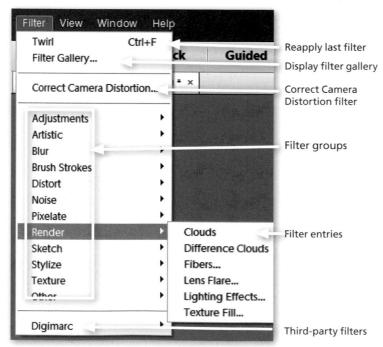

Most filters can be found listed under the filter menu in the Full Edit workspace.

Editor: Filter > Filter Gallery

Most filters that don't work with their own dialog are incorporated into the Filter Gallery (Filter > Filter Gallery) feature. Designed to allow the user to apply several different filters to a single image it can also be used to apply the same filter several different times. The dialog consists of a preview area, a collection of filters that can be used with the feature, a settings area with sliders to control the filter effect and a list of filters that are currently being applied to the picture.

Multiple filters are applied to a picture by selecting the filter, adjusting the settings to suit the image and then clicking the New effect layer button at the bottom of the dialog. Filters are arranged in the sequence

they are applied. Applied filters can be moved to a different spot in the sequence by click-dragging them up or down the stack. Click the eye icon to hide the effect of the selected filter from preview. Filters can be deleted from the list by selecting them first and then clicking the dustbin icon at the bottom of the dialog.

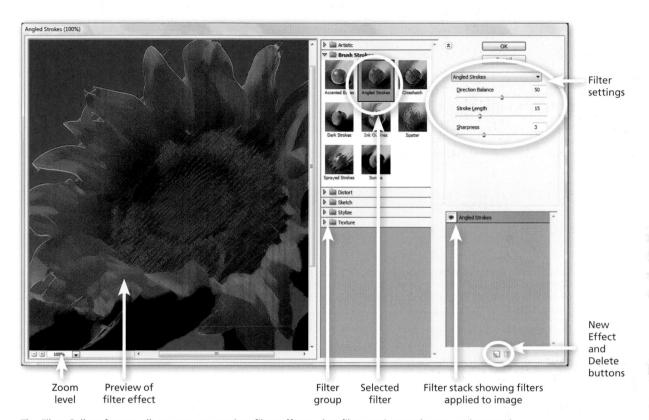

The Filter Gallery feature allows users to preview filter effects, alter filter settings and even apply several different filters to the same image interactively.

Most of the filters that can't be used with the Filter Gallery feature are either applied to the picture with no user settings or make use of a special filter preview and settings dialog.

If neither of these preview options is available then, as an alternative, you can make a partial selection of the image using the Marquee tool first and then use this to test the filter. Remember, filter changes can be reversed by using the Undo feature.

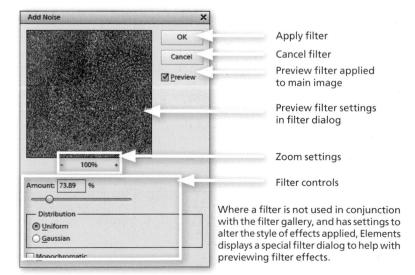

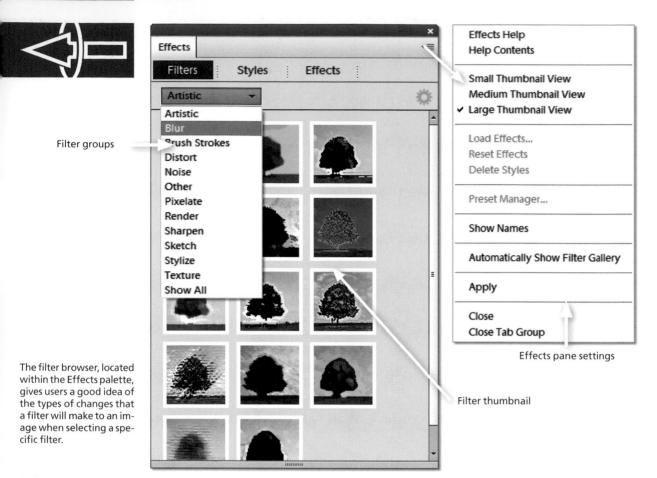

Editor: Window > Effects

The number and type of filters available can make selecting which to use for a given image, a difficult process. To help with this decision, Elements also contains a Filter Browser type feature that displays thumbnail versions of different filter effects. This feature provide a third way to locate and apply filter changes to your photos. The browser is located with other thumbnail previews of shapes, graphics, themes, frames and layer styles in the Effects palette (Window > Effects), previously located in the Contents palette.

Double-clicking the thumbnail will either open the Filter Gallery or a filter dialog, where settings can be adjusted, or simply apply changes directly to your picture. The selection of filters previewed in the gallery at any one time can be changed by altering the selection in the drop-down menu at the top of the palette.

Adjustment Filters

If you have experience with earlier versions of Elements or Photoshop then the Adjustments filter group may seem a little out of place, positioned under the Filter menu, as the options listed here were previously located under the Enhance menu.

The Adjustments filters used to reside under the Enhance menu in previous versions of Elements.

Equalize – When you apply the Equalize filter Elements redistributes the brightness values of the image's pixels so that they more evenly represent the entire range of brightness levels.

Gradient Map – The Gradient Map filter converts the underlying tones (grayscale information) of the photo to the colors and tones of the selected gradient.

Invert – The Invert filter produces a negative version of your image. The feature literally swaps the values of each of the image tones.

Posterize – The Posterize filter reduces the total number of colors in an image by letting you set the number of brightness levels per channel.

Threshold – The Threshold filter converts the picture to pure black and white, removing any tonal detail in the process.

Photo Filter – The Photo filter simulates the color changes that are made to a picture when it is photographed through a color correction filter.

Sharpen Filters

The other exception to general filter rules in Elements is the Sharpening filters. These three options – Auto Sharpen, Unsharp Mask and Adjust Sharpness are all listed under the Enhance menu. At first this may seem strange but when you think that adding a little sharpening to your images should be a regular part of your enhancement workflow, we can start to see where Adobe is coming from. Go to the Sharpening filter entry in the examples on the next pages for greater detail on each of these options.

Let's get filtering

To give you a head start with your filtering, the next few pages contain some examples of the effects of a range of filters when applied to the same base image. The results, along with a summary of how the filter works, is included with each example image.

All sharpen filters in Elements reside under the Enhance menu, not the Filter menu as you may first think.

New filters for Elements 11

Adobe doesn't add new filters to those already available in Elements very often, but in this revision the team has included three new options—Pen and Ink, Comic, and Graphic Novel. The new options are all listed under the Filter > Sketch menu and are variations on a theme. The filtering process reduces the colors in the image using a posterizing effect before outlining key shapes with a dark outline.

These new filters do not work via the Filter Gallery but instead each has its own dedicated dialog containing the usual preview of the image with the filter applied, and slider controls to alter the style of the filter effect. In addition, there are a set of presets designed to apply pre-designed filtering styles to your image quickly and easily.

Render

Stylize

Texture Other

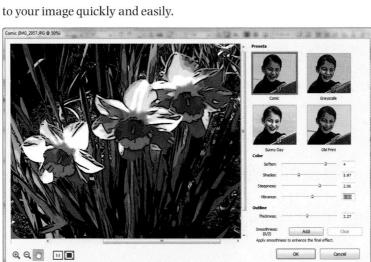

The Comic filter flattens color and surrounds key shapes with a black line.

Chalk & Charcoal.

Charcoal...

Chrome.

Comic...

Conte Crayon... Graphic Novel...

Graphic Pen... Halftone Pattern..

Note Paper... Pen and Ink...

Photocopy... Plaster...

Reticulation.

Torn Edges... Water Paper..

Filter > Sketch > Comic

The Comic filter creates a flat color version of your photo and then outlines the dominant shapes using a strong black line. Four preset thumbnails are included at the top left of the dialog providing one-click processing for these specific 'looks'. Use the slider controls for a more manual approach. They are grouped under two headings—Color and Outline—which reflect the two-step process you use to filter the photo.

Starting with the adjustments in the Color section, use Soften to control detail, Shades for image tones, Steepness for the strength of the posterization effect and Vibrance for the strength of the color. The Thickness slider under the Outline section determines the width of the black line drawn along the edge of the shapes in the image. Click the Add button at the bottom of the dialog to smooth the overall effect. You can click the button twice to increase the effect. Zoom and Hand tool are included in a small toolbar on the bottom-right of the dialog and handy 100% and Fit To View buttons are positioned alongside. Clicking OK applies the filter.

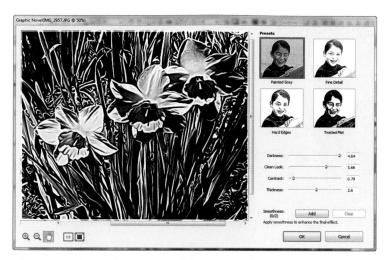

The Graphic Novel filter produces stark and contrasty monochrome effects.

Filter > Sketch > Graphic Novel

Reproducing the stark and contrasty effect made popular by films such as the 300, the Graphic Novel filter creates highly stylized monochrome versions of your photos. Start by clicking one of the preset thumbnails to establish a style direction for your filtering and then use the four slider controls to adjust the results. Darkness alters the overall brightness of the image, Clean removes unwanted detail, Contrast determines how black and white or gray the picture becomes, and Thickness is used to change the outline width. The same Smoothness option found in the Comic filter is also available here where it evens out the effect across the whole of the image.

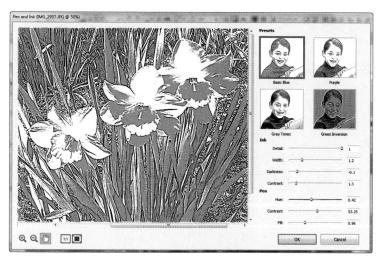

The Pen and Ink filter converts images to flat color and adds fine lines for details.

Filter > Sketch > Pen and Ink

The Pen and Ink filter works in a similar way to the Graphic Pen filter but provides more control and variation in possible results. The four sliders in the Ink section provide control over the way that key shapes are outlined and shaded and the Pen settings alter the conversion of tones to flat areas of color. Again, starting with one of the presets and then fine-tuning with the slider controls will speed up the process of achieving great results.

Accented Edges filter

Filters > Brush Strokes > Accented Edges

The Accented Edges filter searches out the edges within a picture and then highlights them with a line.

The size of the line is controlled by the Edge Width slider in the filter's dialog. The darkness or lightness of the line is determined by the Edge Brightness slider. A high value produces a lightly colored edge that appears like chalk and a low value, like the one used in the illustration here, creates an ink-like outline. The Smoothness slider is used to even out the roughness of jagged edges of the line.

Add Noise filter

Filter > Noise > Add Noise

troduce this texture into your digital pic-

The filter uses a single Amount slider to The higher the setting the more obvious the results will be. Two different types of texture are provided - Uniform and Gauss- Sharpness of the brush effect are controlled ian. The Uniform option adds the noise by the sliders in the filter dialog. evenly across all the tones in the picture. In contrast the Gaussian setting concentrates the noise in the midtones with fewer changes being applied to the highlight and shadow areas.

Selecting the Monochrome option restricts the noisy pixels added to white, black and gray only.

Angled Strokes filter

Filter > Brush Strokes > Angled Strokes

Using the Add Noise filter is one way to in- The Angled Strokes filter, as one of the group of Brush Strokes filters, repaints the picture using diagonal strokes. The brush strokes in the light area of the photo are control the strength of the texture effect. drawn in one direction and those in the darker parts in the opposite direction.

The Direction Balance, Stroke Length and

Bas Relief filter

Filter > Sketch > Bas Relief

The Bas Relief filter simulates the surface texture of the picture using the current foreground and background colors.

The edges in the picture are used as the basis for the effect, with the three settings in the dialog providing control over how the colors are applied.

The Detail slider alters the amount of the original photo detail used to create the end result. Higher numbers create more detailed results.

The Smoothness slider alters the sharpness of the detail and the Light menu contains a series of options for the direction of the light that is used to create the textured look of highlights and shadows.

Blur Filters

Filter > Blur > ...

Photoshop Elements contains a extensive array of blur filters including the Motion, Smart and Surface Blur options. It might seem strange for image makers to actually want to destroy the sharpness of their photos but many interesting enhancement effects make use of these filter options.

Surface Blur - The Surface Blur filter is an edge preserving filter that produces results faster than Smart Blur.

Average - Averages all the color in the picture and then fills the canvas with this color.

Blur and Blur More - Makes transitions smooth and softens details. Blur More is stronger.

Gaussian Blur - Slider-controlled blurring based on the Gaussian distribution of pixel changes.

Motion Blur - Blurs the image in a specific direction. Great for speed enhancing effects.

Radial Blur - Creates either spinning or zooming blur effects.

Smart Blur - Provides more control over the type and placement of blur using Radius, Threshold, Quality and Mode adjustments.

Above: Motion Blur example left. Radial Blur right.

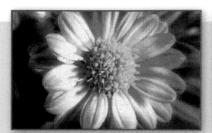

Chalk & Charcoal filter

Filter > Sketch > Chalk & Charcoal filter

The Chalk & Charcoal filter simulates the effect of making a drawing of the photograph with white chalk and black charcoal. The filter gives you control over the balance of the amount and placement of the charcoal and chalk areas as well as the pressure of the stroke used to draw the picture. Higher values for the Charcoal and Chalk Area sliders will increase the number and variations of tones that are drawn with these colors. High settings for the Stroke Pressure slider produce crisper transitions between tones and a more contrasty result. To add color to your Chalk and Charcoal 'drawings' select colors for the foreground and background values. Double-click each swatch to open the Color Picker where you can select the new hue.

Charcoal filter

Filter > Sketch > Charcoal

coal filter makes use of only one drawing tone to create the sketching effect.

Three sliders control the appearance of the final result. Charcoal Thickness (1) adjusts the look of polished chrome. the density of the drawn areas whereas the Detail slider adjusts the level of detail that is retained from the original picture.

Care should be taken with the settings used for the Light/Dark Balance slider to ensure that some shadow and highlight detail is retained.

Chrome filter

Filter > Sketch > Chrome

Giving similarly textured results to the The Chrome filter is another Sketch filter Chalk & Charcoal filter, the straight Chardesigned to change the appearance of your picture so that it looks like it is created from another surface. In this case the filter converts the detail of the picture to simulate

> During the transformation you have control over both the detail that is retained in the filter photo as well as the smoothness of the chromed surface.

> In some instances a further levels enhancement to increase the contrast of the final filtered picture will help produce brighter highlights on the silvered surface.

Color Halftone filter

Filter > Pixelate > Color Halftone

The Color Halftone filter replicates the look of the CMYK (Cyan, Magenta, Yellow and Black) printing process. The photograph is broken into the four colors and the tone for each of the colors represented by a serles of dots. Where the color is strongest the dots are bigger and can even join up. In the lighter tones the dots are small and are surrounded by large areas of white pa-

The controls in the filter dialog are separated into two sections - the size of the dot that makes up the screen and the angle that will be applied to each of the color screens. In practice the best results are obtained when the dot size is altered and the screen angle left alone. Color Halftone is one of the Pixelate group of filters.

Colored Pencil filter

Filter > Artistic > Colored Pencil

The Colored Pencil filter is one of the options in the Artistic group of filters. The feature creates a drawn version of the photograph simulating the effect of colored pencils. The detail in the image is retained and different tones are created using crosshatching.

Three slider controls can be found in the filter dialog. The Pencil Width controls the bands of drawn color that replicate the picture's detail, the Stroke Pressure adjusts the drawn on (from black to white).

Conté Crayon filter

Filters > Sketch > Conté Crayon

The Conté Crayon filter is one of the options in the Sketch group of filters. The feature replicates the effect of a traditional conté crayon drawing created with dark and light cravons on a textured paper background. The detail in the image is retained and different tones and colors are created using shaded areas of background and foreground color.

The controls for the filter are divided into two sections - one that controls the interamount of color laid down on the paper action of the dark and light tones or picture surface and the Paper Brightness deterdetails and a second that houses sliders and mines the tone of the paper the pencil is drop-down menus for adjusting the surface texture.

Craquelure filter

Filters > Texture > Craquelure

The Craquelure filter is one of the options in the Texture group of filters. The feature creates an effect that looks as if the picture has been created on a surface of cracked mud

Three slider controls can be found in the filter dialog. The Crack Spacing controls the distance between crack edges, the Crack Depth adjusts the width of the crack line and its shadow, and the Crack Brightness determines how dominant or strong the crack lines will appear in the final result.

Crosshatch filter

Filter > Brush Strokes > Crosshatch

The Crosshatch filter is one of the options The Custom filter is one of the options in in the Brush Strokes group of filters. The tones in the picture using crosshatching or their own customized filter effects. a series of overlapping strokes.

Three slider controls can be found in the es into which you can enter numbers that filter dialog. The Stroke Length controls will alter the brightness of the pixels that the length of the crosshatching stroke, the the filter is applied to. Values from -999 to Sharpness adjusts how crisp the edge of +999 can be entered into any of the boxes. the stroke appears and the Strength deter- Values don't have to be entered into all mines how obvious the effect is to the boxes. viewer.

Custom filter

Filter>Other>Custom

the Other group of filters. The feature alfeature recreates the color and different lows the user to create, save, load and share

The filter dialog contains a grid of text box-

The central box represents the pixels being evaluated, with the values placed in those around the center being adjustments made to the surrounding pixels.

Cutout filter

Filter > Artistic > Cutout filter

The Cutout filter is one of the options in the Artistic group of filters. The feature recreates the tone and shape of the original photo using a series of flat areas of color similar to pieces of 'cutout' paper. Three slider controls can be found in the dialog. The Number of Levels controls the number of colors, Edge Simplicity adjusts how much detail will be in the edge of the flat areas and the Edge Fidelity determines how flat the edge detail will be.

High Pass filter

Filter > Other > High Pass

The High Pass filter, as one of the group of The Ink Outlines filter, as one of the group Other filters, isolates the edges in a picture and then converts the rest of the picture to mid gray. The filter locates the edge areas by searching for areas of high contrast Three controls in the filter dialog allow ador color change.

The filter contains a single slider, Radius (1), that controls the filtering effect. When the Radius value is set to low only the most prominent edge detail is retained and the remainder of the picture converted to gray. The Dark Intensity and Light Intensity slidthe picture converted to grav.

make this feature a tool that is often used produce a more contrasty result overall. for advanced sharpening techniques.

Ink Outlines filter

Filter > Brush Strokes > Ink Outlines

of Brush Strokes filters, draws fine black ink lines over the edge details of the original picture.

justment of the filtering process and re-

The length of the stroke used in the outlining process can be varied with the Stroke Length slider.

Higher values produce a result with less of ers provide control over the brightness and contrast of the final result. When low val-The combination filter effects of edge find-ues are used for both sliders a low contrast ing and changing picture parts to gray picture results. Conversely, higher settings

Lens Flare filter

Filter > Render > Lens Flare

The Lens Flare filter adds a bright white spot to the surface of photos in a way that resembles the flare from light falling on a camera lens.

The filter dialog contains a preview thumbnail on which you can position the center of the flare by click-dragging the cross hairs. Also in the dialog is a Brightness or Strength slider and a selection of lens types to choose

The filter was revamped for CS2 so that it can also be used in 16 bits per channel mode.

You can set the Lens Flare center precisely by Alt/Opt-clicking on the preview image and then inputting the X and Y coordinates for the center of the effect.

Lighting Effects filter

Filter > Render > Lighting Effects

The Lighting Effects filter, as one of the group of Render filters, simulates the look of various light sources shining onto the picture surface. Single or multiple light sources can be added to the photo. The filter dialog contains a preview thumbnail that is used to adjust the position, shape and size of the projected light. The rest of the dialog is broken into four different control sections:

Style - Provides a drop-down menu of pre-designed light styles along with any customized styles you have created and saved.

Light type - Alters the color, intensity and focus of the selected light.

Properties - Contains controls for how the subject reacts to the light.

Texture Channel - Has options for creating texture with the light shining onto the photo.

This feature is often used for creating, or enhancing existing, lighting type effects on the main subject in a picture.

Above: Five Lights Down example (left). Spotlight example (right).

Maximum filter

Filter > Other > Maximum

The Maximum filter, as one of the Other group of filters, grows or bleeds the lighter areas of the picture whilst reducing the size of the darker toned parts.

In making these changes, the filter analyzes the brightness of the pixels in a given area (radius) and increases the brightness to the level of the darkest pixel in the

The filter contains a single slider control that adjusts the radius or size of the area used to determine the pixel brightness value

Median filter

Filter > Noise > Median

The Median filter, as one of the Noise group of filters, reduces the speckle type noise in brightness.

The filter contains a single slider control used to determine the median, or middle, pixel brightness value.

The filter has a blur effect as well as a reduction in local contrast.

Mezzotint filter

Filters > Pixelate > Mezzotint

The Mezzotint filter, as one of the Pixelate group of filters, recreates tone and color a picture by finding the middle pixel bright- in a similar way to the way it is produced ness across the selected radius and remov- with etched printing plates. A series of ing pixels that deviate greatly from this strokes, dots or lines is used in a pattern to create detail and tone. Grayscale pictures are recreated in black and white strokes, that adjusts the radius or size of the area and colored photos remade with a fully saturated pattern of colored texture.

The filter contains no single slider control to adjust the strength or positioning of the effect, rather a drop-down menu of texture types is provided. Each type (stroke, line, dot) creates a different pattern of texture and tone.

Minimum filter

Filters > Other > Minimum

The Minimum filter, as one of the Other group of filters, grows or bleeds the darker areas of the picture whilst at the same time reducing the size of the lighter toned parts. In making these changes, the filter analyzes the brightness of the pixels in a given area (radius) and reduces the brightness to the level of the darkest pixel in the area.

The filter contains a single slider control that adjusts the radius or size of the area used to determine the pixel brightness value.

Mosaic filter

Filter > Pixelate > Mosaic

The Mosaic filter, as one of the Pixelate The Mosaic Tile filter, as one of the Texture group of filters, simulates the look of a pixel-based picture that has been enlarged

The photo is recreated in large single colored blocks. The filter contains a single slider control that adjusts the Cell Size or 'pixel' block size.

The higher the value entered here the larger the blocks used to recreate the photo.

Mosaic Tile filter

Filter > Texture > Mosaic Tiles

group of filters, simulates the look of a picture that is constructed of small pieces of broken tiles. True to the tile idea, each tile is surrounded by an area of grout.

The filter contains three slider controls. The Tile Size slider adjusts the size of each tile fragment.

The Grout Width setting determines the size of the grout in relationship to the tiles and the Lighten Grout option controls the brightness of the grout area.

Neon Glow filter

Filter > Artistic > Neon Glow

The Neon Glow filter colors the image with foreground and background hues, adds a glow color and then softens the image.

The Glow Size setting adjusts the position of the glow in the tonal range of the picture. Low values place the glow in the shadow areas, higher settings move the glow to the highlights.

The Glow Brightness slider oscillates the picture's tinting between foreground, background and glow colors.

The Glow Color can be selected by doubleclicking (single-click) the color box and selecting a new hue from the Color Picker dialog. Changing the foreground and background colors greatly alters the nature of the filtered results.

Note Paper filter

Filter > Sketch > Note Paper

The Note Paper filter redraws the photo as textured light and dark tones based on the current selection of fore- and background colors.

The Image Balance setting adjusts which areas are toned the color of the foreground or background hue. Low values favor the background color swatch and high settings color more of the picture with the foreground color. The Graininess slider determines the amount of grain in the picture. The Relief slider adjusts the strength of the side lighting falling. With higher values the texture is more pronounced. Changing the foreground and background colors away from their defaults greatly alters the nature of the filtered results.

Ocean Ripple filter

Filter > Distort > Ocean Ripple

The Ocean Ripple filter, as one of the Distort group of filters, applies a rippled distortion to the whole of the picture surface. In this way it can create similar looking results to those obtained with the Glass or Ripple filters.

The filter contains two slider controls.

The Ripple Size setting adjusts the scale of the wave-like ripples that are added to the picture. Low values create smaller, less dramatic ripples.

The Ripple Magnitude slider determines how far each ripple is distorted. High settings create a greater level of distortion in the final result.

Offset filter

Filter > Other > Offset

The Offset filter displaces the picture within the image window. The Horizontal and Vertical sliders adjust how offset the picture is from its original position. The greater the values the larger the offset will be. The Undefined Areas option determines how the space left in the image will be treated.

Set to Background - This options fills the gap left in the image window with the current background color.

Repeat Edge Pixels - The pixels at the edge of the repositioned picture are repeated to the edge of the image window. Wrap Around - The picture is wrapped around the image window so that the edges that are cropped are added back into the picture on the opposite side.

Paint Daubs filter

Filter > Artistic > Paint Daubs

effect to the whole of the picture surface. In the process the fine detail of the photo is eclipsed by large areas of painted color. areas of paint with a palette knife. The filter contains two slider controls and The filter contains three slider controls. a Brush Type menu.

the painted areas. Low values create smaller areas with finer detail. The Sharpness slider determines how much of the original detail is maintained in the painting process. High settings create a greater level of detail and low values create broad areas of smooth color.

The Brush Type menu contains a list of duces strokes with a softer edge. different styles of brushes. Changing brush types can alter the final filter result greatly.

Palette Knife filter

Filter > Artistic > Palette Knife

The Paint Daubs filter applies a painterly The Palette Knife filter, as one of the Artistic group of filters, simulates the look of a picture created by applying thick broad

The Stroke Size setting adjusts the strength The Brush Size setting adjusts the scale of of the effect and the size of the broad areas of paint. Low values retain more of the detail of the original picture.

The Stroke Detail slider determines how coarsely the color is applied. Low values create a more broken-up result.

The Softness control alters the sharpness of the stroke's edge. A high setting pro-

Patchwork filter

Filter > Texture > Patchwork

The Patchwork filter, as one of the Texture group of filters, simulates the look of the surface of a patchwork quilt. In the process the picture is broken up into a series of

The filter contains two slider controls. The Square Size setting adjusts the size of each

The Relief slider determines the degree of shadow that is applied to the texture squares. Low values have less shadow and therefore the appearance of lower relief.

Pinch filter

Filter > Distort > Pinch

The Pinch filter, as one of the Distort group The Plaster filter converts colors and shadof filters, bloats or squeezes in a picture according to the setting selected.

squeezes the picture.

Also included in the dialog is a wire frame the changes and a preview window.

Plaster filter

Filters > Sketch > Plaster

ows of broad areas of the photo in textureless shapes. Some picture parts are The filter contains a single slider control, raised and flattened, the rest is made to Amount, that varies both the strength of look hollow and low lying. The colors in the effect and whether the filter bloats or the filtered picture are based on the current foreground and background colors.

The filter contains two slider controls and representation of the type and strength of a drop-down menu for selecting the direction of the light used for creating depth, shadow and highlight effects.

The Image Balance control adjusts the amount of the image that is converted to a raised flat surface and that which is changed to receding areas. The Smoothness slider determines how much detail is retained in the raised areas.

Plastic Wrap filter

Filters > Artistic > Plastic Wrap

The Plastic Wrap filter simulates the look of wrapping the photograph in a sheet of close-fitting plastic or cling film.

The filter contains three controls. The Highlight Strength controls the size, amount and dominance of the highlight areas. The Detail slider determines how broad the highlight areas are and the Smoothness option adjusts the sharpness of the edge of the highlight.

Pointillize filter

Filter > Pixelate > Pointillize

end result simulates the look of a pointil- simple stippled shading to the picture. list painting.

The filter contains a single slider control. The Edge Thickness setting adjusts the Cell Size, that varies the size of the dots weight of the line and the heaviness of the used to create the effect.

Poster Edges filter

Filter > Artistic > Poster Edges

The Pointillize filter, as one of the Pixelate The Poster Edges filter, as one of the Artisgroup of filters, recreates the picture in a tic group of filters, posterizes the colors in series of colored dots on a background the a picture whilst surrounding the edges with color of the current background color. The a dark border. The filter also adds some

The filter contains three controls.

The Edge Intensity slider controls the darkness of the border and shading, and the Posterization setting alters the number of colors used in the final result.

Posterize filter

Filter > Adjustments > Posterize

The Posterize filter, as one of the Adjustments group of filters, reduces the total number of colors in an image by letting you set the number of brightness levels per

A setting of 3 will produce three levels of tone for each of the Red, Green and Blue channels, giving a nine-color result.

Reticulation filter

Filter > Sketch > Reticulation

The Reticulation filter simulates the look of film that has been reticulated. This traditional effect is created by immersing film in hot and then cold baths during process-

The dialog contains three controls.

The Density slider determines the overall darkness of the effect. The Foreground Level control is used to adjust how the texture is applied to shadow areas and the Background Level slider performs the same task but for the lighter tones in the picture.

As the filter uses the current foreground and background colors in the creation of the effect, altering these hues can change the end results radically.

Rough Pastels filter

Filter > Artistic > Rough Pastels

The Rough Pastels filter recreates the photo so that it looks like it has been drawn with colored pastels on a roughly textured

The filter dialog contains several controls that adjust the look and feel of the effect. The Stroke slider determine how strong the pastel stroke effect will be. High values create a coarse result. Low settings retain more of the original detail.

The controls in the Texture section vary the strength and type of texture that is added to the picture. Increasing the values used for both Scaling and Relief sliders will create a more textured result.

The Light option controls the direction of the light used to create the highlight and shadow areas in the texture.

Sharpen filters

Enhance >

Unlike earlier versions of Elements where the sharpening filters were located under the Filter menu, now all the sharpening filters are grouped in the Enhance menu. There are three sharpening options including the ever-reliable Unsharp Mask fea-

Auto Sharpen - This auto only option works in a similar way to the Quick Fix Auto sharpen button (which is based on Unsharp Mask) providing a single click sharpening result.

Unsharp Mask - The Unsharp Mask filter provides the greatest control over the sharpening process by giving the user three sliders to alter the way the effect is applied to your pictures. The Amount slider controls the strength of the sharpening effect.

The Radius slider value determines the number of pixels around the edge that are affected by the sharpening. The Threshold slider is used to determine how different the pixels must be before they are considered an edge and therefore sharpened.

Adjust Sharpness - The Adjust Sharpness feature provides all the control that we are familiar with in the Unsharp Mask dialog plus better edge detection abilities, which leads to better results and in particular less apparent sharpening halos.

The feature's dialog contains a zoomable preview, two slider controls (Amount and Radius), a drop-down menu to choose the sharpening approach used and a More Refined option.

Example images above: Left - No sharpening. Right - Unsharp Mask filter with Amount 500, Radius 1.0 and Threshold 0.

Shear filter

Filter > Distort > Shear

The Shear filter creates a twisted and push/ pulled version of the original photo.

The filter dialog contains an interactive effect box that contains a graph and a control line. Using the mouse the user can add control points to the line and push, pull and twist the line within the confines of the graph. The distortions are then reflected in the preview thumbnail at the bottom of the screen.

Also included are two options for controlling the way that the undefined areas are handled. Wrapping uses the picture parts on the opposite side of the frame to fill the space whereas the Repeat Edge Pixels option duplicates the color and brightness of the detail at the edge of the distortion.

Smudge Stick filter

Filter > Artistic > Smudge Stick

The Smudge Stick filter recreates the photo so that it looks like it has been drawn with coarse pastels or crayons.

The filter dialog contains several controls that adjust the look and feel of the effect. The settings used for the Stroke Length determine the strength of the effect. High values create a coarse result.

The Highlight Area slider sets the brightness of the middle and shadow areas.

The Intensity option controls how much of the original image detail is retained. Low values maintain much of the detail from the original photo.

Solarize filter

Filter > Stylize > Solarize

The Solarize filter, as one of the group of The Spatter filter repaints the colors and a color photograph is exposed to light durpaint effect. graphic effect is called solarization.

of the unfiltered image and then adding values retain more detail. with the original colors.

Spatter filter

Filters > Brush Strokes > Spatter

Stylize filters, simulates the look of when tones of the photo with a spattered spray

ing its processing. This traditional photo- The filter has two slider controls to adjust the way that the filtered result appears.

The filter contains no controls to adjust the The Spray Radius slider determines the strength or look of the effect. The end re-strength of the effect and how much of sult is based on inverting some of the hues the original photo detail is retained. Low

them back to the picture in combination The Smoothness control varies the way that the color is applied to the picture. High values create an almost watercolor-like effect, whereas low values produce a detailed spattered result.

Spherize filter

Filters > Distort > Spherize

The Spherize filter shapes the picture onto either the ballooned outside surface of a ball, or the concave inside surface.

The filter dialog contains several controls that adjust the look and feel of the effect. The Amount slider determines the strength of the effect.

The wire frame thumbnail provides an example of the distortion level associated with the Amount setting.

The Mode choice allows the user to select to spherize the picture either horizontally, vertically or in both directions.

Sprayed Strokes filter

Filter > Brush Strokes > Sprayed Strokes

The Sprayed Strokes filter combines the textured stroke appearance of filters like of Texture filters, simulates the look of a the Graphic Pen with the sprayed-on approach of the Spatter filter.

The filter dialog contains several controls ing them with a thick black border. that adjust the look and feel of the effect. The Cell Size slider determines how large values, to a pen-like stroke at higher set- of the original picture detail.

the strength of the effect and the amount ored cell. of original detail that is conserved. Low The Light Intensity slider controls brightvalues retain more of the original photo ness of the center of the image. and produce subtle results. The Stroke Direction option controls the direction of the line that is used in a repeated pattern.

Stained Glass filter

Filter > Texture > Stained Glass

The Stained Glass filter, as one of the group stylized stained glass window by breaking the picture into colored cells and surround-

The Stroke Length slider adjusts the look each individual 'glass panel' is. Higher valof the sprayed pattern from a dot, at low ues create bigger cell sizes and retain less

The Border Thickness control varies the size The Spray Radius control determines both of the black edge that surrounds each col-

Stamp filter

Filter > Sketch > Stamp

The Stamp filter converts the picture to just black and white areas and works like a sophisticated version of the Threshold filter. The filter dialog contains two controls that adjust the look and feel of the effect.

The Light/Dark Balance control determines the tones that are converted to white and those that are changed to black. High values convert more of the tones to black.

The Smoothness slider varies the amount of edge detail retained in the picture. Lower values contain more detail.

Sumi-e filter

Filter > Brush Strokes > Sumi-e

The Sumi-e filter recreates the photo with softer hues in broad areas of color that are defined with a dark outline and small strokes to indicate texture.

The filter dialog contains several controls that adjust the look and feel of the effect. The Stroke Width slider determines how fine the border and texture stroke will be. High values create pictures with strong edges and dark texture.

The Stroke Pressure control varies the strength of the texture as well as what proportion of the image it covers.

The Contrast option adjusts the overall contrast present in the filtered photo.

Texturizer filter

Filter > Texture > Texturizer

The Texturizer filter recreates the picture to give the appearance that the photo has been printed onto the surface of a particular texture.

The Scaling and Relief sliders control the strength and visual dominance of the texture, whilst the Light direction menu alters the position of the highlight and shadow areas. Different surface types are available from the Texture drop-down menu.

The filter also contains the option to add your own files and have these used as the texture that is applied by the filter to the image.

See Chapter 11 for more details on how to use this filter with your own textures.

Threshold filter

Filter > Adjustments > Threshold

The Threshold filter, as one of the group of Adjustment filters, converts the picture to pure black and white, removing any tonal detail in the process.

Tones darker than a selected point in the tonal scale are converted to black and those lighter than the selected value are converted to white.

The filter dialog contains a single slider control that selects the precise tonal level, which marks the change point between black and white.

A histogram of the distribution of the pixels in the picture is also included.

Tiles filter

Filter > Stylize > Tiles

The Tiles filter breaks the photo into a series of same-size tiles that are then randomly offset.

The filter dialog contains two main control areas. The number of tiles and the Maximum Offset setting that is used in the filter are set in the first section of the dialog. Start with low values and then adjust if necessary.

The second area contains four options that determine what will be used to fill the vacant areas in the image that are created between the offset tiles.

Torn Edges filter

Filter > Sketch > Torn Edges

The Torn Edges filter converts the picture to pure black and white shapes like the Threshold filter. Unlike this option though, the edges of the shapes are coarse and feathered and the dark and light tones contain a slight texture.

The filter dialog contains three sliders to alter the look of the end result.

The Image Balance slider selects a tonal level to act as a turning point between black and white. The Smoothness option adjusts how rough the edge areas are. The Contrast control adjusts the starkness of the final result. High values produce a more contrasty result.

Twirl filter

Filter > Distort > Twirl

The Twirl filter, as one of the group of Distort filters, twists the picture around a central point, creating a spiral effect.

The filter dialog contains a single slider that controls the Angle of the effect. Movements to the right (positive values) create a clockwise rotation of the picture. Sliding the control to the left produces an anticlockwise spiral (negative values).

The wire frame and standard previews indicate the strength at the settings selected and predict the look and feel of the end results.

Underpainting filter

Filters > Artistic > Underpainting

The Underpainting filter adds both texture and brush stroke effects to the photo.

The dialog contains several controls that adjust the painting and texture effects. The top slider, Brush Size, alters the broadness of the brush stroke used to paint the picture. The Texture Coverage slider controls how much of the picture the texture is applied to.

Texture options are provided in the bottom section of the dialog. The Texture and Light drop-down menus found here, along with the Scaling and Relief sliders, determine the type and strength of the underlying texture effect.

Water Paper filter

Filter > Sketch > Water Paper

The Water Paper filter simulates the look of the photo being painted on a very wet textured watercolor paper. The edges of the filtered picture are very soft and with some details lost altogether. The colors and shapes blend into each other and, in contrast to these parts, occasionally the sharp texture of the paper shows through.

The dialog contains three controls that adjust the tone and texture effects. The top slider, Fiber Length, alters the sharpness and clarity of the painted image. The Brightness slider works like a standard brightness control. The final setting, the Contrast slider, determines the overall contrast of the final result.

Watercolor filter

Filters > Artistic > Watercolor

The Watercolor filter adds both texture and brush stroke effects to the photo.

The dialog contains three controls that adjust the painting and texture effects. The top slider, Brush Detail, alters the look of the painted areas.

The Shadow Intensity slider controls how much of the picture is converted to darker tones. High values mean more of the picture is shadowed.

The final setting, the Texture slider, determines how detailed the painted areas of the picture will be.

Wave filter

Filters > Distort > Wave

The Wave filter, as one of the group of Dis- The Wind filter, as one of the group of Styltort filters, breaks up the picture by push- ize filters, simulates the look of wind blasting and pulling the pixels in the form of a ing across the canvas surface by adding series of vertical and horizontal waves. The trailing lines from the edge details. end results can be subtle or extreme depending on the settings used.

are used to adjust the wave-like pattern the correct combination of settings for your created on the picture surface. These in- photo. clude wavelength, amplitude, scale and number of wave generators.

The effects of different settings for these controls can be previewed in the accompanying thumbnail.

Wind filter

Filter > Stylize > Wind

The dialog contains two controls, Method, or type of wind, and Direction. A preview The dialog contains several controls that window is also supplied to help you judge

ZigZag filter

Filter > Distort > ZigZag

The ZigZag filter simulates up and down waves such as pond ripples.

The dialog contains controls that adjust the style and intensity of the effect. The Amount slider alters the strength of the ripple effect, which basically translates to the depth and height of the resultant waves.

The Ridges slider increases or decreases the number of ridges used in the effect.

Three different types of ZigZag filtration are available from the drop-down Style menu - Pond ripples, Out from the center and Around the center.

Also included is a simulated preview window, where the filter is applied to a wire frame representation of your picture.

The 10 commandments for good filter usage

- 1. Subtlety is everything. The effect should support your image not overpower
- 2. Try one filter at a time. Applying multiple filters to an image can be confusing.
- 3. View at full size. Make sure that you view the effect at full size (100%) when deciding on filter settings.
- 4. Filter a layer. For a change, try applying a filter to one layer and then using the Layer opacity slider to control how strongly the filter image shows through.
- 5. Print to check effect. If the image is to be viewed as a print, double-check the effect when printed before making final decisions about filter variables.
- 6. Fade strong effects. If the effect is too strong, try fading it. Apply the filter to a duplicate image layer that is above the original. Then reduce the opacity of this layer so the unfiltered original shows through.
- 7. Experiment. Try a range of settings before making your final selection.
- 8. Select then filter. Select a portion of an image and then apply the filter. In this way you can control what parts of the image are affected.
- 9. Different effects on different layers. If you want to combine the effects of different filters, try copying the base image to different layers and applying a different filter to each. Combine effects by adjusting the opacity of each layer.

10. Did I say that subtlety is everything?!

Photomerge

Photomerge is Adobe's very own stitching technology designed, initially, to blend together several overlapping images to form a panoramic photograph. In the last few versions of Elements, the utility has received a complete overhaul and can now be used for other stitching tasks as well. The tasks are broken down into six distinct ways of using the utility - Photomerge Group Shot, Photomerge Faces, Photomerge Scene Cleaner, Photomerge Panorama, Photomerge Exposure and the Photomerge Style Match feature.

Over the next few pages we will look at each feature in turn.

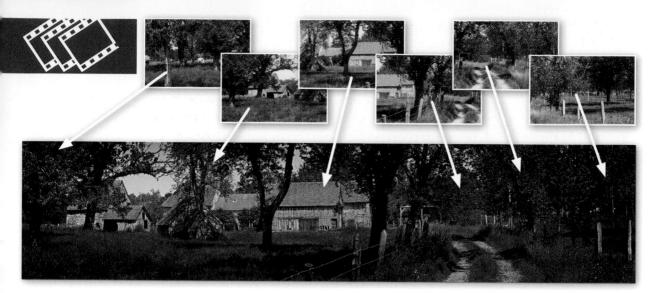

Careful capturing of source files in the first place will make the stitching process in Photomerge easier and more accurate

Taking images with Photomerge in mind

easier and more accurate. Although the various Photomerge features are designed to simplify and solve many of the problems associated with image stitching, a great deal of your own success will be based on how your source images are taken in the first place. A little care and planning at the shooting stage can ensure a more successful panorama or composite photo with little or no 'touch-up' work later.

General Photomerge shooting tips

Although each Photomerge option will require a slightly different approach to capturing the source files they use, there are some common key tips that will help you obtain the best stitched results.

1 Keep the camera level

Although Photomerge is designed to adjust images that are slightly rotated, it is far better to ensure that all source images are consistently level to start with. The easiest way to achieve this is by photographing your scene with your camera connected to a level tripod (with a rotating head for panorama photos). If you are out shooting and don't have a tripod handy, try to locate a feature in the scene that remains horizontal in all shots and use this as a guide to keep your camera level when photographing your image sequence.

2 Be careful with exposure

Generally speaking, the more consistent the exposure between the source photos the easier Photomerge will find the stitching process. This in turn will mean better, more seamless results. Modern cameras contain specialized metering systems designed to obtain the best exposure for a range of lighting conditions. Each time the camera is aimed at a scene, a new

Change the exposure system to manual to keep images consistent.

calculation is made for the brightest and darkest areas of the view. This system, though very helpful for normal picture taking, can be problematic when shooting Photomerge source files, as the exposure needs to be constant throughout the shooting sequence. If possible, you should change your camera's metering system to manual for the period whilst you are capturing the source images.

The files needed for the Photomerge Exposure feature is, of course, the exception to this constant exposure rule. See the shooting tips for this feature for instructions on how to control exposure.

3 Keep white balance consistent

A similar problem can occur with the auto white balance system contained in many digital cameras. This feature assesses not the amount of light entering the camera but the color of the light, in order to automatically rid your images of color casts that result from mixed light sources in the scene. Leaving this feature set to Auto can mean drastic color changes from one frame to the next as the camera attempts to produce the most neutral result. Switching to manual can produce results that are more consistent, but you must assess the scene carefully to ensure that you base your White Balance settings on the most prominent light source in the scene.

Be careful of changes in color cast from frame to frame resulting from inconsistent White Balance settings.

4 Maintain focal length

Sometimes it is tempting to zoom in to capture a closer view of important details when you are in the middle of shooting an image sequence. Doing so will change the focal length of the lens and will make it very difficult, or almost impossible in the case of panoramas, to stitch this picture with all the others from the scene. Check what is the optimum focal length or framing for the scene before starting to photograph and once you start to shoot don't touch the Zoom control.

Try to avoid placing moving objects at the edge of frames, as they will disappear or be ghosted when the images are stitched.

5 Watch for moving subjects

Because all Photomerge features are based on combining details from multiple photos into a single picture, it is important to watch out for subjects that are moving in the frame. For instance, when capturing source files for panoramic stitching, it is the edges of the image frame which are the most critical part of the source picture. It is important to make sure that moving details such as cars, or pedestrians, are kept out of these areas. Objects that appear in the edge of one frame, and not the next, cause problems for the stitching program and may need to be removed or repaired later with tools like the Clone Stamp.

TRIPOD HEADS

Special panoramic heads designed to position the lens above the center of the tripod are available for this purpose. These virtual reality (VR) heads offset the camera so the nodal point of the lens is directly over the pivot point of the camera. Models are available for specific cameras or you can purchase a multi-purpose design that can be adjusted to suit a range of film and digital bodies. Shooting with these heads is by far the best way to ensure that your images stitch well.

For the other Photomerge options where the images are layered on top of each other, any moving subjects in the frame can cause problems. Often a little patience when shooting to wait for movement to stop before snapping the source photo can reap big rewards back at the desktop, saving you the time and effort needed to retouch the problem picture part.

Capturing Photomerge Panorama source files

Although previous versions of Photomerge Panorama relied heavily on accuracy in the capture stage for the creation of successful panoramic results, the improvements and additional power of Photomerge Panorama as it appears in the latest versions of Photoshop Elements means that great images are still possible with images shot in less than ideal conditions.

Image overlap

Photomerge Panorama works by identifying common edge elements in sequential images and using these as a basis for blending the two pictures together. When you are making your source photographs, ensure that they overlap by a minimum of 15% and a maximum of 30%. These settings give the program enough information to ensure accurate stitching. I find that if I locate a feature about one-third of the way in from the right-hand side of the viewfinder (or display screen) in one shot and then position the same detail one-third from the left in the next shot, I end up with sufficient overlap for Elements to process the picture.

Overlapping images by more than 50% may seem like a good idea, but this can cause the image blending process to be less effective.

Pivot around the lens

Photomerge Panorama uses sophisticated perspective calculations to help reconstruct the scene you photographed. Changing your position, even by a few inches, will alter the perspective of all the images taken from that point on. Even the way that you hold and rotate the camera can alter the picture's vanishing point. To get the best results always try to pivot the camera around the axis of its lens; this will ensure that all the images in your sequence will have a similar perspective.

Automatic bracketing for Photomerge Exposure

The Photomerge Exposure option stitches together a series of images of the one scene that have been captured with different exposures to form a single photo with more detail in both highlights and shadows. Capturing the source images to be used with this feature requires the photographer to change the camera's exposure between each successive shot. Ideally you should aim for difference of 1–2 stops between photos in a sequence of 3 to 7 images.

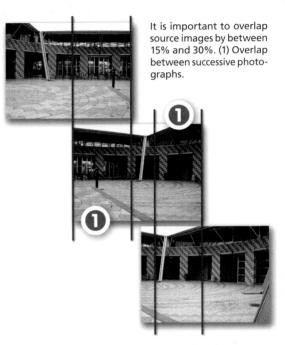

Change shutter speed not aperture

The variation in exposure is best achieved by altering the shutter speed up or down while keeping the aperture or f-stop setting constant. Altering the aperture and keeping the shutter speed constant would also result in a change of exposure, but this approach has the unwanted effect of altering the depth of sharpness between source photos.

To capture your sequence, either set the camera to manual exposure and adjust the shutter speed between successive photos, or make use of the Automatic Bracketing feature now included in most DSLR cameras. This control effectively changes the shutter speed or aperture (make sure you pick shutter speed) used to capture individual images over a series of photos. Most cameras allow changes between images of up to 2 f-stops in a bracketing sequence of 3 to 7 photos. Once activated from the menu system, pressing and holding the shutter button down will capture the sequence of frames with different exposure settings.

Background matching for Group Shot and Scene Cleaner

Both Photomerge Group Shot and Photomerge Scene Cleaner features use a series of images with a common background to help build a composite photo. For best results, you should endeavor to capture the source photos without moving the camera as any changes in posi-

PANO CAPTURE

Some compact digital cameras contain a special panorama capture mode design to help maintain overlap. A ghosted third of the previous capture is shown on the back of the camera screen to help align the next image to ensure accurate positioning and overlap.

Often this special shooting feature also locks the white balance, focus and exposure settings and titles the source photos with a special number or letter sequence making their identification later easier.

PHOTOMERGE

tion can result in the loss of edge detail as Elements aligns each photo. Whenever possible try to keep the quality of the light falling on the background and the subjects the same in all source photos. Having one picture with full sun and another in the sequence photographed under cloudy skies will make it more difficult to achieve a seamless composition.

Face to face positioning

The Photomerge Faces option is used to create a composite face from several different portrait photos. To obtain convincing results it is helpful to ensure that the faces are of similar size and facing in the same direction in each of the source photos. This is not to say that 'interesting' results can be obtained when using dissimilar photos, just that it is easier to stitch portrait photos that are similar.

Source files can be selected in the Organizer workspace before choosing the Photomerge option from the Enhance menu.

Getting images into Photomerge

With the source files carefully captured, it is now time to bring these photos into one of the Photomerge options and commence the stitching process. There are two main ways to do this – via the Organizer or in the Editor workspace.

Organizer: Edit > Photomerge option

From early versions of Elements, Photomerge features have also been able to be accessed from the Organizer workspace as well as from within the Editor. This means that you can locate and multi-select a series of source files using the Photo Browser before selecting one of the Photomerge options from the Edit menu (previously Enhance). This action will open the source files into the Editor workspace. The images will be automatically added to the Photomerge workspace ready for you to start the stitching process. The specific workspace will depend on which of the Photomerge options were selected.

Editor: Enhance > Photomerge option

The same Photomerge options are available from inside the Editor workspace and are located under the Enhance menu (previously the File > New menu). After picking the Photomerge option, a new pop-up dialog will appear where you can choose the Open All button to use all open photos in the stitching process.

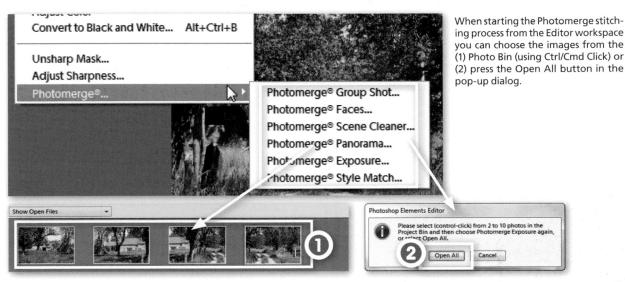

Using Raw files as source files

Many readers will no doubt be using images captured in the Raw format as source files for their stitching projects. These too can be selected in the Organizer space first before selecting the required Photomerge options from the Edit menu.

Now because the source files are in a Raw format it is necessary to convert these photos to a file type that Elements understands before adding them to the stitching process. For this reason, Adobe Camera Raw will open first with the selected files listed on the right of the workspace. Next, you will need to make any adjustments necessary to each individual file

in turn, before clicking the Select All button at the top of the thumbnail list and then pressing the Open Images button (bottom right of the workspace).

The processed files are then opened in the Editor space and loaded into the Photomerge workspace. From this point on the files can be used as any other file type.

When using Raw files for with the Photomerge Exposure option it is important to click the Default setting in the Basic panel of Adobe Camera Raw to use the capture settings of the files. If the Auto option is used then ACR will try to even out the exposure between the source files making it impossible to use the results in the feature.

Source files captured in the Raw format need to be converted via Adobe Camera Raw before being included in the Photomerge stitching process.

The Photomerge Group Shot option combines the elements of two or more photos to create a montaged result.

Photomerge Group Shot

Ever tried taking a group photo where all the members were facing the right direction and had their eyes open at the same time? If you have, then you will know that it is not an easy task. Often photographers will capture multiple frames in the hope that one photo will be perfect. Well, the Group Shot feature is designed to help with this problem. It is still necessary to shoot several images of the group but, rather than having to capture one perfect photo, you can combine the best elements of several (maximum 10) into a single picture. The feature is accessed via the Photomerge entry in the Enhance menu or, in previous versions, the Guided edit panel in the Editor workspace. The dialog uses an interface design with a side-by-side preview of the source and final images. Think of the final image as the base of the composite photograph. It should be the photo where most of the group members are looking good. The source image, on the other hand, is the photo (or photos) that you will use to overlay corrected areas for group members that are blinking in the final photo.

If you are using a series of photos, taken in the same location, then the feature is clever enough to automatically align the common elements in both the source and final pictures. Alternatively, you can use the Alignment tool in the Advanced options of the panel to position three alignment points on the common areas of the source and final images. Then it is just a matter of using the Pencil tool to draw over the Source areas and Photomerge will automatically (and seamlessly) paint them over the same area in the final image. Hey presto, blinks be gone.

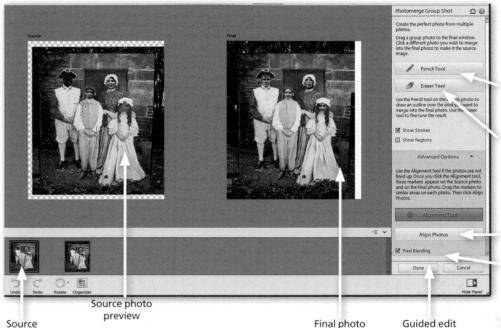

Photomerge Group Shot workflow:

photos

In this example, not having a tripod handy is not a problem when it comes time to capture a portrait of the whole family on holidays. Simply take two photos of the same scene, swapping the family member who is acting as the photographer, and then use the Photomerge Group Shot utility to merge the best part of both photos. Here's how:

preview

instructions panel

- 1 Start by locating the source files that you will use to create your montaged image in the Organizer workspace.
- 2 Multi-select the pictures and then transfer the photos to the Guided edit workspace by choosing Enhance > Photomerge Group Shot. This action will open the pictures into the Group Shot panel and select the Group Shot instructions.
- 3 Automatically Elements will position one of the images in the Source preview (left). Drag the best photo from the Photo Bin to the Final preview space. This will act like a background to which you will add other image parts.
- 4 Now click onto the Pencil tool in the Group Shot panel and paint over the picture parts from the source file that you want to add to the final image. Here it is the faces. Adjust the pencil size with the Size control in the options bar. Use the Eraser tool to remove pencil marks and refine the size and shape of the Source area used for the montage. To see the area in the final photo affected by the change, click the Show Regions option. This will display regions that are tinted the same color as the source photo.

Pencil tool for marking areas to be copied from the source to the final photo

Eraser for removing marked areas

Alignment controls

Pixel blending

The Photomerge Group Shot workspace contains the tools and the instructions needed to blend photo image parts together. To start the process select the images in the Organizer workspace and then choose Enhance > Photomerge Group Shot.

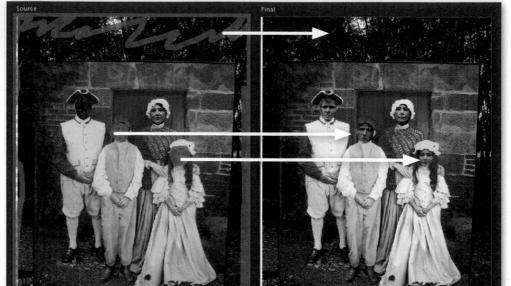

The Pencil tool is used to draw over the areas in the source photo that are to pasted into the final image. The Eraser can be used to refine these areas by changing the shape and size of the pencil marks.

- 5 If you have more than one source image in the Photo Bin, click onto alternative photos to display them in the Source preview area and then use the Pencil tool to draw over the areas to add to the final picture. The highlight color around the edge of the source image in the Photo Bin matches the color of the pencil strokes in the Source area so that you always know which photo is the source.
- 6 For the best results it is important for the Source pictures to be aligned with the final image. If the photos weren't aligned in the transfer process from the Organizer space then manually align them by selecting the Alignment tool in the Group Shot workspace. Position the three alignment markers on similar positions in both the source and final photos and then click the Align Photos button to line the images up.
- 7 The Pixel Blending option softens the edges of the source and final picture parts and often creates a smoother transition between the elements. Deselecting this option leaves the pasted source picture parts with a hard edge. Click the Done button to create the montage.

Photomerge Faces

The Faces feature is used to mix, or blend, facial characteristics from two or more (maximum 10) different images to create a single, montaged, caricatured face as the end result. Like the Group shot option, the feature is assessed by clicking the Edit > Photomerge entry in the Organizer workspace or Enhance > Photomerge Faces in the Editor, and then following the directions in the panel. Unlike other features involving the Photo Bin

BEFORE

The Photomerge Faces option provides the ability to merge the characteristics of two or more face photos together into a single photo.

where all the images are used, Faces and Group Shot both require you to multi-select the images to use before invoking the feature. To help match facial characteristics, the feature also contains an Align option, where three points (eyes and mouth) are pinpointed on both the final and source files and then the source image is distorted to match the size and shape of the face in the Final Image section of the dialog. After alignment, the Pencil tool is used to draw over the parts of the source photo that you want to appear in the final image.

Photomerge Faces workflow:

- 1 Find the source files that you will use to create your montaged image in the Organizer workspace. Multi-select the photos (you can use up to 10) and then choose Enhance > Photomerge Faces. The images will be opened into the Guided edit workspace and the Photomerge Faces tutorial will be displayed in the right-hand panel.
- 2 Drag the photo you want to use as a base, the one that you want to use as a backdrop for the composition, from the Photo Bin to the Final preview area.
- 3 Select the Alignment tool and place the three markers on the eyes and mouth of the Source picture and the Final image. Click the Align Photos button. The source image will distort to match the position of the eyes and mouth in the final image.
- 4 Now select the Pencil tool and draw over the facial features in the source image that you want to overwrite in the final photo. Elements will automatically copy and blend the details from the source to the final image. Use the Show Regions option to see regions and their associated source files.

Click the Alignment tool to place three markers on both the final Image and the source Image. Drag the marker to the eyes and mouth of each face. Click Align Photos.

Align Photos

After selecting the alignment tool the three markers are placed on the eyes and mouth area of each face before clicking the Align Photos button. Notice how the source photo is distorted to suit the final image.

- 5 If you have more than one source image in the Photo Bin then click on an alternate photo, realign and draw over other image areas to copy these parts to the final photo. The areas drawn from different source photos will be marked in different colors and the source photo will be outlined in the same color in the Photo Bin. This makes identifying which source files are link to specific picture parts an easy task.
- 6 The Eraser tool can be used to refine the size and shape of the Source areas. Clicking the Show Regions setting will display a color-coded overlay on the final image that shows which source images are being used for which parts of the final composite.

Photomerge Scene Cleaner

The Photomerge Scene Cleaner is a recent addition to the Photomerge lineup. The feature is a little like Group Shot in that it can be used to select parts from several images and merge them together, but differs slightly in that it is designed to montage the best bits of a series of

photos of a single scene. This process will help build travel photos that are free of tourists who are frequently caught mid-frame obscuring important details in the scene.

The trick with using this feature is remembering that you have it in your Elements' kit bag when you are out and about photographing. If you are having trouble getting a clean shot then capturing a series of photographs of the same scene will give you the option of using the Photomerge Scene Cleaner to recreate the photo when you return to your desktop.

Like other Photomerge options, Scene Cleaner has its own workspace that sits in the Elements' Editor. The screen contains two picture preview areas – Source, on the left, and Final. On the right of these previews is a dedicated pane containing both instructions, as well as the tools (Pencil, Eraser and Alignment), settings (Show Strokes and Show Regions) and processing buttons (Done and Cancel) for the feature. Scene Cleaner works by the user drawing over parts of the source file that they want transferred to the Final photo. Elements automatically patches the new picture parts together.

The Photomerge Scene Cleaner option merges the content that you select from several images together to create a single photo. With this process you can do things like remove tourists from photos of monuments.

The amount of the source photo used in the final image is controlled by the pencil strokes used. These can be modified with the Eraser tool. Removing marks reduces the size of the picture parts transferred. It can be helpful to select the Show Strokes and Show Regions, the areas being used for the montage, settings when fine-tuning your results.

It is possible to use the feature with only two files, using one as the source for changes and the other as the base for the final image, but the best results are obtained by selecting picture parts from several source images and in this way gradually building up the final photo. To do this the user can swap source files by simply clicking a new thumbnail in the Photo Bin. Each source file is outlined with a different color and the same hue is used for the pencil marks used to select picture parts to transfer. By color coding pictures and pencil marks it is possible to locate which images are the source for specific picture parts.

Pro's Tip: When shooting Scene Cleaner source images try to ensure that the people that are obscuring the scene are in different positions in the photos with successive captures. This will ensure that Elements can build a people-free scene using picture parts from several photos.

When shooting the photos to be used with the Scene Cleaner feature it is important to make sure that you photograph each important part of the scene, free of obstructions, over the series of pictures. If for instance, a tourist is sitting in the same place for all the photos, then it won't be possible for Elements to remove them from the picture.

Photomerge Scene Cleaner workflow:

- 1 Start by multi-selecting the source images in the Organizer workspace. Remember that you can drag a selection marquee around the thumbnails to choose more than one photo at a time.
- 2 With the source photos selected, choose the Photomerge Scene Cleaner option from the Enhance menu. The pictures will be transferred to the Editor workspace and placed in the Photo Bin.
- 3 The first image that you selected will be automatically placed in the Source position (left) in the workspace. The next step is to drag another one of the source photos and drop it into the Final position (right) in the workspace.
- 4 Now select the Pencil tool from the Photomerge Scene Cleaner pane on the right of the workspace and make a few marks over the areas on the Source image that you want to transfer to the Final image.
- 5 If too much of the source photo is being pasted to the Final image, select the Eraser tool from the pane and erase some of the Pencil strokes. Add more of the Source photo's contents by drawing more strokes on the image.
- 6 Click the Done button to process the files and create the montaged picture. Press the Cancel button to stop the feature, close the window and return to Elements.

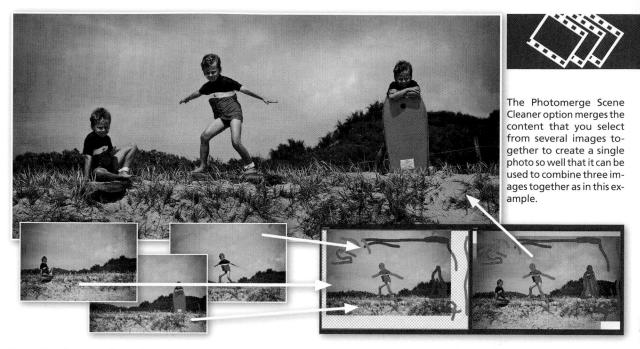

Show Regions and Strokes

The Scene Cleaner feature does its magic by selecting parts of the photo and then blending them together with the background or base image. In creating the final composite picture it searches out and isolates picture parts based on the strokes that you draw on the source photos. Each of these areas are called regions and the size and shape of these regions determine which areas are included and which are left out of the final photo.

The Show Strokes and Show Regions settings are designed to help you see how the feature is working and therefore more easily fine-tune the results. Notice in the top example on the right that the blue stroke has been drawn just over the middle boy. Looking to the region display below you will see such carefully application of the strokes results in the creation of a more specific region. In contrast, the broader green strokes applied to the boy on the right means that part of the sky and sand are included in the montage region as well as the boy himself.

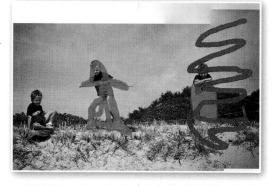

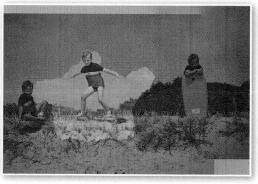

I find that displaying the regions really helps when I am adjusting the image parts included in the composition, as it gives you an insight into how Photoshop Elements is creating the montage.

SCENE CLEANER VS GROUP SHOT

With Scene Cleaner you paint on the Final photo to cover an unwanted feature, or person, that is not present in the Source photo. You can also paint on the Source (just like Group Shot) to bring over something from there. The ability to work back and forth lets you have exactly who or what you want in the final image.

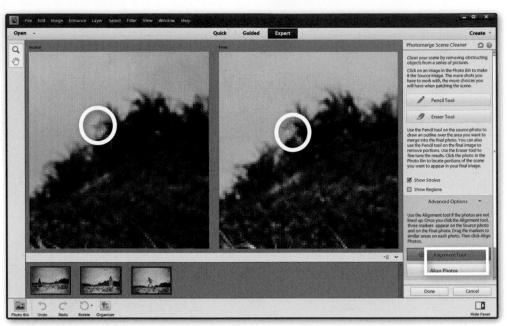

Alignment tool

In some situation the auto-align system used by Scene Cleaner has a little trouble matching the various source photos. This results in one or more photos being misaligned. To correct this problem the Adobe guys included an Alignment Tool in the feature.

Once you have selected and placed the Final image (the one on the right) click on the Alignment Tool button in the Advanced Options section of the dialog. Now when you move your cursor over the preview images you will see three cross hair markers. Click and drag the markers to three picture parts that are common to both images. Next, click the Align Photos button and Photoshop Elements will realign the source file to match the final image. If you are still having trouble you can switch to another source file and repeat the procedure. This manual process aligns the source files to the final image.

Photomerge Exposure

Our cameras are only capable of capturing a specific range of brightness from the lightest part of the scene to the darkest areas. If the environment that we are photographing contains a wider range than the camera is capable of recording, then some detail will be inevitably lost. Most photographers, when confronted by this situation, choose to ensure that highlight details are retained and therefore it is the poor old shadows that lose out. But what if it was possible to record a series of photos of the same scene but with different exposures designed to capture shadows midtones and highlights and then blend the best parts from each frame to produce a fully detailed composite?

Well dream no more! This is the exact scenario that the Adobe engineers were thinking of when they created the Photomerge Exposure feature. Next time you are confronted with a contrasty scene, simply capture three or more photos with varying exposure, from under

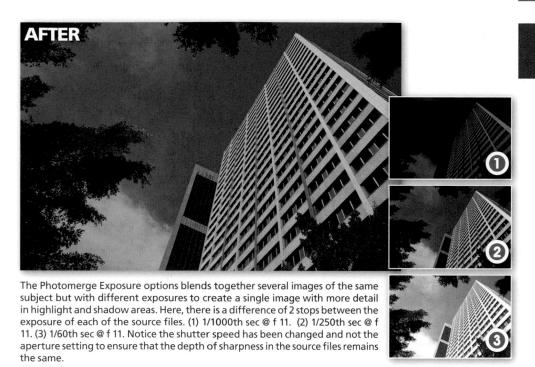

exposed, to record the delicate highlight details, to over exposed for capturing shadow information, and then set this new tool to work. When the source files are brought into Photomerge Exposure the images are aligned ensuring the registration of key details in each photo. Next, the brightness of each file is assessed and used as part of the blending process. A preview of the stitched image is then displayed in the Photomerge workspace.

Taking control of the exposure blending

This is not the finished photo as the user can now decide on how the brightness values of the source files are mixed together. There are two basic approaches – Automatic and Manual.

Automatic – The automatic mode is displayed by default. In this mode you have a choice of two blending styles – Simple Blending, where Elements makes all the decisions for you, and Smart Blending, where Elements provides a starting point and then the user fine-tunes the result with the aid of three slider controls. The Highlight Details and Shadow sliders adjust the brightness of these key areas and the Saturation control alters the strength of the images colors. The mode settings and the sliders are contained on the right hand side of the dialog.

Manual – Selecting the manual mode changes the workspace to a side-by-side arrangement of foreground and background images. Working in a similar way to the Photomerge Scene Cleaner feature, the user starts by selecting the image to use as the background. In most cases this is the source photo capture with 'normal' exposure settings. The photo is dragged to the right side preview space (background). Next, one of the other source files is selected from the Photo Bin. This places the image in the left side preview space (foreground). Now the Selection tool (pencil icon) is chosen and the user draws over parts of the

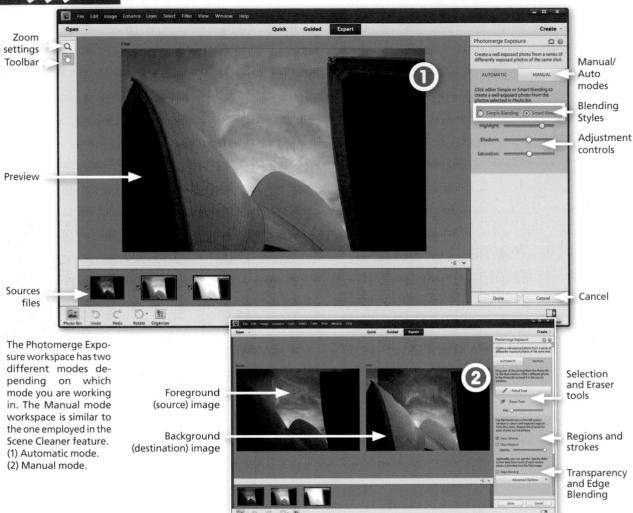

foreground image to add them to the background photo. Clicking onto another source photo places the new image in the foreground space, allowing the user to paint over more areas to add to the background. Switching back and forth between source files it is possible to build up a composite image from the most detailed section of each of the source files.

Extra tweaking in Manual Mode

The pane on the right of the Manual Mode workspace also contains a few other tools and features to help ensure a better match between blended areas on the background. Like the Scene Cleaner, there are Show Strokes and Show Regions settings to display what parts of each image is being used in the final composite. The color of the stroke and region is matched to the outline color of the source file where the detail has been taken from. There is

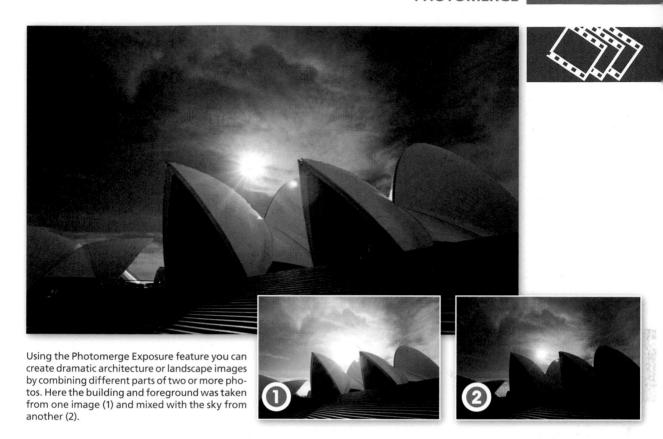

also an Eraser tool to remove any strokes, or just to modify the shape of existing strokes that in turn will alter the size and shape of the region they create.

Along with the Alignment tool which works in a similar fashion to the one found in the Scene Cleaner feature, the lower part of the panel includes an Edge Blending setting and also a transparency slider. Both these settings are designed to fine-tune the results of the paint-on exposure changes. Use the Edge Blending setting to minimize harsh edges between parts of the image that are taken from different source files. The transparency slider drops the opacity of the painted-on section of the image to reveal more of the underlying background image.

Photomerge Exposure is a great new tool that will work well for either creating full detailed images taken under trying lighting conditions, or dramatic photos produced by painting on

different exposure settings.

To help create accurate edge transitions between source photos, zoom in close to the edge detail and use a smaller brush tip to paint either side of the line.

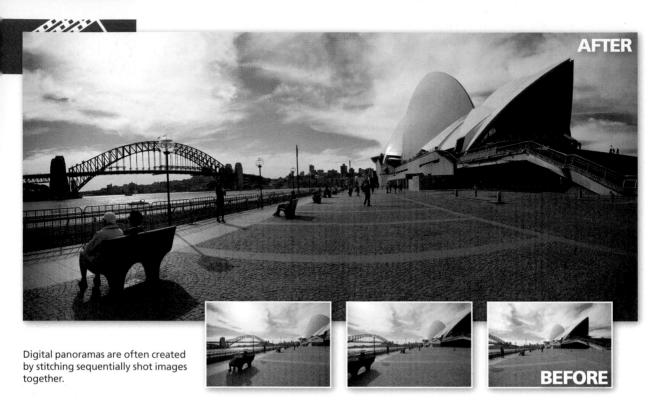

Photomerge Panorama

Panoramic images have always been a very inspiring aspect of photography. Until recently, making these types of pictures has been restricted to a small set of lucky individuals who are fortunate enough to own the specialized cameras needed to capture the wide images. With the onset of the latest image-editing packages, software manufacturers have now started to include features that allow users with standard cameras to digitally create wonderful wideangle vistas.

These extra pieces of software are sometimes referred to as 'stitching programs', as their actual function is to combine a series of photographs into a single picture. The edge details of each successive image are matched and blended so that the joins are not detectable. Once all the photographs have been combined, the result is a picture that shows a scene of any angle of anything up to a full 360° .

Photomerge Panorama (Editor: Enhance > Photomerge Panorama) started its life in Photoshop Elements (it now also exists in Photoshop) and is Adobe's version of the stitching technology. The feature has undergone a variety of enhancements over the last few releases so that Photomerge Panorama now includes enhanced support for larger file sizes, better fine-tuning controls, improved edge-matching capabilities and the ability to produce the final composition as separate source picture layers. In version 9 two other layout options were added bring the total to seven and we also saw the introduction of the ability to automatically fill the areas around the stitched panorama with the Clean Edges feature.

Producing your panorama

After successfully capturing our source pictures, it is time to stitch them together to form a panorama. When selecting the Photomerge Panorama option from inside the Editor workspace, you are presented with an enhanced dialog that not only contains Browse/Open and Remove options, that prompt the user to nominate the picture files that will be used to make up the panorama, but also a list of stitching approaches (on the left of the dialog).

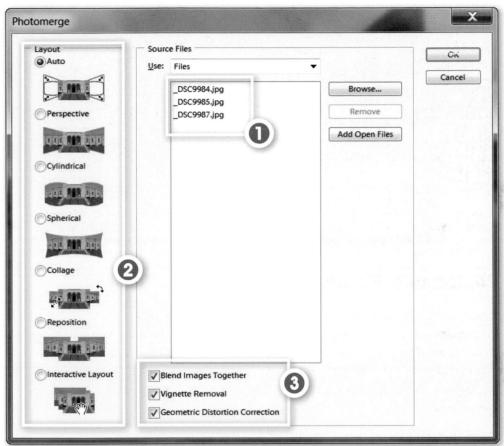

As well as the source files list (1) the dialog now includes seven different Layout modes (2). This is two more than in the last release.

The first six options stitch the source images automatically using different approaches and the seventh transfers the pictures to the Photomerge workspace where the pictures can be manually placed.

The options at the bottom of the dialog (3) control settings used in the processing and stitching of the source files. You should select all three for best results with most panoramas.

The Photomerge Panorama stitching modes

The seven different Photomerge Panorama Stitching and Blending or Layout options in Photoshop Elements are:

Auto – aligns and blends source files automatically.

Perspective – deforms source files according to the perspective of the scene. This is a good option for panoramas containing 2–3 source files.

Cylindrical – designed for panoramas that cover a wide angle of view. This option automatically maps the results back to a cylindrical format rather than the bow-tie shape that is typical of the Perspective option.

The auto Layout options in the Photomerge dialog use different approaches when producing the final panoramic photo.

- (1) Auto and Perspective. (2) Cylindrical.
- (3) Reposition Only.
- (4) Auto with Blend Images Together, Vignette Re-
- moval and Geometric Distortion options selected. (5) Same settings as example 4 with the inclusion of the Clean Edges option to fill in around the stitched panorama.

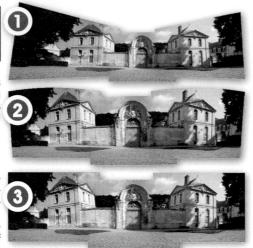

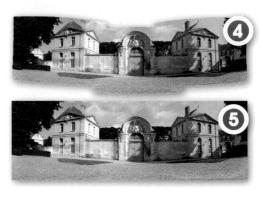

Spherical – this option should be used when you are stitching overlapping images that cover a full 360-degree view of the scene.

Collage – transforms (rotate and scale) the source files in order to align them.

Reposition – aligns the source files without distorting or transforming the pictures.

Interactive Layout – transfers the files to the Photomerge workspace (which was the only option available in previous releases of Elements) where individual source pictures can be manually adjusted within the Photomerge composition. This is the only non-auto option.

In most circumstances one of the auto options will easily position and stitch your pictures, but there will be occasions where one or more images will not stitch correctly. In these circumstances use the Interactive Layout option. This displays the Photomerge workspace where individual pieces of the panorama can be moved or rotated using the tools from the toolbar on the left hand side of the dialog. Reposition Only and Perspective options are set using the controls on the right.

The Clean Edges option fills in the areas around the stitched panorama. Although not always perfect, this feature will save you a lot of time editing later. Select the Always Perform This Action seteach time you create panoramas.

Clicking the OK button instructs Photoshop Elements to create the panorama. During the process the images are imported, aligned and blended and then you will be presented with the Clean Edges dialog asking if you want Photomerge to automatically fill in the detail around the stitched panorama. This is option only appears for versions 9.0 and newer and takes a lot of the work out of manually building this information with a tool like the Clone Stamp.

The auto workflow

If you have selected one of the auto Layout options then Photomerge Panorama will take care of the rest. The feature will open all images, combine them as separate layers into a ting (1) to use the feature single Photoshop Elements document and then align and blend the source photos. The final result will be the completed panorama.

The manual workflow

If you have selected the Interactive Layout option in the Photomerge dialog then the Photomerge Panorama dialog will display and you will see the utility load, match and stitch the source images together. If the pictures are stored in Raw, or 16-bit form, they will be converted to 8-bit mode during this part of the process as well.

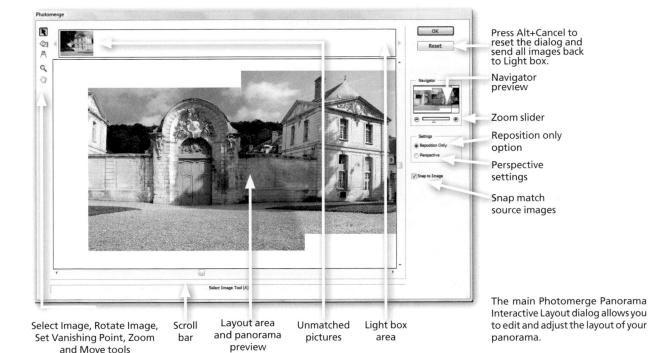

For the most part, Photomerge Panorama will be able to correctly identify overlapping sequential images and will place them side-by-side in the editing workspace. In some instances, a few of the source files might not be able to be automatically placed and Elements will display a pop-up dialog telling you this has occurred. Don't be concerned about this as a little fine-tuning is needed even with the best panoramic projects, and the pictures that haven't been placed can be manually moved into position in the main Photomerge Panorama workspace.

Whilst in the Photomerge Panorama workspace you can use the Select Image tool to move any of the individual parts of the panorama around the composition or from the layout to the Light box area. Click and drag to move image parts. Holding down the Shift key will constrain movements to horizontal, vertical or 45° adjustments only. The Hand or Move View tool can be used in conjunction with the Navigator window to move your way around the picture. For finer control use the Rotate Image tool to make adjustments to the orientation of selected image parts.

PRO'S TIP

When moving the cursor over the photos in the preview area, hold down the Alt key to see which image is active. This is useful when you are changing the vanishing point of your images.

PHOTOMERGE

The Perspective settings option, together with the Set Vanishing Point tool, manipulates the perspective of your panorama and its various parts. Keep in mind when using the perspective tools that the first image that is positioned in the Composition area is the base image (light green border), which determines the perspective of all other image parts (red border). To change the base image, click on another image part with the Set Vanishing Point tool. It is not possible to use the perspective correction tools for images with an angle of view greater than 120° , so make sure that these options are turned off. After making the final adjustments, the panorama can be completed by clicking the OK button in the Photomerge Panorama dialog box. This action creates a layered stitched file.

You can move source images to and from the Light box and Layout areas by clicking and dragging them.

PRO'S TIPS

1. Holding the Alt key lets you see borders around the images you hover over, so it is easier to select a new Vanishing Point.

2. Ctrl Z (Undo) is handy in this dialog because sometimes when you don't like a perspective correction and uncheck it, the result is not as it was before you applied the perspective.

Interactive Layout workflow:

- 1 Select Photomerge Panorama from the Enhance menu to start a new panorama.
- 2 Click the Browse button in the dialog box.
- 3 Search through the thumbnails of your files to locate the pictures for your panorama.
- 4 Click the Open button to add files to the Source Files section of the dialog.
- 5 Choose the Interactive Layout option at the base of the list.
- 6 Select OK to open the Photomerge Panorama main workspace. Edit the layout of your source images.
- 7 To change the view of the images use the Move View tool or change the scale and the position of the whole composition with the Navigator.
- 8 Images can be dragged to and from the Light box to the work area with the Select Image tool.
- 9 With the Snap to Image function turned on, Photomerge Panorama will match like details of different images when they are dragged over each other.
- 10 Ticking the Perspective box will instruct Elements to use the first image placed into the layout area as the base for the composition of the whole panorama.

Images placed into the composition later will be adjusted to fit the perspective of the base picture.

- 11 To align the images without distorting the photos to fit select the Reposition Only
- 12 The final panorama file is produced by clicking the OK button.

option.

Tricky exposure situations can be solved by shooting twice – make one image so that the exposure is adjusted for shadows and one for highlights – and then combine the details of both shots to produce the frame that contains both shadows and highlights that will be used for stitching. (1) Shadow details captured. (2) Highlight details captured. (3) Combined photograph with both highlights and shadows.

Fixing Photomerge problems

No matter how sophisticated the stitching technology in Photomerge is, there are sometimes small problems in the final picture where the blending process has not produced perfect results. Some of these defects can be corrected by re-producing the Photomerge project again. But there are also occasions where the stitching process is not at fault.

The causes of these problems usually fall into one of two groups – subjects moving or changing places when capturing source files and differences in lighting and/or color between sequential images.

 $\begin{tabular}{l} \textbf{Solution 1} - \textbf{Time your shooting sequence to accommodate moving objects in the frame.} \\ \textbf{Wait until the objects are in the middle of the frame or are not in the frame at all before pushing the button.} \\ \end{tabular}$

PHOTOMERGE

Solution 2 – Shoot a single frame featuring the moving object so that, after stitching, the object can be cut and pasted into position over the top of the completed panorama.

Solution 3 – Shoot two complete sequences of source images: one with the camera's exposure system to suit the highlights of the scene and one with the settings adjusted for the shadows. Try adjusting your camera to 2 stops under the camera setting for the highlight picture and 2 stops over for the image in which the shadows are captured.

Before stitching, combine the individual images into a single document. Arrange the layers so that the darkest picture is on top. Change the blend mode of the dark layer to Multiply and open the Levels feature. Drag the black point Output slider to the center of the dialog to add the highlight detail to the midtone and shadow areas of the layer beneath. Save the combined image and then use the correctly exposed and detailed picture as one of the source images used for creating the panorama.

Launch the Style Match option from the Enhance > Photomerge menu in the Editor workspace

Photomerge Style Match

The Style Match Photomerge option enables you to transfer the 'look and feel' of the processing from one image to another. It does this by incorporating a series of sample images that can be used as the basis for the transfer. The feature has its own workspace with previews of both the Style and After image, an extra bin at the bottom of the screen, called the Style Bin, to store the example photos, and a series of slider controls in the right pane to adjust the effects of the styling.

Photoshop Elements ships with several example images already loaded into the Style bin, but the feature also has the option to load your own pictures, providing a fast way to transfer the overall processing 'look' of tone and color to other photos quickly and easily.

The slider controls play a key role in the success of the style matching process. With some example images the styling changes are too strong when first applied and a little time spent adjusting the effect allows for better fine-tuning.

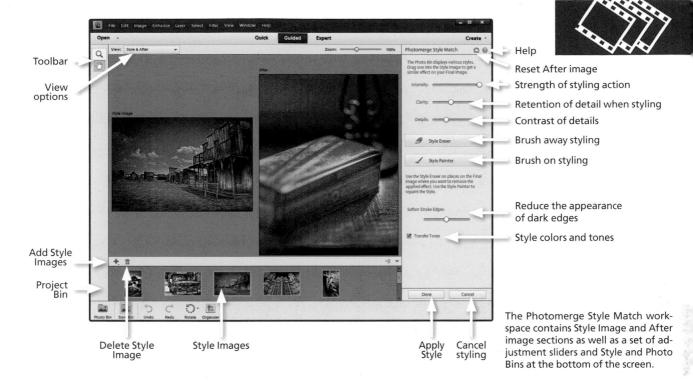

Photomerge Style Match workflow:

- 1 Start by either opening a photo onto the main Editor workspace or selecting its thumbnail in the Organizer space.
- 2 Now select Photomerge Style Match from the Enhance menu. In previous versions it is also possible to choose the Style Match option from the Photomerge section of the Guided edit pane.
- 3 The image will then be displayed in After image position (right) in the Photomerge Style Match workspace and the new Style bin will be displayed at the bottom of the screen.
- 4 Double-click on a thumbnail in the bin to place it in the Style Image area. Alternatively you can drag the image from the bin to the space.
- 5 Use the Style Intensity slider to control the amount of styling applied to the photo. Move the slider to the right to add more styling, to the left to retain more of the tones, colors and details from the original photo.
- 6 Use the Style Clarity control to adjust the appearance of details in the photo. Move the slider to the right to make details more apparent and to the left to soften them.

- 7 Move the Enhance Details slider to increase or decrease the local contrast and diffusion in the photo. Movements to the left lead to a more diffused and lower contrast result whereas sliding the control right creates a high contrast photo where the detail is more pronounced.
- 8 By selecting the Style Eraser and painting onto the photo you can remove the style matching effects from these parts of the image. Tones and colors from the original photo will be displayed in these erased areas. The Style Brush can be used to paint in the styling in areas where effects have already been erased.
- 9 The Transfer Tones setting applies the color and tonal rendition of the Style Image as well as the overall 'look and feel'. Use this option to convert color images to black and white or when you want the color tinting of the Style Image to be replicated in the After photo.
- 10 Finally, you can click Reset to remove the current Style Image from the workspace and return the After photo to its original state, Done to apply the styling or Cancel to close the workspace and remove any styling from the photo.

Styling using your own pictures

The example style images supplied by Adobe do provide a good range of possible styling options but you can add to this set by loading your photos into the Style Bin. To do this simply click the green '+' at the top left of the bin and choose to add images from the Organizer or your hard disk. Next, the Add Photos dialog appears and you can select the images to include.

When picking photos via the Organizer, the dialog includes a range of options to determine where you are selecting the images from. If you choose to get your photos from the hard drive then you will be presented with a standard browser window where you can navigate to, and select, the images to include.

Pressing the Add Selected Pictures button (or Open if you are working with the browser window) adds the photos to the Style Image Bin. These images can then be used to style your photos in the same way as those supplied by Adobe. Pictures already listed in the Style Bin can be removed by selecting the thumbnail first and then clicking the Dust Bin button at the top left of the bin.

Paint-on styling

The Style Eraser and Style Painter tools allow you to remove the styling from portions of the photo and paint-back the styling in areas where the effects of the feature have already been erased. When used together, these tools provide a quick way to style only those sections of the photo that you want to change.

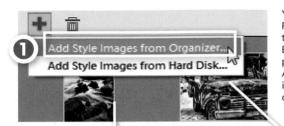

You can add your own example images to the Photomerge Style Match workspace by clicking on the big green '+' button in the top left of the Style Bin (1), selecting one of the Add options and then picking the images from the browser window (2) or Add Photos dialog (3). The images will be loaded into the Style Bin as new thumbnails ready to use on your own pictures (4).

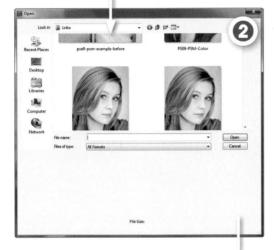

In the example images on the next page, the original color photo was styled to moody black and white using one of the monochrome Style Images first. Next the black and white conversion effect is removed from the car area by painting over this section of the photo with the Style Eraser tool. The Style Painter tool is used to tidy up any edges where the eraser has inadvertently paint over the edges of the car by painting back the styling. Once you are happy with the result, clicking the Done button produces the composite image in a single PSD document.

Pro's Tip: Although it is not possible to take the finished, saved, image back into the Photomerge Style Match workspace, you can still refine the styled and non-styled areas. Open the completed photo into the Full Edit workspace and then display the Layers panel (Window > Layers). Notice that the Style Matching has been applied to a copy of the original background layer. This styled layer sits above the original background layer in the layers panel and a

PHOTOMERGE

layer mask is used to adjust the parts of the photo which area style and not-styled. To reveal more of the unstyled layer beneath select the mask thumbnail and then paint onto the picture with a black brush. To restore the styled areas, make sure that the layer mask is still selected, choose a white brush and then paint over the non-styled areas.

The Style Eraser and Style Painter tools can be used to alter the parts of the image which are style and those areas left untouched. Here the original photo (1) was styled with a monochrome Style Image (2) and then the styling was removed from the car area with the Style Eraser tool (3).

You can still refine the styled and non-styled areas after the final image has been saved. Just open the saved PSD file and edit the layer mask associated with the Style Image layer.

100% (Wedding Classic 1, RGB/8)

Photo Books, Collages, Calendars and Cards

The Photo Layout feature first appeared in Elements 5.0 but owes much of its heritage to the album page creation wizards of previous versions of the program. In recent releases of Elements the feature has been totally revamped and now is broken into four main categories — Photo Books, Photo Calendars, Greeting Cards and Photo Collages.

The Photo Book option is designed to help create professional quality photo albums and scrapbooks containing up to 80 pages. The Photo Collage option provides all the template, styles, power and finesse of the Photo Book workspace with single page documents. And Photo Calendars and Greeting Card options fast track the creation of these seasonal products.

In this chapter we will concentrate on the various steps involved in creating, styling, editing and printing Photo Books, Collages, Calendars and Cards.

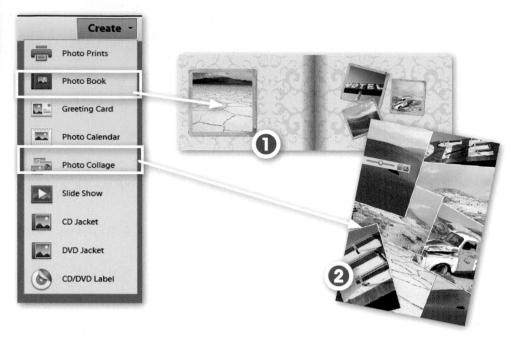

Elements' advanced layout options

Some of the real power that exists within Photoshop Elements lies beneath a deceptively simple features such as Photo Books and Photo Collages and, since version 9.0, Photo Calendar and Greeting Cards as well. With these options we have the ability to create layouts containing many images, each complete with their own frame style, text, graphics and background. The images, and their frames, can be easily sized, rotated and repositioned on the page. It is also possible to make changes to the photos inside the frames and swap background designs for alternatives. All this happens while Elements maintains the highest quality images in the background. With your design finished you then have the option to output your collages, calendars, cards or books to a desktop printer or, in the case of books, calendars and cards, to have an online provider handle this task for you.

Know your destination before starting the journey

So essentially we have four different layout options. All are capable of creating multi-image documents, but with Photo Books, the layout is customized for being printed with proper left and right pages and a title page and with Photo Calendars you produce a month by month multi-page document. All of these options are available from the Create pane in the Editor and Organizer workspaces. The first decision that users need to make is, 'What type of document am I wanting to create?'

After determining the type of layout to create, you will be presented with a new dialog containing design (called Themes), size and output options. The range of output options will vary according to the online services available in your country and the layout type you are working with (book, card or calendar), but a typical list would include:

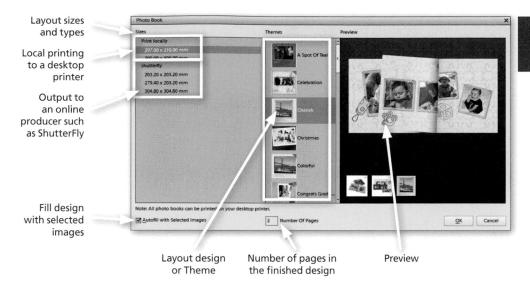

The first dialog you see when starting the creation process will have a range of choices for the layout design (theme), size and output option. The theme of the design can be changed later but you should choose the output option carefully as locally printed designs can not be uploaded for production online later.

Print Locally – Use this option to create a book inside Elements and print it on a desktop machine that is attached to your computer.

ShutterFly – Use this entry for creating books that will be printed and bound by online provider, ShutterFly. This option also automates the uploading of your photos and the linking to the online service.

NOTE: It should be noted that layouts designed for online production can also be printed locally but the reverse is not true. If you select the Print Locally option you will not then be able to upload the design at the end of the creation process.

Edit pictures before adding them to a book or collage

The production of Photo Books, Collages, Calendars, Greeting Cards, or any of the other photo projects in Photoshop Elements, is essentially a presentation exercise for images that have already been enhanced. For this reason it is a good idea to complete any preliminary editing work such as color and tonal correction, spotting and retouching changes and the application of sharpening before including the picture in a new photo project.

This is especially true when working with the special framed picture elements of a Photo Book, Calendar, Card or Collage, as these visual components are stored in a special Frame layer that has to be simplified before it can be edited. The act of simplification, which is also called rasterization, converts the Frame layer to a standard image layer and in the process removes the layer's ability to scale, rotate and distort repeatedly without image quality loss.

Selecting images for inclusion in photo projects

Most users will opt for choosing their images from the Organizer space before commencing the creation process by selecting an option from the Create menu, but it is also possible to choose images to include from the Photo Bin as well. Starting life as a humble place to store photos open in the Editor workspace, the Photo Bin now contains two drop-down menus — on the right upper edge of the bin and one on the left. The menu on the left provides a choice of what images are displayed in the bin. The options include:

Show Open Files – This option displays all images currently open in the editor workspace in a group in the Photo Bin.

Show Files Selected in Organizer – Use this choice to display any images currently selected in the Organizer workspace.

Show Albums – Although not a specific entry itself, the next group of options in the menu are headings for all the Albums that have been saved in the Organizer workspace. The number of entries listed here will be determined by the number of Albums you have created in the Organizer. Selecting an entry here will display all the images contained in the Album in the Photo Bin.

Providing better control over the images that are displayed in the Photo Bin helps users when they are constructing Photo Book and Calendar pages or individual Greeting Cards or Photo Collages. It is no longer necessary to bounce back and forwards between Editor and Organizer workspaces, locating suitable photos to include in your compositions. Just group all the images into an Album and then proceed to the Editor workspace. Display the images in the Photo Bin by choosing the Album entry from the

The Auto-Fill with Selected Photos option inserts the selected images from the bin into the frames and onto the page or pages in the document. In the case of Photo Book projects, Elements will create as many pages as is needed to place all of the images displayed in the bin.

drop-down list. Next select the Create Option from the Settings menu (at the top-right of the Bin) and choose the Photo Book, Photo Calendar, Greetings Card or Photo Collage option from the Create menu.

By selecting the Auto Fill with Selected Photos option at the bottom of the layout dialog, the pictures will be inserted into new frames and pages. Alternatively a blank multi-page document can be created by deselecting this option and then the pictures can be dragged to the blank frames from the Photo Bin.

Photo Bin Settings Menu actions

On the right of the Photo Bin drop-down menu there is a second menu containing special actions that can be performed directly from the Photo Bin.

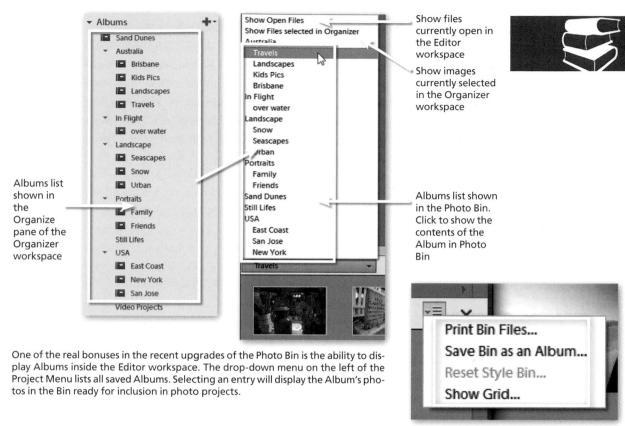

There are four possible Photo Bin actions:

Show Grid – Selecting this entry switches displays a grid pattern between the thumbnails in the Photo Bin.

Print Bin Files – Select this entry to automatically add the images currently displayed in the Bin to the Print Photos dialog. This is a fast way to print all open files.

Save Bin as an Album – Use this option to save all files displayed in the Bin as a new Album. This provides a great way to group images that you have been working on in the Editor workspace so that you can return to them later.

Reset Style Bin – This option is only available when the Style Bin is in use alongside the Photomerge Style Match feature.

NOTE: The Create and Share options have been removed from the Photo Bin in Photoshop Elements 11.

The Photo Book feature in Photoshop Elements can be used to quickly create a series of photo album pages using images selected in the Organizer workspace. A variety of layout designs are shipped with the program, with other variations available as down-

The Settings menu is located at the right hand end of the top edge of the Photo Bin. The menu contains three different actions that can be performed from the Photo Bin. There is also another option, Reset Style Bin, which can be selected when the Style Bin is being used.

Creating Photo Books with Elements

This Photo Book feature combines the template-like production of the original Elements photo projects along with some unique, newer, features which include:

- the ability to auto place and size a series of selected photos,
- a special Frame layer type that can store, and provide, edit options for both an image and its frame, and a Smart Object layer that is used for storing image content such as photos (when dragged from the Photo Bin), graphics and shapes,
- a unique multi-page document format called the Photo Project Format or .PSE document.
- the option to apply frames, backgrounds and whole themes (a combination of frames and backgrounds) to photo projects, and
- the ability to add text, graphics, shapes and special effects to the project from those listed in the Content panel.

Photo Books are a real bonus for all those users who regularly want to produce a series of pages containing multiple photos. The scrapbooking fraternity will certainly find plenty to love as the feature provides more ease of use, flexibility and customization than was previously available. General photographers too will find the whole book production process truly infectious.

Random or selected page layout options

Once you have selected the Photo Book option a new dialog will appear. Here you choose the size and type (print locally or online) of book you desire, you get to pick the theme (frames and background) used for the pages. There is also a preview panel in the dialog providing an indication of the look of the final design. At the bottom of the window is an option to auto fill the layout with the selected images and a page count detailing the number of pages that Elements will create automatically. You can alter the page count by changing the number here but you can also add or delete pages later on so no need to be too precise at this point.

Double page spreads can now be moved to a new location in Photo Book by simply dragging the thumbnail in the pages panel.

Drag 'n' Drop page sequencing

New for last couple of revisions of Elements is the ability to rearrange the 'double-page-spreads' in the pages panel on the right of the workspace. Just click and drag the two page set to a new position in the sequence of vertical thumbnails. The pages will then shuffle to accommodate the newly positioned spread.

The exception to this feature is the title page, which is a special case. As the standard photo book requires a carefully positioned image on the front cover to suit the requirements of printing and binding, this page can't be moved from its position at the top of the Pages panel.

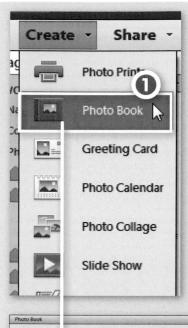

Selecting a Photo Book Layout workflow:

The Photo Book panel groups together the options that govern the way that your multipage Photo Layout document is created. The first step is to select the option from the Create pane (1).

Next, you need to select how you would like to output the book, to a local printer or online, and its size (2). Here we have three headings with several options each but the list may vary according to the online services available in your country. Remember that all books created for online production can also be printed locally, but the reverse is not true.

Now you choose the look of the book from the list of options available in the Themes (3) section of the dialog. This selection is not final as the frame design and background image that together form the Theme can be altered later in the process, but careful selection here will save time. Select the AutoFill With Selected Images option (4) to allow Elements to fill the frames in the design automatically with images. The Number Of Pages option (5) is used to set the total page count for the book. Extra pages can be added or unwanted pages deleted later. With the settings selected clicking the OK button creates the book document and displays the pages in the workspace (6).

The multi-page book documents created with this process are editable later inside the Create Tab workspace and pane (7) where extra images, text, graphics, effects and pages can be added or removed.

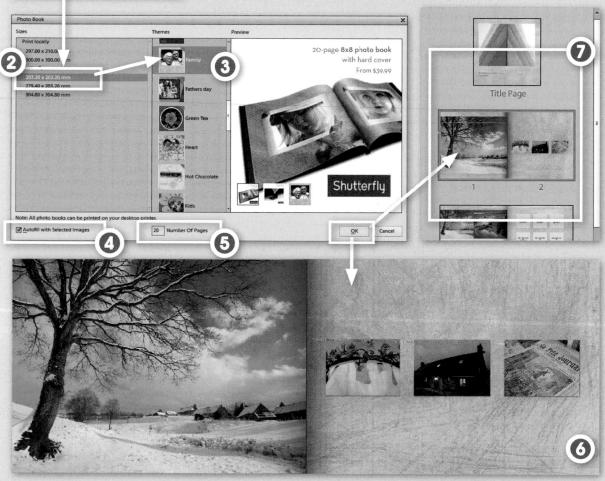

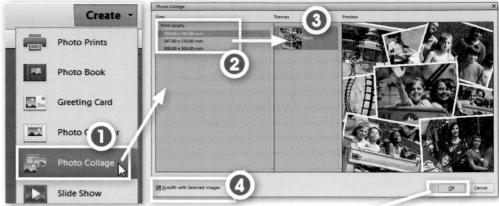

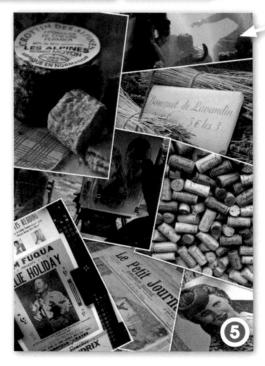

Start your Photo Collage project by selecting the images to include in the Organizer workspace. Next, click on the Photo Collage entry in the Create panel (1) and choose a page size for the project (2) and theme (3) from the Photo Collage dialog. Now select the Autofill option (4) if you want Elements to automatically fill the frames in the layout. Click the OK button to produce the collage (5).

Creating Photo Collages with Elements

Whereas the Photo Books option creates multi-page documents, the Photo Collage entry in the Create panel is used to produce single page documents. Like book projects, each collage page is styled with a theme (frame design and background) and can include images, text and graphics. Photo Collage projects are a great way to show off your images and can be edited and fine-tuned even after they have been saved and you have left the Photo Collage workspace.

The process for creating a Photo Collage is similar to the workflow we looked at for Photo Books. After selecting the pictures in the Organizer workspace you choose the Photo Collage option from Create panel. This action opens the Elements' Editor and displays the Photo

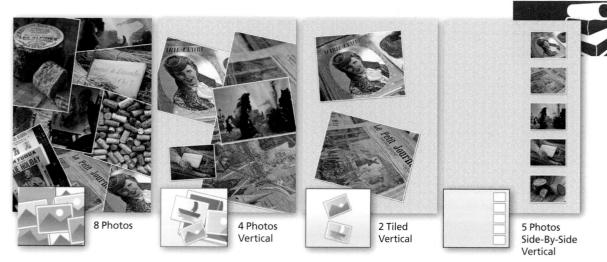

Collage dialog. Here you will pick the size, theme and if the selected images will auto fill the layout. Notice that there are no options available for producing collages online. All output for this project option is via your desktop printer.

Click the OK button produces the collage and displays the document in the main workspace. Most users will see this as just the start of the process as they will want to fine-tune the layout, images displayed, background and frame selection. All this is possible with the options available in the various sections (Pages, Layout, Artwork and Text) of the Create pane. More details on how to customize your photo projects can be found later in this chapter. The last step in the process is to click the Done button and save the newly-created Photo Collage. Unlike Photo Books, Photo Collages are saved as standard Elements documents or .PSD files.

The composition of the photos in the collage can be changed by selecting a new layout option from those listed in the Layouts section of the create menu. To apply a new layout just double-click the thumbnail in the Create panel. Elements will automatically update the page design.

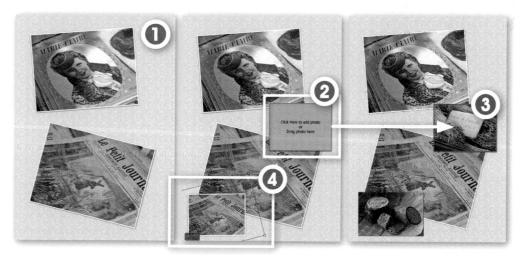

All frame areas of the predefined layout templates (1) can be adjusted manually, allowing you to drag, resize and rotate frames at will. It is also possible to add extra pictures and frames to the layout by dragging a new frame from the Artwork section of the create panel first (2), and then dragging a picture to the frame from the Photo Bin (3). Alternatively you can drag a picture directly from the Photo Bin to add it to the composition (4).

Results after resampling down and up when using a Frame Layer.

But why use Photo Collage?

You may well ask why you would use the Photo Collage route for creating such compositions, rather than a more traditional layered Elements document? Good question. Well the Frame layer is the Photoshop Elements' equivalent of the Smart Object layer in Photoshop. When adding an image to a frame layer you are effectively embedding the photo in a Smart Object layer. The bonus of working this way is that by placing a photo in a frame layer you are protecting the pixels from alteration from that time forward.

To demonstrate this fact look at this example image. The same photo is used for both examples. On the left the picture was stored in a standard image layer. On the right the photo was placed in a Frame Layer. Next the picture was drastically scaled downwards, and then in a reverse action, the picture was returned to its original size. These changes were handles with the Scale feature (Image > Resize > Scale). Notice

the difference in the quality of the resized photo. The one on the left has been degraded substantially by the changes whereas the one on the right looks as sharp as the original. Why is this so?

Well when an standard image layer is made smaller, some of the original pixels are discarded as the photo is resampled. When the photo is resized larger new pixels are created (using interpolation) from the now smaller original. The result is a picture of lesser quality than when you started.

When the same changes are made to a photo embedded in a Frame Layer the original image is safeguarded and is used as a reference in the scaling process for the final result that you see on screen. This is why no matter how often you change size, rotate or distort a Frame layer, the picture will remain crisp. With each change Photoshop Elements recreates the preview using the original image as the reference. Cool!

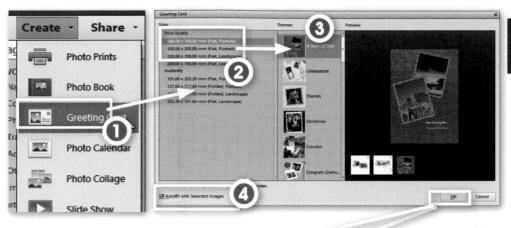

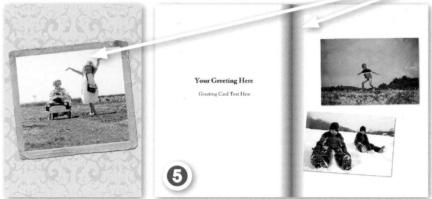

After selecting your images in the Organizer choose the Greeting Card option from those listed in the Create panel (1). The size and type of output is then selected in the Size section of the Greeting Card dialog (2). The frame type and background design are chosen in the Themes area (3) and AutoFill is used to add the selected images automatically to the frames (4). The resulting greeting card may have several pages depending on the design (5).

Creating Greeting Cards with Elements

The Greeting Card project was updated in Photoshop Elements 9.0 and now follows the same basic workflow as Photo Books, Collages and Calendars. Users have the opportunity to create a range of cards that can be printed locally or produced by one of the online companies. If you are based in the US then you will be able to select card options from ShutterFly. Other regions will have different options with some locations having no online options.

The Greeting Card production process is a familiar one with the images being selected first before picking the entry in the Create panel. Next, the size, theme and output option is chosen. This is essentially a choice between printing locally or using the services of an online provider. Remember that you can always print the designs you make for online providers but you can't upload the designs you create for printing locally. Again there is an option for getting Elements to automatically fill the frames created in the card design with the images you have selected. Clicking OK produces the card. Once this is completed you can adjust the design before selecting the Done button to save the projects, the Print button to output the project locally or the Order button to send the project to an online provider.

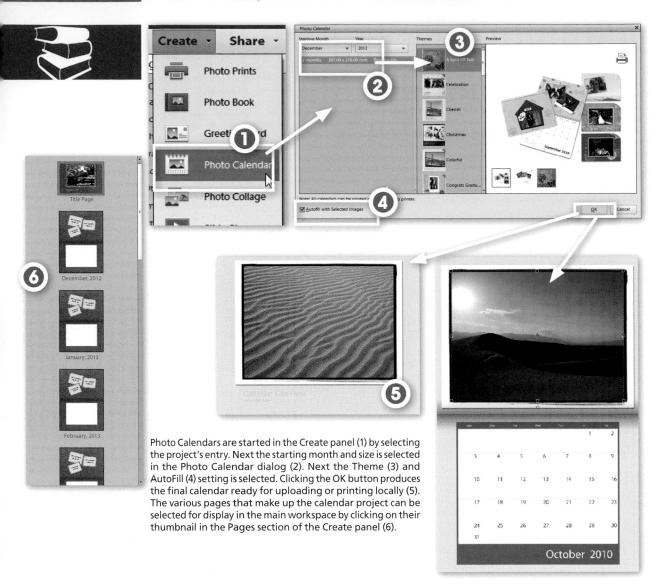

Creating Photo Calendars with Elements

Photo Calendars are multi-page documents that feature your photos and a series of days in a month-by-month format. The design has a Title, or cover page, and several calendar pages. Like the other photo projects we have looked at, you can choose the way that your layout looks and which provider you will use to produce the calendar. There is also an option for choosing the start month and year making it a cinch to get those Christmas calendars organized well ahead of time. Once created the various pages of the project can be selected in the Page section of the Create panel. Frames and backgrounds are adjustable just as is the case with the other projects and yes you can add extra pictures, text and graphics if you wish. And if you decide not to go online to produce the calendar then you also have the option to print the project to a desktop printer.

Creating an Elements Photo Book in detail

Now that we have an idea of the different key Elements projects let's look at the Photo Book project in a little more detail. It is a simple five-step process with the creation options centered around the Projects panel in the Create module of the Organizer and Editor workspaces.

Step 1: Select the images to include

As we have already seen the process of creating a Photo Book will generally start in the Organizer workspace. Here you can multi-select the photos that will be used in the layout. To choose a series of images click on the first thumbnail and then hold down the Shift key and click the last picture in the series. To pick non-sequential photos, select the first one and then hold down the Control key whilst clicking on other thumbnails to be included in the selection.

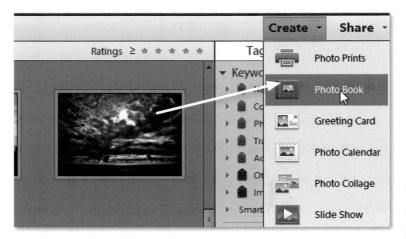

With the images highlighted, the next step is to choose the Create module (top right of the Organizer workspace) and then the Photo Book option from the projects listed.

Alternative starting options

Using an Elements Album (previously called a Collection) as a starting point means that you can alter the order or sequence in which the photos appear in the multi-page document. After rearranging the position of photos in the Album, multi-sclect those to be included in the layout. Alternatively a blank document can be created in the Editor workspace by selecting the Create module, the Projects heading and then the Photo Book option. Open images can then be dragged into the blank document from the Photo Bin area of the Editor. Images grouped in Albums can be easily displayed in the Photo Bin by selecting the Album entry from the bin's Show File menu.

Step 2: Choose output type and size

Selecting the Photo Book entry In the Create panel displays a new dialog. On the left is a list of options where you can select whether the book is to be printed online or via a desktop printer. At this point you will also select the size of the pages. From version 9 all photo book options use the Elements book creation process to produce the multi-page document first. After that, you can send the book to a desktop printer or, if you chose an online option, place an order for printing with an online provider. All book options can be printed locally, but only those listed under an online provider, can be ordered.

Step 3: Adjust AutoFill and Page settings

The bottom of the dialog contains two other settings that affect the book production process:

Autofill with Selected Images – Choose this option to instruct Elements to fill the frames that are created on each of the pages with the images that you have selected in the Organizer before entering the project. You can choose to leave this option unchecked which will create the book with a series of empty frames layered against the theme's background. Then you can drag pictures from the photo bin to the frames or click onto the frame itself and locate a suitable image in the browser window that appears.

Number of Pages – The number of pages for books to be produced online is set to a minimum of 20 as this equates to the smallest page count (18 pages plus title and end paper). If you have selected one of the 'print locally' options then the page count will equal the number of pages needed to display the images you have selected. Few selected images will mean fewer pages, but the total number will also be determined by the theme you choose as each design uses different numbers of frames on each page.

Note: You can create more pages than the number indicated in this setting by adjusting the figure displayed here.

Step 4: Adjusting the look of the book pages

Each book page is created based on two style characteristics – the **Theme** and the **Layout**. The central part of the Photo Book dialog contains a series of thumbnails representing different designs or Themes. Themes in Elements refer to matched frame designs and background image combinations created to provide a uniform look to your multi-page documents. Layouts, on the other hand, control the number and general position of the pictures on the document pages. You select a Theme in this dialog, click the Ok button and when the book is produced the layout is random – a setting where Elements creates the pages in the book using a variety of the default layout options.

Choosing a different layout

In previous versions of Elements, you could choose a specific layout for left and right pages at this point in the book creation process. This workflow changed in version 9.0. From that release a random layout setting is used first and then you can fine-tune each page later using the different settings in the Pages section of the Create panel.

It is important to realize that all settings in this dialog except for the page size and the ability to order the book online can be adjusted later in the process. Extra pages and images can be added or removed. The frames, backgrounds and themes can also be changed by applying an alternative design from those listed in the Content panel.

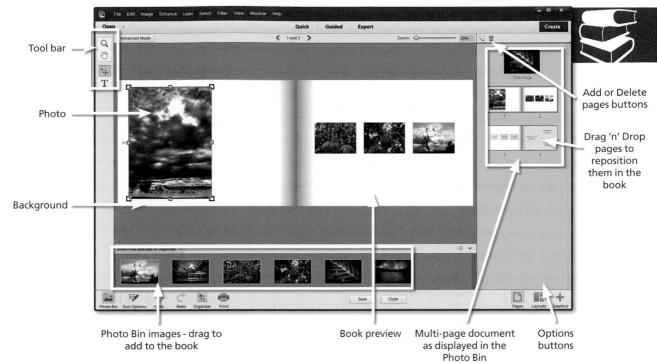

Step 5: Create the Photo Book

Once the size, output type, theme and other options are set, clicking the Ok button at the bottom of the panel will instruct Elements to create the multi-page document. This process can take a little while as the program creates the pages and then sources, sizes and inserts the pictures into the new pages and layouts.

Each photo is stored on a separate Frame layer that is indicated by a small plus icon in the bottom right of the layer's thumbnail when viewed in the Layers panel. Frame layers are unlike other image layers in that they contain both the photo as well as its surrounding frame. These picture parts are stored separately and remain editable even though they appear as a single layer. When the creation process is finished, the book is displayed in a book preview mode complete with its own tool bar (top left), the Pages section of the Create panel (right) and the Photo Bin.

The tool bar contains a subset of the tools found in the regular Edit workspace and includes Move, Zoom and Hand tools. The + and – buttons are located at the top of the Pages panel, to add or delete pages, and Next and Previous page navigation buttons and Zoom and Safe Zone settings can be found below the preview area. There is also the Order button used to place an order for the selected Photo Book with an online publisher, Print button for outputting the book to a local printer and the Done button to complete the creation process and save the book project file.

The completed pages are displayed in a special book form preview. Here you can flip between pages by clicking on the Next (or Previous) page buttons above the preview area. Also, you can move between three different sections of the Create panel – Pages, Layouts, and Graph-

Once a Photo Book is created it is displayed in a preview mode showing the left and right pages in a spread.

ics – allowing the user to add special effects, graphics, shapes or swap themes, backgrounds or frame designs.

Step 6: Fine-tuning the book

Although the book looks like a finished product, there are still many more adjustments and changes that can be made to the project using the options in the different sections of the Create panel:

Pages – Displays the book pages and allows for new pages to be added and others deleted.

Layouts – Change the composition of photos on the page.

Artwork – Contains alternative background and frame designs that can be added to or used in place of those already in the book. There is also a section for graphics here.

Text (Basic Mode only) – Add and style text to your book using the options found here.

Effects (Advanced Mode only) – Add Filter effects and/or Layer Styles to your images.

VIEW

SELECT

P (

DRAW

O

£3 mm

COLOR

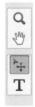

Changing the sequence of the pages

And don't forget that there is now the option to re-sequence the pages that you have laid out. Click on any of the double page spreads listed in the Pages panel and drag it to a new position in the page sequence.

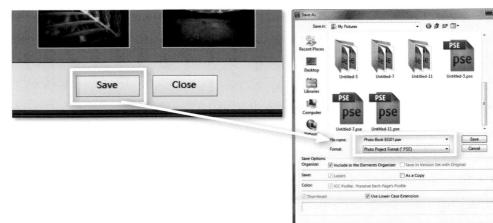

The multi-page nature of Photo Books means that they must be saved in the Photo Project format or . PSE or Acrobat .PDF file format. The PSE format maintains editability of the project whereas the PDF file can be uploaded to online book publishers.

Step 7: Save the Photo Book

Unlike the album pages in earlier versions of Elements, Photo Books and their contents remain editable after they have been saved and reopened. To enable this ability, Adobe created a completely new file format for the multi-page editable documents. Called the Photo Project Format it has an extension of .PSE as opposed to the .PSD that is associated with standard Photoshop Elements documents. When saving a newly-created Photo Book the file format in the Save dialog automatically changes to .PSE. By default the Include in the Organizer option is also selected ensuring that the new document is cataloged and displayed in the Organizer space. A small multi-page icon is displayed at the top right of the thumbnail of each Photo Book document and double-clicking the thumbnail displays a special book preview complete with page navigation buttons that allow the user to flick through the pages they need to open the book into the Editing space.

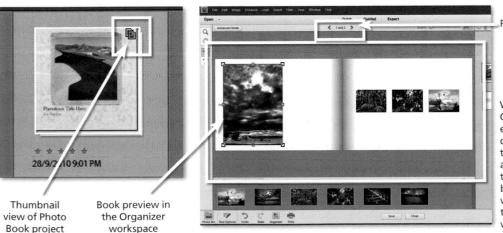

Page navigation buttons

When the Include in the Organizer option is selected in the Save dialog, the document is shown as a thumbnail in the Content area. Double-clicking the thumbnail will preview the book and all its pages without having to open the file into the editing workspace.

Edit an existing design

As we have seen, the Photo Book feature creates a multi-page document complete with photos in frames on a background and the Photo Collage option uses similar features to create single page documents. In producing this design Elements will make decisions about the size and position of the frames and the pictures within them. On many occasions you will probably want to use the pages that the feature produces with no alterations, but there will be times when you will want to tweak the results. At these times use the following techniques to edit the automatically-produced designs.

The frame and its contents can be edited using either the handles on the edge or options in the right-click menu.

Right-clicking the picture when the frame is selected produces the menu above.

Adjusting the frame and picture

To move the picture and frame combination to a new position on the canvas just click and drag the combination. The size and orientation of the frame/picture can be altered by clicking on the picture and frame first, to select it, and then using the corner, edge and rotate handles to scale or pivot. Click on the Commit button (green tick) at the bottom of the selected picture to apply the changes. To disregard the changes click the Cancel button (red circle with diagonal line through it) instead. Other adjustment options are available via the right-click menu when the Move tool is selected. Selections in this menu allow you to:

Rotate 90° Right or Left – Pivot the picture by a set amount. **Position Photo in Frame** – Switch to Picture Select mode to allow scaling, rotating and moving the photo within the frame.

Fit Frame to Photo – Automatically adjust the frame size to accommodate the dimensions and format of the placed photo. Use this option if you don't want to crop the photo with the edges of the frame.

Replace Photo – Displays a file dialog where you can select a new photo for the frame.

Clear Photo – Removes the photo but keeps the frame.

Clear Frame – Removes the frame but keeps the photo.

Bring to Front/Bring Forward – Moves the frame and photo up the layer stack.

Send to Back/Send Backward – Moves the frame and photo down the layer stack.

Edit Layer Style – Displays the Style Settings dialog when a style is applied to the frame.

Adjusting the picture

As well as being able to alter the characteristics of the frame by selecting the photo, you can perform similar changes to the picture itself. Double-clicking or choosing the Position Photo in Frame option from the right-click menu selects the photo and displays a marquee around the picture. A small Control Panel is also displayed at the top of the marquee.

To move the position of the photo in the frame simply click on and drag the image, releasing the mouse button when the picture is correctly placed.

You can alter the size of the photo within the frame by moving the Scale slider (in the control panel) or by dragging one of the handles of the marquee. Moving a corner handle will scale the photo proportionately, whereas dragging a side handle will squish or stretch the image.

The picture can be rotated in 90 degree increments (to the left) by clicking the Rotate button in the control panel. Alternatively, you can rotate the image to any angle using the rotate handle (middle of the bottom edge of the marquee) or by clickdragging the cursor outside the boundaries of the marquee.

The photo can be replaced with a new picture by clicking the Replace button in the control panel and then selecting the new picture from the file dialog that is displayed.

Extra image adjustment options are available from the right-click menu. These include the ability to switch the default action of dragging a marquee handle from scaling, as it is in the Free Transform mode, to alternatives such as Skew or Distort. To return to the default action choose Free Transform from the right-click menu. The actions available are:

Free Transform – The default mode where dragging the corner of the marquee scales proportionately, and dragging the edges, squashes or stretches the picture. The following keys alter the action of dragging a handle when in this mode:

- **Shift + corner handle** to scale proportionately,
- Ctrl + any handle to distort the picture,
- Ctrl + Shift + middle edge handle to skew the picture, and
- **Ctrl + Alt + Shift + corner handle** to apply perspective.

Scale – Resizes in the same manner as the Free Transform mode.

The picture inside the frame can be scaled and rotated independent of the frame by firstly double-clicking the photo (to select the picture without the frame) and then click-dragging the side, corner or rotate handles. Alternatively you can scale, rotate 90° left, replace the current picture with a new one and apply or cancel the changes with the buttons in the new pop-up control that appears at the top of the picture border.

Rotate

Photo

Scale

Photo

Replace with Cancel/

new photo

Right-clicking a selected picture will also display a range of adjustment options.

Free Rotate Layer - Rotates the image when click-dragging outside of the marquee.

Skew - Skews the photo when dragging an edge handle.

Distort – Distorts the picture when moving any handle.

Perspective – Applies a perspective effect when dragging a corner handle.

Adding, replacing and removing photos

Photo Books do not become static documents once they are created. In the previous section we saw how it is possible to adjust the size, position and orientation of both the photos and frames that were added during the initial creation process, but the feature's flexibility doesn't end there. You can also add new photos, replace existing pictures with alternative choices and even remove images that you no longer want to keep. Here's how.

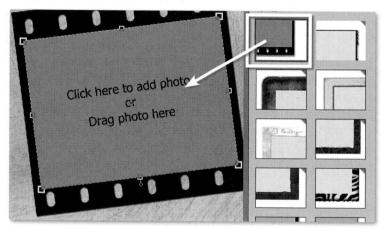

Select a frame from the Ef-Apply to add to the page.

Adding new photos

All editing of Photo Books occurs in the Create Tab workspace. So to add new photos to an existing layout you need to add a new blank frame to the composition. Do this by clicking on the selected frame in the Artwork section of the Artwork panel and pressing the Apply button. A new frame will be created on the current page of the document.

To add a photo to the frame, click-drag a

fects panel and then click thumbnail from the Photo Bin to the frame or click the text in the empty frame and select a photo from the file browser that opens. Using this approach you can add a photo without it

> first having to be open in the Photo Bin. When moving the photo make sure that the frame is highlighted with a blue rectangle before releasing the mouse button to insert the picture.

The last part of the process is to fine-tune the picture by adjusting size, orientation and position within the frame. Use the techniques in the previous section to make these alterations.

Click-drag a new photo to the blank frame.

Replacing existing photos

It is just as easy to replace existing photos with different images whilst still retaining the frame. Select the frame first and then click-drag a picture from the Photo Bin to the frame. This action swaps the two pictures but you will need to have the replacement image already open in the Full edit workspace beforehand. If this isn't the case, then an alternative is to select the Replace

Photo entry from the right-click menu and choose a new picture via the file dialog that is displayed.

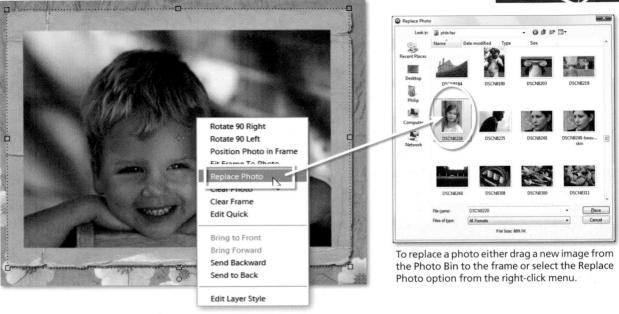

Removing photos

Pictures inserted into frames can be removed whilst still retaining the frame by selecting the Clear Photo option from the right-click menu. The frame will then revert to a blank state providing the opportunity to add a new image to the composition.

If you want to remove both the frame and the photo it contains then select the frame first and click the Delete key. A warning window will display asking you if you want to delete Selected Layers. Answer Yes to remove the frame and picture from the composition.

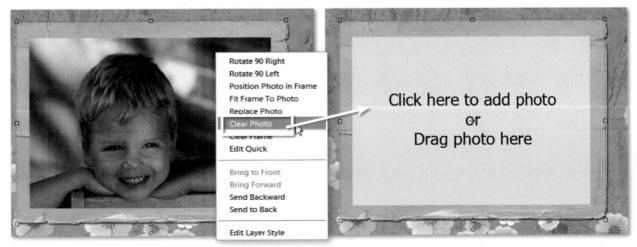

To remove a picture but leave the frame in place select the Clear Photo option from the right-click menu. To remove both frame and photo select the frame, press the Delete key and then answer Yes to the Delete Selected Layers warning.

Adding, moving and deleting pages

If you selected the Auto Fill option when first creating your Photo Book then Elements will have generated a minimum of 18 pages or enough pages to insert the photos that were initially included. If you want to add images, some text or graphics later on then you will need to add some extra pages. The Photo Creation file format (.PSE) was developed especially to handle multi-page documents and to ensure that tasks such as adding, deleting and moving pages were as easy as possible.

All page management activities are centered around the PSE document in the Pages section of the Create panel where the pages can be viewed as thumbnails. This is a change from the last version of the program where the pages were displayed in the Photo Bin.

Adding pages

All new pages in a PSE document are added after the current selected page. So start by making sure that the Pages Section of the Create panel is on view, then select the thumbnail of the page before the position where the new page is to be created.

To add a new page click on the New Page button located in the top left of the panel. A new page is then added to the document and a new thumbnail is displayed in the Pages panel just underneath the selected page. The theme and layout of the new page is the same as the one selected.

Deleting pages

Pages, and the frames and photos they contain, can be deleted from a multi-page document by selecting the page thumbnail in the Pages section of the Create Panel and then clicking the dustbin button located in the top left hand corner of the Pages panel.

Viewing pages

Navigate between the different pages of your PSE document by selecting the thumbnail of the page that you want to display from the Pages panel. Alternatively, you can move from one page to the next using the Forward and Back buttons located at the bottom of the document window.

Moving pages

The position of pages (from top to bottom) in the Pages panel indicates the page's location in the production. The first page in the document is the one positioned right at the top, the second page is the next one down, and so on. Changing the position of the page thumbnail in the Pages panel alters the page's actual position in the document. Moving pages is a simple task – just click on the page to move and drag it to a new location in the document, release the mouse button and the page is relocated. **NOTE:** The title page can't be moved.

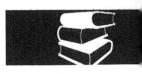

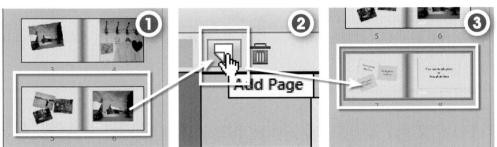

Pages are added to a PSE document by selecting the page before the position of the new entry in the Pages Panel (1) and then choosing the green + button from the top of the panel (2). This action will create a new page (or double page spread in this case) with the same theme and layout design as the selected pages (3).

To delete an existing page from a Photo Book start by selecting the page to be removed in the Pages Panel (1) and then click the red - button in the top of the panel (2). A confirmation dialog will appear where you can agree to the deletion (3) or stop the process. Clicking the Yes button will delete the page and all the frames associated with it (4). The images located in the frames will now be removed from your Elements catalog so you can easily drag and drop them onto other pages.

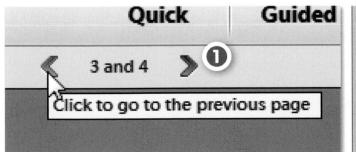

Navigate to different pages by clicking the Forward and Back buttons located at the top of the document window. (1) Or by selecting a different page thumbnail in the Pages section of the Create panel (2).

An overview of the Projects pane

The Projects pane is the center of all activity for the creation and styling of photo projects and their content. With no projects open, both the Organizer and Editor versions of the module contain the list of possible Elements photo projects. With a project open the Editor version contains four different tabbed panes. They are Pages, Layouts, Artwork and Text.

The options change a little when switching from the Basic Mode to Advanced Mode in the Photo Book workspace where the Text section is swapped with Effects.

Let's look at each in turn.

When a photo project is open in the Editor workspace, the Create pane contains Pages, Layouts, and Artwork sections.

When switching to the Advanced Mode, other options become available including the Layers panel.

Create > Pages

As we have already seen, the Pages section of the Create panel contains a series of thumbnails versions of the different double page spreads contained in your project. From Photoshop Elements 9.0 this panel takes the place of the Photo Bin that was previously used to display the various pages in a Photo Book.

At the very top is a single page, called the Title page, used to start the book and with some templates designed for online production, is designed for being viewed through a 'cut-out' section of the front cover.

The pages section of the Create pane displays thumbnails of the pages included in your Photo Book.

The pages are listed in order from first to last down the panel and depending on the number of pages in the book you may need to scroll down the panel to see each in turn. Alternatively you can select a thumbnail (single-click) and then use the up and down arrow keys to move between pages thumbnails in the panel. This won't alter the pages being displayed in the workspace. To change this display, you will need to double click a thumbnail.

The top left of the Pages pane contains + and - buttons to add and remove pages to the book. At the bottom there are generally three action buttons:

Done – To finish editing the book and close the file. If the book hasn't been saved then clicking this button displays a Save dialog before closing the book project.

Print – All book designs can be printed to a desktop printer so clicking this button will prepare your book for printing. After that process has finished the Print dialog will be displayed.

Order – If you selected one of the templates designed for online production when you first created the book, you will also have a third button titled Order. Click this option to start uploading your book to the selected provider.

Create > Layouts

The Layout panel was added in Elements 9.0. It is here that you will find a variety of different page layouts that you can add to your photo book. Unlike the version of the Photo Book project found in previous editions of Photoshop Elements, a range of random layout styles are used by the program when first creating the pages in the book. If you want a little more control over the number and positioning of the images on the pages then you can substitute any of the entries in the Layout pane for the page designs in the book.

The process is simple. First navigate to the page you want to change. Next drag the thumbnail from the Layout panel over the page to change. Elements automatically switches the page designs and adds the images that were already on the page to the frames of the new design. If you want the same layout option to be used for both right and left pages then just double-click the thumbnail entry in the panel and the design of both pages will change.

The Layout pane displays thumbnails of different page compositions that you can apply to your book pages.

Create > Graphics

The Artwork section contains backgrounds, picture frames and graphics that can be added to your layouts. Once a multi-image document is created, the various components that are housed in this panel can be used to add to, or alter, the look and feel of your design. Many of the frame and background options featured in these sections are also available as Themes (a combination of both frame and background design) in the Photo Book dialog that you first used to create the Photo Book

Adding a new Background or Frame

To add a frame, background or any other entry from the panel, select the entry and then drag the thumbnail from the panel to the pages displayed in the workspace.

To replace an existing frame, select the frame first in the workspace and then double-click the frame thumbnail. To replace a background, select the thumbnail first in the pages section and then double-click the background entry in the Artwork section.

Working with Graphics

To add a graphic to the layout either double-click on the thumbnail entry in the Graphics pane of the Artwork section of the Create panel, or drag the thumbnail from the pane to the layout.

All graphics can be scaled and rotated via the corner, middle edge and rotate handles. Click the graphic to activate the handles.

Adding Text

Unlike the previous version of Elements, the Type tool can be used to add text to any page layout. There is no need to use a special text block. Text can still be styled using the Styles section of the Effects panel. This true for both the Basic and Advanced modes of the photo projects workspace. Double-clicking a thumbnail versions of a variety

The Artwork pane contains Background, Frames and Graphics areas with a series of thumbnails of content that can be added to your book designs.

of styled effects that you can apply to the type in your Photo Book documents.

The Effects panel also include include bevels, drop shadows, glows and gradients, and only work with text layers. You can apply a text effect to an existing type layer by selecting the type and then double-clicking the thumbnail of the effect that you want to add. In addition, you can drag a thumbnail from the Styles area onto the layout. This will add a text box to the design with some sample text already applied ('Your Text Here'). To add your own type, just click onto the sample text, and type in the new caption.

Like Layer Styles the attributes of the text effects (size of drop shadow, color of stroke, etc.) can be adjusted via the Edit Layer Style option in the right-click menu. Text effects can be removed by selecting the Clear Layer Style entry from the right-click menu.

Create > Effects

The Effects pane is available in the photo project workspace in Photoshop Elements. The pane is displayed when you are working on a project that you have created using the Photo Book or Photo Collage options and it groups together Filters and Layer Styles options. You will need to switch to the Advanced Mode of the Photo Book workspace by clicking the button in the bottom left of the screen. This action replaces the Text tab at the top of the Create panel with the Effects option. Layers styles add effects such as drop shadows, outer glows and strokes to selected book objects such as framed images, text entries and graphics.

After selecting the object in the composition, the effect is selected from the panel and added by double-clicking the thumbnail. When applying the effect to a framed image, you will be warned that the frame and image will be simplified in order to apply the effect. The simplification process converts the frame and picture to a single layer. This removes the ability to edit the photo and frame independently.

The characteristics of the styles can be customized by right-clicking the object and then selecting the Edit Layer Style entry from the menu that appears. Individual style characteristics are then altered with the controls in the Style Settings dialog.

The Styles area of the Effects pane contain options for adding a range of effects to the type in your images by simply double-clicking the thumbnail entry.

Advanced Mode

To access the Effects section of the Create panel you need to select the Switch to Advanced Mode button. This will replace the Text option with the Effects.

The Effects section also contains Filters and Layer Styles areas. The thumbnails in each of these areas can be applied your photos by double-clicking the thumbnail.

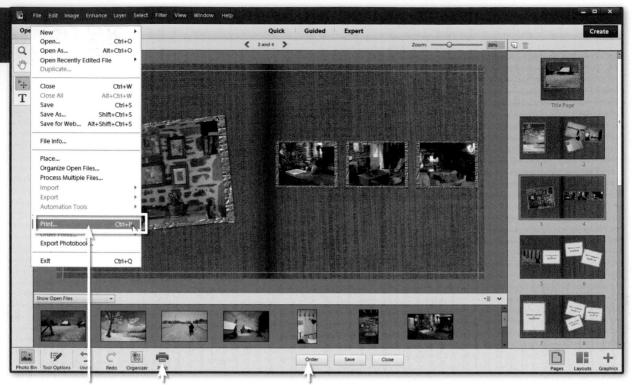

Print to desktop machine

Alternative Print to local machine button

Use the Order button for Order online printing and binding

Once the Photo Book document is completed it can be printed via a desktop machine or professionally printed and bound using the special Order button located at the bottom of the Create panel.

Bringing it all together

Using the features and techniques described over the last few pages, it is possible to build a very sophisticated Photo Book or Photo Collage document. As we have seen, Photoshop Elements cleverly provides both the multi-page structure that is necessary to underpin the whole project and the frames, graphics, shapes, text options, effects and backgrounds needed for quality presentation, but the story doesn't stop there. Once you have created your photo album, or digital scrapbook, you then have the ability to print the Photo Book either with your own desktop machine, or have the document professionally printed and bound by an online provider.

Online printing and binding (available in some countries only)

The easiest and, arguably, the most professional-looking results, are obtained when ordering printing and binding online. The features of the Photo Book project, and in particular the way that the file is set up at the beginning of the process, is specifically designed to suit this method of producing your book. The position and size of the image on the title page, for instance, matches precisely with the window in the hard cover of the completed bound book. This close linking of the production of the multi-page document, and its online output, is the prime reason why many photographers will bypass printing and binding the title themselves.

To start the online production process remember that you need to have selected an online production book at the beginning of the creation process. This will mean that once the book has been created and edited you just need to click the Order button located at the bottom of the Create panel to place an order. A warning window will appear letting you know that

the process required to prepare the book for uploading can take between 5 and 20 minutes to complete. Obviously placing an order for a Photo Book online requires an Internet connection and you won't be able to proceed from this point if one is not available. Next, you will see the Shutterfly wizard display. If you haven't used the service before you will need to register before proceeding. Work your way through each of the screens choosing cover material and color and adding recipient and billing details before finally uploading the book file and confirming the order. With the order process completed the book file will be printed and bound and then returned to you in the post or by courier.

Printing at home

The alternative to online production is printing your Photo Book project via a desktop inkjet printer. The multi-page document is designed for producing

book pages in standard A4 or Letter sizes as well as the typical scrapbook format of 12×12 inches, so make sure that you have paper either equal to these dimensions, or greater, and a printer capable of outputting to this size sheet. Alternatively, you can use standard paper

sizes and simply select the Scale to Fit option (in the Print dialog) to squeeze your book pages to suit.

To get the look and feel of a traditionally printed book some photographers, who regularly produce their own albums or scrapbooks, use paper that can be printed on both sides. After printing on one side, the sheet is reinserted into the printer to print the reverse. When bound these pages replicate a professionally printed page.

With the paper and printer organized, outputting the file is a simple matter of selecting the Print entry from the File menu or the floating book options bar.

Elements will then display the Print dialog. Here you can select the printer, adjust the size and position of the book page on the paper and choose how the color will be managed.

ShutterFly use an online wizard to step you through the Photo Book ordering process.

Print sizes for Photo Book pages are determined in the first step of creating a book. The range of paper sizes available to you will depend on the country in which you live.

When outputting Photo Book pages to a desktop printer using the File > Print feature you can adjust the size and position of the page on the paper in the Photoshop Elements Print dialog.

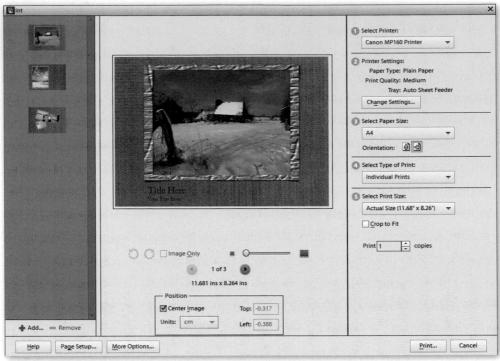

For more details about the settings in the Print dialog turn to Chapter 20. With all the settings selected, press Print to start the output process.

Exporting Photo project pages

There is also the ability to export photo project pages as individual files. To export a project page select the project in the Photo Browser workspace of the Organizer and then choose File > Export Photo Book. This displays the Export Photo Book dialog where you can select the file type and the location for the exported documents.

Web and Services

Since the first edition of this book, the World Wide Web has become an even greater part of our daily lives and, as I mentioned then, it is no longer sufficient to concentrate solely on the process of making great prints from digital files. Knowing how to output your pictures, so that they are suitable for the web, is not just a nice idea, it is now an essential part of the image-making process. In fact, there is a growing band of professional photographers whose work never becomes a print and only ever exists on our screens.

This chapter looks at the various tools and features Photoshop Elements users can employ to take their pictures from their desktops and share them with the world.

4 - (c) + 0

In the web age it is critical that users are able to output their images in a format that is suitable for Net use quickly and easily. Photoshop Elements has always been great at getting users' photos to the web quickly and easily, but in the latest versions, the level of interaction with the web is nothing short of revolutionary.

Along with the change of photographers wanting to display and distribute their images online, there is also a big move towards community sharing of ideas, techniques and photos. I'm not suggesting that this hasn't always been the case, just look at the level of commitment in your local camera club, but as we have all become more web-literate, many of the activities that used to occur at such clubs are now being conducted online. People from all over the world not only share their photos with each other, but they also provide feedback on the images and suggest different techniques that could be used to improve the pictures; all via the internet.

In recognition of this situation, Adobe has been gradually introducing internet services and links to their software. Photoshop Elements 7.0 led this change with the inclusion of a full community program and even though version 11.0 has removed some of these features there are still a bunch of great web-aware features, tools and services. These include online galleries, sharing content to popular web sharing services like FaceBook and YouTube, the ability to easily upload video and share your pictures by email.

The web features in both the Windows and Mac versions are a mix of the abilities of Photoshop Elements (1) and those found in Photoshopshowcase.com (2), Adobe's own web-based photo site. Internet access and an account (there is a free option) are both needed to access these features.

Photoshop Elements and the Web

The majority of the features that we will cover over the next few pages are based around the abilities of both Elements and Photoshopshowcase.com. To use this Elements-linked website you will need to have an active account.

It is an easy process to get started. Just go to www.photoshopshowcase.com and click the Join option. The account creation screen will appear where you can fill in your details. Pressing the Join Now button will process your application, allowing you to Sign In the next time you open Photoshopshowcase.com site or use one of the web linked features in Photoshop Elements.

NOTE: Keep in mind that for your membership application to be processed or for you to be able to sign in and use the new web features, your computer must be connected to the internet.

Facebook Email Attachments Photo Mail Vimeo You Video to Photoshop Showcase Flickr Online Album burn video DVD / Brundy Online Video Sharing Mobile Phones PDF Slide Show Adobe Revel

Photoshop Elements users need to create an account at Photoshopshowcase.com first before being able to take advantage of the web-linked features in Elements.

REGION-BASED WEB

The level and type of internet services you will be able to access with Photoshop Elements is dependent on the geographic region you are working in. Not all services are available in all regions.

Account creation workflow:

Creating an Adobe ID and the associated Photoshop.com account is an easy process. See below.

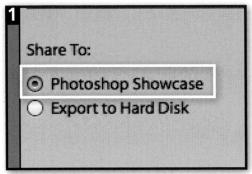

When selecting any of the web-linked options in the Share menu the process will take you eventually to the sign up page for Photoshopshowcase.com.

In the next screen add in your details including your email address and a password. These will become login and password for your Adobe ID.

usage. A the same time you can choose to have photoshopshowcase.com remember your login details.

Now agree to the terms and conditions of the site The next screen will continue the sharing process from Elements. In this example the selected images are being uploaded to the site as an online album.

Images and the Net

Before we start to play with our newly-created Photoshopshowcase.com account, it is worth looking at some key ideas that underpin working with images on the Net. Even though fewer people are accessing the web through a modem and telephone line, the size of the images used for web work is still critical in the age of broadband. It is still true to say that the larger a picture file, the slower it will download to your machine. So preparing your files for Net use is about balancing picture quality and file size.

To help with this, several different file formats have been developed to include a compression system that shrinks file sizes to a point where they can be used on a website or attached to emails. The most popular of these is GIF and JPEG with the SWF, or Flash format, gaining more and more popularity in the last few years (especially with Photoshop Elements

including several Flash output options for its Online Album feature). The problem with all these file formats is that small file size comes at a cost of image quality so some care has to be exercised with adjusting compression settings for web photos.

Picture formats for the web

GIF

With the GIF or Graphics Interchange Format, it is only possible to save a picture with a maximum of 256 colors. As most photographic pictures are captured and manipulated in 24-bit color (16.7 million colors), this limitation means that GIF images appear posterized and coarse compared with their full color originals. This isn't always the case, but because of the color restrictions this format is mainly used for logos and headings on web pages and not for photographic imagery. GIF is also used for simple animations, as it has the ability to flick through a series of images stored in the one file.

JPEG

In contrast, the JPEG format was developed specifically for still images. It is capable of producing very small files in full 24-bit color. When saving in this format it is possible to select the level of quality, or the amount of compression, that will be used with a particular image. In more recent years, two new formats – PNG (Portable Network Graphics) and JPEG 2000 – have been developed that build upon the file format technology of JPEG and GIF. At present, these file types are not used widely but as time passes they are gaining more popularity.

JPEG 2000

JPEG 2000 (JPX or JP2) uses wavelet compression technology to produce smaller and sharper files than traditional JPEG. The downside to the new technology is that to make use of the files created in the JPEG 2000 file format, online users need to install a plugin into their web viewers. Until native (i.e. built-in) browser support for the format becomes the standard Elements users can freely exchange JP2 files with

each other as support for the format is built right into the software. From version 2.0 to version 8.0 Elements supported the saving of pictures to this version of the JPEG format – JPEG 2000. From Version 9.0 Elements doesn't support this format anymore. If you are using an earlier release then the controls for this format are accessed in the format's own preview dialog via the Save As option in the File menu.

PNG

PNG24 is a format that contains a lossless compression algorithm, the ability to save in 24-bit color mode and a feature that allows variable transparency (as opposed to GIF's on and off transparency choice). File sizes are typically reduced by 5–25% when saved in the PNG format. Greater space savings can be made by selecting the PNG8 version of the format, which allows the user to select the number of colors (up to 256) to include in the picture. Reducing the size of the color set results in smaller files and works in a similar way to the GIF. Most browsers and image-editing programs support the PNG format natively, so no extra viewer plug-in is necessary.

Flash

Elements 5.0 was the first version of the program released after Adobe's purchase of Macromedia. Since then Elements has embraced the Flash or SWF format that Macromedia developed for web sites. The galleries produced via the Elements' Online Album feature, as well as those displayed at the Photoshopshowcase. com website, all use the Flash file format rather than the more traditional HTML pages and JPEG or PNG files. Like JPEG, the Flash format is designed to quickly display high quality photos on the Internet using small file sizes.

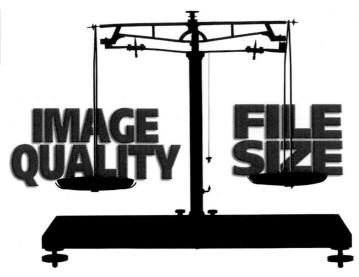

Preparing any content for web use is concerned with balancing quality and file size. This is especially true when placing your pictures on the Internet. Too high quality will mean that your photos will take a long time to display, too little and they will download quickly but be of poor quality.

Getting the balance right

Most of the web features in Photoshop Elements automatically handle the process of optimizing your photos so they are suitable for viewing on the Net, but there will be times when you may need to save an image in a web-ready format yourself. So let's look at the process that you can use to optimize photos manually.

Both JPEG formats, as well as GIF and PNG8, make small files by using 'lossy' compression algorithms. This means that image quality and information are lost as part of the compression process. In simple terms, you are degrading the picture to produce a smaller file. Too much JPEG compression, in particular, and the errors or 'artifacts' that result from the quality loss become obvious.

The compression technology built into the GIF format makes files smaller by reducing the number of colors in your pictures to a maximum of 256 (8-bit color). This means that GIF images are small and fast to display but the lack of colors makes them unsuitable for use with photographs. (1) Original 3.53 Mb picture containing 16.7 million colors. (2) Detail of original. (3) Detail of the same file converted to GIF format so that it is 0.43 Mb in size and contains 32 colors only.

The compression level in the JPEG format is selectable via the Quality slider in the JPEG dialog. Moving the slider to the left (1) creates a small, low quality file; moving it to the right (2) produces a better quality image but with a bigger file size.

So how much compression is too much? Well, Elements includes a special Save for Web feature that previews how the image will appear before and after the compression has been applied. Start the feature by selecting the Save for Web option from the File menu of either the Full or Quick Fix editor workspaces. You are presented with a dialog that shows 'before' and 'after' versions of your picture side by side. The settings used to compress the image can be changed in the top right-hand corner of the screen. Each time a value is altered, the image is recompressed using the new settings and the results redisplayed.

JPEG, GIF and PNG can all be selected and previewed in the Save for Web feature. For Elements users of versions 2.0-8.0 you can preview JPEG 2000 compressed images via the Save As option in the File menu and select JPEG 2000 as the file type. This step will open the preview dialog specifically designed for this format.

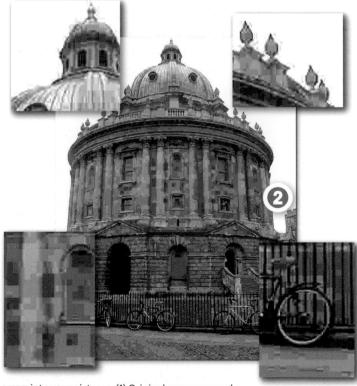

Too much JPEG compression introduces artifacts or visual errors into your pictures. (1) Original uncompressed picture. (2) Overcompressed version of the photo showing extensive artifacts.

WEB AND SERVICES

By carefully checking the preview of the compressed image (at 100% magnification) and the file size readout at the bottom of the screen, it is possible to find a point where both the file size and image quality are acceptable.

By clicking OK you can save a copy of the compressed file to your hard drive ready for attachment to an email or use in a web page.

Creating web-ready images:

- 1 With an image already open in Elements, pick the Save for Web (Editor: File > Save for Web) or Save As (Editor: File > Save As > JPEG 2000 Elements 2.0 to 8.0 only) option.
- 2 Adjust the magnification of the images in the preview windows to at least 100% by using the Zoom tool or the Zoom drop-down menu.
- 3 Select the file format from the Settings area of the dialog.
- 4 Alter the image quality for JPEG and JPEG 2000 or the number of colors for GIF and PNG8.
- 5 Assess the compressed preview for artifacts and check the file size and estimated download times at the bottom of the dialog.
- 6 If the results are not satisfactory, change the settings and recheck file size and image quality.
- 7 Click OK to save the compressed, web-ready file.

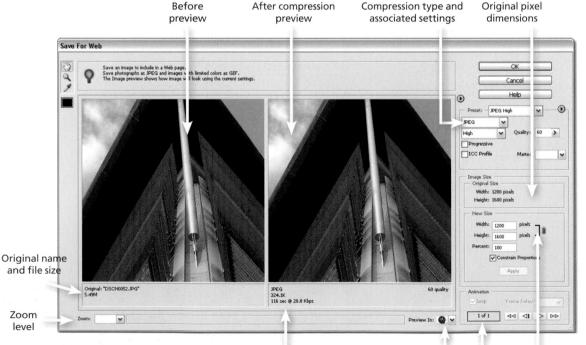

The Elements Save for Web feature produces a side-by-side comparison of your image before and after compression. The Save for Web option is available from both the Full and Quick Fix editor workspaces.

File size and predicted download time after compression

Preview in browser Animation New settings for pixel size GIF format settings

Elements users of versions 2.0–8.0 can start the JPEG 2000 preview dialog, select the Save As option from the File menu and pick the JPEG 2000 format there.

Zoom level Predicted download time Preview of compressed picture

Compression settings

Download preview settings

Web compression formats side by side

To give an indication of the abilities of each particular format, I optimized the same image and saved it in five different web formats. The differences in image quality and file sizes, as well as the best uses and features of each format, can be viewed in the following table.

	Best uses or format features						
Compression settings	Photo	Logo	Heading	Anim- ation	Trans- parency	File size	Detail*
Minimum	✓					791 Kb	1
Maximum	✓					60 Kb	2
Minimum	✓					880 Kb	3
2000 Maximum	✓					49 Kb	4
256 colors		✓	✓		✓	502 Kb	5
16 colors		✓	✓		✓	216 Kb	6
_	✓				✓	1358 Kb	7
256 colors		✓	✓ ,	√ ·	✓	398 Kb	8
16 colors		✓	✓	✓	✓	201 Kb	9
	settings Minimum Maximum Minimum Maxlmum 256 colors 16 colors — 256 colors	settings Minimum Maximum ✓ Minimum ✓ Maxlmum ✓ 256 colors 16 colors — 256 colors	Compression settings Photo Logo Minimum ✓ ✓ Maximum ✓ ✓ Maxlmum ✓ ✓ 256 colors ✓ ✓ — ✓ ✓ 256 colors ✓	Compression settings Photo Logo Heading Minimum ✓ ✓ Maximum ✓ ✓ MaxImum ✓ ✓ 256 colors ✓ ✓ — ✓ ✓ 256 colors ✓ ✓	Compression settings Photo Logo Heading Animation Minimum ✓ ✓ ✓ Maximum ✓ ✓ ✓ MaxImum ✓ ✓ ✓ 256 colors ✓ ✓ ✓ — ✓ ✓ ✓ 256 colors ✓ ✓ ✓	Compression settings Photo Logo Heading Animation Transparency Minimum ✓ ✓ ✓ ✓ Maximum ✓ ✓ ✓ ✓ MaxImum ✓ ✓ ✓ ✓ 256 colors ✓ ✓ ✓ ✓ — ✓ ✓ ✓ ✓ 256 colors ✓ ✓ ✓ ✓ 256 colors ✓ ✓ ✓ ✓	Compression settings Photo Logo Heading ation Animation Transparency File size Minimum ✓ ✓ 791 Kb Maximum ✓ 60 Kb Minimum ✓ 49 Kb Maximum ✓ ✓ ✓ 502 Kb 16 colors ✓ ✓ ✓ 216 Kb — ✓ ✓ ✓ ✓ 398 Kb

Comparison of file formats suitable for web use. * See detail of the compression type and setting applied to the same photograph in the examples on the next page.

Side-by-side comparisons of the image quality of a variety of web optimized file formats at different compression settings.

- (1) JPEG, minimum compression.
- (2) JPEG, maximum compression.
- (3) JPEG 2000, minimum compression.
- (4) JPEG 2000, maximum compression.
- (5) PNG8, 256 colors.
- (6) PNG8, 16 colors.
- (7) PNG24.
- (8) GIF, 256 colors.
- (9) GIF, 16 colors.

Making your own web gallery

With the basics of photo optimizing for the Net under our belt let's look at the features that Elements offer photographers wanting to create their own web gallery.

Never before in the history of the world has it been possible to exhibit your work so easily to so many people for such little cost. The web is providing artists, photographers and business people with a wonderful opportunity to be seen, but many consider making their own website a prospect too daunting to contemplate. For the last few versions of Elements, Adobe has included a feature that takes several images and transforms them into a fully functioning website in a matter of a few minutes. More recently this feature has been overhauled so that now in Windows and, for the first time, in Mac as well, it links directly with your Photoshopshowcase.com account and the photos that are stored there.

The Online Album feature (previously called the Online Galleries or Web Photo Galleries) can be found under the Share pane in the Organizer workspaces. Clicking the Online Album button changes the display in the panel on the right of the workspace.

There are two options displayed at the top of the panel which determine the next steps in the process. As the gallery creation process is based on

The Online Album feature is one of the photo projects that can be found in the Share pane of the Organizer workspace in both the Mac and Windows version of Photoshop Elements.

Elements' albums, you have the choice of using an existing album or creating a new one. You will also need to choose how the album is to be shared – online, CD/DVD or hard disk. Selecting the online route makes use of the free hosting options provided at Photoshopshowcase.com. So you will need to have already signed up for a free account.

The settings in the rest of the panel allow you to add to or take away images from the set you have in the selected or newly created album, set the template and style of the website, input the heading, adjust the colors used on the pages (depending on the template used) and choose who has access to the gallery once it is on the Net. You can choose to display the gallery and all the images publicly or only allow access to invited friends or colleagues.

Images from the Organizer are selected first before picking the Online Album option from the Share menu.

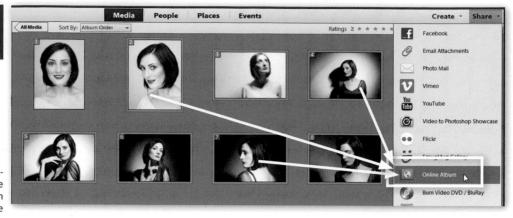

Choosing the pictures to include in the web gallery

Before moving any further it is important to restate that all Online Albums are created from Albums that already exist in the Organizer workspace or ones you create during the process. For this reason, there are two ways to choose the images to include in your gallery. You can multi-select the photos from the Photo Browser first, before entering the feature and use these photos as the basis of a new album or, alternatively, you can select an Album you created earlier. When working with multi-selected photos, the first step when entering the Online Album wizard is to create a new Album.

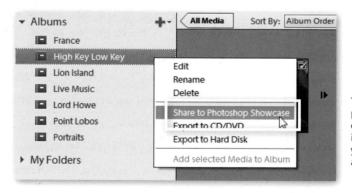

The fastest way to get your photos online is to regularly create Albums from your best images and then share these via your Photoshopshowcase.com account.

Album Sharing options

Elements calls the process of creating online versions of your Elements albums 'sharing' and if you want to place images on the web regularly, then organizing your photos into Albums in Elements first, and then sharing them, is the fastest route to building a variety of web galleries. Choosing how you want to share your album is the next part of the process. Elements provides four key ways to share your gallery:

Photoshopshowcase.com – Upload to a free online sharing area on the website.
 Export to CD/DVD – An option for burning the gallery to a CD or DVD.
 Export to Hard Drive – An option for saving a copy of the gallery to your computer.

Creating Online Albums

(1) The Online Album wizard is accessed by clicking the Online Album button in the Share task pane on the right of the Organizer workspace.

There are two distinct workflows for creating an Online Album depending on if you are sharing an existing album or creating a new one.

- (2) After selecting the Share Existing Album entry choose an Album from those listed.
- (3) Alternatively click the Create New Album option.
- (4) Now pick the way to share the Album. In this example we will select the Photoshop Showcase entry.
- (5) Next add a title for the new Album, drag thumbnails from the Organizer to Content pane or use the Add and Remove buttons to alter the pictures included. Drag the photos to change their position in the album sequence.
- (6) Clicking the Done button at the bottom of the pane displays a preview of the gallery in the last-used web template.
- (7) To change the template, choose and double-click a template thumbnail in the section above the preview area. Other template groups are available from the Select A Template menu.
- (8) If the template has settings you can change they will appear on a floating palette or in this case in a menu. Toggle the settings display by clicking the button on the right of the Template Menu bar.
- (9) The last step is to adjust the settings in the Sharing pane on the right of the preview space. The options available here will depend on the option selected in step 4. The example shows the pane as it appears when sharing to Photoshopshowcase.com.
- (10) Once all the settings are complete click the Ok button to complete the process and, in this case, start the uploading of the files to Photoshopshowcase.com.

Sharing your Element's Album to Photoshopshowcase.com publishes an online gallery version of the album's contents.

The Photoshopshowcase.com option provides the easiest mechanism for getting photos online and includes the added advantage of access to all the Elements' backup and synchronization features. This takes a lot of the hassle out of uploading your website as Adobe provides the ability to transfer your web pages to its own hosting service from inside the Online Album's wizard. There is no need to add complex server details or know how to facilitate the transfer, this is all taken care of in the background as long as you log into your Photoshopshowcase.com account in the Welcome Screen.

That said, some readers might have existing websites to which they want to add Elements' galleries. In these cases, the next step is to transfer all the files to their server space on the Net. Companies called ISPs, or Internet Service Providers, host this space. The company that you are currently using for 'dial-up' or broadband connection to the internet will probably provide you space as part of your access contract. Choosing this option means that you will need to transfer your site's files from your home machine to the ISP's machine. Previous versions of Elements contained an integrated FTP utility within the Share To section of the dialog. From version 9.0 this option has been removed but you can still upload your gallery to your own website via a third party FTP or File Transfer Protocol program such as FileZilla. Just choose the Share To Hard Disk option, add in the details supplied to you by your ISP into the FTP program to set up the link between your computer and the website and then transfer the whole Online Album folder. You will be able to view the gallery by typing your website name and upload folder into your browser address bar.

Online Albums export to hard drive or CD/DVD can be viewed by clicking on the index.html file in the album's folder.

The Export to Hard Drive and Export to CD/DVD options save all the website files to a new folder titled the same as the Album name you have selected and either writes these to the hard drive or CD/DVD. The gallery can then be viewed with any computer equipped with an internet browser program such as Firefox or Internet Explorer. The viewer just needs to double-click the index.html file located in the album folder to display the gallery.

Template designs are selected from the thumbnails above the preview space. Double-clicking the thumbnail will rebuild the current album using the new design. The five example templates shown here are:

- (1) Home Decor
- (2) Old Map
- (3) Reflection
- (4) Moving
- (5) Photo Book
- The entries in the Select a Template menu display different template groupings (6) including those available for download.

Designing the gallery with templates

For several versions now Photoshop Elements has included animated and interactive gallery types as well as the more traditional static thumbnail and display image templates. The template galleries have been arranged thematically and include the following groups: Classic, Family, Fun, Occasions, Seasons and Travel. When creating an Online Album, the Template design is selected by default after clicking the Sharing tab in the Create Album pane. To select a different design the user needs to double-click on a different template thumbnail in the area just above the preview.

Also included in the Select a Template menu is a Show All entry to display all available templates as well as those templates available to download.

Step-by-step Online Album creation:

Use these steps to guide you through creating your first photo website.

- If you want to create a new Album to share online start by selecting the pictures you want to include in the site from those thumbnails displayed in the Organizer workspace. Hold down the Ctrl key to multi-select individual files and the Shift key to select all the files in a list. Alternatively, you can also drag a selection marquee around thumbnails in the Photo Browser.
- 2 Select the Online Album entry from the Share menu.
- 3 Add in a title for the Album name and choose how you want to share the album (Photoshopshowcase.com, CD/DVD, Hard Drive). Click Next to move to the following pane.
- 4 Add or remove photos from the list of those to be included in the album (thumb-nails listed in the panel) by displaying other images in the Photo Browser space and then dragging the images to those already listed. To remove images, select the thumbnail and then click the Dustbin icon at the bottom of the panel. Adjust the position of the images in the presentation sequence by click-dragging the thumbnail within the group. Click the Sharing tab to move to the next step.
- 5 Alternatively, you can share an existing Album by clicking on the Online Album button in the Share Task Pane without first selecting images to include. Next select the Share Existing Album option first and then the way that you wish to share the Album. Click next to proceed to the following pane.

Album designs can be changed at any time by double-clicking on another thumbnail in the list above the preview area.

6 A preview of the images in the last template used will now display in the workspace. Also if the template can be customized, a floating palette containing a summary of any changeable settings and details will be displayed on the left of the workspace. Its display can be toggled on and off using the button on the right hand end of the Templates menu bar. Some web gallery designs have many settings and controls that can be used to adjust the look and feel of the gallery as well as the text included in it; others, particularly the highly automated ones, have only a few user-controlled settings to play with. You will need to click the Refresh button at the bottom of the palette to see the changes displayed in the preview section of the workspace. If you are happy with the design, click on the Sharing tab to display sharing settings. Add in the necessary details and click OK to publish the gallery.

7 If you want to alter the look of your online gallery then double-click an alternative design thumbnail from those listed horizontally above the preview space. Extra sets of templates are available from the Select a Template drop-down menu. Picking one of these entries will display a list of design thumbnails for each group. Clicking a thumbnail will display a description of the template features and its intended use.

8 Many designs use photo details, like the caption entry, to provide titling for the individual photos. So if you want to, or need to, include these

details in the design; exit the wizard by clicking the Cancel button. Add in caption details for your photos by adding text in the Properties palette (Window > Properties) and then restart the Online Album process.

9 There is no formal Save step in the wizard as clicking the OK button in the final pane automatically adds the new Album to list in the Organizer workspace as well as publishing it online.

The settings in the Sharing pane change according to which sharing option you select in the first part of the

- (1) Export to Hard Disk
- (2) Export to CD/DVD (3) Photoshopshowcase.com

Online Album creation process. Here we see settings

Other ways to share Albums

As we have already seen, the Online Albums feature is linked to the general Album options found in the Photoshop Elements' Organizer workspace. Given this link then it will come as no surprise that it is also possible for you to publish your pictures online via the settings in the Albums Pane directly without the need to access the Online Album option. There are a couple of ways that you can create a gallery of images using this approach so let's look at each in turn.

Albums can be quickly shared at time of creation by filling out the settings in the Sharing tab.

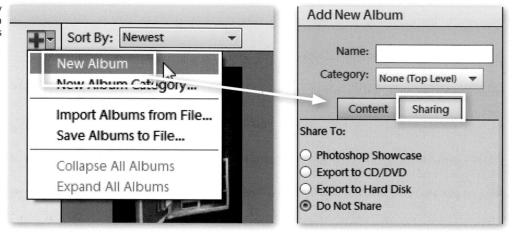

Share a new Album to Photoshopshowcase.com

The first approach starts with the creation of a new Album. You might not have noticed that Share tab is present when creating a new Album. The Share tab sits next to the Content tab at the top of the Album Details pane that is used to create a new Album entry. After adding images to the content pane you can click onto the Sharing tab to immediately set up options for transferring files to Photoshopshowcase.com as an Online Album. Once the Sharing tab is selected, the workflow is exactly the same as the Online Album creation process. This includes the ability to nominate a template design for the site. With a couple more clicks of your mouse (to move through the steps) the photos are published. In one easy sequence you have created an Album and published the contents online. Good job!

Now if you are an experienced Elements user then you probably have already developed a workflow for publishing web galleries that involves steps such as these:

- 1 creating an album,
- 2 adding selected images to the album,
- 3 adjusting the sequence of the pictures,
- 4 selecting the photos from the album that you want to use.
- 5 create the web gallery, and then
- 6 publish the gallery online.

As you can see, in this version, this process is much simpler than in previous releases. Now you can fast-track your gallery production right from the Album pane. It may take a little time to get used to this way of working, but it is certainly faster than the old method.

Note: The Backup/Synchronize settings featured in previous versions have been removed from Photoshop Elements 11. For more details about creating and using Albums go to Chapter 3.

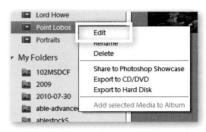

Existing Albums with Photoshopshowcase.com links can be edited directly from the right-click menu of the entry in the Album pane.

Share an existing Album

Okay, so you say to me, 'This is great Phil. I can really speed up my organization and web publishing using this new way of working, but what of the Albums that I have already created?' Good question!. Thankfully these too can be easily uploaded to Photoshopshowcase.com in a template-based web gallery of your own choosing. Here's how.

Start by displaying the list of albums on the left of the workspace. To publish an existing Album, select its entry and then choose the Share to Photoshop Showcase entry on the right-click menu. This action will transfer the contents of the Album to the Online Album wizard. From here it is a simple matter of following the steps to select the design of the gallery and publish the photos to Photoshopshowcase.com.

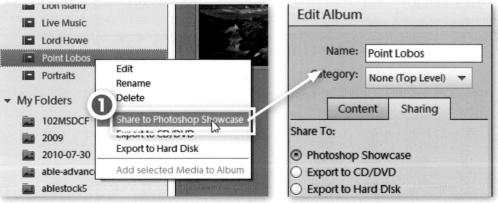

Sharing an existing Album online is a simple as selecting its entry in the Albums pane and then choosing he Share to Photoshop Showcase on the right-click menu (1).

The pane will switch to show the Album Details where you can click onto the Sharing tab to start the process of placing the Album online.

The photos in published Online Albums can be viewed on the web via your account at Photoshopshowcase.com and only by you when you are signed in to the site. For your images to be seen publicly in a template-based Album you must publish them from Photoshop Elements and select the 'Share your Media with Everyone' setting in the Photoshop Showcase online wizard.

Alternatively, you can make your albums visible to the public or viewable by a group of invited friends by altering the permissions settings in the Album Settings section of the My Account area of Photoshopshowcase.com.

The Settings button located in the My Account section of Photoshopshowcase.com gives you the ability to set all galleries (Online Albums) as public or private.

Sharing an existing Album in other ways

Once an Album has been published online it is also possible to export the Album to the other formats offered in the Online Album creation process. By clicking the Album entry you can choose to export to CD/DVD or hard disk from the options listed. There is also a menu item here for finding and sorting album contents, editing or deleting the album entry and for adding items to the album.

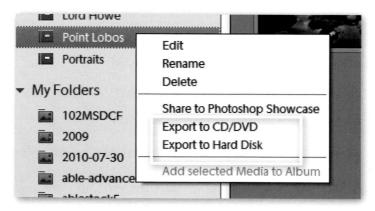

The options on the right-click menu of any Album entry allow for the user to also share the album via CD/DVD or hard disk.

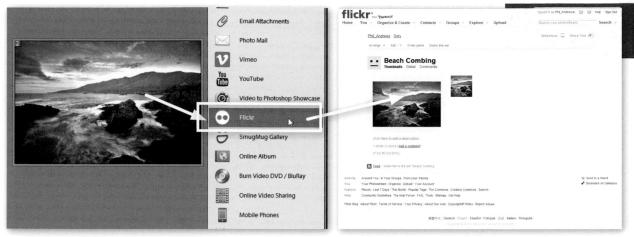

Other options for sharing your images online

Although producing and Online Album linked to your Photoshopshowcase.com account is a very easy and efficient way to get your photos online, some readers may already have established accounts on other photo sharing sites such as Flickr, Facebook or SmugMug. Well there is no need to stop using these sites just because you are now managing your photos with Photoshop Elements.

Dedicated options for exporting photos directly to these popular web sites have been available for few versions now. Once the connection between Elements and your favorite sharing site has been authorized, it is a simple matter of selecting the photos to upload and then clicking on the associated entry in the Share panel.

Elements contains options for quickly optimizing photos so they are suitable for photo sharing sites such as Flickr.

Sending your Elements photos to Flickr

Flickr.com is a very popular photo sharing site that allows image makers to upload their photos and then display them publicly for all the world to view, or provide only selected,

invited, friends to see their work. The Share To Fickr option in the Share panel of Photoshop Elements provides a very simple way for Elements users to add the photos they manage in the Organizer to their Flickr site.

Obviously to take advantage of this feature you must already have a Flickr account. A new account can be created for free by visiting www.Flickr.com and clicking the Sign Up option in the site's menu bar.

As with all the sharing options that involve established photo sites, the first step in the process is to get both Photoshop Elements and Flickr.com talking to each other. This involves an authorization process

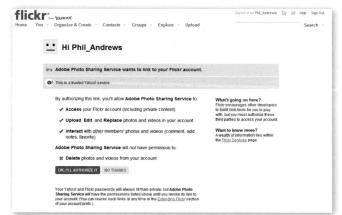

Before you can start to share the photos you are managing with Photoshop Elements on your Filckr site you must authorize access to Flickr from Elements. This is a once-only process which you complete the first time you use the Create > Share To Flickr feature.

where Elements sends a message to your Flickr account, you log into the site and okay the link Elements is trying to establish and then you return to Elements to complete the process. Once this 'trusted' link between the two entities is set up you will be able to upload your photos directly to your Flickr account from inside Photoshop Elements.

Step-by-step for setting up your Flickr and Elements link

Use these steps to set up and share your photos to your Flickr account:

- 1 Before you start make sure that you have a current Flickr account and that you have the login name and password handy.
- 2 Next select a single image from the Organizer workspace and choose the Share To Flickr entry from the Share Task panel.
- 3 A new dialog will be displayed asking if you want to commence the linking process. Click the Authorize button to continue.
- 4 Next a new web browser window will open displaying a Flickr login screen. Add your login name or ID and your password before clicking the Sign In button.
- 5 The next screen will summarize the types of activities that Photoshop Elements will be able to undertake within your Flickr account. Click the OK, I'll Authorize It button to establish the link.
- 6 Now switch back to the Organizer workspace and you will notice that the open dialog is now displaying a message that the linking process is almost finished. Click the Complete button to finalize the process.

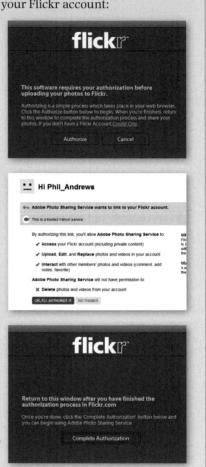

Step-by-step for sending your photos to Flickr

Follow the steps below to send your photos directly to your Flickr account:

- 1 With the link to Flickr now authorized, uploading your photos to your account is a very simple matter. Start by selecting your photos from the Organizer workspace.
- 2 Now click the Share To Flickr option in the Share menu.
- 3 The image or images you selected will then be listed as thumbnails on the left of a new dialog which appears. You can add to or remove images from the list using the + and buttons.

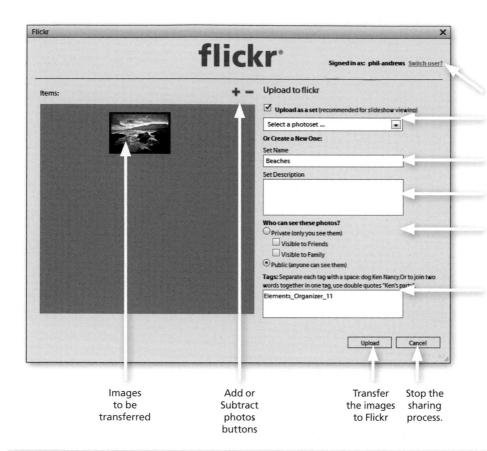

Change Flickr accounts.

Upload images to an existing set. Pick Set here.

Upload images to a new set. Add new Set name here

Add new Set description here.

Adjust privacy settings of the images.

Add tags used for searching for images on your Flickr site.

The Share To Flickr dialog contains settings to add or remove photos from those being transferred, a section for adding tags or keywords, privacy controls and options for including the images in specific Flickr sets.

- 4 Choose who can view the photos from the options on the right of the dialog.
- 5 Add Tags or search words to help viewers find your work. Separate individual tag words with a space and group multiple words as a single tag by encasing them in double quotes.
- 6 Click Upload to optimize and then transfer your selected image(s) to your Flickr Photostream. Alternatively you can send the image(s) to an existing photo Set by choosing the set from the drop-down menu or creating a new Set (by adding a Set Name and Set Description into the palette) before clicking the Upload button.

Other Photo Site Sharing options

Alongside the Share To Flickr feature there are three other opportunities to transfer your Elements photos to a third-party photo site. In the main Share panel we have entries for sharing to Facebook and SmugMug Gallery sites and also to Adobe's device sharing option Adobe Revel. All of these online opportunities require you to link an existing site account

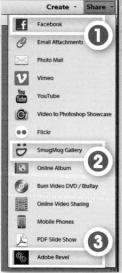

Other online sharing options include (1) Facebook, (2) SmugMug Gallery and (3) Adobe Revel.

WEB AND SERVICES

with Photoshop Elements, but each are slightly different in the steps needed to complete the authorization process:

Facebook – Authorization process requiring you to send a message from Elements to your Facebook account. When you log in you can authorize the link and then finish the process in Elements. The steps are very similar to the Flickr setup detailed above. Accounts are free.

SmugMug Gallery – SmugMug provides the option to create a new account while setting up the link between Elements and the sharing site. At the time of writing, Elements users get a discount on their SmugMug Gallery membership for the first year. Accounts are free for the first 14 days.

Adobe Revel – A pre-existing account is needed to upload photos to the service. The account is free for the first 30 days and then has a monthly subscription fee. Unlike the Flickr and Facebook links you will need to log in each time you want to upload your photos. The same account can be used synchronizing files across phones, tablets and Mac desktops.

Once the formal links between Photoshop Elements and the photo sharing sites have been established it is then a very easy task to regularly update your online presence with (1) Adobe Revel, (2) Flickr, (3) Facebook and/or (4) SmuqMuq.

Sending images as email attachments

For many people, sharing images by sending them as email attachments has become a commonplace activity. Whether you are showing grandparents in another country just how cute their new granddaughter is, or providing a preview look at some holiday property, using email technology to send pictures is both fast and convenient.

Both versions of Elements (Mac and Windows) include special attach to E-mail functions designed just for this purpose. Things have progressed with successive versions and now Windows Elements users can email their images in two different ways – as Photo Mail or as E-mail Attachments. There is also a Contacts Book dialog in place of the old Add a Recipient option found in previous releases. Here you can add individual contacts, make groups from several email addresses, and import from and export to common email contact formats such as vCards or Microsoft Outlook.

Macintosh users can access a simplified version of the E-mail Attachment feature which transfers the selected image or images to Apple's Mail program.

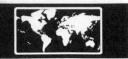

Email Attachments in Windows

The E-mail Attachment button located on the Share menu starts the emailing process. Images are dragged from the content area in the Organizer workspace onto the Items section of the panel. The size and compression settings for the images are selected with the controls directly under the Items area. At the bottom of the same pane you can choose who to send

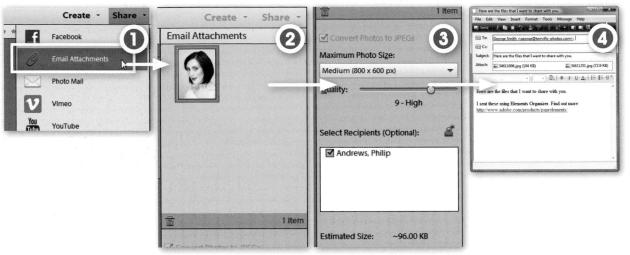

To add photos selected in the Organizer to an email in Elements for Windows, start by picking the E-mail Attachments option from the Share Task Pane (1). Now adjust photo size and quality level (2) before clicking Next. Add in a message and select recipients (3) and click Next once again. Elements will then create a new email message in the default email program (4). All you need to do is click Send.

the email to. New recipients can be added with the Edit Contacts button (small person icon) in the top right of the panel. After all the participants have been selected, clicking the Next button will open your email program, create a new message and add in your pictures and recipients.

Adding photos to emails workflow:

- 1 You can select to use a photo that is currently open in the Editor workspace or multi-select images from inside the Organizer workspace.
- 2 Select the E-mail Attachments option in the Share menu to start the feature.
- 3 Add or delete photos from the thumbnail list of those to include with the buttons at the top right of the dialog. Adjust size and compression of the photos and click Next.
- 4 Choose an existing recipient from the contacts list or add a new contact; add in a message and click Next to open your email program and create the new message.

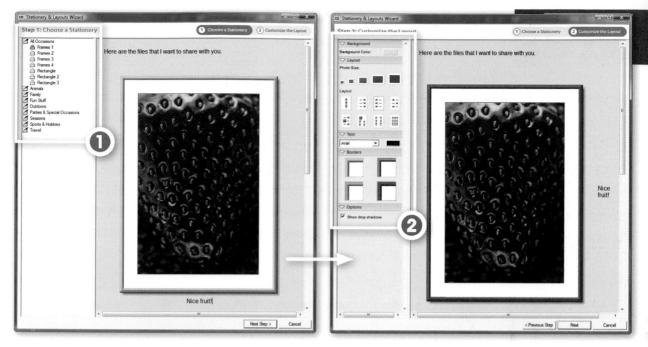

The Photo Mail contains the same selection ad optimization steps found in the E-mail Attachments feature but adds the ability to lay out the photos on a stationery background, add some frames and include captions.

Photo Mail includes two extra wizard screens. One for choosing the stationery (1) and a second for customizing the layout (2).

Photo Mail (Windows only)

The second way to send your image by email is to use the Photo Mail option located in both the Share task pane of both the Organizer and Editor spaces. The first couple of screens are the same as the E-mail Attachment feature but, once you have selected the images and recipients to include in the message, clicking the Next button opens a new window where you can adjust the stationery, framing and layout of the images.

Creating Photo Mails:

- 1 After selecting the Photo Mail option from the Share menu use the same steps as above (steps 1-3) to add images, choose recipients and include a message. Click Next.
- 2 In the new dialog that is displayed, select the stationery (frames and background) style for the Photo Mail. Click the Next Step button.
- 3 Customize the look of the stationery by adjusting the background color, layout, photo size, font, borders and the inclusion of drop shadows.
- 4 Click Next to open your email program and create the new Photo Mail message.

Photoshop.com is your online partner

Photoshopshowcase.com is not the only online place where you can feature your images. In previous versions there was a clear partnership between Photoshop Elements and Photoshopshop.com. In version of 11 this link has been removed but even without Elements connectivity Photoshop.com still is a great place to show off your images. As it grew out of Photoshop Express, the site also contains simple editing features such as the ability to crop, resize, auto correct, alter white balance, adjust highlights, boost color, tint and distort photos.

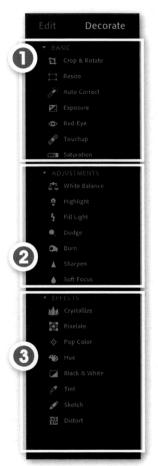

Image enhancement options in Photoshop.com are broken into three broad groups: (1) Basic, (2) Adjustments and (3) Advanced. Each group contains a series of enhancement features.

Enhancing online

To adjust an image online, click onto the Photoshop Express Editor entry in the Online Tools menu at the main Photoshop.com screen. Next, either select a sample photo to practise on, upload a new photo or click the Organizer button to navigate the files you already have online. You can look for the photos visually by selecting an Album entry on the left of the screen and then scrolling through the thumbnails in the main workspace. Alternatively, you can locate the photo by typing a search term into the Search box at the top left of the workspace and then hitting the Enter key. Photoshop.com tries to match the search term with album and file names, tags associated with the photos and picture captions.

Once you have located the photo, double-click the thumbnail to display the photo full screen and then click the Edit button at the bottom to switch the workspace to the edit mode. All the adjustments that can be applied to the photo are grouped under three headings: Basic, Adjustments and Advanced on the left.

For most options, when an adjustment is selected from the list, a series of thumbnails displaying varying degrees of application for the adjustment are displayed above the image. Clicking a thumbnail will preview a change to the photo. With some adjustments a slider control is also provided below the thumbnails for finer control. One thumbnail of the group will be displayed with a curved yellow arrow. Click this entry to reset the photo to the way it was before selecting the current adjustment. Click the green tick (top right) to save the current adjustment changes and click the red cross to cancel the alterations.

Despite the preview being updated to reflect the changes that you have made, the adjustments are not actually applied to the image until they are saved upon exiting the Editing mode. This way of working allows you to revert the photo to its original state by clicking the Reset All button at the bottom of the window. Also contained at the bottom of the editing window is the View Original image which allows you to see how the photo looked before your adjustments. Hold down the button to see the before image, let go of the button to return the picture to its current state.

Some enhancement options, such as Red-Eye Removal and Touchup, require the user to interact directly with the image. With these tools you will need to click on or paint over the

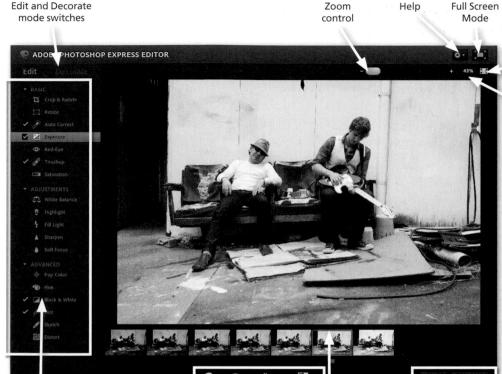

All image adjustments performed in Photoshop.com are undertaken in the Editing mode pictured here.

Fit to screen

Current magnification

Adjustment entries

Undo, Redo, Reset and View Original

Processing Example Thumbnails

Save, Cancel

parts of the photo that you want to change. The touchup tool in particular is very useful as it provides a way to remove small dust marks and spots from your photo. Once selected, you simply click and drag the a circle around the dust mark and then let the mouse button go. Automatically the dust spot is removed. If the result didn't work as you expected, just click the circular orange arrow icon at the bottom right of the window. This is the Reset button and pressing it will remove all your retouching changes, allowing you to start again.

Once you are satisfied with your changes, you can save the altered photo by clicking the Save button at the bottom of the editing window. This action will update the photo in the Photoshop.com library and, in version 10.0 of the software, will also update the picture in your Photoshop Elements Catalog if the picture belongs to an Album that is set for Backup/ Synchronization. In Elements 11 there are no synchronization options.

One great feature of the way that photos are saved is that it is always possible to return the photo back to its original state, that is, how it looked when you first imported it into Photoshop.com. To do this when working at Photoshop.com, hover the mouse cursor over the thumbnail of the

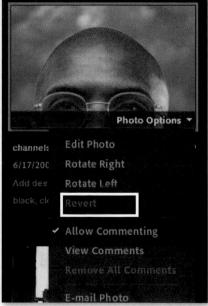

Changes made in the Photoshop.com Edit workspace can be reversed by selecting the Revert entry from the Photo Options menu.

WEB AND SERVICES

photo and a Photo Options menu heading will appear at the bottom of the thumbnail. Clicking on the downwards-facing arrow, beside the heading, displays a pop up menu of choices. To remove the editing changes select the Revert entry.

Note: The changed versions of the photo are no longer saved in the Photoshop Elements catalog in a version set. The user can no longer choose a version to display as the main thumbnail.

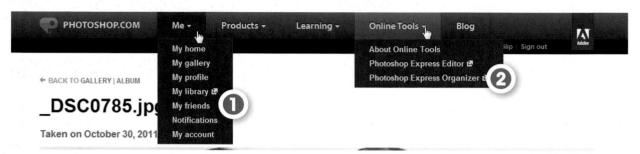

The key workspaces for registered members of Photoshop.com can be found under the Me (1) and Online Tools (2) menus.

Photoshop.com workspaces

As well as the editing mode (now called Photoshop Express Editor) we have been looking at here, Photoshop.com has two other tool areas – Photoshop Express Organizer and Photosus.

As well as the editing mode (now called Photoshop Express Editor) we have been looking at here, Photoshop.com has two other tool areas – Photoshop Express Organizer and Photosus.

Shop Express Style Match – and two viewing areas – My Gallery and My Library – that can be used to manage and view your photos. Access these areas from the entries in the Me and Online Tools menus of Photoshop.com.

My Library and My Gallery areas are available only when you are signed in as a registered member of the site. These workspaces are private and viewable only by you. You can decided to invite specific friends and family to view the Online Albums stored here and marked as private, but apart from these selected viewers, no-one else can access the photos stored in this area. Even then, they only have access to the Albums that you choose. A special version of My Gallery complete with your details and any public albums is viewable when the public navigates their way to your Photoshop.com webspace. The My Friends area is also part of the public face of your Photoshop.com account. Here you can not only view any of your Albums that you have chosen to invite others to view, but also the shared albums of other Photoshop.com users as well.

My Gallery - public and private viewing

The My Gallery area is unique among the workspaces in Photoshop.com as it can be viewed both by the public and also by the user. When signed in, you see a list of public Albums on the left of the screen, some details about the member that can be edited and thumbnails for the public albums in the main display area. You can choose whether albums are private, viewed by invitation only or totally public. These changes are made in the My Library workspace where all albums are displayed. Public or shared albums are marked green if they are shared with select viewers and blue if they are made public on Photoshop.com and those

Home – The Home area is accessed by clicking the Photoshop.com icon on the left of the menu bar. It contains a menu bar across the top of the screen. Clickable adverts or information spots in the central area and most importantly a Sign In option to allow you access to your personal working space. This is typically where you will first land when typing www.photoshop.com into the browser.

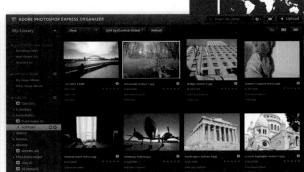

My Library/Organizer – This area is the same as the Organizer tool workspace. It contains an Upload Photos button (top right). Just below this is a file manager view of your library and albums plus links to other photo sharing sites. The main workspace displays image thumbnails and their associated information. This is the starting point for most image actions including rating, editing, printing, publishing, decorating, linking, saving and emailing.

My Gallery – This workspace displays any online albums that you have created in Photoshop.com or uploaded from Photoshop Elements. There is also space for displaying member details and buttons for publishing, emailing or linking your albums. Albums marked public can be seen here by anyone. This is what the public sees when they navigate to the URL – phil-andrews.photoshop.com.

My Friends – Switch to the My Friends space for viewing all the online albums created and shared by Elements users. Only albums that you mark as Available to invited friends will appear here. Albums of other Photoshop.com users that you have been invited to share are also displayed here.

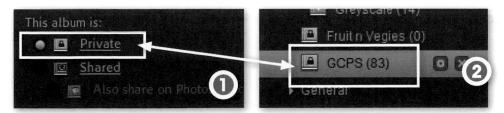

Who has permission to view the photos in your albums can be altered by choosing a different setting in the Permissions section (1) of the Album Settings dialog. Private albums are marked with a lock (2). Those viewable by invitation only are green and those shared with the public at Photoshop.com are blue.

The view of My Gallery that you see when you are signed in (1) and the view the public sees when displaying your Photoshop. com web page (2).

that are private are indicated in gray with a small lock icon. The state of any album can be changed by selecting the entry, clicking on the Settings icon to the right of the album title and selecting a new set of permissions from the dialog that pops up.

A different view of this My Gallery is displayed when a user navigates to your Photoshop. com website. The public will see a list of albums that you have marked as being able to viewed by everyone on the right of the screen. The member details are displayed in the same spot but when viewed by the public this information is not editable.

Private and Shared Albums

Using the idea of private and public albums provides the Elements user with security over the content that they produce, but the choice doesn't have to be one or the other. You also have the option to invite a set of individuals to view your otherwise private album. The invitations are sent out via email and each message contains a special link that the viewer can follow to see your photos.

Setting up and sending the viewing invitations can be accomplished in several ways. The first is at the time of creating the Online Album in Photoshop Elements. As we saw earlier in

To display an Album to only those people you invite choose the Shared option (1) and then click the Link to Slideshow entry (2). Next, add the recipients' and click Share (3).

E-mail Link to Grid or Email this chapter, one of the options available to the user when working their way through the Sharing Options in the Online Album wizard is to Send Email To my contacts. Here you can addresses and a message add a message and select the recipients before hitting the Done button to send out the email invitations.

As an alternative for Online Galleries being managed in Photoshop.com, you can select the Shared and Email Link options in the Permissions section of the Album settings dialog. Albums that are marked private or Shared on Photoshop.com can be made semi-private, or is that semi-public, in this way.

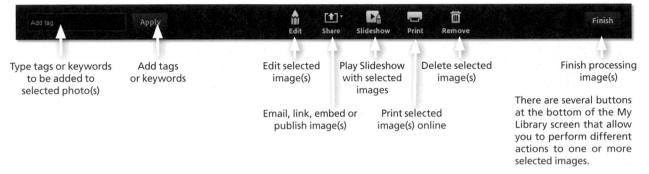

Extra Photoshop.com features

If you look to the bottom of the My Library window you will see a range of other Photoshop. com features that we have yet to cover. These include a Slideshow option to view the current Album as a slideshow, the Decorate button for adding graphics, text and frames to selected photos, Link, Publish and Save buttons and a Remove Photo option for clearing the images from the Photoshop.com image collection.

Adding Tags or Keywords

As we have already seen, in Photoshop Elements keywords or tags are an essential tool used by photographers to help locate images in their ever-increasing library of photos. Tags can be added in three ways in the My Library workspace:

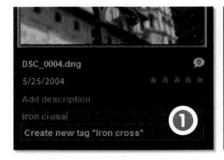

- 1. By clicking the Add Tags entry under the image thumbnail and typing keyword into the text box that appears.
- 2. By selecting the image first, typing the keyword into the Add Tag text box at the bottom left of the workspace and then clicking the Apply button.

Add keywords to your photos in Photoshop.com via the (1) Add Tags section below the thumbnails, (2) the Add Tags area at the bottom of the My Library workspace or (3) the Add Tags area of the Photo Info panel.

WEB AND SERVICES

By adding the keywords into the Add Tags section of the Photo Info panel. Display the panel by Selecting the Show Photo Info entry from the Photo Options menu.

Edit/Decorate

Clicking the Edit button at the bottom of the My Library workspace with an image selected will open the file in the Photoshop Express Editor. We have already reviewed the key controls in this part of the site, but alongside the editor is a second mode – Decorate. Switch between the two modes by clicking the entry at the top of the right-hand panel.

This workspace provides you with the ability to add graphics, text and frames to images in Photoshop. com. Clicking the button displays a larger view of the selected photo and changes the options available on the left of the window to a list of graphics that can be added to the photo. Selecting any of the entries other than Text will display a small floating palette containing the graphics options available for the entry.

Graphics, text and frames can be added to your photo via options in the Decorate area.

Using the Text option in Library workspace it is possible to add type to your alignment and opacity can tings at the bottom of the screen (1).

the Decorate section of My In the case of the Animal group, the palette contains thumbnails of different animal characters that can be added to the photo. To include one of the creatures just click on pictures. The font, color, the thumbnail and then press the Add button. Next, use the corner handles of the placed be adjusted with the set-graphic to change its size and click-drag anywhere on the graphic itself to reposition the picture. A further set of options is available from the drop-down menu accessed by clicking the downward-facing arrow at the top of the frame.

> Text can be added to images in a similar way by selecting the entry from the Decorate menu on the left of the window, typing the text into the text window and then adjusting the settings available at the bottom of the preview area.

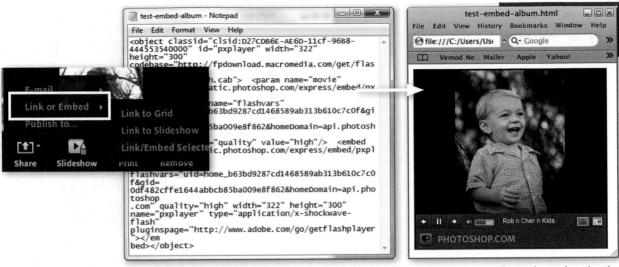

Linking, emailing and publishing Photos and Albums

Clicking the Share button at the bottom of the screen displays a menu contain three headings – Email, Link or Embed and Publish To.

Under the Email heading there are options to email links to Grid or Slideshow views of the

photos as well as a third choice to email a selected image file. The Link heading contains entries for providing links for both Grid and Slideshow views and an option to embed selected items as well. Both embedding and linking copy a piece of html code that describes the image, its size and where it is stored on the internet, to the clipboard. HTML or Hyper Text Markup Language is the coding used to build web pages. This piece of code can then be pasted (Ctrl/Cmd V) into a webpage to either provide a link to the photo, or as a means of embedding the picture in the webpage. Rather

Link code needed by different social networking sites can be obtained by clicking the Publish button at the bottom of the My Library workspace.

than embedding an individual Image, the Link Slideshow or Link Grid version of the feature embeds the whole album. This gives you the ability to place Photoshop Elements Online Albums in websites other than Photoshop.com. Cool!

Clicking the Publish button will display a floating palette containing a set of options for popular sharing websites. These include sites such as Facebook, MySpace, iGoogle, Yahoo! and Blogger. Clicking one of these options will provide you with a quick way to place a link for your image or album into the pages of your favorite social networking site.

By copying and pasting the code needed to display your album into new or existing web page, you can successfully display your photos in a range of websites other than Photoshop.com.

WEB AND SERVICES

These features may seem a little obscure to many of you, but they do provide a way of featuring your photos on other websites around the world quickly and easily. In the example above, the copied text was pasted into a new text document that was saved as the 'test-embed-album.html' file. The file was then opened into a web browser and the animated album appeared.

Slideshows at Photoshop.com

Alongside managing and editing your pictures, Photoshop.com is also great at displaying images. As we saw earlier in the chapter, the Online Albums, or slideshows as they are called in Photoshop.com, that you create in Elements can be uploaded to the website and viewed either by the general public or by a select group of friends or family members. Using the Online Album feature in Elements to create these slideshows provides the user with a

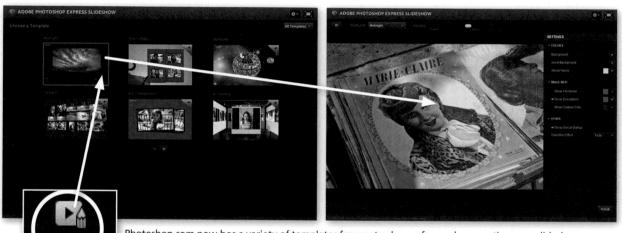

Photoshop.com now has a variety of templates for you to choose from when creating your slideshows.

great deal of control over the look of the final web gallery. Apart from being able to select from a range of designs or templates for the website, you also have the chance to adjust colors and titles for most designs.

However, this is not the only way to view your images on Photoshop.com. The website has a range of built-in slideshow templates that can be automatically applied to albums stored on the site. In the latest update of Photoshop.com you can choose from many more web gallery

templates than the three main styles that were available previously. Like the slideshow options available in Elements itself, you get to choose from a variety of designs and then customize the look of the gallery by altering the text included, the colors used and, in some cases, the layout of the design as well.

To add a slideshow style to an Album, select its entry in the My Library workspace and then click onto the Slideshow option at the bottom of the screen. You will be presented with a set of slideshow templates that you can use to style the look of the presentation. Some of the designs, the ones with a gold ribbon across the top right of the thumbnail, are only available to Plus members.

Template designs with a gold ribbon across the top right are only available to Plus members.

Next, click the Choose button at the bottom of the template screen. A new screen will appear and you will see a preview of the album's images in the selected slideshow template. Some templates will also display a settings palette where you can alter design settings like color, included text and titling of the presentation. Clicking the Finish button will apply the slideshow style to the album.

Next time you share the album as a slideshow, embed a link to the slideshow or a member of the public selects the slideshow view of the album, the images will be presented in the design you selected.

To switch between slideshow styles return to the My Library workspace, select the album again and then click onto the Slideshow button at the bottom of the workspace. Next choose a different template, adjust the design's settings and click the Finish button once more.

Adjusting the template

Photoshop.com has a variety of controls that can be used to adjust how your slideshows look and work. The range of controls varies from one template to another.

With most designs you can alter the length of time that each slide is displayed using the Pacing slider at the top of the slideshow screen.

More specific controls for each slideshow style are displayed in a Settings panel on the left of the workspace when they are available for the design. In the Settings panel you will often find controls for Layout, Viewing Settings and Audio.

If you find the design you have selected is not all you expected then you can switch templates midway through styling by selecting another design from the drop-down Template menu located at the top of the workspace.

The slideshow display can be altered via the controls in the settings pane. The pane will be displayed in the slideshow workspace automatically if the template has design characteristics which are adjustable (1).

The timing of the presentation can be altered with the Pacing slider located at the top of the Slideshow workspace (2).

Template designs can be switched without having to recommence the styling process by selecting a new option from the dropdown template menu at the top of the workspace (3).

To send a photo via email just select the image in the My Library area of Photoshop.com and then click onto the Share button and choose the Email Selected Item option.

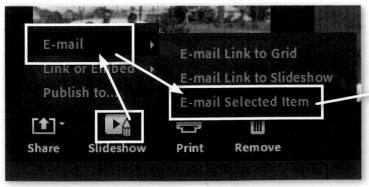

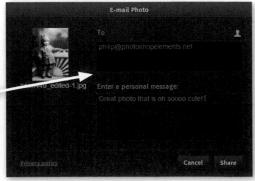

Emailing from Photoshop.com

In an earlier section of this chapter we looked at different ways to email your photos to your friends and relatives from Photoshop Elements, but while we are discussing features found at Photoshop.com, we should examine the site's email potential as well.

Let's start with the simple task of how to email individual photos. After selecting the photo that you want to send from the My Library workspace, click onto the Share button at the bottom of the screen and choose the Email Selected Item option from the pop-up menu. This will display a small E-mail Photo window where you can add an address and a short message before clicking the Share button.

If you want to send the same image to multiple recipients then you can add several addresses in the dialog as long as they are each separated by a comma.

Photoshop.com also lets you make use of the email contacts that you already have stored on your computer. Most users will already have a collection of addresses stored in their email

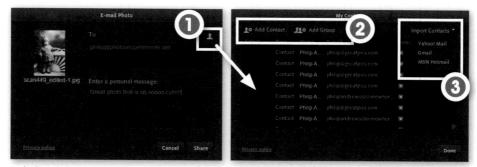

Include existing contact details in the To area of the E-mail Photo dialog by clicking on the (1) person icon in the top-right and selecting the contact from the listed entries. New entries can be created with the Add Contact or Add Group buttons (2). Sets of existing details can be added via the options in the Import Contact menu (3).

program. Photoshop.com can import and use these contacts with its email features. You can import contacts from Yahoo!Mail, Gmail or MSN Hotmail or synchronize the contacts you already have in your Photoshop Elements Contacts Book (this happens by default). When emailing a photo from Photoshop.com you have the option of clicking onto the person icon in the top right of the E-mail Photo window and selecting the recipients for the message from the contacts listed.

Contacts are managed in the My Contacts dialog. They are imported by selecting the type from the Import Contacts menu on the top left of the dialog. Individual email addresses or groups of details can also be created via the Add Contact and Add Group buttons.

Emailing an Album

Photoshop.com also has the ability to email a link to an album of photos. At the moment this is the only way to email a group of images. So if you are wanting to send several pic-

tures to your friends add them to an album first and then select the album entry from those listed on the left of the My Library workspace.

Next, select the Share button at the bottom of the screen and choose the E-mail Link to Grid or E-mail Link To Slideshow option that appears on the pop-up menu. Insert the email addresses of the recipients and add a short message in the dialog that appears. Keep in mind that this option doesn't actually email all the photos in a message to your recipients. Instead, the feature sends a message containing a link that recipients can use to view the photos at your Photoshop.com webspace.

Order Prints

As you will see in the next chapter, Photoshop Elements has a very powerful print engine built into the program. It is just as easy to print individual photos, groups of images and order photos to be printed by a third-party printing laboratory from the Organizer as it is the Editor workspaces. With the linking of Elements to Photoshop.com we now have a couple of extra printing options.

The same Order Print option (called just Print here) found in Photoshop Elements is also available to use with images that are stored online. To use the feature, select one (or a few) of the images in the My Library workspace and click the Print button at the bottom of the window. This will transfer the file to Adobe's printing partner ShutterFly.com. By following the steps in the ShutterFly.com wizard you will then be able to choose the size and quantity of photos, pay for the order and have them printed and delivered.

A confirmation screen is displayed when deleting files. When deleting files from an Album there is also an option to remove them permanently from your library.

Deleting images from Photoshop.com

Selecting a photo in the My Library workspace and clicking the Remove button at the bottom of the screen is the easiest way to remove a photo from a selected Album. Selecting the 'Permanent Delete' option in the Remove Item dialog that is displayed also removes the photo from the library.

Downloading images to the desktop

Selecting the Download Photo entry from the Photo Options menu will display the Download Photo dialog. Here you can select the size of the file (the image dimensions) that you

want to transfer, before pressing the Save button to complete the process. This sizing option is very handy if you are wanting to add the photo to a website, as the dialog presents you with options for downloading a thumbnail size as well as an image that is suitable for full screen viewing. A link button is also included in the dialog. This option displays the code needed to display the selected photo at the size nominated.

The fully featured Slide Show editor in Elements provides a variety of output options.

Creating your own slideshows

As we have already seen in Chapter 5 Elements contains a Slide Show editor that can produce a variety of different types of presentations. The feature contains an easy-to-use interface and options that allow users to create true multimedia slide shows complete with music, narration, pan and zoom effects, transitions, extra graphics, and backgrounds and titles. The finished presentations can be output as a file, burnt to CD or DVD, emailed as a slideshow, or sent to Premiere Elements for further editing (for users who have this program installed).

Creating slideshows

Creating presentations in Elements uses an approach that centers all production activities around a single editor interface and it is only at the time of outputting that you choose the type of slideshow that you want to create. In this way you can create (and save) a single slideshow project and then repurpose the presentation in many different forms (online, DVD, PDF slide show or direct to TV) by simply selecting different output options.

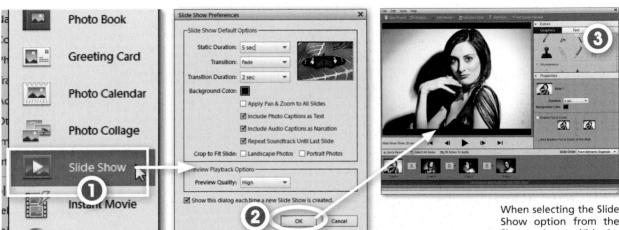

Slideshows in action

Although the Slide Show editor may at first seem a little complex, having all the controls in one place certainly means that you can create great multimedia presentations easily and efficiently.

The following key features are included in the Editor:

- Automatic editing: Rotate, size, change to sepia, black and white or back to color and
 apply Smart Fix and Red Eye Fix to your photos without leaving the Slide Show editor.
 Click the Preview image to display the edit options in the Properties palette.
- Styled text: Select from a range of text styles with click, drag and drop convenience.
- Add graphics: The Slide Show editor now includes a variety of clip art that can be
 added to your presentations. Double-click or click-drag to place a selected graphic onto
 the current slide.
- **Transitions:** Add individual transitions between slides by clicking the area in the middle of the slides in the storyboard and then selecting the transition type from those listed in the Properties pane.
- Pan and Zoom: Add movement to your still pictures by panning across or zooming into your photos. Simply select the slide in the storyboard and then check the Enable Pan & Zoom option in the Properties pane. Click on the left thumbnail (Start) and set the starting marquee's (green) size and position, then switch to the right thumbnail and adjust the ending marquee's (red) size and position.

Show option from the Share task pane (1) in the Organizer workspace, the Slide Show Preferences (2) dialog is displayed first, allowing you to set the default options that will apply to the whole presentation. After clicking OK the full Slide Show editor is displayed (3).

Add photos/ video/audio

Output options Add blank slide

Extra palettes for adding graphics, text and narration

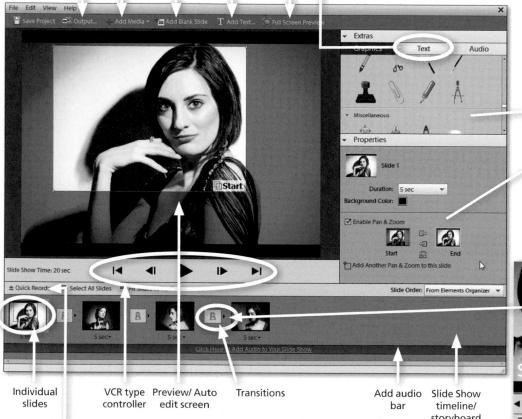

Extra palettes area

Pan & Zoom, duration and Background color settings palette

> Transition settings palette

storyboard

Jump to Quick Reorder screen

Preview screen

return to main screen

Quick Reorder screen

The Slide Show editor provides a single workspace for the creation and editing of your presentation.

- Quick Reorder: This sequencing screen enables you to quickly and easily adjust the
 position of any one photo in the presentation sequence using click and drag.
- Music and narration: Add music and extra audio to the show using the Add Media button and incorporate narration using the built-in slide show recorder.

Step-by-step Slideshow creation:

- 1 Preselect the photos to include in the show from within the Photo Browser and then select Organizer: Create task pane > Slide Show.
- 2 Set the defaults for the presentation in the Slide Show Preferences dialog.
- 3 Adjust the slide sequence by click-dragging thumbnails within the storyboard or Quick Recorder workspaces.
- 4 Insert transitions by clicking the space in between slides and selecting a type from the menu in the Properties pane.
- 5 Add graphics and text by click-dragging from the Extras pane.
- 6 Record voice-over by selecting a slide and then using the Narration option in the Extras pane.
- 7 Add existing audio by clicking the soundtrack bar at the bottom of the storyboard.
- 8 Produce the slideshow by selecting File > Output Slide Show and picking the type of presentation to produce from the Slide Show output dialog.

Editing the slide photos

The Properties palette displays several simple editing controls when you click a photo in the preview area of the Slide Show editor. Although the best approach is to ensure that all editing and enhancement changes are applied to the photos before their inclusion in a presentation project, these controls can be used for making quick simple changes to the images used in individual slides.

The options include:

Rotate – Pivots the photo 90° left or right.

Scale – Makes the photo bigger or smaller.

Crop to Fit – Enlarges the photo to fill the whole slide frame even if this action crops the edges of the picture.

Crop to Slide – Fits the photo within the boundaries of the slide without cropping any image details.

Clicking the photo in the preview area of the Editor switches the contents of the Properties palette to contain simple editing tools. These include Rotate left and right, Scale and Crop options, Auto Smart Fix, Convert to black and white or sepia buttons and Auto Red Eye Fix.

WEB AND SERVICES

Auto Smart Fix – Applies automatic adjustment of color, contrast, brightness and sharpness to the picture.

Convert to Black and White - One-click conversion to black and white.

Convert to Sepia – One-click conversion to sepia-toned monochrome.

Auto Red Eye Fix – Removes red eye from portraits taken with a flash.

More Editing – Opens the slide in Elements' Editor workspace where the edited file is saved as a Version Set and added to a catalog once complete.

For more advanced editing tasks click the More Editing button to transfer the photo to the Expert workspace.

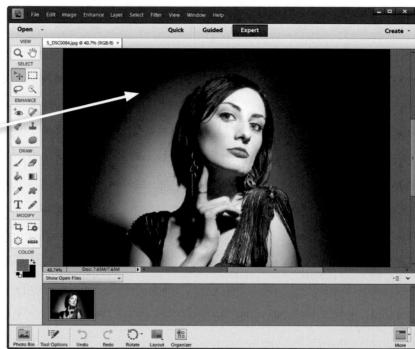

Printing

Despite the great rush of picture makers to 'all things web', most treasured digital images still end up being printed at some stage during their existence. Contributing to this scenario is the current crop of affordable high quality inkjet printers whose output quality is nothing short of amazing. A decade ago it was almost impossible to get photographic quality output from a desktop machine for under \$5000, now the weekend papers are full of enticing specials providing stunning pictures for as little as \$50.

In this chapter we'll look at the way that you can get great prints using Elements.

1 of 3

Printer manufacturers have simplified the procedure of connecting and setting up their machines so much that most users will have their printer purring away satisfactorily within the first minutes of unpacking the box. Software producers too have been working hard to simplify the printing process so that now it is generally possible to obtain good output from your very first page.

Elements is a good example of these developments, providing an interactive printing system that previews the image on the paper background 'virtually' before using any ink or paper to output a print. It also has the ability to print multiple photos, make a contact sheet of different images or produce a print package of different sized pictures optimized to fit on a specific paper stock.

Current inkjet printers are capable of providing photographic quality images at a fraction of the cost of comparative technology just a few years ago.

Pathways to printing in Elements

One of the fantastic things about working in Photoshop Elements is the sheer variety of print options available to you. Not only can you print from the main Editor workspace, but you are also able to output from the Organizer. If that isn't enough choice, there is also the option to print online using third-party print providers such as ShutterFly. Cool!

Elements users can print from the Organizer (1) or Editor (2) workspaces. The same Print dialog (3) is used for both workflows.

Output from the desktop

Photoshop Elements can also print multiple images in a batch form from the Editor work-space. You will also notice that the Print dialog is the same design irrespective of whether you are printing from the Organizer or Editor workspaces. There are also more print controls exactly where you need them...in the Print dialog! No longer is there any need to exit the Elements print environment to change things such as the paper type, print quality, paper tray, or paper size. The task of sizing and positioning your photos on the page also gets easier with a zoom slider and the ability to click-drag the photo around the page.

Elements.

Web-based printing

Easy desktop printing with your own machine is not the only output option in Elements. There are also several ways to have your photos printed by trusted online providers such as ShutterFly.

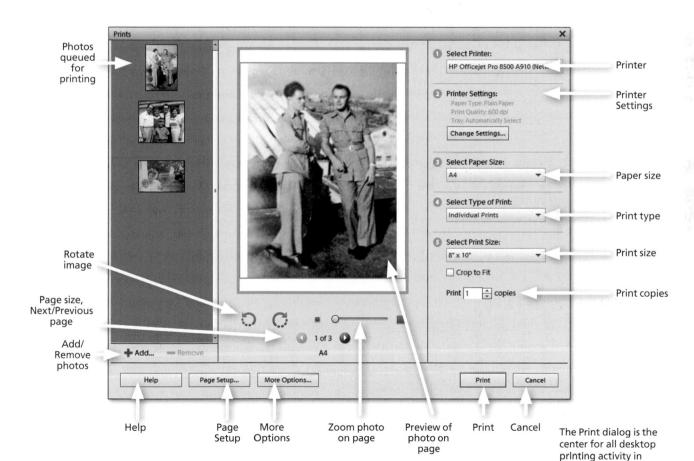

Printing the Elements way

All of the key print settings for Elements are now contained in Print dialog. This is a change from previous versions where multiple dialogs were used depending on the workspace you were working in, or the number of photos you wanted to print.

The Print dialog is the first stop for most users wanting to make a hard copy of their digital pictures. The same dialog is displayed when you select File > Print from either the Editor or Organizer workspaces, or by clicking the Print Bin Files entry located on the Bin Actions menu of the Project Bin.

The Print Dialog

The settings in the dialog are broken into five different sections that are numbered and are located on the right on the window. They are:

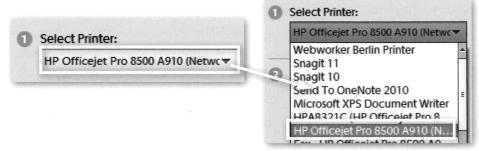

Select Printer – This drop-down menu contains a list of all the printers installed on your computer. The settings listed in other parts of the dialog are dependent on the choice of printer so it is important that you select your printer first before proceeding to adjust other options.

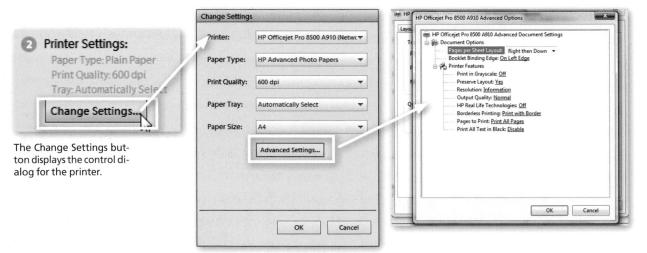

Printer Settings – A list of current printer settings is displayed in this section of the dialog. This is handy as it gives you a place where you can quickly check that you have not done something silly like picking a low print quality when you are producing a high quality presentation print.

To alter the settings displayed here you will need to click the Change Settings button. This action displays the new Change Settings dialog. Here you can change printer, paper type, print quality, paper tray and paper size via the associated drop-down menu. For the most

part, altering the settings listed here will allow you to match the printer settings with your required outcome but if you need finer control, then you can access the printer driver controls directly by clicking the Advanced Settings button.

Different print manufacturers supply different controls and dialogs with their printers. The example shown here is for a Epson printer, but it could just as easily be a Canon, Lexmark or HP printer. The Epson dialog contains three tabbed screens with settings for paper, print, orientation, page and quality options alongside feedback on ink levels and maintenance functions.

You will need to click the OK button to apply changed settings in either the Printer, or Change Settings, dialogs. This action also closes the window.

The Paper Size is the dimensions of the paper that you are using for printing.

Select Paper Size – The third setting in the Print dialog is the Select Paper Size option. Here you can choose a specific paper size from those available for your printer. To change the paper size displayed just select an alternative from the drop-down list.

Elements contains an interactive print system that can not only produce single image prints, but also contact sheets, picture labels and multi-print packages.

- (1) Individual print.
- (2) Contact print.
- (3) Picture package.

Select Type of Print – The Type of Print setting determines how your images appear on the page. The Individual Prints option places a single photo on the paper, Contact Sheet creates a print with all selected photos displayed as thumbnails and Picture Package provides the ability to print more than one on a page.

The Print Size setting determines the maximum dimensions of the photo on the paper.

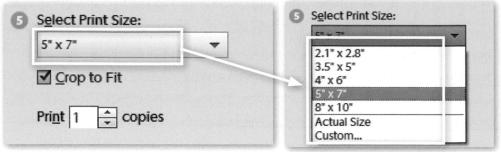

Select Print Size – The Print Size setting selects the size of photo on the page. So choosing a 5" x 7" print size will create a space this size on the page that you can fill with a photo. This space is also called the Photo Well. A variety of Print Sizes are included in a drop-down menu.

There are also options to display the photo as Actual Size, or with a Custom print size, a frame size of your own choosing. The print size and position is displayed as a blue frame on the paper background in the Print dialog preview. The blue frame will not print. It is just to show you where the frame is on the page.

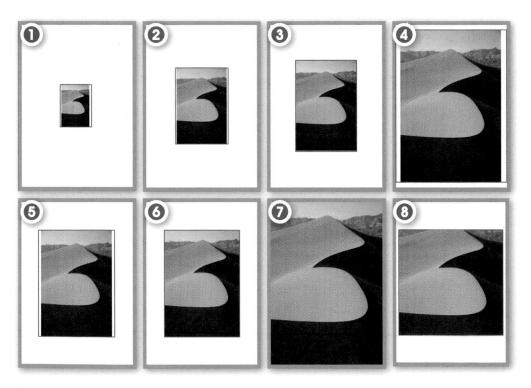

The Print Size setting in the Print dialog controls the size of the photo on the background. Here you can see varying print sizes on an A4 sheet. (1) 2.1"x 2.8". (2) 3.5" x 5". (3) 4" x 6". (4) 10" x 8". How the photo fills the Print Size (or Photo Well) is controlled by the Crop to Fit setting. (5) Crop to Fit not selected. (6) Crop to Fit selected. There are also two other options on the Print Size menu: the (7) Actual Size and the (8) Custom size.

If the photo is not the same shape as the Print Size you have selected, then the image will be resized to fit within the frame. This may mean that you will have some white space on the left or right of the photo, or top and bottom. If you want the blue frame filled totally with the photo, even if this means that the some parts of the picture will be cropped in the process, then select the Crop to Fit option just below the print size menu.

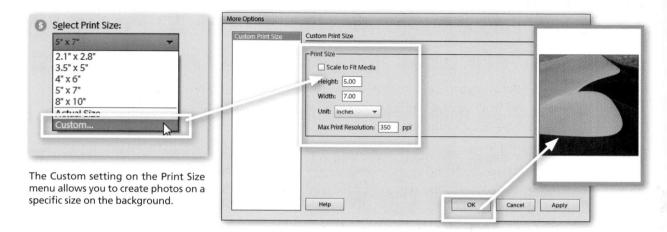

Creating a Custom Print Size

Choosing the Custom entry from the Print Size menu displays a More Options dialog. Here you can enter specific dimensions and format for a set Print Size. Clicking the OK button will close the dialog and redraw the print preview in the new Print Size. Clicking the Apply button will redraw the preview with the new print size but keep the More Options dialog open. This allows you to try a few different size and format combinations before pressing the OK button.

Additional dialog options

The five key controls listed above contain the majority of the settings that you will use for many print jobs. Elsewhere throughout the dialog are other options, menus and settings for further printing refinement. They include:

The Print copies setting controls the number of copies of the photo which are printed.

Print copies – The Print Copies setting is located at the bottom of the Print Size section on the right of the dialog. Here you can set the number of copies of the print that you are instructing the printer to create. By default this option is set to 1 but can be easily changed with the up and down arrows.

Help – The Help button links through to the Printing section of the Elements' help system.

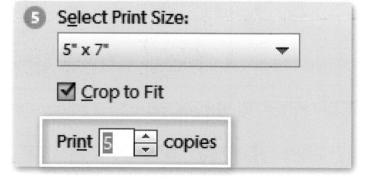

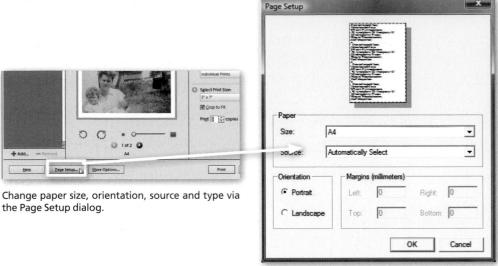

Page Setup – The Page Setup button opens an operating system dialog of the same name with settings that control the paper size, source and orientation.

More Options – This button opens a More Options dialog containing three different settings groups: Printing Choices, Custom Print Size and Color Management.

Printing Choices include options for printing information stored with the photo. This includes the capture date, any captions added in the Elements Organizer workspace and the file name.

The One Photo Per Page setting available in Organizer Print dialog is critical for ensuring that only one image is placed per page. If you regularly select multiple pictures for printing then ensure that this setting activated or you'll end up with multiple photos on a single page.

The Flip Image setting reverses the photo when printing and is typically used for outputting to iron-transfer material.

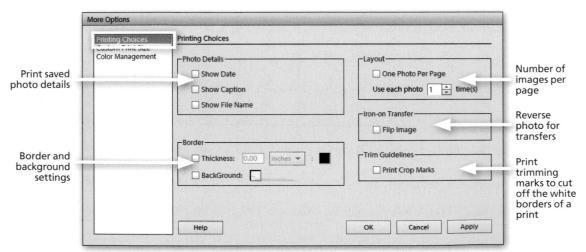

The color and thickness of an image border and page background can be selected from the Border section of the dialog.

Printing trim guidelines provide a quick cutting guide if you want to remove the white edges surrounding a photo smaller than the page that it has been printed on.

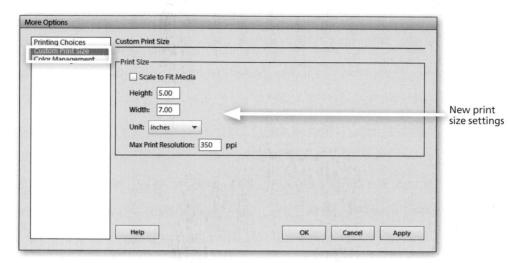

The *Custom Print Size* section of the More Options dialog provides another way to enter a print size of a specific set of dimensions and format. You can also set the maximum resolution used for creating prints. This value is measured in PPI or pixels per inch.

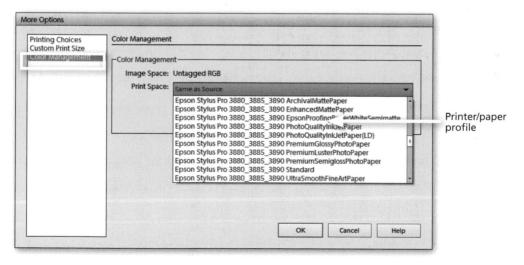

The last section of the More Options palette contains a key setting for print color management. Here you can select the Print Space used by Elements to correctly adjust the photos' colors to match the characteristics of printer, inks and paper stock. Most print manufacturers supply such Print Space profiles with the print drivers for their machines. If your printer is properly installed then all you need to do is select the correct profile from the drop-down list. Here you can see a list of the profiles available for different papers when used with the Epson Stylus Pro 3890 printer.

PRINTING

Differences between More Options in Editor and Organizer

There are slight differences in the settings available in the More Options dialog when printing from the Editor and Organizer workspaces. The Color Management section in the Editor Print dialog has more options including the ability to change how color is handled by Elements and what rendering intent is being used when matching colors to a printer's abilities. There are more details about color

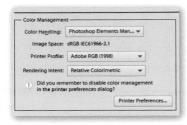

management later in this chapter. Another difference is that there are fewer settings in the Print Choices section. When printing from the Editor you do not have the One Photo Per Page layout option.

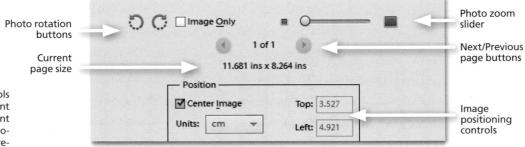

There are several controls located beneath the print preview part of the Print dialog. These include photo rotation and next/previous buttons as well a zoom slider for magnifying images within the photo well.

Zoom Control – Located just below the print preview in the center of the dialog, the photo zoom control provides the ability to enlarge the selected photo within the photo well. Once the picture is larger than the well, the edges of the photo will be cropped. You can then click and drag the photo around the well, choosing what parts of the photo to review and what to crop.

Image orientation buttons – Also in this section are two image orientation buttons. One rotates the photo ninety degrees to the right and the other does the same action, but to the left. Keep in mind that these buttons rotate the photo inside the photo well, not the well itself.

Add/Remove buttons – The add remove buttons located at the bottom of the thumbnails on the left of the dialog provide another way to add extra images to the print dialog. Or, alternatively, the remove button can be used to drop a selected thumbnail from the print queue.

Printing from the Project Bin

As we have already seen you can print your pictures directly from either the Editor or Organizer workspaces. For quick printing tasks, there is also the option to output from the Project Bin as well. The Project Bin provides a way for you to quickly access the files you have in the Organizer space without leaving the Editor. Open files are automatically displayed in the Bin but other files can also be displayed by selecting their entry in the menu on the right of the bin's title bar. The menu options include Show Files from Elements Organizer, a list of Organizer Albums and Show Open files. After selecting an entry you can print all

photos displayed in the bin by choosing the Print Bin Files option from the Bin Actions menu located at the top right of the Bin. This will open the photos into the Editor workspace and then add them to the Print dialog ready for printing.

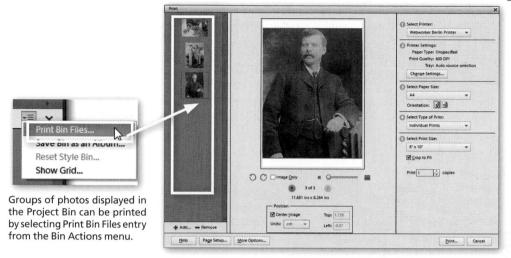

The link between paper type and quality prints

When you first start to output your own images, the wide range of printer settings and controls can be confusing. To start with, it is best to stick to a standard setup and allow the built-in features of the driver to adjust the printer for you. For most printing tasks, selecting the paper type in the Print Settings of the Print dialog will be sufficient to ensure good results.

The manufacturers have determined the optimum ink and resolution settings for each paper type and, for 90% of all printing tasks, using the default settings is a good way to ensure consistently high quality results. So if you are using gloss photographic paper, for example, make sure that you select this as your paper type in the Printer Settings section.

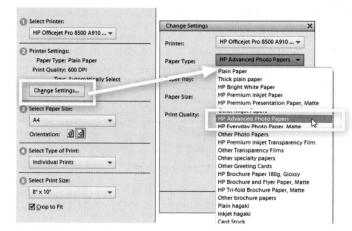

Correctly selecting the right paper will go a long way towards ensuring good print quality.

Most photographers choose to print their photos one at a time. The Individual Print option in the Print dialog is designed for this purpose.

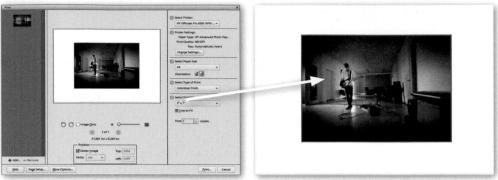

Making your first print

With an image open in the Editor workspace or selected in the Organizer, display the Print dialog (File > Print). Start by selecting the correct printer for the job from the drop-down list at the top right of the dialog. Then work your way down the numbered options making sure to check the preview to ensure that the whole of the picture is the size and format that you desire. Select the Individual Prints option from the Type of Print section of the dialog. If you are printing from the Organizer space then you should also choose the One Photo per Page setting from the More Options section. This ensures that the selected photo is centered on the page. To print, select the Print button.

Single print workflow:

- 1 Open a photo into the Editor workspace or select a thumbnail in the Organizer. Select File > Print.
- 2 Choose the correct printer from the drop-down section of the Select Printer section in the Print dialog. This section is labeled 1 in the dialog.
- 3 Check the paper type and print quality in the summary section of the Printer Settings (labeled 2). If you need to alter any of these options then click the Change Settings button and choose different values from the drop-down menus.
- 4 In the third section of the dialog select the paper size that you want to print on.
- 5 Now set the Type of Print (labeled 4) to the Individual Prints setting. If you are working in the Editor space this selection will automatically center your photo in the middle of the page. When printing from the Organizer, make sure that you also select the One Photo Per Page settings located in the More Options dialog (accessed by clicking the More Options button).
- 6 Now to set the size of the print on the page. This is often called the photo well as the image will sit within the borders of this size. Select Print Size from the dropdown menu or create your own using the Custom setting. Click the Crop to Fit option to fill the well with the image. Set the number of copies of the print to output. All these settings are in section 5 of the print dialog.
- 7 Click Print to output the photo.

Making multiple prints

In the last few years the digital camera market has exploded. Now digital camera sales easily outstrip their film-based counterparts over the same selling period. And with the onslaught of these new silicon shooters has come a change in the way that people take pictures. Users are starting to alter the way they shoot to accommodate the strengths of the new technology. One of these strengths is the fact that the act of taking a picture has no inherent cost. In comparison, film-based shooting always involved a development cost associated with the production of negatives and prints, as well as the initial purchase of the film, whereas digital picture taking is essentially without cost. Yes, there is the outlay for the camera and the expense associated with the storage, manipulation and output of these images, but the cost of shooting is zero. Hence, it seems that the typical digital camera user is shooting more pictures, more often, than they were when capturing to film. So it is very important to be able to print good quality photos quickly and easily. Thankfully Elements provides a range of ways to output multiple files.

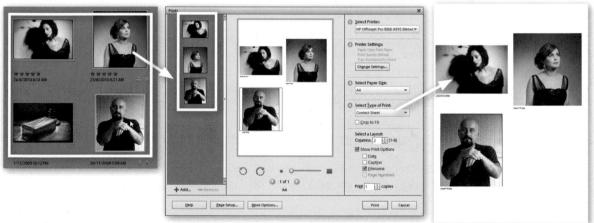

Contact sheets

Digital photographers are not afraid to shoot as much as they like because they know that they will only have to pay for the production of the very best of the images they take. Consequently, hard drives all over the country are filling up with thousands of pictures. Navigating this array of images can be quite difficult and many shooters still prefer to edit their photographs as prints rather than on screen. The people at Adobe must have understood this situation when they developed the Contact Print feature for Photoshop Elements.

From within one feature, the imaging program creates a series of small thumbnail versions of all the images in a catalog or those that were multi-selected before opening the tool. These small pictures are arranged on pages and can be labeled with file name, captions and dates. From there it is an easy task to print a series of these contact sheets that can be kept as a permanent record of a folder's images. The job of selecting the best pictures to manipulate and print can then be made with hard copies of your images without having to spend the time and money to output every image to be considered.

The Contact Sheet option provides the ability to create thumbnail versions of your images collated on a single page.

The options contained within the Contact Sheet dialog allow the user to select the number of columns of image thumbnails and the content of the text labels that are added. The page size and orientation can be chosen via the Page Setup button.

Contact Sheet workflow:

1 If working in the Editor workspace, open the images to be printed; otherwise multi-select the pictures from inside the Organizer.

- 2 Select File > Print and choose Contact Sheet from the Type of Print menu. If you are working in the Editor space this action will transfer you to the Organizer and open another version of the Print dialog there.
- 3 Use the Add and Remove Photos buttons to adjust the list of pictures to be included in the contact sheet.
- 4 Select the printer from the drop-down list in section 1 of the dialog. If need be, change the Printer Settings and Paper Size values.
- 5 With Contact Sheet selected from the drop-down list of print types, a Select a Layout option is displayed. Here you can choose the number of columns to use (and therefore the total number of thumbnails to be placed on a single sheet) and select if any text, such as file names, captions or date, is to be included alongside the thumbnails.
- 7 Click Print to output the contact sheet.

The options in the Contact Sheet dialog allow the user to select the number of thumbnails per page by adjusting the columns value as well as what text will be included as labels.

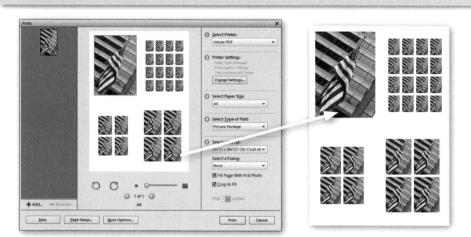

Picture packages

At some stage in your digital imaging career you will receive a request for multiple prints of a single image. The picture might be the only shot available of the winning goal from the local football match, or a very, very cute picture of your daughter blowing out the candles on her birthday cake, but whatever the story, multiple requests mean time spent printing the same image. Adobe included the Picture Package feature in its Elements to save you from such scenarios. The feature is part of the Print dialog and can be selected from the Type of Print section.

There are many different Layout and Frame designs included in the revised Picture Package feature.

The feature allows you to select one of a series of pre-designed multi-print layouts that have been carefully created to fit many images neatly onto a single sheet of standard paper. There are designs that place multiples of the same size pictures together and those that surround one or two larger images with many smaller versions. The feature provides a preview of the pictures in the layout. You can also choose to repeat the same image throughout the design by selecting the Fill Page with First Picture option. There is also the option to select a frame from one of the many listed to surround the photos you print.

Whichever layout and frame design you pick, this feature should help you to keep both family members and football associates supplied with enough visual memories to make sure they are happy.

Picture Package workflow:

- 1 If working in the Editor workspace, then open the images to be printed first; otherwise multi-select the pictures from inside the Organizer.
- 2 Select File > Print and choose Picture Package from the Type of Print menu. From the Editor this action will open the Organizer and display another version of the Print dialog with your selected images already included.
- 3 Now use the Add and Remove Photos buttons to adjust the list of pictures to be included in the Picture Package.
- 4 Select the printer from the drop-down list in section 1 of the dialog. If need be, change the Printer Settings and Paper Size values.
- 5 With Picture Package selected from the drop-down list of print types, you will be able to choose the Layout and Frame design to be included.
- 6 To repeat a single image on a page click the Fill Pages with First Photo option. To add many different pictures to the same page leave this item unchecked.
- 7 Click Print to output the Picture Package pages.

When selecting the Print Package option in the Type of Print section you will be presented with extra layout and frame options.

The Individual Prints option provides both the ability to output a single photo as well as the mechanism to print many photos in a batch.

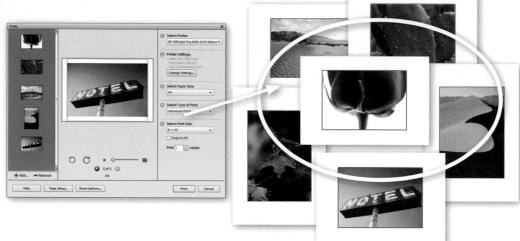

Multiple Individual Prints

We have already looked at the way the Individual Prints option can be used to output a single photo but this Print Type can also be used to allow users to print multiple photos on individual pages. Until recently you were able to only print one photo on a page at a time. This approach is fine if all you want to do is print a single photo, but what if you have 10 pictures that you want to print quickly and easily? Well, this is where the Individual Print option comes into play.

This option allows the user to 'batch' a variety of one-image-to-one page photos at the same time. Although you don't have as many options when outputting your picture with this feature you can still choose the size of the photo on the page and whether it will be cropped in order to fill the paper size fully.

Multiple individual prints workflow:

- 1 Multi-select the pictures from inside the Organizer workspace.
- 2 Select File > Print and choose Individual Prints from the Type of Print section. Choose One Photo Per Page from the More Options dialog.
- 3 Use the Add and Remove Photos buttons to adjust the list of pictures to be included.
- 4 Select the printer from the drop-down list in section 1 of the dialog. Check the Printer Settings and click the Change Settings button to adjust the hardware settings to suit your output.
- 5 In section 3 of the dialog select choose the Paper Size.
- 6 Next select the Print Size you desire. Picking the Crop to Fit option will fill the print size with photo.
- 7 Click Print to output the individual prints.

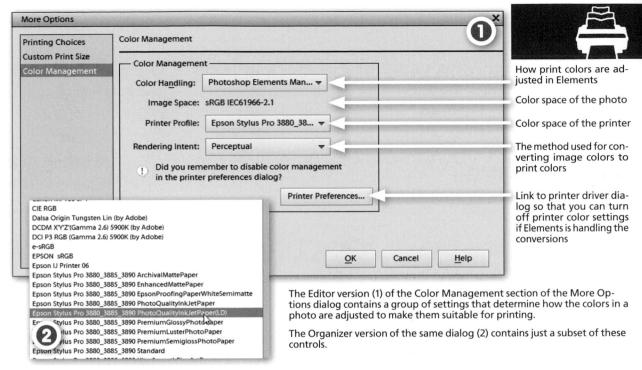

Color Management in the Print Dialog

There are several settings in the Color Management Section located under the More Options section of the Print dialog that are useful for ensuring that you get the best color match between screen and print. These settings are also the ones that many users have difficulties with understanding how and when to use them. Let's look at each in turn.

Color Handling

One of the key tasks that needs to be handled when printing is the massaging of the colors in the photo so that they fit the range of colors that can be output by the printer. The choices in the Color Handling menu determine how this massaging will be handled. There are three options:

Printer Manages Color – The picture is sent to the printer and the printer massages the colors to fit. This option provides good results and is simplest to use.

Photoshop Elements Manages Color – Photoshop Elements controls the adjustment of the image tones to suit the printer's capabilities. This provides the best results but does require the user to set both the Printer Profile and Rendering intent carefully as well as making sure that the printer is not using its own color management system.

No Color Management – This option is not recommended as using it will mean that the photo, printer and Photoshop Elements will not share a common understanding about the colors in the photo.

Printer Profile

The Printer Profile is a small settings file that describes to Photoshop Elements the range of colors that are capable of being printed by the device. Most often these files are downloaded to your computer when you install the drivers for a new printer. Some printers have a single printer profile, others have several different versions depending on the paper surface that you are printing on. If you have selected the Photoshop Elements Manages Colors option then you need to also correctly choose the printer profile from the drop-down list in the Color Management section of More Options area of the Print dialog.

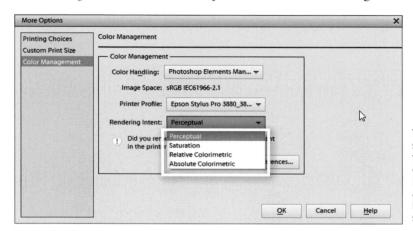

The Rendering Intent setting you pick determines how the colors that are present in your photo but not able to be printed are handled by Photoshop Elements.

Rendering Intent

At various points in the digital photography process it is necessary to change or alter the spread of colors in a picture so that they fit the characteristics of an output device, such as a screen or printer, more fully. The Photoshop Elements user has four choices of approach that the program can use in this conversion process. Each approach produces different results and is based on a specific conversion or 'rendering intent'. Specific conversion approaches can be selected from the Rendering Intent drop-down menu in the Color Management section of the print dialog. The options are:

The **Relative Colorimetric** setting squashes or stretches the range of colors in the original photo so that they fit the range of possible colors that the new device can display or print.

The **Saturation** option tries to maintain the strength of colors during the conversion process (even if color accuracy is the cost).

The **Perceptual** setting puts conversion emphasis on ensuring that the adjusted picture, when viewed on the new output device, appears to the human eye to be very similar to the original photo.

The **Absolute Colorimetric** option translates colors exactly from the original photo to the range of colors for the new device. Those colors that can't be displayed are clipped.

Sound a little confusing? Well don't worry. The default setting, Relative Colorimetric, is usually a fine choice for most subjects.

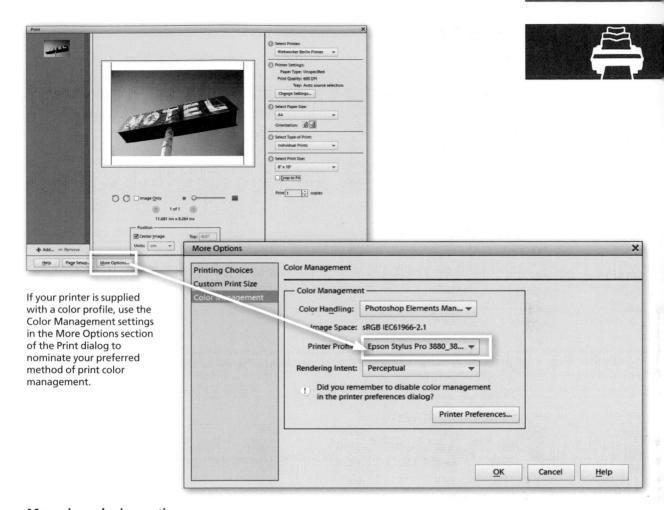

Managing color in practice

As computer operating systems have developed, so too has the way that they have handled the management of color, from capture through the manipulation phase to output. A central part of this process is a group of settings, called a color profile, that governs the conversion of an image's color from one device to another. A well-calibrated system will contain a profile for scanner/camera, screen, printer and a working profile that is used when editing the file in Elements. These profiles are used so that the image is passed from one managed space to another.

When printing with Adobe Elements it is possible to select the type of color management you want to apply to the output. If your printer came supplied with a profile, you can select it in the Print Space from the More Options section of the Print dialog. Some printers are supplied with several profiles matched to different paper types.

If no profile is supplied, then you can either elect to use the same space the image was captured in or select the Printer Manages Color option in the Color Handling section of the Print dialog. Alternatively you may be able to download and install profiles for your printer from the company's website.

Rid images of persistent casts using the color slider settings built into your printer's driver software.

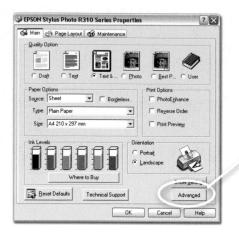

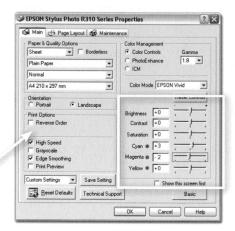

For the majority of output scenarios these options will provide good results. If you do happen to strike problems where images that appear neutral on screen continually print with a dominant cast, then most printer drivers (the special printer software that manages the activity of printing) include a feature that can be used to change individual colors to eliminate casts.

Typical printing problems and their solutions

Surface puddling (pooling)

Prints with this problem show puddles of wet ink on the surface of the paper resulting from too much ink being applied. To help this situation, reduce the Cyan, Yellow and Magenta sliders in the printer's dialog box. Make sure that you make the same change to all three sliders, otherwise you will introduce a color cast into the print. Also increase the Saturation slider; this will decrease the volume of ink going to the black nozzle.

Surface puddling results from too much ink hitting the paper surface.

Cleaning the print heads usually solves banding problems.

Banding

This problem usually results from one or more of the print heads being clogged. Consult your printer's manual to find out how to activate the cleaning sequence. Once completed, print a 'nozzle test' page to check that all the print needs are working correctly. If banding still occurs after several cleaning attempts it may be necessary to install a new cartridge.

Edge bleeding can result from using an uncoated porous paper.

Edge bleeding

Edges of the print appear fuzzy and shadow areas are clogged and too dark. This usually occurs when using an uncoated paper. Use the corrective steps detailed in 'puddling' above, as well as choosing a media or paper type such as 'Plain Paper' or 'Backlit Film'. These measures will change the amount of ink being applied, and the spacing of the ink droplets, to account for the absorbency of the paper.

Web-based Printing

In designing Elements, Adobe realized that the web plays, and will continue to play, a large role in the life of most digital image makers. The inclusion of a web-based Printing option in the package shows just how far online technology has developed.

Although many images you make, or enhance, with Elements will be printed right at your desktop, occasionally you might want the option to output some prints on traditional photographic paper. The Order Prints option, located in the File menu, and in the Create tab after clicking the Photo Prints button, provides just this utility.

Using the resources of **ShutterFly.com**, Elements users can upload copies of their favorite images to the company's site and have them photographically printed in a range of sizes. The finished prints will then be mailed back to you. This service provides the convenience of printing from your desktop with the image and archival qualities of having your digital pictures output using a photographic, rather than inkjet, process.

Making your first online prints

In earlier versions of Elements you needed to access the Online Services feature before uploading your pictures to print, but from Photoshop Elements 9.0 the process was streamlined by allowing you to upload directly from the Editor or Organizer workspace. The first time you use the feature you will need to register for the service but from that time onwards the feature works seamlessly from inside the Elements package.

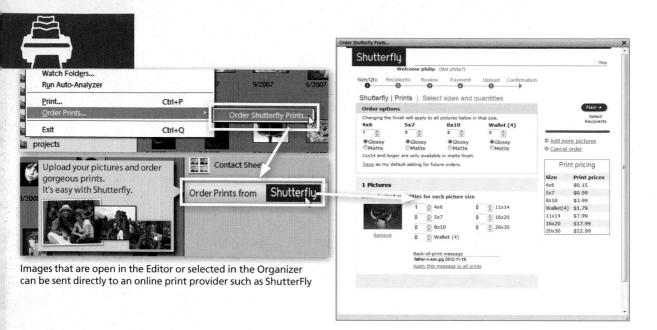

Although some online print providers do have a set of simple online editing and enhancement tools at their main site, I prefer to alter my images in Elements first before uploading. In addition to printing your favorite pictures, companies like ShutterFly also provide album creation and image-sharing services, allowing you and your friends to upload your favorite photos, review them and then print those that you like the most.

If you like the look of true photographic quality prints, then this online option provides a quick, easy and reliable service to output your digital images from your desktop.

Online printing workflow:

- 1 Select or multi-select pictures from Organizer or have the files open in the Editor workspace.
- 2 Choose File > Order prints.
- 3 Choose print numbers and size from the Customize section of shutterfly.com. Click Next.
- 4 Select the recipient of the prints from the list or add new contact details and then click Next.
- 5 Review print and shipping charges at the next screen and then click Next.
- 6 At the Billing section insert your credit card information and add the billing address. Click Place Order, which will upload your pictures and then display an order confirmation.

Index

Index

8-bit mode, 164
12-bit mode, 6
16-bit mode, 6, 164, 218–9, 224
24-bit color, 6, 216
36-bit color, 6
48-bit color, 6, 164, 218
Accented Edges filter, 350
ACR. See Adobe Camera Raw
Add Noise filter, 243-4, 350
Adjust Color Curves, 229–30
Adjust Color for Skin Tone, 211
Adjust Hue/Saturation, 151, 225-6
Adjustment filters, 346–7
Adjustment layers, 286, 297–8
Adjust Sharpness, 235–6
Adjust Smart Fix, 101, 200-1
Adobe Camera Raw (ACR):
introduction, 140
advantages, 164
capture workflow, 137
controls, 144–54
Conversion Settings menu,
144–5
importing photos, 36
keeping up-to-date, 160–1
manual raw conversion
process, 157–60
Noise Reduction, 154
output, 155–6
plug-ins, 161
Raw files
multiple, 162–3
queue, 162-3
rated, 163
sharpening, 152–4
tools, 141
white balance, 146
Adobe com 161

Adobe Revel, 125, 443-4

Advanced mode workflow (importing pictures), 24-6 Advanced techniques: introduction, 215 bit depth, 216-9 16-bit mode, 224 color control, 225-32 image size, 248-52 lighting, 222-4 manual tonal control, 220-4 retouching, 237-43 sharpening, 232-7 texture, 243-7 Airbrush tool, 191, 236, 325 Albums: categories (groups), 85 finding photos in, 87 in Full Screen mode, 84-5 group alike photos in, 80-5 importing into, 73-4 Online (See Online Albums) Photoshop Elements, 54–6 Smart, 56, 81-4 Alignment and justification (text), 310-1, 318 Alignment tool, 376 Android tablet applications, 3, 332 Angled Strokes filter, 350 Anti-Alias, 313 Arrange document windows, 187 Automatic features: Auto Color, 101 Auto Color Correction, 207, 225

Auto Contrast, 102, 199–200,

Autofill settings (Photo Books),

221 - 2

404

Auto Levels, 102, 200, 221–2 automatic bracketing (Photomerge Exposure), 365 automatic corrections, 46-9 automatic editing, 14 Fix Task pane, 101-6 semi-automatic editing, 14-5 Auto Raw conversions, 139-40 Auto Red Eye Fix, 103 Auto Sharpen, 103, 234 Auto Smart Fix, 101, 200 Auto Straightening, 44-5 Auto Tonal control, 151 Auto White Balance, 206 Editor workspace options, 48 Organizer workspace options, 46-8 Panorama workflow (Photomerge), 382 people recognition, 77-8 Photo Stacks automatic suggestions for, 72 Auto stacks, 56-7, 98 skin tone protection, 214

Background Eraser tool, 331
Background layers, 284–5
Backup, 57–8, 93–6
Banding (printing), 484
Bas Relief filter, 350
Bit depth, 5–6, 216–9
Black points, pegging, 222–3
Blacks, 149
Blank File, 37–8
Blur filters, 350
Blur tool, 188–9, 237
Bridge workspace (Mac), 11

Brightness/Contrast, 197–201, 220–1, 226 Brush tools: introduction, 188–9, 324 Airbrush tool, 191, 236, 325 Brush Settings panel, 324–5 custom brush creation, 333–4 Detail Smart Brush tool, 263, 267–8 dodging and burning, 337 Healing Brush tool, 241 Impressionist Brush tool, 328 Paint Brush tool, 298 Selection Brush tool, 257–9, 296–7 Smart Brush tool, 188–9, 263–7, 280, 287 Spot Healing Brush tool, 188–90, 240 Burn or Dodge tool, 190, 203–5, 337 Calendars: introduction, 111, 391 creation, 109, 111, 402 editing photos before adding, 393 exporting, 420 Frame layers, 288 layout options, 392–3 production, 393 selection of images, 394–5 summary, 418 Canvas Size, 251–2 Cards. See Greeting Cards CDs: create options, 115, 117	Collages: introduction, 110, 391 creation, 109–10, 398–400 editing existing design, 408 editing pictures before adding, 393 Effects pane, 417 exporting, 420 Frame layers, 288 layout options, 392–3 production, 393 selection of images, 394–5 summary, 418 Color correction: introduction, 205–6 auto correction, 207, 225 color cast removal, 207–8 color curves, 229–30 color variations, 145, 208–9, 227 gray point eyedropper, 223 red eye removal, 209–10 skin tone, 211 tonal adjustments, 146 Color (bit) depth, 5–6, 216–9 Colored Pencil filter, 351 Color Halftone filter, 351 Color Halftone filter, 351 Color Replacement tool, 329 Color Variations, 145, 208–9, 227 ColorVision calibration, 196 Comic filter, 348 Compare Photos Side by Side, 39–40 Computers, importing photos from, 30 Contact sheets. 477–8	Clipping Mask, 299–300 greeting cards, 112 instant movie, 118 Photo Books/Collages, 109–10 Photo Calendars, 111 Photo Prints, 113 Photo projects, 108–9 slide shows, 114 VCD/DVD with menu, 116 Create Task panes, 19–20 Cropping: introduction, 42 canvas size, 252 Instant Fix option, 104 photo shape, 211 tools, 42–5, 188–9, 191, 339–40 Crosshatch filter, 352 Custom brush creation, 333–4 Custom filter, 352 Custom Path tool, 306, 311 Custom print size, 471 Custom Shape tool, 188–9 Cutout filter, 352 Depth of Field (DOF), 170–1 Detail Smart Brush tool, 263, 267–8 Digital basics: photography, 2–3 Photoshop Elements, 8 process, 6–7 quality factors, 5–6 scanners, 5 Divide Scanned Photos, 30–1 Document windows, arranging, 187
	100 July 100	•
_		
create options, 115, 117 export to, 435 jackets/labels, 115, 117 Chalk & Charcoal filter, 351 Charge-coupled devices (CCDs), 4 Chrome filter, 351 Clarity, 149–50 Clipboard, 38 Clone Stamp tool, 188–90, 239	Contact sheets, 477–8 Conté Crayon filter, 351 Contrast, 148 Cookie Cutter tool, 188–9, 191, 339–40 Craquelure filter, 352 Create options: introduction, 107–8 CD/DVD, 115, 117	187 Dodge and Burn tools, 190, 203–5, 337 Drawing: introduction, 321–2 tools, 190–1, 337–42 Dust & Scratches filter, 237–8

Eyedropper buttons, 222–3

DVDs:	Facebook, 128, 443–4	Brightness/Contrast, 197-201,
Create options, 115, 117	File formats:	220–1, 226
export to, 435	introduction, 55	color corrections, 205-11
jackets/labels, 115, 117	Flash, 425	color management, 196–7
with menu, 116	GIF, 425-30	document windows, arranging,
Online Video sharing, 124	JPEG, 134-6, 145, 164, 243,	187
presentations, 3	425–30	Dodge and Burn tools, 190,
•	JPEG 2000, 425-30	203–5, 337
Edge bleeding (printing), 485	online compression, 429–30	interface, 184–5
Editor workspace:	Photo Creation (.PSE), 412	menus, 186–7
introduction, 11, 14	PNG, 425–30	options bar, 192
auto options, 48	PSD, 285	palettes, panels and panes,
cropping, 43	TIFF, 134-6, 145, 164, 216, 285	192–3
importing photos, 35–9	FileZilla software, 434	screen set up, 194–6
into Photomerge, 366–7	Fill layers, 287, 297–8	Shadows/Highlights, 202–3
moving between Organizer	Fill Light, 149	tone alterations, 201–2
workspace and, 17–9	Filter Gallery, 344–6	tools, 188–91
multiple files, processing, 106	Filters:	Full Screen mode:
Print dialog options, 468	introduction, 343-4	albums in, 84–5
printing, 50–1	adjustment, 346–7	photos in, 39–40
viewing pictures, 40–1	new filters, 348–9	Full View tagging, 79
Elliptical Marquee tool, 255–6,	Sharpen, 347, 357	GIF format, 425–30
258	types of, 350–60	Global enhancement, 218
E-mail:	usage tips, 360	Gradient tool, 188–9, 191
attachments, 122, 445-7	Find feature, 87–8	Grain filter, 245–6
Photoshop.com, 455-6, 458-9	Fix Task pane:	Graphic Novel filter, 349
Enhancement tools, 190	introduction, 99	Graphics:
Eraser tools:	automatic editing, 101-6	in content pane, 340–2
introduction, 188-9, 330	editing options, 105	in Projects pane, 416
Background Eraser tool, 331	features, 100	Gray point eyedropper, 223
layer masks, 298	Flash format, 425	Greeting Cards:
Magic Eraser tool, 331	Flickr.com, 89, 127, 441-3	introduction, 112, 391
Style Eraser tool, 268–9,	Fonts:	creation, 109, 112, 401
388–90	family and style, 317	editing photos before adding,
types of, 330–1	size, 316–7	393
Export:	Frame from Video, 38–9	exporting, 420
to CD/DVD, 435	Frame layers, 288, 400	Frame layers, 288
to Hard Drive, 435	Free Transform tool, 211, 409	layout options, 392–3
Photo Books, Collages,	Full editor:	production, 393
Calendars and Cards,	introduction, 183	selection of images, 394–5
420	Adjust Smart Fix, 200–1	summary, 418
Exposure:	Auto Contrast, 102, 199–200,	Group Custom Name, as tag, 72–3
highlights, 147–8	221–2	Group Shot (Photomerge), 365–6,
Photomerge, 365, 376-9	Auto Levels, 102, 200, 221-2	368–70

Auto Smart Fix, 101, 200

Guided editor: introduction, 165–7 automated processing, 178 Depth of Field, 170–1 Lomo Camera effect, 174 new entries, 167 options, 167–8 Orton effect, 172–3 Out of Bounds, 175 Perfect Portrait, 177 Photoshop Elements, 16 Photo Stack Guided Edit, 168–9 Pop Art, 176 Reflection, 176	Impressionist Brush tool, 328 Ink Outlines filter, 352 Internet Service Providers (ISPs), 434 Invert tool, 231 iPad tablet applications, 3, 332 ISO values, 242 'Jaggies' (text), 313 JPEG 2000 format, 425–30 JPEG format, 134–6, 145, 164, 243, 425–30 Keyword tags: introduction, 74	Lighting: advanced techniques, 222–4 exposure highlights, 147–8 Fill Light, 149 Lighting Effects filter, 353 Shadows/Highlights, 202–3 Local enhancement, 218 Lomo Camera effect, 174 Luminance, 154 Magic Eraser tool, 331 Magic Extractor, 278–9, 332 Magic Wand tool, 188–90, 259–60, 326–7 Magnetic Lasso tool, 256–7, 259
restricted access, 178	categories/subcategories, 75	Manual editor, 16–7
Tilt Shift, 173	finding photos, 87	Manual tonal control, 220–4
Hand coloring black and white photos, 335–6	Make Group Custom Name a Tag, 72–3 new, 75	Map reference (Windows only), 89 Marquee tool, 190, 255–6, 258, 345
Hand tool, 188–90	Photoshop.com, 453–4	Masking:
Healing Brush tool, 241	Photoshop Elements, 53–4	Clipping Masks, 299–300
Highlights, 148	workflow, 75	layers, 296–302
High Pass filter, 352		type masks, 312
Histogram, 220–1	Lasso tools, 190, 255–9	Maximum filter, 353
Hue/Saturation, 151, 225–6	Layers:	Media-Analysis and smart tags, 78
	introduction, 281	Median filter, 353
Image from Clipboard, 38	blend mode, 291	Mezzotint filter, 353
Image layers, 284, 286	Clipping Masks, 299–300	Minimum filter, 354
Image rotation, 41–2	creation, 294–5	Monitor calibration, 196
Image Size, 248–51 Importing photos:	masking, 296–302 advanced, 300	Mosaic filter, 354 Mosaic Tile filter, 354
into Albums, 73–4	filling and adjusting layers,	Move tool, 188–90, 320
from cameras, 24–7	297–8	Wove tool, 166–30, 320
from computers, 30	shortcuts, 301–2	Navigator tool, 41
Editor workspace, 35–9	nondestructive sizing, 288–9	Neon Glow filter, 354
Frame from Video, 38–9	organization, 302–4	New documents, 37–8
from iPhoto (Mac), 34	origins, 282	Noise:
Organizer workspace:, 24-39	palette, 283–4	Add Noise filter, 243-4, 350
into Photomerge, 366–7	shortcuts, 304	Noise Reduction, 154
Raw files, 36	style, 292–3	Reduce Noise tool, 242–3
resolution, 27–9, 37–8	transparency, 290	Note Paper filter, 354
from scanners, 27–31	types of, 284–9	Ocean Pipple filter 254
by searching, 33–4 from Watched Folders, 32–3	Leading (text), 318 Lens Flare filter, 353	Ocean Ripple filter, 354 Offset filter, 355
s trateried Folders, 52 S	Lens Flate Intel 333	onset intell 333

Online Albums:	saving, 52–3	step 2: output type and size,
introduction, 431	searching, 74, 87, 90–2	403
choosing pictures for, 432	Shortcuts bar, 66–7	step 3: adjust Autofill and
creation, 433, 435-7	SmugMug Gallery, 129	Page settings, 404
with Flickr, 441–3	tagging photos, 74–5	step 4: adjusting the look of
print access, 485–6	versioning edits, 96–7	book pages, 404
sharing options, 121, 432-4,	viewing pictures, 39–40	step 5: production, 405–6
438–40	welcome screen, 62–3	step 6: fine-tuning, 406–7
Online Video sharing Burn DVD/	Orton effect, 172–3	step 7: saving, 407
BluRay, 124	Out of Bounds, 175	editing existing design, 408
Open options (importing photos),		editing photos before adding,
35–7	Paint Brush tool, 298	393
Organize Open Files, 37	Paint Bucket tool, 191, 326–7	exporting, 420
Organizer Search Box, 87	Paint Daubs filter, 355	frame and picture adjustments,
Organizer workspace:	Painting:	408–10
introduction, 11, 12–3, 59–61	introduction, 321–2	Frame layers, 288
Actions bar, 67–8	tools, 323-37 (See also Brush	layout options, 392–3
advanced options (Photo	tools)	pages (adding, deleting,
Downloader), 72–4	colors, 323	moving), 412–3
albums, 80–5	description, 190–1	photos (adding, removing,
asset protection, 93-6	hand coloring black and	replacing), 410–1
auto options, 46-8	white photos,	printing, 418–9
backup, 57-8, 93-6	335–6	production, 393
Bottom bar, 68	Palette Knife filter, 355	projects, 109–10
cropping, 42–3	Palettes, panels and panes, 192-3	Projects pane, 414–7
find feature, 87–8	Panorama (Photomerge):	selection of images, 394-5
Full View tagging, 79	introduction, 380-1	ShutterFly.com, 393
importing photos, 24-39	auto workflow, 382	summary, 418
into Photomerge, 366	manual workflow, 383-5	Photo Calendars. See Calendars
keyword tagging, 74-5	stitching modes, 381–2	Photo Cards. See Greeting Cards
locating files, 86–9	Patchwork filter, 355	Photo Collages. See Collages
managing photos, 69-71	PDF Slide show, 130	Photo Creation file format (.PSE),
map reference, 89	Pen and Ink filter, 349	412
media-analysis and smart tags,	Pencil tool, 191, 326	Photo Filter, 231–2
78	People Recognition technology	Photo frames (digital), 2
Menu bar, 64–5	(face tagging), 76–7	Photo Mail (Windows), 123, 447
moving between Editor	Perfect Portrait, 177	Photomerge:
workspace and, 17–9	Phone folios, 3	introduction, 361–2
multiple files, 106	Phone photos, 126	automatic bracketing, 365
People Recognition technology,	Photo Books:	background matching, 365-6
76–7	introduction, 391	exposure, 376–9
Photo Stacks, 56-7, 97-8	creation	faces, 370–2
printing, 50–1, 468	introduction, 396–7	face to face positioning, 366
recognizing people	step 1: selection of images,	Group Shot, 365-6, 368-70
automatically, 77–8	403	importing images, 366–7

options, 38 paint-on styling, 388–90 Panorama, 380–5 Photomerge Panorama source files, 364–5 problems, 385–6 Raw files as source files, 367 Scene Cleaner, 365–6, 372–6 shooting tips, 362–4 Style Match, 268, 386–8 Photo Prints, 113 Photo projects, 109–10. See also Calendars; Collages; Greeting Cards; Photo Books Photoshop.com:	straightening, 42–6 step 5: automatic corrections, 46–9 step 6: printing, 50–1 step 7: saving, 52–3 step 8: organizing pictures, 53–7 step 9: back up, 57–8 tools, 10 Watched Photos, 32–3 welcome screen, 10–2, 23, 62–3 workflow, 10–2 workspaces, 11 Photoshop Elements community, 62–3, 422	Poster Edges filter, 356 Posterize filter, 356 Posterize tool, 230 Premiere Elements, 22, 118, 124 Printing: introduction, 2, 465–8 contact sheets, 477–8 first prints, 476 multiple prints, 477, 480 output from desktop, 467 paper type and print quality,
deleting images, 459	Photoshopelements.net, 2–3	color management, 481–4
downloading images to	Photoshop Express Editor, 448,	custom print size, 471
desktop, 459–60	450, 453	help, 471
edit/decorate, 454	Photoshopshowcase.com, 131,	options, 472–4
e-mailing, 458–9	423–4, 438–9, 448	page setup, 472
enhancing online, 448–50	Photo Stacks:	paper size, 469
extra features, 453	introduction, 56, 97	print copies, 471
keyword tagging, 453–4	automatic suggestions for, 72	printer selection, 468
linking, e-mailing and	Auto stacks, 56–7, 98	printer settings, 468–9
publishing photos/	creation, 57, 97	print size, 470–1
albums, 455–6	Guided Edit, 168–9	type or print selections, 469
My Gallery area, 450–2	Pinch filter, 355	printer profile, 482
order prints, 459	Pixels:	problems and solutions, 484–5
private and shared albums,	Detail Smart Brush tool, 268	project bin, 474–5
452–3	digital basics, 4–6	rendering intent, 482
slideshows, 456–7	Dodge and Burn tool, 337	web-based printing, 467,
template adjustments, 457	Eraser tools, 330–1	485–6
workspaces, 450 Photoshop Elements:	fonts, 316	Project Bin, 19, 474–5
introduction, 22–3	Histogram, 220–1 image size, 248–50	Projects pane: effects, 417
Apple Macintosh, 22	importing photos, 27–9, 37–8	graphics, 416
16 bit enabled, 218–9	Place command, 37	layouts, 415
new features in, 10, 20–1	Plaster filter, 355	pages, 414–5
Premiere Elements, 22	Plastic Wrap filter, 356	text, 416–7
step 1: importing pictures,	Plug-ins, 344	PSD format, 285
24–39	PNG formats, 425–30	,
step 2: viewing pictures, 39–41	Pointillize filter, 356	Quick editor, 179–82
step 3: image rotation, 41–2	Polygonal Lasso tool, 255, 257–9	Quick Fix panel controls, 181–2
step 4: cropping and	Pop Art, 176	

Quick Selection tool, 188–9, 255, 261–2, 310 Raw shooting: introduction, 133 Adobe Camera Raw (See Adobe Camera Raw) Auto Raw conversions, 139–40 bit depth, 216 capture workflow, 137 digital capture, 134–5 enabling Raw camera, 136 enhancement workflow, 147–51 file description, 135 file queue, 162–3 histogram, 142–3 importing photos, 36 other options, 155–6 Photomerge, 367 preview space, 142 RGB readout and camera sittings summary, 143	Divide Scanned photos, 30–1 importing photos from, 27–31 Scene Cleaner (Photomerge), 365–6, 372–6 Scratches filter, 237–8 Screen set up for Elements, 194–6 Search: Duplicate Photos, 92 importing photos by, 33–4 Objects within Photos, 91 Organizer workspace, 74, 87, 90–2 Visually Similar Photos, 90 Selection Brush tool, 257–9, 296–7 Selections: introduction, 253 adding, 270 basics, 254–5 beyond one step, 270–80 color and tone tools, 259–60 Combination tools, 261–2 drawing selection tools, 255–9	tool, 337–9 Shapes, in content pane, 340–2 Share video with YouTube, 122 Sharing: introduction, 19–20, 119 Adobe Revel, 125, 443–4 Burn DVD/BluRay, 124 e-mail attachments, 122, 446 Facebook, 128, 443–4 Flickr, 127, 441–3 Online Albums, 121, 432–4, 438–40 options, 120 PDF Slide Show, 130 phone photos, 126 Photo Mail, 123 Photoshopsshowcase.com, 131, 423–4, 438–9, 448 photo sites, 443–4 SmugMug Gallery, 129 Vimeo, 132 YouTube, 122
	_	
Recognizing People Automatically, 77–8	growing, 274 intersecting, 271	Sharpen: Adobe Camera Raw, 152–4
Recompose tool, 188–9, 191,	inverting, 273	advanced techniques, 232–7
211–4	layer masks, 298	Auto Sharpen, 103, 234
Rectangular Marquee tool, 188–9,	loading saved, 272	filters, 347, 357
255–6, 258	Magic Extractor, 278–9	tools, 235–7
Red Eye Removal tool, 103, 188–	modifying, 275–7	Shear filter, 357
90, 209–10, 448	paint on changes, 280	Show Regions/Strokes (Scene
Reduce Noise tool, 242–3	saving, 272	Cleaner), 375
Refine Edge tool, 276–7	similar picture parts, 274	ShutterFly.com:
Reflection, 176	Style Painter, 268–9	Photo Books, 393
Remove Color Cast, 145, 207-8	subtracting, 271	photo prints, 110, 113
Resizing, 248–52	tools, 190, 255	printing, 459, 485
Resolution, 27–9, 37–8	transforming, 273	Size:
Reticulation filter, 356	Semi-automatic editing, 14–5	canvas size, 251–2
Retouching techniques, 237–43	Shadows, 149	fonts, 316–7
Rotation controls, 44–6	Shadows/Highlights, 202–3	image size, 248–52
Rough Pastels filter, 356	Shape:	online files, 426–8
Caturation 1E1 22E C	cropping, 211	Photo Books, 403
Saturation, 151, 225–6 Scanners:	Custom Shape tool, 188–9	print size, 469–71
digital basics, 5	layers, 285	
digital pasics, 3	text, 306, 311	

Slideshows:	leading, 318	Warping type, 314
introduction, 2	paragraph type, 308	Watched Folders, 32–3
online, 460–4	Projects pane, 416–7	Watercolor filter, 359
PDF, 130	selection, 306, 311	Water Paper filter, 359
Photoshop.com, 456–7	shape, 306, 311	Wave filter, 359
presentations, 114	simple type, 308	Websites and photography, 3
Smart Albums, 56, 81–4	styles, 314–6	Welcome screen, 10–2, 23, 62–3
Smart Brush tool, 188–9, 263–7,	text layers, adding effects to,	White balance, 145–6, 164
280, 287	319–20	White points, pegging, 222–3
Smart erasing, 332	tools, 191, 311	Whites, 149
Smart Fix, 101, 200–1	type layers, 314–6	Wind filter, 359
Smudge Stick filter, 357	type masks, 312	World Wide Web:
SmugMug Gallery, 129, 443–4	warping type, 314	introduction, 421–3
Solarize filter, 357	WYSIWYG formats, 306–7	account creation, 423–4
Spatter filter, 357	Texture, adding, 243–7	compression formats, 429–30
Spherize filter, 358	Texturizer filter, 247, 358	e-mail attachments, 445–7
Sponge tool, 188–9, 228	Threshold filter, 359	image quality/file size, 426–8
Spot Healing Brush tool, 188–90,	TIFF format, 134–6, 145, 164, 216,	images on, 424–5
240	285	Photo Mail, 123, 447
Sprayed Strokes filter, 358	Tiles filter, 359	Photoshop.com, 448–59
Stacks. See Photo Stacks	Tilt Shift, 173	Photoshop Elements
Stained Glass filter, 358	Tonal adjustments, 146	community, 62–3, 422
Stamp filter, 358	Torn Edges filter, 359	picture formats, 425
Standard dialog workflow	Twirl filter, 359	web gallery (See Online
(importing pictures), 24	Type:	Albums)
Straightening tools, 188–9	layers, 285	WYSIWYG formats, 306–7
Straighten tool, 45, 188–9, 191	masks, 312	s 2 4 5 1
Style Eraser tool, 268–9, 388–90	tool, 190–1, 320	ZigZag filter, 359
Style Painter tool, 268–9, 388–90		Zoom tool, 40, 190, 238, 428
Sumi-e filter, 358	Underpainting filter, 359	
Surface puddling (pooling), 484	Undo revert and undo history, 49	
	Unsharp Mask, 234–5	
Tablets, 3, 332		
Tagging photos. See Keyword tags	VCD/DVD with menu, 116	
Talbot, Fox, 2	Versioning edits, 96–7	
Task-based panes, 13	Version sets, 48–9, 104	
Text:	Vibrance, 150–1	
introduction, 305–6	Video cameras, 5	
adding, 318–9	View:	
alignment, 310–1, 318	Editor workspace:, 40–1	
changes, 308–9	Full Screen, 39–40	
Custom Path, 306, 311	Full View tagging, 79	
fonts, 316–7	Organizer workspace:, 39–40	
'jaggies,' 313	tools, 190	
justification, 318	Vimeo, 132	

On the Website...

To coincide with the release of Photoshop Elements 11 for Photographers I have put together a series of video tutorials for book owners on the supporting website (www.photoshopelements.net) that will help you make the most out of the new features in the program. There are also a bunch of free resources that are featured in the book. Use these images to work along with me when building your Elements skills.

ALL WEBSITE VISITORS GET:

- 1. Top ten tips and what's new video tutorials
- 2. Book resources and
- 3. Example chapter from Photoshop Elements 10 for Photographers
- 4. FAQ section

www.PhotoshopElements.net